The Grove Dictionary of Art

From David to Ingres

The Grove Dictionary of Art

Other titles in this series:

From Renaissance to Impressionism
Styles and Movements in Western Art, 1400–1900
ISBN 0–333–92045–7

From Expressionism to Post-Modernism
Styles and Movements in 20th-century Western Art
ISBN 0–333–92046–5

From Rembrandt to Vermeer
17th-century Dutch Artists
ISBN 0–333–92044–9

From Monet to Cézanne
Late 19th-century French Artists
ISBN 0–333–92043–0

Praise for *The Dictionary of Art*

'It is hard to resist superlatives about the new *Dictionary of Art*... If this isn't the most important art-publishing event of the 20th century, coming right at its end, one would like to know what its plausible competitors are. In fact there aren't any....'
Robert Hughes, *Time Magazine*

'The *Dictionary of Art* succeeds in performing that most difficult of balancing acts, satisfying specialists while at the same time remaining accessible to the general reader.'
Richard Cork, *The Times*

'As a reference work, there is nothing to compare with *The Dictionary of Art*. People who work in the arts - lecturers, curators, dealers, researchers and journalists - will find it impossible to do their jobs without the magnificent resource now available to them.'
Richard Dorment, *The Daily Telegraph*

'These are whole books within books... An extraordinary work of reference.'
E. V. Thaw, *The Wall Street Journal*

'It's not at all hyperbolic to say the dictionary is the rarest kind of undertaking, one that makes you glad it happened during your life.'
Alan G. Artner, *Chicago Tribune*

The Grove Dictionary of Art

From David to Ingres

Early 19th-century French Artists

Edited by Jane Turner

GROVEart

The Grove Art Series
From David to Ingres
Early 19th-century French Artists
Edited by Jane Turner

© Macmillan Reference Limited, 2000

Published in the United Kingdom by
MACMILLAN REFERENCE LIMITED, 2000
25 Eccleston Place, London, SW1W 9NF, UK
Basingstoke and Oxford
ISBN: 0-333-92042-2
Associated companies throughout the world
http://www.macmillan-reference.co.uk

British Library Cataloguing in Publication Data
From David to Ingres: early 19th-century French artists. -
 (Grove art)
 1. Artists–France–Biography
 2. Art, Modern–19th century–France
 3. Art, French
 I. Turner, Jane, 1956–
709.4'4'09034
ISBN 0-333-92042-2

Typeset in the United Kingdom by Florence Production Ltd, Stoodleigh, Devon
Printed and bound in the United Kingdom by TJ International Ltd, Padstow, Cornwall

Contents

Preface

In these days of information glut, *The Dictionary of Art* has been a godsend, instantly relegating all its predecessors to oblivion. Within its stately thirty-four volumes (one for the index), the territory covered seems boundless. Just to choose the most amusingly subtitled of the series, *Leather to Macho* (vol. 19), we can learn in the first article not only about the way animal skins are preserved, but about the use of leather through the ages, from medieval ecclesiastical garments to Charles Eames's furniture. And if we then move to the last entry, which turns out to be a certain Victorio Macho, we discover that in the early 20th century, he graced Spanish cities with public sculpture, including a monument to the novelist Benito Pérez Galdós (1918) that many of us have passed by in Madrid's Parque del Retiro. And should we wish to learn more about Macho, there is the latest biblio-graphical news, bringing us up to date with a monograph of 1987.

Skimming the same volume, we may stumble upon everything from the art of the LEGA people in Zaïre and the use of artificial LIGHTING in architecture to somewhat more predictable dictionary entries such as LICHTENSTEIN, ROY; LONDON: WESTMINSTER ABBEY; LITHOGRAPHY; or LOS ANGELES: MUSEUMS. If browsing through one volume of *The Dictionary of Art* can open so many vistas, the effect of the whole reference work is like casting one's net into the waters and bringing back an unmanageable infinity of fish. Wouldn't it be more useful at times to single out in one place some of the myriad species swimming through the pages of *The Dictionary*? And then there is the question of cost and dimensions. In its original, complete form, the inevitably stiff price and the sheer size of all thirty-four volumes meant that it has fallen mostly to reference libraries to provide us with this awesome and indispensable tool of knowledge.

Wisely, it has now been decided to make this overwhelming databank more specialized, more portable, and more financially accessible. To do this, the myriad sands have been sifted in order to compile more modest and more immediately useful single volumes that will be restricted, say, to Dutch painting of the 17th century or to a survey of major styles and movements in Western art from the Renaissance to the end of the 19th century. So, as much as we may enjoy the countless delights of leafing through the thirty-four volumes in some library, we can now walk off with only one volume that suits our immediate purpose, an unparalleled handbook for a wide range of readers, especially for students and scholars who, rather than wandering through the astronomical abundance of art's A to Z, want to have between only two covers the latest words about a particular artist or 'ism'.

The great art historian Erwin Panofsky once said 'There is no substitute for information'. This new format of *The Dictionary of Art* will help many generations meet his sensible demands.

ROBERT ROSENBLUM
Henry Ittleson jr Professor of Modern European Art
Institute of Fine Arts
New York University

List of Contributors

Alegret, Celia
Bajou, Valérie M. C.
Barbin, Madeleine
Barker, Emma
Beard, Dorathea K.
Bell-Carrier, Cheryl E.
Benge, Glenn F.
Boime, Albert
Brisac, Catherine
Caffort, Michel
Chaudonneret, Marie-Claude
Chazal, Gilles
Chessex, Pierre
Condon, Patricia
Conisbee, Philip
Corbin, Donna
Cuzin, Jean-Pierre
Daguerre De Hureaux, A.
Davenport, Nancy
Drapkin, Joshua
Durey, Philippe
Eitner, Lorenz
Genardière, Y. De La
Grunewald, Marie-Antoinette
Guicharnaud, Hélène
Harrison, Colin
Hauptman, William
Hellyer, M.-E.
Herding, Klaus
Howard, Michael
Hubert, Gérard
Huchard, Viviane
Johnston, William R.
Jones, Mark
Klingsöhr Le Roy, Cathrin
Lapparent, Anne-Marie De
Lee, Simon
Legrand, Catherine
Leighton, John
Lemaistre, Isabelle
Leoussi, Athena S. E.
Méker, Pascale
Mainz, Valerie
Margerie, Laure De
Marin, Régis

McCormick, Thomas J.
McPherson, Heather
Melot, Michel
Menu, Daniège
Mercier, Huguette
Michel, Christian
Michel, Olivier
Millard, Charles
Miquel, Pierre
Mitchell, Peter
Morel, Dominique
Mosby, Dewey F.
Munhall, Edgar
Munro, Jane
Nevison Brown, Stephanie
Nicholson, Kathleen
Normand-Romain, Antoinette Le
Pérez, Marie-Félicie
Parmantier-Lallement, Nicole
Pauchet-Warlop, Laurence
Peake, Lorraine
Pellicer, Laure
Picquenard, Thérèse
Pingeot, Anne
Pointon, Marcia
Preston, Harley
Preston Worley, Michael
Reynolds, Graham
Rocher-Jauneau, Madeleine
Roland Michel, Marianne
Rosenthal, Donald A.
Sandt, Anne Van De
Sandt, Udolpho Van De
Scherf, Guilhem
Scottez-De Wambrechies, Annie
Sells, Christopher
Sorel, Philippe
Soubiran, Jean-Roger
Spencer-Longhurst, Paul
Stearn, William T.
Stevenson, Lesley
Stocker, Mark
Thompson, James P. W.
Trapp, Frank
Tscherny, Nadia

Volle, Nathalie
Ward-Jackson, Philip
Weisberg, Gabriel P.
Wells Robertson, Sarah
Weston, Helen

Whiteley, Jon
Whiteley, Linda
Willk-Brocard, Nicole
Wissman, Fronia E.
Wright, Beth S.

General Abbreviations

The abbreviations employed throughout this book do not vary, except for capitalization, regardless of the context in which they are used, including the bibliographical citations and for locations of works of art. For the reader's convenience, separate full lists of abbreviations for locations, periodical titles and standard reference books and series are included as Appendices.

AD	Anno Domini	*d*	died	**inc.**	incomplete		
addn	addition	**ded.**	dedication,	**incl.**	includes,		
a.m.	ante meridiem		dedicated to		including,		
	[before noon]	**dep.**	deposited at		inclusive		
Anon.	Anonymous(ly)	**destr.**	destroyed	**Incorp.**	Incorporation		
app.	appendix	**diam.**	diameter	**inscr.**	inscribed,		
Assoc.	Association	**diss.**	dissertation		Inscription		
attrib.	attribution,	**Doc.**	Document(s)	**intro.**	introduced by,		
	attributed to				introduction		
		ed.	editor, edited (by)	**inv.**	inventory		
B.	Bartsch [catalogue	**edn**	edition	**irreg.**	irregular(ly)		
	of Old Master	**eds**	editors				
	prints]	**e.g.**	*exempli gratia* [for	**jr**	junior		
b	born		example]				
bapt	baptized	**esp.**	especially	**kg**	kilogram(s)		
BC	Before Christ	**est.**	established	**km**	kilometre(s)		
bk, bks	book(s)	**etc**	*et cetera* [and so on]				
BL	British Library	**exh.**	exhibition	**l.**	length		
BM	British Museum			**lb, lbs**	pound(s) weight		
bur	buried	**f, ff**	following page,	**Ltd**	Limited		
			following pages				
c.	*circa* [about]	**facs.**	facsimile	**m**	metre(s)		
can	canonized	**fasc.**	fascicle	**m.**	married		
cat.	catalogue	*fd*	feastday (of a saint)	**M.**	Monsieur		
cf.	confer [compare]	**fig.**	figure (illustration)	**MA**	Master of Arts		
Chap., Chaps		**figs**	figures	**MFA**	Master of Fine Arts		
	Chapter(s)	*fl*	*floruit* [he/she	**mg**	milligram(s)		
Co.	Company;		flourished]	**Mgr**	Monsignor		
	County	**fol., fols**	folio(s)	**misc.**	miscellaneous		
Cod.	Codex, Codices	**ft**	foot, feet	**Mlle**	Mademoiselle		
Col., Cols	Colour;			**mm**	millimetre(s)		
	Collection(s);	**g**	gram(s)	**Mme**	Madame		
	Column(s)	**gen.**	general	**Movt**	Movement		
Coll.	College	**Govt**	Government	**MS., MSS**	manuscript(s)		
collab.	in collaboration	**Gt**	Great	**Mt**	Mount		
	with, collaborated,	**Gtr**	Greater				
	collaborative			**N.**	North(ern);		
Comp.	Comparative;	**h.**	height		National		
	compiled by,	**Hon.**	Honorary,	**n.**	note		
	compiler		Honourable	**n.d.**	no date		
cont.	continued			**NE**	Northeast(ern)		
Contrib.	Contributions,	**ibid.**	*ibidem* [in the	**nn.**	notes		
	Contributor(s)		same place]	**no., nos**	number(s)		
Corp.	Corporation,	**i.e.**	*id est* [that is]	**n.p.**	no place (of		
	Corpus	**illus.**	illustrated,		publication)		
Corr.	Correspondence		illustration	**nr**	near		
Cttee	Committee	**in., ins**	inch(es)	**n. s.**	new series		
		inc.	Incorporated	**NW**	Northwest(ern)		

Occas.	Occasional	**red.**	reduction,		Santissimi
op.	opus		reduced for	**St**	Saint, Sankt,
opp.	opposite; opera	*reg*	*regit* [ruled]		Sint, Szent
	[pl. of opus]	**remod.**	remodelled	**Ste**	Sainte
oz.	ounce(s)	**repr.**	reprint(ed);	**suppl., suppls**	supplement(s),
			reproduced,		supplementary
p	pence		reproduction	**SW**	Southwest(ern)
p., pp.	page(s)	**rest.**	restored,		
p.a.	per annum		restoration	**trans.**	translation,
Pap.	Paper(s)	**rev.**	revision, revised		translated by;
para.	paragraph		(by/for)		transactions
pl.	plate; plural	**Rev.**	Reverend;	**transcr.**	transcribed
pls	plates		Review		by/for
p.m.	post meridiem				
	[after noon]	**S**	San, Santa,	**unpubd**	unpublished
Port.	Portfolio		Santo, Sant',		
Posth.	Posthumous(ly)		São [Saint]	*v*	*verso*
prev.	previous(ly)	**S.**	South(ern)	**var.**	various
priv.	private	**SE**	Southeast(ern)	**viz.**	*videlicet*
pseud.	pseudonym	**sect.**	section		[namely]
pt	part	**ser.**	series	**vol., vols**	volume(s)
pubd	published	**sing.**	singular	**vs.**	versus
pubn(s)	publication(s)	**sq.**	square		
		SS	Saints, Santi,	**W.**	West(ern)
R	reprint		Santissima,	**w.**	width
r	*recto*		Santissimo,		

Note on the Use of the Book

This note is intended as a short guide to the basic editorial conventions adopted in this book.

Abbreviations in general use in the book are listed on p. x; those used in bibliographies and for locations of works of art or exhibition venues are listed in the Appendices.

Author's signatures appear at the end of the articles. Where an article was compiled by the editors or in the few cases where an author has wished to remain anonymous, this is indicated by a square box (□) instead of a signature.

Bibliographies are arranged chronologically (within a section, where divided) by order of year of first publication and, within years, alphabetically by authors' names. Abbreviations have been used for some standard reference books; these are cited in full in Appendix C. Abbreviations of periodical titles are in Appendix B. Abbreviated references to alphabetically arranged dictionaries and encyclopedias appear at the beginning of the bibliography (or section).

Biographies in this dictionary start with the subject's name and, where known, the places and dates of birth and death and a statement of nationality and occupation. In the citation of a name in a heading, the use of parentheses indicates parts of the name that are not commonly used, while square brackets enclose variant names or spellings.

Members of the same family with identical names are usually distinguished by the use of parenthesized small roman numerals after their names. Synonymous family members commonly differentiated in art-historical literature by large roman numerals appear as such in this dictionary in two cases: where a family entry does not contain the full sequence (e.g. Karel van Mander I and Karel van Mander III); and where there are two or more identical families whose surnames are distinguished by parenthesized small roman numerals (e.g. Velde, van de (i) and Velde, van de (ii)).

Cross-references are distinguished by the use of small capital letters, with a large capital to indicate the initial letter of the entry to which the reader is directed; for example, 'He commissioned LEONARDO DA VINCI...' means that the entry is alphabetized under 'L'. Given the comprehensiveness of this book, cross-references are used sparingly between articles to guide readers only to further useful discussions.

Abel de Pujol, Alexandre [Abel, Alexandre-Denis]

(*b* Douai, 30 Jan 1785; *d* Paris, 28 Sept 1861). French painter. He was the natural son of Alexandre de Pujol de Mortry, a nobleman and provost of Valenciennes, but did not use his father's name until after 1814. He trained first at the Académie de Valenciennes (1799–1803), then at the Ecole des Beaux-Arts, Paris, and in the studio of Jacques-Louis David. At the end of 1805 it seemed he would have to end his apprenticeship for lack of money but David let him continue free of charge, so impressed had he been by *Philopoemen . . . Splitting Wood* (1806; ex-Delobel priv. col., Valenciennes). The astonishing *Self-portrait* (Valenciennes, Mus. B.-A.; see fig. 1), showing the artist as the very image of a romantic hero, dates from this period.

From 1808 Abel exhibited history paintings at the Salon, making his living, however, by painting shop signs. In 1811 he won the prestigious Prix de Rome and his father subsequently permitted him to adopt his name. Thus from 1814 he signed his pictures *Abel de Pujol*. His stay in Italy was brief; he returned to Paris in 1812 and painted portraits in a finely executed Neo-classical style (e.g. *Nicolas Legrand and his Grandson*, exh. Salon, 1817; ex-Heim Gal., London, see 1978 exh. cat., no. 14). He won the prize for history painting at the Salon of 1817, with *St Stephen Preaching* (Paris, St Thomas d'Aquin), a representative work, characterized by impeccable drawing, clear composition, broad light effects and an evident predilection for painting beautiful drapery. At the Salon of 1819 he won acclaim for the *Death of the Virgin* (untraced), commissioned for the cathedral of Notre-Dame, and the *Renaissance of the Arts*, a ceiling painting over the grand staircase at the Louvre (destr. 1855; fragments, Valenciennes, Acad.). These anticipate the two main aspects of his future work: religious paintings and ceiling paintings with allegorical (e.g. *Egypt Saved by Joseph*, 1827; Paris, Louvre) or mythological subjects (e.g. decoration for the Galerie de Diane, 1822–4; Fontainebleau, Château). The grisaille decoration he executed in collaboration with Charles Meynier in 1826 on the coving in the great hall of the Bourse, Paris, was much acclaimed and won him a reputation as a painter in grisaille.

The revival of the use of frescoes in churches was another aspect of his work, first realized in the chapel of St Roch in the church of St Sulpice (1819–22) in which he modified his palette and simplified his forms to obtain monumental effects. His technical inventiveness was demonstrated again in 1828 when he painted the antependium made from lava in the church of St Elisabeth, Paris, where he also designed three stained-glass windows. Further experimental work was his participation in research into encaustic techniques of decoration (King's staircase, 1835; Fontainebleau, Château). Meanwhile he continued to execute numerous large-scale decorations in public buildings, two examples being the *Apocalypse* (2.5×13 m, 1837; Paris, Notre-Dame de Bonne-Nouvelle) and *St Denis Preaching in Gaul* (3.5×14 m, 1838–40; Paris, St Denys du St Sacrement). These are linked to the Nazarenes in

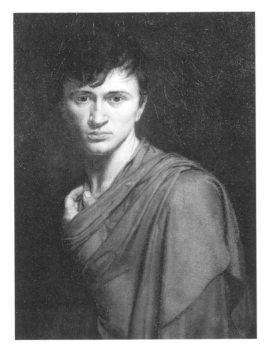

1. Alexandre Abel du Pujol: *Self-portrait*, *c.* 1806 (Valenciennes, Musée des Beaux-Arts)

the austerity of their frieze composition and the choice of archaic subject-matter. More striking is his unusual use of grisaille in more intimate works, such as the portrait of *Mademoiselle de L* (exh. Salon, 1831; Valenciennes, Mus. B.-A.).

In 1835 Abel de Pujol was elected to a chair in the Académie. His studio, which was particularly popular between 1817 and 1830, was attended, among others, by Camille Roqueplan, Alexandre-Gabriel Decamps, Adrienne Grandpierre-Deverzy (*b* 1798)—his second wife—and Théophile Vauchelet (1802–73). His son, Alexandre (1816–84), was also a pupil and exhibited at the Salons of 1847 and 1850. Alexandre's works, particularly his portraits, have been attributed to his father, but his signature, 'Adre de Pujol', identifies them securely as his own.

Bibliography

De David à Delacroix (exh. cat., Paris, Grand Pal., 1974)
Trésors des musées du Nord de la France, II: Peinture française, 1770–1830 (exh. cat., Calais, Mus. B.-A.; Arras, Mus. B.-A.; Douai, Mus. Mun.; Lille, Mus. B.-A.; 1975–6) [notes on Abel de Pujol by D. Vieville]
Forgotten French Art from the First to the Second Empire (exh. cat., London, Heim Gal., 1978)
P. Grunchec: *Le Concours des Prix de Rome, 1797–1863* (Paris, 1986)
B. Foucart: *Le Renouveau de la peinture religieuse en France, 1800–1860* (Paris, 1987)

ISABELLE DENIS

Aligny, Théodore Caruelle d'

(*b* Chaume, Nevers, 24 Jan 1798; *d* Lyon, 24 Feb 1871). French painter. His father was the artist Jean-Baptiste Caruelle (*d* 1801). About 1859 he added to his name that of his stepfather, Claude Meure-Aligny. He spent his early life in Paris, leaving the Ecole Polytechnique in 1808 to frequent the studios of Jean-Baptiste Regnault and the landscape artist Louis-Etienne Watelet (1780–1866). He exhibited at the Salon for the first time in 1822 with *Daphnis and Chloe* (untraced), which went unremarked. He finished his apprenticeship with the customary journey to Italy, staying in Rome from 1822 to 1827. During 1826 and 1827 he became friendly with Corot, whom he acknowledged as his master, although Aligny preceded Corot in his repeated studies of the Roman countryside and even appears to have led the way for the group of landscape artists who stayed there at the same time as himself, such as Edouard Bertin and Prosper Barbot. The sketches from this period (Rennes, Mus. B.-A. & Archéol., and Rome, Gab. Stampe) already bear witness to his conception of landscape as an organization of form and mass. He established himself in Paris in 1827 and that year exhibited at the Salon with *Saul Consulting the Witch of Endor*, which went unnoticed. From 1828 he spent much time in the Forest of Fontainebleau, one of the first of several generations of landscape artists who frequented the place.

In 1831, Aligny exhibited six landscapes and a historical landscape, *Massacre of the Druids under the Emperor Claudius* (Nîmes, Mus. B.-A.), which won him a second-class medal. He made trips to Normandy (1831) and Switzerland (1832). From 1833 he exhibited regularly at the Salon. The same year, he presented three landscapes that surprised his contemporaries with their naturalism. In 1834–5 he made a second journey to Italy, where he made large numbers of studies and sketches, especially in the environs of Rome and Naples (e.g. *View of Genazzano*, 1835; Paris, Louvre; see fig. 2). He returned to Fontainebleau, once more keeping company with Corot, Diaz and Rousseau. At the Salon of 1837 his *Prometheus on the Caucasus* (Paris, Louvre) was bought by the state and won him a first-class medal; his studio became much visited, and numerous landscape artists studied there, including Eugène Desjobert (1817–63), Charles Lecointe (1824–86), Jean-Joseph Bellel (1816–98), Théophile Chauvel, François-Louis Français and Auguste Ravier. Aligny spent the summer of 1838 in the Auvergne, where he executed an important series of drawings. He exhibited regularly at the Salon and drew attention in 1842 with his *Hercules Fighting the Hydra* (Carcassone, Mus. B.-A.), for which he was awarded the Légion d'honneur. The same year, he was given a state commission to paint a *Baptism* (*in situ*) for the church of St-Paul-Saint-Louis in Paris. Two years later, Corot was to paint the same subject in the chapel of St Nicolas du Chardonnet in Paris.

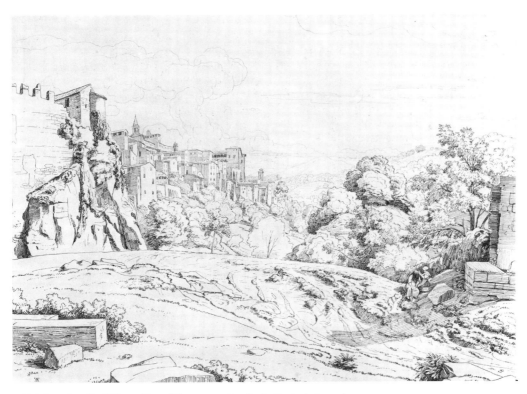

2. Théodore Caruelle d'Aligny: *View of Genazzano*, 1835 (Paris, Musée du Louvre)

Aligny's next commission followed in 1850 with two decorative paintings for the church of St-Etienne-du-Mont in Paris: *Baptism* and *St John Preaching in the Desert* (both *in situ*).

With all the advantages of an official career, Aligny was commissioned to draw the sites of ancient Greece. The year after his return in 1844 he published a series of engravings entitled *Views of the Most Famous Sites of Ancient Greece*; these were admired by Baudelaire who paid homage to his 'serious and idealistic talent' (Salon, 1846). His Salon exhibits bore witness to his travels, for example the *Infant Bacchus Reared by the Nymphs on the Island of Naxos* (Salon of 1848; Bordeaux, Mus. B.-A.) and *Solitude of a Monk at Prayer in a Landscape* (Salon of 1850; Rennes, Mus. B.-A. & Archéol.). These large compositions were accompanied by more modest landscapes, all attesting

to a profound knowledge of nature founded on the constant practice of sketching from life. In 1861 he reached the height of his career as Director of the Ecole des Beaux-Arts in Lyon, a position he occupied until his death, but he continued to produce studies from nature, in Haute-Saône and around Lyon and Grenoble, and to take part in the Salon until 1869. Two sales of his studio were held in Paris (Hôtel Drouot) in 1874 and 1878.

Aligny belonged to a generation of landscape artists for whom landscape painting was first and foremost a study of nature. His large paintings seem marked by a concern for strict and rigorous composition, dominated by the search for arabesques and the harmonies of large masses: rocks, foliage and depressions. This aesthetic, which became less rigid after 1860, was nevertheless considered cold when Realism triumphed. His art

continued to be founded on careful study of, and meditation on, nature as his numerous drawings and sketches in oil demonstrate. His contemporaries saw him as the true leader of landscape reform.

Bibliography

M. M. Aubrun: *Théodore Caruelle d'Aligny et ses compagnons* (exh. cat., Orléans, Mus. B.-A.; Dunkirk, Mus. B.-A.; Rennes, Mus. B.-A. & Archéol.; 1979)
P. Ramade: 'Théodore Caruelle d'Aligny: Dessins du premier séjour italien (1822–7)', *Rev. Louvre*, ii (1986), pp. 121–30
M. M. Aubrun: *Théodore Caruelle d'Aligny, 1798–1871: Catalogue raisonné de l'oeuvre peint, dessiné, gravé* (Paris, 1988)

PATRICK RAMADE

Revolutionary subjects might invite persecution. He then took up historical subjects and styles derived from Classical antiquity. Important works of his late career include *Napoleon as General of the Army of Italy* (1798), *Napoleon as First Consul* (1803) and *Napoleon with Cambacérès and Lebrun*. (Copies of all works cited in this article Paris, Bib. N., Cab. Est.; see also Laran and Roux).

Bibliography

Portalis–Beraldi; Thieme–Becker
J. Laran: *Inventaire du fonds français: Après 1800*, Paris, Bib. N., Cab. Est. cat., i (1930), pp. 84–8
M. Roux: *Inventaire du fonds français: Graveurs du dix-huitième siècle*, Paris, Bib. N., Cab. Est. cat., i (1931), pp. 77–117

VIVIAN ATWATER

Alix, Pierre-Michel

(*b* 1762; *d* Paris, 27 Dec 1817). French printmaker. During the last two decades of the 18th century he followed Jean-François Janinet and Louis-Marin Bonnet in popularizing the technique of multiple-plate colour printing for the progressive tonal intaglio processes of mezzotint, aquatint, stipple and crayon manner. Alix produced many illustrations of contemporary Parisian life and fashion but was best known for his colour aquatint portraits of celebrated figures of the French Revolution and the Napoleonic period. In 1789 he provided 18 sheets for an engraved portrait collection published by Levacher de Charnois, which documented members of the French National Assembly. Alix also produced colour prints of such Revolutionary heroes as *Jean-Paul Marat*, *Marie-Joseph Chalier* and *Antoine-Laurent de Lavoisier*, after pastel drawings by Jacques-Louis David and other artists. Chief among such prints, which were widely distributed to promote patriotic zeal, were Alix's portraits of the boy heroes *Joseph Barra* and *Agricola Viala*. One of his best works of the period is a portrait of *Queen Marie-Antoinette*, after Elisabeth Vigée-Lebrun. During the late 1790s, with the establishment of the Directory and the Consulate, Alix destroyed many of his best copperplates, fearing that his depiction of

Amaury-Duval [Pineu-Duval], Eugène-Emmanuel

(*b* Montrouge, Paris, 4 April 1806; *d* Paris, 29 April 1885). French painter and writer. A student of Ingres, he first exhibited at the Salon in 1830 with a portrait of a child. He continued exhibiting portraits until 1868. Such entries as *M. Geoffroy as Don Juan* (1852; untraced), *Rachel, or Tragedy* (1855; Paris, Mus. Comédie-Fr.) and *Emma Fleury* (1861; untraced) from the Comédie-Française indicate an extended pattern of commissions from that institution. His travels in Greece and Italy encouraged the Néo-Grec style that his work exemplifies. Such words as refinement, delicacy, restraint, elegance and charm pepper critiques of both his painting and his sedate, respectable life as an artist, cultural figure and writer in Paris. In contrast to Ingres's success with mature sitters, Amaury-Duval's portraits of young women are his most compelling. In them, clear outlines and cool colours evoke innocence and purity. Though the portraits of both artists were influenced by classical norms, Amaury-Duval's have control and civility in contrast to the mystery and sensuousness of Ingres's.

Amaury-Duval's extant drawings, often of carefully contoured, barely modelled nudes, again link him to Ingres, although the expressions of his

figures are often more dreamy than those of his master's. The drawings of nudes were incorporated into such paintings as the *Birth of Venus* (1863; Lille, Mus. B.-A.), using a pose from Ingres's *Venus Anadyomene* (Chantilly, Mus. Condé), and in the fresco decorations for two rooms (one a Pompeian Revival dining-room) of the château at Linières in the Vendée in 1865 (destr. 1912).

Though a religious sceptic, Amaury-Duval was active, along with many of Ingres's other students, in the programme of church decoration pressed on the Second Empire by the conservative Catholic Church. His commissioned works include frescoes for the chapel of the Virgin (1844–66) in St Germain-l'Auxerrois, Paris, the chapel of St Philomena (1844) in St Merri, Paris, apse and wall decorations for the church (1849–57) at Saint-Germain-en-Laye, cartoons for two stained-glass windows in Ste Clotilde in Paris (all *in situ*) and a number of large canvases, such as the *Annunciation* (1860; Mâcon, Mus. Mun. Ursulines). The artist's reliance on Perugino and more particularly on Fra Angelico's frescoes for the convent of S Marco in Florence has been noted (Foucart, 1987). Amaury-Duval visited the Nazarenes and admired their Casino Massimo frescoes in Rome in 1836 but, unlike their sophisticated mix of 15th-century Renaissance styles, his religious art is consciously archaic. Angels stand in serried rows as in a 14th-century *Maestà*, air is still and transparent, light casts no shadows (backgrounds are often painted in gold leaf), defined outlines freeze profiles, gestures are repeated as in a chorus, and drapery falls in columnar flutes over Gothic tubular bodies. Visual effects are architecturally severe, although the subjects are more likely to be naive and simple than those of other students of Ingres. Amaury-Duval's writings, such as *Souvenirs de l'atelier d'Ingres* (1878), centre on his connections to the Ingres circle.

Writings

Journal de Voyage (MS.; 1836); ed. B. Foucart (Paris, in preparation)

Souvenirs de l'atelier d'Ingres (Paris, 1878; preface and notes by D. Ternois (Paris, 1986))

Souvenirs de jeunesse, 1829–30 (Paris, 1885)

Bibliography

Bénézit; Thieme–Becker

E. J. Délécluze: *Les Beaux-arts dans les deux mondes en 1855* (Paris, 1856), pp. 247–9

L. Legrange: 'Salon de 1864', *Gaz. B.-A.*, xxv (1864), p. 510

H. Delaborde: 'Des oeuvres et de la manière de M. Amaury-Duval', *Gaz. B.-A.*, xviii (1865), pp. 419–28

P. Mantz: 'Salon de 1867', *Gaz. B.-A.*, xxii (1867), pp. 517–18

Amaury-Duval, 1806–85 (exh. cat. by V. Noël-Bouton, Montrouge, Hôtel de Ville, 1974)

The Second Empire: Art in France under Napoleon III (exh. cat., ed. G. H. Marcus and J. M. Iandola; Philadelphia, PA, Mus. A.; Detroit, MI, Inst. A.; Paris, Grand Pal.; 1978–9), pp. 249, 362

B. Foucart: *Le Renouveau de la peinture religieuse en France, 1800–1860* (Paris, 1987), pp. 212–14

NANCY DAVENPORT

Andrieu, Bertrand

(*b* Bordeaux, 4 Nov 1761; *d* Paris, 10 Dec 1822). French medallist, engraver and illustrator. He was first apprenticed to the medallist André Lavau (*d* 1808) and then attended the Académie de Peinture et de Sculpture in Bordeaux. In 1786 he travelled to Paris and entered the workshop of Nicolas-Marie Gatteaux. His first great success was a large, realistic and highly detailed medal representing the *Fall of the Bastille* (1789); because it would have been difficult and risky to strike, he produced it in the form of single-sided lead impressions or clichés, coloured to resemble bronze. The following year he used this novel technique again, to produce an equally successful companion piece illustrating the *Arrival of Louis XVI in Paris*. Andrieu lay low during the latter part of the French Revolution, engraving vignettes and illustrating an edition of Virgil by Firmin Didot (1764–1836). He reappeared in 1800, with medals of the *Passage of the Great St Bernard* and the *Battle of Marengo*. His elegant *Peace of Lunéville* (1801) was much admired: from then on, Andrieu flourished, receiving numerous commissions from Vivant Denon, such as those for medals commemorating the *Battle of Austerlitz*, the *Battle of Jena*, the *Marriage of Jérôme Bonaparte*, and the *Marriage of Napoleon and Maria Louisa*. His medallic portraits of Napoleon, which were used

for the majority of the pieces in Vivant Denon's series commemorating Napoleon's reign, were among the most beautiful and widely circulated images of the Emperor. Andrieu likewise found favour under the Bourbon Restoration, particularly with his medal of 1818 commemorating the *Erection of a Statue to Henry IV* and another in 1820–21 celebrating the *Birth of the Duc de Bordeaux*, which brought him 15,000 francs from the Municipality of Paris and the Order of St Michel from Louis XVIII.

Bibliography

DBF

C. Gabet: *Dictionnaire des artistes de l'Ecole française au XIXe siècle* (Paris, 1831), pp. 9–10

A. Evard de Fayolle: *Recherches sur Bertrand Andrieu* (Paris, 1902)

D. Nony: 'Bertrand Andrieu', *Bull. Club. Fr. Médaille*, xxiii (1969), pp. 12–14

MARK JONES

Antigna, (Jean-Pierre-)Alexandre

(*b* Orléans, 7 March 1817; *d* Paris, 26 Feb 1878). French painter. He was taught at the school of drawing in Orléans by a local painter, François Salmon (1781–1855). On 9 October 1837 he entered the Ecole des Beaux-Arts in Paris, first in the atelier of Sebastien Norblin de la Gourdaine (1796–1884). A year later he became a pupil of Paul Delaroche, from whom he acquired his understanding of dramatic composition.

Antigna exhibited at the Salon for the first time in 1841 with a religious canvas, the *Birth of Christ* (untraced), and showed there every year for the rest of his life. Until 1845 his exhibits were primarily religious scenes and portraits. Influenced by the effects of industrialization and the sufferings of the urban working class, which he witnessed at first hand while living in the poor quarter of the Ile St Louis in Paris, he turned towards contemporary social subjects dominated by poverty and hardship. The 1848 Revolution confirmed him in his allegiance to Realist painting, and he continued to paint in this style until *c.* 1860. During this period he produced his most important and personal

works, which frequently dramatized natural or manmade disasters with bold lighting, dramatic poses and rich colour, almost exclusively on a large scale: for example *Lightning* (1848; Paris, Mus. d'Orsay), *The Fire*, his most famous painting (1850; Orléans, Mus. B.-A.), the *Forced Halt* (1855; Toulouse, Mus. Augustins) and *Visit of His Majesty the Emperor to the Slate Quarry Workers of Angers during the Floods of 1856* (1856–7; Angers, Mus. B.-A.). In 1849 he painted *After the Bath*, a large canvas bought by the state and sent the same year to the Orléans museum. The sensuality of the nudes and the topical quality of the scene provoked a local scandal.

Around 1860 Antigna moved from tragic Realism to a gentler Naturalism, and social subjects were replaced by anecdotal scenes, although he never lost his sense of compassion for the poor. He travelled in search of local colour and the picturesque: from 1857 onwards he made several journeys to Spain; in 1858 he stayed in Gargilesse and the Creuse. He visited Brittany many times over several years. Landscape, including the sea, appeared with increasing frequency in his works, which often had a moralizing or satirical flavour: the *Village Cock* (*c.* 1858; Bagnères-de-Bigorre, Mus. A), *Young Breton Sleeping* (*c.* 1858–9; Orléans, Mus. B.-A.), *Young Girls Reading a Lament* (1860; Nantes, Mus. B.-A.), *Summer Evening* (1862; Dinan, Hôtel de Ville) and *High Tide* (1874; Dunkirk, Mus. B.-A.).

At the same time Antigna also produced a number of canvases of mystical and sentimental inspiration and of a Symbolist tendency: for example *A Mother's Last Kiss* (*c.* 1865; Lille, Mus. B.-A.). Children appear in most of his works, and he painted them with sympathy, whether happy or sad. Antigna received numerous distinctions and honours, including the Chevalier of the Légion d'honneur in 1861. In the same year he married Hélène-Marie Pettit (1837–1918), who herself became a painter. Their son, André-Marc Antigna (1869–1941), was also a painter and miniaturist.

Bibliography

Alexandre Antigna (exh. cat. by D. Ojalvo, Orléans, Mus. B.-A., 1978)

The Realist Tradition: French Painting and Drawing, 1830–1900 (exh. cat. by G. P. Weisberg, Cleveland, OH, Mus. A., 1980), pp. 265–6

DAVID OJALVO

Attiret, Claude-François

(b Dôle, Jura, 14 Dec 1728; d Dôle, 15 July 1804). French sculptor. He was the son of a joiner, who sent him to Paris to train with Jean-Baptiste Pigalle. In 1757 Attiret was in Rome, where he received a prize from the Accademia di S Luca; returning to Paris, he was accepted as a member of the Académie de St Luc in 1760, and was a professor there. He exhibited several times at the Salon of the Académie de St Luc: among the works that he showed was *Roman Charity* (terracotta, 1726; Dijon, Mus. B.-A.); *Hannibal Preparing to Take Poison* (terracotta, 1764); and the *Chercheuse d'esprit* (terracotta, 1774; Dijon, Mus. B.-A.; marble version, Paris, David–Weill col.). This idealized portrait bust of a young woman, graceful in concept and mischievous in expression, is his best-known work.

By 1776 Attiret had settled in Dijon and had executed two stone statues for St Bénigne, *St Andrew* and *St John the Evangelist*, and a bronze low relief of the *Apostles at the Tomb of the Virgin* (1773). Portraits dating from this period are: *Benigne Legouz de Gerland* (Beaune, Mus. Marey); bust of a *Young Girl* (terracotta; Dijon, Mus. B.-A.); bust of a *Woman* (marble; Paris, Louvre); and bust of *François Devosges* (Besançon, Bib. Mun.). Commissions from the local aristocracy gave scope to his talents as a decorative sculptor. He executed statues of the *Four Seasons* for the staircase of the château of Choisy-le-Roi; *Jupiter Hurling a Thunderbolt* and *Cybele* for the château of Bussy-Rabutin; and for the bishop's palace in Plombières-les-Dijon, four Tonnerre stone low reliefs of putti (*Spring, Summer, Autumn, Winter*; Dijon, Mus. B.-A.). The naturalism of Attiret's style is tempered by an increasingly distinct tendency to Neo-classicism, evident in the décor of the Salle des Antiques in the Palais des Etats de Bourgogne, now the Musée des Beaux-Arts in Dijon. Attiret retired to Dôle, where he executed a statue of *Louis XVI* (destr. 1793); two allegorical figures representing the *Arts* and the *Sciences* survive.

Attiret's uncle, the Jesuit Jean-Denis Attiret (b Dôle, 1702; d Beijing, 1768), was a painter who, after spending some time in Rome, travelled in 1737 to China. He became a favourite of the Emperor Qian Long. The famous series of engravings, the *Conquests of the Emperor of China* (1767–73) by Charles-Nicolas Cochin, was based on drawings by Attiret.

Bibliography

Lami

E. Kyot: 'C. F. Attiret: Statuaire', *Rev. Bourgogne* (1923), pp. 5–39

P. Quarré: 'Un Buste d'Attiret', *Bull. Mus. Dijon* (1955–7), p. 83

CATHERINE LEGRAND

Aubry-Lecomte, Hyacinthe(-Louis-Victor-Jean-Baptiste)

(b Nice, 31 Oct 1787; d Paris, 2 May 1858). French draughtsman and lithographer. The artist's family name was Aubry, but after his marriage he added his wife's maiden name to his own. Aubry-Lecomte was originally employed at the Ministry of Finance in Paris, but his interest in drawing led him to enrol at Girodet's atelier at the Ecole des Beaux-Arts. Aubry-Lecomte proved to be a proficient draughtsman and rapidly mastered the new technique of lithography, encouraged by Girodet, becoming one of its leading practitioners. He was also one of Girodet's most valued pupils, making lithographic reproductions of the master's paintings to be copied in the atelier. Among the most important of these are the suite of 16 prints (1822) showing the heads of the main figures from *Ossian and the French Generals* (1802; Malmaison, Château N.), a print (1824) of *Danaë* (1797) and another of an *Amazon* painted for the Duchesse de Berry (both untraced). With other pupils of Girodet he contributed lithographs based on the master's illustrations for two publications, *Les Amours des dieux* (1826) and the *Enéide* (1827). Aubry-Lecomte also made prints after Pierre-Paul Prud'hon, François Gérard, Horace Vernet, Louis

Hersent and others. His original works consist mainly of landscape and genre subjects and portraits of his family and friends (e.g. *Mlle Aubry-Lecomte*, lithograph, 1834; Paris, Bib. N.). He exhibited regularly from 1819, won several medals and was popularly known as the 'prince of lithographers'. He did much to raise the status of printmaking and in 1849 was decorated with the Légion d'honneur.

Bibliography

Auguste Gallimard: *Aubry-Lecomte* (Paris, 1860)

J. Adhémar: 'L'Enseignement académique en 1820: Girodet et son atelier', *Bull. Soc. Hist. A. Fr.* (1934), pp. 270–83

S. Nevison Brown: *Girodet: A Contradictory Career* (diss., U. London, 1980)

STEPHANIE NEVISON BROWN

Augustin, Jean-Baptiste(-Jacques)

(*b* Saint-Die, Vosges, 1759; *d* Paris, 1832). French painter. After receiving instruction in art from Jean Girardet (1709–78) and Jean-Baptiste-Charles Claudot (1733–1805), he went to Paris in 1781, where he won recognition as a miniature painter. The miniatures he painted in the 1790s, for example his portrait of *Mme Vanhée, née Dewinck* (1792; Paris, Louvre), are among his most animated works; often portraying figures in a landscape setting, they develop the exuberant style of Niclas Lafrensen and Peter Adolf Hall. He also admired the work of Jean-Baptiste Greuze, whose *Bacchante* (Waddesdon Manor, Bucks, NT) in his own collection he copied in miniature (London, Wallace) and in enamel (Paris, Louvre).

By the end of the century the influence of David's Neo-classicism had brought a new austerity to Augustin's style. He painted some presentation miniatures of Napoleon I. On the restoration of the monarchy in 1815 he was appointed Peintre-en-ordinaire to Louis XVIII. He remained a versatile artist: his large, rectangular portrait of the cornet-player *Frédéric Duvernois* (1817; Meilen, Holzscheiter priv. col., see Schidlof no. 48, pl. 26) is a penetrating theatrical portrait in the tradition of François Dumont (1751–1831). Following Dumont, it shows a clarity and freshness, and

accents are highlighted in strong vivid colours. In smaller miniatures of the same period Augustin shows an understanding of the British use of transparent washes on ivory. He had many English sitters and travelled to England in 1820. Among his pupils were Pauline Ducruet [Du Cruet] (1781–1865) whom he married in 1800, Alexandre Delatour (1780–1858) and Mme de Mirbel [née Rue] (1796–1849). Augustin's collection of works of art was auctioned in 1839. There is a representative collection of his miniatures in the Louvre, Paris.

Bibliography

G. C. Williamson: *Catalogue of the Collection of Miniatures the Property of J. Pierpont Morgan*, iv (privately printed, 1908), pp. 112–69 [based on family papers; incl. biog. notes, lists of sitters and a facs. of 1839 sale cat.]

L. R. Schidlof: *The Miniature in Europe in the 16th, 17th, 18th and 19th Centuries* (Graz, 1964)

GRAHAM REYNOLDS

Auzou [née Desmarquet(s)], Pauline

(*b* Paris, 24 March 1775; *d* Paris, 15 May 1835). French painter. After studying in Jacques-Louis David's studio, at the age of 18 Auzou exhibited a *Bacchante* and a *Study of a Head* in the Salon of 1793. She exhibited regularly at the Salon until 1817. She was awarded a Prix d'Encouragement for *Departure for a Duel* in 1806 and a medal for *Agnès de Méranie* (untraced) in 1808. In 1810 Vivant Denon drew the Emperor Napoleon's attention to the 'genre anecdotique', which he maintained was unique to the French school. Denon cited Auzou as well as Pierre-Nolasque Bergeret, Jean-Antoine Laurent, Fleury-François Richard and Adolphe-Eugène-Gabriel Roehn (1780–1867) among the practitioners of this distinctive genre.

Auzou's oeuvre consists of portraits (e.g. *Portrait of a Musician*; Manchester, NH, Currier Gal. A.) and genre scenes, a great many of which still belong to the artist's descendants. In the early genre scenes she took her inspiration from history and Greek mythology or used playfully erotic subjects in the style of Louis-Philibert Debucourt. Later she sought inspiration in the history of the

French kings (e.g. *Agnès de Méranie*, exh. Salon 1808; untraced) or in contemporary history, as in the *Arrival of the Empress Marie-Louise at Compiègne* (exh. Salon 1810; Versailles, Château) and *Marie-Louise Taking Leave of her Family* (exh. Salon 1812; Versailles, Château). Avoiding the customary pompous rhetoric of such historical scenes, she depicted them in an intimate, sentimental manner. Auzou's genre scenes, which were exhibited from 1800 onwards, reveal her as one of the best representatives of 'anecdotal genre' or the Troubador style, as much in her choice of subjects—moralizing and emotive—as in her debts to 17th-century Dutch painters, particularly the smooth technique and the effects of light and composition found in the work of Pieter de Hooch and Gerrit Dou.

Bibliography

P. Marmottan: *L'Ecole française de peinture (1789-1830)* (Paris, 1886), pp. 280–81
F. Benoit: *L'Art français sous la Révolution et l'Empire* (Paris, 1897), pp. 335–6
V. Cameron: 'Portrait of a Woman by Pauline Auzou', *Currier Gal. A. Bull.*, ii (1974), pp. 1–17
Women Artists, 1550-1950 (exh. cat. by A. B. Sutherland Harris and L. Nochlin, Los Angeles, Co. Mus. A., 1977)

MARIE-CLAUDE CHAUDONNERET

Baron, Henri (Charles Antoine)

(*b* Besançon, 23 June 1816; *d* nr Geneva, 13 Sept 1885). French painter and illustrator. He was a pupil of Jean Gigoux in Paris *c.* 1835 and travelled through Italy with him and François-Louis Français. He made his début at the Salons of 1837 and 1838 with *Under the Willows* (1837; Tours, Mus. B.-A.) and *Macbeth and the Witches* in collaboration with Français and showing the paintings under Français' name. Baron emerged as a reputable painter of genre and idyllic scenes, painting fanciful scenes, often set in Renaissance Venice. His rather precious style and romantic, dashing subject-matter won him lasting success with a clientele much enamoured of facile compositions. Such works included *Sculpture Studio* (1840), *Fêtes galantes* (1845) and the *Mother of the*

Family (1847; Marseille, Mus. B.-A.). Baron paid homage to several famous painters in such anecdotal works as *An Evening with Giorgione* (1844) and *Andrea del Sarto Painting* (1847). Among other works were the spirited *Wedding of Gamache* (1849; Besançon, Mus. B.-A. & Archéol.) and *Cabaret Scene* (1859; Paris, Louvre), purchased by Napoleon III. Baron also illustrated books, including François de Salignac de la Mothe-Fénelon's *Aventures de Télémaque* (Paris, 1846), and he collaborated on Honoré de Balzac's *La Peau de chagrin* (Paris, 1838) and an edition of Boccaccio's *Decameron* (Paris, 1842). With Français and Célestin Nanteuil (1813–73) he also produced the three-volume *Les Artistes anciens et modernes* (1848–62), a collection of lithographs after works by contemporary artists.

Prints

with F.-L. Français and C. Nanteuil: *Les Artistes anciens et modernes*, 3 vols (Paris, 1848–62)

Bibliography

A. Estignard: *H. Baron: Sa vie, ses oeuvres* (Besançon, 1896)
P. Brune: *Dictionnaire des artistes et ouvriers d'art de la Franche-Comté* (Paris, 1912)

RÉGIS MARIN

Barre, Jean-Auguste

(*b* Paris, 25 Sept 1811; *d* Paris, 5 Feb 1896). French sculptor and medallist. After training with his father the medallist Jean-Jacques Barré (1793–1855) and with Jean-Pierre Cortot, he entered the Ecole des Beaux-Arts in Paris in 1826. He was one of the few 19th-century French sculptors who pursued a successful official career without having competed for the Prix de Rome. He was principally a portrait sculptor and exhibited at the Salon from 1831 to 1886, initially showing medals and medallions such as the series of the *Orléans Family* (Paris, Mus. A. Déc.). With Jean-Etienne Chaponnière he was one of the first French sculptors to produce miniature portraits of eminent contemporaries in plaster, biscuit or bronze editions for broad popular circulation, showing figures ranging from *Queen Victoria* to

the dancer *Marie Taglioni* (both 1837; e.g. in bronze, Paris, Mus. A. Déc.).

As his reputation grew Barre also received commissions for life-size busts and statues of royalty, including the recumbent tomb effigy of King Louis-Philippe's mother *Louise-Marie-Adelaide, Duchesse of Orléans* (marble, 1847; Dreux, Chapelle Royale) and no less than 26 varied busts of *Napoleon III* (e.g. marble, 1857; Paris, Ecole B.-A.). He also executed historical portraits for the Musée Historique at Versailles, including a bust of *Louis de la Trémoille* (plaster, 1839; *in situ*), as well as a certain number of ideal statues (e.g. *Ulysses Recognized by his Hound*, marble, exh. Salon 1834; Compiègne, Château) and religious works (e.g. *St Luke*, stone, 1844; Paris, St Vincent de Paul). In addition he received commissions for allegorical statues in stone for the rebuilding of the Louvre (*c.* 1853–*c.* 1868). His talents as a sympathetic portrait sculptor, uncritical but highly skilled, assured him an important position in official sculpture of the 19th century.

Bibliography

La Sculpture française au XIXe siècle (exh. cat., ed. A. Pingeot; Paris, Grand Pal., 1986), nos 144, 146–8, 150–52

ISABELLE LEMAISTRE

Barrias, Félix(-Joseph)

(*b* Paris, 13 Sept 1822; *d* Paris, 25 Jan 1907). French painter and illustrator. He was a pupil of his father, a miniaturist and painter on porcelain. He began his training in the studio of Léon Cogniet at the Ecole des Beaux-Arts, Paris, on 7 April 1838. From 1840 he exhibited in the Salon many portraits that were dismissed by the critics as insignificant. This failure induced him to turn to the elevated genres of history and religious painting, which were more likely to bring him critical recognition. In 1844 he won the Prix de Rome with *Cincinnatus Receiving the Ambassadors of the Senate* (Paris, Ecole N. Sup. B.-A.). Profoundly academic in handling, this work adheres closely to the rules of Neo-classicism. The clearly legible frieze composition exhibits a severity and a certain stylistic rigidity that characterized almost all his subsequent output. His career developed within the sphere of academic art, of which he was a notable representative. He also enjoyed the rewards of an official career: third-class medal in 1847 for *Sappho*, first-class medal in 1851 for the *Exiles of Tiberius* (1850; Paris, Mus. d'Orsay; on loan to the Hôtel de Ville, Bourges), another medal in 1855 for the *Jubilee of 1300 in Rome* (Laval, Mus. Vieux-Château) and a gold medal in the Exposition Universelle of 1889.

In tandem with his career as a history painter, Barrias also devoted himself to large-scale mural decorations, both religious and secular. In 1851 he decorated the chapel of St Louis in the church of St Eustache in Paris. In the following years he produced numerous religious works: scenes from the life of the Virgin (1863) in the church of Notre-Dame at Clignancourt; five tympana in the main nave and the great tympanum at the end of the sanctuary (started 1864) in the church of the Trinity, Paris, where he also decorated the chapel of Ste Geneviève (1873). He was responsible for important state decorations for the museum in Amiens (*France Crowning the Glories of Picardy*, 1865; Amiens, Mus. Picardie); for the Opéra in Paris (salon Ouest du Foyer, 1874; *in situ*); for the Pavilion of the Argentine Republic in the Exposition Universelle in 1889; and for the Hôtel de Ville in Paris (north portico of the Ceremonial Hall, commissioned 1889, completed 1892).

Barrias also executed such private commissions as the ceiling (1855) of the reading-room of the former Hôtel du Louvre, which he reworked at the time of the conversion of the building into a shop in 1876 (now in Paris, Mus. d'Orsay); a hemicycle (1856) in the Institut Eugénie; and a great ceiling (1866) for the residence of Prince Nariskine in St Petersburg.

A champion of academicism, Barrias left a considerable oeuvre, in which the qualities that gained him the Prix de Rome—a predictable palette and flawless technique—are employed in works that were inspired by mythology (e.g. *The Sirens*, 1893; Périgueux, Mus. Périgord) and ancient and contemporary history (e.g. the *French Army Disembarking at Old Port, September 14*

1854, 1859; Versailles, Château), as well as the Orientalist tradition. He also illustrated works of Classical literature (Horace, Virgil) as well as the great French dramatists (Racine, Corneille, Molière) and the popular novels of Alexandre Dumas and Frédéric Soulié.

Bibliography
Thieme–Becker

A. DAGUERRE DE HUREAUX

Barye, Antoine-Louis

(*b* Paris, 24 Sept 1796; *d* Paris, 25 June 1875). French sculptor, painter and printmaker. Barye was a realist who dared to present romantically humanized animals as the protagonists of his sculpture (see col. pl. I). Although he was a successful monumental sculptor, he also created a considerable body of small-scale works and often made multiple casts of his small bronze designs, marketing them for a middle-class public through a partnership, Barye & Cie. His interest in animal subjects is also reflected in his many watercolours. He thus challenged several fundamental values of the Parisian art world: the entrenched notion of a hierarchy of subject-matter in art, wherein animals ranked very low; the view that small-scale sculpture was intrinsically inferior to life-size or monumental work; and the idea that only a unique example of a sculptor's design could embody the highest level of his vision and craft. As a result of his Romantic notion of sculpture, he won few monumental commissions and endured near poverty for many years.

1. Training and early work, to c. 1830
The son of a goldsmith from Lyon, Barye learnt his father's craft at an early age and retained some of its values as a mature artist. At the age of 13 he worked for the military engraver Fourier. Soon after he worked in the prestigious workshop of Martin-Guillaume Biennais, goldsmith to Napoleon. In 1816 he studied with the Neo-classical sculptor François-Joseph Bosio; Barye also studied painting briefly with the Romantic history painter Antoine-Jean Gros.

As a student at the Ecole des Beaux-Arts, Paris (1818–23), Barye repeatedly failed to win the Prix de Rome. Nonetheless his experiences there deepened his commitment to the classical tradition and acquainted him with a very broad spectrum of artistic sources. He also read works on art theory and archaeology by E.-M. Falconet, Quatremère de Quincy and Emeric-David and studied the engravings of John Flaxman. He studied animal anatomy diligently, reading scholarly essays by the naturalists François Marie Daudin and Georges Cuvier. He made drawings after zoological displays in the Musée d'Anatomie Comparée and after dissections performed at the Jardin des Plantes. He also made a close study of ancient sculptures of animals.

Barye's earliest works, dated *c.* 1819 to *c.* 1830, were executed in three divergent styles: painterly, naturalist and hieratic. These are epitomized respectively by his delicately modelled medallion relief *Milo of Crotona Devoured by a Lion* (1819; Baltimore, MD, Walters A.G.), which echoes Pierre Puget's marble group of the same title (1671–82; Paris, Louvre), the humorous *trompe l'oeil* piece *Turtle on a Base* and the *Stork on a Turtle* (both Baltimore, MD, Walters A.G.), based on an ancient prototype engraved by Lorenzo Roccheggiani (*fl* 1804–17).

2. Mature work, c. 1830 and after
(i) **Large-scale sculpture.** Barye's style had become more unified by *c.* 1830, and his images of predators grew larger, more humanized and more dramatic, as in the *Tiger Devouring a Gavial Crocodile of the Ganges* (bronze, exh. Salon 1831; Paris, Louvre). This exotic, exquisitely detailed and satanic work is an image of evil in the sense of Victor Hugo's notion of the grotesque. Astonishingly, it was characterized by the classical critic and follower of David, Etienne-Jean Delécluze, as 'the strongest and most significant work of the entire Salon'. This unforgettable image, of a sphinx-like tiger slowly biting into the genitalia of a writhing and serpentine gavial, launched Barye's artistic career.

Larger but more restrained, *Lion Crushing a Serpent* (1832; Paris, Louvre) was shown in the

Salon of 1833, in its plaster version, and was cast in bronze for Louis-Philippe in time for the Salon of 1836. In recognition of its excellence Barye was named Chevalier of the Légion d'honneur on 1 May 1833. An allegory on two levels, *Lion Crushing a Serpent* was intended to flatter the King: the lion connotes not only courage, strength and fortitude but also kingship itself as triumphant over the serpent of evil; as a commemoration of the July Revolution of 1830, which had placed Louis-Philippe on the throne, it also represents the lion of Leo, the constellation that 'ruled the heavens' on 27, 28 and 29 July 1830. Indeed, the appellation *Lion of the Zodiac* occurs in the official documents for Barye's slightly later bronze relief (1835–40s) on the July Column in the Place de la Bastille, Paris. *Lion of the Zodiac* recalled an ancient marble relief in Rome, engraved by Pietro Bartoli. Remains of the fallen heroes of 1830 were taken to the July Column cenotaph on 18 April 1840.

Another monumental work of Barye's maturity is *St Clotilde* (marble, 1840–43), executed for the church of the Madeleine in Paris. This figure is based on the Roman marble of Julia, daughter of Augustus (Paris, Louvre), and is also reflected in a contemporary portrait by Ingres (e.g. *Comtesse d'Haussonville*, 1845; New York, Frick). Barye also executed the *Seated Lion* (bronze, 1847; Paris, Louvre), a companion piece to *Lion Crushing a Serpent* in a less detailed style, and eight colossal eagle reliefs (1849) for piers of the Jena Bridge over the Seine, which echo an ancient oil-lamp relief engraved by Bartoli. In 1848 Barye was named director of plaster casting and curator of the gallery of plaster casts at the Musée du Louvre. He also taught drawing for natural history in the Ecole Agronomique at Versailles in 1850. The same year he submitted two monumental sculptures to the Salon; he had not exhibited there since 1837, when the jury had rejected his ensemble of nine small sculptures made for the young Ferdinand-Philippe, Duc d'Orléans (*see* §3 below). *Jaguar Devouring a Hare* (Baltimore, MD, Walters A.G.) is a Romantic animal combat reminiscent of his innovations of c. 1830, while *Theseus Combating the Centaur Bienor* (Washington, DC, Corcoran Gal. A.) is an academic piece whose figures recall

Giambologna's *Hercules and Nessus* (1594; Florence, Loggia Lanzi). By pairing these two works at the Salon, Barye aimed to reaffirm his conviction that an image of a predator with its prey, encapsulating his own Romantic vision of nature, was worthy to stand beside an academically sanctioned mythological combat.

Around 1851 Barye produced a series of 97 decorative masks in stone for the cornice of the Pont Neuf in Paris; the expressive range and formal variety of facial representations that encompasses the Buddha, Christ and Hercules may be regarded as a virtuoso feat. For the vast new Louvre of Napoleon III, Barye created a stone ensemble of four groups representing *Strength*, *Order*, *War* and *Peace* (1854–6), which were installed on the façades of the Denon and Richelieu pavilions. He also produced a stone relief, *Napoleon I Crowned by History and the Fine Arts* (1857), for the façade pediment of the Sully Pavilion. Focal points in the Cour du Carrousel (also known as the Place Napoleon III) of the new Louvre, these works were a pinnacle of Barye's official career, though they were executed in an academic style. *Napoleon I Crowned by History and the Fine Arts* is a splendid example of imperial propaganda intended to enhance the reign of Napoleon III by recalling the legend and aura of Napoleon I.

In 1854 Barye was appointed Master of Zoological Drawing in the Musée d'Histoire Naturelle, Paris (where Rodin was among his pupils in 1863), a position he retained until his death. Later monumental works include a classical bronze relief for the Riding Academy façade of the new Louvre, *Napoleon III as an Equestrian Roman Emperor* (1861; destr. 1870–71), a tribute to the Emperor's great love of horsemanship. Between 1860 and 1865 Barye executed *Napoleon I as an Equestrian Roman Emperor*, a free-standing bronze, for the Bonaparte family monument in Ajaccio, Corsica. Around 1869 he carved four feline predators standing over their prey for the Palais de Longchamp at Marseille, not with the nervous intensity of the 1830s but with a hieratic formality and lordly grandeur of mood, qualities appropriate to this late statement of his favourite theme.

(ii) **Small bronze works.** Barye often made multiple casts of his designs, marketing them for the homes of middle-class Parisians through Barye & Cie, the partnership he formed in 1845 with the entrepreneur Emile Martin (see doc. in Pivar, 1974). Small bronzes were his greatest love, as the 230 or so designs offered in his last sale catalogue (1865) amply attest. After 1830 his style became more subtle, embracing a wide range of moods, compositional types and themes, albeit within the larger framework of a decoratively detailed realism. He produced many animal portraits from the mid-1830s to the mid-1840s, such as the exotic *Turkish Horse* and the poignant *Listening Stag* of 1838 (both Baltimore, MD, Walters A.G.). Predators with prey abound. Hunting scenes may include man, as in *Arab Horseman Killing a Lion*, or animals only, as in the *Wounded Boar* (both Baltimore, MD, Walters A.G.), which depicts a fallen boar with a spear jutting from its side. Scenes from history include an equestrian group in plaster, *Charles VI, Surprised in the Forest of Mans* (exh. Salon 1833; Paris, Louvre), showing the assassination attempt that triggered the King's lunacy. Among the literary subjects is *Roger Abducting Angelica on the Hippogriff* (Baltimore, MD, Walters A.G.), from Ariosto's *Orlando Furioso* (1532), a scene made famous by Ingres's *Roger Rescuing Angelica* (1819; Paris, Louvre). Barye depicted equestrian figures from several periods of history: *Charles VII* (Baltimore, MD, Walters A.G.), *General Bonaparte* (Calais, Mus. B.-A.) and *Ferdinand Philippe, Duc d'Orléans* (Baltimore, MD, Walters A.G.). In mood his works encompass the agony of *Wolf Caught in a Trap* (New York, Brooklyn Mus.), the exuberant vigour of *African Elephant Running*, the playful dreaminess of *Bear in its Trough*, the excitement of *Bear Overthrown by Three Dogs* and the powerfully restrained tension of *Panther Seizing a Stag* (all Baltimore, MD, Walters A.G.).

Barye's designs range from the delicately atmospheric, painterly effects of *Lion Devouring a Doe* (1837) to the architectural clarity of *Python Killing a Gnu* (c. 1834–5; both Baltimore, MD, Walters A.G.). The latter was one of nine small bronzes (four animal combats and five hunting scenes) executed for Ferdinand-Philippe, Duc d'Orléans, between 1834 and 1838. They were intended as an elaborate decoration for a banqueting table. The Salon jury rejected the models for the ensemble in 1837, and Barye did not again submit works to the Salon until 1850. The Baroque manner of the hunting scenes (all Baltimore, MD, Walters A.G.), for instance the *Tiger Hunt* (1836), contrasts strongly with the classical severity of the tiny reliefs *Walking Leopard* and *Walking Panther* (both 1837) and of the free-standing *Striding Lion* and *Striding Tiger* (all Baltimore, MD, Walters A.G.). A similar restraint is apparent in the *Candelabrum Goddesses*, the classical *Juno* and *Minerva* and the mannerist *Nereid* (all Baltimore, MD, Walters A.G.). An understated tone and a descriptive realism are evident in the late *Caucasian Warrior* (Baltimore, MD, Walters A.G.) and *Horseman in Louis XV Costume* (Paris, Louvre), both of which were included in Barye's last sale catalogue (1865).

(iii) **Paintings and prints.** Barye's extensive oeuvre as a painter of landscapes and of animal subjects linked with his sculpture awaits further study, though Zieseniss produced an introductory catalogue raisonné of 216 animal watercolours in 1956. Noting that an exact chronology for the wholly undated painted oeuvre cannot be established, he nonetheless distinguished an early and late style, contrasting the emphatic detail, exaggerated drama, confused movement and theatrical chiaroscuro effects of the former (e.g. *Two Tigers Fighting*; Cambridge, MA, Fogg) with the majestic ease, glowing colour and unity and balance of the latter (e.g. *Two Rhinos Resting*; Baltimore, MD Inst., Decker Gal.; see Zieseniss, nos B52, K2).

Barye's tiny watercolours of animals are technically intricate and often combine several media: a single work may show the use of both transparent watercolour and bodycolour as well as pastel chalk, black ink, lead-white highlights, scratched-in lines for whiskers or fur and varnishes of various colours and densities. He developed the surfaces of his watercolours almost as he would patinate a bronze. Most of the subjects of his paintings are the same as those of his small bronze images. These include *Tiger Hunt* (priv. col., z E9,

E10; cf. Benge, 1984, fig. 127), *Turkish Horse* (priv. col., z I2, I3; cf. Benge, 1984, fig. 82), *Elk Attacked by a Lynx* (priv. col., z D19; cf. Benge, 1984, fig. 134), *Bear Attacking a Bull* (priv. col., z H3; cf. Benge, 1984, fig. 120), *Lion of the Zodiac* (priv. col., z A29, A30, A32, A33; cf. Benge, 1984, figs 25, 64) and *Seated Lion* (priv. col., z A22; cf. Benge, 1984, fig. 27). A few creatures, however, appear only in watercolours, for example the *Bison* (priv. col., z J3, J4), the *Rhinoceros* (priv. col., z K1, K2) and *Vultures* (priv. col., z G1–G5). The *Dead Elephant* (priv. col., z E1–E3; cf. Benge, 1984, fig. 179) surely reflects dissection drawings made in the Musée d'Anatomie Comparée. The very precise paintings of serpents (priv. col., z F1–F6) must also have been derived from specimen study; by contrast, Barye's *Two Tigers* (priv. col., z B51) approaches the moodiness and emotional fullness of Delacroix. Cast shadows and a concern with natural light are rare in Barye's paintings. Some of his landscapes have a central area of bright light (z D1, D3, D5, D15, D35, H1, I1), an obvious device seen in Barbizon landscapes by Diaz and Rousseau; others range from the depiction of an elaborate tracery of tree limbs above the antlered head of a stag (z D28) to the larger and subtler systems of craggy rock-fields whose swirling arabesques echo the outlines of a creature (z B18, D18, D20).

In Zieseniss's view, Barye regarded his paintings in oil as merely preparatory; he neither exhibited nor offered any for sale, although more than 90 were listed for the posthumous sale of his studio effects, held at the Ecole des Beaux-Arts, Paris, in 1875. Eleven lithographs and one etching of his animal subjects are illustrated in Delteil.

Bibliography

Lami

A. Alexandre: *Antoine-Louis Barye* (Paris, 1889)

C. DeKay: *Barye: Life and Works* (New York, 1889)

R. Ballu: *L'Oeuvre de Barye* (Paris, 1890)

L. Delteil: *Barye: Le Peintre graveur illustré*, vi (Paris, 1910)

C. Saunier: *Barye* (Paris, 1925)

G. H. Hamilton: 'The Origin of Barye's *Tiger Hunt*', *A. Bull.*, xviii (1936), pp. 248–51

A. Dezarrois: 'Le Monument de Napoléon Ier à Grenoble par Barye: Un Projet mystérieusement abandonné', *Rev. A.*, lxxi (1937), pp. 258–66

G. Hubert: 'Barye et la critique de son temps', *Rev. A.*, vi (1956), pp. 223–30

C. O. Zieseniss: *Les Aquarelles de Barye: Etude critique et catalogue raisonné* (Paris, 1956) [z]

Barye: Sculptures, peintures, aquarelles des collections publiques françaises (exh. cat., Paris, Louvre, 1956–7) [major exhibition, excellent documentation]

J. de Caso: 'Origin of Barye's *Ape Riding a Gnu*: Barye and Thomas Landseer', *Walters A.G. Bull.*, xxvii–xxviii (1964–5), pp. 66–73

G. F. Benge: *The Sculptures of Antoine-Louis Barye in the American Collections, with a Catalogue Raisonné*, 2 vols (diss., Iowa City, U. IA, 1969)

J. Peignot: 'Barye et les bêtes', *Conn. A.*, 243 (1972), pp. 116–21

S. Pivar: *The Barye Bronzes: A Catalogue Raisonné* (London, 1974) [incl. doc. forming and liquidating Barye & Cie, 1845–57, and Barye's last sale cat., 1865]

G. F. Benge: 'Antoine-Louis Barye (1796–1875)', *Metamorphoses in Nineteenth-century Sculpture* (exh. cat., ed. J. L. Wasserman; Cambridge, MA, Fogg, 1975), pp. 77–107

—: 'A Barye Bronze and Three Related Terra Cottas', *Bull. Detroit Inst. A.*, lvi/4 (1978), pp. 231–42

—: 'Barye, Flaxman and Phidias', *La scultura nel XIX secolo. Acts of the 24th International Congress of Art History: Bologna, 1979*, vi, pp. 99–105

—: 'Antoine-Louis Barye', *The Romantics to Rodin: French Nineteenth-century Sculpture from North American Collections* (exh. cat., ed. P. Fusco and H. W. Janson; Los Angeles, CA, Co. Mus. A., 1980), pp. 124–41

—: 'Barye's Apotheosis Pediment for the New Louvre: *Napoleon I Crowned by History and the Fine Arts*', *Art the Ape of Nature: Studies in Honor of H. W. Janson* (New York, 1981), pp. 607–30

D. Viéville: 'Antoine-Louis Barye', 'Napoléon Ier en redingote, 1866', *De Carpeaux à Matisse: La Sculpture française de 1850 à 1914 dans les musées et les collections publiques du nord de la France* (exh. cat., Calais, Mus. B.-A.; Lille, Mus. B.-A.; Paris, Mus. Rodin; 1982–3), pp. 93–7

G. F. Benge: *Antoine-Louis Barye, Sculptor of Romantic Realism* (University Park, PA, 1984) [crit. disc., documentation, good illus.]

GLENN F. BENGE

Beauvallet, Pierre-Nicolas

(*b* Le Havre, 21 June 1750; *d* Paris, 15 April 1818). French sculptor, draughtsman and engraver. He

arrived in Paris in 1765 to become a pupil of Augustin Pajou. Although he never won the Prix de Rome, he appears to have travelled to Rome in the early 1770s. About 1780 or 1781 he was involved in the decoration of Claude-Nicolas Ledoux's Hôtel Thélusson, Paris. From 1784 to 1785 he carried out work at the château of Compiègne, including the decoration of the Salle des Gardes, where his bas-reliefs illustrating the *Battles of Alexander* (*in situ*) pleasantly combine a Neo-classical clarity of composition with a virtuosity and animation that are still Rococo in spirit.

Beauvallet was approved (*agréé*) by the Académie Royale in 1789. During the French Revolution he was a passionate republican and presented plaster busts of *Marat* and of *Chalier* (1793–4; both destr.) to the Convention. He was briefly imprisoned after the fall of Robespierre in 1794. Until 1805 his principal occupation was the restoration of medieval and Renaissance sculpture for Alexandre Lenoir at the Musée des Monuments Français, including the famous marble statue of *Diana* (Paris, Louvre) from the château of Anet.

Beauvallet also collaborated with the architect and designer Charles P.-J. Normand in the *Décorations intérieures et extérieures* (Paris, 1803), a collection of designs in the Neo-classical style. His interest in Classical antiquity led in 1804 to the publication of the collection of engraved plates in the *Fragments d'architecture, sculpture, peinture dans le style antique . . .*, which he dedicated to David. During the empire (1804–14) he received numerous state commissions, including reliefs for the Colonne de la Grande Armée in the Place Vendôme, Paris (bronze, 1806–10; *in situ*). His masterpiece is the statue *Susanna at the Bath* (plaster, 1810 Salon: marble, 1814 Salon; Paris, Louvre). In its refined idealization and elegant pose it shows the influence that Canova exercised over Beauvallet's late style.

Writings

with C.-P.-J. Normand: *Décorations intérieures et extérieures* (Paris, 1803)

——: *Fragments d'architecture, sculpture, peinture dans le style antique, composés, recueillis et gravés au trait, dédiés à M. David* (Paris, 1804)

Bibliography

Lami

J. Robiquet: *Pour mieux connaître le Palais de Compiègne* (1938), pp. 56–60, 94

G. Hubert: 'Early Neo-classical Sculpture in France and Italy', *The Age of Neo-classicism* (exh. cat., 14th Council of Europe exh.; London, 1972), pp. lxxvi–lxxxii

M. Beaulieu: *Description raisonnée des sculptures du Musée du Louvre*, ii, *Renaissance française* (Paris, 1978), pp. 47, 96–8

PHILIPPE DUREY

Bellangé, (Joseph-Louis-)Hippolyte

(*b* Paris, 17 Jan 1800; *d* Paris, 10 April 1866). French painter and printmaker. He was enrolled briefly at the Lycée Bonaparte, Paris, and at 16 he entered the studio of Antoine-Jean Gros, where Nicolas-Toussaint Charlet, R. P. Bonington and Paul Delaroche were also pupils. Influenced by Charlet in particular, in 1817 Bellangé worked as a commercial illustrator, employing the still new process of lithography, notably for the publisher Godefroy Engelmann. Bellangé's independent works can only be traced, however, from 1822 onwards. Between 1823 and 1835 he published 15 albums of lithographs devoted to the patriotic military subjects that had long attracted popular favour, and he turned increasingly to representing them in oil. The narrative appeal of his depictions of the veterans of the Napoleonic campaigns—the Old Guard or *grognards*—soon won him official and commercial approval: he was awarded a second-class medal at the Salon of 1824. Ten years later he was made a Chevalier of the Légion d'honneur for the *Return of Napoleon from Elba* (1834; Amiens, Mus. Picardie), a composition widely lithographed by Bellangé himself. Further successes soon followed with *Battle of Fleurus* (exh. 1835) and *Battle of Wagram* (exh. 1837; both Versailles, Château). Bellangé also produced humorous genre scenes, such as *Mistress of the Household* (exh. Salon 1838; untraced), in which a soldier is being dragged home from his wayward pleasures by his wife.

In 1837 Bellangé left Paris to head the Museé des Beaux-Arts in Rouen, where he remained for

16 years before returning to Paris in 1853. His much admired *Eve of the Battle of Moscow* (untraced) was painted at Rouen; Napoleon is depicted being shown Baron François Gérard's portrait of the King of Rome, which he orders to be removed because it is too soon for his son to see a battlefield. Bellangé's theatrical sense is also apparent in such works as the *Field of the Battle of Wagram* (1857; untraced), in which Napoleon tends a fallen carabinier. For these qualities, as well as for his capacity to render scenes of massive encounters, as in the *Taking of Malakoff* (1858; untraced) by Marshal MacMahon's forces, Bellangé earned the admiration of contemporaries, who compared him with Auguste Raffet and Charlet as a master of his chosen genre. At the end of his life he took up lithography again to create a series of scenes from the Crimean War.

Bellangé's paintings are rather dryly detailed, while his drawings are apt to be freer and hence more attractive to the modern viewer. They were often sketched in crayon broadly toned with watercolour and pen-and-ink, but other media were also used, sometimes with elaborate hatching. His reputation faded after his death, but he remains an informative witness to the enthusiasms of an age when the military role in society was the subject of popular satisfaction and approval.

Bibliography

Catalogue de l'exposition des oeuvres d'Hippolyte Bellangé à l'Ecole Impériale des Beaux-Arts (exh. cat. by F. Way, Paris, Ecole N. Sup. B.-A., 1867)
J. Adeline: *Hippolyte Bellangé et son oeuvre* (Paris, 1880)
H. Beraldi: *Les Graveurs du XIXe siècle*, ii (Paris, 1885), pp. 5–24

FRANK TRAPP

Belle, Clément(-Louis-Marie-Anne)

(*b* Paris, 16 Nov 1722; *d* Paris, 29 Sept 1806). French painter. Son of painter Alexis-Simon Belle (1674–1734), he trained with the history painter François Lemoyne and visited Rome. From 1755 he worked for the Gobelins, painting tapestry cartoons adapted from pictures by his contemporaries and from his own designs. In 1759 his altarpiece

The Atonement (Paris, St Merri), a work that demonstrates Belle's gifts as a colourist, achieved great success at the Salon. Two years later he was received (*reçu*) as a history painter by the Académie Royale. Among his surviving works for the Gobelins is a cartoon of *Leda and the Swan* (1778; Paris, Louvre) in the manner of François Boucher, designed to add a new subject to the famous tapestry series *The Loves of the Gods*. In 1788 Belle was commissioned by Louis XVI's Directeur des Bâtiments, the Comte d'Angiviller, to design cartoons in triptych format for tapestries to decorate the Palais de Justice, Paris. He was later called on to transform them into Republican allegories by the Revolutionary authorities. The resulting monumental canvases, *Allegory of the Republic* and *Allegory of the Revolution* (both 1788–94; Paris, Louvre), display the classicizing yet dynamic characteristics that Belle could achieve in his compositions. In 1790, shortly before its dissolution, he became Rector of the Académie Royale.

Bibliography

Thieme–Becker
L. Dimier: *Les Peintres français du XVIIIe siècle*, ii (Paris and Brussels, 1930), pp. 283–90
P. Rosenberg: 'Une Commande à Clément Belle retrouvée (1788–1794)', *Rev. Louvre*, 4–5 (1965), pp. 229–32
I. Compin and A. Roquebert, eds: *Ecole française A–K* (1986), iii of *Catalogue sommaire illustré des peintures du Musée du Louvre et du Musée d'Orsay* (Paris, 1983–6)

CATHRIN KLINGSÖHR-LE ROY

Benoist [née Leroulx-Delaville; (de) Laville-Lerou(l)x], Marie-Guillemine

(*b* Paris, 18 Dec 1768; *d* Paris, 8 Oct 1826). French painter. She first studied with Elisabeth Vigée-Lebrun in 1781 and in 1786 worked in the studio of Jacques-Louis David. In 1784 she met the poet Charles-Albert Demoustier (1760–1801), and the figure of Emilie in his *Lettres de la mythologie* represents Benoist. She exhibited at the Salon in 1791 (*Psyche Taking Leave of her Family*) and obtained a gold medal there in 1804. Her reputation as

a portrait painter brought her commissions from Napoleon and his family: in 1803 the portrait of the emperor *Napoleon* (1804; Ghent, Law Courts) for the town of Ghent; in 1805 that of *Marshal Brune* (destr.; copy Versailles, Château) for the Tuileries; in 1807 that of *Pauline Bonaparte* (Versailles, Château). She also executed the portraits of *Marie-Elise, Grand Duchess of Tuscany* (Lucca, Mus. & Pin. N.) and the empress *Marie-Louise* (Fontainebleau, Château). She made her name with the semi-nude *Portrait of a Negress* (exh. Salon 1800; Paris, Louvre), in which she broke with the graceful style of her early works. The picture was praised by the public and the critics for the purity of the drawing and the skill of the colouring combined with a plastic strength lacking in the earlier portraits, achieved by the faithful application of David's aesthetic. Benoist also attempted genre scenes, for example *The Fortune-teller* (1812; Saintes, Mus. B.-A.) and the *Bible Reading* (exh. Salon 1810; Louviers, Mus. Mun.), an intimate scene close to those of Martin Drolling, although with less emphasis on detail and anecdote than on sentiment. On the restoration of the Monarchy in 1815, her husband, the advocate Pierre-Vincent Benoist, whom she had married in 1793, was made a member of the Council of State and, although at the summit of her career, she was obliged to abandon painting.

Bibliography

J. Renouvier: *Histoire de l'art pendant la Révolution* (Paris, 1863), pp. 360–62

P. Marmottan: *L'Ecole française de peinture, 1789–1830* (Paris, 1886), pp. 459–60

F. Benoit: *L'Art français sous la Révolution et l'Empire* (Paris, 1897), p. 310

M.-J. Ballot: *Une Elève de David, la comtesse Benoist, l'Emilie de Demoustier, 1768–1826* (Paris, 1914)

Women Artists, 1550–1950 (exh. cat. by A. B. Sutherland Harris and L. Nochlin, Los Angeles, CA, Co. Mus. A., 1977)

MARIE-CLAUDE CHAUDONNERET

Bergeret, Pierre-Nolasque

(*b* Bordeaux, 30 Jan 1782; *d* Paris, 21 Feb 1863). French painter, printmaker and designer. He first trained with Pierre Lacour the elder (1745–1814) in Bordeaux and on going to Paris studied with François André Vincent and then Jacques-Louis David. While a pupil of David, he became friendly with both François-Marius Granet and Jean-Auguste-Dominique Ingres. Bergeret played a major role in introducing lithography into France, with prints after Poussin and Raphael: his lithograph *Mercury* (1804), after Raphael's fresco in the Villa Farnesina, Rome, was one of the earliest examples of the technique. He also contributed greatly to Napoleonic propaganda by designing medals, extravagant pieces of Sèvres porcelain and, most important, the decoration of the Vendôme Column (1806–11; Paris, Place Vendôme) to satisfy Napoleon's desire for a copy in Paris of Trajan's Column in Rome. Bergeret was responsible for designing the bas-reliefs on the Vendôme Column, which record the campaigns of 1805 and 1806 (Austerlitz) in the way that those on Trajan's Column record the Dacian Wars. It was destroyed in 1814, replaced in 1833 and again in 1863, before being demolished by the Communards in 1871. It was restored in 1875.

Bergeret played a part in the rise of romantic historicism by popularizing genre scenes from French history, such as *Henry IV on his Deathbed* (Pau, Château). He treated scenes concerning the relationship between famous artists and their patrons, for example *Francis I in the Studio of Titian* (1807; Le Puy, Mus. Crozatier), which possibly influenced Ingres's small-scale Troubadour paintings of almost a decade later. He was also attracted to the contemporary vogue for oriental subjects: for example *A Pasha Ushering a Young Captive Princess into the Presence of Mahomet II* (1810; Bordeaux, Mus. B.-A.). Ultimately Bergeret abandoned his profession, outlining his reasons in *Lettres d'un artiste sur l'état des arts en France, considérés sous les rapports politiques, artistiques, commerciaux et industriels* (Paris, 1848).

Bibliography

H. Naef: 'Ingres et son collègue Pierre N. Bergeret', *Bull. Mus. Ingres*, xxxvii (July 1975), pp. 3–18

L. N. El-Abd: *Pierre Nolasque Bergeret (1782–1863)* (diss., Columbia U., 1976)

A. Malissard: 'La Colonne Vendôme, une colonne Trajane à
 Paris', *Doss. Archéol.*, xvii (July–Aug 1976), pp. 116–21
D. H. Vasseur: *The Lithographs of Pierre-Nolasque Bergeret*
 (Ohio, 1981)

SIMON LEE

Berjon, Antoine

(*b* St Pierre de Vaise, Lyon, 17 May 1754; *d* Lyon, 24
Oct 1843). French painter, teacher and designer.
According to his uncorroborated 19th-century
biographer J. Gaubin, he was intended for holy
orders and began studying flower painting as a
novice (*Rev. Lyon.*, i, 1856). Certainly he studied
drawing under the sculptor Antoine-Michel
Perrache (1726–79) and worked for Lyon's silk
industry as a textile designer, visiting Paris annu-
ally, ostensibly to keep abreast of the latest fash-
ions. He first exhibited at the Paris Salon of 1791
and settled in Paris in about 1794, probably as a
consequence of the catastrophic siege and destruc-
tion of Lyon by revolutionary forces the previous
year. Initially he eked out a precarious living dec-
orating snuff-boxes and painting miniatures, sup-
ported by friends such as Marceline Desbordes-
Valmore, the poetess, and the miniature painter
Jean-Baptiste Augustin, to whom Berjon dedicated
The Gift (1797; Lyon, Mus. B.-A.). He contributed to
seven Paris Salons between 1796 and 1819 and
again in 1842, and he had built up a considerable
reputation for his work by the early 19th century.
On his return to Lyon in 1810 he succeeded Jean-
François Bony (1760–1825) as professor of flower
design at the Ecole des Beaux-Arts.

When Lyon's Ecole des Beaux-Arts was founded
by Napoleon's decree of 1807, it was stated that
'the chief purpose of the school will be to give
tuition to artists whose talents will be devoted
mainly to the silk industry'. Himself a product of
an education with a similar aim, Berjon became
Lyon's finest silk designer and acquired a mastery
of drawing that underlies the quality of his work
in all media—oil, pastel, watercolour, sepia and
ink. Though a gifted teacher, his temperamental
and unruly nature led to disagreement with the
director of the school, François Artaud
(1767–1838). In 1823 he was dismissed from his
post in favour of Augustin Thierrat (1789–1870),
his most gifted pupil. Freed from commitments,
he spent the last 20 years of his life somewhat
reclusively, working in his studio and instructing
pupils with a vigour akin to that of his near con-
temporary Pierre Joseph Redouté.

Though known primarily as a flower painter,
Berjon executed numerous portraits, for example
J. Halévy with his Brother and Sister (1820; Lyon,
Conserv. N. Sup. Musique). Characteristic of his
work as a flower painter is the *Bouquet of Lilies
and Roses in a Basket Resting on a Chiffonier*
(1814; Paris, Louvre), with objects carefully
arranged within the composition and details
delineated with a precision reminiscent of 17th-
century Dutch still-life painting. Berjon's flower
paintings are often composed with formality, in
contrast to the rich profusion of flowers in works
by his contemporaries Gérard van Spaendonck and
Jean-François van Dael. Their work overshadowed
Berjon's exhibits at the Paris Salon, though he was
certainly the most outstanding flower painter of
the Lyon school. He exhibited at the Lyon Salon in
1822, 1836 and 1837. On his death six paintings
and two hundred drawings were selected from his
studio for the town's Musée des Beaux-Arts. Only
about a dozen of his drawings can be traced.

Bibliography

E. Hardouin-Fugier and E. Grafe: *The Lyon School of
 Flower Painting* (Leigh-on-Sea, 1978), p. 27
Fleurs de Lyon, 1807–1917 (exh. cat. by E. Hardouin-Fugier
 and E. Grafe, Lyon, Mus. B.-A., 1982), p. 100, pl. 39
B. Scott: 'Master of the Magical: Antoine Berjon
 (1754–1843), Flower Painter', *Country Life*, clxxix (30
 Jan 1986), pp. 244–6

PETER MITCHELL

Bertin, Edouard(-François)

(*b* Paris, 7 Oct 1797; *d* Paris, 14 Sept 1871). French
painter and writer. He trained initially under
Anne-Louis Girodet before entering the Ecole des
Beaux-Arts in Paris where he studied under Jean-
Joseph-Xavier Bidauld and was later taught by
Ingres. From 1821 to 1823, and again in 1825,
he travelled around Italy during which time he

developed his mature style. He first exhibited at the Salon in 1827 with the work *Cimabue Meeting Giotto* (untraced). In 1833 he was appointed Inspecteur des Beaux-Arts and returned to Italy with the task of making casts of the Baptistery doors by Lorenzo Ghiberti in Florence and of the *Singers* (Florence, Mus. Opera Duomo) by Luca della Robbia. He continued to exhibit works at the Salon, mainly landscapes, such as *View Taken in the Apennines on the Summit of Mount La Vernia* (1836; Montpellier, Mus. Fabre), executed in a free Neo-classical style. Bertin later spent a considerable time travelling through Greece, Turkey, Egypt, Spain and Switzerland and painted a number of works evoking the landscapes he saw, such as *Christ on the Mount of Olives* (1837; Paris, S Thomas Aquinas). He also published a series of drawings derived from these travels, entitled *Souvenir de voyages*. On the death of his brother, Bertin took over the direction in 1854 of the periodical *Journal des débats*, originally founded by his father, Louis-François Bertin (1766–1841), who was portrayed by Ingres (1832; Paris, Louvre); he ceased to exhibit and devoted himself to his literary activities.

Bibliography
Bénézit; *DBF*
C. Blanc: *Les Artistes de mon temps* (Paris, 1876)

□

Bertin, Jean-Victor

(*b* Paris, 20 March 1767; *d* Paris, 11 June 1842). French painter and lithographer. In 1785 Bertin entered the Académie Royale de Peinture as a pupil of the history painter Gabriel-François Doyen. By 1788 he had become a pupil of the landscape painter Pierre-Henri de Valenciennes who directed him towards idealized Italianate landscape. Between 1785 and 1793 Bertin participated unsuccessfully in academic competitions and his official début came only in 1793 when he exhibited in the 'open' Salon. After 1793 he contributed consistently to the Salon until his death. In 1801 he received a Prix d'Encouragement for the *Town of Pheneos*. Like many of his early Salon works, it

is now known only through engravings. Among his early extant Salon works are the *Statue, or Interior of a Park* (1800; Dijon, Mus. Magnin), *View of Ronciglione* (1808; Nantes, Mus. B.-A.) and *Arrival of Napoleon at Ettlingen* (1812; Versailles, Château).

Bertin constructed his paintings predominantly according to Poussin's principles of idyllic landscape and drew on stock compositional devices from the master's repertory. The results are decorative but distinguished by a marked correctness and balance in design, severe draughtsmanship and harmonious colour. It was probably their decorative quality that led to the state purchase of many works for official palaces such as the Grand Trianon at Versailles and Fontainebleau, and for provincial museums. Further official recognition came in 1822 when he was awarded the Légion d'honneur.

Bertin also championed classical idealization in the teaching of landscape painting. In 1801 he proposed that the Académie create a Prix de Rome for historical landscape painting, and this was eventually implemented in 1817, when the first competition was won by his pupil Achille Michallon. To facilitate the teaching of correct landscape principles he also published two series of lithographs: *Recueil d'études de paysage* (from 1816) and *Etudes de paysages* (1823).

From the Salon of 1808 onwards Bertin increasingly exhibited Italian landscapes with precisely identified locations, suggesting that he visited Italy between 1806 and 1808. The mechanical execution of his work became more delicate and graceful in its lighting effects. Between 1810 and 1830 he produced his most successful compositions, which use the motif of a path presented within an elongated horizontal schema, combining ingenious spatial construction with delicate lateral lighting. Such compositions include *View of a Town in the Sabine Hills, with Setting Sun* (1814, known through a lithograph of 1822 by Jules-Louis-Frédéric Villeneuve (1796–1842)) and the *Italian Landscape with Horseman* (*c.* 1810; Boulogne-Billancourt, Bib. Marmottan).

Like his master, Valenciennes, and his contemporary Lancelot-Théodore Turpin de Crissé, Bertin

perpetuated the classicizing formulae of the 17th century while introducing more direct observation of atmosphere and topography. After 1830, in keeping with contemporary taste, Bertin brought an increased degree of empirical naturalism to his stylized Neo-classical compositions, resulting in an awkward compromise. This combination was more successfully achieved by his pupil Corot, who, together with Michallon, Camille-Joseph-Etienne Roqueplan and Jules Coignet (1798–1860), showed Bertin to have been one of the most influential teachers of the next generation of landscape painters. Bertin also produced competent portraits in the Neo-classical style.

Bibliography

S. Gutwirth: *L'Oeuvre de Jean-Victor Bertin* (diss., Ecole Louvre, 1969)
——: 'Jean-Victor Bertin, un paysagiste néo-classique (1767–1824)', *Gaz. B.-A.*, n.s. 6, lxxxiii (1974), pp. 337–8
De David à Delacroix: La Peinture française de 1774 à 1830 (exh. cat., ed. P. Rosenberg; Paris, Grand Pal., 1974), pp. 315–17
Le Néoclassicisme français: Dessins des musées de Provence (exh. cat., ed. A. Sérullaz, J. Lacambre and J. Vilain; Paris, Grand Pal., 1974), p. 26
Théodore Caruelle d'Aligny (1798–1871) et ses compagnons (exh. cat., ed. M. M. Aubrun; Orléans, Mus. B.-A., 1979)

STEPHANIE NEVISON BROWN

Bervic [Balvay], Charles-Clément [Jean-Guillaume]

(*b* Paris, 23 May 1756; *d* Paris, 23 March 1822). French engraver. At baptism he was erroneously registered as Jean-Guillaume instead of Charles-Clément and has consequently been known by two different sets of Christian names, while his assumed surname was taken from his father's nickname. He received his earliest training in Jean-Baptiste Le Prince's studio; at the age of 14 he enrolled in the studio of the engraver Jean-Georges Wille, who thought highly of him and of his work, particularly admiring his draughtsmanship. Like his teacher, Bervic worked entirely in burin, which resulted in a severity of style comparable to that of his master. He received numerous prizes and honours. On 24 September 1774 the Académie Royale de Peinture et de Sculpture in Paris awarded him first prize for drawing from the nude in the quarterly competition for students. On 25 May 1784 he was approved (*agréé*) as a member by the Académie. In 1792 he won the prize awarded for the encouragement of line-engraving and in 1803 became a member of the Institut de France.

Contemporary critics were unanimous in their praise of Bervic's print, the *Education of Achilles* (1798) after Jean-Baptiste Regnault; equally admired was its pendant, the *Rape of Deianeira* (1802) after Guido Reni. Bervic's engraving, made in 1790, of Antoine-François Callet's portrait of *Louis XVI* was said to improve on the original painting; during the period of the French Revolution, Bervic broke the plate in two but soldered it together again after the Bourbon Restoration. His engraving of the *Laokoon* for S. C. Croze-Magnan's *Le Musée français* (Paris, 1803–9) is also considered one of his masterpieces. In 1810 Bervic was awarded the Prix Décennal for *Deianeira* as the most beautiful print of the decade. In 1819 he was appointed Chevalier of the Légion d'Honneur. By the end of his life he was a member of most of the academies of Europe, including Berlin (1804), Bologna (1805), Amsterdam (1809), Milan and Turin (1811), and Vienna and Munich (1812). Bervic's great reputation rests on an oeuvre of fewer than 20 pieces. He has been called the Jacques-Louis David of the print, on account of his enormous influence on his contemporaries: his pupils included Adolphe-Alexandre-Joseph Caron (1797–1867), Joseph Coiny (1795–1829), Christian Didrik Forssell (1777–1852), Henriquel-Dupont, André Benoît Barreau Taurel (1794–1859) and Paolo Toschi (1788–1854), who completed Bervic's *Eudamidas*.

Bibliography

DBF
F.-L. Regnault-Delalande: *Catalogue d'un choix d'estampes après le décès de M. le Chevalier Bervic, précédé d'une notice historique sur feu M. Bervic* (Paris, 1822)
L.-G. Michaud, ed.: *Biographie universelle ancienne et moderne*, iv (Paris, 1843), pp. 195–6
J.-G. Wille: *Mémoire et journal de Jean-Georges Wille, graveur du roi*, ed. G. Duplessis, 2 vols (Paris, 1857)

M. Roux: *Inventaire du fonds français: Graveurs du dix-huitième siècle*, Paris, Bib. N., Cab. Est. cat., ii (Paris, 1933), pp. 466–76

J. Laran: *Inventaire du fonds français après 1800*, Paris, Bib. N., Cab. Est. cat., ii (Paris, 1937), pp. 332–4

S. J. Taylor: 'Le Portrait du sacre gravé de Drevet à David: Continuité et synthèse', *Nouv. Est.*, 88–9 (Oct 1986), pp. 6–16

G. D. McKee: 'Collection publique et droit de réproduction: Les Origines de la chalcographie du Louvre', *Rev. A.*, xcviii (1992), pp. 54–65

M.-E. HELLYER

Bidauld, Jean-Joseph-Xavier

(*b* Carpentras, 10 April 1758; *d* Montmorency, 20 Oct 1846). French painter. He was apprenticed in Lyon for six years with his brother Jean-Pierre-Xavier Bidauld (1745–1813), a landscape and still-life painter. Subsequently, they left Lyon to travel together in Switzerland and Provence. In 1783 he moved to Paris, where he met Joseph Vernet (from whom he received valuable advice), Joseph-Siffred Duplessis and Jean-Honoré Fragonard. In 1785 he went to Rome with the assistance of Cardinal de Bernis and his patron, the dealer and perfumer Dulac. He stayed there for five years, travelling through Tuscany, Umbria and Campania and painting such works as *Roman Landscape* (1788; Basle, Kstmus.). Bidauld was closely involved with the circle of French Neo-classical painters in Rome in the 1780s. He was friendly with Louis Gauffier, Nicolas-Antoine Taunay and especially with Guillaume Lethière, who became his brother-in-law and with whom he occasionally collaborated. On his return to Paris in 1790 he travelled extensively in France, visiting Brittany, the Dauphiné and in particular Montmorency, where he stayed in the Mont-Louis house that had been the home of Jean-Jacques Rousseau.

Bidauld was, with Pierre-Henri de Valenciennes, among the best of the few exponents of Neo-classical landscape painting. During his travels in Italy he developed his own distinctive style, working up in his studio studies made directly from nature into numerous landscapes, which sometimes included diminutive figures added by artists such as Lethière, Carle Vernet, François Gérard and Louis-Léopold Boilly. Bidauld's *Landscape with Waterfall* (1800; Compiègne, Château) epitomizes Neo-classical historical landscape painting, the genre for which he became famous: the composition is strict and rigorously ordered and the bucolic subject served merely as a pretext for the vast landscape setting, which is treated with precise brushwork and clear lighting. During the same period he received a commission for four landscapes for the Casita del Labrador, an annexe of the palace of Aranjuez in Spain. Between 1804 and 1812 many commissions for landscapes and Troubadour subjects from the French imperial family and the aristocracy followed. Under Louis XVIII he continued to enjoy official patronage and was commissioned to paint two large works on subjects from French history for the Galerie de Diane in the château of Fontainebleau, the *Departure of the Chevalier Bayard from Brescia* (1821; Valence, Mus. B.-A. & Hist. Nat.) and *View of the Plain of Ivry*, commemorating Henry IV (1822; Toulouse, Pal. Maréchal Niel).

Bidauld exhibited regularly in the Paris Salon between 1791 and 1844, winning a gold medal in 1812. He was the first landscape painter to be admitted to the Académie des Beaux-Arts, in 1823. His most important pupil was Edouard-François Bertin.

Bibliography

Jean-Joseph-Xavier Bidauld (1758–1846): Peintures et dessins (exh. cat. by S. Gutwirth, Carpentras, Mus. Duplessis, 1978)

A. DAGUERRE DE HUREAUX

Bilcoq, L(ouis-)M(arc-)A(ntoine)

(*b* Paris, 27 July 1755; *d* Paris, 24 Jan 1838). French painter. At the age of 13 he became the pupil of Louis Lagrenée and later studied with Pierre-Antoine Demachy (1723–1807). On 24 September 1785 he was approved (*agréé*) by the Académie Royale de Peinture et de Sculpture, Paris, with his *Fortune-teller*, and on 27 June 1789 he was received (*reçu*) as a member, his *morceau de réception* being *The Naturalist* (both untraced). He

exhibited at the Salons between 1787 and 1812, specializing in interior scenes of everyday life, generally in oil on wood panels. Bilcoq created a poetic pictorial language, influenced by 17th- and 18th-century Dutch, Flemish and French genre painters. He liked to contrast rays of golden light with sombre shadows in a manner reminiscent of Rembrandt's chiaroscuro (e.g. *The Soothsayer*, 1785; priv. col., see Florisoone, p. 127, fig. 91). His compositions, conceived according to classical academic canons, were characterized by harmonious tones of grey and brown and highlighted with vivid colours that he reserved for major details and persons. A profusion of objects, depicted with still-life precision, recalls the art of David Teniers the younger and Gerrit Dou and suggests an allegorical reading of the scene, as in *The Store-room* (*c.* 1795; priv. col., see Bergström and others, p. 177). Bilcoq's portraits depict individuals with naturalistic realism, whether in the silence of their personal worlds, as in *Woman Reading* (*c.* 1787; Paris, Mus. Cognacq-Jay), which is inspired by Chardin, or against a neutral background rapidly coloured with large, visible brushstrokes. His paintings were engraved by Jean-Jacques Le Veau and Géraud Vidal (1742–1801; Paris, Bib. N., Cab. Est.).

Bibliography

M. Florisoone: *La Peinture française, le dix-huitième siècle* (Paris, 1948), p. 127, fig. 91
I. Bergström and others: *Natura in posa: La grande stagione della natura morta europea* (Milan, 1977), p. 177
C. Bell-Carrier: *Recherches sur la peinture de genre au temps de la révolution française, 1789-1799: L'Exemple de L. M. A. Bilcoq* (MA thesis, 2 vols, U. Paris IV, 1987)

CHERYL E. BELL-CARRIER

Blanchard, Auguste (Thomas Marie), III

(*b* Paris, 18 May 1819; *d* Paris, 23 May 1898). French engraver. He first studied with his father, Auguste Jean-Baptiste Marie Blanchard II (1792–1849), and then in 1836 enrolled at the Ecole des Beaux-Arts, Paris. In 1838 he took part in the competition for the Prix de Rome and won second prize, which enabled him to study in Italy. In 1840 he made his début in the Salon in Paris with an engraving of *Spartacus* after the painting by Domenichino. His first major plate was a portrait of the architect *Jean Nicolas Huyot* (1842) after the painting by Michel-Martin Drolling, in which he displayed complete mastery of the medium. Its success brought him the patronage of two major publishers, Adolphe Goupil in Paris and Ernest Gambart in London. In his later engravings he adopted the fashionable contemporary calligraphic style, although he also produced some luminous plates in the new technique of *taille douce* (Fr.: 'smooth-cut'). He also specialized in reproducing the work of Ernest Meissonier (e.g. the *Chess Players*, 1873) and Lawrence Alma-Tadema (e.g. the *Parting Kiss*, 1884).

Bibliography

Bellier de La Chavignerie–Auvray; Bénézit; Thieme–Becker
J. Laran and J. Adhémar: *Inventaire du fonds français après 1800*, Paris, Bib. N., Dépt Est. cat., 3 vols (Paris, 1930–42)

ATHENA S. E. LEOUSSI

Bléry, Eugène(-Stanislas-Alexandre)

(*b* Fontainebleau, 3 March 1805; *d* Paris, 10 June 1887). French printmaker and draughtsman. At the age of 20 he became a mathematics tutor to Charles Montalivet in Berry and during his three years in the post began the first of his long series of tours of France commemorated in a set of 12 lithographs of 1830, which marked his decision to concentrate on landscape art. The etchings of Jean-Jacques de Boissieu, which he encountered in Lyon, appear to have confirmed him in this vocation by 1836, when he exhibited with increasing popular success under the initial patronage of the Montalivet family. Worked either directly from nature or from his own drawings, his etchings (frequently combined with drypoint, burin or roulette) are meticulous, delicate and highly wrought, although superficially they often seem uneventful and repetitious. They usually appeared in series, concentrated particularly between 1838

and 1868. Although his subjects owe a little to Claude, they are principally a skilful and well-integrated compendium of Rococo motifs; picturesque Boucher-like water-mills and farm buildings inhabited by elegant peasants underline the 18th-century mood. Despite their occasional Romantic overtones of transience, the formal topography of his landscapes and tree portraits belongs essentially to Barbizon naturalism. He also produced many closely focused botanical studies gracefully composed with an acute realization of species. The strongest influence on him (perhaps initiated by the example of Jean-Jacques de Boissieu) was that of Dutch 17th-century art, in particular Antoni Waterlo and contemporary etchers, as well as Meindert Hobbema and Jacob van Ruisdael, both of whom Bléry copied. The finest collection of his work is in the Bibliothèque Nationale, Paris.

Bibliography

C. Le Blanc: *Manuel de l'amateur d'estampes*, i (Paris, 1854/R Amsterdam, 1970), pp. 359–71 [incorporates Bléry's own cat. rais. of his prints]

H. Béraldi: *Les Graveurs du XIXe siècle*, ii (Paris, 1885), pp. 94–131

HARLEY PRESTON

Blondel, Merry-Joseph

(*b* Paris, 25 July 1781; *d* Paris, 12 June 1853). French painter. After an apprenticeship at the Dihl et Guerhard porcelain factory in Paris, where he was taught by Etienne Leguay (1762–1846), Blondel moved to Jean-Baptiste Regnault's atelier in 1802. He won the Prix de Rome in 1803 with *Aeneas and Anchises* (Paris, Ecole N. Sup. B.-A.) but did not go to Rome until 1809, when he stayed there for three years. After gaining a gold medal in the Salon of 1817 for the *Death of Louis XII* (Toulouse, Mus. Augustins), Blondel embarked on a wide-ranging and successful career as official decorative painter. In addition to the decoration of the Salon and of the Galerie de Diane at Fontainebleau (1822–8) and the ceiling of the Palais de la Bourse (*Justice Protecting Commerce*, sketch, 1825; Dijon, Mus. Magnin), he received commissions for several ceilings in the Louvre, of which the earliest and most remarkable is in the vestibule to the Galerie d'Apollon (*The Sun* or the *Fall of Icarus*, exh. Salon, 1819; *in situ*). The ceiling painting in the Salle Henri II (the *Dispute between Minerva and Neptune on the Subject of Athens*, exh. Salon, 1822) was removed in 1938, while those in the Salles du Conseil d'Etat, *France Victorious at Bouvines* (1828) and *France Receives the Constitutional Charter from Louis XVIII* (1827), are still in place. These monumental allegorical compositions belong to the tradition of David, which by the 1820s had become academic, and display more learning than originality.

Blondel adhered to classicism in most of his works: *Maternal Tenderness* or *Hecuba and Polyxena* (exh. Salon, 1814; Dijon, Mus. B.-A.; reduced version, Los Angeles, CA, Co. Mus. A.); *Philippe Auguste before the Battle of Bouvines* (exh. Salon, 1819, for the Galerie du Duc d'Orléans); the *Assumption of the Virgin* (exh. Salon, 1824, commissioned by the State for the church of St Amand at Rodez). However, in pictures such as *Elisabeth of Hungary Placing her Crown at the Feet of the Image of Jesus Christ* (exh. Salon, 1824; Paris, St Elisabeth) he revealed greater originality in his emphasis on theatrical effects of lighting and gesture. Blondel received the Légion d'honneur after the 1824 Salon and became a member of the Institut in 1832. He executed *Ptolemaïs Delivered to Philippe Auguste and Richard the Lionheart* for the Musée Historique in Versailles (exh. Salon, 1841; Salle des Croisades). The orientalist figures in the foreground and the contrasts between light and shadow prefigured the art of Eugène Fromentin and Alexandre-Gabriel Decamps.

In 1839 Blondel spent several months in Rome as the guest of Ingres, who valued his talent. After 1841 Blondel took part in the ornamental painting movement inspired by Ingres. He worked on the Salle des Séances in the Senate and decorated the cupola above the crossing and the chapel of St-Vincent-de-Paul in St-Thomas-d'Aquin, Paris (1851). In this, Blondel's last work, the influence of David was less ponderous, the style more flexible and eclectic. His murals in the cupola show an animation and a mastery of *trompe l'oeil*

drawn from the 17th-century Italian masters. Only the Apostles against gilded backgrounds on the pendentives recall the taste for early Italian painting advocated by the school of Ingres.

Blondel was also a portrait painter. The *Portrait of his Daughter at the Age of Five* (*c.* 1839; Gray, Mus. Martin) shows the influence of the English school. Among the many portraits he executed for the Musée Historique in Versailles, the portrait of *Percier* (exh. Salon, 1839; Versailles, Château) has a genuine psychological acuity.

Bibliography

G. Guillaume: 'Merry-Joseph Blondel et son ami Ingres', *Bull. Soc. Hist. A. Fr.*, i (1936), pp. 73–91

P. Grunchec: *Le Grand Prix de peinture: Les Concours des Prix de Rome de 1797 à 1863* (Paris, 1983), p. 135

T. W. Gaehtgens: *Versailles: De la résidence royale au Musée Historique* (Paris, 1984), pp. 142–3

B. Foucart: *Le Renouveau de la peinture religieuse en France (1800–1860)* (Paris, 1987), pp. 358, 369, 407

PASCALE MÉKER

Boguet, Nicolas-Didier

(*b* Chantilly, 18 Feb 1755; *d* Rome, 1 April 1839). French painter and draughtsman, active in Italy. Sent to Paris at the age of 23 as a protégé of the Prince de Condé, he was admitted to the Académie on the recommendation of Augustin Pajou to study history painting. In 1783 he went to Rome, where he began to concentrate on landscape, spending the summer months outdoors in the Roman Campagna. These trips resulted in hundreds of drawings (Rome, Pal. Farnesina), the best of which have been compared to those of Claude Lorrain. In the 1790s Boguet painted views for European aristocrats staying in Rome, in particular Frederick Augustus Hervey, 4th Earl of Bristol, for whom he painted a *View of Lake Albano* (Grenoble, Mus. Peint. & Sculp.) in 1795. The following year Boguet was introduced to Napoleon, who persuaded him to paint a number of works celebrating his Italian campaigns, including the *Battle of Castiglione* (Versailles, Château).

In 1800, the year Boguet made his Salon début, he also began to paint such mythological scenes

as the *Triumph of Bacchus* (1803; Naples, Capodimonte). From 1825 a new note of naturalism emerged in Boguet's Roman views, as seen in the *Grounds of the Palazzo Chigi, Arriccia* (signed and dated 1825; oil on canvas, 610×736 mm; sold London, Christie's, 25 June 1982, for £8,500). This tendency may be explained in part by the presence in Rome at that time of Boguet's friend the painter François Granet. Boguet's son, also named Nicolas-Didier (1802–after 1861), was painting by this date and there are several works that show evidence of collaboration between the two artists; however, the *View of the Villa Aldobrandini at Frascati* (1824; Aix-en-Provence, Mus. Granet) is probably the son's work alone.

Bibliography

L'Italia vista dai pittori francesi del XVIII e XIX secolo (exh. cat., ed. G. Bazin; Rome, Pal. Espos., 1961)

M. M. Aubrun: 'N.-D. Boguet (1755–1839): Un Emule du Lorrain', *Gaz. B.-A.*, lxxxiii (1974), pp. 319–36 [cat. of paintings]

De David à Delacroix: La Peinture française de 1774 à 1830 (exh. cat., Paris, Grand Pal.; Detroit, MI, Inst. A.; New York, Met.; 1974–5), pp. 319 21 [mainly about Boguet's son]

LORRAINE PEAKE

Boichot, Guillaume

(*b* Chalon-sur-Saône, 30 Aug 1735; *d* Paris, 9 Dec 1814). French sculptor, draughtsman and painter. He probably first trained in Chalon, under the sculptor Pierre Colasson (*c.* 1724–70); later he studied in Paris at the school of the Académie Royale, under Simon Challes. In 1766 he travelled to Italy, remaining there until 1770. The art of Raphael and his school and the Fontainebleau school influenced Boichet's art (e.g. *Agrippina Bearing Germanicus's Ashes*, Lille, Mus. B.-A.) from an early date by giving his work a Neo-classical character. Boichot next worked in Burgundy, where he was responsible for architecture, sculpture and paintings at the château of Verdun-sur-le-Doubs (destr.). He also produced decorative work for the salon of the Académie de Dijon, of which he was a member; for the refectory of the abbey

of St Benigne, Dijon, he executed a painting of the *Triumph of Temperance over Gluttony* (Dijon, Mus. B.-A.). In Paris his studio was in the Passage Sandrier off the Chaussée d'Antin. Introduced by Augustin Pajou, he was approved (*agréé*) by the Académie Royale in 1788.

During the French Revolution, Boichot participated in the decoration of the Panthéon, Paris, including the sculpture of the *Declaration of the Rights of Man*, drawings of which are preserved in the Bibliothèque Nationale and in the Musée Denon, Chalon-sur-Saône; a plaster model has been rediscovered. He also produced *Strength under the Emblem of Hercules*, known from a bronze reduction (Los Angeles, CA, Co. Mus. A.). For the church of St Roch, Paris, he executed a statue of *St Roch*, as well as the *Four Evangelists* (plaster, 1823) for the pulpit and a painting in grisaille of *Jesus Shown to the People by Pilate*. Boichot was an excellent draughtsman and contributed to the illustrations for Jean-Baptiste Gail's translations of works by Theocritus, Xenophon, Thucydides and Herodotus and also to illustrations for the 1803 edition of Chateaubriand's *Génie du Christianisme*. He also sculpted a number of portraits, including busts of *Vivant Denon* (1802; Chalon-sur-Saône, Mus. Denon) and of *Bernardin de Saint-Pierre* (1806; Versailles, Château). Boichot regularly exhibited sculptures and drawings at the Salons from 1789 to 1812.

Bibliography

Bellier de la Chavignerie–Auvray; Lami

L. Armand-Calliat: 'Sculptures et dessins de Guillaume Boichot', *Rev. A.* [Paris], 5 (1958), pp. 229–34

S. Laveissiere: *Dictionnaire des artistes et ouvriers d'art de Bourgogne*, i (Paris, 1980), pp. 53–4

Autour de David: Dessins néo-classiques du Musée des Beaux-Arts de Lille (exh. cat., Lille, Mus. B.-A., 1983), pp. 25–6

Le Panthéon: Symbole des révolutions, de l'église de la nation au temple des grands hommes (exh. cat., Paris, Hôtel de Sully; Montreal, Can. Cent. Archit.; 1989), pp. 234, 242

Nouvelles acquisitions du département des sculptures, 1988–1991, Paris, Louvre cat. (Paris, 1992), pp. 91–4

PHILIPPE SOREL

Boilly, Louis-Léopold

(*b* La Bassée, nr Lille, 5 July 1761; *d* Paris, 4 Jan 1845). French painter and printmaker. The son of a wood-carver, Arnould Boilly (1764–79), he lived in Douai until 1778, when he went to Arras to receive instruction in *trompe l'oeil* painting from Dominique Doncre (1743–1820). He moved to Paris in 1785. Between 1789 and 1791 he executed eight small scenes on moralizing and amorous subjects for the Avignon collector Esprit-Claude-François Calvet (1728–1810), including *The Visit* (1789; Saint-Omer, Mus. Hôtel Sandelin). He exhibited at the Salon between 1791 and 1824 and received a gold medal at the Salon of 1804. From the beginning his genre subjects were extremely popular with the public and collectors. In 1833, at a time when his popularity was declining, he was admitted to the Légion d'honneur and the Institut de France.

His early works (1790–1800) show a taste for moralizing, amorous and sentimental subjects inherited from Jean Honoré Fragonard and Jean-Baptiste Greuze that combine anecdote and a delight in the tactile qualities of textiles. Boilly sought the 'sensibilité' and the 'émotion' dear to Jean-Jacques Rousseau and Denis Diderot. His mannered colouring and precise techniques are almost those of a miniaturist, and recall such Dutch 17th-century genre painters as Gabriel Metsu and Gerard Terborch; Boilly owned an important collection of their work (sold Paris, 13–14 April 1824). The *Thoughtful Present* (Paris, Mus. A. Déc.) is typical of his early period, mannered and tinged with a gentle sentimentality. In the same vein, but with a more erotic emphasis, is the *Lovers and the Escaped Bird* (Paris, Louvre). Because of this picture Boilly was condemned by the Comité du Salut Public in 1794, at the height of the Terror and at the instigation of his fellow artist Jean-Baptiste-Joseph Wicar, for painting subjects 'd'une obscénité révoltante pour les moeurs républicaines' (*J. Soc. Pop. & Républicaine A.*, April/May 1794, pp. 381–3). To refute these accusations he painted the more patriotic *Triumph of Marat* (1794; Lille, Mus. B.-A.), a compromise between history and genre painting. Generally, however, he had little interest in politics.

After 1800 Boilly's compositions became smaller and more complex, with more figures and animation. He turned to scenes of popular and street life noted down spontaneously and depicted with great refinement of colouring, for example the *Arrival of a Stagecoach in the Cour des Messageries* (1803; Paris, Louvre; see fig. 3). He still studied human feelings but preferred the observation of popular customs, positioning the figures and recording their facial details meticulously. Paintings such as the *Game of Billiards* (exh. Salon 1808; Norfolk, VA, Chrysler Mus.), executed with the virtuosity of a Dutch 17th-century domestic scene, reveal a genuine concern to provide an objective chronicle of daily life, albeit tinged with sentimentality. Boilly showed a great sense of humour and capacity for the theatrical organization of space in such works as *Entrance to the Ambigu Comic Theatre* (1819; Paris, Louvre). The pursuit of a humorous description of reality led to caricature in his *Study of 35 Facial Expressions* (Tourcoing, Mus. Mun. B.-A.).

Boilly's taste for group portraiture led him to depict the artistic world in such pictures as *Gathering of Artists in the Studio of Isabey* (1798; Paris, Louvre) and the *Amateurs of Prints* (1810; Paris, Louvre). His concern for veracity encouraged him to produce an increasing number of grisailles, such as *Galeries du Palais-Royal* (1809; Paris, Carnavalet), and *trompe l'oeil* works, for example *Christ* (1812; Oxford, Magdalen Coll.). Boilly also depicted historical events, interpreting them in domestic terms (e.g. the *Emperor's Mercy*; Paris, Bib. Thiers). The *Departure of the Volunteers in 1807* (Paris, Carnavalet) is not a heroic or patriotic picture but a study of the emotions aroused by conscription. In *Napoleon Bestowing the Légion d'honneur on Cartellier* (exh. Salon 1808; Arenenberg, Napoleonmus.) he played on the contrast between the faces of the artists and the graceful poses of the women, with a correspondingly subtle use of colours. He produced many portraits of the middle classes (e.g. series, Paris, Mus. Marmottan) and of his famous contemporaries (e.g. *Robespierre*; Lille, Mus. B.-A.). The composition of these works is extremely sober, the use of colour harmonies equally delicate (e.g. *Lucile Desmoulins*; Paris, Carnavalet).

3. Louis-Léopold Boilly: *Arrival of a Stagecoach in the Cour des Messageries*, 1803 (Paris, Musée du Louvre)

Boilly was also a skilled painter in watercolour and active as an engraver and lithographer. He published a series of 94 plates in an album entitled *Recueil de grimaces*, which demonstrates his capacity for observation and sense of humour. His ability to seize on the comic aspect of a situation places him in the tradition of 19th-century caricaturists.

Prints

Recueil de grimaces (Paris, 1823–8)

Bibliography

A. Dinaux: 'Boilly', *Archv Hist. N. France & Midi Belgique*, iv (1849), pp. 194–5

C. Blanc: *Histoire*, viii (1861–76), pp. 38–40

H. Béraldi: *Les Graveurs du XIXe siècle*, ii (Paris, 1885), pp. 144–6

H. Harrisse: *L.-L. Boilly, peintre, dessinateur et lithographe: Sa vie et son oeuvre, 1761–1845* (Paris, 1898)

P. Marmottan: *Le Peintre Louis Boilly (1761–1845)* (Paris, 1913)

J. Monneraye: 'Documents sur la vie du peintre Louis Boilly pendant la Révolution', *Bull. Soc. Hist. A. Fr.* (1929), pp. 15–30

A. Mabille de Poncheville: *Boilly* (Paris, 1931)

M.-C. Chaudonneret: 'Napoléon remet la Légion d'honneur au sculpteur Cartellier, par Boilly', *Thurgau. Beitr. Vaterländ. Gesch.*, cxviii (1981), pp. 185–92

J. S. Hallam: 'The Two Manners of Louis-Léopold Boilly and French Genre Painting in Transition', *A. Bull.*, lxiii (1981), pp. 618–32

Louis Boilly (exh. cat. by M. Delafond, Paris, Mus. Marmottan, 1984)

The Charged Image: French Lithographic Caricature 1816–1848 (exh. cat. by B. Farwell, Santa Barbara, CA, Mus. A., 1989), pp. 38–46

The Art of Louis-Léopold Boilly: Modern Life in Napoleonic France (exh. cat., Fort Worth, TX, Kimbell A. Mus.; Washington, DC, N.G.A.; in preparation)

MARIE-CLAUDE CHAUDONNERET

Boissieu, Jean-Jacques de

(*b* Lyon, 30 Nov 1736; *d* Lyon, 1 March 1810). French printmaker, draughtsman and painter. Apart from studying briefly at the Ecole Gratuite de Dessin in Lyon, he was self-taught. His first concentrated phase as a printmaker was 1758–64, during which he published three suites of etchings. Boissieu spent 1765–6 in Italy in the company of Louis-Alexandre, Duc de la Rochefoucauld (1743–93), returning to Lyon via the Auvergne with a cache of his own landscape drawings. He remained in Lyon, where he published further prints at intervals, making occasional trips to Paris and Geneva. Boissieu's prints earned him the reputation of being the last representative of the older etching tradition—he particularly admired Rembrandt van Rijn—at a time when engraving was being harnessed for commercial prints, and lithography was coming into use. For his landscape etchings Boissieu drew upon the scenery of the Roman Campagna, the watermills, windmills and rustic figures of the Dutch school (notably Salomon van Ruysdael) and the countryside around Lyon. He also engraved *têtes d'expression* and genre scenes. His work as a printmaker was intermittent, covering the periods 1758–64, 1770–82 and after 1789, although his skill was such that he was much sought after as a reproductive engraver; one example of his work is the *Landscape with Huntsmen and Dogs* after a painting (San Francisco, CA Pal. Legion of Honor) by Jan Wijnants.

Boissieu's drawings (of which over 700 survive) are widely scattered (examples in Darmstadt, Hess. Landesmus.; Florence, Uffizi; Frankfurt am Main, Städel. Kstinst.; London, BM; Paris, Louvre; Vienna, Albertina; and elsewhere). The best-known are his large landscapes enhanced by grey wash, in which he specialized from 1780 to 1800; they include *Cart in a Farmyard* (after 1765; Paris, Louvre), a *plein-air* drawing in which a workaday setting is transformed by Boissieu's pale washes of sky. His portraits drawn in red or black chalks show an acute sensitivity to individual psychology, for example the *Artist's Brother* (Berlin, Kupferstichkab.). Some 20 or so small paintings (oil on panel) comprise Boissieu's extant undertakings in this medium, many of which are after the subjects of his best-known prints. They appear to be little more than the productions of a diligent amateur, however, and include portraits (e.g. *Mme Boissieu Playing the Mandolin*, Lyon, Mus. B.-A.), landscapes strongly influenced by the Dutch

tradition (e.g. *Animal Market*, Lyon, Mus. B.-A.) and several genre scenes (e.g. *Children's Dance*, Paris, Petit Pal.).

Boissieu taught several amateur artists in Lyon as well as Jean-Michel Grobon (1770–1853), who studied both etching and painting under him. The generation of Lyon artists after Grobon was also influenced by Boissieu's bias towards Dutch art, and one of them, Antoine Duclaux (1783–1868), held up Boissieu's works in turn as models from which to learn. Eugène Bléry, Joseph Guichard and, most notably, Félix Bracquemond all benefited from this, as, independently, did Adolph Friedrich Erdmann Menzel and Félix Vallotton. The wide distribution of Boissieu's prints in the 19th century played a significant part in the dissemination of a taste for works whose style and subject-matter derive from Dutch 17th-century art.

Prints

Livre de griffonnements (Paris, 1758)
Paysages dessinés et gravés (Paris, 1759)
Suite de dix paysages à l'eau-forte (Paris, 1763)

Bibliography

Mariette
[A. de Boissieu]: *Jean-Jacques de Boissieu: Catalogue raisonné de son oeuvre* (Paris and Lyon, 1878); rev. ed. by R. M. Mason and M.-F. Pérez (Geneva, 1994)
—: *Notice sur la vie et l'oeuvre de Jean-Jacques de Boissieu* (Paris and Lyon, 1879)
Jean-Jacques de Boissieu (exh. cat. by F. Baudson, Bourg-en-Bresse, Mus. Ain, 1967)
De David à Delacroix: La Peinture française de 1774 à 1830 (exh. cat., ed. F. Cummings, R. Rosenblum and A. Schnapper; Paris, Grand Pal.; Detroit, MI, Inst. A.; New York, Met.; 1974), pp. 325–8
M.-F. Pérez: *Jean-Jacques de Boissieu (1736–1810): Artiste et amateur lyonnais du XVIIIe siècle* (diss., U. Lyon, 1982)
—: 'Pour Jean-Jacques de Boissieu peintre', *Trav. Inst. Hist. Art Lyon*, xiv (1991), pp. 103–23

MARIE-FÉLICIE PÉREZ

Boizot, Louis-Simon

(*b* Paris, 9 Oct 1743; *d* Paris, 10 March 1809). French sculptor. He was the son of Antoine Boizot (1704–82), a designer at the Gobelins, and a pupil of René-Michel Slodtz. He studied at the Académie Royale, Paris, winning the Prix de Rome in 1762, and after a period at the Ecole Royale des Elèves Protégés he completed his education from 1765 to 1770 at the Académie de France in Rome. He was accepted (*agréé*) by the Académie Royale in 1771, presenting the model (untraced) for a statuette of *Meleager*, but was not received (*reçu*) as a full member until 1778, when he completed the marble version (Paris, Louvre). He exhibited regularly at the Paris Salon until 1800.

The first years of Boizot's career were dedicated primarily to decorative sculpture, such as the model for the elaborate allegorical gilt-bronze clock known as the 'Avignon' clock (*c.* 1770; London, Wallace), some caryatids for one of the chimney-pieces at the château of Fontainebleau (marble and bronze, 1772; now Versailles, Château) and various works for the château of Louveciennes, Yvelines. In 1773, perhaps at the instigation of Mme Du Barry, for whom he worked at Louveciennes, he was appointed artistic director of the sculpture studio at the Sèvres porcelain manufactory, and during his time there he made more than 150 models that were reproduced in biscuit porcelain. In addition to models for official portrait busts such as those of *Louis XVI* and *Marie-Antoinette* (both 1774–5) and numerous allegorical groups, he executed some unusual and prestigious pieces, for example the *surtout de table*, the 'Russian Parnassus' (1778; Sèvres, Mus. N. Cér.), a toilet set (1782; Pavlovsk Pal.) for the Comtesse du Nord (later the Tsarina) and the so-called large 'Medici' vases (1783; Paris, Louvre). The style of the models he made for Sèvres shows the influence of his predecessor there, Etienne-Maurice Falconet, though Boizot favoured softer modelling and somewhat contrived poses and drapery; characterizing his entire oeuvre, these derive from his large-scale work, a bas-relief representing a *Nymph* (stone; 1775–6) for the Fontaine de la Croix-du-Trahoir (now the Fontaine de l'Arbre Sec, intersection of the Rue de l'Arbre Sec and the Rue St-Honoré), Paris.

The most fruitful period of Boizot's career was in the 1770s and 1780s. He produced portrait busts

of high quality, paying great attention to detail in such works as *Marie-Antoinette* (marble, exh. Salon 1781; untraced), *Louis XVI* (marble, exh. Salon 1777; untraced) and *Joseph II of Austria* (marble, 1777; Versailles, Petit Trianon), while his less formal busts, such as that of *Claude-Joseph Vernet* (marble, 1806; Paris, Louvre), show a more relaxed attitude and are generally more sympathetic. In his plaster reliefs (1777) for the Chapelle des Fonts Baptismaux at St Sulpice, Paris, he tried to adopt a more rigorous, classicizing style, although his statue of *St John the Baptist* (marble, 1785) and his large relief of the *Baptism* (plaster, 1781; both St Sulpice, Paris) look more to his teacher, Slodtz, and to Roman Baroque sculpture. In 1785–7 Boizot executed a marble statue of *Jean Racine* (Paris, Louvre) to contribute to the series of *Illustrious Frenchmen* commissioned by the Bâtiments du Roi.

During the French Revolution Boizot professed Republican views and played an important role in the Commission des Monuments, which advised on the preservation of the artistic heritage. Around 1800 he executed four large marble reliefs for the monument to *Gen. Lazare Hoche* (Versailles, Château), thereby demonstrating his continuing attachment to the descriptive relief style of the French school of the 17th century. Despite his difficulties in adapting his sculpture to the prevalent Neo-classical style, Boizot received official commissions under the Consulate (1779–1804) and Empire (1804–14), including bronze reliefs for the Colonne de la Grande Armée (1806–7), Place Vendôme, Paris, a statue of *Militiades* (plaster, *c.* 1806; untraced) for the Senate in the Palais du Luxembourg, Paris, decorative sculpture (bronze and stone, 1806; *in situ*) for the Fontaine du Palmier, Place du Châtelet, Paris, and numerous portrait busts.

Although he was a first-class craftsman working in an elegant and eclectic style, Boizot never really developed as an artist. He tended to couple his taste for beautiful forms with a weakness for complicated draperies and accessories, and his sense of grace with a rather chilly severity. His portrait busts are perhaps his most successful works.

Bibliography

Lami

P. de Nolhac: 'Les Sculpteurs de Marie-Antoinette: Boizot et Houdon', *Les Arts* [Paris], clx (1917)

E. Bourgeois: *Le Biscuit de Sèvres au XVIIIe siècle* (Paris, 1919)

THÉRÈSE PICQUENARD

Bonheur, (Marie-) Rosa [Rosalie]

(*b* Bordeaux, 16 March 1822; *d* Thomery, nr Fontainebleau, 25 May 1899). French painter and sculptor. She received her training from her father, Raymond Bonheur (*d* 1849), an artist and ardent Saint-Simonian who encouraged her artistic career and independence. Precocious and talented, she began making copies in the Louvre at the age of 14 and first exhibited at the Salon in 1841. Her sympathetic portrayal of animals was influenced by prevailing trends in natural history (e.g. Etienne Geoffroy Saint-Hilaire) and her deep affinity for animals, especially horses. Bonheur's art, as part of the Realist current that emerged in the 1840s, was grounded in direct observation of nature and meticulous draughtsmanship. She kept a small menagerie, frequented slaughterhouses and dissected animals to gain anatomical knowledge. Although painting was her primary medium, she also sculpted, or modelled, studies of animals, several of which were exhibited at the Salons, including a bronze *Study for a Bull* (1843; ex-artist's col., see Roger-Milès, p. 35) and *Sheep* (bronze; San Francisco, CA, de Young Mem. Mus.). In 1845 she attracted favourable notice at the Salon from Théophile Thoré. In 1848 she received a lucrative commission from the State for *Ploughing in the Nivernais* (1849; Paris, Mus. d'Orsay; see fig. 4), which, when exhibited the next year, brought her further critical and popular acclaim. Typical of the Realist interest in rural society manifested in the contemporary works of Gustave Courbet and Jean-François Millet, *Ploughing* was inspired by George Sand's rustic novel *La Mare au diable* (1846). She exhibited regularly at the Salon until 1855. Her paintings sold well and were especially popular in Great Britain and the USA.

4. Rosa Bonheur: *Ploughing in the Nivernais*, 1849 (Paris, Musée d'Orsay)

Bonheur's masterpiece, the *Horse Fair* (1853; New York, Met.), which is based on numerous drawings done at the horse market near La Salpetrière, was inspired by the Parthenon marbles (London, BM) and the works of Théodore Gericault. This immense canvas (2.45×4.07 m) combines her Realist preoccupation with anatomical accuracy and a Romantic sensitivity to colour and dramatic movement rarely found in her work. After its triumphant showing at the Paris Salon, the painting went on tour in Great Britain and the USA and was widely disseminated as a print. In 1887 Cornelius Vanderbilt purchased the *Horse Fair* for £53,000 and donated it to the newly founded Metropolitan Museum of Art, New York.

After 1860 Bonheur withdrew from the Paris art world and settled in the Château de By on the outskirts of the Forest of Fontainebleau with her companion, Nathalie Micas. Independent and financially secure, she painted steadily and entertained such celebrities as the Empress Eugénie and Buffalo Bill, whose portrait she painted in 1889 (Cody, WY, Buffalo Bill Hist. Cent.). In favour at court, Bonheur received the Légion d'honneur from the Empress Eugénie in 1865, the first woman artist to be so honoured. Although she

enjoyed widespread renown during her lifetime, she was not universally admired by contemporary critics. Her spectacular success in Great Britain, her eccentric lifestyle and her militant feminism no doubt contributed to her mixed critical reception at home. Bonheur, who wore her hair short, smoked and worked in masculine attire, was a nonconformist who transcended gender categories and painted, according to various critics, like a man. After her English tour in 1856 she adopted a more detailed realistic manner, influenced perhaps by Edwin Landseer, though her style evolved little during her long career. She never abandoned her strict technical procedures and was unaffected by contemporary artistic trends. Her reputation declined after her death but has been revived in the 20th century by feminist art historians.

Bonheur was devastated by the death of Micas, her lifelong companion, in 1889. Her final years were brightened by Anna Klumpke (1856–1942), a young American portrait painter who was her biographer and her sole heir when Bonheur died in May 1899. In 1901 the town of Fontainebleau erected a monument in honour of Bonheur that was melted down during the German occupation

of World War II. Her studio at the Château de By in Thomery has been restored and is open to the public.

Writings

'Fragments of my Autobiography', *Mag. A.*, xxvi (1902), pp. 531–6

Bibliography

L. Roger-Milès: *Rosa Bonheur: Sa vie, son oeuvre* (Paris, 1900)

A. E. Klumpke: *Rosa Bonheur: Sa vie, son oeuvre* (Paris, 1908)

T. Stanton, ed.: *Reminiscences of Rosa Bonheur* (New York, 1910/R 1976)

Women Artists: 1550–1950 (exh. cat. by A. Sutherland Harris and L. Nochlin, Los Angeles, CA, Co. Mus. A., 1976)

D. Ashton and D. Browne Hare: *Rosa Bonheur: A Life and a Legend* (New York, 1981)

A. Boime: 'The Case of Rosa Bonheur: Why Should a Woman Want to be more like a Man?', *A. Hist.*, iv (1981), pp. 384–409

C. Styles-McLeod: 'Historic Houses: Rosa Bonheur at Thomery', *Arch. Digest*, 43 (1986), pp. 144–50, 164

B. Tarbell: 'Rosa Bonheur's Menagerie', *Art and Antiques*, 15 (1993), pp. 58–64

HEATHER MCPHERSON

Bonhommé, (Ignace-)François

(*b* Paris, 15 March 1809; *d* Paris, 1 Oct 1881). French painter, draughtsman and printmaker. His father painted scenes on carriages, and he provided his son with a rudimentary artistic training in an artisan's milieu of simple machinery and fellow workers. In 1828 Bonhommé entered the Ecole des Beaux-Arts in Paris under the aegis of Guillaume Lethière, whom he always listed first among his masters. Bonhommé drew from the model with Horace Vernet and studied further with Vernet's son-in-law, Paul Delaroche. Bonhommé's first Salon exhibit, in 1833, was a painting of a Newfoundland dog (untraced). In 1835 he showed a sequence of portraits in pastel and watercolour, owned by the writer Alexandre Dumas, who later published an article on Bonhommé in *L'Indépendance belge*. In 1835 Bonhommé also made two prints detailing the installation of the Luxor obelisk in the Place de la Concorde, Paris, on 25 October of that year, one made at noon and the other at 3 o'clock, an early manifestation of his facility for rapid and accurate description of machinery and topography. During the next year Delaroche chose Bonhommé to undertake a task he had himself declined, to paint the factories of Forchambault. Bonhommé claimed his first sight of molten metal being cast determined the course of his career. His Salon début as an industrial artist came in 1838, when he showed *Sheet Metal Manufacture in the Forges of Abbainville* (untraced). Two years later he exhibited another view of the Abbainville works, as well as a dramatic cross-section of the Forchambault factory, irregularly shaped to conform with the building. From then on Bonhommé executed almost exclusively industrial scenes, although he did occasionally exercise his talent as a portraitist, as in his portrait of M. Aubertot, the head of an iron manufactory (1847; Paris, Mus. d'Orsay). The 1848 Revolution excited Bonhommé as much as had that of 1830. He was commissioned by the Republican government to provide etched portraits of its major figures, as well as two important lithographs of key events, *Session of 15 May 1848, at the Constitutional Assembly* and *Barricade on the Saint-Martin Canal, 23 June 1848*, turbulent works reflecting his admiration for Delacroix.

In 1851, with the help of his neighbour Champfleury, Bonhommé won a state commission to produce pictures for the Ecole des Mines. During 1854–5 he worked for the same patrons on a more ambitious project, which included framed horizontal scenes on a large scale of metallurgical processes and crowds of workers. For the Exposition Universelle of 1855 Bonhommé assembled four of his past Salon works and received a third-class medal, his only such award. Later that year he executed a spectacular watercolour, *Fireworks set off at Versailles in Honour of Queen Victoria, 25 August 1855* (Paris, Carnavalet), which possesses the architectural sweep and cosmic chiaroscuro of John Martin's work. Bonhommé sent mining and factory scenes to the Salon

intermittently until 1873, varying his perspective from that of the factory floor (e.g. *Workshop with Mechanical Sieves at the Factory of La Vieille Montagne, c.* 1859; Paris, Mus. N. Tech.) to an aerial viewpoint that recalls some of his teacher Vernet's battle scenes (e.g. *Coalpits and Clay Quarries at Montchanin*; Montchanin, Mairie). Bonhommé spoke of his intention to compile a project entitled *Soldiers of Industry*, in which he could celebrate the 'peaceful conquests' of his favourite 'army'. His knowledge of professional dress was thorough and complete, and his impressive pen and ink drawings of individual workers can be equally exact in their description of occupational poses and gestures. In many of Bonhommé's works expressive power was subordinate to technical accuracy, but the best, like his nightmarish scene of a blindfolded white horse being lowered for work down a mine shaft (Jarville, Mus. Hist. Fer), have the descriptive poetry of Zola's *Germinal*. Bonhommé's mills are dark and satanic, but the artist, who signed his work 'François Bonhommé, called the Blacksmith', felt enthusiasm for industry and its magnates, as well as empathy for the workers.

Never prosperous, Bonhommé was saved from absolute indigence when Charles Lauth appointed him Professor of Drawing at the Sèvres Manufactory, through the intercession of supporters such as Jules Simon. Bonhommé was given a studio and associated with friends also employed there, such as Bracquemond and Champfleury, director of the Sèvres Museum. However, his salary was low and his admirably consistent career ended sadly when he lost his mind and had to be committed to the Sainte-Anne Asylum, where he died shortly afterwards.

Bibliography

H. Béraldi: *Les Graveurs du XIXe siècle*, ii (Paris, 1885), pp. 155–6

J. F. Schnerb: 'François Bonhommé', *Gaz. B.-A.*, n.s. 4, ix (1911), pp. 11–25, 132–42

Exposition François Bonhommé, dit le Forgeron (exh. cat. by B. Gille, Nancy, Mus. Fer, 1976)

L. Nochlin: *Gustave Courbet: A Study of Style and Society* (New York, 1977), pp. 111–14

P. Le Nouëne: '"Les Soldats de l'industrie" de François Bonhommé: L'Idéologie d'un projet', *Les Réalismes et l'histoire de l'art*, *Hist. & Crit. A.*, 4/5 (1977–8), pp. 35–61

G. Weisberg: 'François Bonhommé and Early Realist Images of Industrialization, 1830–1870', *A. Mag.*, 54 (April 1980), pp. 132–4

The Realist Tradition: French Painting and Drawing, 1830–1900 (exh. cat. by G. Weisberg, Cleveland, OH, Mus. A., 1981), pp. 71–9, 270–71

JAMES P. W. THOMPSON

Bonvin, François (Saint)

(*b* Vaugirard, Paris, 22 Nov 1817; *d* Saint-Germain-en-Laye, 19 Dec 1887). French painter. François trained first as a printer and later briefly at the Gobelins. From 1828 to 1830 he was a student at the École de Dessin, Paris, and later attended the Académie Suisse. In 1843 Bonvin showed some of his drawings to François Granet, whom he considered his only mentor.

In his earliest known canvas, *Still-life with a Beer Mug* (1839; Paris, priv. col., see Weisberg, 1979, p. 208), painted while working as a clerk for the Paris police, he displayed a predilection for still-lifes that he maintained throughout his career. By the mid-1840s Bonvin devoted more time to his painting, although he did not officially leave the police until February 1850. In 1844 Bonvin met his first patron, Laurent Laperlier (1805–78), an official in the War Office, who bought some drawings that Bonvin showed under the arcades of the Institut de France, Paris. In 1847 he exhibited a portrait in the Salon and continued to show there until ill-health forced him to retire in 1880.

Through his friends, the novelist and art critic Jules Champfleury and the painter and writer Gustave Courbet, Bonvin joined the Realist movement. He had lengthy discussions with Amand Gautier, the writer Max Buchon (1818–69) and later the art critic Jules-Antoine Castagnary at the Brasserie Andler, Paris. These conversations probed the nature of Realism and the principles of truth and exactitude held by the artists in the group. François remained attached to the group until the mid-1860s.

In *La Silhouette* (1849) Champfleury singled out François's small *The Cook* (exh. Salon 1849; Mulhouse, Mus. B.-A.), comparing it with the work of Chardin, an artist whom François greatly admired. (Indeed, Bonvin convinced Laperlier to collect works by Chardin, from which he then borrowed motifs.) *The Cook* was awarded a third-class medal and won Bonvin a much-needed 250 francs. By the early 1850s François's dark-toned canvases were frequently exhibited and were sufficiently successful to win him a state commission to complete *The Girls' School* (exh. Salon 1850–51; Langres, Mus. St-Didier), which was awarded a second-class medal.

During the Second Empire (1852–70) François became well known for his small still-lifes and intimate genre scenes inspired by earlier painting. His *Interior of a Tavern* (1859; Arras, Mus. B.-A.) shows the influence of the Le Nain brothers. *Interior of a Tavern (Cabaret flamand)* (1867; Baltimore, MD, Walters A.G.) is reminiscent of 17th-century Dutch painting, especially the work of Pieter de Hooch. Bonvin's preference was for thin tones of brown, grey and black, enlivened with red or yellow highlights. In 1859, when a number of young painters (including Whistler and Fantin-Latour) were rejected at the Salon, Bonvin held an exhibition of their work at his own atelier.

After his half-brother's death in 1866 François went to the Netherlands, where he studied Dutch painting in order to find inspiration for his images of 'an art for man' as expressed by the critic Théophile Thoré. Bonvin spent a year in London during the Franco-Prussian War (1870–71). When he returned to France he settled in the village of Saint-Germain-en-Laye, where, despite failing health and eyesight, he continued to create intimate Realist charcoal drawings and paintings of humble everyday objects and scenes.

GABRIEL P. WEISBERG

Bosio, François-Joseph [Giuseppe Francesco], Baron

(*b* Monaco, 19 March 1768; *d* Paris, 29 July 1845). French sculptor of Monegasque birth. He trained in Paris in the studio of Augustin Pajou in the period 1785–8. He was an officer in the French army in Italy during the Revolutionary wars, but by 1802 he had resigned his commission. He stayed in Italy, presumably studying and practising as a sculptor until his return to Paris in 1807. Thanks to Lorenzo Bartolini he was employed to work on some of the stone bas-reliefs (1807–10; *in situ*) for the Colonne de la Grande Armée in the Place Vendôme, Paris. His first exhibit at the Salon was *Cupid Shooting his Arrows* (plaster; untraced) in 1808. A marble version (St Petersburg, Hermitage) was ordered by Empress Josephine. Reminiscent of Giambologna's *Mercury*, this Neo-classical work was completed in 1812.

Before 1815 the imperial family and court formed a large part of the subject-matter of Bosio's sculpture: at the 1810 Salon he exhibited marble busts of *Napoleon* (Versailles, Château), *Empress Marie-Louise* (Monte Carlo, Mus. N.) and *Queen Hortense* (Malmaison, Château N.) among others. Somewhat earlier he had carved a marble statue of *Empress Josephine* (destr. 1870) based on the antique *Venus Pudica* type, at the same time executing a ravishing portrait bust of her (numerous versions, e.g. plaster; Malmaison, Château N.). In 1812 he exhibited a statuette of the *King of Rome as a Child* (marble; Versailles, Chateau; see Hubert, 1964, pl. lv), as well as the plaster version (untraced) of his statue of *Aristeus, God of Gardens* (marble, exh. 1817 Salon; Paris, Louvre; see Barbarin, pl. 34/1) and the statue of the *King of Westphalia* (marble; Ajaccio, Mus. Fesch).

Bosio continued to receive important official commissions under the restored Bourbon monarchy (1814–30), having shown a marble bust of *Louis XVIII* (numerous versions, e.g. Marseille, Mus. B.-A.) at the 1814 Salon. These included a marble statue of *Louis-Antoine, Duc d'Enghien* (commissioned 1815; Versailles, Château); a bronze equestrian statue of *Louis XIV* (1816–22), still in the Place des Victoires, Paris; and a kneeling marble statue of *Louis XVI* (completed 1825) in the Chapelle Expiatoire, Paris. For all these commissions he returned to the traditions of 17th-century French sculpture. He also made a well-known costume piece, the life-size statue of *Henry of Navarre as a Boy* (plaster, 1822; untraced; marble,

exh. 1824 Salon; Pau, Mus. B.-A.; silver, 1824; Paris, Louvre), as well as the bronze *Quadriga Driven by the Personification of the Restoration* (1829) designed to replace the *Horses of San Marco* on top of the Arc de Triomphe du Carrousel, Paris (*in situ*).

Bosio became a member of the Institut de France in 1816 and a professor at the Ecole des Beaux-Arts the following year. He received numerous honours, becoming Premier Sculpteur du Roi in 1822 and eventually being created Baron Bosio in 1828. After 1830 his Neo-classical style was regarded as old-fashioned, but he still received commissions from the new government of Louis-Philippe (1830–48). These included a marble group of *History and the Arts Consecrating the Glory of France* (exh. 1844; Versailles, Château) for the new historical museum at Versailles; a marble statue of *Queen Marie-Amélie* (commissioned 1841; Versailles, Château); and a colossal bronze statue of *Napoleon I* (1840; taken down after 1945; rest. 1985; in store) for the Colonne de la Grande Armée at Boulogne-sur-Mer.

Bosio was both extremely gifted and productive. He was committed to Neo-classicism and drawn to youth and feminine charm, so that his statues of *Hyacinthus* (marble, exh. 1817 Salon; Paris, Louvre), *Flora* (plaster, 1840; Turin, Pal. Reale) and *Young Indian Girl* (marble, 1842–5; Avignon, Mus. Calvet) compare favourably with the colossal bronze group *Hercules Fighting Achelous in the Guise of a Snake* (1814–24; Paris, Louvre). One of his last portraits, the bust of his daughter the *Marquise de la Carte* (1836; priv. col.; see Hubert, 1964, pl. lvii), shows traces of a delicate talent inspired by Canova.

Bosio's brother, Jean-Baptiste-François Bosio (1764–1827), with whom he is sometimes confused, was a painter and draughtsman. Jean-Baptiste-François's son, Astyanax-Scévola Bosio (1793–1876) was a sculptor and pupil of his uncle.

Bibliography

Lami

L. Barbarin: *Etude sur Bosio: Sa vie et son oeuvre* (Monaco, 1910)

G. Hubert: *Les Sculpteurs italiens en France sous la Révolution, l'Empire et la Restauration, 1790–1830* (Paris, 1964)

—: 'François-Joseph Bosio, sculpteur monégasque', *An. Monég.*, xi (1985), pp. 82–119

N. Hubert: 'Jean-Baptiste-François Bosio, peintre monégasque (1764–1827)', *An. Monég.*, x (1986), pp. 105–112

La Sculpture française au XIXe siècle (exh. cat., ed. A. Pingeot; Paris, Grand Pal., 1986)

G. Hubert: 'Astyanax-Scévola Bosio, sculpteur (1793–1876)', *An. Monég.*, xviii (1994), pp. 57–92

GÉRARD HUBERT

Boulanger, Louis(-Candide)

(*b* Vercelli, Piedmont, 11 March 1806; *d* Dijon, 5 March 1867). French painter, illustrator, set designer and poet. He studied at the Ecole des Beaux-Arts in Paris under Guillaume Lethière from 1821. The *Punishment of Mazeppa* (1827; Rouen, Mus. B.-A.), inspired by the scene from Byron's poem, in which Mazeppa is tied to the back of a wildly stampeding horse, is his most important early painting and one of the key images of the Romantic movement.

Early in his career Boulanger became friendly with Eugène and Achille Devéria. Through them he met Victor Hugo, who became his ardent supporter and the source of many of his most typical works. Among Boulanger's illustrations were those for Hugo's *Odes et ballades* (1829), *Les Orientales* (1829), *Les Fantômes* (1829) and *Notre-Dame de Paris* (1844). Boulanger interpreted the macabre and romantic quality of Hugo's texts with an imaginative power and freedom that anticipated Redon (e.g. '*She died at 15, beautiful, happy, adored . . .*' from *Les Fantômes*). He also designed scenery for Hugo's plays, *Hernani* (1830), *Marion de Lorme* (1831) and *Lucrèce Borgia* (1833).

Boulanger was a capable portrait painter, who depicted many of the figures of the Romantic milieu, including Hugo himself (*c.* 1832; Paris, Mus. Victor Hugo). In 1828 Hugo dedicated a poem inspired by *Mazeppa* to the painter and for a brief time Boulanger's critical reputation and popular esteem rivalled that of Delacroix. However, like many other artists of the period, he found himself

unable to develop his youthful energetic manner into an equally powerful mature style. By the 1840s he was working in an increasingly insipid and unconvincing academic manner (e.g. *Shepherds at the Time of Virgil*, exh. Salon 1845; Dijon, Mus. B.-A.), although his pastels possess qualities that link him to the more spontaneous and intimate work of Paul Huet and Eugène Boudin. In 1847 he painted *St Denis Preaching* for the church of St Médard, and in 1850 *Souls in Purgatory* and *Souls Delivered* for St Roch (both in Paris). In 1860 Boulanger became the Director of the Ecole Imperiale des Beaux-Arts at Dijon where he encouraged an enlightened and progressive teaching programme.

Bibliography

A. Marie: *Le Peintre poète Louis Boulanger* (Paris, 1925)

T. Gautier: *Histoire du Romantisme suivie de notices romantiques* (Paris, 1927)

Louis Boulanger, peintre-graveur de l'époque romantique, 1806–1867 (exh. cat., ed. M. Geiger; Rouen, Mus. B.-A., 1970)

M. Geiger: 'Louis Boulanger, ami et illustrateur d'Alexandre Dumas', *Mém. Acad. Sci., A. & Lett. Dijon*, cxxii (1973–5), pp. 319–28

MICHAEL HOWARD

Boze, Joseph, Comte de

(*b* Martinques, Bouches du Rhône, 6 Feb 1745; *d* Paris, 17 Jan 1826). French painter and inventor. He was the son of a sailor and studied painting at Marseille before settling in Arles. In 1778 he moved to Paris, where he studied with the pastellist Maurice-Quentin de La Tour. He attempted some technical improvements in the fixing of pastel and established a reputation for himself as an engineer and mechanic, his system for bridling and instantaneously unbridling four-horse wagons receiving the approval of the Académie des Sciences when tested at Versailles. Boze was presented to Louis XVI by the Abbé de Vermont, confessor to the Comte de Brienne and Queen Marie-Antoinette. Thereafter, he had a fairly successful semi-official career executing miniatures and portraits of the royal family and the court,

most notably his *Louis XVI* of 1784 (France, priv. col.) and the ravishing *Jeanne-Louise Genet, Mme Campan*, Marie-Antoinette's Première Dame de la Chambre (1786; Versailles, Château). He also, from 1782, exhibited pastels and miniatures at the Salon de la Correspondance, Paris. These are mostly in an oval format and are of varying quality—some spirited and lively, others stiff and wooden.

During the French Revolution, Boze depicted numerous important figures—*Honoré-Gabriel Mirabeau* (pastel, 1789, Versailles, Château; full-length oil, 1789–90, Aix-en-Provence, Mus. Granet), *Maximilien de Robespierre* (1791; Paris, Carnavalet; Versailles, Château) and *Jean-Paul Marat* (1792; Paris, Carnavalet). Boze's prolific output during the early years of the Revolution has led to the dubious attribution to him of many pastels and drawings of court and political figures. He was not an academician, and so his first Salon exhibit did not come until the open Salon of 1791. There his work was severely criticized, his weaknesses in draughtsmanship betraying his lack of formal training, and he gave up exhibiting. Later his pre-Revolutionary connections worked against him, and in 1793 he was arrested and imprisoned for refusing to testify against Marie-Antoinette. He was freed after the fall of Robespierre in August 1794, but lack of work forced him to move to the Low Countries and later England, where he was given a pension by the Comte de Provence, the future Louis XVIII. On the rise of Napoleon, Boze returned to France. In 1801 his work for Napoleon led to an acrimonious exchange with his fellow artist Robert Lefèvre. Boze exhibited a canvas depicting the *First Consul and General Berthier at the Battle of Marengo* (untraced; coloured stipple engraving by Antoine Cardon), painted mostly by Lefèvre with background by Carle Vernet. He charged an admission fee and showed the work in London and Amsterdam under his own name. Lefèvre accused Boze of this deception in the *Journal des Arts* and the *Moniteur Universel*, saying that Boze was incapable of painting a full-length figure in oils and in his turn claiming that he had painted other, earlier works presented by Boze as his own, such as the portrait of *Mirabeau*. There is some evidence

that this was more than a retaliatory blow, differences in execution indicating that Boze painted only the head of Mirabeau.

After the restoration of the monarchy in 1814, Boze's previous loyalty was rewarded with the title of Comte in 1816. His last years were not very productive, his best-known late work being his *Maréchal Charles, Marquis de Castries* (Versailles, Château).

Bibliography

J. A. Volcy-Boze: *Le Comte Joseph de Boze, peintre de Louis XVI* (Marseille, 1873)
N. Herbin-Devedjian: 'Un Artiste sous la Révolution: Le Peintre Joseph Boze', *Bull. Soc. Hist. A. Fr.* (1981), pp. 155–64

SIMON LEE

associated with Saint Simonian, Christian Socialist and Somnambulist groups, and prophesied an exalted role for the arist in a perfected society. Copious literary jottings, accompanied by eccentric, visonary pen and ink drawings, are preserved at the Bibliothèque Municipale, Douai. After 1847 he worked in Lille, notably on the pediment of the Hôtel de Ville (1849–50), but his final years were spent in Douai.

Bibliography

Lami
J. de Caso: *David d'Angers: L'Avenir de la mémoire* (Paris, 1988)
N. McWilliam: *Dreams of Happiness: Social Art and the French Left, 1830–1850* (Princeton, 1993)

PHILIP WARD-JACKSON

Bra, Théophile-François-Marcel

(*b* Douai, 23 June 1797; *d* Douai, 2 May 1863). French sculptor. He was the son of the sculptor Eustache-Marie-Joseph Bra (1772–1840) and studied in Paris under Pierre-Charles Bridan and Jean-Baptiste Stouf. He competed unsuccessfully for the Prix de Rome in 1816 and 1817, winning second prize in 1818 with his relief *Chélonis Pleading for her Husband Cléombotte* (Douai, Mus. Mun.). However, he enjoyed early success at the Salon; after the plaster of his *Aristodemus at his Daughter's Tomb* had been shown in 1819, a marble version (Douai, Mus. Mun.) was commissioned by the State: it was exhibited at the 1822 Salon. Similarly, Bra showed a plaster of his *Ulysses on Calypso's Isle* at the Salon of 1822, which resulted in a commission for a marble version of the same subject (1831 Salon; Compiègne, Château). In this colossal figure, Bra eschews outward drama in favour of a calm, meditative attitude. The commissions that he received from the State under the Bourbon Restoration and during the July Monarchy included statues of a *Guardian Angel* (1833–5) and of *St Amelia* (1835–8) for La Madeleine, Paris; spandrel reliefs of a *Grenadier* and a *Chasseur* (1833–5) for the Arc de Triomphe de l'Etoile, Paris; and work for the Colonne de la Grande Armée at Boulogne. Bra was

Brascassat, Jacques-Raymond

(*b* Bordeaux, 30 Aug 1804; *d* Paris, 28 Feb 1867). French painter. He began his artistic career in Bordeaux at the age of 14 with the landscape painter Théodore Richard (1782–1859) and showed an early interest in drawing animals. By 1825 he was studying under Louis Hersent at the Ecole des Beaux-Arts in Paris and was sent to Italy the following year, despite coming only second in the Prix de Rome with *Hunt of Meleager* (Bordeaux, Mus. B.-A.). In Rome Brascassat met Théodore-Caruelle d'Aligny, with whom he spent most of his first year sketching in the surrounding countryside, producing such masterly works as *View of Marino, Morning* (Orléans, Mus. B.-A.). The history paintings he sent back to Paris, however, met with little success. Returning to Paris in 1830, he rejoined d'Aligny at Barbizon in 1831 and exhibited six landscapes of the area at the Paris Salon.

At the Salon of 1831 Brascassat received a first prize for his landscapes, while a special mention was made of his animal pieces, a genre that he subsequently made his own, abandoning history painting completely. By 1837 when he exhib-ited *Bulls Fighting* (Nantes, Mus. B.-A.) at the Salon his reputation as an animal painter was firmly established. The massive popularity of his works provoked the scorn of the critics, whose cutting

comments on his entries at the Salon of 1845, coupled with the artist's failing health, prompted him to stop exhibiting at the Salon, despite his reception as an Academician the following year. Brascassat continued to produce landscapes from nature, drawing when he was no longer able to paint, and such works as a *Study of Oak and Elm Trees at Magny* (1865; Reims, Mus. St-Denis) show his continuing sensitivity as a landscape painter.

Bibliography

P. Miquel: *Le Paysage français au XIXe siècle, 1824–1874: L'Ecole de la nature*, ii (Maurs-la-Jolie, 1975), pp. 248–67

Barbizon au temps de J.-F. Millet, 1849–1875 (exh. cat., ed. G. Bazin; Barbizon, Salle Fêtes, 1975), pp. 126–9

Théodore Caruelle d'Aligny et ses compagnons (exh. cat., ed. M. M. Aubrun; Rennes, Mus. B.-A. & Archéol., 1975)

LORRAINE PEAKE

Brian

French family of sculptors.

(1) Joseph Brian

(*b* Avignon, 25 Jan 1801; *d* Paris, 1 May 1861). He was introduced to drawing and sculpture in the small private art school opened in Avignon by his father (who ran a barber's shop next door); he also attended the local Ecole de Dessin. In 1815 he won a prize from the Musée Calvet, Avignon, which enabled him to go to Paris c. 1827; he became a pupil of François-Joseph Bosio and in 1829 won second place in the Prix de Rome competition with the group the *Death of Hyacinthus* (plaster; Avignon, Mus. Calvet). He spent two years at the Académie de France in Rome, where he was joined by his brother (2) Jean-Louis Brian; thereafter their work is often indistinguishable. They worked on several projects together, mostly in a Neo-classical style, among them the bronze statue of *Jean Althen* (1847; Avignon, Jardin du Rocher des Doms), which is signed *Brian frères*. In their partnership Joseph's role was principally that of entrepreneur.

(2) Jean-Louis Brian

(*b* Avignon, 20 Nov 1805; *d* Paris, 15 Jan 1864). Brother of (1) Joseph Brian. Like his brother, he received his early training in Avignon, winning a Musée Calvet prize (1827) that enabled him to study in Paris in the studio of David d'Angers. In 1832 he won the Prix de Rome and joined his brother, at the Académie de France in Rome, where among other works he executed a marble statue of a *Young Faun* (Avignon, Mus. Calvet), which was much admired by Jean-Auguste-Dominique Ingres but which had only moderate success in the Salon of 1840. He collaborated with his brother on several works. Among his official commissions were some busts for Versailles and the Palais du Luxembourg, statues for the churches of St Vincent de Paul and St Augustin in Paris, a series of *Fames* (destr.) for the Hôtel de Ville, Paris, and a statue of *Nicolas Poussin* (bronze, 1847; Les Andelys, Place du Marché, destr.). His marble statue of *Jeanne d'Albret* (1843–8; Paris, Luxembourg Gardens), a particular success, is part of a series of famous women. During the Second Empire (1852–70) he worked on a number of decorative architectural projects, including some caryatids for the Denon and Daru pavilions of the Louvre and the clock ornament of the Gare de l'Est, Paris. His classicizing style changed little during his career, and despite his training with David d'Angers there is no trace of Romanticism in his sculpture.

Bibliography

Lami

A. Le Normand: *La Tradition classique et l'esprit romantique* (Rome, 1981), pp. 243–56

ISABELLE LEMAISTRE

Bridan

French family of sculptors.

(1) Charles-Antoine Bridan

(*b* Ravières, Burgundy, 31 July 1730; *d* Paris, 28 April 1805). He was a pupil of Jean-Joseph Vinache and won the Prix de Rome in 1754. Following a period in Paris at the Ecole Royale des Elèves

Protégés, he was in Rome at the Académie de France from 1757 to 1762. On his return to France he was accepted (agréé) by the Académie Royale in 1764 and received (reçu) as an academician in 1772 on presentation of the group the *Martyrdom of St Bartholomew* (marble; Paris, Louvre). The somewhat flaccid quality of this work is also apparent in the statue *Vulcan Presenting Venus with the Arms of Aeneas* (marble, exh. Salon 1781; Paris, Luxembourg Gardens) and in his marble statues of *Sébastien Leprestre de Vauban* (exh. Salon 1785) and *Bayard* (1790; both now Versailles, Château), commissioned for the Crown by Charles-Claude de Flahaut de la Billarderie, Comte d'Angiviller, director of the Bâtiments du Roi, for the series of 'Illustrious Frenchmen'.

Bridan's portrait busts include that of *François César le Tellier, Marquis de Courtanvaux* (marble, exh. Salon 1775; Paris, Bib. Ste–Geneviève), for whom he executed a funerary monument (fragments, 1785; Tonnerre, Hôp.); he also provided a funerary monument for *Jean-Baptiste Boyer* (marble, 1775; Aix-en-Provence, Mus. Granet). He was, however, principally known for his pleasingly modelled and widely reproduced statuettes on allegorical themes, such as *Fidelity* (plaster painted as terracotta, Chartres, Mus. B.-A.), which were a pretext for the execution of charmingly erotic female nudes. He also executed matched pairs with libidinous overtones, such as the *Little Girl with a Nest* and the *Little Boy with a Bird*, commissioned in marble by Victor, Duc de Luynes (terracotta versions c. 1784; Chartres, Mus. B.-A.).

Bridan's monumental masterpiece was the sculptural decoration for the choir of Chartres Cathedral to designs by the architect Victor Louis. The marble group of the *Assumption of the Virgin* on the high altar (marble, 1767–73; *in situ*) is an astonishingly theatrical Baroque ensemble and one of the last manifestations of its kind in the religious art of 18th-century France. The eight low reliefs surrounding it representing *Scenes from the Life of the Virgin* (marble, 1786–8; *in situ*) have a more classicizing style, with clear and symmetrical compositions and measured movement. Together they illustrate some of the stylistic contradictions in late 18th-century French sculpture.

Bibliography
Lami
F. Benoit: 'Le Conflit de styles dans la cathédrale de Chartres au XVIIIème siècle', *Rev. Hist. Mod. & Contemp.*, ii (1901), pp. 45–57
M. Furcy-Raynaud: *Inventaire des sculptures exécutées au XVIIIème siècle pour la direction des Bâtiments du Roi* (Paris, 1927), pp. 62–73
M. Jusselin: 'Projets pour la transformation du choeur de la cathédrale de Chartres au XVIIIème siècle', *Bull. Mnmtl* (1929), pp. 503–8

GUILHEM SCHERF

(2) Pierre-Charles Bridan

(*b* Paris, 10 Nov 1766; *d* Versailles, 4 Aug 1836). Son of (1) Charles-Antoine Bridan. He studied with his father; in 1791 he won the Académie Royale's first prize for sculpture and in 1793 went to Italy as a *pensionnaire*. He remained in Rome until 1799, when he returned to Paris. He contributed to Napoleon I's monumental projects in Paris, notably providing 12 sections of bronze low relief for the Colonne de la Grande Armée (1806–10) in the Place Vendôme and a statue of a cannonier for the Arc de Triomphe du Carrousel (1807–8). In 1813 he was commissioned by the imperial administration to produce an enormous elephant as the central feature of a fountain for the Place de la Bastille. Never cast in bronze, it remained in the square in its plaster version until after 1830. During the Bourbon Restoration (1815–30) he produced the statue of *Bertrand Duguesclin* (marble, 1824) for the Pont de la Concorde in Paris. In 1831 the work was removed from the bridge and in 1966 sent to the military academy at Coëtquidan. Bridan also executed the tomb of *Margaret of Burgundy, Queen of Sicily* (1826; Tonnerre, Hôp.). These two works adopt the same costume medievalism found in his father's statue of *Bayard*.

Bibliography
Lami

PHILIP WARD-JACKSON

Broc, Jean

(*b* Montignac, Dordogne, 16 Dec 1771; *d* Poland, 1850). French painter and designer. He came from a family of shopkeepers and tailors and he served in the Republican army during the wars of the Vendée. By 1798 he was a student of Jacques-Louis David, who provided a small apartment in the Louvre where Broc often lived. With a group of David's students and some writers, Broc formed a dissenting sect called les Primitifs, Barbus (bearded ones), Méditateurs or Penseurs. Broc was typical of the Primitifs in finding inspiration in Greek vase painting and Italian 15th-century art.

The *School of Apelles* (1800; Paris, Louvre) was Broc's first Salon entry and the first exhibited work by a member of the Primitifs. The picture represents Apelles speaking to his students about his unfinished allegory of *Calumny*. The composition derives from Raphael's *School of Athens* (Rome, Vatican, Stanza Segnatura), and the picture on the easel is based on a drawing of *Calumny* then attributed to Raphael (Paris, Louvre). The *School of Apelles* has been interpreted as a statement on the isolation of the artist and his subjection to the injustices of the ruling class, a theme relevant to the Primitifs' own ideals. In the 1801 Salon Broc exhibited the *Death of Hyacinth* (Poitiers, Mus. B.-A.); its subtle pastel colour scheme, for which Broc was often criticized, and the attenuated figure proportions recall the art of Botticelli and Perugino, and it anticipates the stylistic mannerism of Ingres's early work. Broc's *Shipwreck of Virginie*, known only from a sketch of it by Antoine Monsaldy (1768–1816), was also exhibited in the Salon of 1801 and received more critical acclaim.

Broc was the first to leave the Primitifs; he abandoned primitivism and pursued more conventional Napoleonic history painting and portraiture, for example his full-length portrait of *Maréchal Soult* for the Salle de Concert in the Palais des Tuileries (1805; destr.; copy at Versailles, Château). In the Salon of 1806 he exhibited the *Death of General Desaix* (Versailles, Château), which was indebted to Benjamin West's *Death of General Wolfe* (1771; Ottawa, N.G.). Broc continued to exhibit at the Salon until 1833, but received little notice. He accepted students into his studio and created designs for a wallpaper manufacturer. These have been noted for their early use of Oriental landscape motifs.

Bibliography

E.-J. Delécluze: *David, son école et son temps: Souvenirs* (Paris, 1855)

G. Levitine: 'The "Primitifs" and their Critics in the Year 1800', *Stud. Romanticism*, i/4 (1962), pp. 209–19

——: '"L'Ecole d'Apelle" de Jean Broc: Un "Primitif" au Salon de l'an VIII', *Gaz. B.-A.*, lxxx (1972), pp. 285–94

J. H. Rubin: 'New Documents on the Méditateurs: Baron Gerard, Mantegna and French Romanticism circa 1800', *Burl. Mag.*, cxvii (1975), pp. 785–90

Search for Innocence: Primitive and Primitivistic Art of the 19th Century (exh. cat. by M. Curtis, College Park, U. MD, A.G., 1975)

G. Levitine: *The Dawn of Bohemianism: The Barbus Rebellion and Primitivism in Neo-classical France* (University Park, PA, 1978)

NADIA TSCHERNY

Bruandet, Lazare

(*b* Paris, 3 July 1755; *d* Paris, 26 March 1804). French painter and etcher. A pupil of Martin Roeser (1757–1804) and Jean-Philippe Sarazin (*d* ?1795), Bruandet was a wild and dissolute character who achieved posthumous fame as a precursor of the Barbizon School of landscape painters. Inspired by the Dutch masters of the 17th century, he favoured a naturalistic depiction of landscape and painted extensively in the open air. His most frequent subjects were the forests of the Ile-de-France, notably that of Fontainebleau, where he became a familiar if solitary figure: Louis XVI noted in his diary on 14 July 1789 that, while out hunting in the forest of Fontainebleau, he had encountered nothing but boars and Bruandet. Bruandet exhibited a *View in the Forest of Fontainebleau* (untraced) at the Salon of 1789, but, though he continued to exhibit regularly until his death, he met with no great critical acclaim. He was a good friend of his contemporary Georges Michel and, like Michel, he often called on other artists to paint the figures in his landscapes, especially Jean-Louis Demarne and Jacques-François

Swebach. The *Monks in the Forest* (exh. Salon 1793; Grenoble, Mus. Grenoble) is one such collaboration, the brooding forest landscape by Bruandet and the monks by Swebach. Bruandet also made a number of etchings (Roux attributes seven to him), all small in size and of similar subjects to his paintings.

Bibliography

A. Sensier: 'Conférence sur le paysage', suppl. to *Souvenirs sur Théodore Rousseau* (Paris, 1872), p. x

M. Roux: *Inventaire du fonds français: Graveurs du dix-huitième siècle*, Paris, Bib. N., Cab. Est. cat., iii (Paris, 1934), pp. 379–81

☐

Cabat, (Nicolas-)Louis

(*b* Paris, 12 Dec 1812; *d* Paris, 13 March 1893). French painter. From 1825 to 1828 he was apprenticed as a decorator of porcelain at the Gouverneur Factory in Paris. He then studied under Camille Flers, who taught him to paint landscape *en plein air* and compelled him to sharpen his powers of observation of nature at the expense of the rules of classical landscape. In 1830 he visited Normandy and on his return to Paris he associated with two avant-garde painters, Philippe-Auguste Jeanron, founder of the Société Libre de Peinture et de Sculpture, and Jules Dupré. The latter was a committed member of the Barbizon school who sought to portray the truthfulness of nature in his landscapes rather than an arranged composition. In order to deepen their study of nature, Cabat and Dupré painted together in the Forest of Fontainebleau. In 1832 they also visited the region of Berry. The following year, Cabat exhibited for the first time at the Salon in Paris, where until 1891 he showed landscapes inspired by his travels to Normandy, Picardy, Berry, the Ile de France and Italy (e.g. *Farm in Normandy*; Nantes, Mus. B.-A.). His paintings feature trees and ponds and often show the influence of the Dutch school of the 17th century. Around 1840 the honest emotion and sincerity of his early works began to be superseded by a conventional manner that gained him some official honours and cost him the friendship of other members of the Barbizon school. He was a member of the Institut de France in 1867 and was Director of the Académie de France in Rome from 1877 to 1885. His paintings embody a confrontation between two tendencies prominent at that time: realism and classicism.

Bibliography

Bellier de La Chavignerie–Auvray

M.-M. Aubrun: 'La Tradition du paysage historique et le paysage naturaliste dans la première moitié du XIXe siècle français', *Inf. Hist. A.*, xiii (1968), pp. 63–73

The Realist Tradition: French Painting and Drawing, 1830–1900 (exh. cat. by G. Weisberg, Cleveland, OH, Mus. A.; New York, Brooklyn Mus.; St Louis, MO, A. Mus.; Glasgow, A.G. & Mus.; 1980–82), pp. 277–8

Louis Cabat, 1812–1893 (exh. cat., Troyes, Mus. B.-A. & Archéol., 1987)

ANNIE SCOTTEZ-DE WAMBRECHIES

Callet, Antoine-François

(*b* Paris, 1741; *d* Paris, 1823). French painter. He studied under Antoine Boizot, attending drawing classes at the Académie Royale. In 1764, with his painting *Epponina and Sabinus Condemned by Vespasian* (Paris, Ecole N. Sup. B.-A.), he won the Prix de Rome, which allowed him to complete his artistic education at the Académie de France in Rome. Callet remained in Italy until 1772, when he executed a ceiling painting for the ballroom of the Palazzo Spinola in Genoa, which shows the influence of Veronese and the Bolognese school. His first major work on returning to Paris was the decoration of the cupola of the Salon de Compagnie in the Petits Appartements of the Palais Bourbon (1774; destr. 1864; painting of the decoration by the artist, Paris, Musées Nationaux). Its mythological scenes, with classicizing figure types, virtuoso foreshortenings and *trompe l'oeil* effects, again draw on Italian models. Another ceiling painting, the *Triumph of Flora* (1775), is known from an oil sketch (Cholet, Mus. A.) and a small replica (Paris, Louvre).

In 1781 Callet's *Allegory of Spring*, intended for the Galerie d'Apollon of the Louvre, gained him membership of the Académie: the Baroque *sotto*

in sù composition of this monumental ceiling painting is preserved in a preparatory sketch (priv. col.). A portrait of *Louis XVI* (versions, Paris, Carnavalet; Clermont-Ferrand, Mus. Bargoin) was one of Callet's best-known and most frequently reproduced works; he remained, however, a much sought after artist after the Revolution, adapting a Neo-classical style in such works as the axially structured oil sketch of the *Rape of Europa* (1790; Meaux, Mus. Bossuet) and meeting the demands of the Napoleonic era in such paintings as the *Installation of the First Consul in Lyon* (1804; untraced; preparatory sketch, Lyon, Mus. Hist.). Callet's work has been compared with that of Jean-Honoré Fragonard but has a more official and imposing character.

Bibliography

Bénézit; Thieme–Becker

P. Rosenberg, N. Reynaud and I. Compin: *Ecole française, XVIIe et XVIIIe siècles*, i of *Catalogue illustré des peintures: Musée du Louvre* (Paris, 1974)

M. C. Chaudonneret: 'A propos des tableaux du Palais Saint Pierre détruits en 1816', *Bull. Mus. & Mnmts Lyon.*, vi/1 (1977), pp. 9–18

J. Wilhelm: 'La Coupole peinte par Antoine Callet pour le Salon de Compagnie des Petits Appartements du Palais Bourbon', *Bull. Soc. Hist. A. Fr.* (1979), pp. 167–77

B. Gallini: 'Acquisitions des Musées de Cholet et de Meaux: Les Esquisses d'Antoine-François Callet (1741–1823)', *Rev. Louvre*, xxxiii/2 (1983), pp. 134–7

CATHRIN KLINGSÖHR LE ROY

Cals, Adolphe-Félix

(*b* Paris, 17 Oct 1810; *d* Honfleur, 3 Oct 1880). French painter and printmaker. A workman's son, he was apprenticed to the engraver Jean-Louis Anselin (1754–1823) at the age of 12. On his master's death he went to the workshop of Ponce and Bosc, where he learnt to use the burin. He also lithographed works by François Boucher and Devéria. In 1828 he joined the studio of Léon Cogniet. Cals was never attracted by the brand of history painting practised by Cogniet, who failed to recognize his talent and compared him with Jean-Baptiste-Camille Corot. This conventional apprenticeship, therefore, had no influence on his

art. At the beginning of the 1830s he drew and painted landscapes, and he made his début in the Salon in 1835 with a genre painting, *Poor Woman* (untraced), and several portraits. He exhibited regularly in the Salon until 1870.

Cals painted his landscapes in front of the motif, in the outskirts of Paris, at Argenteuil, Versailles and Saint-Cyr, initially with a rather firm and heavy touch. He depicted models he came across in everyday life, favouring tired faces and expressions of melancholy and restrained sorrow. His relative poverty in the 1840s brought him close to the poor, and his earliest, little-known works reveal an interest in peasant life, sometimes anticipating Jean-François Millet. In 1846 he exhibited 11 canvases in the Salon, probably including *Peasant Woman and her Child* (Barnard Castle, Bowes Mus.). Cals treated the deprivation of the figures (echoed by the bareness of the setting) with a sentimentality that he never entirely shook off and which distinguishes him from Gustave Courbet.

In the 1850s Cals specialized in peaceful scenes of family life, painted in a manner similar to contemporary works by Octave Tassaert and Edouard Frère. *Young Girl Knitting* (1850; Reims, Mus. St-Denis) shows the influence of Dutch art in the simplicity of the pose and use of chiaroscuro. Cals was also interested in still-lifes of rustic objects and domestic themes, as in *Woman Plucking a Duck* (1854; Barnard Castle, Bowes Mus.). These intimist scenes, in which he depicted the activities of his daughter Marie or children playing, also indicate the influence of Jean-Siméon Chardin. The technique used in panels such as *Portrait of a Young Woman* (Honfleur, Mus. Boudin) was looser and more sketchlike than in his earlier work. Chiaroscuro tended to mask the sad expressions of his subjects, while his lighter touch blended the colours in a misty harmony. Although he was accepted by the Salon, his pictures were little valued, badly hung and ignored by the critics.

In 1848 Cals met the dealer Père Martin, who sold the works of Corot, Millet and Cals in his Paris shop in the Rue Mogador, later in the Rue Laffitte. In 1858 Père Martin introduced Cals to Count Armand Doria, who became his most important

patron and invited him often to his château at Orrouy, until 1868. The second half of Cals's career coincided with a more settled life, which he divided between Paris and Orrouy. These new circumstances explain the commissions he received for portraits and the importance of the works he painted for Doria (sold, 4 May 1899). He continued to work on intimist genre scenes: *The Caress* and *Reading* (1867; priv. col.), *The Nurse and the Child* (1869; priv. col.) and *Woman Mending Nets* (after 1873; Dijon, Mus. B.-A.). His paintings of the 1860s had a greater freedom and the colour was organized in less brilliant harmonies than the more patiently executed earlier panels. Representation of light became his major concern, particularly in the landscapes produced in the Nièvre (1861), at Saint-Valéry-en-Caux (1864) and at Elbeuf-en-Bray (1869), in which his brushwork became more vaporous and transparent; for example, *Bend in the Marne* (Lyon, Mus. B.-A.).

In 1871 Cals met Adolphe Hervier, Eugène Boudin and Johan Barthold Jongkind at Honfleur, where he settled. He became increasingly interested in landscape and developed a greater spontaneity of expression with which to describe different times of day, using a lighter range of colours. He took part in the Salon des Refusés in 1863 and exhibited with the Impressionists in 1874, 1876, 1877 and 1879. *Woman in an Orchard* (1875; Paris, Mus. d'Orsay) revealed his interest in the new artistic developments in France in the 1870s. Although he was a friend of Claude Monet he remained closer in spirit to the precursors of the Impressionist movement such as Auguste Ravier and the painters of the Barbizon school, Charles-François Daubigny and the group who met at the Saint Siméon farm, where he often stayed.

Bibliography

A. Alexandre: *A.-F. Cals ou le bonheur de peindre* (Paris, 1900)

L'oeuvre de A.-F. Cals (exh. cat., Paris, Gal. Petit, 1901)

V. Jannesson: *Le Peintre A.-F. Cals* (Paris, 1913)

Exposition de peintures de A.-F. Cals (rétrospective) et de sculptures de Paul Paulin (exh. cat., Paris, Gal. Louis-le-Grand, 1914)

Exposition rétrospective de A.-F. Cals (exh. cat., Paris, Gal. Druet, 1930)

Exposition rétrospective de A.-F. Cals (exh. cat., Paris, Gal. Dubourg, 1943)

A. Doria: 'Un Peintre injustement oublié: Adolphe-Félix Cals', *A. Basse-Normandie*, 22 (1961)

A.-F. Cals (exh. cat., London, Hazlitt, Gooden & Fox, 1969)

Cals, 1810–1880 (exh. cat. by F. Delestre, Paris, Gal. Delestre, 1975)

VALÉRIE M. C. BAJOU

Caresme [Carême], Jacques-Philippe

(*b* Paris, 25 Feb 1734; *d* Paris, 1 March 1796). French painter, engraver and illustrator. He was the son of the painter Claude-François Caresme (*b* 1709) and studied with his cousin Charles-Antoine Coypel. In 1753 he was a pupil at the Académie Royale, where in 1761 he won second place in the Prix de Rome competition with *Judith and Holofernes* (untraced). Following his acceptance by the Académie in 1766, he was able to exhibit regularly at the Salon until his expulsion in 1778. In 1768 he received a commission for a *Presentation of the Virgin*, one of a group of three paintings destined for Bayonne Cathedral, where it still remains. The following year Caresme showed an oil sketch for the picture at the Salon. Shortly after this he was one of a number of painters selected to work at the Petit Trianon, Versailles, where he was commissioned to produce two overdoors for the antechamber: *Myrrha Changed into Myrrh* and *The Nymph Minthe Changed into Mint* (both *in situ*). The latter work, dated 1772, was exhibited at the Salons of 1775 and 1777, the year in which the Académie commissioned from Caresme, as his *morceau de réception*, a painting for the ceiling of the Galerie d'Apollon in the Louvre, Paris; his failure to produce this work resulted in his expulsion from the Académie at the end of 1778.

The production of Caresme is very various and includes portraits, still-lifes, *fêtes galantes* reminiscent of paintings by Antoine Watteau, Nicolas Lancret or even Jean-Honoré Fragonard (e.g. *Harlequin*; Paris, Mus. Cognacq-Jay) and tavern scenes in the Flemish 17th-century style, as well as landscapes, historical, mythological, and religious subjects, bacchanals and other light-hearted themes. Although he had been accepted into the

Académie as a history painter, he is best known as a painter of gallant themes and as an illustrator of risqué subjects. His engravings (see Portalis–Béraldi) enabled him to reach a wide public: he provided illustrations for La Fontaine's *Fables* (Paris, 1765–75) and for *Le Décaméron français* (Paris, 1762). During the French Revolution, which inspired him to produce several works, he adopted a severe classicizing style, as in the *Market-women going to Versailles on 5 October 1789* and the *Execution of the Marquis de Favras on 19 February 1790*.

Bibliography

Portalis–Béraldi
P. Mantz: 'Jacques-Philippe Caresme', *Chron. A. & Curiosité*, i/5 (21 Dec 1862), pp. 37–9
M. Roux: *Inventaire du fonds français: Graveurs du dix-huitième siècle*, Paris, Bib. N. Dépt. Est. cat., iii (Paris, 1934), pp. 432–3

HÉLÈNE GUICHARNAUD

Cartellier, Pierre

(*b* Paris, 22 Dec 1757; *d* Paris, 12 June 1831). French sculptor. He was the son of a locksmith and studied at the Ecole Gratuite de Dessin, Paris, and then in the studio of Charles-Antoine Bridan and at the Académie Royale. He failed to win the Prix de Rome and began to earn his living modelling decorative motifs for bronze founders. He also worked as an assistant to Joseph Deschamps (1743–88) on decorative sculpture for Queen Marie-Antoinette at the châteaux of Trianon and Saint-Cloud, near Versailles, taking over from Deschamps on his death. During the French Revolution he was one of a number of sculptors who collaborated on Antoine Quatremère de Quincy's scheme to turn the church of Ste Geneviève, Paris, into a mausoleum, the Panthéon, to which he contributed a stone relief representing *Force and Prudence* (1792–3; destr.). He exhibited a terracotta statuette of *Friendship* (priv. col., see Hubert, 1980, p. 7, fig. 4) in the 1796 Salon and in 1801 achieved his first major success when he exhibited the plaster version (untraced) of his statue of *Modesty*, based on the antique Capitoline *Venus* (Rome, Mus.

Capitolino); the marble version (exh. 1808 Salon; Amsterdam, Hist. Mus.), executed for Empress Josephine, demonstrates not only his commitment to the prevalent Neo-classical style but his distinctive personal grace of composition and delicacy of execution.

Cartellier contributed to many of Napoleon's schemes for embellishing Paris. For Jean-François-Thérèse Chalgrin's project to adapt the Luxembourg Palace for the use of the Senate he executed high-reliefs of *Peace* and *War* (stone, after 1800; *in situ*) as well as statues of *Aristides* (plaster, exh. 1804 Salon; untraced) and *Pierre-Victurnien Vergniaud* (plaster, 1804–05; Bordeaux, Mus. Aquitaine, on deposit from Versailles, Château), the latter a powerful, draped effigy of the Girondin orator. For the Salle de Diane at the Louvre he produced a plaster bas-relief of the *Dance of the Spartan Maidens* (1802; *in situ*). His contribution to the series of portraits depicting great Frenchmen, intended for the Tuileries, was an austere marble bust of *Maurice, Maréchal de Saxe* (Versailles, Château). Other official commissions included statues of *Napoleon as Legislator* (marble, 1803; Versailles, Château) for the Ecole de Droit, of *Louis Bonaparte, King of Holland* (marble, exh. 1810 Salon; Versailles, Château) and of *General Roger Valhubert* (marble, 1810–15; Avranches, Jar. Plantes), intended for the Pont de la Concorde, Paris. Cartellier also carved the Antique-inspired stone relief *Glory Distributing Crowns* (1807; *in situ*) over the portal of the Louvre colonnade and the marble relief of the *Capitulation before Ulm* (1806–09; *in situ*) on the east face of the Arc de Triomphe du Carrousel, Paris. He continued to work as a decorative sculptor under the Empire, making the models for the feet of the imperial throne at Saint-Cloud and for putti decorating Empress Marie-Louise's famous jewel cabinet (1812; Paris, Louvre), designed to complement one made for Josephine in 1809. In 1808 he was rewarded with the Cross of the Légion d'honneur and in 1810 he was elected to the chair at the Institut de France vacated by the death of Antoine-Denis Chaudet, some of whose works he helped to complete.

Cartellier was equally in demand as an official sculptor under the Restoration after 1815, now

taking royalist heroes as his subject-matter. He produced the monumental equestrian relief of *Louis XIV* (stone, 1814–16) for the tympanum of the entrance façade of the Hôtel des Invalides, Paris, to replace a badly damaged work by Guillaume Coustou. He also made a bronze statue of *Louis XV* to replace a destroyed work by Jean-Baptiste Pigalle in the Place Royale in Reims and a statue of *General Charles Pichegru* (marble, 1815–19; Versailles, Château). His marble statue of *Minerva* (1818–22; Versailles, Château) is a somewhat doctrinaire Neo-classical exercise. In 1816 Cartellier became a professor at the Ecole des Beaux-Arts, where his many pupils included some of the foremost sculptors of the next generation, notably François Rude and Louis Petitot. He was awarded the Order of Saint-Michel by Charles X at the Salon of 1825.

The Revolution of 1830 prevented the completion of two royal commissions of the 1820s, a bronze equestrian statue of *Louis XV* to replace Edme Bouchardon's destroyed work in the Place Louis XV (Place de la Concorde), Paris, and a memorial to *Charles, Duc de Berry*, which he began after the Duc's assassination in 1820 in collaboration with Louis-Marie-Charles Dupaty (1771–1825) and Jean-Pierre Cortot (fragments, marble; Saint-Denis Abbey). He did, however, model a horse which was cast in bronze in 1834 and, provided with an accompanying statue of *Louis XIV* by Petitot, this now stands in the Cour d'Honneur of the château of Versailles. Among Cartellier's late works on a more modest scale are the touching marble statue for the funerary monument of *Empress Josephine* (1814–25; Rueil-Malmaison, Hauts de Seine, SS Pierre et Paul), which portrays the Empress at prayer; the marble portrait relief on the tomb of *Mgr de Juigné, Archbishop of Paris* (1825; Paris, Notre-Dame); and the lifelike, bronze, seated statue for the tomb of *Dominique-Vivant Denon* (1826; Paris, Père Lachaise Cemetery).

Cartellier was unusual among contemporary French sculptors in that his training was as much that of a craftsman as that of an academic sculptor. Despite his attachment to the Neo-classical aesthetic, he never visited Rome. The demands of his monumental commemorative commissions often obliged him to seek inspiration in the realist aspects of the tradition of French sculpture of the 17th and 18th centuries.

Bibliography

Lami

G. Hubert: 'Pierre Cartellier, statuaire: Oeuvres et documents inédits: Ancien Régime, Révolution, Consulat', *Bull. Soc. Hist. A. Fr.* (1976), pp. 313–29

—: 'L'Oeuvre de Pierre Cartellier: Essai de catalogue raisonné', *Gaz. B.-A.*, 6th ser., xcvi (1980), pp. 1–44

La Sculpture française au XIXe siècle (exh. cat., ed. A. Pingeot; Paris, Grand Pal., 1986)

GÉRARD HUBERT

Cassas, Louis-François

(*b* Azay-le-Ferron, Indre, 3 June 1756; *d* Versailles, 1 Nov 1827). French draughtsman, engraver, sculptor and archaeologist. He received instruction in drawing from Joseph-Marie Vien, Jean-Jacques Lagrenée and Jean-Baptiste Le Prince. In 1778 he departed for Italy, where he developed his landscape draughtsmanship and his passion for antiquity. He travelled incessantly, recording everything he saw and venturing out from Rome to Venice, Naples and Sicily. An example of the numerous drawings he produced is the *Ruins of the Baths of Titus Seen from the Colosseum* (Paris, Ecole N. Sup. B.-A.). In 1782 a group of amateurs, under the patronage of Emperor Joseph II, commissioned from him a series of views of the Istrian and Dalmatian coast; these were eventually published in J. Lavallée's *Voyage pittoresque et historique de l'Istrie et de la Dalmatie*. After a brief spell in France, Cassas followed Marie-Gabriel, Comte de Choiseul-Gouffier, to his new ambassadorial post in Constantinople in 1784. He subsequently visited Syria, Egypt, Palestine, Cyprus and Asia Minor, recording his impressions of Alexandria, Cairo, Smyrna, the Temple of Diana (Artemis) at Ephesos and the Palmyra and Baalbek ruins. Many of the 250 drawings dating from this trip were of hitherto unrecorded sights. With Choiseul's assistance Cassas published these works in the *Voyage pittoresque de la Syrie, de la*

Phoenicie, de la Palaestine et de la Basse Aegypte, though only 30 copies were printed. In 1787 Cassas left Constantinople, returning to France via Rome and reaching Paris in 1792. After the Revolution he was appointed drawing-master at the Gobelins, where he remained until his death. He also produced 74 models in cork and terracotta of the principal ancient monuments for the Ecole des Beaux-Arts, Paris, influencing the development of Neo-classicism at the beginning of the 19th century.

Prints

Voyage pittoresque de la Syrie, de la Phoenicie, de la Palaestine et de la Basse Aegypte (Paris, 1799)
J. Lavallée: *Voyage pittoresque et historique de l'Istrie et de la Dalmatie* (Paris, 1802)

Bibliography

R. de Portalis: *Les Dessinateurs d'illustrations au dix-huitième siècle* (Paris, 1877), pp. 49–58
French Landscape Drawings and Sketches of the Eighteenth Century (exh. cat., London, BM, 1977), pp. 105–6

JOSHUA DRAPKIN

Cavelier, Pierre-Jules

(*b* Paris, 30 Aug 1814; *d* Paris, 28 Jan 1894). French sculptor. The son of the painter and draughtsman Adrien Cavelier (1785–1867), he began his studies at the Ecole des Beaux-Arts in 1831 as the pupil of David d'Angers and Paul Delaroche. He won the Prix de Rome in 1842 and in the same year received a third-class medal at the Salon for the plaster version of his statue *Penelope* (marble, 1849; Dampierre, Château), whose success is reflected in numerous marble reductions, most notably those by the firm of Barbedienne.

His stay in Rome between 1843 and 1848 consolidated his style: a return to the Classical Antique tempered with a discreet lyrical note. He pursued a successful official career during the Second Empire (1851–70) and was involved in the sculptural decoration of many public buildings, of which the most important was the Palais Longchamp in Marseille, for which he executed several pieces including the colossal principal group, the *Durance* (stone, 1869; *in situ*). He also sculpted many portraits, a few free-standing statues, including *Cornelia, Mother of the Gracchi* (marble, 1855–61; Paris, Mus. d'Orsay), and sometimes provided models for decorative objects.

Bibliography

Lami
M. Pajot-Villerelle and J. Marchand: *Pierre-Jules Cavelier, 1814–1894* (Paris, 1979)
La Sculpture française au XIXe siècle (exh. cat., ed. A. Pingeot; Paris, Grand Pal., 1986), pp. 36–7, 47, 251, 301

LAURE DE MARGERIE

Cham [Amédée-Charles-Henry de Noé, Comte]

(*b* Paris, 26 Jan 1818; *d* Paris, 6 Sept 1879). French caricaturist. After failing the examinations at the Ecole Polytechnique in Paris, he entered the Ministry of Finance as a trainee. He soon abandoned this career to train as an artist and entered first the studio of Nicolas-Toussaint Charlet, then that of Paul Delaroche. Under the influence of Charlet he developed his talent for making caricatures and grotesque drawings. He began his career as a caricaturist in 1839, when he published anonymously his first album entitled: *M. Lajaunisse* (Paris). In 1840, being a 'son of Noah' (Fr.: Noé), he adopted the pseudonym Cham (from Ham, Noah's son), which he first used in his third album, entitled *Histoire de M. Jobard* (Paris). In December 1843 he joined the staff of the magazine *Le Charivari* and, from then until he died, he produced at least 40,000 designs. He also worked (1842–4) for the *Musée Philipon*, a weekly satirical publication to which Paul Gavarni, Honoré Daumier and J.-J. Grandville were also contributors. Cham's work was much appreciated in Britain, where both *Punch* and the *Illustrated London News* carried drawings by him. His designs, made in a style much influenced by Daumier and accompanied by captions, are essentially illustrations of the salons and minor social types of everyday Paris, a city he hardly ever left except for journeys to Boulogne-sur-Mer, Baden-Baden and

London. Cham despised the revolutionary tenor of contemporary politics, and during the 1840s and 1850s he produced for *Le Charivari* a few series of comic, reactionary drawings, such as *P.-J. Proudhon on Tour* and *Comic History of the Assemblée Nationale*. Most of his drawings were also collected and published in such albums as *Punch à Paris* (Paris, 1850).

Bibliography

DBF

F. Ribeyre: *Cham: Sa vie et son oeuvre* (Paris, 1884)

D. Kunzle: 'Cham: The "Popular" Caricaturist', *Gaz. B.-A.* (Dec 1980), pp. 213–24

ATHENA S. E. LEOUSSI

Charlet, Nicolas-Toussaint

(*b* Paris, 20 Dec 1792; *d* Paris, 30 Dec 1845). French lithographer, painter and draughtsman. After working as a minor civil servant in Paris, he joined the army and in 1814 distinguished himself in the defence of Clichy. As a Bonapartist, he lost his commission upon the restoration of the monarchy and so devoted himself to painting and drawing. He first studied under Charles Jacques Lebel (*fl* 1801–27), a pupil of David, and then entered the studio of Antoine-Jean Gros in 1817. During this apprenticeship he had a number of lithographs published and in 1820 *La Vieille Armée française*—a collection of his drawings showing infantry uniforms—appeared. In 1822 the firm of Gihaut issued *Recueil de croquis à l'usage des petits enfants*, the first of several albums of Charlet's lithographs to be published. At the same time he worked on a number of drawings for Antoine-Vincent Arnault's *La Vie politique et militaire de Napoléon* (Paris, 1826). After the revolution of 1830 Charlet was made a captain in the National Guard and held various military positions until 1840. Though best known for his lithographs, he also produced a number of paintings which are, however, of a lesser quality than his graphic work (e.g. *Episode from the Russian Campaign*, 1836; Lyon, Mus. B.-A.). In whatever medium he worked, his subject was usually military exploits under the First Empire, which made his work popular with the

opposition under the Restoration and influential in the propagation of a mythic view of the Napoleonic era. He was elected to the Académie des Beaux-Arts in 1836 and in 1839 was appointed professor at the Ecole Polytechnique in Paris. Numerous examples of his work are held in the Bibliothèque Nationale in Paris.

Bibliography

J. F. L. de La Combe: *Charlet, sa vie, ses lettres, suivi d'une description raisonnée de son oeuvre lithographique* (Paris, 1856)

A. Dayot: *Charlet et son oeuvre* (Paris, 1893)

G. Hédiard: *Les Maîtres de la lithographie: Charlet* (Paris, 1894)

Inventaire du fonds français après 1800, Paris, Bib. N., Dépt. Est. cat. (Paris, 1930–), iv, pp. 306–75

The Charged Image: French Lithographic Caricature, 1816–1848 (exh. cat. by B. Farwell, Santa Barbara, CA, Mus. A., 1989), pp. 47–54

Charpentier [née Blondelu], Constance Marie

(*b* Paris, 1767; *d* Paris, 3 Aug 1849). French painter. She was a pupil of François Gérard and Jacques-Louis David, and in 1788 she received a Prix d'Encouragement. She exhibited at the Salon from 1795 until 1819, when she received a gold medal. Like other female painters of her period, she specialized in sentimental genre scenes and portraits of women and children. Although she was considered by contemporary critics to be one of the finest portrait painters of the age, few works by her have been traced. One of the first known works is *Scene of Family Life* (1796; exh. Paris, Gal. Pardo, 1980), a genre scene closer to Elisabeth Vigée Le Brun than to David. Among her portraits shown in the Salon of 1801 may have been that of *Charlotte du Val d'Ognes* (New York, Met.), previously attributed to David, showing a young girl drawing, posed against the sunlight. The painting reflects the influence of Gérard and is close in style to a portrait of *Mme Pagnière-Drölling* (St Louis, MO, A. Mus.).

The best known of Charpentier's paintings is *Melancholy* (exh. Salon 1801; Amiens, Mus. Picardie), which was bought by the State. It was

universally praised by the critics as giving a new inflection to art in the style of David. Charpentier invoked a theme central to Neo-classicism—the silently weeping woman—adding anecdote and emotion to Johann Joachim Winckelmann's ideal 'beauty'. The central female figure, frozen like a tomb sculpture by Antonio Canova, was placed in a symbolic landscape (the spring and willow representing nostalgia and tears), and was herself the personification of eternal sorrow.

Bibliography

C. Sterling: 'A Fine David Reattributed', *Bull. Met. Mus. A.*, ix (1951), pp. 121–32

——: 'Sur un prétendu chef d'oeuvre de David', *Bull. Soc. Hist. A. Fr.* (1951), pp. 118–30

De David à Delacroix: La Peinture française de 1774 à 1830 (exh. cat., Paris, Grand Pal., 1974), pp. 346–7

MARIE-CLAUDE CHAUDONNERET

Chassériau, Théodore

(*b* El Limón, nr Samaná [now in the Dominican Republic], 20 Sept 1819; *d* Paris, 8 Oct 1856). French painter and printmaker. In 1822 Chassériau moved with his family to Paris, where he received a bourgeois upbringing under the supervision of an older brother. A precociously gifted draughtsman, he entered Ingres's studio at the age of 11 and remained there until Ingres left to head the Académie de France in Rome in 1834. He made his Salon début in 1836 with several portraits and religious subjects, including *Cain Accursed* (Paris, priv. col.), for which he received a third-class medal. Among his many submissions in subsequent years were *Susanna Bathing* (1839, exh. Salon 1839; Paris, Louvre), a *Marine Venus* (1838; exh. Salon 1839; Paris, Louvre) and the *Toilet of Esther* (1841, exh. Salon 1842; Paris, Louvre; see col. pl. II); these three paintings of nude female figures combine an idealization derived from Ingres with a sensuality characteristic of Chassériau.

By 1840–41, when Chassériau rejoined Ingres in Rome, he had begun to turn away from his teacher's linear stylization. He became increasingly critical of the academic curriculum and passed his time making sketches of the Italian countryside and studying Renaissance frescoes, which later influenced his approach to painting monumental decorations. His best easel paintings of the early 1840s, the portraits of the Dominican friar *Jean Baptiste Henri Lacordaire* (1840; Paris, Louvre) and the *Two Sisters* (1843; Paris, Louvre; see fig. 5), continue to show a concern with Ingres's formal values and idealization, though with an intensity of feeling indicative of his growing interest in Romantic art. The influence of Delacroix is most apparent in Chassériau's large *Ali ibn Hamid, Caliph of Constantine, Followed by his Escort* (1845; Versailles, Château). Baudelaire criticized the work as imitative of Delacroix's *Abd al-Rahman, Sultan of Morocco* (1845; Toulouse, Mus. Augustins); Chassériau's painting, however, puts a far greater emphasis on the portrayal of its central figure, and its flat composition may reflect the artist's knowledge of Italian Renaissance frescoes.

5. Théodore Chassériau: *Two Sisters*, 1843 (Paris, Musée du Louvre)

Chassériau's most important graphic work is his series of 15 etchings for Shakespeare's *Othello*. The contemplative mood of these splendid plates, which were published in the *Cabinet de l'amateur* (1844), contrasts with the dramatic power of Delacroix's series of lithographs (1843) for *Hamlet*: while Delacroix's fluid, spontaneous line and dynamic compositions are well suited to lithography, Chassériau's ambitious etchings, developed through a series of states, are tighter and more static in drawing and highly stylized in composition. The latter's concentration on moments of intense emotion, rather than on narrative action, makes the series a landmark in the expression of Romantic sensibility. Chassériau also made prints after some of his most important paintings, both in etching and in lithography (for instance the *Marine Venus* and *Susanna Bathing*).

Chassériau began his career as a painter of decorations for Parisian public buildings with his scenes from the *Life of St Mary of Egypt* for the church of Ste Merri (1843). Subsequent religious commissions include the baptismal chapel of St Roch (1854) and a *Descent from the Cross* in the choir of St Philippe-du-Roule (1855). His *St Philip Baptizing the Eunuch of the Queen of Ethiopia* (h. 5m) in St Roch is a splendid example of Chassériau's application of Orientalist exoticism to the tradition of history painting in the grand style. His masterpiece in this genre, however, was the series of allegorical paintings *War* and *Peace* for the grand staircase of the Cour des Comptes in the Palais d'Orsay (1844–8), largely destroyed by fire in 1871. Like Delacroix, Chassériau preferred to paint in an oil medium on plaster, rather than in true fresco. The surviving fragments of the Cour des Comptes decorations (Paris, Louvre) appear subdued and fresco-like in colour, showing grandly conceived figures. Chassériau's decorative paintings had a marked effect in the 1850s on the works of such artists as Gustave Moreau; his influence may best be seen in Puvis de Chavannes's large wall decorations, for example *War*, *Peace*, *Work* and *Repose* (1861–3; Amiens, Mus. Picardie).

In 1846 Chassériau followed in the footsteps of Delacroix and of his friends Adrien Dauzats and Prosper Marilhat by travelling to North Africa. He stayed two months with Ali ibn Hamid in Constantine, Algeria. His detailed drawings of the local populace served as a basis for the Orientalist canvases painted in the last decade of his life, of which the most important was an enormous genre scene, *Sabbath Day in the Jewish Quarter of Constantine* (exh. Salon 1848; destr.). Among the surviving works of this kind are many fine small interior scenes, now in the Louvre, and the brooding *Arab Horsemen Carrying Away their Dead* (exh. Salon 1850–51; Cambridge, MA, Fogg).

Chassériau is one of the most important, yet least known, figures in the history of early 19th-century painting. The destruction of the Cour des Comptes and the artist's early death have hindered an appraisal of his ambitions as a painter of monumental decorative works. Many of his most important works remained with his family after his death until they were donated to the Louvre in the 20th century. His historical position has traditionally been defined as that of an artist who attempted to reconcile the styles of Ingres and Delacroix, though he is now increasingly acknowledged for his personal style, at once sensual and contemplative. While some of his subjects are close to those of Delacroix, his *Tepidarium of Pompeii* (exh. Salon 1853; Paris, Mus. d'Orsay) seems to foreshadow Ingres's *Turkish Bath* (1862; Paris, Louvre), yet its technique is far warmer and more colourful. Chassériau's Orientalist works are not all equally convincing, because of his tendency to use European models after his return from Algeria. At his best this fine draughtsman and distinguished colourist epitomizes many of the ideals of the Romantic period.

Bibliography

A. Bouvenne: 'Théodore Chassériau: Souvenirs et indiscrétions', *Bull. B.-A.*, i (1883–4), pp. 134–9, 145–50, 161–6

A. Baignères: 'Théodore Chassériau', *Gaz. B.-A.*, n.s. 2, xxxiii (1886), pp. 209–18

A. Bouvenne: 'Théodore Chassériau', *L'Artiste*, lvii/2 (1887), pp. 161–78; as book (Paris, 1887)

V. Chevillard: *Un Peintre romantique: Théodore Chassériau* (Paris, 1893)

R. Escholier: 'L'Orientalisme de Chassériau', *Gaz. B.-A.*, n.s. 5, iii (1921), pp. 89–107

Chassériau (exh. cat., Paris, Mus. Orangerie, 1930)

L. Bénédite: *Théodore Chassériau, sa vie et son oeuvre*, 2 vols (Paris, 1932)

G. M. Doyon: 'The Positions of the Panels Decorated by Théodore Chassériau at the Former Cour des Comptes in Paris', *Gaz. B.-A.*, n.s. 6, lxxiii (1969), pp. 47–56

M. Sandoz: *Théodore Chassériau, 1819–1856: Catalogue raisonné des peintures et des estampes* (Paris, 1974)

J. M. Fisher: *Théodore Chassériau: Illustrations for 'Othello'* (Baltimore, 1979)

Orientalism: The Near East in French Painting, 1800–1880 (exh. cat., U. Rochester, NY, Mem. A.G., 1982), pp. 57–61

The Orientalists: Delacroix to Matisse (exh. cat., ed. M. A. Stevens; London, RA; Washington, DC, N.G.A.; 1984), p. 120

DONALD A. ROSENTHAL

Chaudet

French artists. In 1793 (1) Antoine-Denis Chaudet married his pupil (2) Jeanne-Elisabeth Chaudet (née Gabiou). Both subsequently enjoyed successful artistic careers.

(1) Antoine-Denis Chaudet

(*b* Paris, 3 March 1763; *d* Paris, 19 April 1810). Sculptor, painter, draughtsman and designer. He was a pupil of Jean-Baptiste Stouf and Etienne-Pierre-Adrien Gois. In 1784 he won the Prix de Rome with the bas-relief *Joseph Sold into Slavery by his Brothers* (Paris, Louvre), which is in a style very different from that of his mature statues and reliefs. He spent the next four years as a pupil at the Académie de France in Rome, where he was much influenced by the sculpture of antiquity and by the Neo-classical work of Antonio Canova. He was approved (*agréé*) as an associate of the Académie Royale in 1789, and though he never became a full member he exhibited regularly at the Salon throughout his career.

During the troubled years of the French Revolution (1789–94) he produced such small-scale groups as *Nest of Cupids* (marble, 1791; Paris, priv. col.) and *Belisarius* (plaster, 1791; Paris, Louvre; bronze, Malmaison, Château N.), while his stone relief *Devotion to the Motherland* (Paris, Panthéon), commissioned in 1792, is one of two surviving sculptural works produced under the direction of Antoine Quatremère de Quincy for the Revolutionary transformation of Ste Geneviève into the Panthéon. In 1794 Chaudet contributed ephemeral works to the great Festival of the Supreme Being planned by Jacques-Louis David. He was also active as a painter in a style influenced by David. In 1793 he exhibited *Archimedes Killed by a Barbarian Soldier during the Siege of Syracuse* (untraced). He was an accomplished draughtsman, and a number of his drawings were engraved and published as individual sheets during the 1790s, including *Kneeling Youth Embracing a Girl*. In addition he collaborated on such book illustration projects as Didot's editions of the works of Racine and Montesquieu (both 1801).

In the more stable political conditions of the Directory (1795–9) and the Consulate (1799–1804) Chaudet was able to produce more permanent works in a style of refined Hellenistic elegance, delicately modelled with pure lines and sometimes verging on the precious. Among works of this period are *Cyparissus Mourning for a Stag that He Loved* (plaster, exh. Salon 1798; untraced; marble, exh. Salon 1810; St Petersburg, Hermitage), the famous and much-reproduced *Cupid Playing with a Butterfly* (plaster, exh. Salon 1802; untraced; marble completed by Pierre Cartellier, exh. Salon 1817; Paris, Louvre) and the group *Oedipus as a Child Restored to Life by the Shepherd Phorbas* (plaster, begun 1799, exh. Salon 1801; untraced; marble, completed 1815–18 by Pierre Cartellier and Louis-Marie Dupaty (1771–1825); Paris, Louvre).

Chaudet was a prolific sculptor of portrait busts that combine Neo-classical austerity of format with vigour of characterization as well as idealization. Among his work in this genre are busts of *Chrétien-Guillaume de Malesherbes* (plaster, exh. Salon 1801; Paris, Louvre), *Antoine-François de Fourcroy* (marble, exh. Salon 1804; Paris, Mus. N. Hist. Nat.), *Jean Chaptal* (marble; Tours, Mus. B.-A.) and one of *Dominique-Vivant Denon* (plaster, 1804; Dijon, Mus. B.-A.). His bust of *Napoleon Bonaparte as First Consul* (plaster, Angers, Mus. B.-A.) became, with slight modifications, the much reproduced official bust of *Napoleon as Emperor* (numerous versions in marble, bronze, plaster and biscuit porcelain; e.g.

bronze; Paris, Louvre). Chaudet also produced a marble statue in antique dress of *Napoleon as Legislator* (inaugurated 1805; St Petersburg, Hermitage; repetition, Compiègne, Château), and a colossal bronze statue of the *Emperor Holding a Winged Victory* that was installed on top of the Colonne de la Grande Armée in the Place Vendôme, Paris, in 1810 but destroyed in 1814 (the *Victory* survives, Malmaison, Château N.).

Chaudet received a member of other important commissions under the First Empire (1804–14), including a seated statue of *Peace* (silver and silvergilt, 1803–5; Paris, Louvre); a statue of *General Jacques-François Dugommier* in military uniform (marble; Versailles, Château); an allegorical relief depicting *Heroic Poetry*, *Homer* and *Virgil* for the Cour Carrée at the Palais du Louvre, Paris (*in situ*); and the pedimental sculpture for the Palace of the Corps Legislatif, Paris, representing the *Emperor Presenting the Colours Conquered at the Battle of Austerlitz* (stone, inaugurated 1810; destr. after 1814). He was active as a decorative sculptor and designer, making the models for the elegant reliefs on the Empress Josephine's jewel cabinet (1809; Paris, Louvre) and designing the famous eagle surmounting the standards of the Imperial army (1804; Paris, Mus. Armée).

As a convinced Neo-classicist and one of the principal sculptors of the First Empire, Chaudet was widely honoured: he was a Chevalier of the Légion d'honneur, a professor at the Ecole des Beaux-Arts and from 1805 a member of the Institut de France. He was also an artist of great sensitivity, as witnessed by his freely modelled preparatory sketches, such as those for *Oedipus and Phorbas* (bronze cast, 1799; Paris, Louvre) and the *Activities of Commerce* (plaster, 1807–8; Paris, Carnavalet), a projected relief for the Paris Bourse, as well as by his drawings, of which there is an album in the Louvre, Paris.

Bibliography

Lami

P. Vitry: *Temps modernes* (1922, suppl. 1933), ii of *Musée National du Louvre: Catalogue des sculptures du moyen âge, de la Renaissance et des temps modernes* (Paris, 1922)

——: 'Un Album de dessins du sculpteur Chaudet', *Bull. Soc. Hist. A. Fr.* (1924), p. 27

G. Hubert: 'Note sur deux oeuvres retrouvées du sculpteur Chaudet', *Archvs A. Fr.*, xxii (1959), pp. 287–92

La Sculpture française au XIXe siècle (exh. cat., ed. A. Pingeot; Paris, Grand Pal., 1986)

GÉRARD HUBERT

(2) Jeanne-Elisabeth Chaudet [née Gabiou]

(*b* Paris, 23 Jan 1767; *d* Paris, 18 April 1832). Painter, wife of (1) Antoine-Denis Chaudet. She exhibited in the Salon between 1798 and 1817. From the beginning she enjoyed the approval of the public and the critics. The *Little Girl Trying to Teach her Dog to Read* (exh. Salon, 1799; Rochefort, Mus. Mun.) made her famous. The Empress Josephine bought *Young Girl Feeding Chicks* (exh. Salon, 1802; Arenenberg, Napoleonmus.) for the gallery at Malmaison. Chaudet increasingly produced genre scenes incorporating young girls, children and pets, such as *Child Sleeping in a Cradle Watched by a Good Dog* (exh. Salon, 1801; Rochefort, Mus. Mun.) and *Young Girl Crying over her Dead Pigeon* (exh. Salon, 1808; Arras, Mus. B.-A.). She used muted colours, for which she was reproached by the critics, a mannered style of drawing and an extremely glacial finish. The figures are often seen in profile, like antique bas-reliefs, and have a marmoreal quality, particularly in *Young Girl Feeding Chicks*, perhaps influenced by her husband's work as a sculptor. She is best known as a genre painter but also produced a large number of portraits, such as the full-length portrait of a *Young Child in a Lancer's Costume* (*c.* 1808; Arras, Mus. B.-A.). Chaudet obtained a Prix d'Encouragement at the Salon of 1812 for the *Little Girl Eating Cherries* (Paris, Mus. Marmottan), but after 1812 her popularity declined. Her second husband, Pierre-Arsène-Denis Husson, whom she married in 1812, left an important collection of her work to the Musée des Beaux-Arts in the Abbaye St-Vaast, Arras.

Bibliography

P. Marmottan: *L'Ecole française de peinture, 1789–1830* (Paris, 1886)

F. Benoit: *L'Art français sous la Révolution et l'Empire* (Paris, 1897)

Women Painters, 1550–1950 (exh. cat. by A. B. Sutherland Harris and L. Nochlin, Los Angeles, CA, Co. Mus. A., 1977)

<div align="right">MARIE-CLAUDE CHAUDONNERET</div>

Chauvin, Pierre-Athanase

(*b* Paris, 9 June 1774; *d* Rome, 7 Oct 1832). French painter. He was a pupil of Pierre Henri de Valenciennes in Paris; although a painter of classical landscapes, he did not inherit his master's aspirations to history painting. Chauvin's major debt to Valenciennes is his mastery of light and atmospheric recession. No sketches made *sur le motif*, for which his master is famous, are known by Chauvin, but his first known work, the *Banks of the Anio, near Rome* (1807; Boulogne-Billancourt, Bib. Marmottan), executed three years after he settled permanently in Rome, indicates that he did learn from direct observation of nature. The picture also displays Chauvin's picturesque form of Neo-classicism which proved to be extremely popular. He exhibited at the Salon from 1793 and by 1806 had become a pensioned protégé of Talleyrand. By 1814 his works could be found in major collections in Rome and Paris, and he was well respected by the international artistic circle in Rome. Ingres painted portraits of Chauvin and his wife in 1814 (Bayonne, Mus. Bonnat).

Chauvin's greatest triumphs came in 1819, when he painted a view of the Villa Medici in Rome (untraced) for Prince Metternich, the Austrian foreign minister, and exhibited *Charles VIII's entry into Acquapendente* (Amboise, Mus. Mun.) at the Paris Salon. For the latter, commissioned by Louis XVIII for the Galerie de Diane at Fontainebleau, Chauvin received the Grande médaille d'or. The painting gave a poetic image of national history from the fashionable Gothic past. Chauvin's ability to grasp and fuse styles and genres was remarked upon at the Salon of 1824, when he exhibited *La Ruffinella* (Paris, Mus. A. Déc.).

Bibliography

De David à Delacroix: La Peinture française de 1774 à 1830 (exh. cat., Paris, Grand Pal.; Detroit, MI, Inst. A.; New York, Met.; 1974–5), pp. 349–51

M. M. Aubrun: 'Pierre-Athanase Chauvin', *Bull. Soc. Hist. A. Fr.* (1977), pp. 191–216 [catalogue of paintings]

<div align="right">LORRAINE PEAKE</div>

Chenavard, (Claude-)Aimé

(*b* Lyon, 1798; *d* Paris, 16 June 1838). French painter, designer and interior decorator. Throughout his career he was an advocate of the importance of art and design for industry and manufacture. In 1830 he was appointed adviser to the Sèvres Porcelain Factory by the director Alexandre Brongniart (1770–1847). There Chenavard made cartoons for stained-glass windows, a stoneware 'Vase de la Renaissance' shown at the 1833 Sèvres exhibition and designs for the Duc d'Orléans (future King Louis-Philippe), such as a silver-gilt ewer made by M. Durant and shown at the 1834 Paris Exposition Universelle. Chenavard exhibited designs at the Paris Salons of 1827, 1831, 1833 and 1834, among them his Gothic-style designs, in collaboration with Achille Mascret, for the decoration of the chapel at the château of Eu, and his sketches for the restoration of the Théâtre Français and Opéra Comique in Paris. Material by Chenavard is preserved in the Musée National de Céramique at Sèvres and the Musée des Beaux-Arts, Angers. Chenavard also published several design and pattern books. His *Recueil de dessins* consisted of 30 plates of designs for furniture, stained glass, tapestry and carpets and was widely distributed, being published also in London by Rudolph Ackermann. The title-page proudly proclaims 'by appointment to the Dauphine'. The designs are in a variety of imitative styles, such as Chinese, Egyptian, Turkish, Renaissance and Gothic, although a late Grecian style predominates. In the *Nouveau recueil de décorations intérieures* (42 pls) and its sequel, the *Album de l'ornemaniste* (72 pls), which also include designs for textiles, metalwork and porcelain, Chenavard favoured a Renaissance Revival style as well as introducing a neo-Persian style. In general, however, Chenavard's designs are

in the Troubadour style, which was popular in France between 1825 and 1850.

Published work

Recueil de dessins de tapisseries, tapis et autres objets
 d'ameublement (Paris, 1828)
Nouveau recueil de décorations intérieures (Paris, 1833–5)
Album de l'ornemaniste (Paris, 1836)

Bibliography

Thieme–Becker; Penguin Dictionary of Design & Designers
P. Thornton: Authentic Decor: The Domestic Interior,
 1620–1920 (London, 1984), pp. 212, 228

□

Chenavard, Paul(-Marc-Joseph)

(b Lyon, 9 Dec 1807; d Paris, 12 April 1895). French painter. From 1825 he studied under Louis Hersent, Jean-Auguste-Dominique Ingres and Eugène Delacroix at the Ecoles des Beaux-Arts in Lyon and Paris. At an early age he held Republican and perhaps masonic beliefs. He was a learned scholar of history, philosophy, Orientalism and mythological symbolism, but his erudition impeded clarity of thought. He was rich enough not to have to support himself by painting, and in 1827 he went to Italy, where he was particularly impressed by the art of the Florentine Renaissance. From 1828 he was associated with the German Nazarenes, who reinforced his belief in the pedagogical value of art and encouraged him to adopt a cooler, more linear style. Peter Joseph Cornelius introduced him to Georg Wilhelm Friedrich Hegel, who soon afterwards tried to interest Chenavard in his own ideas about the philosophy of history. He acquired the idea of 'palingenesis', or rebirth, from the philosopher Pierre-Simon Ballanche; this doctrine, taken from Charles Bonnet and Giambattista Vico and fashionable between 1825 and 1850, interpreted history as an ascending circular movement progressing by leaps, in contrast to the linear development from Genesis to Last Judgement in the Judeo-Christian tradition. 'Palingenesis by water' began with the Flood (or Kataklysmos) and ended in a holocaust, which destroyed the degenerate

human race and from which the phoenix, symbol of 'renaissance' or palingenesis, would arise.

Chenavard's early paintings Mirabeau Addressing the Marquis de Deux-Brézé (1831) and the Convention after the Vote on the Death Sentence of Louis XVI (1835; both Lyon, Mus. B.-A.) depict scenes from French revolutionary history in a broad Romantic style. Two religious paintings followed, the Martyrdom of St Polycarpus (exh. Salon 1841; Argenton-sur-Creuze) and the Resurrection of the Dead (1842–5; Bohal Church; see fig. 6), and at the Salon of 1846 he exhibited the Inferno (Montpellier, Mus. Fabre), inspired by Dante and painted in the style of Michelangelo. A close friend of Louis Blanc (1811–82) and Charles Blanc and a supporter of the 1848 Revolution, Chenavard was given an unrivalled opportunity to visualize his complex philosophy when, in a decree of 11 April 1848, Alexandre-Auguste Ledru-Rollin (1807–74), already his patron, appointed him to decorate the walls and floors of the Panthéon in Paris. Chenavard's plan was to depict the unfolding progress of history according to Hegel, from chaos to the present. Forty panels around the walls were to depict the history of man from Adam and Eve to Napoleon Bonaparte, and above these scenes he planned a frieze showing great men from all periods. Under the great dome he intended to install a circular mosaic floor covering 500 sq. m and representing 'universal palingenesis'. This would illustrate the past, present and future of mankind; being a pessimist he foresaw the latter as decadence arising from the profit motive and the Americanization of French society. From the evidence of the surviving cartoons (e.g. the Social Palingenesis, exh. 1855; Lyon, Mus. B.-A.) and engravings made after them the style was extremely eclectic (with much borrowing from Michelangelo) and coldly severe: grisaille was preferred throughout. The syncretism and the masonic conception of the project appealed to the provisional government. It also fascinated leading critics, notably Théophile Gautier, Théophile Silvestre (1823–76) and Charles Baudelaire, although it is doubtful whether anyone fully understood all its subtleties. Chenavard worked on the scheme for four years until it was cancelled

6. Paul Chenavard: *Resurrection of the Dead*, 1842–5 (Bohal Church)

by the decree of 6 December 1851 restoring the Panthéon to the Catholic Church, which considered Chenavard's programme overtly anticlerical.

Chenavard exhibited only one other work, the *Divine Tragedy* (exh. Salon 1869; Paris, Mus. d'Orsay), a huge canvas painted in Rome which depicts the Fall, the ordeals, the victory of the 'Eternal Androgyne' and the return to unity in divine light. Despite a detailed explanation in the Salon catalogue of the subject, which was based on the ideas of the philosopher Louis-Claude de Saint-Martin (1743–1803), the painting was greeted with incomprehension. Chenavard made further plans for the decoration of the great staircase of the Musée des Beaux-Arts in Lyon, but the clearer design by Pierre Puvis de Chavannes was preferred. An artist always more interested in ideas than execution, Chenavard died a forgotten and disappointed man.

Bibliography

C. Sloane: *Paul-Marc-Joseph Chenavard, Artist of 1848* (Chapel Hill, 1962)

Paul Chenavard et la décoration du Panthéon de 1848 (exh. cat. by M.-A. Grunewald, Lyon, Mus. B.-A., 1977)

M.-A. Grunewald: 'La Palingénésie de Paul Chenavard', *Bull. Mus. & Mnmt Lyon.*, vi (1980), pp. 317–43

—: 'La Théologie de P. Chenavard: Palingénésie et régénération', *Romantisme et religion*, ed. M. Baude and M.-M. Münch (Paris, 1980), pp. 141–52

—: [Paul Chenavard] (diss., U. Paris IV, 1985)

—: 'Paul Chenavard et la donation Dufournet', *Rev. Louvre*, xxxvi (1986), pp. 80-86

MARIE-ANTOINETTE GRUNEWALD

Chinard, Joseph

(*b* Lyon, 12 Feb 1756; *d* Lyon, 20 June 1813). French sculptor. He was the son of a silk merchant and trained under the painter Donat Nonotte at the Ecole Royale de Dessin in Lyon. He then worked with the local sculptor Barthélemy Blaise (1738–1819). In 1772 he assisted Blaise with the restoration of the sculptures on the façade of the Hôtel de Ville. By 1780 he was working independently and received a commission from the canons of St Paul for chalk statues of *St Paul*, *St Sacerdos* and the *Four Evangelists* (all destr. 1793–4). He subsequently made stone statues of *St Bruno* and *St John the Baptist* (partially destr.) for the Charterhouse at Selignac, near Bourg-en-Bresse. In 1784, thanks to the patronage of the Lyonnais official Jean-Marie Delafont de Juis, Chinard was able to go to Rome, where he remained until 1787. There he studied the art of antiquity but seems not to have had any contact with Antonio Canova, the most influential Neo-classical sculptor in the city. In 1786 he won first prize for sculpture at the Accademia di S Luca, the first French artist to do so for 60 years, with the terracotta group *Perseus Delivering Andromeda* (Rome, Accad. N. S Luca).

Chinard returned to Lyon in late 1787 and executed a marble statue of the *Virgin* for Belley Cathedral (*in situ*) and as a life-size marble version of the *Perseus* group and a bust of *Roland de la Platière* (both Lyon, Mus. B.-A.). In 1791 he went back to Rome, taking with him a number of commissions, including that for a pair of allegorical candelabra bases for a Lyon merchant called van Risambourg, for whom he had already sculpted the group *Wisdom Protecting Youth from the Darts of Love* (terracotta, 1789; priv. col.). The subjects of the candelabra, *Reason in the Guise of Apollo Trampling Superstition* and *Liberty and the Will of the People in the Guise of Jupiter Striking Down the Aristocracy*, were considered to be subversive by the papal authorities, and in September 1792 Chinard was incarcerated in the Castel Sant'Angelo. He was released in November, after the discreet intervention of the elderly Cardinal de Bernis, and arrived in Lyon at the end of the same month.

In Lyon, Chinard zealously threw himself and his art into the service of the French Revolution. The municipal authorities commissioned from him a relief of *Liberty and Equality* (destr. 1810; plaster model, Lyon, Mus. B.-A.) to replace an effigy of *Louis XIV* in the pediment of the Hôtel de Ville. He was, nevertheless, accused of being a moderate by the Jacobins and in October 1793 found himself once again in prison. There he made the small terracotta group *Innocence Seeking Refuge in the Bosom of Justice* (untraced), which he presented to his judge. He was released in February 1794 and became the official designer of temporary decorations for the Revolutionary festivals in Lyon (all works destr.).

The following year Chinard made his first visit to Paris, where he made many useful contacts, including the Lyonnais banker Récamier, for whom he executed the first of several bust portraits of his wife, the celebrated beauty *Juliette Récamier* (France, priv. col.). This version is on a small scale; the famous life-size marble version (Lyon, Mus. B.-A.) was carved in 1801. In 1802 Charles Delacroix (*d* 1805), Prefect of Marseille, ordered from Chinard a series of sculptures for the city that included a marble statue of *Peace* (Marseille, Château Borély), while the authorities at Clermont-Ferrand commissioned a monument to *Gen. Desaix* (marble; Clermont-Ferrand, Jard. Pub.).

From 1804 to 1808 Chinard worked at Carrara under the patronage of Napoleon's sister Elisa Bonaparte. His studio produced marble portrait busts of members of the Imperial court, including those of *Empress Josephine* (version, Malmaison, Château N.), *Eugène de Beauharnais* and *Gen. Leclerc* (versions of both at Versailles, Château). He returned to France in 1808 after a disagreement with the Napoleonic authorities at Carrara and reestablished himself in Lyon, where he taught at the Ecole Impériale de Dessin and made portrait busts of local personalities, including *Gen. Baron Piston* (marble; Lyon, priv. col.) and the *Comte de Bondy*, Prefect of the Rhône (marble; priv. col.). In 1808 he completed his stone statue of a *Carabineer*, begun in 1806, for the Arc de Triomphe du Carrousel in Paris. Chinard exhibited at the Paris Salons of 1798, 1802, 1806, 1808, 1810 and 1812.

Chinard was often swayed by the pressure of political and stylistic fashion in his decorative and monumental sculptures, which vary between the alexandrine grace of *Apollo Trampling Superstition*, which is reminiscent of the work of the 18th century, and the impersonal Neo-classicism of his seated statue of the *Republic* (terracotta model, 1794; Paris, Louvre). In his portraits, on the other hand, he made no concessions either to the tastes of his patrons or to fashion, employing a sensitive and very personal realism. It is this remarkable gallery of portraits that earns him a place among the masters of French sculpture.

Bibliography

Lami

S. de la Chapelle: 'Joseph Chinard', *Rev. Lyon.*, xxii (1896), pp. 76–98, 209–18, 272–91, 337–57

P. Marmottan: *Les Arts en Toscane* (Paris, 1901)

Chinard (exh. cat. by P. Vitry, Paris, Mus. A. Déc., 1909)

W. G. Schwark: *Die Porträt-werke Chinards* (Freiburg im Breisgau, 1929)

R.-G. Ledoux-Labard and C. Ledoux-Labard: 'Chinard et ses rapports avec les Récamiers', *Bull. Soc. Hist. A. Fr.* (1947–8), pp. 72–7

G. Hubert: *La Sculpture dans l'Italie napoléonienne* (Paris, 1964)

M. Rocher-Jauneau: 'Chinard and the Empire Style', *Apollo*, lxxx (1964), pp. 220–26

The Age of Neo-classicism (exh. cat., 14th Council of Europe exh., London, RA and V&A, 1972), pp. 222–6

M. Rocher-Jauneau: *L'Oeuvre de Joseph Chinard (1756–1813) au Musée des beaux-arts de Lyon* (Lyon, 1978)

MADELEINE ROCHER-JAUNEAU

Chintreuil, Antoine

(*b* Pont-de-Vaux, Ain, 15 May 1814; *d* Septeuil, Seine-et-Oise, 8 Aug 1873). French painter. He grew up in Bresse and in 1838 moved to Paris, where in 1842 he joined the studio of Paul Delaroche. Through the landscape painter Léopold Desbrosses (*b* 1821), in about 1843 Chintreuil met Corot, who became his true teacher and encouraged his inclination towards landscape painting. Following Corot's advice Chintreuil began to paint *en plein air*. During the early part of his career the art

critic Champfleury and the songwriter Pierre-Jean de Béranger (1780–1857) befriended Chintreuil and gave him great support. Béranger helped him financially by buying some of his paintings and persuading the French government to purchase others, such as *Pool with Apple Trees* (exh. Salon 1850; Montpellier, Mus. Fabre).

Chintreuil's work can be divided into three main periods. The first period (*c*. 1846–1850) mainly consists of views of the immediate environs of Paris, especially Montmartre, as in *Study of Montmartre* (Douai, Mus. Mun.) and the *Hill of Montmartre*. The latter was, in 1847, his first successful submission to the Salon following a series of rejections. The second period began in 1850 when Chintreuil settled at Igny, in the valley of the River Bievre, south-east of Paris, to study nature and render his 'impressions'. In 1850 he also met Charles-François Daubigny and sometimes painted in Barbizon. Chintreuil spent about seven years at Igny in the company of his friend and pupil Jean-Alfred Desbrosses (1835–1906), the brother of Léopold. He made numerous studies of trees and painted such views of the woods, forests and villages of the area as *Landscape with Ash* (Cambridge, Fitzwilliam) and the *Rogations at Igny* (1853; Bourg-en-Bresse, Mus. Ain).

The beginning of the third and final period is marked by Chintreuil's move in 1857 to La Tournelle-Septeuil near Mantes-la-Jolie, in the Seine valley, where he died, and this period is generally recognized as that of the full maturity of his talent. It was also around this time that critics started noticing his work, Frédéric Henriet being the first to devote an article to him, in the magazine *L'Artiste* in 1857. During this third period Chintreuil produced no less than 250 paintings, the majority of his landscapes. Completely freed from all artifice, and faithful to his 'impressions', his palette became lighter in tone, and he used glazes to enhance the fluidity of the paint. His subjects were the great, wide spaces of the Seine valley and the subtly changing tones and colours of the sky and of the receding planes when the sun dawns and sets. He also painted mists and rain, as in *Rain and Sun* (exh. Salon 1873; Paris, Mus. d'Orsay; see fig. 7).

7. Antoine Chintreuil: *Rain and Sun*, exh. Salon 1873 (Paris, Musée d'Orsay)

Chintreuil's compositions are open and simple, and his brushwork is broad and summary. Avoiding details he built up iridescent masses and volumes, as is shown in *Space* (exh. Salon 1869; Paris, Mus. d'Orsay). His interest in light effects and in rendering his 'impressions' of nature make him, along with Eugène Boudin, Johan Barthold Jongkind and the Barbizon painters, a precursor of the Impressionists (in 1859 he met Camille Pissarro). Towards the end of his career Chintreuil produced a few marine paintings. In 1861 he went to Fécamp where he made a series of studies of the sea, such as the *Sea at Sunset: Fécamp* (Bourg-en-Bresse, Mus. Ain). In 1869 and 1872 he spent some time in Boulogne-sur-Mer, producing such works as the *Hamlet and Dunes of Equihem: The Environs of Boulogne* (Pont-de-Vaux, Mus. Chintreuil).

Bibliography

Bellier de La Chavignerie–Auvray; *DBF*

Antoine Chintreuil (exh. cat., ed. G. Pillement; Pont-de-Vaux, Salle Fêtes; Bourg-en-Bresse, Mus. Ain; 1973)

P. Miquel: *Le Paysage français au XIXe siècle, 1824–1874: L'Ecole de la nature*, iii (Maurs-La-Jolie, 1975), pp. 646–63

L. Harambourg: *Dictionnaire des peintres paysagistes français au XIXe siècle* (Neuchâtel, 1985)

ATHENA S. E. LEOUSSI

Cibot, (François-Barthélemy-Michel-) Edouard

(*b* Paris, 11 Feb 1799; *d* Paris, 10 Jan 1877). French painter. He entered the Ecole des Beaux-Arts in Paris in 1822, studying with Pierre Guérin and François-Edouard Picot. Between 1827 and 1838 he exhibited small-scale literary genre scenes or historical works in the *juste-milieu* style, in which poignant incidents are enacted in authentic costume. *Waverley Falling Down in Ecstasy upon Hearing Flora Mac-Ivor Improvising on her Harp* (*c.* 1827; untraced; preparatory sketch in French priv. col.) was inspired by Walter Scott's novel *Waverley* (1814) and quoted François Gérard's *Corinna at Cape Misenum* (1819; Lyon, Mus. B.-A.). *Anne Boleyn in the Tower of London in the First Moments of her Arrest* (exh. Salon 1835; Autun, Mus. Rolin) owes its composition to Paul Delaroche's *Execution of Lady Jane Grey* (exh. Salon 1834; London, N.G.) and its subject to Gaetano Donizetti's opera *Anna Bolena* (first Paris performance in 1831). He also painted scenes from French history, such as *Fredegonde and Pretextatus* (exh. Salon 1833; Rouen, Mus. B.-A.) and the *Funeral of Godefroy de Bouillon on the Day of Calvary (January 1100)* (exh. Salon 1839; Versailles, Mus. Hist.); and, from the lives of great artists, he painted *Perugino Giving a Lesson to Raphael* (exh. Salon 1839; Moulins, Mus. Moulins).

Cibot's visit to Italy in 1838–9 marked a turning-point in his career. Thereafter he produced religious paintings and landscapes (encouraged by his friend Adrien Dauzats). *View at Bellevue, near Meudon* (1852; Paris, Louvre) and *Pit near Seine-Port (Seine-et-Marne)* (1864; Rochefort-sur-Mer, Mus. Mun.) are naturalistic studies of light and foliage. A group of 11 paintings described manifestations of charity for the choir of the church of St Leu, Paris (1846–66; destr.). In 1863 Cibot was awarded the Légion d'honneur.

Bibliography

DBF

M. Lapalus: *Le Peintre Edouard Cibot, 1799–1877* (diss., U. Dijon, 1978)

The Second Empire, 1852–1870: Art in France under Napoleon III (exh. cat. by A. Jolles, F. Cummings and H. Landais, Philadelphia, Mus. A.; Detroit, Inst. A.; Paris, Grand Pal.; 1978–9), pp. 270–71

M. Lapalus: 'Le Sejour romain du peintre d'histoire, Edouard Cibot', *Actes du colloque international Ingres et son influence: Montauban, 1980*, pp. 189–203

B. Wright: 'Scott's Historical Novels and French Historical Painting, 1815–1855', *A. Bull.*, lxiii (1981), pp. 268–87

M. Pinette: 'Autun, Musée Rolin: *Anne de Boleyn* par Edouard Cibot', *Rev. Louvre*, xxxiii (1983), pp. 429–30

Un Certain Charme britannique (exh. cat. by B. Maurice, M. Geiger and A. Strasberg, Autun, Mus. Rolin, 1991)

Les Salons retrouvés: Eclat de la vie artistique dans la France du Nord, 1815–48 (exh. cat. by A. Haudiquet and others, Calais, Mus. B.-A.; Dunkirk, Mus. Mun.; 1993), ii, p. 33

BETH S. WRIGHT

Clérisseau, Charles-Louis

(*b* Paris, *bapt* 28 Aug 1721; *d* Auteuil, 19 Jan 1820). French architect, archaeologist and painter. He was an important if controversial figure associated with the development of the Neo-classical style of architecture and interior design and its dissemination throughout Europe and the USA. He studied at the Académie Royale d'Architecture, Paris, under Germain Boffrand and won the Grand Prix in 1746. He spent the years 1749 to 1754 at the Académie Française in Rome but left after an argument with the director Charles-Joseph Natoire over his refusal to make his Easter Communion; this may have been due to his Jansenist sympathies. He nevertheless remained in Italy until 1767. During these years he became a close friend of Piranesi, Winckelmann, Cardinal Alessandro Albani and other members of the international circle interested in the Antique.

In his early student days in Rome, Clérisseau became acquainted in particular with English travellers and began to sell them his attractive topographical drawings of Roman architecture. Initially these were influenced by his studies with Giovanni Paolo Panini at the Académie, while the more dramatic and fanciful ones derived from his friendship and travels with Piranesi, whose vision of antiquity became increasingly influential. Clérisseau served as teacher and cicerone to such influential future architects as William Chambers (in 1754), Friedrich Wilhelm von Erdmannsdorff (in 1765) and, most importantly, Robert Adam and James Adam (from 1755), both of whom he instructed in the study, drawing and adaptation of Roman architectural forms. After travelling throughout Italy, where they planned various archaeological and architectural publications, Clérisseau and Robert Adam spent five weeks in 1757 in Spalato (now Split, Croatia), studying Diocletian's palace. This resulted in Adam's book *Ruins of the Palace of the Emperor Diocletian at Spalato in Dalmatia* (London, 1764), the first study of Roman domestic architecture. Clérisseau's help was barely acknowledged, although most of the plates were based on his drawings.

Clérisseau's main activity during his years in Italy was the production of hundreds of gouache drawings of real and imaginary scenes of Roman monuments, which he sold to Grand Tourists. Few of his architectural projects of these years were executed. A ruin garden (1767) for Abbé Farcetti at Sala is known only from a description in a letter from Winckelmann, and his decoration (1764) of the café in the Villa Albani with Classical scenes set in grotesque decorations has not survived and indeed may not have been executed. His one surviving work from this period is the monastic cell painted *c.* 1766 to resemble an ancient ruin

complete with furniture; inhabited by a hermit, it was commissioned by Père Thomas Lesueur at the monastery (now convent) of Trinità dei Monti, Rome. In 1767 Clérisseau returned to France following his marriage to Thérèse, the daughter of the sculptor Pierre L'Estache, and he began a long-planned study of the Roman ruins in southern France, although he produced only the first volume, on Nîmes, in 1778. A large house (1767) for Louis Borély in Marseille was not executed as planned, but the surviving drawing shows a sensitive use of Classical motifs. Finally back in Paris, he was admitted, in 1769, to the Académie Royale as a painter of architecture.

The 1770s were Clérisseau's most active period. He was in London early in the decade, perhaps working for the Adam brothers (who had earlier paid him to stay away). He designed a library (1774) at Lansdowne House, Berkeley Square, London, for William Petty, 2nd Earl of Shelburne, which was not carried out, and a screen for the garden, which was later modified. During this time he also exhibited drawings in London. His major commission, in 1773, was a design for a Roman House and museum for the grounds of Tsarkoe Selo, near St Petersburg, for Catherine the Great, but due to its enormous size it was not built. Catherine's refusal led to acrimony, but she eventually purchased over 1100 of his drawings, including originals of many of the drawings he repeated as well as those for the house, with the result that the State Hermitage Museum has the largest collection of the artist's work. Later, in 1782, Catherine commissioned a triumphal arch, also not executed; the drawings are in the Hermitage, and the large wooden model is in the Academy of Arts. During the same decade Clérisseau decorated two salons with arabesque decoration for Laurent Grimod de la Reynière, the first in his house on the Rue Grange-Batelière (1773–4), and the second for a new mansion on the Rue Boissy d'Anglas (1779–81). The date and character of these has been the subject of much debate, but it seems evident that he was not the first to introduce the style, as has been claimed. The painted decoration of the second salon is probably that now in the Victoria and Albert Museum, London, and was executed in part by Lavallee

Poussin. Clérisseau's one complete building is the gigantic Palais de Gouverneur (1776–89) in Metz. It is a ponderous but impressive building in the Louis XVI style, with inset panels on historic subjects. Clérisseau also continued to produce great numbers of beautiful and often colourful gouache drawings of Classical subjects. As earlier, many of these were purchased by the English and are still in English private and public collections, for example the Fitzwilliam Museum, Cambridge, and Sir John Soane's Museum, London.

As the authority on the Roman architecture of Nîmes, Clérisseau was asked by Thomas Jefferson, American ambassador to France in 1785, to design a new State Capitol for Virginia, based on the Maison Carrée, the well-preserved Roman temple in Nîmes. This became a joint work with Jefferson, and together they redesigned the angle of the pediment, altered the capitals to Ionic and made the portico shallower. The building, further modified in execution, was completed in 1796. It is often identified as the first monumental building of the later 18th century to imitate a specific ancient temple.

After the French Revolution in 1789, Clérisseau produced few drawings, and his only architectural commission was the salon (1792; unexecuted) for the Schloss at Weimar. The last two decades of his long life were spent in retirement in Auteuil. He produced few drawings during this period, but in 1804 a second edition of his book on Nîmes was published, with a new text supplied by his son-in-law Jacques-Guillaume Legrand. He was made a member of the Académie at Rouen in 1810 and of the Légion d'honneur in 1815.

Writings
Antiquités de la France: Monuments de Nismes, première partie (Paris, 1778); rev. edn by J. G. Legrand (Paris, 1804)

Bibliography
J. Fleming: 'The Journey to Spalato', *Archit. Rev.* [London], cxxiii (1958), pp. 102–7
——: *Robert Adam and his Circle in Edinburgh and Rome* (London, 1962, rev. 2/1978)
J. Fleming and T. J. McCormick: 'A Ruin Room by Clérisseau', *Connoisseur*, clix (1962), pp. 239–43

E. Croft-Murray: 'The Hôtel Grimod de la Reynière: The Salon Decorations', *Apollo*, lxxviii (1963), pp. 377–83

T. J. McCormick: 'An Unknown Collection of Drawings by Charles-Louis Clérisseau', *J. Soc. Archit. Historians*, xxii (1963), pp. 119–25

—: 'Virginia's Gallic Godfather', *A. VA*, iv (1964), pp. 2–13

—: 'Charles-Louis Clérisseau', *Pap. Amer. Assoc. Archit. Bibliographers*, iv (1967), pp. 9–16

D. Stillman: 'The Gallery for Lansdowne House: International Neoclassical Architecture and Decoration in Microcosm', *A. Bull.*, lii (1970), pp. 75–80

Piranèse et les Français (exh. cat., ed. A. Chastel and G. Brunel; Rome, Acad. France; Paris, Caisse N. Mnmts Hist. & Sites; 1976)

T. J. McCormick: 'Piranesi and Clérisseau's Vision of Classical Antiquity', *Actes du colloque Piranèse et les Française: Paris, 1978*, pp. 305–14

B. Gäbler: *Charles-Louis Clérisseau, 1722–1820: Ruinmalerei* (Wörlitz, 1984)

THOMAS J. MCCORMICK

Clésinger, (Jean-Baptiste) Auguste

(*b* Besançon, 20 Oct 1814; *d* Paris, 5 Jan 1883). French sculptor and painter. In 1832 his father, the sculptor Georges Philippe Clésinger (1788–1852), took him to Rome, where he was the pupil of the sculptor Bertel Thorvaldsen and the architect Gaspare Salvi (1786–1849). His travels around Europe took him to Paris for the first time in 1838, Switzerland (1840) and Florence (1843) and again to Paris in 1845. In 1847 he married Solange Dudevant, daughter of the novelist George Sand, separating from her in 1852; he was later charged with bigamy. In 1849 Clésinger was appointed Chevalier du Légion d'honneur and Officier in 1864. He joined the Photosculpture society in 1864 and organized public sales of its works in 1868 and 1870. Clésinger led a disordered and reckless existence, weighed down with unfulfilled commissions and reproachful letters from successive administrations. He supported his grand lifestyle with bursaries, including one obtained from the state. He was, however, an instinctive, sensual sculptor and an outstanding craftsman in marble, skillfully exploiting his popularity commercially: the manufacturer Ferdinand Barbedienne bought the rights to his sculptures in advance in order to

reproduce them in a range of materials and sizes. Marnyhac also ensured, after 1870, diffusion of his work.

Clésinger's best-known work, the *Woman Bitten by a Snake* (1847; Paris, Mus. d'Orsay), brought him both fame and scandal, being allegedly the 'portrait' of Appolonie-Aglaé Sabatier, the 'muse and madonna' of the poet Charles Baudelaire. Her lover, a banker, had asked Clésinger to cast the piece from life; shown at the Salon of 1847, the work heralded the thirst for pleasure that accompanied the economic expansion of the Second Empire (1852–70). Self-interest caused Clésinger to support all the regimes in France during the 19th century: for the Second Republic (1848–52) he sculpted *Liberty* and *Fraternity* (both 1848; destr.); for Napoleon III, he sculpted, on the occasion of the birth of the Prince Imperial, the *Infant Hercules Strangling the Snakes of Envy* (1857; destr., scale model; Paris, Mus. d'Orsay); and for the Third Republic (1870–1940) a colossal seated figure of the *Republic* (1878; destr.).

Despite the quality of Clésinger's work, few of his sculptures are exhibited outside. The one exception, *Louise of Savoy, Regent of France, Mother of Francis I* (1847), commissioned by King Louis-Philippe, is in the garden of the Palais du Luxembourg, Paris. Clésinger's equestrian statue of *Francis I* (1853–5; destr.), for the Cour Carrée of the Louvre, is now known only from engravings and photographs (Paris, Archvs N.), notably those by Edouard-Denis Baldus. Of four equestrian statues of French generals commissioned under the Third Republic for the façade of the Ecole Militaire in Paris, only the bronze *Marceau* and *Kléber* (both *c*. 1882; Coëtquidan, Ecole Mil. St Cyr) have survived.

Clésinger's religious commissions included the *Pietà* (1850; Paris, church of St Sulpice) and the *Virgin and Child* (1874; Bagnères-de-Bigorre). His bust of *Christ* (1874), reproduced in various materials, was used for numerous tombs, including those of *Henri Joret* (*d* 1883) and *Edmond Leclère* (*d* 1891) in Montparnasse Cemetery, Paris. Among his allegorical or mythological compositions are the *Dream of Love* (1844), *Melancholy* (1846) and

the *Gypsy Girl* (all marble, 1859; all St Petersburg, Hermitage), the *Reclining Bacchante* (1848; Paris, Petit Pal.), *Diana at Rest* (1861; Malmaison, Château N.), the *Triumph of Ariadne* (1866; Amiens, Mus. Picardie), inspired by Johann Heinrich Dannecker, *Andromeda* (1869; Perigueux, Mus. Périgord), *Bacchante and Faun* (1869; Minneapolis, MN, Inst. A.) and the *Rape of Deianira* (plaster model, 1878; Nogent-sur-Seine, Mus. Paul Dubois–Alfred Boucher). His paintings often represent the Roman Campagna and depict bulls, a theme he also favoured in sculpture (e.g. *Roman Bulls Fighting*, 1864; Marseille, Mus. B.-A.) between 1864 and 1874.

Bibliography

G. Bresc-Bautier and A. Pingeot: *Sculptures des Jardins du Louvre, du Carrousel et des Tuileries*, 2 vols (Paris, 1986), pp. 84–95

F. Thomas-Maurin: *La Vie et l'oeuvre sculptée d'Auguste Clésinger* (diss., U. Besançon, in preparation)

<div align="right">ANNE PINGEOT</div>

Clodion [Michel, Claude]

(*b* Nancy, 20 Dec 1738; *d* Paris, 28 Mar 1814). French sculptor. He was the greatest master of lyrical small-scale sculpture active in France in the later 18th century, an age that witnessed the decline of the Rococo, the rise of Romanticism and the cataclysms of revolution. Clodion's works in terracotta embody a host of fascinating and still unresolved problems, questions of autograph and attribution, the chronology of his many undated designs, the artistic sources of his works, and the position of his lyric art in the radically changing society of his time. Little is known of the sculptural activity of Clodion's brothers (see 1992 exh. cat., nos 90–93): Sigisbert-Martial Michel (*b* 13 Jan 1727); Sigisbert-François Michel (*b* Nancy, 24 Sep 1728; *d* Paris, 21 May 1811; see 1992 exh. cat., p. 29, nos 11 and 12); Nicholas Michel (*b* 17 Nov 1733); and Pierre-Joseph Michel (*b* 2 Nov 1737).

1. Training and Roman period, to 1771

Clodion trained in Paris with his uncle Lambert-Sigisbert Adam, whose mannered, late Baroque works grace the gardens of Versailles and of the Sanssouci Palace at Potsdam. He encountered in Adam's sculpture qualities of warmth and intimacy, and a spirit suited to designs on a small scale, traits his own oeuvre would sustain. Adam even created small bacchanalian groups, a concept of great importance for Clodion.

In 1759, the year of his uncle's death, Clodion won the Prix de Rome for sculpture. He remained in Paris, however, as a student at the Ecole Royale des Elèves Protégés until 1762, when he left for Rome to begin an Italian sojourn of nine years. This stay, for part of which he shared a studio with Jean-Antoine Houdon, was crucial in shaping his art. Antique sculpture, the art of Michelangelo and the great early marbles of Bernini in the Villa Borghese at Rome affected him deeply. Bernini's small terracotta studies for monumental designs doubtless also impressed Clodion with their intimacy and dynamism, arguing for the excellence possible in work on a small scale, the mode ultimately central for him.

The Roman terracottas address a wide array of figure-types, themes and technical challenges. The beautiful *Penitent Magdalen* (195×195×250 mm, 1767; Paris, Louvre), is semi-recumbent in pose, like the ancient *Cleopatra* in the Vatican. A Baroque psychological richness and a consummate freshness of technical handling stamp her grieving figure with Clodion's unmistakable fire. *River Rhine* (305×279×457 mm, 1765; Fort Worth, TX, Kimbell A. Mus.), displays the wide torso and extended arms, the physical bulk and acrobatic lassitude of Pietro da Cortona's *Defeated Giants*, a fresco in the Palazzo Barberini, Rome. Clodion's *Minerva* (h. 475 mm, 1766; New York, Met.), an elegant standing figure, is hieratic in tone, an antiquarian melding of two Roman exemplars studied in the Chiaramonti and Giustiniani collections. *Egyptian Girl with a Shrine of Isis* (h. 480 mm; Paris, Louvre) contrasts the archaic style of its tiny idol with the easy contrapposto of the maiden. Archaeological discoveries made at Hadrian's Villa in the 1760s echo here, as they do in the art of Piranesi. Clodion's pictorial friezes balance intaglio linear passages with images subtly raised in very low relief. *Vase with Five*

Women Offering Sacrifice (h. 389 mm, 1766; Paris, Louvre) is an elegant *rilievo schiacciato*, conceived in a style somewhere between the painterly atmospherics of Donatello's *Delivery of the Keys* (London, V&A) and the classical presence of the *Gemma Augustea* (Vienna, Ksthist. Mus.).

2. Career in France up to the French Revolution

Clodion was reluctant to leave Rome, but in 1771 he was ordered to return to Paris by the Marquis de Marigny, Directeur des Bâtiments du Roi. There he was approved (*agréé*) by the Académie Royale in 1773 and established a productive workshop in the Place Louis XV. Clodion's early sculptures in relief prepare us for the brilliance of later designs, such as the *Triumph of Galatea* (terracotta, 298×1612 mm, exh. Salon 1779; Copenhagen, Stat. Mus. Kst.), whose trumpeting Triton rivals in impact the *Marine Frieze* on the Altar of Ahenobarbus (Munich, Glyp.). *Vase with a Dance of Satyrs and Satyresses* (Tonnerre stone, h. 1070 mm, 1782; Paris, Louvre) demonstrates a playful warmth and an atmospheric sensuality of surface, a work from an ensemble made for the bath at the Hôtel de Besenval.

The finest of his several works on a monumental scale is the marble *Montesquieu*, commissioned by the Comte d'Angiviller for the series the Great Men of France. A sparkling portrayal, the forceful, spiralling posture of the seated *Montesquieu* recalls Michelangelo's *Erythrean Sibyl* on the ceiling of the Sistine Chapel, Rome. Clodion's greatest concentration, however, was on small terracotta groups. *Satyr and Bacchante* (h. 590 mm, c. 1780; New York, Met.) embodies the Baroque traits of the genre: a relief-like composition reminiscent of Bernini's *Apollo and Daphne* (1622–4; Rome, Gal. Borghese), a design at once sensuous, energetic and psychologically intimate. This seated, drunken satyr tips backwards as the advancing bacchante embraces him, his precarious posture recalling the *Barberini Faun* (Munich, Glyp.).

Clodion also created allegorical works, most notably a terracotta model for a monument to the *Balloon Ascent of the Physicians Charles and Robert* (h. 1105 mm; New York, Met.), the theme of a royal competition of 1784, an unrealized project intended for the Tuileries Gardens. This is composed of a sphere, representing the balloon, resting on a half-column, a severity of geometric form like that of the visionary architecture of Etienne-Louis Boullée and Claude-Nicolas Ledoux. Over these crisp solids moves a low-relief layer of billowing smoke clouds rising from fires stoked for hot air by a throng of putti. The putti are in very high relief, their joyous movements leading to the focal figure of a trumpeting Fame atop the sphere. For the spectators of 1783 the fateful meaning of the balloon ascent was that the seemingly limitless power of scientific principle now overshadowed the waning capacities of the absolute monarchy. This level of meaning is perhaps implicit in Clodion's symbolic contrast of the great looming sphere of Science (a kind of orb of dominion) with the frail figure of Fame, the latter an allegory associated with rulership at least since Roman times.

3. Later career

Clodion spent the years c. 1793–8 in Nancy away from the hazards of Revolutionary Paris. After his return the tone of his work became cool and restrained, as in the elegant embrace of the terracotta group *Zephyrus and Flora* (h. 527 mm, 1799; New York, Frick). Their entwined, mannerist dance recalls the palpably slow movement of Giambologna's *Rape of a Sabine* (1582; Florence, Loggia Lanzi). In *Bacchus and Ariadne* (h. 539 mm, 1798; Philadelphia, PA, Mus. A.) Clodion imbued the god of wine with an ennobling, Neo-classical quotation from the stance of the well-known Borghese *Mars*, its long diagonal line ordering this mythological abduction. Nobler still, *Scene from the Deluge* (h. 533 mm, 1800; Boston, MA, Mus. F.A.) shows a vigorous, bearded man carrying across his shoulders the limp body of a drowned youth. Essentially a pastiche of several similarly burdened figures in Michelangelo's *Deluge* fresco in the Sistine Chapel, this late design also reflects a preference for longer flowing lines, like those in the engravings of John Flaxman. As a moral statement suited to the tenor of the strife-ridden Napoleonic era, and as a winner of a first-class medal at the Salon of 1801, *Scene from the Deluge* attains

the greatest possible distance from the titillation and caprice of many of Clodion's earlier terracottas. During the Empire period, Clodion worked mainly as a highly placed artisan, executing the academic concepts of others. He carved a marble relief after a design by C. Meynier, *Napoleon's Entry into Munich* (2.00×3.75 m, 1805–6), for the Arc de Triomphe du Carrousel in Paris. He modelled some 15 of the total of 75 relief panels designed by P.-N. Bergeret for the Colonne de la Grande Armée (1807–9) on the Place Vendôme; he was also a member of a team of artists charged in 1807 to create a model for the standing figure of Napoleon intended to crown the column.

Bibliography

Lami; Thieme–Becker

L.-A. Dingé: *Notice nécrologique sur M. Clodion* (Paris, 1814)

H. Thirion: *Les Adam et Clodion* (Paris, 1885)

J.-J. Guiffrey: 'Le Sculpteur Claude Michel, dit Clodion (1738–1814)', *Gaz. B.-A.*, n. s. 2, viii (1892), pp. 478–95; ix (1893), pp. 164–76, 392–417

G. Varenne: 'Clodion à Nancy: Ses années d'enfance; Sa maison et son atelier de 1793 à 1798', *Rev. Lorraine Ill.*, 3 (1913), pp. 39–57

'Clodion', *Conn. A.*, xl (1955), pp. 72–7

T. Hodgkinson: *The Frick Collection: An Illustrated Catalogue*, iv (New York, 1970)

——: *The James A. Rothschild Collection at Waddesdon Manor: Sculpture* (Fribourg, 1970)

——: 'Houdon and Clodion', *Apollo*, xciii (1971), pp. 397–9

W. Kalnein and M. Levey: *Art and Architecture of the Eighteenth Century in France*, Pelican Hist. A. (Harmondsworth, 1972)

F. Souchal: 'L'Inventaire après décès du sculpteur Lambert-Sigisbert Adam', *Bull. Soc. Hist. A. Fr.* (1973), pp. 186, 190

T. Hodgkinson: 'A Clodion Statuette in the National Gallery of Canada', *N.G. Canada Bull.*, xxiv (1974), pp. 13–21

C. Avery: *Fingerprints of the Artist: European Terracotta Sculptures from the Arthur M. Sackler Collections* (Cambridge, MA, 1980)

Actes du colloque organisé au musée du Louvre: Clodion et la sculpture française de la fin du XVIIIe siècle: Paris, 1982

Clodion Terracottas in North American Collections (exh. cat. by A. L. Poulet, New York, Frick, 1984); review by A. B. Weinshenker: in *A. Bull.*, lxiv (1984), pp. 383–5

I. Wardropper: 'Adam to Clodion: Four French Terracotta Sculptures', *Mus. Stud.*, xi (1984), pp. 22–37

Clodion, 1738–1814 (exh. cat. by A. L. Poulet and G. Scherf, Paris, Louvre, 1992)

GLENN F. BENGE

Cogniet, Léon

(*b* Paris, 29 Aug 1794; *d* Paris, 20 Nov 1880). French painter. He entered the Ecole des Beaux-Arts in 1812, where he studied with Pierre Guérin and became friendly with Théodore Géricault, Eugène Delacroix, Ary Scheffer and Henry Scheffer (1798–1862), Jean Alaux (1786–1864) and Xavier Sigalon. He won the Prix de Rome in 1817 with *Helen Freed by Castor and Pollux* (Paris, Ecole N. Sup. B.-A.). While in Rome, he made his Salon debut in 1817 with *Metabus, King of the Volscians* (Chartres, Mus. B.-A.), based on an incident from Livy. A self-portrait from this period, the *First Letter from Home* (Cleveland, OH, Mus. A.), shows him in his room at the Villa Medici but focuses on the view from his window of the sunlit Italian landscape.

Cogniet's first success was in the Salon of 1824. The Neo-classical *Marius on the Ruins of Carthage* (1824; Toulouse, Mus. Augustins) was bought by the State for the Musée du Luxembourg, and *Massacre of the Innocents* (1824; Rennes, Mus. B.-A. & Archéol.) was bought by J. W. Lafitte for 7000 francs. Both Adolphe Thiers and Charles-Paul Landon praised the latter picture's powerful brushwork, compositional simplicity and dramatic content. In 1827 Cogniet painted a series of works on the life of St Stephen for the church of St Nicholas-des-Champs, Paris. In 1831 he appeared to be moving towards Romanticism when he re-exhibited his *Rebecca and Sir Brian de Bois Guilbert* of 1828 (London, Wallace), based on Sir Walter Scott's *Ivanhoe*, with a *Scene of the Barricades* (untraced). A view of the interior of his studio in 1831 (Orléans, Mus. B.-A.) by his sister, Marie-Amélie Cogniet (1798–1869), suggests that he was at that time wavering between painting modern historical scenes and academic biblical and mythological subjects. (A canvas of a gesturing nude figure is prominent.) However, after

1831 Cogniet abandoned a style that paralleled Delacroix's contemporary themes and Sigalon's emotive nudes for a *juste-milieu* position, which garnered him great institutional recognition.

In 1833 Cogniet was commissioned to decorate a ceiling in the Louvre with the *Expedition to Egypt* (completed 1835; *in situ*). Works for the Musée d'Histoire at Versailles include the *National Guard Marching to Join the Army in 1792* (1836; see fig. 8), the *Battle of Mount Tabor on 16 April 1799* and the *Battle of Heliopolis on 20 May 1800* (both in collaboration with Félix Henri Emmanuel Philippoteaux (1815–84) and Edouard Girardet). In 1843 he exhibited his most successful work: *Tintoretto Painting his Dead Daughter* (Bordeaux, Mus. B.-A.). When he re-exhibited it with *Massacre of the Innocents* at the Exposition Universelle of 1855 (where he earned a first-class medal), he was praised for his passionate subjects, vigorous figures, sensitive choice of colour and bravura brushwork, combined with a respectful appreciation of the Old Masters.

8. Léon Cogniet: *National Guard Marching to Join the Army in 1792*, 1836 (Versailles, Musée National du Château de Versailles et du Trianon)

Cogniet's teaching was highly regarded. In 1830 he established a studio for men and another, for women, directed by his sister Marie-Amélie. From 1831 to 1876 he served as drawing instructor at the Lycée Louis-le-Grand, Paris, and also taught for 16 years as a professor at the Ecole Polytechnique. He became one of the most popular professors at the Ecole des Beaux-Arts (which he left in 1863), where his pupils included Ernest Meissonier, Léon Bonnat and Jean-Paul Laurens. In 1848, in elections for the jury that was to organize the Salon, Cogniet received more votes than any other artist on the first ballot. In 1846 he was awarded the Légion d'honneur, and in 1849 he entered the Institut de France.

Bibliography

E. Vinet: 'M. Léon Cogniet', *Rev. N., Etrangère, Polit. Sci. & Litt.*, ix (1862), pp. 272–4

H. Delaborde: *Notice sur la vie et les ouvrages de M. Léon Cogniet* (Paris, 1881)

P. Mantz: 'Léon Cogniet', *Gaz. B.-A.*, n.s. 2, xxiii (1881), pp. 33–42

J. Claretie: *Les Peintres et ses contemporains*, i (Paris, 1882), pp. 361–84

Ingres & Delacroix through Degas & Puvis de Chavannes: The Figure in French Art, 1800–1870 (exh. cat., New York, Shepherd Gal., 1975), pp. 61–3

W. S. Talbot: 'Cogniet and Vernet at the Villa Medici', *Bull. Cleveland Mus. A.*, lxvii/5 (1980), pp. 135–49

P. Grunchec: *Le Grand Prix de peinture: Les Concours des Prix de Rome de 1797 à 1863* (Paris, 1983), pp. 108–9

Peintures et sculptures de maîtres anciens (exh. cat. by P. Carlier, Brussels, Gal. Arenberg, 1986), pp. 28–33

A. Haudiquet and others: 'Répertoire des artistes', *Les Salons retrouvés: Eclat de la vie artistique dans la France du Nord, 1815–1848*, 2 vols (Lille, 1993)

BETH S. WRIGHT

Colson [Gilles], Jean-François

(*b* Dijon, 2 March 1733; *d* Paris, 2 March 1803). French painter, architect and writer. He was apprenticed to his father, Jean-Baptiste Gilles, called Colson (1686–1762), who copied the work of the portrait painters Charles Parrocel and Jean-Baptiste van Loo and also painted miniatures, mainly for a provincial clientele. Jean-François got to know many studios, and worked for the portrait painters Daniel Sarrabat and Donat Nonnotte, among others. One of his liveliest early works is the informal, intimate and meditative portrait of *The Artist's Father in his Studio* (Dijon, Mus. B.-A.). Through the acting career of his brother Jean-Claude, Jean-François also came into contact with the theatrical world, as in his portrait of the actress *Mme Véron de Forbonnais* (1760; Dijon, Mus. B.-A.). The manner of this painting—with its subject looking up as if disturbed from reading a letter—is attuned to contemporary developments in portraiture. Later theatrical work includes *Mlle Lange in the Role of Silvie* (1792; Paris, Mus. Comédie-Fr.), showing the actress in costume in a scene from Claude Collet's play *L'Ile déserte*.

Colson also executed commissions with entirely conventional formats, such as the bust-length portrait of *Mme Geoffrin* (1757; Paris, Carnavalet)—one of the few works that show him as an outstanding portrait painter of his age—and the *Marquis de Piré* in dragoon uniform (Rennes, Mus. B.-A. & Archéol.) and the chemist *Balthasar Sage* (1777; Dijon, Mus. B.-A.), both with stiff-looking poses. He also did genre scenes, conceived as allegories: *Peace* (1759; Dijon, Mus. B.-A.), a young girl asleep with a symbolical cat and bird, and *Action* (1759; USA, priv. col., see exh. cat., repr. 3), two youths experimenting with a toy cannon. Both these were engraved by Nicolas-Gabriel Dupuis, and the former was dedicated to Charles-Godefroy de La Tour d'Auvergne, Prince de Turenne, who probably owned the original.

From 1771 Colson served the son and successor of this Prince de Turenne, Godefroy-Charles-Henri, as an architectural draughtsman. He designed garden buildings and ornaments (destr.) for his château of Navarre, near Evreux (Eure). A group of architectural drawings in the Musée des Beaux-Arts in Dijon may conceivably be related to this work by Colson.

Colson's not very innovative work as a painter contrasted with his theoretical views concerning portraiture, which he expressed in 1775 in *Observations sur les ouvrages exposés au Salon du Louvre*. Among the portraits he examined he gave particular prominence to Chardin's pastel *Self-*

portrait with his Wife (1775; Paris, Louvre), praising its 'facilité' and 'légèreté' and remarking on its highly unconventional use of pastels—a medium Colson never himself employed, keeping always to oil paint. Colson was not a member of the Académie Royale, but taught and wrote on academic lines: he held classes in perspective drawing at the Lycée des Arts in Paris, and in 1765-6 he published a *Traité de perspective élémentaire*.

Writings

Traité de perspective élémentaire à l'usage des peintres, sculpteurs et architectes (Paris, 1765-6)
Observations sur les ouvrages exposés au Salon du Louvre ou Lettre à M. Le Comte de xxx (Paris, 1775)

Bibliography

D. Diderot: *Salons*, ed. J. Seznec and J. Adhémar (Oxford, 1967), iv, pp. 236, 246
Trois Peintres bourguignons du XVIIIe siècle: Colson, Vestier, Trinquesse (exh. cat. by P. Quarté, Dijon, Mus. B.-A., 1969)
P. Quarré: 'Dessins d'architecture de Colson', *Bull. Soc. Hist. A. Fr.* (1970), pp. 115-23

CATHRIN KLINGSÖHR-LE ROY

Compte-Calix, François Claudius

(*b* Lyon, 27 Aug 1813; *d* Chazay d'Azergues, Rhône, 29 July 1880). French painter and lithographer. He took his first drawing lessons under the genre painter Claude Bonnefond (1796–1860) at the Ecole des Beaux-Arts, Lyon, from 1829 to 1833 and again in 1835-6. During his formative period he earned a living as a drawing-master at Thoissey (1829-31) and in the Pensionnat de la Favorite in Lyon (1832-6). After settling in Paris in 1836 he regularly sent work to the Lyon exhibitions. He made his début at the Paris Salon in 1840 with two pictures, *Little Sister* and *The Likeness* (untraced), which launched him on his career as one of the most successful genre painters of the July Monarchy. He was scorned on the whole by critics, but remained popular with publishers, collectors, dealers and the public. His work in Paris retained the poetic and sentimental bias of the Lyon school, epitomizing the international Biedermeier manner of the early 19th century.

During the July Monarchy (1830-48) he modified the hard Dutch-inspired manner of Bonnefond, using the freer and lighter touch which was fashionable during this period among a number of genre painters who took their inspiration from 18th-century scenes of *fêtes galantes*. In Paris Compte-Calix also worked as a lithographer and provided illustrations for such magazines as *Musée des dames* and *Bijou*.

Family connections probably explain his decorative work in the interior of Algiers Cathedral (his only recorded work of this type) and the portrait of *Monseigneur Pavy, Bishop of Algiers* (untraced), which was exhibited in 1848. In the Musée Carnavalet, Paris, there is a series of watercolours on the theme of Monseigneur Affre's intervention in the Revolution of 1848. Related compositions are *Mme Lamartine Adopting the Children of Patriots Slain in 1848* (Barnard Castle, Bowes Mus.) and a *Monk Serving in the National Guard* (Leipzig, Mus. Bild. Kst). These examples were unusual excursions into a more serious branch of painting which he treated with characteristic sentimentality. This is even true of his *Monseigneur Affre Speaking to the Insurgents* (Paris, Carnavalet), where he used Delacroix's *Liberty on the Barricades* (1830; Paris, Louvre) as a model. Compte-Calix spent his later years painting whimsical scenes, often with the epigrammatic titles for which he was well known.

Bibliography

Thieme–Becker

JON WHITELEY

Constantin, Jean-Antoine

(*b* Marseille, 20 Jan 1756; *d* Aix-en-Provence, 9 Jan 1844). French painter. He was apprenticed to the faience manufacturer Joseph Gaspard Robert (*fl* 1759-93) when young. In 1771 Constantin went to the Marseille Academy and in 1777 he left for Rome. In 1786 he was made head of the Ecole Municipale de Dessin in Aix-en-Provence, which he directed until its closure in 1795. When a new school was formed in Aix in 1806, Louis-Mathurin Clérian (1768-1851), one of his pupils, was made

Director, and Constantin obtained a subordinate position only in 1813. He enjoyed a certain reputation during the Restoration in 1815 thanks to the patronage of Comte Auguste de Forbin, a former pupil who had become Director of the Musées Royaux. In 1817 Constantin exhibited at the Salon for the first time, receiving a gold medal, and three of his drawings were bought for the Musée Royal (further drawings were bought in 1824 and 1826). He exhibited at the Salon again in 1822, 1827 and 1831.

He was more prolific as a draughtsman (e.g. drawings in Paris, Louvre, Aix-en-Provence, Mus. Granet, and Marseille, Mus. B.-A.) than as a painter and was primarily a landscape artist in the naturalist tradition. He was influenced by the Dutch, Salomon van Ruysdael and Karel Dujardin in particular, and his work may be compared in its lack of artifice to that of Jean-Jacques de Boissieu. He used the pen-and-wash technique admirably to portray foliage enlivened by specks of light and chiaroscuro effects. He had a taste for Mediterranean light and often depicted rocky landscapes in bright sunlight. In such a painting as the *Spring at Vaucluse* (Avignon, Mus. Calvet), the contrast between harshly lit patches of rock and the surrounding dark masses prefigures the landscapes of Emile Loubon (1803–63). Constantin is often called the father of the 19th-century Provençal landscape school, because he trained its most famous adherents of the first half of the 19th century (François-Marius Granet, Forbin, Clérian and Loubon).

Bibliography

A. Meyer: *Jean-Antoine Constantin, peintre: Sa vie et ses oeuvres* (Marseille, 1860)

E. Parrocel: *Annales de la peinture* (Paris, 1862), pp. 340–41

A. Meyer: 'Les Peintres provinciaux: J.-A. Constantin', *L'Artiste* (Jan 1870), pp. 58–82

F. N. Nicollet: *L'Ecole centrale du département des Bouches du Rhône (1798–1802)* (Aix-en-Provence, 1913), pp. 111–13

Jean-Antoine Constantin: Marseille 1756–Aix-en-Provence 1844 (exh. cat. by E. Vidal-Naquet and H. Wytenhove, Marseille, Mus. B.-A., 1986)

MARIE-CLAUDE CHAUDONNERET

Corbet, Charles-Louis

(*b* Douai, 26 Jan 1758; *d* Paris, 10 Dec 1808). French sculptor. He trained in Douai and then in Paris with Pierre-François Berruer. In 1781 he exhibited a group of animal sculptures at the Salon de la Correspondance, Paris, but by the following year he was settled in Lille, exhibiting regularly from 1782 to 1790 at the Salon organized by the Lille Académie. Little of his work from this period has been identified, but a terracotta group, signed and dated 1776, of *Time Clipping Cupid's Wings* (Paris, Louvre) and two male portrait busts (Lille, Mus. B.-A.) give an idea of his style. The group is clumsy but powerful, treated with Flemish verve in the manner of a genre subject, while the busts of the architect *Thomas-François-Joseph Gombert* (1725–1801; terracotta, 1782) and of an unknown man (terracotta, 1786), though somewhat dry, are undeniably imbued with life and spirit. Other, untraced works by Corbet in this period include a sketch for a bas-relief in honour of Louis XVI (1782); Anacreontic subjects influenced by Clodion (e.g. *Fête à Flore*, terracotta, 1784; priv. col.); allegories such as *Voltaire and Death* (exh. Lille, Acad. 1783); and a number of portrait busts, including the composers *Gluck* (terracotta) and *André Grétry* (exh. Lille, Acad. 1783).

Despite the probable sincerity of Corbet's revolutionary convictions—in 1794 he executed a plaster statue of *Liberty* (untraced) for the deconsecrated church of St Maurice, Lille, converted into a temple—he was little employed during the Revolution and worked for a time as a librarian. During the Empire (1804–15), however, he exhibited regularly at the Paris Salon, showing in 1808 an entry for the competition for a statue of *Napoleon* for the Senate (untraced). He also contributed in this period to the sculptural decoration of the Arc de Triomphe du Carrousel and the column of the Grande Armée in the Place Vendôme in Paris. This work followed the success of his widely reproduced bust of *General Bonaparte, First Consul of the Republic* (plaster version, exh. Salon 1798; Lille, Mus. B.-A.: marble version, exh. Salon 1800; untraced), executed from life before Bonaparte's coup d'état of 1799. Apart

from this masterpiece, which dramatically presents Bonaparte as a romantic hero, Corbet's sculpture is not outstanding, seen in the context of his Parisian contemporaries; but his career in Lille demonstrates the highly developed level of artistic activity in the provincial towns of 18th-century France.

Bibliography

Lami

G. Mabille: 'Une Terre cuite de Corbet: Le Temps coupant les ailes de l'amour', *Rev. Louvre*, ii (1977), pp. 89–93

GUILHEM SCHERF

Cornu, Sébastien (Melchior)

(*b* Lyon, 6 Jan 1804; *d* Longpont, nr Paris, 23 Oct 1870). French painter. He was taught by Fleury Richard and Claude Bonnefond (1796–1860) at the Ecole des Beaux-Arts, Lyon. He probably left to study in Ingres's atelier in Paris, but he returned to direct Bonnefond's atelier between 1825 and 1828, while the latter was in Rome.

In 1828 Cornu went to Rome where, according to Ingres, he stayed for seven years. On his return to Paris he enjoyed the favour of the July Monarchy (1830–48), being commissioned to produce original paintings and copies of others. In 1841 he worked on the decoration of St Louis d'Antin, Paris (figures of Apostles), and painted the *Surrender of Ascalon to Baudouin III* for the Palace of Versailles. In 1857 he executed murals for St Séverin, Paris. Among his other decorative projects were the completion of a *Transfiguration* (1864) in the north transept of St Germain-des-Prés, Paris, completing work left unfinished by Hippolyte Flandrin at his death, and figures in the chapel of the Palais d'Elysée, Paris (1869). Cornu painted many different subjects, including portraits, mythological, historical and genre scenes, such as *A Bacchante* (1831; Grenoble, Mus. Grenoble). His cold, unimaginative and impersonal style was derived from Ingres. In 1862 he was made administrator of the Campana collection, whose acquisition by the state the previous year he had helped to negotiate.

Bibliography

B. Foucart: *Le Renouveau de la peinture religieuse en France (1800–60)* (Paris, 1987)

MADELEINE ROCHER-JAUNEAU

Corot, (Jean-Baptiste-)Camille

(*b* Paris, 17 July 1796; *d* Paris, 22 Feb 1875). French painter, draughtsman and printmaker.

1. Life and work

After a classical education at the Collège de Rouen, where he did not distinguish himself, and an unsuccessful apprenticeship with two drapers, Corot was allowed to devote himself to painting at the age of 26. He was given some money that had been intended for his sister, who had died in 1821, and this, together with what we must assume was his family's continued generosity, freed him from financial worries and from having to sell his paintings to earn a living. Corot chose to follow a modified academic course of training. He did not enrol in the Ecole des Beaux-Arts but studied instead with Achille Etna Michallon and, after Michallon's death in 1822, with Jean-Victor Bertin. Both had been pupils of Pierre-Henri Valenciennes, and, although in later years Corot denied that he had learnt anything of value from his teachers, his career as a whole shows his attachment to the principles of historic landscape painting which they professed.

Following the academic tradition Corot then went to Italy, where he remained from November 1825 to the summer of 1828, the longest of his three visits to that country. In Rome he became part of the circle of painters around Théodore Caruelle d'Aligny, who became a lifelong friend. With d'Aligny, Edouard Bertin and Léon Fleury, Corot explored the area around Rome, visiting Terni, Città Castellana and Lake Nemi, and produced some of his most beautiful works. He adhered to Michallon's dictum to paint out of doors directly from the motif and made oil studies of the Colosseum (1826; Paris, Louvre), the Farnese gardens, Caprarola (1826; Washington, DC, Phillips Col.), the bridge at Narni (1826; Paris, Louvre; see col. pl. III) and the Castel Sant'Angelo

(1826; San Francisco, CA Pal. Legion of Honor). From Rome he successfully submitted two canvases to the Salon of 1827: the *Bridge at Narni* (Ottawa, N.G.), which is based on an oil study and modelled after Claude, and *La Cervara* (Zurich, Ksthaus). These pictures were the first of over 100 that Corot showed at the Salon during the course of his career. His submissions ranged from early paintings that emulated Claude and 17th-century Dutch masters, through biblical and literary subjects such as *Hagar in the Wilderness* (1835; New York, Met.), *Macbeth* (1859; London, Wallace) and bacchanals inspired by Poussin, such as *Silenus* (1838; Minneapolis, MN, Inst. A.), to the evocative reveries of his later years such as *The Lake* (1861; New York, Frick) and *Souvenir of Mortefontaine* (1864; Paris, Louvre). In later years he was on the Salon jury and used his influence to help younger artists.

Corot was an inveterate traveller; he toured France in the summer, working on studies and small pictures, which provided the impetus for the larger, more commercial exhibition pieces he produced in the winter. This habit was established early and continued throughout most of his long life. He made two more trips to Italy (1834 and 1843) and visited Switzerland frequently, often in the company of Charles-François Daubigny, whom he met in 1852. With Constant Dutilleux (1807–65) he went to the Low Countries in 1854 and in 1862 travelled to London for a week to see his pictures on show at the International Exhibition. Corot continued to travel until 1874, with a break from 1866 to 1870 due to gout, gradually restricting his journeys to northern France. He visited friends, relations and collectors, seeking both new and familiar sites to paint and producing more and more *souvenirs*, whose popularity ensured brisk sales.

Corot's reputation as a painter of careful and sincere landscapes grew steadily throughout the 1830s and 1840s. He received generally favourable if lukewarm criticism from a wide range of critics until 1846, when Baudelaire and Champfleury began to write warmly about his art. Ferdinand-Philippe, Duc d'Orléans, bought a picture from Corot as early as 1837 and in 1840 the State purchased another in the manner of Claude, his *Shepherd Boy* (1840), for the Musée d'Art et d'Histoire in Metz. Corot also produced a number of religious works during the 1840s, including *St Jerome in the Desert* (1847; Paris, Church of Ville d'Avray) and the *Baptism of Christ* (1847; Paris, St Nicholas-du-Chardonnay). The turning-point of his career, however, came with the accession to power of Louis-Napoléon. Following the unrest of 1848 Corot was elected to the 1849 Salon jury, and in 1851 (the year before he became Emperor Napoleon III) Louis-Napoléon bought from the Salon Corot's *Morning, Dance of the Nymphs* (1850; Paris, Louvre). Collectors and dealers, among them Paul Durand-Ruel, began to be interested in his work, especially in the *plein-air* studies; the first of these to be exhibited was *View of the Colosseum* (1826; Paris, Louvre; see fig. 9) at the Salon of 1849.

By the early 1850s Corot's reputation was firmly established, and he moved away from landscapes in the Neo-classical style to concentrate on rendering his impressions of nature. His exhibited pictures and *plein-air* studies grew closer together in motif and execution. High points of this development are *Harbour of La Rochelle* (1851; New Haven, CT, Yale U. A.G.) and *Belfry of Douai* (1871; Paris, Louvre). Concurrent with his landscape work were figure pieces, ranging from the straightforward *Seated Italian Monk* (1827; Buffalo, NY, Albright–Knox A.G.) to the seductive *Marietta, the Roman Odalisque* (1843; Paris, Petit Pal.). The series of bathers, bacchantes and allegorical figures of his later years are among his most provocative and intellectual works. He also painted several allegories of painting entitled the *Artist's Studio* (1865–8; Paris, Louvre; Washington, DC, N.G.A.; and Lyon, Mus. B.-A.).

Corot painted many portraits of family and friends throughout his life, but he regarded these as private works and did not exhibit them. *Capitaine Faulte du Puyparlier* (1829; Cincinnati, OH, A. Mus.) is one such example. His decorative work was also mainly created for family and friends and included the summer-house at his parents' house at Ville d'Avray (1847), Decamps's studio in Fontainebleau (1858–60) and Daubigny's house in Auvers (1865–8), though the best known

9. Camille Corot: *View of the Colosseum*, 1826 (Paris, Musée du Louvre)

is the suite of six Italian landscapes (Paris, Louvre) originally executed for the bathroom of the Roberts' house in Mantes (1840–42). Among the few commissions from those outside his immediate circle were the two panels of *Orpheus* (Madison, U. WI, Elvehjem A. Cent.) and *Diana* (ex-Met., New York; priv. col.), made in 1865 for Prince Demidov's dining-room in Paris. Corot's landscape motifs and style were well suited to this type of work; his feeling for composition through mass and tonal values translated easily into a larger scale.

Corot accepted criticism philosophically and embraced his eventual fame and fortune with equal unconcern. Although he frequently sat on the Salon jury, he was in general too bound up in his own art to engage in the artistic controversies of his time. He cared little either for the work of his academic contemporaries or for the more avant-garde canvases of Rousseau and Millet. A notable exception was Courbet, with whom he painted in Saintonge in 1862 and whose *Covert of*

Roe-deer (Paris, Louvre) he championed at the 1866 Paris Salon. Corot's generosity towards less fortunate artists was also famous. In the 1860s he helped to buy a house at Valmondois for the near-blind Daumier.

2. Working methods and technique

Corot's career can be divided into two parts. The period before *c.* 1850 was a time of experimentation with various styles and models. After this date, his subject-matter was more limited and the difference between *plein-air* and studio work lessened. The harsh light of his earlier paintings became softer and more diffuse. Corot's reputation has always rested on his ability to paint light and to render subtle gradations of tone and value convincingly. While his first trip to Italy sharpened his perception and manual dexterity, he had always been sensitive and responsive to the various effects of light, and his lifelong practice of sketching out of doors forced him to respond and adapt to its vagaries.

Corot developed a shorthand system whereby he could record the relative values he observed in nature: in his pencil sketches circles represent the lightest areas of the scene and squares the darkest. Colour notes were of little use to an artist whose interest was mainly in tonal relationships. He drew constantly, recording scenes and figures in sketchbooks (37 of which are in the Louvre, Paris) as well as on larger sheets. Seldom, however, did a particular sketch serve as a model for a painting. Until *c.* 1850 he used a hard pencil, exploiting the hardness to record the structure of a tree or the geological history of a rock. Sensitive portraits in pencil date from the first part of his career, for instance *Study of a Girl* (1831; Lille, Mus. B.-A.). His paintings from this earlier stage are of two types: *plein-air* and studio work. The *plein-air* pictures are small and generally characterized by a creamy, if thin, paint surface and by rapid brushstrokes that carry a limited range of colours, chiefly ochres, yellows and greens. Corot's insistence on tonal values eschewed a wide range of hues. His oil studies are notable for the unity achieved through atmosphere and tone. The studio pictures, on the other hand, are large, ambitious works whose subjects were often taken from classical mythology: *Diana and Actaeon* (1836; New York, Met.), the Bible: the *Destruction of Sodom* (first version 1843, second version painted over the first 1857; New York, Met.) or poetry: *Homer and the Shepherds* (1845; Saint-Lô, Mus. B.-A.), which was inspired by André Chénier's *L'Aveugle*. These studio pictures have come to be overlooked in favour of the *plein-air* studies, and while it is true that their execution is less fluid, their atmosphere not as convincing and their figures often stiff in appearance, they are nonetheless strangely moving and reveal an unhackneyed earnestness of purpose.

During the decade 1850–60 Corot sought new subjects and new means of expression and experimented with more overtly allegorical subjects, such as *Melancholy* (Copenhagen, Ny Carlsberg Glyp.) and *Antique Idyll* (Lille, Mus. B.-A.). He was also introduced, through Dutilleux, to Cliché-verre, an experimental medium that combined the techniques of printmaking and photography.

Robaut (1905) listed 66 compositions produced by this method, for which Corot chose subjects closely related to those of his oil paintings. The opportunity to experiment with tonal relationships in a new medium and the speed and novelty of the process must have appealed to Corot, who was not particularly interested in the technical aspects of traditional printmaking. Félix Bracquemond helped to bring some of Corot's etching plates to a point where they could be printed. At the same time, Corot also freed himself from some of his self-imposed constraints, such as the hard graphite pencil for drawings and the choice of academic subjects for Salon paintings, and experimented with different means to render observed or, in later years, remembered effects. He began to sketch in charcoal, smudging it in order to soften the contours of objects and to suggest their dissolution by light and atmosphere.

Souvenir of Mortefontaine (1864; Paris, Louvre) epitomizes Corot's later painting style and combines his favourite motifs: a still body of water, hills and trees dimly visible on the distant shore, a gracefully leaning tree with diaphanous foliage and a note of colour provided in the clothing of the figures to the left. The paint is thinner than before and the colour range reduced to greys mixed with greens, yellows and whites. In contrast to such early paintings as *Hagar in the Wilderness*, which were based on the Italian countryside, Corot's later works are only vaguely reminiscent of places; their moist, diffuse atmospheres defy particularity and are rather an invitation to personal reverie.

Corot's style became very popular in the Second Empire. His name came to be associated with a kind of painting that was soft, hazy and subdued, with simple compositions evoking a tranquil mood. His images of private meditation and mysterious women and his reiteration of music and dance subjects have much in common with the spirit of the Rococo revival. Although he had no atelier, other artists were welcome to copy his pictures, either as learning exercises or as a means of producing works for sale. Corot even signed some of the copies made by younger, less fortunate painters in order to increase their value. This practice has complicated the connoisseurship of

his oeuvre, as have the numerous forgeries and unauthorized copies of his works.

Antoine Chintreuil and Paul-Désiré Trouillebert were the most faithful followers of Corot, whose fidelity to the effects of light also had a great impact on younger artists such as Camille Pissarro, Berthe Morisot (who took lessons from him in the early 1860s) and Claude Monet. Monet's series of early morning views of the Seine painted in the 1890s are particularly evocative of Corot's *Souvenir of Mortefontaine*.

Unpublished sources

Paris Bib. N. Cab. Est., 3 vols, Yb3 949 [Robaut's invaluable notes for the cat. rais. of 1905]

Bibliography

T. Silvestre: *Histoire des artistes vivants* (Paris, 1856)
A. Robaut: *L'Oeuvre de Corot: Catalogue raisonné et illustré, précédé de l'histoire de Corot et de son oeuvre par E. Moreau-Nélaton*, 4 vols (Paris, 1905); supplements compiled by A. Schoeller and J. Dieterle, 3 vols (Paris, 1948–74)
L. Delteil: *Le Peintre-graveur illustré*, v (Paris, 1910)
P. J. Angoulvent: 'L'Oeuvre gravé de Corot', *Byblis* (summer 1926), pp. 39–55
G. Bazin: *Corot* (Paris, 1942, rev. 3/1973)
P. Courthion, ed.: *Corot raconté par lui-même et par ses amis*, 2 vols (Geneva, 1946)
A. Coquis: *Corot et la critique contemporaine* (Paris, 1959)
Barbizon Revisited (exh. cat., ed. R. L. Herbert; Boston, MA, Mus. F.A., 1962)
Figures de Corot (exh. cat., ed. G. Bazin; Paris, Louvre, 1962)
J. Leymarie: *Corot* (Geneva, 1966, rev. 2/1979)
M. Hours: *Corot* (New York, 1970, rev. 2/1984)
Hommage à Corot (exh. cat., ed. M. Laclotte; Paris, Grand Pal., 1975)
P. Galassi: *Corot in Italy* (New Haven and London, 1991)

FRONIA E. WISSMAN

Cortot, Jean-Pierre

(*b* Paris, 20 Aug 1787; *d* Paris, 12 Aug 1843). French sculptor. A grocer's son, from the age of 13 he studied sculpture under Charles-Antoine Bridan and Pierre-Charles Bridan. He subsequently assisted other sculptors, including François-Frédéric Lemot and Philippe-Laurent Roland. On winning the Prix de Rome in 1809 he travelled to Italy, remaining there until 1819, when he returned to Paris. From then until 1840 he regularly exhibited at the Salon. In 1825 he was elected to the Institut de France and to a professorship at the Ecole des Beaux-Arts, succeeding Louis-Marie-Charles Dupaty (1771–1825). In 1841 Cortot was appointed an officer of the Légion d'honneur. He received many prestigious state commissions, becoming one of the most successful official sculptors of the Restoration and the July Monarchy. The object of his first major work, *Marie-Antoinette Succoured by Religion* (marble, *c.* 1825; Paris, Chapelle Expiatoire), was to purge the French nation's guilt for the execution of Louis XVI and his Queen. It was outstandingly successful; Cortot departed from his usual Neo-classical restraint by creating a swooning, neo-Baroque Marie-Antoinette. Other important works include the *Soldier of Marathon Announcing Victory* (marble, 1832–4; Paris, Louvre), which influenced James Pradier's late, austere style; a colossal limestone relief, the *Triumph of Napoleon I* (1833–6; Paris, Arc de Triomphe de l'Etoile), the neighbour of François Rude's better-known *Marseillaise*; and the pedimental relief representing *France between Liberty and Public Order* for the Chambre des Députés (stone, 1841; Paris, Pal.-Bourbon). Such sculpture has long received critical scorn: Cortot remains synonymous with the meticulously executed but lifeless and static Neo-classicism that monopolized sculptural prestige in his day, at the expense of Rude's and Auguste Préault's Romanticism.

Bibliography

Lami
The Romantics to Rodin: French Nineteenth-century Sculpture from North American Collections (exh. cat., ed. P. Fusco and H. W. Janson; Los Angeles, CA, Co. Mus. A., 1980), p. 182
H. W. Janson: *Nineteenth-century Sculpture* (London, 1985), pp. 98, 112
La Sculpture française au XIXe siècle (exh. cat., ed. A. Pingeot; Paris, Grand Pal., 1986)
J. Hargrove: *The Statues of Paris: An Open Air Pantheon: The History of Statues to Great Men* (Antwerp, 1989), pp. 56–8, 65

MARK STOCKER

Couder, (Louis-Charles-)Auguste

(*b* London, 1 April 1789; *d* Paris, 21 July 1873). French painter. A pupil of Jean-Baptiste Regnault and David, he exhibited for the first time in the Salon of 1814 with *The Death of General Moreau* (Brest, Mus. Mun.). In 1817 *The Levite of Ephraîm* (Arras, Abbaye St Vaast, Mus. B.-A.) was widely praised by the critics. In 1818 he received his first official commission, for the decoration of the vaulted ceiling of the vestibule to the Galerie d'Apollon in the Louvre (*in situ*). Couder's reputation as a history painter was based on the commissions he executed for the Musée Historique in Versailles. In addition to many portraits, he produced large paintings, in which rich colouring was combined with precise academic drawing: for example, *The Battle of Lawfeld* (exh. Salon, 1836) and *The Siege of Yorktown* (exh. Salon, 1837; sketch in Blérancourt, Château, Mus. N. Coop. Fr.-Amér.), both painted for the Galerie des Batailles (*in situ*); *The Federation of 14 July 1790* (exh. Salon, 1844; Versailles, Château); and the *Oath Taken in the Jeu de Paume* (exh. Salon, 1848; Versailles, Château), which was inspired very directly by David. *The Opening of the States General at Versailles on 5 May 1789* (exh. Salon, 1840; Versailles, Château) is a good illustration of his ability to present a historical reconstruction containing a large number of figures without monotony, thanks to his talent for portraiture and the skilful disposition of light.

Religious easel painting and church decoration were also important elements in Couder's oeuvre. In 1819 he painted an *Adoration of the Magi* for the Chapelle des Missions Etrangères, Paris (*in situ*). In 1832 he went to Munich in order to acquire a deeper understanding of fresco technique and there collaborated with Peter Cornelius on the decoration of the Alte Pinakothek. On his return to Paris in 1833 he painted a fresco of *The Stoning of St Stephen* for a chapel in Notre-Dame-de-Lorette (*in situ*). Between 1838 and 1841 he was involved with Jules-Claude Ziegler, Victor Schnetz, François Bouchot (1800–42), Léon Cogniet, Alexandre Abel de Pujol and Emile Signol in the decoration of the church of La Madeleine, where he painted *The Meal in the House of Simon* (fresco,

in situ) for one of the lunettes in the nave. The composition, restricted to a few figures, the rigorously classical forms and sober colours reveal the influence of German religious painting and were in distinct contrast to the academicism of his historical commissions. Couder became a member of the Institut in 1839. In 1844 he painted in St Germain l'Auxerrois, Paris, *The Ascension of Christ* (fresco, chapel of the tomb of St Germain l'Auxerrois). His knowledge of fresco procedures gained him the task of restoring the Galerie François Ier in the château of Fontainebleau in the late 1840s.

Couder also produced anecdotal genre paintings in a classical style: for example, *The Death of Masaccio* (exh. Salon, 1817; Quimper, Mus. B.-A.) and *The Death of Vert-Vert*, inspired by a poem by Gresset (1829, according to Breton; Beauvais, Mus. Dépt. Oise). He took inspiration from Ossianic and Romantic literature, evolving a more personal and freer style in such works as *Despair of Cuchulin* (Dijon, Mus. Magnin) and *Scenes from Notre-Dame de Paris* (polyptych in Neo-Gothic frame; exh. Salon, 1833; Paris, Mus. Victor Hugo).

Writings

Considérations sur le but moral des arts (Paris, 1867)

Bibliography

E. Breton: *Notice sur la vie et les ouvrages de A. Couder* (Meulan, 1874)

M.-M. Aubrun: 'La Genèse d'une oeuvre d'Auguste Couder: Le *Repas chez Simon le Pharisien*', *Bull. Soc. Hist. A. Fr.* (1980), pp. 247–56

T. W. Gaehtgens: *Versailles: De la résidence royale au Musée Historique* (Paris, 1984), pp. 211–17

B. Foucart: *Le Renouveau de la peinture religieuse en France (1800–1860)* (Paris, 1987), pp. 186–7

PASCALE MÉKER

Courbet, (Jean-Désiré-)Gustave

(*b* Ornans, Franche-Comté, 10 June 1819; *d* La Tour-de-Peilz, nr Vevey, Switzerland, 31 Dec 1877). French painter and writer. Courbet's glory is based essentially on his works of the late 1840s and early 1850s depicting peasants and labourers, which

were motivated by strong political views and formed a paradigm of Realism. From the mid-1850s into the 1860s he applied the same style and spirit to less overtly political subjects, concentrating on landscapes and hunting and still-life subjects. Social commitment, including a violent anticlericalism, re-emerged in various works of the 1860s and continued until his brief imprisonment after the Commune of 1871. From 1873 he lived in exile in Switzerland where he employed mediocre artists, but also realized a couple of outstanding pictures with an extremely fresh and free handling. The image Courbet presented of himself in his paintings and writings has persisted, making him an artist who is assessed as much by his personality as by his work. This feature and also his hostility to the academic system, state patronage and the notion of aesthetic ideals have made him highly influential in the development of modernism.

I. LIFE AND WORK

1. Training and early works, to c. 1849

Courbet came from a well-to-do family of large-scale farmers in Franche-Comté, the area of France that is the most strongly influenced by neighbouring Switzerland. Ornans is a picturesque small country town on the River Loue, surrounded by the high limestone rocks of the Jura; its population in Courbet's day was barely 3000. This social and geographical background was of great importance to Courbet. He remained attached to Franche-Comté and its peasants throughout his life, portraying rural life in many pictures. In 1831 Courbet started attending the Petit Séminaire in Ornans, where his art teacher from 1833 was Père Baud (or Beau), a former pupil of Antoine-Jean Gros. While there he also met his cousin, the Romantic poet Max Buchon (1818–69), who had a determining influence on his later choice of direction. In the autumn of 1837 he went to the Collège Royal at Besançon and also attended courses at the Académie there under Charles-Antoine Flageoulot (1774–1840), a former pupil of Jacques-Louis David. Except for a few early paintings and drawings (Ornans, Mus. Maison Natale Gustave Courbet),

Courbet's first public works were the four figural lithographs of 1838 illustrating Buchon's *Essais poétiques* (Besançon, 1839). He went to Paris in the autumn of 1839 to embark on a conventional training as a painter. Like many other young artists of his period he was not impressed by the traditional academic teaching at the Ecole des Beaux-Arts in Paris; instead, after receiving a few months' teaching from Charles de Steuben (1788–1856), he attended the independent private academies run by Père Suisse and Père Lapin and also received advice from Nicolas-Auguste Hesse. At the same time he copied works by the Old Masters at the Louvre.

Like Rembrandt and van Gogh, Courbet painted a large number of self-portraits, especially in the 1840s. These quite often show the artist in a particular role or state of mind. The *Self-portrait as a Sculptor* (c. 1844; New York, priv. col., see 1977–8 exh. cat., pl. 9) and *Self-portrait with a Leather Belt* (1845; Paris, Mus. d'Orsay) belong in the first category, and the *Self-portrait as a Desperate Man* (two versions, c. 1843; e.g. Luxeuil, priv. col., see 1977–8 exh. cat., pl. 5), *The Lovers* (1844; Lille, Mus. B.-A.), *Self-portrait as a Wounded Man* (two versions; e.g. c. 1844–54; Paris, Mus. d'Orsay) and *Self-portrait with a Pipe* (c. 1847–8; Montpellier, Mus. Fabre) belong in the second. Courbet seems to have painted himself so often for two main reasons: because of lack of models and because of a protracted crisis of artistic identity. This introspectiveness lasted until the Commune (1871) and shows that he was still influenced by the self-centredness (*égotisme*) typical of the Romantics and that, despite his extrovert image, he felt lonely in Paris for a long time.

In 1846 Courbet visited the Netherlands, where he painted mainly portraits, the most outstanding of which is the portrait of the art dealer *H. J. van Wisselingh* (1846; Fort Worth, TX, Kimbell A. Mus.). He also stayed briefly in Belgium in 1846 and 1847, and travel sketches made in both countries have been preserved (Marseille, priv. col., see 1984 exh. cat.). In the museums in The Hague and Amsterdam he was interested by Rembrandt's chiaroscuro and the expressive, free brushwork of Frans Hals, qualities that subsequently influenced

his own painting technique. These experiences had a beneficial effect on *After Dinner at Ornans* (1849; Lille, Mus. B.-A.), a dark, silent group portrait that won him the esteem of Ingres and Delacroix in 1849. It is not clear whether Courbet ever visited England or whether a passage in a letter of 1854 relating to such a visit (see 1977–8 exh. cat., app.) should be interpreted as an imaginary journey. In this he alludes to Hogarth and, though he did paint some satirical pictures, a mention of Constable would have been more illuminating regarding his painting technique.

2. The Realist debate: peasant and modern 'history' pictures, 1849–55

Courbet achieved his real breakthrough with three works that were exhibited in Paris at the Salon of 1851 (postponed from 1850). Two of these, *The Stone-breakers* (1849; ex-Gemäldegal. Neue Meister, Dresden, untraced) and *A Burial at Ornans* (1849–50; Paris, Mus. d'Orsay; see fig. 10), had already attracted attention in Besançon and Dijon, while the third, the *Peasants of Flagey Returning from the Fair* (1850, revised 1855; Besançon, Mus. B.-A. & Archéol.), was exhibited in Paris only. (*The Stone-breakers* was thought to have been destroyed in 1945, but in 1987 the Gemäldegalerie Neue Meister in Dresden catalogued it as missing.)

Although all three pictures were influenced by the Dutch Old Masters, they are distinguished by their austerity and directness. Courbet's friends, Champfleury and Buchon, saw them as breaking away from academic idealism and spoke approvingly of Courbet's 'realism'.

Many visitors to the Salon were shocked, however, both because the paintings depicted ordinary people (moreover on a scale normally reserved for portraits of the famous) and because the peasants and workers, based on real people, seemed particularly ugly. In these pictures Courbet was trying to blend large-scale French history painting with Dutch portrait and genre painting, thereby achieving an art peculiar to his own period that would introduce the common man as an equally worthy subject. The pictures also reveal unusual characteristics of social commitment. The labourers in *The Stone-breakers*, with their averted faces and ragged clothing, symbolize all those workers who toiled on the edge of subsistence. It was this picture that attracted most attacks from the caricaturists and critics in 1851. The group of country mourners in a *Burial at Ornans*, a scene possibly based on the burial of Courbet's great-uncle Claude-Etienne Teste (1765–1848), stirred the townspeople's fear of being swamped by the rural population. Buchon

10. Gustave Courbet: *A Burial at Ornans*, 1849–50 (Paris, Musée d'Orsay)

saw the grave-digger in this picture as representing the avenger of the stone-breakers. Some years later Pierre-Joseph Proudhon noted the proud superiority of the rugged peasants from Franche-Comté in the *Peasants of Flagey Returning from the Fair*. All three paintings deal with the demographic movements between town and country. At the time this was an acute social issue, which greatly concerned the staunchly regionalist Courbet. The last of these peasant 'history pictures' was *The Grain-sifters* (1855; Nantes, Mus. B.-A.), a quiet, simple picture of people at work, which has even been interpreted as having a feminist message (Fried, 1990).

The Bathers (1853; Montpellier, Mus. Fabre) and *The Wrestlers* (1853; Budapest, Mus. F.A.) are among those provocative pictures that attacked the prevailing aesthetic norms and, as 'modern history pictures', also represented a challenge to society. These pictures show fat, naked women and toil-worn naked men, thus rejecting the academic concept of nude painting and rousing the ire of middle-class Salon critics and caricaturists who considered the pictures un-French. Courbet was able to launch such attacks in the early days of the authoritarian Second Empire only because he had a powerful protector in Charles, Duc de Morny. *The Bathers* won praise from Delacroix and was regarded by Alfred Bruyas, a banker's son from Montpellier, as marking the beginning of an independent, modern form of art. Courbet confirmed this perception a year later with *The Meeting*, also known as *Bonjour Monsieur Courbet* (1854; Montpellier, Mus. Fabre; see fig. 11), which was painted for Bruyas entirely in light colours, with the landscape executed in a concise, free style. Above all, this picture, which includes a self-portrait, reveals something of the identity crisis referred to above, with Courbet fluctuating between underestimating and overestimating himself. Borrowing from the image of the Wandering Jew, he represented himself as a spurned outsider and at the same time as a superior 'wise man', greeting Bruyas and his servant from a somewhat higher plane. He thus shows, albeit defensively, how an artist without state or church patronage becomes precariously dependent on a private patron.

The culmination of the series featuring Courbet's relation to society is the *Painter's Studio* (1854–5; Paris, Mus. d'Orsay), which he painted for the Exposition Universelle held in Paris in 1855. Though he had 11 other works accepted, the *Painter's Studio* was rejected. So Courbet showed it at the independent exhibition he funded and held in the Pavillon du Réalisme on a site close to that of the official exhibition. This large picture has been called a triptych because it consists of three clearly distinguished parts: at the centre Courbet portrayed himself painting a landscape next to a woman or 'Muse', a cat and a peasant boy. On the left he depicted the 'external' or political world, and on the right the 'internal' or aesthetic world. Courbet himself holds the place of the redeemer. He modelled many of the figures on friends and various political and other personalities, including Napoleon III. With this composition, he brought the dispute about the politically and aesthetically disruptive effects of Realist art to a conclusion. The full title of the work is the *Painter's Studio: A Real Allegory Determining a Phase of Seven Years of my Artistic Life*, which suggests that Courbet saw the work as summing up his development since the Revolution of 1848. But at the same time it contains a vision of the future: Courbet sits at his easel, which shows not his surrounding society but a landscape in Franche-Comté. This indicates that he saw nature, rather than politics or industry, as having the power for the renewal and reconciliation needed by contemporary society—still a Romantic concept.

3. Leisure and private life as subject-matter: landscapes, hunting scenes, still-lifes and portraits, late 1850s and the 1860s

In the *Painter's Studio* Courbet had provocatively placed landscape on a higher level than history painting. He had, of course, painted landscapes before this, but now he gave this genre pride of place. While he combined landscape and figure painting in the *Painter's Studio* and also in the *Young Ladies on the Banks of the Seine (Summer)* (1856–7; Paris, Petit Pal.), in most of his pictures of the late 1850s and 1860s landscape predominates.

11. Gustave Courbet: *The Meeting*, also known as *Bonjour Monsieur Courbet*, 1854 (Montpellier, Musée Fabre)

'To be in Paris, but not of it: that was what Courbet wanted' (Clark, 1973, p. 31). He did not produce a single townscape of Paris, and his landscapes confronted Parisians with the image of a different world. The meaning of these landscapes is complex: they reflect an increasing need for recreation areas for leisure and holiday activities, a theme that was to become dominant among the Impressionists in the 1870s and 1880s. Courbet had even wanted to decorate railway stations with pictures of holiday destinations, a project that would have greatly promoted tourism, though it was never realized. However, many of his landscapes are not idyllic but rather enclosed and

fortress-like (according to Champfleury). They represent a kind of regional defence force and thus stress the autonomy of the provinces with regard to the centralist power of the State. Regionalism is emphasized in numerous depictions of hidden forest ravines and grottoes, which give the effect of being places of refuge or even of representing the search for concealment in a womb (1978–9 exh. cat.). In particular, the various versions of the *Puits noir* (e.g. 1865; Toulouse, Mus. Augustins) and the *Source of the Loue* (e.g. 1864; Zurich, Ksthaus) can be cited as examples of this.

Hunting scenes by Courbet such as *Stag Taking to the Water* (1865; Marseille, Mus. B.-A.) or *The*

Kill: Episode during a Deer Hunt in a Snowy Terrain (1867; Besançon, Mus. B.-A. & Archéol.) are similarly ambivalent. They illustrate the artist's passion for hunting, which was enhanced by trips to German hunting reserves around Baden-Baden and Bad Homburg. He often chose the peace after the hunt, as in *The Quarry* (1857; Boston, MA, Mus. F.A.) and the *Hunt Breakfast* (c. 1858–9; Cologne, Wallraf-Richartz-Mus.), but at the same time used hunting to suggest political persecution. The latent social and political messages in the hunting pictures did not prevent them from generally satisfying a non-political clientele. After the success at the Salon of 1866 of *Covert of Roe-deer by the Stream of Plaisir-Fontaine* (1866; Paris, Mus. d'Orsay) Courbet had even hoped for an imperial distinction, though this was not forthcoming.

From 1859 Courbet often stayed on the Normandy coast. While there he painted a large number of seascapes (several versions of the *Cliff at Etretat*, e.g. the *Cliff at Etretat after the Storm*, 1869; Paris, Mus. d'Orsay) and beach and wave pictures, which mark a new peak in his creative achievement. The style of these pictures is very varied: some are block-like and self-contained compositions, which appeared to many critics to have been built by a mason or made from marble (e.g. the two versions of *The Wave*, 1870; Paris, Mus. d'Orsay; Berlin, Alte N.G.), and in the same works Courbet completely dissolved the surface of objects, so moving away from naturalistic representation. The tendency towards abstraction and surface colour increased steadily from about 1864; in this respect Courbet was an important forerunner of Cézanne.

In his paintings of nudes Courbet seems to have taken a different path. He attempted to beat the Salon tradition by painting completely naturalistically and choosing garishly brilliant colours. This is particularly true of *The Sleepers* (1866; Paris, Petit Pal.). Here it was far less the form than the subject-matter that was shocking. Lesbian women had hitherto been a theme treated only in small-scale graphic work, whereas Courbet presented it in a format that was larger even than that used for genre painting. The female nude

entitled the *Origin of the World* (1866; Japan, priv. col., see 1988–9 exh. cat., p. 178) is also extremely provocative (though like the previous picture it was painted for a private client, the Turkish diplomat Khalil-Bey). *Lady with a Parrot* (1866; New York, Met.) again has slightly ironic links with Salon painting, with the parrot symbolizing a magic bird as in the writings of Gustave Flaubert. *Venus and Psyche* (1864 version, destr.; 1866 version, Basle, Kstmus.) is a fourth important picture in this category.

The still-lifes form another theme in Courbet's art. They reached their first peak as early as the mid-1850s when Courbet painted *Bunch of Flowers* (1855; Hamburg, Ksthalle) in which it is unclear whether the pictoral space is limited by a wall or the sky. This deliberate lack of definition links interior and exterior space in an extremely modern manner. Courbet painted some superb still-lifes during his stay in the Saintonge area in 1862–3 where he worked for a time with Corot. Important examples of his still-lifes are the heavy, assembled blooms in *Magnolias* (1862; Bremen, Ksthalle) and *Flowers in a Basket* (1863; Glasgow, A.G. & Mus.). In *The Trellis* (1862; Toledo, OH, Mus. A.) Courbet combined a still-life of flowers in the open air with a portrait of a woman, producing an asymmetric composition similar to that in works by Degas. Courbet did not produce still-life works of equal stature again until after the Commune.

Turning to themes relating to leisure and private life was a move forced on painters by the political situation in the Second Empire—a withdrawal as happened with Honoré Daumier. The *Painter's Studio*, with its reference to Napoleon III, represents an exception to this tendency; it did not attract unpleasant consequences simply because Courbet composed the picture as a group portrait without any offensive intentions. Individual portraits were another category that flourished in this period. The *Sleeping Spinner* (1853; Montpellier, Mus. Fabre), however, shows that Courbet often depicted types rather than individuals, in this case a peasant girl lost in reverie. Of the portraits he painted in Saintonge, *Dreaming: Portrait of Gabrielle Borreau* (1862;

Chicago, IL, A. Inst.) combines a dreamy expression with a very free use of colour in the natural background. The four versions of *Jo: The Beautiful Irish Girl* (c. 1865; e.g. Stockholm, Nmus.), depicting Whistler's mistress Joanna Heffernan, stand halfway between Romanticism and Symbolism, showing links with Whistler and the Pre-Raphaelites. The model's sensuous red hair also conjures up the idea of the *femme fatale*. Among the portraits of men, that of *Pierre-Joseph Proudhon and his Children in 1853* (1865–7; Paris, Petit Pal.) deserves a special mention. Courbet had been a close friend of Proudhon's since the philosopher's arrival in Paris in 1847 and painted the work after his death as a memorial. In a second phase of painting he eradicated Proudhon's wife, leaving only his two small daughters. As a result, the solitariness and monumentality of the philosopher are considerably enhanced. As in *Gabrielle Borreau*, the figures in *Pierre-Joseph Proudhon* are painted carefully, while the background is intentionally rendered in a free, slap-dash manner, which excited both criticism and admiration.

4. Renewed political awareness in the 1860s

Two works, *Priests Returning from the Conference* (1862–3; destr.; oil sketch, Basle, Kstmus.) and *Pierre-Joseph Proudhon*, were precursors to a more open use of pictures as a political weapon. Though Courbet's potential for satirical criticism was repressed during the reign of Napoleon III, it was not extinguished, and, like Daumier, Courbet reverted to explicitly political subjects towards the end of the Second Empire. At the beginning of the decade he had painted a portrait of his friend *Jules Vallès* (c. 1861; Paris, Carnavalet), an anarchist writer and later Communard. In 1868 Courbet published in Brussels the anticlerical pamphlets *Les Curés en goguette* and *La Mort de Jeannot* to accompany works on this theme. Champfleury, wary of this development, feared a whole series of anticlerical frescoes. The same year Courbet painted *Charity of a Beggar at Ornans* (1868; Glasgow, A.G. & Mus.), which made a clear reference to the ragged proletariat. Courbet announced that other 'socialist' pictures would follow, a move

that was obviously encouraged by the electoral success of the Left in the towns. For the Salon of 1868 he planned a portrait of *Martin Bidouré*, a peasant who was executed after having fought against the coup d'état of 1851. It was clearly intended that Courbet's political urge would be discouraged by the offer in 1870 of the Cross of the Légion d'honneur, an award he, like Daumier, refused.

5. The Commune, exile in Switzerland and collaboration: late works, 1871–7

During the Commune in Paris (18 March–29 May 1871) Courbet did little drawing or painting. He was, however, very active in art politics and, as president of the commission for the protection of the artistic monuments of Paris and delegate for the fine arts, he even saved the Louvre. As he was accused of having been behind the demolition of the Vendôme Column, he was put on trial and gaoled after the Commune's overthrow. He painted a few still-lifes while in prison, but his best pictures—*Still-life with Apples and Pomegranate* (London, N.G.), *Still-life: Fruit* (Shelburne, VT, Mus.), *Still-life: Apples, Pears and Primroses on a Table* (Pasadena, CA, Norton Simon Mus.), *Self-portrait in Prison* (Ornans, Mus. Maison Natale Gustave Courbet) and both versions of *The Trout* (Zurich, Ksthaus; Paris, Mus. d'Orsay)—were not painted until after his release, perhaps not until 1872–3, though some are signed *in vinculis faciebat* or 'Ste-Pélagie' (the name of one of the prisons).

On 23 July 1873 Courbet crossed the frontier into Switzerland as he had been judged responsible for the cost of re-erecting the Vendôme Column and was afraid that he might be arrested. The four and a half years of his exile in Switzerland are often regarded as a period of decline. It is true that in this period Courbet definitely painted with an eye to the market: he was in fact hoping to raise the money to pay for the column so that he could return to France, an aim prompted by the great success of an exhibition at the Galerie Durand-Ruel in Paris in 1872. He therefore engaged a number of journeymen painters whom he instructed in his style: first and foremost

Marcel Ordinaire (1848–96), Chérubino Pata (1827–99) and André Slomcynski (1844–1909), but also Auguste Baud-Bovy, François Bocion, Ernest-Paul Brigot (1836–1910), Jean-Jean Cornu (1819–76), Hector Hanoteau (1823–90), Auguste Morel and Alphonse Rapin (1839–89). This collaboration was a disaster, particularly as Courbet apparently signed the works produced by his assistants to augment their value; other works known as 'mixed' pictures must have been only started by him or touched up at the end. Moreover, in his despair Courbet drank a lot as well as suffering from dropsy so that he was only rarely capable of painting well. This makes it all the more remarkable that in these last years he achieved some superb landscapes and portraits. Having experimented with sculpture (1862–4), he turned once more to this medium, creating, for example, a monumental *Bust of Liberty* (1875) for La Tour-de-Peilz, near Vevey.

The first notable painting done by Courbet in Switzerland is a portrait of his father *Régis Courbet* (1873; Paris, Petit Pal.), a picture that once again exercised his full powers. The most noteworthy of his landscapes are the many brilliant versions of Lake Geneva (e.g. *Lake Geneva at Sunset*, 1874; Vevey, Mus. Jenisch) and of the castle of Chillon that stands on its shore (e.g. 1874; Ornans, Mus. Maison Natale Gustave Courbet). Many of these pictures demonstrate marvellous atmospheric effects: *Winter Landscape: The Dents du Midi* (1876; Hamburg, Ksthalle) and *Grand Panorama of the Alps* (1877; Cleveland, OH, Mus. A.) are outstanding among his late works. The former conveys a gloomy mood with heavy, thickly applied colours, while the latter, which used to be wrongly described as unfinished, is in some ways an answer to the Impressionists (even though Courbet was not able to see the First Impressionist Exhibition of 1874). While retaining his use of dark colouring in this work, Courbet broke the objects up into flecks or spots in a technique similar to that of the Impressionists. A basic incoherence between the objects and a consequent independent existence of the painterly means are apparent, anticipating the 20th century.

II. WORKING METHODS AND TECHNIQUE

1. Painting

Courbet's painting technique is not easy to describe because of its variety and disregard for the academic rules governing composition. He often inserted his figures as if they were removable set pieces (Berger). In spite of this 'collage' technique, many of his pictures look as if they had been painted at a single sitting because of their unity of colour. They were in fact often produced very quickly. Courbet prided himself on being able to paint a picture in two hours as well as produce several versions of equal quality. As every object was in theory of equal importance to him, quite often there is an egalitarian structure in his work. On the other hand Courbet's pictures frequently form a closed world: landscapes can give the impression of being locked away, and, though they are at close quarters, people may turn away from the viewer (*The Stone-breakers*, *The Bathers*, *The Wrestlers* and *The Grain-sifters*). Thus a 'wooden' composition is often found in conjunction with a fluid use of colour.

The special quality of Courbet's work is really achieved by means of colour. Courbet initially imitated 17th-century Dutch and Spanish painters (Rembrandt, Hals, Velázquez, Ribera) from whom he derived the use of black as the starting-point. He employed a dark ground throughout his life, but the treatment of surfaces changed. Courbet resorted more and more to using broad brushes: he rejected detailed academic painting and seems never to have used a mahlstick. By working increasingly with a spatula and palette knife—implements that he used to apply and scrape off colour 'like a mason'—he gave colour a special, substantial quality, which influenced van Gogh and Cézanne.

In figure works Courbet used a variety of procedures and often maintained clear, compact boundaries between objects, though in *A Burial at Ornans*, for example, he merged the figures together in a single dark mass. In the portrait of *Adolphe Marlet* (1851; Dublin, N.G.) the flesh tones were applied on top of parts of the clothing, so disregarding naturalism in favour of an emphasis

on the formal qualities of colour. In his final portrait, of his father, the colour does not seem to have been applied spontaneously and freely, but in an even-handed, distanced, almost icy manner—as if Courbet had withdrawn from the outside world.

Colour was applied in a perfunctory, almost careless way in the landscapes, as, for example, in the background of *The Meeting*. In *Rocky Landscape near Ornans* (1855; Paris, Mus. d'Orsay) spots of white were dabbed on to trees to create the effect of blossom. By the 'spontaneous' use of colour, Courbet suggested the effect of instantaneous movement in his landscapes, conveying the impression of light flickering over the rocks, of the surface of the water rippling and of leaves trembling in the wind. By 1864 Courbet's interest in the interaction of colour predominated. In the *Source of the Lison* (1864; Berlin, Alte N.G.) or in the many versions of the *Source of the Loue* Courbet spread colour, dissociated from any object, over the entire surface.

2. Drawing

Unlike Delacroix or Jean-François Millet, Courbet is not one of the foremost French draughtsmen of the mid-19th century. He had taught himself to draw, but his opposition to the classical primacy of drawing led him to work directly with colour. He produced drawings of exceptional expressive power (including two self-portraits; 1847, Cambridge, MA, Fogg; c. 1846–8, Hartford, CT, Wadsworth Atheneum) as well as of great penetration (e.g. *Juliette Courbet, Sleeping*, 1840–41; Paris, Louvre). Courbet emerges as a draughtsman essentially in two ways: firstly he produced large single sheets (in chalk or charcoal) with portrait drawings made as pictures, and secondly numerous sketches (mainly drawn with pencil or chalk, occasionally with a wash), which have been preserved either in sketchbooks or singly. The large picture-like drawings, some of them signed like paintings, were sometimes exhibited, even alongside paintings in the Salon, and are now held in a small number of large museums. For a long time many of the sketches remained in the possession of the Courbet family. In 1907 one sketchbook was acquired by the Louvre, followed by two others in 1939, and many loose sketches were still in private hands in the late 20th century (c. 30 collections). The drawings in the three sketchbooks (with two exceptions) are regarded as being in the artist's own hand, but there is controversy over the date and authenticity of many of the loose sketches, which are very uneven in quality.

A painterly treatment of the surface, using broad layers of strokes and smudging, is typical of the picture-like drawings, while the sketches, varied as they are, are characteristically composed of broken, often stiff lines. In both, however, Courbet's aversion to an academically smooth and beautiful use of line is discernible. In the sketches from his Swiss journey (see 1984 exh. cat.) the material structure of objects is clearly apparent; other travel sketches (e.g. *Tree on Rock near Spa*, c. 1849; Marseille, priv. col., see 1984 exh. cat., no 48) show, in a very similar way to Courbet's landscape paintings, how changeable and fragile the substance of objects is in light.

III. WRITINGS

Courbet was not a theorist, but his manifestos, letters and aphorisms, even though influenced by Buchon, Champfleury, Baudelaire and Jules-Antoine Castagnary, are extremely important in considering the debate over Realism, the concept of the independent artist and the ties between art and politics. Courbet also talked in great detail about his pictures in his letters.

1. The Realist debate

In 1849 at the end of a letter about *The Stonebreakers* Courbet enunciated a principle that he later elevated to be the basis of Realism. Writing to the Director of the Ecole des Beaux-Arts, he said: 'Yes, M. Peisse, art must be dragged in the gutter!' (Riat, p. 74). This one sentence and its logical conversion into practice brought personal enmities and negative criticisms to Courbet for nearly 30 years.

Courbet had adopted the concept of 'Realism', which he first used in the *Journal des faits* in 1851, from Champfleury. It can therefore be supposed

that the following statement (usually described as the 'Manifesto of Realism') was also influenced by Champfleury. It served as the foreword to the catalogue of the special exhibition of Courbet's work that opened on 28 July 1855 in the purpose-built Pavillon du Réalisme in Paris. His insistence on depicting scenes from his own era reflected a demand that had prevailed in France since the Revolution to replace classical imagery with that drawn from contemporary subjects (Courthion, ii, pp. 60–61):

The name 'Realist' has been imposed on me just as the name 'Romantic' was imposed on the men of 1830 Working outside any system and with no previous prejudice I have studied the art of the Old Masters and the art of the Modern Masters. I no more want to imitate the former than copy the latter; nor have I pursued the futile goal of art for art's sake. No! I simply wanted to draw from a complete knowledge of tradition a reasoned and independent sense of my own individuality. I sought knowledge in order to acquire skill, that was my idea. To be capable of conveying the customs, the ideas and the look of my period as I saw them; to be not just a painter, but a man as well; in short, to produce living art, that is my aim.

The idea of 'living art' greatly exercised Courbet's mind thereafter and had a self-liberating effect, for, in contrast to the protagonists of the French Revolution, Courbet did not believe that man was born free, rather that he became free only through work. Work, including art, could lead to freedom only if it also improved the condition of society. He spoke of this at a conference of artists in Antwerp in 1861 (Riat, pp. 191–2):

The basis of realism is the denial of the ideal . . . *Burial at Ornans* was really the burial of Romanticism We must be rational, even in art, and never allow logic to be overcome by feeling By reaching the conclusion that the ideal and all that

it entails should be denied, I can completely bring about the emancipation of the individual, and finally achieve democracy. Realism is essentially democratic art.

Courbet's missionary mentality led to the rapid dissemination of a 'doctrine' of Realism, which inevitably attracted pupils to Courbet. Yet he did not want to be a teacher as he intended to encourage the artistic expression of each individual. He gave the following explanation of this apparent dichotomy at the opening of his studio (Castagnary, pp. 180–83):

I do not and cannot have pupils . . . I cannot teach my art or the art of any school, since I deny that art can be taught, or to put it another way I claim that art is completely individual and for each artist it is only the talent that results from his own inspiration and his own study of tradition In particular it would be impossible for art in painting to consist of any other things than the representation of objects which the artist can see and touch There can be no schools Unless it becomes abstract, painting cannot allow a partial aspect of art to dominate, be it drawing, colour or composition.

2. Political views

Courbet's political aphorisms cover his whole working period and had a far-reaching influence into the 20th century. However he was politically committed in a strict sense for only short periods (1848–51, 1855, 1863–4, 1868–71), and even then it is only rarely possible to discern a directly political iconography in his pictures. In February 1848 he made a chalk drawing of a man on a barricade waving a gun and flag for the periodical *Le Salut public* edited by Baudelaire (printed in the second issue of the journal), yet in letters (Courthion, ii, p. 74) he denied any participation in the political events of that year. Nor did he take part in the competition to produce an allegory for the Republic, though he encouraged Daumier to do so. He wrote that, instead, he was 'going to enter the

competition open to musicians for a popular song' (Riat, p. 53). It is all the more probable that he took part as he did himself write poetry (Herding, 1988).

Throughout his life Courbet was strongly opposed to state power, an attitude that brought him into conflict with the government of the Second Empire. His ideas on this issue emerge in the discussion he had in 1854 with the Comte de Nieuwerkerke, Intendant des Beaux-Arts de la Maison de l'Empereur. The administration wanted to ensnare the recalcitrant artist by offering him an official commission for a large painting for the Exposition Universelle to be held in Paris in 1855. Courbet rejected the invitation with anti-authoritarian arguments (Courthion, ii, p. 81):

Firstly because he [Nieuwerkerke] maintained to me that there was a government and I did not in any way feel included in that government, I myself was a government, and . . . if he liked my pictures he was free to buy them from me, and I asked only one thing of him, that he should allow the art of his exhibition to be free.

This request met with only partial success; the *Painter's Studio* was not admitted into the official exhibition. In this, Courbet, driven by his need for independence, anticipated the later Salon des Refusés and secessionist movements.

In declining the honour of becoming a Chevalier of the Légion d'honneur in 1870, Courbet reiterated his liberal and individualistic principles (Courthion, ii, p. 124):

The State has no competence in matters relating to art When it leaves us free, it will have fulfilled its duties towards us. . . . when I am dead people must say of me: he never belonged to any school, any church, any institution, any academy and above all to any régime, except for the rule of freedom.

This stance as an outsider and individualist did not prevent Courbet from perceiving himself as a socialist and being seen as one. On 15 November 1851 Courbet was described in the *Journal des faits* as a 'socialist painter', and he immediately accepted this designation as his letter of 19 November 1851 to the editor demonstrates; the letter appeared on 21 November, thus just two weeks before Louis-Napoléon Bonaparte's coup d'état (*Bull. Amis Gustave Courbet*, lii (1974), p. 12):

I am strong enough to act alone . . . M. Garcin calls me the socialist painter; I gladly accept that description; I am not only a socialist, but also a democrat and republican, in short a supporter of all that the revolution stands for, and first and foremost I am a realist.

Courbet's individualism extended to the wider demand for decentralization. This idea was first expressed in a letter Courbet wrote to Proudhon in 1863 for Proudhon's essay on his art (published in Paris in 1865 under the title 'Du principe de l'art et de sa destination sociale') in which he linked decentralization with his principle that 'independence leads to everything' (*Bull. Amis Gustave Courbet*, xxii (1958), p. 7). In a letter written to Jules Vallès during the Commune in 1871, Courbet stated that he regarded the USA and Switzerland as models for the future form of the French State; he felt France should be decentralized and divided into cantons (Courthion, ii, pp. 47–9). Courbet returned to the theme of decentralization in two further letters (Courthion, ii, pp. 49–59). However, these ideas should not be seen as forming a purely political manifesto. Courbet's painting provided an analogy for decentralization: firstly in its subject-matter, in his preference for the provinces over Paris, and secondly in its form, since for him each object had the same weight.

3. Character and personality

Courbet was regarded as a remarkable figure by his contemporaries: a sturdy man with a look of the people, far removed from Parisian taste, an artist without restraint, someone who saw himself as an anarchist and socialist but who made more

of a fuss about it than his knowledge of the subject warranted. Presenting a noisy, obstreperous, extrovert image, he apparently found companionship only in bohemian circles (e.g. at the famous Brasserie Andler where he met Baudelaire, Proudhon, Corot and, later on, Monet). This idea of an 'uncivilized' and 'independent' Bohemian formed an important feature of Courbet's self-image. He first expressed this Romantic notion in a letter to his friend Francis Wey in 1850: 'In our so very civilized society I have to live like a savage; I have to free myself even of governments. To accomplish this I have therefore just embarked on the great independent, vagabond life of the Bohemian.' (Riat, pp. 80–81). Later too Courbet was repeatedly described by himself and others as 'sauvage' (Courthion, i, pp. 98, 102, 105, 120, 216; ii, p. 93).

In his writings, including his autobiography of 1866 (Courthion, ii, pp. 25–33), Courbet often appears as a lively man who, though fond of laughter and singing, suffered from bouts of depression and a fear of persecution. These qualities are also evident in his extensive correspondence with his patron Bruyas, to whom he wrote at the end of 1854: 'Behind the laughing mask that you see I conceal inside me suffering, bitterness and a sadness that clings to my heart like a vampire.' (Courthion, ii, p. 84). Courbet's last important letter, of 1 March 1873, was again addressed to Bruyas; in it he links his personal suffering with that of society: 'The devotion I have always had for those who suffer has paralyzed the well-being which I could have achieved for myself in life. I have no regrets; I dread only one thing, ending up like Don Quixote, for lying and self-centredness are inseparable.' (Courthion, ii, p. 152).

IV. CRITICAL RECEPTION AND POSTHUMOUS REPUTATION

Courbet rapidly achieved a high and controversial profile in his lifetime through his character, life style and political views. Art critics (such as Théophile Gautier, Charles Perrier (fl 1850s), Maxime Du Camp, Prosper Mérimée (1803–70) and Alexandre Dumas fils (1824–95)) and caricaturists

(such as Bertall, Cham, Paul Hadol (1835–75) and Quillenbois (b 1821)) reproached him not only for 'democratizing art' (prompted by The Stone-breakers) but also for extolling the world of peasants, labourers or wrestlers and for his coarse painting style. Courbet's defenders (such as Buchon, Champfleury, Castagnary and Théophile Thoré), who pointed to his social commitment, his honest concern with the present and his modernity, were barely able to dent the prevailing academic concepts until the mid-1860s. Only Castagnary eventually succeeded in doing so, but only by a conformist strategy, which sacrificed the content of Courbet's painting. Castagnary was the first to point out the colourful charm, dreamy depths and lively atmosphere of Courbet's pictures; he even maintained that Courbet had never basically been a Realist. Conversely, Champfleury gradually parted company with Courbet for political reasons, and when he learnt in 1882 that Courbet was to be honoured with a large retrospective exhibition in the Ecole des Beaux-Arts, he criticized him as an annoying example of folksiness and spoke of his equivocations and lack of character. Even before that, in 1866, Zola had played Courbet the painter off against Courbet the politician; he particularly hated the sociological interpretation of Courbet's pictures by Proudhon (Picon and Bouillon, pp. 36–56). On the other hand, the socialist writer Thoré thought that Courbet had become depoliticized as he was now 'accepted, bemedalled, decorated, glorified, embalmed' (Thoré, ii, p. 276).

A rehabilitation of Courbet's reputation began in the 1880s when France remembered its republican traditions. Thenceforward Courbet was perceived both as a politically committed artist and as a modernist (see Sanchez), though the polemics against him continued (see Champfleury). In Germany Courbet had been highly regarded by the avant-garde from the time of the exhibitions of his work in Munich (1851, 1869) and Frankfurt am Main (1852, 1854, 1858). Julius Meier-Graefe put this admiration on a scholarly level as early as 1905, emphasizing Courbet's role as a pioneer of modernism, at the same time, moreover, that Cézanne (in conversations recorded by Joachim

Gasquet (1873–1921) in *Cézanne* (Paris, 1926)) expressed his reverence for Courbet. The situation in England was similar after pictures by Courbet were exhibited there (in 1856 and 1862).

The position has not altered much since then. Even in France the reproach of 'lowness' levelled at Courbet and the hatred of the Communards gradually disappeared, and Apollinaire's description of Courbet as the father of modernism has prevailed. In 1946 a small museum devoted to Courbet was opened in Ornans, and in 1971 this was expanded and moved into the house where he was born. The Musée Maison Natale de Gustave Courbet contains works by Courbet and his friends as well as photographs, letters and other material relating to the artist.

Since the 1970s the attitudes of Zola and Thoré have been reiterated and even intensified. A resolution of the sterile dispute over Courbet the artist and Courbet the politician can be achieved only by looking at the multiple meanings in Courbet's work from a different perspective (Hofmann in 1978–9 exh. cat.); by considering new aspects (e.g. the 'gender aspect', see 1988–9 exh. cat.); and by trying to understand Courbet's anti-normative method and rejection of naturalism (which has been so liberating to modernism) as analogies for his anarchic social utopias. Courbet's enduring achievement was unquestionably to free art from the strait-jacket of the academic 'ideal'. Therefore in a special sense he has become 'the artists' artist' (Sedgwick), while some art historians still approach him with reserve.

Writings

P. Courthion, ed.: *Courbet raconté par lui-même et par ses amis*, 2 vols (Geneva, 1948–50)

P. Borel, ed.: *Lettres de Gustave Courbet à Alfred Bruyas* (Geneva, 1951)

P. ten-Doesschate Chu, ed.: *Courbet's Letters* (Chicago, 1992)

Bibliography

early sources

Champfleury: 'Du réalisme: Lettre à Madame Sand', *L'Artiste*, n. s. 5, xvi (1855), pp. 1–5

J.-A. Castagnary: *Les Libres Propos* (Paris, 1864), pp. 174–201

T. Thoré: *Salon de W. Bürger*, 2 vols (Paris, 1870)

P. Mantz: 'Gustave Courbet', *Gaz. B.-A.*, xvii (1878), pp. 514–27; xviii (1878), pp. 17–29, 371–84

J.-A. Castagnary: *Salons (1857–1870)*, 2 vols (Paris, 1892)

—: 'Fragments d'un livre sur Courbet', *Gaz. B.-A.*, n. s. 2, v (1911), pp. 5–20; vi (1912), pp. 488–97; vii (1912), pp. 19–30

general

L. Nochlin, ed.: *Realism and Tradition in Art, 1848–1900* (Englewood Cliffs, 1966)

L. Nochlin: *Realism* (Harmondsworth, 1971)

T. J. Clark: *The Absolute Bourgeois: Artists and Politics in France, 1848–1851* (London, 1973)

G. Lacambre and J. Lacambre, eds: *Champfleury: Le Réalisme* (Paris, 1973)

G. Picon and J.-P. Bouillon: *Emile Zola: Le Bon Combat: De Courbet aux Impressionnistes* (Paris, 1974)

G. Lacambre and J. Lacambre, eds: *Champfleury: Son regard et celui de Baudelaire: Textes choisis et présentés, accompagnés de 'L'Amitié de Baudelaire et de Champfleury' par Claude Pichois* (Paris, 1990)

monographs and symposia

G. Riat: *Gustave Courbet: Peintre* (Paris, 1906)

C. Léger: *Courbet selon les caricatures et les images* (Paris, 1920)

J. Meier-Graefe: *Courbet* (Munich, 1921)

C. Léger: *Courbet et son temps* (Paris, 1949)

G. Mack: *Gustave Courbet* (London, 1951)

L. Aragon: *L'Exemple de Courbet* (Paris, 1952)

R. Fernier: *Gustave Courbet* (Paris, 1969)

A. Fermigier: *Courbet* (Geneva, 1971)

T. J. Clark: *Image of the People: Gustave Courbet and the 1848 Revolution* (London, 1973)

R. Lindsay: *Gustave Courbet: His Life and Art* (New York, 1973)

L. Nochlin: *Gustave Courbet: A Study in Style and Society* (New York, 1976)

B. Foucart: *Courbet* (Paris, 1977)

P. ten-Doesschate Chu, ed.: *Courbet in Perspective* (Englewood Cliffs, 1977)

Malerei und Theorie: Das Courbet Colloquium: Frankfurt am Main, 1979

A. Callen: *Courbet* (London, 1980)

M. Fried: *Courbet's Realism* (Chicago and London, 1990); review by K. Herding in *Burl. Mag.*, cxxxiii (1991), pp. 723–4

K. Herding: *Courbet: To Venture Independence* (New Haven and London, 1991)

J.-H. Rubin: *Gustave Courbet: Realist and Visionary* (in preparation)

catalogues

R. Fernier: *La Vie et l'oeuvre de Gustave Courbet: Catalogue raisonné*, 2 vols (Lausanne and Paris, 1977–8); review by K. Herding in *Pantheon*, xxxix (1981), pp. 282–6

Gustave Courbet, 1819–1877 (exh. cat. by H. Toussaint and M.-T. de Forges, Paris, Petit Pal.; London, RA; 1977–8)

Courbet und Deutschland (exh. cat. by W. Hofmann in collaboration with K. Herding, Hamburg, Ksthalle; Frankfurt am Main, Städel. Kstinst. & Städt. Gal.; 1978–9)

Courbet et la Suisse (exh. cat., ed. P. Chessex; La Tour-de-Peilz, Château, 1982)

Les Voyages secrets de Monsieur Courbet: Unbekannte Reiseskizzen aus Baden, Spa und Biarritz (exh. cat., ed. K. Herding and K. Schmidt; Baden-Baden, Staatl. Ksthalle; Zurich, Ksthaus; 1984)

Courbet à Montpellier (exh. cat., ed. P. Bordes; Montpellier, Mus. Fabre, 1985)

Courbet Reconsidered (exh. cat., ed. S. Faunce and L. Nochlin; New York, Brooklyn Mus.; Minneapolis, Inst. A.; 1988–9)

specialist studies

studies of particular works

R. Huyghe, G. Bazin and others: *Courbet: 'L'Atelier du peintre: Allégorie réelle', 1855* (Paris, 1944)

M. Winner: 'Gemalte Kunsttheorie: Zu Gustave Courbets *Allégorie réelle* und der Tradition', *Jb. Berlin. Mus.*, iv (1962), pp. 150–85

L. Nochlin: 'Gustave Courbet's *Meeting*: A Portrait of the Artist as a Wandering Jew', *A. Bull.*, xlix (1967), pp. 209–22

B. Farwell: 'Courbet's *Baigneuses* and the Rhetorical Feminine Image', *Women as Sex Objects: Studies in Erotic Art, 1730–1970*, ed. T. Hess and L. Nochlin (New York, 1972), pp. 65–79

B. Nicolson: *Courbet: 'The Studio of the Painter'* (New York, 1973)

A. Seltzer: 'Courbet: All the World's a Studio', *Artforum*, xvi (1977), pp. 44–50

J.-L. Fernier: *Courbet: 'Un Enterrement à Ornans', anatomie d'un chef d'oeuvre* (Paris, 1980)

M. Fried: 'The Structure of Beholding in Courbet's *Burial at Ornans*', *Crit. Inq.*, ix (1983), pp. 635–83

——: 'Courbet's Metaphysics: A Reading of *The Quarry*', *Reconstructing Individualism: Autonomy, Individuality and the Self in Western Thought*, ed. T. C. Heller and others (Stanford, 1986), pp. 75–105

L. Nochlin: 'Courbet's *L'Origine du monde*: The Origin without an Original', *October*, xxxvii (1986), pp. 76–86

other

J. Meier-Graefe: *Corot und Courbet* (Leipzig, 1905)

G. Boas: *Courbet and the Naturalistic Movement* (Baltimore, 1938)

M. Schapiro: 'Courbet and Popular Imagery: An Essay of Realism and Naiveté', *J. Warb. & Court. Inst.*, iv (1941), pp. 164–91

K. Berger: 'Courbet in his Century', *Gaz. B.-A.*, n. s. 6, xxiv (1943), pp. 19–40

Bull. Amis Gustave Courbet (1947–)

J. P. Sedgwick: 'The Artist's Artist', *ARTnews*, lviii (1960), pp. 40–44, 65–6

T. J. Clark: 'A Bourgeois Dance of Death: Max Buchon on Courbet', *Burl. Mag.*, cxi (1969), pp. 208–12, 286–90

L. Dittmann: *Courbet und die Theorie des Realismus: Beiträge zur Theorie der Künste im 19. Jahrhundert* (Frankfurt am Main, 1971), pp. 215–39

R. Bonniot: *Courbet en Saintonge* (Paris, 1973)

A. Bowness: 'Courbet and Baudelaire', *Gaz. B.-A.*, n. s. 6, xc (1977), pp. 189–99

K. Herding: 'Gustave Courbet (1819–1877): Zum Forschungsstand', *Kunstchronik*, xxx (1977), pp. 438–56, 486–96

A. Bowness: 'Courbet's Proudhon', *Burl. Mag.*, cxx (1978), pp. 123–8

K. Herding, ed.: *Realismus als Widerspruch: Die Wirklichkeit in Courbets Malerei* (Frankfurt am Main, 1978, rev. 1984)

J.-P. Sanchez: 'La Critique de Courbet et la critique du réalisme entre 1880 et 1890', *Hist. & Crit. A.*, iv–v (1978), pp. 76–83

T. Reff: 'Courbet and Manet', *A. Mag.*, liv (1980), pp. 98–103

J.-H. Rubin: *Realism and Social Vision in Courbet and Proudhon* (Princeton, 1980)

A. M. Wagner: 'Courbet's Landscapes and their Market', *A. Hist.*, iv (1981), pp. 410–31

L. Nochlin: 'The De-politicization of Gustave: Transformation and Rehabilitation under the Third Republic', *October*, xxii (1982), pp. 65–77

N. McWilliams: 'Un Enterrement à Paris: Courbet's Political Contacts in 1845', *Burl. Mag.*, cxxv (1983), pp. 155–6

K. Herding: 'Lautmalereien: Zu einigen unbekannten Gedichten und Briefen Courbets', *Kunst um 1800 und die Folgen: Werner Hofmann zu Ehren*, ed. C. Beutler (Munich, 1988), pp. 233–43

P. ten-Doesschate Chu: *Courbet and the 19th Century Media Culture* (in preparation)

KLAUS HERDING

Court, Joseph-Désiré

(b Rouen, 14 Sept 1797; d Paris, 23 Jan 1865).
French painter and museum director. In 1817 he
entered the Académie des Beaux-Arts in Paris,
where he studied under Antoine-Jean Gros. In 1821
he won the Prix de Rome with *Samson Handed
over to the Philistines by Delilah* (1821; Paris, Ecole
N. Sup. B.-A.). He began exhibiting at the Salon in
1824 and in 1827 showed *Scene from the Deluge*
(1827; Lyon, Mus. B.-A.), painted while he was in
Rome, and the *Death of Caesar* (Paris, Louvre). The
latter proved a sensational success: it was initially
bought by the Musée du Luxembourg, Paris, and
was re-exhibited in 1855 before being sent to the
Louvre. The subject derives from Plutarch and
shows Antony stirring the Roman citizens to
avenge the murder of Caesar. It was praised chiefly
for its dramatic composition.

In 1830 and 1831 Court took part in the com-
petitions set up to provide paintings for the Salon
de Séances in the Chambre de Députés, Paris. His
three works, on the required subjects, were the
Oath of Louis-Philippe (1830; Saint-Germain-en-
Laye, Mus. Mun.), *Mirabeau and Dreux-Brézé* and
Boissy d'Anglas Saluting the Head of Féraud (both
1831; Rouen, Mus. B.-A.). None of Court's entries
was successful, but their reception reflects con-
temporary debates about the requirements of offi-
cial art: although it conformed largely to
traditional modes of representation, *Mirabeau
and Dreux-Brézé* was criticized as being too the-
atrical and was perceived as lacking the historical
literalness required of official art. As a protest
against the decision of the competition jury, Court
exhibited *Boissy d'Anglas* at the Salon of 1833.

At the Salon of 1836 Court exhibited two
further examples of official art: the *Duc d'Orléans
Signs the Act Proclaiming a Lieutenance-générale
of the Kingdom, 31 July 1830* and the *King
Distributing Battalion Standards to the National
Guard, 29 August 1830* (both Versailles, Château).
The latter was hung in the Salle de 1830 in the
south wing of the château of Versailles, a room
designed to celebrate the Revolution of 1830 that
brought Louis-Philippe to power. In order to create
the sense of recording a first-hand experience,
Court depicted a close-up view of the event, rather
than a panoramic scene. As with other official
works, however, the appearance of historical truth
disguised the propagandist intent. The picture
professed the physical strength of the monarchy
and reflected the importance of the National
Guard to its security, though in August 1830 the
Marquis de Lafayette was in fact Commander-in-
Chief of the National Guard.

Court increasingly devoted himself to painting
portraits, such as that of *Marshal Vallée* (1839;
Versailles, Château). He also painted a number of
religious works, such as the *Embarkation of St Paul
for Jerusalem* (1835; Paris, SS Gervais & Protais).
After his early successes and critical acclaim,
Court's later work was rather mediocre, though
his portraits are of historical interest. He contin-
ued to exhibit regularly at the Salon, and in 1853
he was appointed director of the Musée des Beaux-
Arts in Rouen, a post he held until his death.

Bibliography

Bénézit; DBF
H. Marcel: *La Peinture française au XIXe siècle* (Paris,
 1905), pp. 128–31
P. Grunchec: *Le Grand Prix de peinture* (Paris, 1983)
M. Marrinan: *Painting Politics for Louis-Philippe: Art and
 Ideology in Orléanist France, 1830–1848* (New Haven
 and London, 1988)

☐

Couture, Thomas

(b Senlis, 21 Dec 1815; d Villiers-le-Bel, 3 March
1879). French painter and teacher. A student of
Antoine-Jean Gros in 1830–38 and Paul Delaroche
in 1838–9, he demonstrated precocious ability in
drawing and was expected to win the Prix de
Rome. He tried at least six times between 1834 and
1839, but achieved only second prize in 1837 (entry
untraced). Disgusted with the politics of the aca-
demic system, Couture withdrew and took an
independent path. He later attacked the stultified
curriculum of the Ecole des Beaux-Arts and dis-
couraged his own students from entering this
institution. He first attained public notoriety at
the Paris Salon with *Young Venetians after an
Orgy* (1840; Montrouge, priv. col., see Boime, p. 85),

the *Prodigal Son* (1841; Le Havre, Mus. B.-A.) and the *Love of Gold* (1844; Toulouse, Mus. Augustins; see fig. 12). These early canvases are treated in a moralizing and anecdotal mode; the forms and compositional structures, like the debauched and corrupt protagonists, are sluggish and dull. Yet what made his work seem fresh to the Salon audience was his use of bright colour and surface texture derived from such painters as Alexandre-Gabriel Decamps and Eugène Delacroix, while his literary bent and methodical drawing demonstrated his mastery of academic tradition. The critics Théophile Gautier and Paul Mantz (1821–95) proclaimed him as the leader of a new school that mediated between the old and the new, and looked to him for a revitalization of Salon painting. The air of compromise his works projected made him appear a cultural representative of the *juste milieu* policies of Louis-Philippe.

However Couture was far from happy in this role. Longing to make a statement worthy of the grand tradition of David and Gros, he started to work in the mid–1840s on the monumental *Romans of the Decadence* (completed 1847; Paris, Mus. d'Orsay; see col. pl. IV). It was the triumph of the Salon of 1847 and destined to become his best-known picture. An extension of the moralizing themes of his first Salon exhibits, it represents the waning moments of an all-night orgy in the vestibule of a vast Corinthian hall. The exhausted and drunken revellers are contrasted with the solemn tutelary statues of the great Roman republicans in the niches around the hall; the heroes' descendants have fallen into venality and corruption. The work was

12. Thomas Couture: *Love of Gold*, 1844 (Toulouse, Musée des Augustins)

interpreted as a satire on the July Monarchy (1840–48) and a wide range of government critics— aristocratic, radical and bourgeois—perceived it as a forecast of the regime's impending doom. The picture also had its admirers in government circles: François Guizot, the king's chief minister, was instrumental in its purchase by the state.

The collapse of the July Monarchy in 1848 seemed to confirm a prophetic interpretation of the picture, and Couture was encouraged to produce a new monumental painting celebrating the Revolution for the Salle des Séances in the Assemblée Nationale. He had already begun his *Enrolment of the Volunteers of 1792* (incomplete; Beauvais, Mus. Dépt. Oise) near the end of 1847, inspired by a series of lectures given by Jules Michelet at the Collège de France, which aimed to regenerate French society through the invigorating impulses of its youth. Michelet invoked 1789 as an exemplary model, and similarly in the *Enrolment* Couture depicted all classes in society forging a new national unity in the face of external threat. The exhilaration of the picture, its energetic sweep and movement, contrasts sharply with the *Romans* and attests to the sense of revitalization sparked by the 1848 revolution. But the work was never completed: with the counter-revolution in June 1848 and the installation of Louis-Napoléon as emperor the political climate altered so drastically that the *Enrolment* lost its raison d'être. The canvas has some figures almost complete but mainly only underdrawing.

Couture managed to maintain close ties with the various governments of Napoléon III. He received a number of major commissions, but completed only the wall paintings in the chapel of the Virgin, St Eustache, Paris. His *Baptism of the Prince Imperial* (Compiègne, Château), celebrating the dynastic heir of the Second Empire, was commissioned in 1856 with the *Return of the Troops from the Crimea* (Le Havre, Mus. B.-A.) but remained unfinished. A combination of jealous intrigues and his own unstable temperament led to a falling out with the imperial family, and by the end of the 1850s he had nothing to show for his labours except innumerable sketches (e.g. Senlis, Mus. A. & Archéol.).

Couture returned to Senlis in 1859 and devoted the rest of his life to satisfying the tastes of private patrons, many of them Americans. He embarked on a series of pictures based on the characters of the *commedia dell'arte*. His satirical *Realist* (1865; Cork, Crawford Mun. A.G.) shows a bohemian art student seated on the head of the Olympian Jupiter painting the head of a pig. His misanthropic disposition is revealed in his *Courtesan's Chariot or Love Leading the World* (several versions, 1870s; e.g. Philadelphia, PA, Mus. A.), which shows a bare-breasted female pulled in a carriage by four men representing Youth, Riches, Courage and Poetry. The courtesan drives them with a whip, transforming them into beasts of burden. He was a particularly fine portrait painter, as can be seen in the *Young Italian Girl* (1877; Senlis, Mus. A. & Archéol.).

Couture's posthumous reputation rests mainly on his pedagogic skills. In 1847 he announced that he was opening an atelier in Paris independent of both classical and Romantic schools. He soon became a popular teacher. His distrust of academic education and honours, his innovative technical procedures and obsession with the pure colour and fresh brushwork of the sketch, which he encouraged his students to retain into the finished picture, exercised a profound influence. Among his pupils were Edouard Manet, Pierre Puvis de Chavannes, Anselm Feuerbach and many American artists—who preferred his teaching to the more rigid discipline of the Ecole and the Düsseldorf school—notably John La Farge, William Morris Hunt and Eastman Johnson.

Many of Couture's paintings and drawings were destroyed in 1870 during the Franco-Prussian War. The Musée d'Art et Archéologie, Senlis, has a collection of his portraits and oil sketches.

Writings
Méthodes et entretiens d'atelier (Paris, 1867)
Entretiens d'atelier: Paysage (Paris, 1869)

Bibliography
Catalogue des oeuvres de Thomas Couture (exh. cat. by R. Ballu, Paris, Pal. Indust., 1880)
G. Bertauts-Couture: *Thomas Couture (1815–1879): Sa vie, son oeuvre, son caractère, ses idées, sa méthode, par lui-même et par son petit-fils* (Paris, 1932)

American Pupils of Thomas Couture (exh. cat. by M. E.
 Landgren, College Park, U. MD A.G., 1970)
Thomas Couture, 1815–79 (exh. cat. by M. J. Salmon,
 Beauvais, Mus. Dépt Oise, 1972)
P. Vaisse: 'Couture et le Second Empire', Rev. A. [Paris],
 xxxvii (1977), pp. 43–68
——: 'Thomas Couture ou le bourgeois malgré lui',
 Romanticisme, xvii–xviii (1977), pp. 103–22
A. Boime: Thomas Couture and the Eclectic Vision (New
 York, 1979)

ALBERT BOIME

Crauk, Charles-Alexandre

(b Douchy, 27 Jan 1819; d Paris, 30 May 1905).
French painter. He was a pupil of Jacques-François
Momal (1754–1832) and of Antoine-Julien Potier
(1796–1865) at the Académie in Valenciennes,
which gave him a grant, and he then went to the
Ecole des Beaux-Arts in Paris in 1840, where he
studied under François-Edouard Picot. He exhib-
ited regularly at the Salon from 1845, including
such works as Antoine Watteau, Dying, Gives his
last Advice to Jean-Baptiste Pater. In 1846 he won
the Deuxième Prix de Rome for Alexandre, Ill,
with his Doctor, Philip (sketch Paris, priv. col.),
though the Première Prix de Rome was not
awarded that year. He is known mainly for his reli-
gious paintings, among them the Ecstasy of St
Lambert, commissioned by the Interior Minister in
1852, and the Baptism of Christ (church of Lescas,
Basses Pyrenées), commissioned by the Minister of
State in 1852. He also painted the Martyrdom of
St Piat for the cathedral in Angers and four scenes
from the life of the eponymous saint for the choir
of St Francis Xavier in Paris, as well as numerous
cartoons for stained glass in churches at
Compiègne, Versailles, Chartres and elsewhere.
Crauk executed several civic decorative works for
the Galerie des Machines at the Exposition
Universelle in Paris in 1889, producing the cartoon
for a large stained-glass window on the theme of
the Chariot of the Sun. He also painted a ceiling
for the Musée des Beaux-Arts in Amiens. He was
appointed professor of drawing at the Ecole de
Saint-Cyr in 1875 and exhibited regularly at the
Salon until 1902, with one break in 1893.

Bibliography
Bénézit; DBF; Thieme–Becker

A. DAGUERRE DE HUREAUX

Danloux, Henri-Pierre

(b Paris, 24 Feb 1753; d Paris, 3 Jan 1809). French
painter and draughtsman. He was orphaned at an
early age and was brought up by an uncle who was
an architect and contractor. Around 1770 his uncle
apprenticed him to Nicolas-Bernard Lépicié. He
exhibited for the first time in 1771 at the
Exposition de la Jeunesse in Paris, where he
showed a Drunkard at a Table (untraced). About
1773 he was admitted into the studio of Joseph-
Marie Vien, whom he followed to Rome in 1775 on
the latter's appointment as Director of the
Académie de France. Danloux's sketchbooks show
that he also travelled to Naples, Palermo, Florence
and Venice. He was not interested in the monu-
ments of antiquity but concentrated instead on
drawing landscapes and, in particular, portraits,
among them that of Jacques-Louis David
(untraced).

Not being a member of the Académie Royale,
Danloux could not exhibit at the Paris Salon, but
in 1782 he sent several paintings to the Salon de
la Correspondance, including a Hunter Sitting in
a Wood and Caressing his Dog, Young Woman
Seated on a Sofa (engraved as the Pleasant
Surprise), and a portrait of Jean-Baptiste Génillion,
a pupil of Joseph Vernet (all untraced). As well as
intimate genre scenes of the kind painted by
Lépicié, Danloux specialized in informal small-
scale portraits, both painted in oils or drawn to
resemble medallions.

In 1783 Danloux left Italy and settled in Lyon,
moving to Paris at the end of 1785. There he
met the Baronne d'Etigny, who obtained for
him many portrait commissions, including the
portraits of Pierre-François-Jean de Cluzel (1786;
Paris, Mus. Cognacq-Jay) and Antoine-Marie de
Cluzel (1786; Tours, Mus. B.-A.). In 1787 Danloux
married Antoinette de Saint-Redan, the adopted
daughter of Mme d'Etigny, and afterwards
returned to Rome, where his sitters belonged

to the cosmopolitan aristocracy of the *ancien régime*. He posed them informally in familiar settings and paid great attention to the painting of fabrics, embroidery and accessories. He returned to Paris at the beginning of 1789 and was commissioned to execute portraits of members of the royal family, such as *Mme Elisabeth and the Dauphin* (untraced).

During the French Revolution Danloux exhibited at the 1791 Salon, but remaining loyal to the royal family he emigrated to London in 1792. His diary reveals that he cultivated French émigrés and obtained from them portrait commissions such as those for the *Abbé Saint-Far* (1792; oil sketch, Paris, Carnavalet), the actress *Mlle Duthé* (1792) and the *Duc de Bourbon-Condé* (1795; Chantilly, Mus. Condé). He was influenced by such fashionable English portrait painters as Thomas Lawrence, John Hoppner and, in particular, George Romney, and began to excel in family group portraits and portraits of children, whom he painted in the most natural and spontaneous poses. In 1793 he exhibited the *Foster Children* (sold, London, Christie's, 26 June 1981) at the Royal Academy. This led to commissions from a number of British patrons, which took him to Portsmouth in August 1795 and to Scotland in the autumn of 1796, where he painted, among other works, the *Comte d'Artois* (Cambridge, Fitzwilliam), the sumptuous portrait of the *Family of the Duke of Buccleuch* (Duke of Buccleuch priv. col.) and *Admiral Duncan* (Dundee, Camperdown House). At this period he was using a freer technique and incorporating landscape backgrounds.

In 1801 Danloux returned to Paris. During his last years in London he had begun to work on large subject pictures, and this he continued to do. His history painting *The Flood* (Saint-Germain-en-Laye, Mus. Mun.), however, was badly received at the 1802 Salon. From that time Danloux painted only occasional portraits, among them that of the writer the *Abbé Delille* (Versailles, Château) and a few oil sketches of historical genre scenes, such as *Henry IV and Sully* (Pau, Mus. N. Château).

Bibliography

R. Portalis: *Henri-Pierre Danloux peintre de portraits et son journal durant l'émigration (1735–1809)* (Paris, 1910)

VALÉRIE M. C. BAJOU

Dantan

French family of sculptors. Antoine-Laurent Dantan (*b* Saint-Cloud, Hauts-de-Seine, 8 Dec 1798; *d* Saint-Cloud, 25 May 1878), known as Dantan the elder, and his brother Jean-Pierre Dantan (*b* Paris, 28 Dec 1800; *d* Baden Baden, 6 Sept 1869), known as Dantan the younger, both served an apprenticeship with their father, an ornamental woodcarver. Antoine-Laurent entered the Ecole des Beaux-Arts, Paris, in 1816, and Jean-Pierre in 1823. Both were the pupils of François-Joseph Bosio, who passed on to them his skill in elegant, conventional portraiture. While the elder brother was preparing his entry for the Prix de Rome, the younger worked on a variety of decorative commissions. By 1826 he had executed a statuette (Paris, Carnavalet) portraying *César Ducornet* (1805–56), an armless painter. Because of the subject's disability, this work cannot rank as the first of his caricatures or *portraits chargés*, as Jean-Pierre termed his subsequent humorous sculptures; but the interest in physical peculiarities that it displays was in accordance with the Romantics' desire to accommodate the full range of natural phenomena, even the disturbing.

Antoine-Laurent won the Prix de Rome in 1828; in the following year, the brothers travelled together to Rome. In 1831 Jean-Pierre returned to France, where he set about reproducing and marketing his statuettes caricaturing men prominent in the worlds of music, theatre, politics and the law. In Rome, his brother, following in the footsteps of François Rude and François-Joseph Duret, completed, as his farewell piece, a Neapolitan genre statue of a *Young Hunter Playing with his Dog and a Duck* (marble, 1833–5; Paris, Louvre). On his return to France, he produced a pendant to this, a *Young Neapolitan Girl* (exh. 1837 Salon; version, Halifax, W. Yorks, People's Park). He devoted himself, for the most part, to portraiture

and official sculpture, displaying at times a romantic panache, as in the statue of *Abraham Duquesne* (bronze, 1844; Dieppe), which was first shown at the 1843 Salon. Jean-Pierre, despite the huge success of his caricatures, likewise produced statues for public buildings and non-humorous portraits; on one occasion he undertook a commemorative statue, that of the composer *Adrien Boieldieu*, for Rouen (bronze; 1835–7).

While the Dantan brothers' serious work hardly rose above the average of their time, Jean-Pierre's caricatures were a new departure and paved the way for Honoré Daumier's series of satirical busts of members of the Parlement. However, a comparison with Daumier makes it possible to identify the distinctive features of Jean-Pierre's approach, which is drier, more journalistic, and referential in its use of subjects' recognizable attributes. As in contemporary commemorative statuary, these references were sometimes made through reliefs on the base of the statuette or bust, an example being the portrait of *Honoré de Balzac* (plaster, 1835; Paris, Carnavalet) that depicted his jewelled cane on the base. Sometimes the subject's head was enlarged out of proportion with the body, as in the statuette of *Frédéric Lemaître* (1833; Paris, Carnavalet). In cases where the body itself was the butt of mockery, because of obesity (e.g. *Luigi Lablache*, plaster, 1831; Paris, Carnavalet) or scrawniness (e.g. *Paganini*, bronze, 1832; Paris, Carnavalet), the sculptor used a more balanced overall proportion. Jean-Pierre's preoccupation with the world of art and entertainment led him to deride the already exaggerated physical traits of 'romantic genius' in such subjects as *Victor Hugo* and *Hector Berlioz* (both 1833; Paris, Carnavalet).

Jean-Pierre Dantan visited London on several occasions between 1833 and 1841 and caricatured a number of English subjects, such as *Samuel Rogers* (plaster; London, N.P.G.). At the Great Exhibition of 1851 Jean-Pierre showed a seated figure (untraced) of *Queen Victoria*, cast in zinc. His caricatures, which made his fortune and, ironically, contributed to his subjects' celebrity, were chiefly marketed through the Paris shop of the art publishers Susse Frères. His widow donated a large collection of his works, both humorous and serious, to the Musée Carnavalet in Paris.

Bibliography

Lami

H. Delloye: *Musée Dantan* (Paris, 1839)

J. Seligmann: *Figures of Fun: The Caricature Statuettes of Jean-Pierre Dantan* (London, 1957)

The Romantics to Rodin (exh. cat., ed. P. Fusco and H. Janson; Los Angeles, CA, Co. Mus. A., 1980)

A. Le Normand: *La Tradition classique et l'esprit romantique* (Rome, 1981)

PHILIP WARD-JACKSON

Dardel, Robert-Guillaume

(*b* Paris, 1749; *d* Paris, 29 July 1821). French sculptor. He was a pupil of Augustin Pajou. He was never a member of the Académie Royale and until 1791 had no access to the official Salon, exhibiting instead at the Salon de la Correspondance, Paris, from 1781 to 1787; he was also denied access to the marble provided by the Bâtiments du Roi for royal commissions, for which only Academicians were eligible, and was forced to be principally a modeller producing works in terracotta or bronze. His chief patron was Prince Louis-Joseph de Condé, and among works commissioned by the Condé family were a bust of Louis II, the *Grand Condé* (bronze, c. 1780; untraced), and a statuette of the *Grand Condé at Fribourg* (exh. Salon de la Correspondance 1782), the terracotta (1780; Chantilly, Mus. Condé) and bronze (1785; Chantilly, Mus. Condé) versions of which were made were made by the great bronze-founder Pierre Philippe Thomire. Three further commemorative statuettes in bronze are at Chantilly. They represent *Henri de La Tour d'Auvergne, Vicomte de Turenne*; *Bertrand, Chevalier Du Guesclin* (both modelled 1782, cast 1785); and *Pierre du Terrail, Seigneur de Bayard* (1788), and they were cast from Dardel's models by Thomire.

Dardel was inclined by temperament to invent complex and allegorical subjects, similar to those of contemporary history painters and unusual in the context of the Salon de la Correspondance. Such works included *Descartes Piercing the*

Shadows of Ignorance (terracotta, exh. 1782; London, Wallace), an ambitious group uneasily combining a real character and abstract allegory. Similarly, his numerous other portraits of famous Frenchmen shown at the Salon de la Correspondance (all terracotta; all untraced) were placed in context by means of allegory. The group *Aeneas Bearing Anchises* (terracotta, exh. 1787; Paris, Louvre) reveals Dardel's tendency to the severe Neo-classicism of Jean-François-Pierre Peyron and JacquesLouis David.

Although Dardel was of marginal importance under the Ancien Régime, he enjoyed the protection of David during the Revolution and occupied a number of important positions. He exhibited at the 'official' Salon from 1791. He was given a number of state commissions under the Empire (1804–15), including a marble bust of *Général Elliot* (destr.; plaster version, Versailles, Château), and took part in the sculptural decoration of the Arc de Triomphe du Carrousel, Paris. Among his last exhibited works was a terracotta group entitled *Virginius Having Killed his Daughter to Save her from Dishonour Curses the Decemvir Appius* (exh. Salon 1817, see sale cat., no. 92) first presented in 1799, which in subject and style hearkens back to the austere Neo-classicism of the 1780s.

Bibliography

Lami

G. Macon: *Les Arts dans la maison de Condé* (Paris, 1903), pp. 96–7, 119–20

C. Avery and A. Laing: *Finger Prints of the Artist: European Terracotta Sculpture from the Arthur M. Sackler Collections* (Washington, DC, 1981), pp. 192–5

P. Sorel: 'Trois sculptures de l'époque révolutionnaire: Propositions d'attributions', *Gaz. B.-A.* (Oct 1990), pp. 140–44

GUILHEM SCHERF

Daubigny [D'Aubigny]

French family of artists. Edmond-François Daubigny (*b* Paris, 1789; *d* Paris, 14 March 1843) was a pupil of Jean-Victor Bertin and painted historic landscapes and city scenes, such as the *Fountain of the Innocents* (1822; Paris, Carnavalet). From 1819 to 1839 he exhibited at the Salon in Paris, showing views principally of Paris and Naples. He visited Italy in 1833. His brother Pierre Daubigny (*b* Paris, 30 Oct 1793; *d* Paris, 15 July 1858) studied under Louis-François Aubry (1767–1851) and was a miniature painter, exhibiting from 1822 to 1855 at the Salon in Paris. Pierre's wife, Amélie Daubigny (*b* Paris, 1793; *d* Paris, 22 March 1861), also a miniature painter, collaborated with him on many works. She was a pupil of Louis-François Aubry and Jean-Pierre Granger (1779–1840) and showed at the Salon from 1831 to 1844. Edmond-François Daubigny's son (1) Charles-François Daubigny, an admirer of 17th-century Dutch painting, became one of the most important landscape painters in mid-19th century France. He was associated with the Barbizon school and was an influence on the Impressionist painters. His son (2) Karl Daubigny was a landscape painter who studied under his father and exhibited landscapes at the Salon in Paris from 1863.

(1) Charles-François Daubigny

(*b* Paris, 15 Feb 1817; *d* Paris, 19 Feb 1878). Painter and printmaker. He studied under his father Edmond-François Daubigny and in 1831–2 also trained with Jacques-Raymond Brascassat. At an early age he copied works by Ruisdael and Poussin in the Louvre, while also pursuing an apprenticeship as an engraver. At this time he drew and painted mainly at Saint-Cloud and Clamart, near Paris, and in the Forest of Fontainebleau (1834–5). In 1835 he visited several Italian cities and towns, including Rome, Frascati, Tivoli, Florence, Pisa and Genoa. He returned to Paris in 1836 and worked for François-Marius Granet in the painting restoration department of the Louvre. In 1840 he spent several months drawing from life in Paul Delaroche's studio, although his early works were much more heavily influenced by 17th-century Dutch painters, whom he copied in the Louvre, than by Delaroche's work.

In 1838 Daubigny first exhibited at the Salon in Paris, with an etching, *View of Notre-Dame-de-Paris and the Ile Saint-Louis*, and he continued to exhibit regularly there until 1868. He travelled a great deal, visiting Etretat and Dieppe on the coast

of Normandy in 1842. From 1843 he spent much time in the Forest of Fontainebleau, sending his first painting of a Fontainebleau scene, *The Stream at Valmondois* (1844; priv. col.), to the Salon of 1844. In 1846 he painted with Théodore Rousseau and Jules Dupré at Valmondois and L'Isle-Adam (both Val-d'Oise), two of his preferred areas. The following year he travelled through Burgundy and also visited the Morvan Mountains in central France, where he painted the *Valley of the River Cousin* (1847; Paris, Louvre). In 1849 he was in Dauphiné in south-west France and the area around Lyon, painting at Crémieu and Optevoz and meeting Auguste Ravier and Corot, and in 1850 he worked at Auvers-sur-Oise and visited the Pyrénées. Two years later he and Corot—by now his close friend—spent considerable time painting in the Dauphiné and in Switzerland. Daubigny also painted with Armand Leleux at Dardagny, near Geneva, in 1853, and on the banks of the River Oise in 1856. He spent the next year with Jules Breton at Marlotte and made his first trip on the Oise on Breton's boat *Le Botin*, which had been converted into a studio and permanent home. From this time Daubigny untiringly explored the Seine, the Marne and the Oise by boat, mooring wherever he would find a scenic spot and ascertaining the best viewpoint from which to paint his chosen motif. His method of working *en plein air* was later to be greatly significant to Monet.

From the 1850s Daubigny's financial situation improved, and he began to achieve success, eventually becoming well known. Critics praised two of his paintings submitted to the Salon of 1852—the *Harvest* (Paris, Louvre; see fig. 13) and *View of the Banks of the Seine from Bezon* (Paris, Mus. d'Orsay)—for their luminous colours, fluid atmosphere and simple motifs, although they reproached him for what they saw as carelessness of execution. He sold several works to the French government, among them the *Pond of Gylieu near Optevoz, Isère* (1853; Cincinnati, OH, A. Mus.), *Lock in the Valley of the Optevoz* (1855; Rouen, Mus. B.-A.) and the *Valley of the Optevoz* (1857; Paris, Louvre). In 1859 he was commissioned to paint decorative scenes (the *Stags*, the *Herons*, the *Palace*, the *Garden of Tuileries*) for the entrance hall and stairway of the Salons du Ministère d'Etat in the Louvre. He also produced engravings after

13. Charles-François Daubigny: *Harvest*, exh. Salon 1852 (Paris, Musée du Louvre)

works by such artists as Ruisdael and Claude for the Louvre's Department of Chalcography and from 1853 executed numerous prints in the technique of *cliché-verre*. In 1860 he settled in Auvers-sur-Oise but also travelled extensively in other parts of France and abroad (Brittany in 1867; London in 1865 and 1870; Spain in 1868 and 1869; the Netherlands in 1871).

Daubigny was one of the first landscape painters to take an interest in the changing and fleeting aspects of nature, depicting them with a light and rapid brushstroke; this was a highly novel technique that disconcerted such critics as Théophile Gautier, who in 1861 wrote that 'it is really a pity that this landscape artist, having so true, so apt and so natural a feeling for his subject, should content himself with an "impression" and should neglect detail to such an extent. His pictures are no more than sketches barely begun' (Gauthier, p. 119). Nevertheless, four years later Gautier was to acknowledge that 'the impression obtained by these most perfunctory means is nonetheless great and profound for all that'. In 1865 Daubigny painted *Sunrise on the Banks of the River Oise*, which is typical of his work in both technique and subject-matter and is one of a considerable number of variations on the theme executed between 1860 and 1875 (e.g. *Evening on the Oise*, 1863; Cincinnati, OH, Taft Mus.; *Sunset on the Oise*, 1865; Paris, Louvre). These paintings are good examples of his ability to capture the essence of nature purely in its 'sincerity' without resorting to artifice or metaphysics. His numerous pupils included Eugène Boudin and Johan Barthold Jongkind, both of whom he met in Honfleur in 1864, his son (2) Karl Daubigny, Antoine Chintreuil, Eugène La Vieille (1820–89) and Jean Charles Cazin. In 1870 he took refuge in London during the Franco-Prussian War and the following year introduced Camille Pissarro and Monet to his art dealer Paul Durand-Ruel, then in England. In 1871 Daubigny met Cézanne at Auvers. He was an important figure in the development of a naturalistic type of landscape painting, bridging the gap between Romantic feeling and the more objective work of the Impressionists.

Writings

E. Moreau-Nélaton: *Daubigny raconté par lui-même* (Paris, 1950)

Bibliography

T. Gauthier: *Abécédaire du Salon de 1861* (Paris, 1861), p. 119

F. Henriet: *C. Daubigny et son oeuvre gravé* (Paris, 1875)

J. Claretie: 'Daubigny', *Première série de peintres et sculpteurs contemporains: Artistes décédés de 1870 à 1880* (Paris, 1881–4), pp. 265–88

L. Delteil: *Daubigny*, xiii of *Le Peintre-graveur illustré* (Paris, 1906–26/R New York, 1969)

J. Laran: *Daubigny* (Paris, 1913)

M. Fidell-Beaufort: *The Graphic Art of Charles-François Daubigny*, 2 vols (diss., New York U., Inst. F.A., 1974)

J. Bailly-Herzberg and M. Fidell-Beaufort: *Daubigny: La Vie et l'oeuvre* (Paris, 1975)

P. Miquel: *L'Ecole de la nature*, iii of *Le Paysage au XIXe siècle, 1814–1874* (Maurs-la-Jolie, 1975), pp. 664–705

LAURENCE PAUCHET-WARLOP

(2) Karl [Charles-Pierre] Daubigny

(*b* Paris, 9 June 1846; *d* Auvers-sur-Oise, 25 May 1886). Painter and printmaker, son of (1) Charles-François Daubigny. He studied with his father and, like him, specialized in landscape painting. He made his début at the Salon in 1863 and continued to exhibit there until the year of his death, winning medals in 1868 and 1874. His earliest works are obviously influenced by his father, but he soon came to develop a more personal and sombre style. The forest of Fontainebleau or the coastline and landscape of Brittany and Normandy provided most of his subjects (e.g. the *Return of the Fishing Fleet to Trouville*, 1872; Aix-en-Provence, Mus. Granet, and the *Banks of the Seine*, 1880; Brest, Mus. Mun.). He also produced a number of landscape etchings, including several after his father's paintings, two of which appeared in Frédéric Henriet's *C. Daubigny et son oeuvre gravé* (Paris, 1875). Despite his considerable ability, Karl's reputation has been rather eclipsed by that of his father, though he was nonetheless one of the most pleasing French landscape artists of the second half of the 19th century.

Bibliography

DBF

E. Bellier and L. Auvray: *Dictionnaire général des artistes de l'école française*, 3 vols (Paris, 1868–85)

☐

Daudet, Robert

(*b* Lyon, 25 Oct 1737; *d* Paris, 2 June 1824). French engraver and print-seller. He belonged to a family of Lyonnais engravers that included his father, Jean-Louis Daudet (1695–1756), an engraver of illustrations and print-seller, and another Robert Daudet, probably his uncle (*fl* 1728–33). He may have attended the classes of Jean-Charles Frontier (1701–63) at the Ecole Gratuite de Dessin in Lyon (founded in 1757). In 1766 he is documented as entering the workshop of Jean-Georges Wille. There he engraved plates for Wille and for Jacques-Philippe Lebas and Pierre-François Basan. He was also active as a dealer. His correspondence with the Lyonnais artist Jean-Jacques de Boissieu reveals that he saw to the sale of the latter's drawings and prints in Paris.

Daudet's engraved work amounts to 82 pieces and consists exclusively of reproductive prints, often after a preliminary etching done by another printmaker. He specialized in reproducing the work of such fashionable 17th-century Dutch artists as Jan Asselijn, Nicolaes Berchem, Karel Dujardin and Adriaen van Ostade, as well as of contemporary painters working in a Dutch manner. He made a number of prints after works by the landscape and sea painter Joseph Vernet. His engravings contributed to the development of private collections, such as those of Jean-Denis II Lempereur and Etienne-François, Duc de Choiseul, and to the publication of the stock of the dealer Jean-Baptiste-Pierre Le Brun: *Galerie des peintres flamands, allemands et hollandais de M. Le Brun*, published by Pierre-François Basan and Etienne-Léon Poignant (1777–91). After the French Revolution Daudet engraved illustrations for travel books and archaeological publications, providing two plates for Louis-François Cassas's *Voyage pittoresque de Syrie* (1798) and several plates after Edme-François Jomard and Dutertre

for the *Description de l'Egypte* (1804). He collaborated on *Le Musée français* by Simon-Célestin Croze-Magnan (1750–1818), Ennio Quirino Visconti and Toussaint-Bernard Eméric-David, engraving two plates after Giovanni Paolo Panini. He also engraved plates for the second volume of Count Alexandre-Louis-Joseph de Laborde's *Voyage d'Espagne* (1812) and finally for the *Monuments anciens et modernes de l'Indouistan* published by Louis-Mathieu Langles in 1821.

Bibliography

M. Roux: *Inventaire du fonds français: Graveurs du dix-huitième siècle*, Paris, Bib. N., Dépt Est. cat., vi (Paris, 1949), pp. 47–62

M. F. Pérez: 'Quelques lettres concernant Jean-Jacques de Boissieu (1736–1810)', *Archvs A. Fr.*, xxviii (1986), pp. 115–32

MARIE-FÉLICIE PÉREZ

Daumier, Honoré

(*b* Marseille, 26 Feb 1808; *d* Valmondois, 10 Feb 1879). French graphic artist, painter and sculptor.

1. Training and early illustrations, before 1860.

Son of a Marseille glazier, frame-maker and occasional picture restorer, Daumier joined his father in Paris in 1816. He became a bailiff's errand boy and was then employed by a bookseller, but his real enthusiasm was reserved for drawing and politics. He studied drawing with Alexandre Lenoir and at the Académie Suisse and then worked as assistant to the lithographer Béliard. Having mastered the techniques of lithography, he published his first plate in the satirical weekly *La Silhouette* in 1829.

Daumier was 22 when the revolution of July 1830 gave the throne to Louis-Philippe as constitutional monarch and power to the French middle-class business community. On 4 November 1830 the print publisher Aubert and his son-in-law Charles Philipon launched the violently anti-monarchist weekly *La Caricature*, followed on 1 December 1832 by *Le Charivari*, the first daily paper to be illustrated with lithographs. In his association with these newspapers and in the

company of Republican artists, Daumier found a favourable milieu for developing his vigorous style and progressive ideas.

Less whimsical than Grandville, less elegant than Gavarni and less brutal than Traviès, Daumier distinguished himself by a robust but controlled drawing style, with strong contrasts of volume that were nonetheless accurate in their composition, modelling and chiaroscuro, even when used in caricature. This feature of his style gained him the support of the new petit bourgeois public, who could appreciate a caricature that was neither vapid nor crude and behind the exaggerated outlines of which could be discerned traditional academic values. Balzac even compared Daumier with Michelangelo. Daumier's attacks on Louis-Philippe hit their mark so successfully that the monarch had to reintroduce censorship and condemned Daumier to six months in prison (31 Aug 1832 to 14 Feb 1833) for his lithograph *Gargantua*, published in *La Caricature* (15 Dec 1831). In order to pay the fines imposed on his

newspapers, in 1834 Philipon launched a large-format supplement that was even more violent in tone, the *Association mensuelle*. In its pages Daumier published lithographs that have all the power of paintings and are now considered among his masterpieces: *Le Ventre législatif* (see fig. 14), *Ne vous y frottez pas!*, *Enfoncé Lafayette* and *Rue Transnonain, le 15 avril 1834* (see col. pl. V). In the last, Daumier depicted the squalid aftermath of the massacre of working-class opponents of the government. Daumier's undemonstrative title and unheroicized image of corpses sprawled among overturned bedroom furniture lent force to his denunciation of casual State violence.

On 29 August 1835 the government once more prohibited political caricature, and, in order to survive, *Le Charivari* was forced to restrict itself to subjects from everyday life, including street scenes, the theatre and portraits. It published nearly 4000 of these by Daumier. Various series of humorous scenes, all composed with great care, gave a vivid and critical panorama of France's

14. Honoré Daumier: *Le Ventre législatif*, 1834 (Paris, Bibliothèque Nationale)

social classes in transition: businessmen (personified by the flattering swindler Robert Macaire), the professional classes (*Les Gens de justice*, 1845–8), traders and the bourgeois in the country, at the theatre and on public transport (*Les Bons Bourgeois*, 1847–9). His work was not only the essential expression of the new taste for an art that had previously been considered trivial but also reflected developments in French society at the time of its greatest economic expansion (between 1830 and 1870). He was for this reason considered by several progressive critics— Théodore de Banville (1823–91) as early as 1852, Baudelaire in 1857 and Champfleury—as an artist worthy of comparison with Hogarth and Goya.

Besides his lithographs Daumier also made numerous drawings that were reproduced by wood-engravers as illustrations. In this way he participated in some of the great French publishing enterprises of the Romantic era: the series of *Physiologies* (1841), *Les Français peints par eux-mêmes* from the publisher Curmer (1841), *La Némésis médicale illustrée* (1841) and the most important illustrated magazines then in circulation.

2. Sculpture

Daumier was one of the first French artists to experiment with caricature sculpture. In 1832 he began to produce a series of small grotesque busts of parliamentarians, for instance *François-Pierre-Guillaume Guizot* and *Alexandre-Simon Pataille* (both Paris, Mus. d'Orsay), which were kept in Aubert's printshop. They were originally modelled in terracotta and were cast in bronze only after his death. Daumier succeeded in giving each of these works (generally no more than 200 mm high) individuality and considerable satiric force by gross exaggeration of his victim's most prominent features and characteristic expression. Among other important sculptures (first modelled in clay, then transferred to plaster and subsequently cast in bronze) were the bas-relief *The Emigrants* (c. 1848–50; plaster, Paris, Mus. d'Orsay), in which Daumier depicted a forlorn procession of unindividualized figures with grandeur and compassion, and the statuette *Ratapoil* (c. 1851; plaster,

Buffalo, Albright–Knox A.G.), his archetype of the swaggering and corrupt thugs who had brought Louis-Napoléon to power. The dating and priority of the numerous casts of Daumier's sculpture are difficult to establish and remain controversial. Many of Daumier's prints comment sympathetically on the difficulties of the sculptor in mid-19th-century France (e.g. *Sad Appearance of Sculpture Placed in the Midst of Painting*, 1857).

3. Paintings

Although he never sought to make a career from painting and was probably self-taught, Daumier painted for his own pleasure from 1834. From 1847 these isolated attempts gave way to a solid body of work that began with copies of Millet and Rubens and interpretations in oil of details selected from the subjects he habitually treated in lithography, notably genre scenes, bathers, lawyers and so on (e.g. *Three Lawyers in Conversation*; Washington, DC, Phillips Col.). In 1848, following the creation of the Second Republic, an open competition was held among artists to represent it in allegorical form. Daumier produced an oil sketch showing two children being suckled by a muscular female embodiment of the Republic (Paris, Mus. d'Orsay), which was highly praised by Champfleury and Gautier. His design was shortlisted, and he was commissioned to produce a finished painting, but he was unable to complete it. However, he did execute some State commissions for religious paintings, *Mary Magdalene in the Desert* (priv. col., see Maison, 1968, i, pl. 171) and *We Want Barabbas!* (c. 1850; Essen, Mus. Flkwang), thanks to his friend Charles Blanc, who became head of the Bureau des Beaux-Arts in 1848. He exhibited at the Salon of 1849 the *Miller, his Son and the Ass* (Glasgow, A.G. & Mus.), in 1850 *Two Nymphs Pursued by Satyrs* (Montreal, Mus. F.A.) and in 1851 *Don Quixote Going to the Wedding of Gamaches* (Boston, priv. col., see Maison, 1968, i, pl. 147). Apart from one further exhibit in 1861 and the exhibition organized by his friends to help him financially in 1878, shortly before he died, Daumier's paintings were unknown to the public and remained in his studio until his death.

Daumier's paintings, more than 300 oils and numerous watercolours, gained widespread critical recognition after his death, for they reveal qualities similar to those that characterize his lithographs. The brushwork is usually rapid and vigorous, and this, together with the sense of movement and light, ranks them with the finest paintings produced under the Second Empire. He sometimes reverted to observations of daily life (e.g. *Third-class Railway Carriage*, 1864; Ottawa, N.G.; Baltimore, MD, Mus. A.) but frequently drew his subject-matter from mythology (the *Drunkenness of Silenus*, 1863; Calais, Mus. B.-A.) and literature (numerous works featuring Don Quixote and Sancho Panza).

Daumier did not prime his canvases; they are often unfinished and invariably retain a sketch-like appearance. This lack of both preliminary precautions and finish gives a strong effect of spontaneity but makes the paintings fragile and difficult to conserve. Their dating is often uncertain, and when they began to become popular they were extensively 'finished' by restorers and forgers. His usual signature HD has also frequently been forged, often on unsigned genuine works.

4. Late illustrations, 1860 and after

Abandoned by *Le Charivari* in March 1860, as Philipon claimed (until December 1863) that readers had tired of him, Daumier was free to devote himself to painting, despite his lack of recognition in this field. During the authoritarian phase of the Second Empire in the 1850s satire had lost nearly all its outlets, and *Le Charivari* itself had become feeble. Nevertheless, Daumier recovered his original political and graphic energy in a dozen plates he composed for *Le Boulevard*, a newspaper founded in 1862 in opposition to the regime by his colleague Etienne Carjat. It contained such famous lithographs as *Madeleine-Bastille*, *Le Nouveau Paris* and *Nadar élevant la photographie à la hauteur de l'art*. The *Boulevard* experiment ended in 1863. However, Napoleon III's administration became more liberal, allowing and even encouraging caricature in matters of foreign policy. Daumier tended to treat these subjects with a certain loftiness, in a style that was both more sweeping and more elliptical, making great use of allegory and symbolism. Despite the technical restrictions imposed on the lithographers of *Le Charivari* during the 1870s by the use of *gillotage* (whereby the lithograph was turned into a relief plate to facilitate printing), Daumier's art so gained in luminosity and synthetic power that through the work of his late period he came to be seen as the forerunner of Impressionism, and in particular of Cézanne. Daumier's drawing style in pen and ink also became increasingly free, a mazy line no longer modelling form in any conventional sense, but taking on an expressive form of its own.

The last of Daumier's plates to appear in *Le Charivari* dates from 1875. By 1878 he was nearly blind and living in obscurity at Valmondois, to the north of Paris, in a small house bought for him by his friend Corot. His friends organized an exhibition of his work at Durand-Ruel's gallery, but despite Victor Hugo's acceptance of the honorary presidency and a visit by the eminent Republican Léon Gambetta, it was a complete failure, not even covering its costs.

5. Posthumous reputation

Daumier's funeral, on 14 February 1879, coincided with the consolidation of power by the Republican party, which he had been among the first to support and whose cause he had so enthusiastically portrayed. His Republican artist friends and a number of politicians reawakened interest in his work through a further campaign of demonstrations, articles, speeches and exhibitions, and brought his body back to Père Lachaise Cemetery, Paris. At the same time critics sought to raise the status of the popular art forms of lithography, caricature and newspaper cartoons. As a result, a violent debate began on Daumier's merits as an artist, which, in France at least, has never been completely resolved: the centenary of his death in 1979 was marked by an exhibition in Marseille rather than Paris. The quality of Daumier's work has more readily been recognized and celebrated in Germany and the USA, where the main private collections are located and where several major exhibitions have been held.

Bibliography

The Studio (1904) [issue ded. to Daumier and Gavarni]

L. Delteil: *Le Peintre-graveur illustré*, xx-/xxix (Paris, 1925–30/*R* New York, 1969)

E. Bouvy: *Daumier: L'Oeuvre gravé du maître* (Paris, 1933) [wood-engrs and chalk pl. prts]

J. Adhémar: *Honoré Daumier* (Paris, 1954)

Honoré Daumier und sein Kreis (exh. cat., Hamburg, Mus. Kst & Gew., 1962)

O. W. Larkin: *Daumier: Man of his Time* (Boston, 1966)

K. E. Maison: *Honoré Daumier: Catalogue Raisonné of the Paintings, Watercolours and Drawings*, 2 vols (London, 1968) [supplemented by 'Some Additions to Daumier's Oeuvre', *Burl. Mag.*, cxii (1970), pp. 623–4]

H. P. Vincent: *Daumier and his World* (Evanston, 1968)

Daumier Sculpture (exh. cat. by J. L. Wasserman, Cambridge, MA, Fogg, 1969)

A. H. Mayor: 'Daumier', *Prt Colr Newslett.* (March–April 1970), pp. 1–4

L. Barzini and G. Mandel: *Opera pittorica completa di Daumier* (Milan, 1971)

Daumier: Verlaggever van zijn tijd (exh. cat. by J. R. Kist, The Hague, Gemeentemus., 1971)

Honoré Daumier: Druckgraphik aus der Kunsthalle Bielefeld und Privatbesitz (exh. cat. by H. G. Gmelin and L. Fabricius-Josic, Bielefeld, Städt. Ksthalle, 1971)

Honoré Daumier: Gemälde, Zeichnungen, Lithographien, Skulpturen (exh. cat., ed. F. Lachenall; Ingelheim, Int. Tage, Villa Schneider, 1971)

D. Burnell: 'Honoré Daumier and the Composition of Humour', *Prt Colr Newslett.* (Nov–Dec 1973), pp. 102–5

Honoré Daumier . . . Bildwitz und Zeitkritik (exh. cat. by G. Langemeyer, Münster, Westfäl. Kstver.; Bonn, Rhein. Landesmus.; Graz, Neue Gal.; 1978–9)

R. Passeron: *Daumier: Témoin de son temps* (Paris, 1979; Eng. trans., New York, 1981)

Daumier aujourd'hui: 300 lithographies et bois gravés de la collection Louis Provost (exh. cat. by J. Rollin and B. Tabah, Saint-Denis, Mus. A. & Hist., 1979)

Daumier et ses amis républicains (exh. cat., ed. M. Latour; Marseille, Mus. Cantini, 1979)

Daumier in Retrospect, 1808–1879 (exh. cat., Los Angeles, CA, Co. Mus. A., 1979)

Honoré Daumier, 1808–1879 (exh. cat. by J. R. Kist, Washington, DC, N.G.A., 1979)

Honoré Daumier et les dessins de presse (exh. cat., Grenoble, Maison Cult., 1979)

Honoré Daumier: Kunst und Karikatur (exh. cat., ed. J. Schultze and A. Winther; Bremen, Ksthalle, 1979)

P. L. Senna: 'Daumier's Lithographic Works', *Prt Colr/Conoscitore Stampe*, 45 (1980), pp. 2–31

'Honoré Daumier: A Centenery Tribute', *Prt Rev.*, 11 (1980), pp. 5–144

Honoré Daumier, 1808–1879 (Los Angeles, 1982)

J. L. Wasserman, J. de Caso and J. Adhémar: 'Hypothèses sur les sculptures de Daumier', *Gaz. B.-A.*, n.s. 6, c (1983), pp. 57–80

Die Rückkehr der Barbaren: Europäer und 'Wilde' in der Karikatur Honoré Daumiers (exh. cat., ed. A. Stoll; Bielefeld, Städt. Ksthalle; Hannover, Wilhelm-Busch-Mus.; Freiburg, Augustinmus.; Mülheim an der Ruhr, Städt. Mus.; 1985–6)

M. Melot: 'Daumier and Art History: Aesthetic Judgement/Political Judgement', *Oxford A. J.*, xi/1 (1988), pp. 3–24

The Charged Image: French Lithographic Caricature, 1816–1848 (exh. cat. by B. Farwell, Santa Barbara, CA, Mus. A., 1989)

B. Laughton: *The Drawings of Daumier and Millet* (New Haven and London, 1991)

Daumier Drawings (exh. cat., ed. C. Ives, M. Stuffman and C. Sonnabend; New York, Met., 1992)

MICHEL MELOT

Dauzats, Adrien

(*b* Bordeaux, 16 July 1804; *d* Paris, 18 Feb 1868). French painter, illustrator and writer. His early training was as a theatrical scene painter and a designer of lithographic illustrations. In Bordeaux he studied with Pierre Lacour (ii) (1778–1859) and worked with Thomas Olivier (1772–1839), chief scene designer at the Grand-Théâtre. He subsequently studied in Paris in the studio of the landscape and history painter Julien-Michel Gué (1789–1843) and worked for the decorators of the Théâtre Italien.

From 1827 Dauzats provided lithographic designs for Isidore-Justin-Séverin Taylor's series *Voyages pittoresques et romantiques dans l'ancienne France* (1820–78). He travelled in the French provinces, particularly Champagne, Dauphiné and Languedoc, often sketching the medieval monuments that had come into vogue during the Romantic period.

Dauzats also collaborated on lithographs for many other publications, including Taylor's *Voyage en Orient*. For this last project Dauzats travelled to Egypt, Syria, Palestine and Turkey in 1830,

a trip that he described in his book *Quinze jours au Sinaï* (written with Alexandre Dumas *père*) and that ultimately inspired his best-known painting, the *Monastery of St Catherine, Mt Sinai* (exh. Salon 1845; Paris, Louvre). Its medieval subject and dramatic setting clearly show his training as a stage designer; despite his reputation as a brilliant colourist it has a sober and restricted tonal range.

A specialist in architectural views, Dauzats travelled widely in Spain, Portugal, Germany and the Netherlands. Perhaps his most memorable journey, however, was in 1839, when he accompanied the military expedition to southern Algeria led by Ferdinand-Philippe, Duc d'Orléans. Dauzats recorded the assault on the Gates of Iron, a formidable natural fortress in the Djurdjura mountains, in his lithographic illustrations for the *Journal de l'expédition des Portes de Fer* compiled by the poet Charles Nodier in 1844. His series of watercolour studies of the Gates of Iron (Chantilly, Mus. Condé), on which he based his painting the *Gates of Iron* (1853; Lille, Mus. B.-A.), captures the sombre and forbidding atmosphere of the place.

Dauzats exhibited at the Salon from 1831 to 1867, winning numerous medals. He was awarded the Légion d'honneur as early as 1837. Though most of the views he depicted were derived from his own observations, he did accept a commission from a Bordeaux collector around 1865 for a series of four paintings from the *Thousand and One Nights*. Even in an imaginary scene such as his *Sindbad the Sailor* (1865; Bordeaux, Mus. B.-A.), however, the architecture, based on his recollections of Granada and Córdoba, completely dominates the human figure. The Orientalist architectural scenes in which Dauzats specialized, though often encountered in the work of English topographical artists such as David Roberts, were relatively rare in France.

Delacroix admired Dauzats's abilities as an architectural painter and consulted him for advice on at least one occasion: Dauzats in turn exercised his influence at court to help Delacroix win state decorative commissions. In his preference for depicting remote and inhospitable places and his taste for picturesque medieval subjects, Dauzats was fully in accord with the aesthetics of Romantic art. He had an unfailing instinct for selecting exotic and memorable views. Unlike his contemporary Prosper Marilhat, however, his need to record precisely all the details of a scene sometimes prevented him from capturing the subject in its most colourful and dramatic aspect.

Writings

with A. Dumas *père*: *Quinze jours au Sinaï* (Paris, 1841)

Bibliography

H. Jouin: *Adrien Dauzats: Peintre et écrivain* (Paris, 1896)

P. Guinard: *Dauzats et Blanchard: Peintres de l'Espagne romantique* (Paris, 1967)

Orientalism: The Near East in French Painting, 1800–1880 (exh. cat., U. Rochester, NY, Mem. A.G., 1982), pp. 48–9

The Orientalists: Delacroix to Matisse (exh. cat., ed. M. A. Stevens; London, RA; Washington, DC, N.G.A.; 1984), p. 123

DONALD A. ROSENTHAL

David, Jacques-Louis

(*b* Paris, 30 Aug 1748; *d* Brussels, 29 Dec 1825). French painter and draughtsman. He was the most prominent and influential painter of the Neo-classical movement in France. In the 1780s he created a style of austere and ethical painting that perfectly captured the moral climate of the last years of the *ancien régime*. Later, as an active revolutionary, he put his art at the service of the new French Republic and for a time was virtual dictator of the arts. He was imprisoned after the fall from power of Maximilien de Robespierre but on his release became captivated by the personality of Napoleon I and developed an Empire style in which warm Venetian colour played a major role. Following the restoration of the Bourbon monarchy in 1816, David went into exile in Brussels, where he continued to paint but was regarded as something of an anachronism. He had a huge number of pupils, and his influence was felt (both positively and negatively) by the majority of French 19th-century painters. He was a revolutionary artist in both a technical and a political sense. His compositional innovations effected a

complete rupture with Rococo fantasy; he is considered the greatest single figure in European painting between the late Rococo and the Romantic era.

I. LIFE AND WORK

1. Training and early career, to 1789. 2. Painting and political activity during the French Revolution, 1789-95. 3. Work during the Directory and the Empire, 1795-1814. 4. Late works and exile in Brussels, 1814-25.

1. Training and early career, to 1789

David was born into a well-to-do family of Parisian tradesmen. His mother's family included masons and architects, and they played an increasing role in David's education and upbringing following his father's death in a duel in 1757. At first he attempted to become a pupil of François Boucher, his grandmother's cousin. The aged Boucher, however, was disinclined to take on pupils, and instead David entered the studio of Joseph-Marie Vien. He also enrolled at the school of the Académie Royale in 1766. In 1770 he entered the Prix de Rome competition for the first time but failed to reach the final. A year later he won second prize with his Boucher-inspired *Combat of Mars and Minerva* (Paris, Louvre). Claiming that he had deserved first prize and had been downgraded at Vien's insistence, he also harboured a grudge against the first prize winner, Joseph-Benoît Suvée (whom he later described as 'ignorant and horrible'). The defeat seems to have been the start of his grievances against the Académie. In 1772 he was again earmarked for one of the two prizes, along with Pierre-Charles Jombert (1748/9–after 1777). David's suspicions concerning the conduct of the Prix were confirmed when a conspiracy caused Academicians to change votes. The first prize went not to David but to the mediocre Anicet-Charles Lemonnier (1743–1824). David also contributed to his own downfall by painting over his first attempt—the set subject was *Apollo and Diana Killing the Children of Niobe*—before the old paint was dry. Consequently the surface blackened and deteriorated, as can be seen clearly in his picture (Paris, priv. col., see 1981 exh. cat., p. 30, fig. 3). As a result of this judgement

David made a half-hearted suicide attempt but was dissuaded from it by Gabriel-François Doyen. In 1773 David was beaten again, but this time by a most accomplished rival, Pierre Peyron. David's entry, the *Death of Seneca* (Paris, Petit Pal.), attempts to depict the stoic resolve of the philosopher, but the hectic Baroque composition militates against the gravity of the subject. He finally won the Prix de Rome in 1774 with *Erasistratus Discovers the Cause of the Illness of Antiochus* (Paris, Ecole N. Sup. B.-A.), in which he adopted a friezelike grouping of the protagonists and concentrated on narrative clarity.

David left Paris for Rome in October 1775 with Vien, who had just been appointed Director of the Académie de France in Rome. He apparently felt that the eternal city had little to teach him, declaring 'the Antique will not seduce me, it lacks animation, it does not move'. In Italy David drew dutifully from the Antique, but he was not an obsessive antiquarian. Instead he studied the art of 17th-century painters, including Nicolas Poussin, Caravaggio and his followers, the Carracci family and Guido Reni. He then set about creating a rational synthesis of the real and the ideal that was free from the artificialities of the Rococo style. Life drawing and past masters played a crucial role in David's stylistic development. Yet such changes were accomplished only gradually. His early Roman works, such as the *Funeral of Patroclus* (c. 1778; Dublin, N.G.), are still crowded with figures and show little or no change from his Parisian works. However, in his first independent commission, *St Roch Interceding for the Plague-stricken* (Marseille, Mus. B.-A.), David revealed a desire for grandeur, simplicity and clarity that signalled future directions.

David left Rome in July 1780 and returned to Paris with the intention of becoming an associate member of the Académie Royale. The following year he produced as his *morceau d'agrégation* a painting of *Belisarius Receiving Alms* (Lille, Mus. B.-A.). The Belisarius story was highly topical—Jean-François Marmontel had published his historical romance *Bélisaire* in 1767, and François-André Vincent and Peyron had painted the story in 1776 (Montpellier, Mus. Fabre) and 1779 (Toulouse, Mus.

Augustins) respectively. For his version David turned to a format that was striking in its directness and simplicity. A small cast of characters is set solidly against an architectural background. Clear, unequivocal gestures are made, and subdued colours are used. While David's *Belisarius* is often hailed as the first masterpiece of Neo-classicism in France, it is perhaps more accurate to refer to neo-Poussinism, as Poussinesque references are obvious and undisguised.

At this time David started to take on pupils, remaining an influential teacher throughout his life. He operated a separate studio for teaching but also used the more able students as assistants on replicas and large-scale history paintings. The first generation of his very talented pupils included Jean-Germain Drouais, François-Xavier Fabre, Jean-

François Garneray, Philippe-Auguste Hennequin and Jean-Baptiste-Joseph Wicar. In 1783 David was received (*reçu*) as a full Academician with *Andromache Mourning Hector* (exh. Salon 1783; Paris, Ecole N. Sup. B.-A., on dep. Paris, Louvre). This is David at his most severe and drab, although some contemporary critics felt that there was too little restraint in Andromache's grieving.

David's Neo-classicism found its clearest expression in 1784 with the monumental *Oath of the Horatii* (exh. Salon 1785; Paris, Louvre; see fig. 15). To undertake this work, a commission from the Direction des Bâtiments du Roi, David felt it necessary to return to Rome, where he spent October 1784 to August 1785. In the *Horatii* he arrived at an artistic solution whereby stoical content and stylistic gravity were perfectly harmonized. The

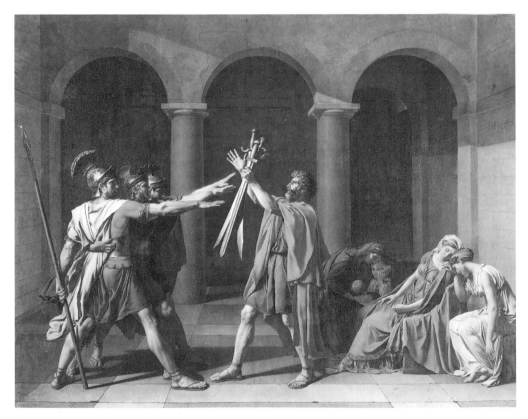

15. Jacques-Louis David: *Oath of the Horatii*, exh. Salon 1785 (Paris, Musée du Louvre)

Horatii theme had been suggested to him as early as 1780. In depicting the three Horatii swearing allegiance to their father (a scene not mentioned in any of the sources David would have consulted for the story, e.g. Livy, Plutarch, Corneille) he underlined the central theme of the sacrifice of the individual for the good of the state. Albert Boime (see 'David et la franc maçonnerie' in *David contre David*) has established that David was a freemason, and this possibly influenced his choice of an oath-taking ritual. David was a freemason, and the depiction of an oath might have been inspired by the rituals of the masonic lodge. A number of historians, notably Crow (1985), have identified an element of pre-Revolutionary radicalism in the painting. Although it was an overwhelming success, bringing David to a position of stylistic dominance in France that eclipsed such rivals as Vincent, Peyron and Suvée, many conservative critics were disquieted by it and wrote that it would be a bad example for young artists to follow. In its simplifications and dissonances of composition it is a profoundly anti-academic work and clear evidence of David's antagonism towards the Académie.

At the following two Salons David continued to exhibit his austere brand of Neo-classicism with the *Death of Socrates* (1787; New York, Met.) and the *Lictors Bringing Brutus the Bodies of his Sons* (1789; Paris, Louvre; see col. pl. VI). The former, although not a royal commission, nevertheless focuses on the moral rectitude of Socrates, who drinks the hemlock without ceasing the flow of his improving words. A note of hysteria is introduced by the reactions of Socrates' disciples (passion is rarely absent from David's work). *Brutus* was painted for Louis XVI and exhibited shortly after the storming of the Bastille. Due to the Republican nature of its theme—Brutus rid Rome of Tarquin, the last of the kings of Rome— the painting later acquired a political significance that David presumably did not originally intend. David invites the viewer to judge Brutus either as a hero, for his devotion to Rome, or as a monster, for executing his own sons.

It would, however, be a mistake to consider David in the 1780s as simply a cold and clinical classicist. He was also interested in mythology and portraiture: his *Courtship of Paris and Helen* (1788; Paris, Louvre) is a complete contrast to the morally elevating history paintings. It has an exquisite refinement of colour, an elegant idealization of bodies and a degree of archaeological accuracy that are absent from the *Horatii*, *Socrates* and *Brutus*. In addition, portraiture played a significant, if minor, part in David's career up to and including the Revolution. Numerous early family portraits exist, for example that of his aunt *Mme Marie-Josèphe Buron* (1769; Chicago, IL, A. Inst.), an animated work reminiscent of the portraits of Joseph-Siffred Duplessis. Then in 1781 David painted the splendid equestrian portrait of the Polish nobleman *Count Stanisław Potocki* (Warsaw, N. Mus.), which reveals debts to the Baroque tradition of Peter Paul Rubens and Anthony van Dyck. David's most striking pre-Revolutionary portrait is the double full-length of *Antoine-Laurent de Lavoisier and his Wife Marie-Anne Pierette* (1788; New York, Met.). This shows the eminent chemist, seated and surrounded by his experimental apparatus, with his wife leaning, muselike, on his shoulder. David could have made a handsome living painting portraits alone but sought the fame and glory that history painting brought.

2. Painting and political activity during the French Revolution, 1789–95

Assessments of David as a rabid regicide who used his art as a political weapon do not take adequate account of the complexity of his political career. After 1789 he took part in the attacks against the privileges of the officers of the Académie Royale. His anti-academic feelings were also fuelled by the Académie's refusal to grant posthumous membership to Drouais, his favourite pupil, who had died in 1788. The dissidents eventually prevailed, and the Académie was abolished on 8 August 1793. It was replaced in 1795 by the Institut de France, of which David was an inaugural member. He was not directly involved in politics until September 1790, when he joined the Revolutionary Jacobin Club. By this time he had been working for about six months on his first Revolutionary picture, the

Oath of the Tennis Court (Paris, Louvre). David had originally approached the Jacobins to sponsor this project, and finance was to come from subscriptions. When this failed, the costs were taken over by the state. The event to be commemorated was that of 20 June 1789, when the Deputies of the Third Estate, meeting in the royal tennis court at the Château of Versailles, swore not to disperse until a constitution was assured. Although many drawings survive for this project (e.g. Versailles, Château), David seems not to have been present on the day and treated this as a straightforward commercial commission rather than as a patriotic duty. He planned a large canvas full of portraits of the Deputies with the President of the Constituent Assembly, Jean-Sylvain Bailly, addressing the spectator. However, political events moved too fast for David; by the winter of 1791–2 this vision of the Revolution had become outmoded, and many of the 'heroes' of 1789 had been discredited or exiled. David painted only four Deputies' heads on the surviving canvas fragment, and a better idea of the project is gained from his highly finished drawing (both Versailles, Château). In the spring of 1792 David also received an unexpected commission to paint *Louis XVI Showing the Constitution to the Dauphin* (incomplete), a work that was intended to hang in the meeting room of the Legislative Assembly (Schnapper, Bordes). Drawings (Paris, Louvre, RF 36942) prove that he started the commission and indicate the gradual nature of his political conversion. Following these abortive projects David became increasingly involved in politics. He was elected a Deputy of the Convention in September 1792 and allied himself closely with Robespierre. In 1793 he voted for the death of Louis XVI, and in January 1794 he served a term of 13 days as President of the Convention. Part of his duties included the signing of arrest warrants—an aspect of his political career he later vehemently denied.

During the Revolution David was given the task of glorifying three martyrs of the cause: *Louis-Michel Lepelletier de Saint-Fargeau* (1793, destr.; engraving by Pierre-Alexandre Tardieu (1756–1844), Paris, Bib. N., Cab. Est.), *Joseph Bara* (1794, unfinished; Avignon, Mus. Calvet) and *Jean-Paul*

Marat (1793; Brussels, Mus. A. Anc.; see fig. 16; versions, Versailles, Château, Paris, Louvre). David was called on by the Convention to paint the last-mentioned work, better known as the *Death of Marat*, the day after Marat's assassination by Charlotte Corday. The sombre greenish setting was possibly inspired by the lighting of the disaffected church of the Cordeliers, Paris, where the body lay in state; David not only exploited the emotional quality of the chill, dark void above Marat's body but leant on aspects of Christian iconography, as if transcending death to excite Revolutionary ardour. In sharp contrast to the heroic Marat is David's brutally realistic pen drawing of *Queen Marie-Antoinette on her Way to the Scaffold* (1793; Paris, Louvre).

From 1792 David also organized some of the great Revolutionary festivals and pageants. The most elaborate of these was the Festival of the Supreme Being on 20 Prairial Year II (8 June 1794), for which he evolved the overall programme and

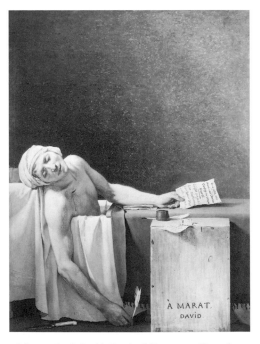

16. Jacques-Louis David: *Death of Marat*, 1793 (Brussels, Musée d'Art Ancien)

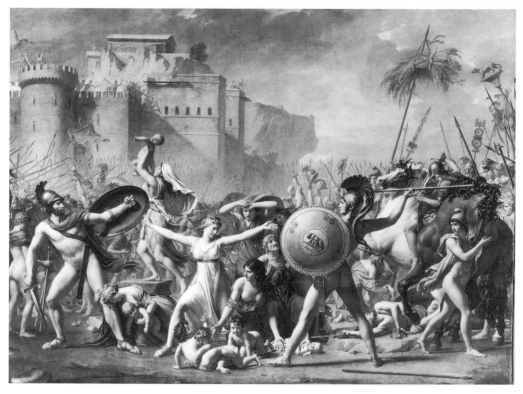

17. Jacques-Louis David: *Intervention of the Sabine Women*, 1799 (Paris, Musée du Louvre)

provided designs for the props and temporary architecture (destr.). Among surviving drawings for such ephemeral works is that entitled the *Triumph of the French People* (c. 1793; Paris, Louvre), designed for a theatre curtain. In addition, he continued to produce portraits, painting figures from the liberal middle and upper classes, as in the unfinished portrait of *Mme Adélaïde Pastoret* (c. 1792; Chicago, IL, A. Inst.), and representatives of foreign governments in Paris, including *Jacobus Blauw* (1795; London, N.G.). One of the Batavian (Dutch) government's plenipotentiary ministers, he is depicted at work at his desk, gazing pensively out into space; David paid great attention to the still-lifes of objects on the desk and to the muted colour harmonies of Blauw's clothes. A portrait of *Bertrand Barère de Vieuzac* (1792–3; Bremen,

Ksthalle), once attributed to David, is now given to his pupil Jean-Louis Laneuville.

On 9 Thermidor (27 July) 1794 Robespierre fell from power and was executed. David, who had once promised to drink the hemlock with him, was lucky to escape with his life. He underwent two periods of imprisonment, though under lenient conditions that allowed him to continue to work, first from 2 August to 28 December 1794 in the Hôtel des Fermes and Palais de Luxembourg and then from 29 May to 3 August 1795 in the Collège des Quatre-Nations. Suffering ill-health, he was released on parole. In prison he painted a *Self-portrait* (1794; Paris, Louvre) that shows him, palette and brush in hand, staring directly at the spectator; his swollen left cheek, concealing a huge benign tumour (the result of a youthful duelling

accident), is clearly visible. In captivity David painted one or two landscapes, his only recorded excursion into this genre. However, the *View of the Luxembourg Gardens* (1794; Paris, Louvre), once attributed to him, has aroused doubts about both its subject-matter and its authorship.

3. Work during the Directory and the Empire, 1795–1814

During his imprisonment David also began work on an ambitious history painting, the *Intervention of the Sabine Women* (Paris, Louvre; see fig. 17), not completed until 1799. This shows the Sabine women separating the belligerent groups of Sabine and Roman men, the latter having come to reclaim their females. The painting focuses on reconciliation, a theme of some contemporary relevance, since following the Reign of Terror, French society was returning to normality under the government of the Directory. It also demonstrates a change in David's aesthetics. He said that he wanted it to be 'more Greek' and thus depicted smoother and more sculptural forms than the muscular Roman bodies of the *Horatii*. In fact, he found himself having to defend the figures' excessive nudity. The overall effect is completely different from the morally exemplary history paintings of the 1780s. By contrast with the tense grouping of the *Oath of the Horatii*, the *Intervention of the Sabine Women* has a very large cast of characters, requiring it to be read serially, incident by incident and group by group. It shows his growing interest in 'Primitive' art, with ideas of formal purity derived from Greek sculpture and 15th-century Italian painting. Similar interests spurred some of his students to pursue these ideals even further and to form a group known as les Primitifs, led by the mysterious Pierre-Maurice Quay (c. 1779–1804). David's work did not adhere closely enough to the students' notion of purity; they even accused him of being too florid, with the result that he asked them to leave his studio. David painted the *Sabine Women* as a tribute to his wife, and to offset the costs of production he took the unprecedented step of exhibiting it in one of the rooms of the Louvre and charging an admission fee. This exhibition lasted from 1799 to 1804, and from the proceeds he bought a country property at Ozoeut le Voulgis in the Seine-et-Marne Valley.

Following his release from prison, David declared that he would no longer follow men, he would follow principles. This indicated a desire to steer clear of controversial subjects. However, he soon came under the spell of the brilliant young Corsican general Napoleon Bonaparte, who first posed for David early in 1798. The product of this three-hour sitting is a fragmentary canvas (Paris, Louvre) showing the figure in outline with details of the head and shoulders sketched in. David's idea was to paint Bonaparte standing full-length after the victorious battle of Castiglione, next to a horse controlled by a groom. But no more sittings followed, and the picture remained unfinished. Nevertheless, this brief meeting had a profound effect on David, who announced, 'Bonaparte is my hero'.

On 18 Brumaire (10 November) 1799, Bonaparte and the army staged a coup d'état that replaced the Directory with the Consulate and made Bonaparte First Consul. He further endeared himself to the French public in 1800 by re-conquering Italy for the second time in five years. Charles IV of Spain commissioned David to paint this event, *Napoleon Crossing the St Bernard Pass* (Malmaison, Château N.), and Bonaparte then ordered copies of the picture (Vienna, Ksthis. Mus.; Versailles, Château, 2 versions; Berlin, Schloss Charlottenburg). Napoleon refused to sit for the portrait, sending instead the uniform he had worn at the Battle of Marengo, and did not submit to David's proposed format either: David wanted to paint him sword in hand, but Napoleon replied that battles were no longer won in this way and that he wanted to be painted 'calm on a fiery steed'; David duly obliged. The magnitude of the event in David's view is indicated by the placing of Napoleon's name on a rock above those of two previous transalpine conquerors, Hannibal and Charlemagne. Like most propaganda images, the painting is economical with the truth, since Napoleon actually crossed the Alps seated on a mule. The impersonal, static quality of the work is doubtless due to the lack of any real contact between artist and sitter.

This distance between David and Napoleon contrasts sharply with the circumstances that surrounded one of his most famous portraits, that of *Mme Juliette Récamier* (Paris, Louvre; see fig. 18), on which he worked early in 1800. The great society beauty was wilful and spoiled and obviously saw herself as something other than the vulnerable and isolated figure that David depicted. The simple and unadorned setting is redolent of tension. She reclines on a fashionable day-bed made by Georges Jacob. No rich accessories surround her, only an Antique-inspired lamp (painted by David's newest pupil, Jean-Auguste-Dominique Ingres). David finally became exasperated with Mme Récamier's late arrivals for sittings and refused to continue, leaving the picture unfinished.

David quickly enjoyed the rewards of Napoleonic patronage: in December 1803 he was made a Chevalier of the Légion d'honneur, and in December 1804, immediately after Napoleon's coronation as Emperor, he became his Premier Peintre. David's relationship with Napoleon and his ministers was, however, ambivalent, mostly due to incessant and inflated demands for remuneration. The coronation took place on 2 December, and David was charged with commemorating the event. Initially the exact subjects for the commission were not specified; not until June 1806 did David submit a detailed description of the four planned paintings. The subjects were the *Coronation of Napoleon in Notre-Dame*, the *Enthronement*, the *Distribution of the Eagle Standards* and the *Reception of the Emperor and Empress at the Hôtel de Ville*. Of these, only the *Coronation* and the *Distribution of the Eagle Standards* were completed; the *Reception at the Hôtel de Ville* got only as far as a detailed drawing (Paris, Louvre) and the *Enthronement* seems never to have been started.

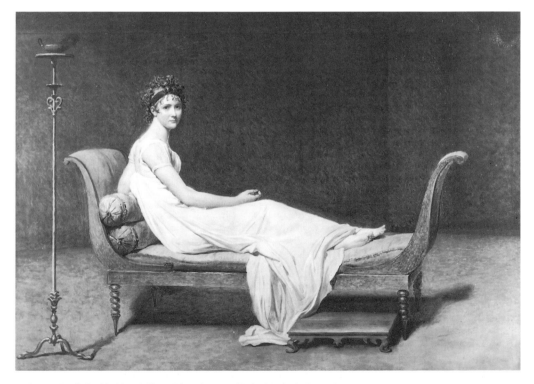

18. Jacques-Louis David: *Mme Juliette Récamier*, 1800 (Paris, Musée du Louvre)

The *Coronation of Napoleon in Notre-Dame*, also known as *Le Sacre* (Paris, Louvre; see col. pl. VII; version, 1822, Versailles, Château), occupied David from 1805 to 1807, and he was given the secularized church of Cluny, in the Place de la Sorbonne, as a studio (destr. 1833). He made exhaustive preliminary studies for all the personages to be shown and enlisted the help of Ignace-Eugène-Marie Degotti (d 1824), a scene painter from the Paris Opéra, for difficulties he encountered with perspective. David had the problem of which moment of the ceremony to depict: at first he proposed Napoleon crowning himself (drawing, Paris, Louvre, RF 4377), but at the suggestion of his former pupil François Gérard, this was abandoned in favour of Napoleon crowning Josephine. The open composition leads the spectator into the picture, almost as if to participate in the ceremony, a feature not lost on Napoleon. With the *Coronation* David had to find an appropriate style to celebrate the magnificence of the Empire, and to this end he turned to the opulence of Rubens, in particular his *Coronation of Marie de' Medici* (Paris, Louvre), then in the Palais du Luxembourg. Whites, reds, greens and golds dominate, and the large cast of characters is manipulated with supreme finesse and clarity. The work was a staggering success and encapsulates the splendour of the First Empire most effectively.

The *Distribution of the Eagle Standards* (1810; Versailles, Château) shows the ceremony held on the Champ de Mars, Paris, three days after the coronation. Here Napoleon, in a deliberate parallel with ancient Rome, presented flags attached to poles topped with the Imperial eagle to all the army regiments and to the National Guard. Oaths of allegiance were then sworn. David's picture is a curious amalgam of high-minded patriotism and romantic Napoleonic pageant and allegory, the end result lacking in cohesion: the group of generals swarming up the steps to the tribune has an awkward, frozen quality, and the work suffered because Napoleon insisted on changes being made. Most radical of these was the removal of the figure of Empress Josephine, whom he had recently divorced, resulting in considerable reworking of the left side of the picture. David's series of grand

Napoleonic paintings ended with this work. His demands for 100,000 francs for each painting were considered excessive, and when other commissions were distributed they went to lesser (and less expensive) artists.

At this time David also began to face serious competition from his own former pupils, notably Gérard, Antoine-Jean Gros and Anne-Louis Girodet. Gros in particular was invited to execute a number of prestigious Napoleonic commissions, including the the *Plague House at Jaffa* (1804) and the *Battle of Eylau* (1808; both Paris, Louvre). In 1802 Girodet produced the wildly allegorical *Apotheosis of French Heroes who Died for the Country during the War for Liberty* (Malmaison, Château N.), a work that left David doubting Girodet's sanity. This increased competition led David to disassociate himself from many of his ex-pupils, whom he then considered as rivals. He did, however, remain on friendly terms with Gros.

Although there were no more official commissions from Napoleon, David was commissioned to paint the Emperor, surprisingly, by an Englishman, Alexander Douglas-Hamilton (later 10th Duke of Hamilton). The life-size, full-length portrait of *Napoleon in his Study* (1812; Washington, DC, N.G.A.; version, Versailles, Château) was considered an excellent likeness and depicts the Emperor as lawgiver, working on the Napoleonic code into the small hours of the morning. In the background the clock shows 4.13 and the candle on his desk is almost burnt out.

David's duties for Napoleon between 1800 and 1810 had delayed the progress on *Leonidas at Thermopylae* (Paris, Louvre), the companion piece to the *Intervention of the Sabine Women*. He also experienced difficulty in finding an image striking enough to convey what he considered to be a deep and final classical statement. Although planned in 1799, this work was not completed until 1815. The story is that of Leonidas, King of Sparta, who with his band of men defended the pass at Thermopylae against superior Persian forces in the knowledge that death awaited them. David wrote at length about his intentions for this work in the anonymously published *Explication* (1814), saying that he wanted an air of calm acceptance

and contemplation to reign over the scene. This is most clearly expressed in the static and pensive figure of Leonidas, taken from a cameo illustrated in Johann Joachim Winckelmann's *Monumenti antichi inediti* (1767). Almost none of David's contemporaries liked the work; it made Napoleon feel uneasy, possibly because he construed it as a presage of defeat.

4. Late works and exile in Brussels, 1814–25

In April 1814, with British, Prussian, Austrian and Russian troops on French soil, Napoleon abdicated, and the Bourbon monarchy was restored under Louis XVIII. David kept a low profile during the first year of the Restoration but returned to Napoleon's side during the Hundred Days of 1815. He also signed the 'Addendum to the Constitution of the Empire', which prohibited any attempt to restore the Bourbons. But after the final defeat of Napoleon at Waterloo in June 1815 and the re-establishment of the Bourbon monarchy, Paris became a dangerous place for David. He applied for passports for England and Switzerland and went on a brief sketching trip to the latter. In January 1816 a law was passed banishing all regicides, and although David was informed that he could be exempted from it, he decided to go into exile in Belgium. He handed his teaching studio over to Gros and departed from Paris in late January 1816. A number of David's pupils were Belgian, notably François-Joseph Navez and Joseph-Denis Odevaere, and they welcomed and assisted him in Brussels, where he settled.

Historians have paid relatively little attention to the final nine years of David's career, a common view being that in Belgium his powers declined dramatically. Yet this was not David's opinion. Undoubtedly his later pictures appear different, but this can be attributed less to an artistic decline than to a change in artistic direction. David felt his Brussels pictures to be among his best, since in them he captured 'the simple and energetic taste of ancient Greece'. In the *Anger of Achilles* (1819; Fort Worth, TX, Kimbell A. Mus.), for example, Achilles, Agamemnon, Iphigenia and Clytemnestra are shown half-length in a highly compressed space close to the picture plane. In

terms of both style and content this is a departure from his Parisian work, showing a concentration on the complex emotional interactions of the protagonists. Agamemnon's gesture and gaze that stop Achilles from drawing his sword may relate to the ideas on magnetism and personal control propagated by the Austrian physician Franz-Anton Mesmer (1734–1815). The colours are hard-edged and brilliant, indicating a study of Flemish painting of the 15th and 16th centuries.

While in Brussels David built up a considerable portrait practice. He painted a whole series of former Revolutionaries and supporters of Napoleon who were fellow exiles. These include the full-length of *Gen. Etienne-Maurice Gérard* (1816; New York, Met.) and the seated three-quarter-length of *Comte Henri-Amédée de Turenne* (1816; Copenhagen, Ny Carlsberg Glyp.). He also received commissions from the Belgian upper classes and nobility, and many of these paintings remain in the possession of the families that commissioned them, such as *Vicomtesse Sophie Vilain XIIII [XIV] and her Daughter* (London, N.G.). David seems often to have enlisted the help of assistants in these portraits.

Mythological painting also occupied a good deal of David's time in Brussels. He once declared that he had no talent for such subjects, but nevertheless many of his late works deal with Anacreontic themes of pairs of lovers. The first of these was *Cupid and Psyche* (Cleveland, OH, Mus. A.), commissioned in 1813 by the distinguished Italian collector Conte Giovanni Battista Sommariva and completed in 1817. Here David's mode of mythological expression is not to idealize and create languorous rhythms. Instead his figure of Cupid is firmly rooted in realism, a rather jarring conjunction of myth and reality. There is some evidence that David was working towards this painting before he left Paris, as it shares many stylistic characteristics with *Sappho and Phaon* (1809; St Petersburg, Hermitage).

The unsettling combination of the real with the ideal is also present in David's last large-scale painting, *Mars Disarmed by Venus and the Three Graces* (1821–4; Brussels, Mus. A. Anc.). David attached great importance to this work, and he saw it as his

last testament in paint. Although there is a good deal of idealization and rhythmic sophistication, a number of the figures–the three Graces especially–are in theatrical and forced poses. The element of fantasy, previously so important in mythological painting, is substituted by parody; David radically re-examined the whole framework of mythology in this and others of his late works. Hence his late activities may be seen as attempts to reinterpret mythology rather than as a regression to the Rococo style of his youth. However, these pursuits were totally out of step with contemporary Parisian developments, and French critics were dismissive of the last paintings.

During David's exile the faithful Gros had been working for his master's return to Paris. David stubbornly insisted that Brussels was to his liking. At one point in 1824 he needed only to sign a draft petition to return, but he refused to do so. In July 1825 he had a stroke and died in December of that year. He was denied burial in France, and so an impressive funeral was arranged for him by the Belgian government. Plans to return David's remains to France in 1989 were frustrated by the Belgian authorities.

II. Working methods and technique

David had an extremely laborious working procedure, in which draughtsmanship played a major role. He used mannequins to study individual details such as drapery, and his own Roman sketchbooks (Paris, Louvre; Cambridge, MA, Fogg; Stockholm, Nmus.) or reference books (e.g. Bernard de Montfaucon's *L'Antiquité expliquée*, 1719) to ensure that antique details were accurate. He drew extensively from posed life models, and such drawings would then be squared-up and transferred to the canvas. This process can be seen particularly vividly by comparing the finished *Oath of the Horatii* with the squared drawing of the group of women on the right (Paris, Louvre, RF 4506). He sometimes went so far as to produce drawings of the skeletons of his figures. David also made numerous small oil sketches for his large canvases in order to clarify the composition and lighting. His finished history paintings show his predilec-tion for strong local colour. His figures have a relief-like modelling with impasto highlights and thinly scumbled opaque shadows. David worked on a single passage of a picture at a time, rather than treating all areas at once. There was little under-painting, and the *ébauche* was little more than a drawing that was completely obliterated by the final paint layer. Such exhaustive preparations meant that very few pentiments are evident. He had little time for recipes for brushwork and handling and wrote to his former pupil Wicar on 14 June 1789, 'What does it matter if one makes strokes to the right, to the left, up and down or sideways; as long as the lights are in their places, one will always paint well' (see David, 1880, p. 56). David's occasional difficulties with perspective are evident in the incorrect orthogonals of the pavement in *Belisarius Receiving Alms*. He frequently depicted paved floors in order to facilitate the location of figures in space (e.g. the *Oath of the Horatii*, the *Death of Socrates* and the *Lictors Bringing Brutus the Bodies of his Sons*). Despite such traditional academic procedures, his compositions were often viewed as unorthodox and anti-academic. Jean-Baptiste Pierre allegedly remarked of the *Brutus*, 'You have in your *Horatii* given us three personages set in the same plane, something never seen before! Here you put your principal actor in shadow But where have you seen, for example, that a sensible composition can be made without using the pyramidal line?' (David, 1880, p. 57). In his portraits David strove towards a tension between the natural and the ideal and gradually evolved the use of a neutral and vibrant background, as in *Mme Adélaïde Pastoret* and *Mme Henriette Verinac* (1799; Paris, Louvre).

David's more talented pupils usually assisted on the large history paintings and occasionally with the portraits as well. Drouais is supposed to have painted the arm of the third Horatii brother and the yellow garment of Sabina in the *Oath of the Horatii*. Jean-Pierre Franque assisted with the *Intervention of the Sabine Women*, and Georges Rouget on *Le Sacre* and *Leonidas at Thermopylae*. David also engaged his best pupils to paint reductions of his most successful pictures, adding the finishing touches himself and then passing them

off as autograph works. That of *Belisarius* (Paris, Louvre), painted by Fabre in 1784 for the Comte d'Angiviller, and that of the *Oath of the Horatii* (Toledo, OH, Mus. A.), painted by Girodet in 1786 for the Comte de Vaudreuil, are examples. The exact proportion of pupil–master participation is impossible to establish, however, and these reductions (particularly the *Horatii*) remain the subject of controversy. A number of artists drew or painted the interior of David's studios, notably Jean-Henri Cless (*fl* 1804–11), who drew the Louvre studio in 1804 (Paris, Carnavalet), and Léon-Matthieu Cochereau (1793–1817), who depicted the studio in the Collège des Quatre Nations (now Institut de France) in 1814 (Paris, Louvre).

III. CRITICAL RECEPTION AND POSTHUMOUS REPUTATION

David has often been accused of opportunism, largely because he lived through a period of unparalleled social and political upheaval. Certainly, he painted successively for the *ancien régime*, the Revolution and Napoleon, but all of his conversions appear to have been genuine and not premeditated. There have been many attempts to define the nature of David's politics. Opinion is sharply divided between those who believe he displayed radical tendencies as early as the 1780s (e.g. Crow) or not until 1790 (e.g. Bordes). Perhaps his clearest characteristic is his extreme pragmatism. What is beyond doubt is that he managed to encapsulate exactly in his painting the different aspirations of successive regimes, and for long periods created his own stylistic parameters. But David's Neo-classicism was by no means static. There are significant differences in aim displayed in the *Oath of the Horatii*, the *Intervention of the Sabine Women* and *Leonidas at Thermopylae*. His diversity is also apparent in his Empire work: 'Neo-classical' would be a singularly inappropriate label for the *Coronation of Napoleon in Notre-Dame*.

Through his approach to teaching and his legions of pupils, David had an enormous influence not only on French but on European art. He himself wrote, somewhat immodestly, 'I founded a brilliant school, I painted pictures that the

whole of Europe came to study' (David, 1880, p. 601). But this view is corroborated, albeit critically, by Stendhal, who wrote, 'The illustrious David has won over Europe with his manner of painting ... only England has resisted this conquest' (*Revue Trimestrielle*, July–Oct 1828). Ironically, many of the tenets of Neo-classicism, a revolutionary art form in the 1780s and 1790s, became staples in a highly orthodox and conservative form of academicism in the 19th century. To many critics David alone was responsible for a decline in French art, whereby all vigour and expression had been reduced to sterile formulae. In addition, by encouraging an emphasis on the intellectual aspects of painting, he was accused of fostering a neglect of technical expertise in the work of young artists. These criticisms, although mostly false, coupled with his Revolutionary past, ensured that soon after his death he was quickly forgotten. Despite maverick praise, such as Charles Baudelaire's haunting evocation of the *Death of Marat* (see col. pl. VIII) (review in *Corsaire Satan*, 21 Jan 1846, of the exhibition held in the Bazaar Bonne Nouvelle, Paris), the resurrection of David's reputation was a slow and painful process, not without bitter controversy. Only since World War II has he been returned to the centre stage of European art.

Writings

There is a substantial holding of David's writings in the Bibliothèque Nationale, Paris. See also the anonymous works of 1799 and 1814 entered below. For a list of his Revolutionary speeches and reports of 1792–3 see Wildenstein (1973), p. 283. For a large part of his correspondence, see J. L. J. David (1880).

Bibliography

Le Tableau des Sabines exposé publiquement au Palais national des sciences et des arts, salle de la ci-devant Académie d'architecture par le citoyen David (Paris, an VIII [1799]) [written by David]

P. Chaussard: Le Pausanias français: Etat des arts du dessin en France à l'ouverture du XIX siècle (Paris, 1806), pp. 145–74

Explication du tableau des Thermopyles par M. David (Paris, 1814) [written with the help of David]

Account of the Celebrated Picture of the Coronation of Napoleon by M. David, First Painter to the Emperor (London, 1821)

Notice sur la vie et les ouvrages de M. J. L. David (Brussels, 1824) [written with David's collaboration]

E. J. Delécluze: *Louis David, son école et son temps* (Paris, 1855)

J. L. J. David: *Le Peintre Louis David, 1748–1825: Souvenirs et documents inédits* (Paris, 1880)

D. L. Dowd: *Pageant-Master of the Republic: Jacques-Louis David and the French Revolution* (Lincoln, NE, 1948) [with valuable essay on sources]

L. Hautecoeur: *Louis David* (Paris, 1954)

R. Herbert: *J. L. David, Brutus* (London, 1972)

D. Wildenstein and G. Wildenstein: *Documents complémentaires au catalogue de l'oeuvre de Louis David* (Paris, 1973) [incl. extensive bibliography but with some omissions]

A. Brookner: *Jacques-Louis David* (London, 1980)

A. Schnapper: *David: Témoin de son temps* (Fribourg, 1980; Eng. trans., New York, 1982)

David e Roma (exh. cat. by R. Michel, A. Serullaz and U. van de Sandt, Rome, Acad. France, 1981) [incl. repr. of several valuable documents]

P. Bordes: *Le 'Serment du Jeu de Paume' de Jacques-Louis David: Le Peintre, son milieu et son temps de 1789 à 1792* (Paris, 1983) [amplified version of article in *Oxford A.J.*, iii/2 (1980), pp. 19–25]

T. Crow: *Painters and Public Life in Eighteenth-century Paris* (New Haven and London, 1985), pp. 212–41

M. C. Sahut and R. Michel: *David, l'art et la politique* (Paris, 1988)

W. Roberts: *Jacques-Louis David: Revolutionary Artist* (Chapel Hill and London, 1989)

David (exh. cat. by A. Schnapper and A. Sérullaz, Paris, Louvre; Versailles, Château; 1989–90)

P. Rosenblum: 'Reconstructing David', *A. America*, lxxviii (1990), pp. 188–97, 257

A. Sérullaz: *Musée du Louvre, Cabinet des dessins. Inventaire général des dessins: Ecole française, dessins de Jacques-Louis David, 1748–1825* (Paris, 1991)

D. Johnson: *Jacques-Louis David: Art in Metamorphosis* (Princeton, 1993)

'David contre David', *Proc. 1989 David Colloq.*, 2 vols (Paris, 1993)

SIMON LEE

David d'Angers [David, Pierre-Jean]

(*b* Angers, 12 March 1788; *d* Paris, 6 Jan 1856). French sculptor. A remarkably comprehensive view of this most prolific of 19th-century sculptors is provided by the collection of his work in the Musée des Beaux-Arts et Galerie David d'Angers in Angers. Begun in 1839 from models for the sculptor's public statues that he had consistently sent to his home town, the collection was enriched after his death by numerous donations; in 1983 it was rehoused in the 13th-century abbey of Toussaints adjacent to the Musée des Beaux-Arts. Unless otherwise stated, plaster or marble versions of specific works mentioned in this article can be found in this collection.

1. Training and travels abroad, to 1816

Son of the ornamental wood-carver Jean-Louis David (1760–1821), who enrolled in 1793 in the Republican force that opposed the anti-revolutionary uprising, Pierre-Jean worked with his father and was further encouraged in his artistic ambitions by Jacques Delusse (1757–1833), painter and curator of the Musée des Beaux-Arts in Angers. In 1807 he went to Paris and found employment as a decorative sculptor on the Arc de Triomphe du Carrousel. Living at this time in dire poverty, he entered the studio of Philippe-Laurent Roland in 1809. A first effort at the Prix de Rome in 1810, *Othryades Dying*, brought him a second prize and attracted the attention of the painter Jacques-Louis David. A grant from the municipal council of Angers in 1811 allowed him to continue his studies. These were rewarded with success in the same year, when his relief of the *Death of Epaminondas* won the Prix de Rome. While in Rome (1811–15), David d'Angers experimented with a linear mannerism, akin to that of Ingres or Girodet, in the relief *Nereid Bringing Back the Helmet of Achilles*. In the *Young Shepherd* he adopted an introverted Greek Revival mode close to Bertel Thorvaldsen's. Later he claimed to have resisted the 'antique sensualism' of Canova, preferring to devote himself to an art celebrating heroes and men of genius. In Rome his imagination was deeply marked by a doomed liaison with a girl of patrician family, Cecilia Odescalchi. Her death, after their forced separation, caused him to retain a poeticized romantic image of her which frequently recurs in his work. In 1816 David travelled to London on Canova's recommendation, to see the Parthenon marbles (which had been

transferred to the British Museum that year at the instigation of Thomas Bruce, 7th Earl of Elgin) and also to visit John Flaxman. The latter, confusing him with the painter David, turned him away.

2. 1816–41

Back in France, David d'Angers suppressed his Republican principles and compromised with the restored Bourbons, participating in official decorative schemes such as the adornment of the Cour Carrée (1824) of the Louvre, and the modification of the Arc de Triomphe du Carrousel (1827). The first of such state commissions was passed down to him in 1816, following the death of his master Roland. It was for a colossal marble statue of the *Grand Condé* (destr.), destined for the Pont Louis XVI (now Pont de la Concorde). The figure can best be judged from the surviving half-size, but still over life-size, plaster model. It harks back to the series of statues of great men commissioned for the state in the 1770s and 1780s by the Comte d'Angiviller. David d'Angers added emphatic drama and simplified the costumed pageantry of the earlier historical figures, producing an image in strong contrast to the preponderantly Neo-classical sculpture exhibited at the Salon of 1817.

For other statues executed during the following decade, David d'Angers preferred to retain elements of the timeless convention of Neo-classical sculpture. His monument to *Jean Racine* (marble, 1819–33) for La-Ferté-Milon combines 17th-century hairstyle with a loosely draped nude figure. In the monument to *Gen. Bonchamps* (marble, 1816–25) at Saint-Florent-le-Vieil, the nature of the event commemorated (a last act of clemency by the dying royalist general towards Republican prisoners of the Vendée War, including David's own father) validates the general's draped nude figure. His dramatically raised hand and commanding expression bring back to life, in its original location, an historical event of which David had a personal recollection. A compromise is reached in the monument to *Gen. Foy* (marble, 1827–31) in Père Lachaise Cemetery, Paris. Here the portrait statue of the soldier–legislator, framed by Léon Vaudoyer's miniature Doric temple, is rendered in antique guise, while the biographical reliefs around the upper podium are formalized interpretations of modern scenes. Following his appointment in 1826 as professor at the Ecole des Beaux-Arts in Paris, David had begun to pursue more personal preoccupations. He undertook at his own expense, having been frustrated in his requests for state sponsorship, a monument to *Marco Botzaris*, one of the martyrs of the Greek War of Independence, to be erected at Missolonghi in Greece (marble, Athens, Hist. Mus.). The statue of the *Young Greek Girl* seated on the tomb of Botzaris and spelling out his epitaph with her finger, was exhibited at the Paris Salon of 1827. This very original rendering of the pre-pubescent female figure was a work for which David retained an almost paternal affection.

Around the same time, David's project began to take shape for a portrait pantheon in the form of a series of medallions and busts of all the outstanding men and women of his time. These, along with the commemorative statues that David executed for towns throughout France, formed the core of that morally uplifting national art for which David found the model in the republics of the ancient world. The medallion series, which he began to think of as a comprehensive survey in 1828 (though a number of significant examples had been executed before this), took David to England and to Germany, in pursuit of persons prominent in the national life. In the medallions, and even more so in his busts, David was influenced by the phrenological theory of Franz Josef Gall to emphasize those physiognomic developments that were supposed to designate specific propensities—sensual, intellectual or emotional—in the subject. Of the more than 500 that he executed, most are large, measuring between 130 and 180 mm, and are profile portraits, with assertively modelled features and tousled hair predominating over elegance of composition. Several others, including *Théodore Gericault* and *Alfred de Musset*, are three-quarter views. Only one, of David's American patron, *Uriah Phillips Levy* (1792–1862), shows its subject full face, while *Mme Récamier* is seen from the back with head turned to present a slightly obscured profile.

Having until then been mainly concerned with marble statuary, the medallion series alerted David to the expressive potential of sculpture modelled for casting in bronze. This coincided with his acceptance into the emergent Romantic *cenacles*, particularly that of Victor Hugo, and, after 1830, a new search for colouristic effects in bronze was shared by David with a number of other Romantic sculptors such as Antoine-Louis Barye, Auguste Préault and Antonin-Marie Moine. David can be seen responding with maximum intensity to the medium in the bust of *Niccolò Paganini* (1830–33; Angers, Gal. David d'Angers; see col. pl. VIII) and the statue of *Thomas Jefferson* (1832–4; see also fig. 19), donated by Levy to the US Capitol in Washington, DC. Both were cast by Honoré Gonon, using the lost-wax method, and reveal a restless pursuit of rugged surface effects. The *Paganini* departs from David's more usual tendency towards the static and monumental in portrait busts. In those of *Chateaubriand* (marble, 1829; Combourg, Château) and *Goethe* (marble, 1831; Weimar, Goethe-Nmus.), Romantic hyperbole

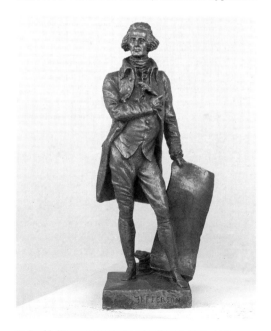

19. David d'Angers: *Statuette of Jefferson*, 1832–4 (Angers, Galerie David d'Angers)

is contained within an abruptly truncated symmetrical format.

The statue of *Jefferson* was the first of a series of bronze commemorative statues, with the subjects seen in the costume of their own time, which David produced thereafter at regular intervals until the end of his life. More than any other artist, David was responsible for promoting the 19th-century cult of the commemorative statue. His seated or standing figures are usually accompanied by distinguishing attributes: *Johann Gutenberg* (bronze, 1839–40) for Strasbourg, standing with his printing press; *Bernardin de Saint Pierre* (bronze, 1851) for Le Havre, seated with the infants Paul and Virginie sleeping amid tropical foliage at his side. On other occasions costume and attitude suffice, as in the *Pierre Corneille* (bronze, 1834) at Rouen, or the *Gerbert* (bronze, 1850) at Aurillac. In many cases narrative reliefs decorate the statue's base. These are in a crowded and purposefully naive style reminiscent of popular imagery, indicating David's intention to make these monuments an elevating text accessible to all. David sculpted two statues of *King René of Anjou*, the first of which had been a marble for Aix-en-Provence commissioned as far back as 1819. (In the second, inaugurated at Angers in 1846, the sculptor surrounded the base of his statue with 12 free-standing bronze statuettes representing figures from medieval and earlier French history.)

The stylistic peculiarities that feature in the narrative reliefs are also to be found in the two major commissions David received from the newly formed government of the July Monarchy. These were the marble pediment relief for the Panthéon, with the subject *To Great Men the Fatherland is Grateful* (commissioned 1830), and the marble decoration of the Porte d'Aix at Marseille (1831–5), with subjects relating to Napoleon's campaigns, the latter commission shared with the sculptor Etienne-Jules Ramey. The Panthéon pediment departs radically from the standard iconography of apotheosis, in bringing together both famous figures and men of the people distinguished for learning or heroism, and also in its emphasis on secular and Republican achievement. Here, as on the Porte d'Aix, Napoleon is celebrated as a soldier

and not as emperor. As the complexion of the July Monarchy grew increasingly authoritarian, David was called on to defend his choices. He remained adamant, and his work was surreptitiously unveiled in September 1837. The populist theme is repeated in the huge relief on the west interior face of the Marseille arch. The subject, like that of François Rude's better-known relief on the Arc de Triomphe de l'Etoile, is the *Departure of the Volunteers*, but, whereas Rude's Frenchmen are depicted as ancient Gauls, David's allegorical Patrie distributes arms to vigorously portrayed representatives of the revolutionary era wearing the costumes of their time. In David's relief the modes are mixed (just as they had been in Delacroix's *Liberty Leading the People* of 1830), whereas history and allegory are firmly segregated on the outer faces of the Marseille arch.

3. 1842 and after

Although ill health obliged David to relinquish his courses at the Ecole in 1842, his productivity as a commemorative sculptor continued unabated. His contribution of funerary monuments to Père Lachaise Cemetery reached its climax with the heroic pathos of the monument to *Gen. Gobert* (1847), in which the young general slips dying from his horse as it tramples his Spanish adversary. In the Salon of 1845, David showed a more intimate piece, an allegorical nude statue of his son Robert, entitled *Child with a Bunch of Grapes* (plaster, Angers, Mus. B.-A.; marble, modified from the original model, Paris, Louvre). The homely philosophizing characteristic of David's voluminous private journals (see Bruel) finds an outlet in this work, though its moral message was overlooked by Baudelaire, who, in his review of the Salon, complained only of its excessive naturalism.

During the shortlived Republic of 1848, David was appointed mayor of the 11th arrondissement of Paris and was elected deputy for Anjou to the Constituent Assembly. He was not re-elected to the assembly the following year but had been sufficiently outspoken during his period in office to provoke arrest and exile after the Bonapartist *coup d'état* of 1851. He had always been insistent in his refusal to celebrate the imperial legend. A sympathetic interest in the fate of Queen Hortense, mother of Louis-Napoléon, had allowed him to submit a project for a monument to her, after her death in 1837. However, when the commission for the monument went instead to Lorenzo Bartolini and then to Jean-Auguste Barre, David was relieved that his sympathy had not led him in the end to compromise his Republicanism.

In exile David travelled to Belgium, then to Greece, where he was distressed to find that his monument to *Botzaris* had been vandalized. The poet Béranger interceded on his behalf in 1852, and he was permitted to return to France. In 1855, the year before his death, he visited the museum at Angers that had been enshrining his works since 1839, having at last overcome his scruples at such a pre-posthumous celebration.

Writings

A. Bruel, ed.: *Les Carnets de David d'Angers* (Paris, 1958)

Bibliography

R. David and E. About: *Les Médaillons de David d'Angers* (Paris, 1867)

H. Jouin: *David d'Angers: Sa Vie, son oeuvre, ses écrits, ses contemporains*, 2 vols (Paris, 1878)

G. Chesneau and C. Metzger: *Les Oeuvres de David d'Angers*, Angers, Mus. B.-A. cat. (Angers, 1934)

The Romantics to Rodin (exh. cat., ed. H. W. Janson and P. Fusco; Los Angeles, CA, Co. Mus. A., 1980) [esp. contributions by J. Holderbaum on portrait sculpture and on David d'Angers]

N. McWilliam: 'David d'Angers and the Panthéon Commission: Politics and Public Works under the July Monarchy', *A. Hist.*, v/4 (1982), pp. 426–46

J. de Caso: *David d'Angers: L'Avenir de la mémoire: Etude sur l'art signalétique à l'époque romantique* (Paris, 1988)

S. G. Lindsay: *David d'Angers' Monument to Bonchamps: A Tomb Project in Context* (Ann Arbor, 1992)

PHILIP WARD-JACKSON

Debucourt, Philibert-Louis

(*b* Paris, 13 Feb 1755; *d* Paris, 22 Sept 1832). French painter and printmaker. He was a protégé of Gabriel-Christophe Allegrain and was taught by

Joseph-Marie Vien. His own preference was for genre painting in the Flemish style. In 1781 he was approved (*agréé*) as a member of the Académie Royale, Paris, on the basis of several works to be exhibited at that year's Salon; among these, the *Charitable Gentleman* (Paris, Gal. Cailleux) is a moralistic scene clearly inspired by Jean-Baptiste Greuze but using the technique of Isaack van Ostade. The pictures Debucourt exhibited at the Salons of 1783 and 1785 continued to draw their inspiration from Flemish art, then very popular in Paris, while remaining faithful to the realities of French peasant life. One of these works, *The King's Act of Charity and Humanity* (untraced; engraved in 1787 by Laurent Guyot), was accepted for exhibition in 1785 only after Debucourt had, by royal command, changed the title and made Louis XVI less easy to recognize.

Debucourt was principally known, however, as an engraver. In 1782, he reproduced in etching and dry point one of his own paintings of 1781, *The Judge or the Broken Pitcher* (Fenaille, nos 1 and 2). Shortly afterwards he took up colour printing; trained by his friend Guyot, by 1785 he was able to publish his first prints, the *Lovers Revealed* (F4) and its pendant, the *Lovers Pursued* (F5), both printed from four plates but in rather coarse colours. By 1786 he had perfected the technique in the *Bride's Minuet* (F8), engraved on five plates and forming a pendant to the *Village Wedding*, engraved by Charles-Melchior Descourtis after Nicolas-Antoine Taunay.

The following year Debucourt published one of his most famous prints, *Walk in the Gallery of the Palais-Royal* (F11), inspired by Thomas Rowlandson's *Vauxhall Gardens*. Here Debucourt caricatured in a comic vein the crowd in one of the busiest places in Paris. He returned to the same subject in 1792 in his engraving and aquatint *Public Promenade* (F33). These two large colour prints were apparently his greatest successes.

From 1785 to 1800 Debucourt created 64 engraved works, all after his own paintings in oil, gouache and watercolour: they include several portraits, such as those of *Louis XVI* (1789; F19) and *Marie-Joseph, Marquis de La Fayette* (1790; F23), as well as several small patriotic scenes, such as

Almanach National (1791; F26). Most numerous were genre scenes; some, such as the *Happy Family* (1796; F61), are in a tender vein, but most are on themes of gallantry, such as the *Rose in Danger* (1791; F27). He experimented widely with colour-printing techniques, including intaglio engraving, mezzotint, soft-ground etching and aquatint. For the most part the colour was printed using several plates, but in a few cases a single plate was coloured *à la poupée*. He later took up crayon manner and lithography. This many-sided production, the quality of which was uneven, became even more intensive after 1800; by the end of his life Debucourt had engraved 494 plates, chiefly reproductions of other artists' work. He made prints after the paintings of Carle Vernet, Louis-Léopold Boilly, Jean-Baptiste Isabey, Nicolas-Toussaint Charles and Martin Drolling. When engraving his own works, he exploited in particular his caricature style, as in *The Visits* (1800; F65) and its pendant, *The Orange, or a Modern Judgement of Paris* (F66). At about the same time Debucourt began to paint again, exhibiting his works, chiefly peasant scenes, at the Salons of 1810, 1814, 1817 and 1824. He died poor, however, as the dependant of his nephew and pupil Jean-Pierre-Marie Jazet, who left interesting accounts of the artist.

Bibliography

F. Fayot: 'Jazet et Debucourt', *L'Artiste*, n. s. 1, viii (1841), pp. 138–9

E. and J. de Goncourt: 'Debucourt', *L'Art du XVIIIème siècle* (Paris, 1875, rev. 1914), iii, pp. 161–210

M. Fenaille: *L'Oeuvre gravé de P.-L. Debucourt (1755–1832)* (Paris, 1899) [F] [cat. rais.]

Debucourt (exh. cat., Paris, Mus. A. Déc., 1920)

M. Roux: *Inventaire du fonds français: Dix-huitième siècle*, Paris, Bib. N., Cab. Est. cat., vi (Paris, 1949), pp. 162–91

J. Adhémar: *Inventaire du fonds français: Dix-neuvième siècle*, Paris, Bib. N., Cab. Est. cat., vi (Paris, 1953), pp. 66–79

CHRISTIAN MICHEL

Decamps, Alexandre-Gabriel

(*b* Paris, 3 May 1803; *d* Fontainebleau, 23 Aug 1860). French painter, draughtsman and print-maker. With his brother Maurice-Alexandre

(1804–52), the art critic and essayist, he spent some years of his youth at Orsay, in Picardy, 'in order to learn to rise early and know the hard life of the fields'. The artwork of the peasants stimulated an interest in drawing. He entered the atelier of Etienne Bouhot (1780–1862) in 1816. Towards the end of 1818 he left Bouhot to study under Alexandre-Denis Abel de Pujol, quitting his studio in 1819–20 in order to embark upon a career as an independent professional artist. He had been an inattentive student, who thought that 'the formula of instruction of the academic doctrine reduced the least examination almost to the proportions of silliness'. Memories of Orsay remained his point of departure throughout his working life, and in this sense he was a self-trained artist. Nevertheless, he admired, and learnt from, the art of such diverse artists as Raphael, Titian, Giovanni da Bologna, Poussin, Rembrandt, Géricault and Léopold Robert.

Decamps made his début at the Salon of 1827/8 with *Hunting in a Swamp* (untraced) and *The Janissary* (London, Wallace), simple compositions where recession is effected by the overlapping of edges, with fresh local colour and a finesse of touch. In 1828 he travelled throughout Asia Minor and eastern North Africa, becoming the first major European artist to travel extensively in the Near East. On his return he began a vogue for Oriental themes with such works as *Turkish Patrol* (c. 1830–31; London, Wallace) and *Route of Smyrna* (1833; Chantilly, Mus. Condé). At the same time he painted his memories of Orsay in *Chasse au miroir* (1830; Williamstown, MA, Clark A. Inst.), developed a long-lasting interest in rendering animals, evinced in the *Monkey Painter* (c. 1833; Paris, Louvre), and painted numerous genre scenes, such as *The Mendicants* (c. 1833; Algiers, Mus. N. B.-A.). The size of these works ranges from 1.15×1.79 m to 0.35×0.28 m.

Decamps sent his most famous work, *Defeat of the Cimbrians* (1833; Paris, Louvre; see col. pl. IX), to the Salon of 1834; it is a large painting, consistent in style with other works but demonstrating a fully developed understanding of atmospheric perspective. It is painted in his characteristic *cuisine*, a golden, brittle, dry-brushed texture. He

spent the rest of his career trying to reconcile his two strengths: a desire to create high-minded art and an interest in rendering his immediate surroundings.

During the late 1830s, after travelling to Italy in 1835, Decamps completed numerous canvases with biblical themes, such as *Joseph Sold by his Brothers* (1838; London, Wallace). Characteristic of such works is an emphasis on horizontal recession into space, with the principal action taking place in a valley, and a fusion of classical elements with naturalistic description. The result was a completely new approach to religious subjects. Through such devices as small architectural structures in the background and barren landscapes, Decamps created a believable image of the Orient, both historically and geographically, whereas previous artists had unconvincingly located scenes in Egypt and other Near Eastern countries merely by inserting pyramids or tropical growths. His work

20. Alexandre-Gabriel Decamps: *Mocking of Christ*, 1847 (Paris, Musée d'Orsay)

of the 1840s continued in the same stylistic vein, although he placed a greater emphasis on the figures and strong contour lines (e.g. *The Mocking of Christ*, 1847; Paris, Mus. d'Orsay; see fig. 20). The *History of Samson* series (Salon 1845; Paris, priv. col.) is characteristic of the period; these nine drawings also show that Decamps's drawing style paralleled that of his paintings and of his print-making. His oeuvre includes over 2000 paintings, drawings and prints, though he was not highly active during the last decade of his life. However, his style took on a new interest in light, while colour began to play a minor role. *Job and his Friends* (1853; Minneapolis, MN, Inst. A.) and the *Truffle Searcher* (c. 1858; Amsterdam, Stedel. Mus.) are characteristic works of this period.

Decamps received most of the major awards and recognitions bestowed on contemporary artists and enjoyed economic success: Eugène Leroux (1807–63) made lithographs after many of his works, and Decamps's patrons included such important 19th-century collectors as Marquis Maison (1771–1840), the 4th Marquess of Hertford, Henry, Lord Seymour (1805–59), the Barons Rothschild and the Duc d'Orléans. The *Job* was commissioned by the French government in 1849. Perhaps the crowning point of his career was the Paris Exposition Universelle of 1855, where he was given a retrospective exhibition, as were Ingres and Delacroix: all three were awarded the Grand Medal of Honour. Decamps was an avid sportsman and champion of artists' rights. The esteem in which he was held is illustrated by Albert-Ernest Carrier-Belleuse's *Monument to Decamps*, erected in 1862 in the Place Decamps, Fontainebleau.

Bibliography

Dr Véron: *Mémoires d'un bourgeois de Paris* (Paris, 1854)
P. Mantz: 'Decamps', *Gaz. B.-A.*, 1st ser., xii (1862), pp. 97–128
A. Moreau: *Decamps et son oeuvre* (Paris, 1869)
G. Hédiard: *Les Maîtres de la lithographie: Decamps* (Le Mans, 1893)
D. F. Mosby: 'The Mature Years of Alexandre-Gabriel Decamps', *Minneapolis Inst. A. Bull.*, lxiii (1976–7), pp. 97–109
—: *Alexandre-Gabriel Decamps, 1803–1860*, Outstanding Diss. F.A., 2 vols (New York, 1977)
—: 'Decamps dessinateur', *Rev. Louvre*, i (1980), pp. 148–52
—: 'Decamps' *History of Samson* Series in Context', *Art the Ape of Nature: Studies in Honor of H. W. Janson* (New York, 1981), pp. 569–84

DEWEY F. MOSBY

Dedreux, Alfred

(*b* Paris, 23 May 1810; *d* Paris, March 1860). French painter and draughtsman. His father was the architect Pierre-Anne Dedreux (1788–1849); Alfred's sister, Louise-Marie Becq de Fouquières (1825–92), was also an artist. His uncle, Pierre-Joseph Dedreux-Dorcy (1789–1874), a painter and intimate friend of Gericault, took Dedreux frequently to the atelier of Gericault whose choice of subjects, especially horses, had a lasting influence on him. During the 1820s he studied with Léon Cogniet, although his early style was more influenced by the work of Stubbs, Morland, Constable and Landseer, exposure to which probably came through Gericault and the painter Eugène Lami who lived in London in the mid-1820s.

Dedreux's stylistic development can be traced from 1830 with the *White Stallion* (exh. Salon 1831; sold London, Sotheby's, 31 March 1965, lot 87), which recalls both the work of Gericault and Stubbs's *Horse Attacked by a Lion* (1770; New Haven, CT, Yale U. A.G.). This style remained unchanged in the *Battle of Baugé* (1838; Narbonne, Mus. A. & Hist.). Although Dedreux did not usually paint history subjects, his penchant for painting horses led him to depict historical cavalry scenes, ranging in size from 1.65×2.30 m (*Baugé*) to 980×810 mm (*White Stallion*). Dedreux's most famous work of the period, *La Fuite* (1840; whereabouts unknown), depicts medieval lovers on horseback and is dominated by his preferred colours at this stage, deep greens, blues and reds, bathed in the brooding light of Romanticism.

Dedreux's mature style dates from *c*. 1848. Although his subjects remained the same, they were characterized by less rugged landscape settings, by luminous colour and crisp light, as in *L'Amazone: Portrait of Marguerite Mosselman Riding in the Champs-de-Mars* (Detroit, MI, Inst. A.).

He received medals from the Salons of 1834, 1844 and 1848, the Cross of the Légion d'honneur in 1857, and commissions from the Duc d'Orléans, Queen Victoria and Napoleon III. Archille Giroux (1820–54) and Eugène Ciceri made lithographs after his works. He was killed in a duel provoked by an argument over the price of a painting.

Bibliography

C. Blanc: *Histoire*, iii (Paris, 1861–76)
J. Doin: 'Alfred Dedreux, 1810–1860', *Gaz. B.-A.*, iv (1921), pp. 237–51
D. F. Mosby: 'Notes on Two Portraits of Alfred Dedreux by Géricault', *A. Mag.*, lviii (1983), pp. 84–5

DEWEY F. MOSBY

Dejoux, Claude

(*b* Vadans, Jura, 23 Jan 1732; *d* Paris, 18 Oct 1816). French sculptor. He worked as a carver and joiner in his native village before studying at the Académie de Peinture et Sculpture in Marseille, where he won second place in the sculpture competition of 1763. He then entered the studio in Paris of Guillaume Coustou. In 1768 he accompanied his fellow student Pierre Julien to Rome at his own expense. He remained in Rome until 1774. On his return to Paris, he was received (*reçu*) as a member of the Académie Royale in 1779. His *morceau de réception*, a very traditional statue of *St Sebastian* (h. 1.08 m; Paris, Louvre), was carved from a block of marble given to him by the Académie because he was too poor to buy his own. In the same year he executed busts of *Aesculapius* and *Hygeia* (bronze versions, Arbois, Hôp.). He was later awarded a commission by the Comte d'Angiviller, Directeur des Bâtiments du Roi, for a statue in the patriotic series of *Illustrious Frenchmen*, producing the standing marble statue of *Nicolas, Maréchal de Catinat* (exh. Salon 1783; Versailles, Château). The bulk of his work has, however, disappeared: his statue of a *Doctor of the Greek Church* for St Geneviève, Paris, was destroyed in 1791, and a colossal statue of *Fame* designed for the same church during its transformation into the Panthéon never got beyond the stage of a model (untraced). His monument to *Gen. Louis Desaix de Veygoux* (bronze, 1808) in the Place des Victoires, Paris, was demolished after the Restoration of the Bourbon monarchy in 1814, and his sculpture for the façade of the Pavillon de Flore at the Louvre, Paris, was destroyed during the reconstructions of the Second Empire (1851–70). Nevertheless, the surviving low-relief of *Charity* (marble, 1788), which serves as a monument to the *Curé Dubuisson* in the church at Magny-en-Vexin, Val-d'Oise, and the terracotta bust of *Marie-Christine de Brignole, Princesse de Monaco* (h. 570 mm, 1783; Paris, Louvre) show Dejoux as a competent portrait sculptor and a modeller of sensibility.

Bibliography

J. Gauthier: *Dictionnaire des artistes Franc-Comtois antérieurs au XIXe siècle* (Besançon, 1892), p. 8
M. Beaulieu: 'Deux Bustes de la fin du XVIIIe siècle', *Rev. Louvre*, 3 (1978), pp. 197–8
Diderot et l'art de Boucher à David (exh. cat., Paris, Admin. Monnaies & Médailles, 1984), no. 129

Delacroix, (Ferdinand-)Eugène(-Victor)

(*b* Charenton-Saint-Maurice, nr Paris, 26 April 1798; *d* Paris, 13 Aug 1863). French painter, draughtsman and lithographer. He was one of the greatest painters of the first half of the 19th century, the last history painter in Europe and the embodiment of Romanticism in the visual arts. At the heart of Delacroix's career is the paradox between the revolutionary and the conventional: as the arch-enemy of JEAN-AUGUSTE-DOMINIQUE INGRES and as the leading figure of the French Romantic movement, he was celebrated for undermining the tradition of painting established by JACQUES-LOUIS DAVID, yet he nevertheless enjoyed official patronage from the beginning of the Restoration (1814–30) until the Second Empire (1852–70).

Delacroix disliked the 19th century, hated progress, was conservative in his tastes and manners, but—for Baudelaire, at least—was the most modern of artists, resembling the great painters of the First Republic (1792–1804) and the First Empire (1804–14) in his wish to rival the written word. His subjects, like those of David,

were serious and historical, but he replaced the Stoic ideal with one equally grand and dramatic, yet lacking any kind of moral or political certainty. Nevertheless, he was the last representative of the Grand Manner. He lived long past the years of the Romantic movement, although a Romantic interest in suffering, insanity, death and violence is always present in his art, which is essentially literary and personal.

I. LIFE AND WORK

1. *Early years, to 1821*

Eugène Delacroix's father, Charles Delacroix (*d* 1805), was briefly Ministre des Affaires Etrangères during the Directory (1795–9) and was later Préfet de la Gironde. At the time of Delacroix's birth, he was Ministre Plénipotentiaire at The Hague. Théophile Silvestre was the first to suggest, in his *Histoire des artistes vivants* (Paris, 1856), that the French statesman Charles-Maurice de Talleyrand was Delacroix's father, a persistent rumour for which there is no documentary evidence. The cultivated milieu in which Delacroix grew up, and where Talleyrand was a frequent visitor, was that of his mother, Victoire Oeben (*d* 1815), daughter of the cabinetmaker Jean-François Oeben. Delacroix's step-grandfather was the well-known cabinetmaker Jean-Henri Riesener, and his mother's half-brother was the painter Henri-François Riesener (1767–1828), who was a pupil of David, and who later took a warm interest in Delacroix's education. Delacroix was always conscious of his French origins but was one of the first artists of his generation to respond to the writings of Goethe and Schiller and to Shakespeare, Sir Walter Scott and Lord Byron; he first read Byron's *Childe Harold* (begun 1809) with the help of his aunt, Henri-François Riesener's wife. It is probable that during his youth he absorbed from this clever and cosmopolitan background a breadth of interest uncommon during the long isolation of French culture under successive Napoleonic regimes. He was not only one of the first 'Shakespeareans', as the writer Etienne-Jean Delécluze called the young Romantics, but was also devoted to the writings of Voltaire and

was passionately fond of Mozart's opera *The Marriage of Figaro*. Nevertheless, Delacroix's work is as inconceivable without the Romantic movement as Antoine-Jean Gros's would have been without Napoleon's battles and campaigns.

Between 1806 and 1815 Delacroix attended the Lycée Imperial (now Lycée Louis-le-Grand) in Paris, which was noted for its teaching of Classics. He won prizes in Classics and drawing and acquired a love of French literature that he retained the rest of his life. While still at school, he met Pierre Guérin, a friend of his uncle Henri-François Riesener, and, having decided to study painting, he entered Guérin's popular studio in October 1815. The studio came to be seen as a nursery of Romanticism: Gericault, seven years older than Delacroix, was one of his fellow students, as were Ary Scheffer and Léon Cogniet. Delécluze, commenting on Guérin's teaching methods, related that, like David, he was a liberal master. In 1816 Delacroix entered the Ecole des Beaux-Arts and from an early age he frequently visited the Musée du Louvre, where he was particularly attracted to the paintings of Raphael, Titian, Veronese and Rubens. During this time he met and admired the young English artist Richard Parkes Bonington, who was also making copies after Flemish paintings in the Louvre.

Delacroix's first commission, a *Virgin and Child* (1819; Orcemont, parish church), was painted in the tender and sentimental vein of early Romanticism. His notes for it contain studies after Leonardo, Raphael and Domenichino, although in appearance the painting is very nearly a pastiche of Raphael. In 1821 he executed a second religious painting, a *Madonna of the Sacred Heart* (Ajaccio Cathedral), originally commissioned from Gericault. It appears to have been based on Gericault's style: sweetness has been abandoned for a monumental strength, and, although rather clumsy in handling, it is impressive in its uncompromising solidity. Several drawings (Paris, Louvre) he made for it were starting-points for later compositions, and, in spite of its awkwardness, there is already some hint of the power, relief and eloquence of gesture that were later to characterize his art. During

these years his interests—copying Old Masters in the Louvre, experimenting in lithography and drawings from coins, medals and Persian miniatures—found expression in a variety of ways. He dabbled in literature, played the harpsichord and violin and in 1821 painted four panels representing *The Seasons* (Paris, Mme F. Jouët-Pastré priv. col., see Johnson, 1981–9, nos 94–7) in Pompeian Revival style for the dining-room of the actor François-Joseph Talma.

2. Public recognition, 1822–31

In 1822 Delacroix made his début at the Salon with *Dante and Virgil* (or the *Barque of Dante*; Paris, Louvre; see fig. 21), which caused a sensation and immediately heralded him as a major figure of the French school. The theme of a fragile craft on a stormy sea was derived from Gericault's *Raft of the Medusa* (1819; Paris, Louvre; see col. pl. XIV), and the curious composition combined elements from the works of Michelangelo, Rubens and John Flaxman with swaying upright figures and with the horizontal naked bodies of the damned who cling to the boat. The pose of Dante in the painting was already part of Delacroix's invented repertory of pathetic gesture. The literary subject distinguishes it from the works of Gericault and Gros, its immediate models, while the palette, though sombre, is rich in hue, unlike the livid tones of Gericault's work. Moreover, as one critic remarked, Delacroix may have been constitutionally incapable of painting his own times, which were, in any case, so different from those of the Napoleonic era. Guérin had tried to discourage Delacroix from exhibiting the picture, but Gros admired it, and it was bought by the State

21. Eugène Delacroix: *Dante and Virgil* (or the *Barque of Dante*), 1822 (Paris, Musée du Louvre)

22. Eugène Delacroix: *Massacres at Chios*, 1824 (Paris, Musée du Louvre)

and exhibited at the Musée du Luxembourg.

For the Salon of 1824 Delacroix painted the *Massacres at Chios* (Paris, Louvre; see fig. 22), a huge canvas inspired by contemporary life in the Near East. Oriental subjects had interested him since his youth: before having painted *Dante and Virgil* he had been considering a scene from the Greek War of Independence (1821–32), which was at that time attracting much interest in France. After his success at the Salon of 1822, he returned to the idea and in 1823 decided on the subject of Turkish massacres of the Greek population on the island of Chios, in which all but 900 of the 90,000 inhabitants were killed or abducted. Although this was a subject from contemporary life, Delacroix knew nothing about Greeks or Turks and based his scene on newspaper reports and eye-witness accounts, supplemented by a study of costumes and accessories in the collection of his friend, the amateur painter M. Auguste. The immediate pictorial source was probably Gros's *Bonaparte Visiting the Victims of the Plague at Jaffa, 11 March 1799* (1804; Paris, Louvre; see col. pl. XVIII).

As Delacroix worked on the painting, he returned to his reading of Dante, and notes in his *Journal* reveal a morbid and literary response: 'O smile of the dying . . . embraces of despair'. The most pathetic motif, that of the child trying to feed from the breast of its murdered mother, occurred in Colonel Olivier Voutier's account, *Mémoires sur la guerre actuelle des Grecs* (1823), but was also used as a motif in earlier subjects dealing with plagues. The wicked Turk on his rearing horse appears to belong to the group of Oriental subjects in Byron's writings; at this time Delacroix was reading Byron's *Giaour* (pubd 1813), which he illustrated in 1826. The *Combat of the Giaour and Hassan* (oil on canvas; Chicago, IL, A. Inst.) shows the Giaour as a heroic figure, but the ambiguity of the triumphant Turkish horseman in the painting is characteristic of Delacroix. The richly sombre coloration, very different from the contrasting hues of *Dante and Virgil*, probably owes something to Delacroix's study of Spanish art; the assistance of his friends, the watercolourists Charles Soulier (*fl* after 1774) and Thales Fielding, combined with the example of Constable, whose work he had known for some time, gave the surface of the picture an unfamiliar brilliance of effect, causing Delécluze to make the startling comparison with Watteau's *Pilgrimage to the Isle of Cythera* (1717; Paris, Louvre).

The State's purchase of the *Massacres at Chios* enabled Delacroix to visit England, where he stayed from May to August 1825. His first impressions were unfavourable: he found London immense and 'lacking in all that we call architecture', and the people seemed savage and ill-bred. He was received by the painters David Wilkie, whose sketches he admired; William Etty, whose Rubensian nudes were rather like his own; and Sir Thomas Lawrence, 'the flower of politeness', who showed him his incomparable collection of Old Master drawings. With Bonington, Delacroix visited the collection of armour (most London, Wallace) belonging to Dr (later Sir) Samuel Rush Meyrick and sketched various pieces. He was also able to improve his knowledge of contemporary British literature, notably Byron and Scott, and earlier literature, especially Shakespeare. He attended

the theatre and saw Edmund Kean's performances in Shakespeare's *Richard III*, *Othello* and *The Merchant of Venice* and was struck by a musical version of Goethe's *Faust* at the Theatre Royal, Drury Lane, which he recalled many years later. The painting most obviously influenced by his stay in England was the portrait of *Louis-Auguste Schwiter* (1826; London, N.G.), rejected at the Salon of 1827. It is a bravura exercise in the manner of Lawrence, whose work inspired the pose, elegance and handling. In the same year Delacroix painted a subject taken from Byron, the *Execution of the Doge Marino Faliero* (London, Wallace), on which Bonington's Anglo-Venetian manner has left its mark. Byron's poems, which Delacroix probably read in Amédée Pichot's French translation, were to provide him with exactly the kind of subject to which he was drawn. *Greece on the Ruins of Missolonghi* (1826; Bordeaux, Mus. B.-A.), Delacroix's second subject from the Greek Wars, is perhaps in part a tribute to Byron, who had died at Missolonghi in April 1824. Indeed, Byron, Greece and the exhibition in aid of the Greek cause held in 1826 at the Galerie Lebrun in Paris (to which Delacroix sent *Marino Faliero*) all absorbed his attention at this time.

The *Death of Sardanapalus* (1827; Paris, Louvre; see col. pl. X) was shown at the Salon of 1827 (though after the opening, from Feb 1828) and became as important a manifesto for Romantic painting as Victor Hugo's *Préface de Cromwell* of the same year was for Romantic literature. It provoked more general hostility than any other painting by Delacroix, and Sosthène de la Rochefoucauld, the Surintendant des Beaux-Arts, warned the artist that, unless he changed his style, he could no longer expect to receive State commissions. Delacroix instantly became the leader of the Romantic school. In fact, the painting bears a slight resemblance to Horace Vernet's *Massacre of Mamelukes* (1812; Amiens, Mus. Picardie) and rather incongruously combines Byronic exoticism and melancholy with the cheerful sensuousness of Rubens, for which Delacroix's own copy of a *Nereid* (c. 1822; Basle, Kstmus.) from the Flemish artist's *Landing of Marie de' Medici at Marseille* (1622–5; Paris, Louvre) may have provided a model.

The subject is ostensibly based on Byron's *Sardanapalus* (1821), although, unlike Delacroix's painting, Byron's play ends with the Assyrian king alone on a pyre set alight by Myrrha. The tangle of bodies and the friezelike foreground countering the extravagant recession make this a difficult picture. Delacroix remained attached to the painting, which stayed in his studio until 1846.

In 1828, in the course of a somewhat short-lived friendship with Victor Hugo, Delacroix made costume designs for the latter's play *Amy Robsart* (1828), based on Scott's novel *Kenilworth* (1821) and produced at the Théâtre de l'Odéon in Paris that year. In February of the same year, a set of 17 lithographs illustrating Goethe's *Faust* was published to accompany a new French translation by Albert Stapfer. As Delacroix later remembered, these were full of the grotesque and a 'sense of the mysterious'. The plate of *Faust and Mephistopheles on Walpurgisnacht* inspired at least one early imitation, Scheffer's *The Dead Go Quickly* (1829; Lille, Mus. B.-A.). In 1828, Delacroix received a government commission to depict the *Battle of Nancy* (Nancy, Mus. B.-A.), and the following year the Duchesse de Berry commissioned him to paint the *Battle of Poitiers* (Paris, Louvre). Both owe much to Gros's work but also to Delacroix's recognition of the picturesque possibilities inherent in medieval subjects, presented as moments of dramatic conflict. This is also the theme of the *Murder of the Bishop of Liège* (1829; Paris, Louvre), based on Scott's novel *Quentin Durward* (1823) and bought by Ferdinand-Philippe, Duc d'Orléans. These paintings show that Delacroix's palette darkened in these years, possibly owing to his use of bitumen, a pigment also favoured by English artists, but also, probably, to his dawning interest in Rembrandt, shared by such friends as Bonington and Hippolyte Poterlet (1803–35).

Delacroix's next important painting, *Liberty Leading the People* (1830; Paris, Louvre; see col. pl. XI), shows the obvious influence of Gericault, which had been evident even in his early works. Like the *Raft of the Medusa*, *Liberty* combines fact with allegory and represents a scene witnessed by Delacroix near the Pont d'Arcole in Paris during the early, troubled days of the July Monarchy as a

heroic emblem of the struggle for freedom from oppression. Despite the difficulties inherent in representing an ideal in the form of a realistic portrait of a young working-class woman, the painting was generally well received by both critics and the public, was bought by the State (though exhibited for only a few months) and earned Delacroix the Légion d'honneur.

3. North Africa and Spain, 1832

During the late 1820s and early 1830s Delacroix had maintained his interest in the East and in the last years of the Restoration painted a number of Oriental genre scenes. Between January and July 1832, he accompanied the Comte de Mornay, Louis-Philippe's ambassador to the Sultan of Morocco, to Spain, Morocco and Algeria. The notes and sketches he made on this journey provided him with material for the rest of his life. The most important result of the journey was the discovery, as he saw it, of a living antiquity in the nobility of bearing and gesture that he saw around him. As he wrote to a friend, 'Imagine what it is to see, lying in the sun, walking in the streets, or mending shoes, men of consular type, each one a Cato or a Brutus'. The pages of his sketchbook from this journey are filled with written descriptions of a richly pictorial kind and finely composed vignettes drawn from life. From Meknes he wrote, 'At every step there are ready-made pictures', expressing an enthusiasm for the external reality of objects that was matched only by his interest in painting flowers during the 1840s. His visit to Spain, though brief, was equally intense, and in addition to admiring paintings by Murillo, he was reminded, by the bustle of life in the streets, of those of Goya. The Dominican monastery at Cádiz later provided the setting for Christopher Columbus at the Monastery of La Rabida (1838; Washington, DC, N.G.A.). In Algeria he was able to visit a harem, where he admired the tranquil domestic occupations of its inhabitants. While there he made notes that formed the basis for his first large painting based on his recollections, the Women of Algiers in their Apartment (1834; Paris, Louvre, see fig. 23). Although this work seemed to herald a new mood

of realism combined with a scientific use of colour, it is not, however, the fragment of observed life it appears. The pose of the figure on the left (of which there is a watercolour of 1832; Paris, Louvre) is close to one in a Persian miniature that Delacroix copied in 1817, and the tall figure seen from the back adopts the curious twisting pose of Ariadne in Titian's Bacchus and Ariadne (1522–3; London, N.G.). The colour, like the forms, is calculated and is a blend of observation and invention. The harmonious lines, the flatly drawn and decorative character of many of the elements and the occasionally exaggerated brilliance of the colours—particularly the reds, pinks and blues— later appealed to Matisse. A similarly artful use of colour intensified for decorative effect, while giving an appearance of documentary realism, is found in the painting of the Comte de Mornay's Apartment (1832–3; Paris, Louvre).

4. Literary and historical subjects and mural decorations, 1833–c. 1850

Although Arab subjects were to recur in the years following Delacroix's journey to North Africa, the general tenor of his work became increasingly literary. The death of his young nephew, Charles de Verninac, in New York in 1834 was a source of profound grief and almost certainly played a part in the increasingly sad character of his subject-matter during the 1830s. The Prisoner of Chillon (Paris, Louvre), painted for the Duc d'Orléans in 1834, depicts François Bonivard (c. 1496–1570) in prison for opposing the increasing power of Emanuel-Philibert, 10th Duke of Savoy, and watching helplessly as his two younger brothers die. It is at least possible that the tragic mood of the picture was intensified by the death of the young Verninac.

In 1834, while staying with his cousin Alexandre Bataille at the abbey of Valmont, Delacroix painted three subjects in fresco (Anacreon and a Girl, Leda and the Swan and Bacchus and a Tiger; in situ) as overdoors in a corridor of the abbey. All mythological, they are Delacroix's only known work in fresco, a technique that, unlike Ingres's pupils, he did not use for his decorative schemes. However, this experiment

23. Eugène Delacroix: *Women of Algiers in their Apartment*, 1834 (Paris, Musée du Louvre)

marks an increasing interest in the technical problems of mural painting. The subjects, in a light-hearted antique idiom, as well as the decorations for the Salon du Roi at the Palais-Bourbon in Paris that were already in hand (see below), developed the classicism he had discovered in Morocco, which he then characteristically applied to literary subjects. At the same time, he moved closer to Titian and to Rubens, two artists whom he considered closest to the true spirit of antiquity. *St Sebastian Tended by the Holy Women* (1836; Nantua, St Michel) recalled Titian for some critics; others mentioned Pietro da Cortona and Carlo Maratti. The painting also contains references to the work of Michelangelo and, in the saint's pose, to Rubens's *Descent from the Cross* (1612–14;

Antwerp Cathedral). While preparing drawings for this subject, Delacroix began to plan one of his most striking pictures, *Medea* (exh. Salon 1838; Lille, Mus. B.-A.). Indeed, this can be seen as the culmination of the various currents of the 1830s, combining the exoticism of the *Women of Algiers in their Apartment* and the frenzy of the *Fanatics of Tangiers* (1838; Minneapolis, MN, Inst. A.) with references to the Old Masters, specifically Leonardo's *Virgin of the Rocks* (1482–3), Raphael's *La Belle Jardinière* (1507) and especially Andrea del Sarto's *Charity* (1518; all Paris, Louvre). The result is a highly original example of Delacroix's own statuesque, allegorical figures.

During the 1830s Delacroix received two commissions for pictures to hang in Louis-Philippe's

Musée de l'Histoire de France at the château of Versailles: in 1834 the *Battle of Taillebourg* for the Galerie des Batailles (1837; *in situ*) and in 1838 the *Entry of the Crusaders into Constantinople* (1840; Paris, Louvre) to be placed in the Salles des Croisades. The subject of the earlier painting was Louis IX's victory over the English in 1242 as they guarded the bridge over the River Charente at Taillebourg. Delacroix, who attended the opening of the gallery on 10 June 1837 before the *Battle of Taillebourg* was actually installed, found the galleries anything but historic and felt that the painting had no place there. Clearly indebted to Rubens, it also contains several archaizing elements that almost recall Uccello's panels of the *Rout of San Romano* (Florence, Uffizi; London, N.G.; Paris, Louvre): a restricted field of vision, an enlarged scale for the foreground figures and a central white horse of wooden solidity, in spite of its tossing head. The same imaginative fancy is brought to bear on the second commission, depicting the arrival in Constantinople of one of the leaders of the Fourth Crusade (1202–4), Baldwin VI of Flanders, who in 1204 became the first Latin emperor of Constantinople, together with a Venetian, Tommaso Massini, who became Patriarch, and Doge Dandolo, who thus added part of the eastern empire to his own possessions. Delacroix called the picture his 'third massacre', but it shows the invaders' procession through the streets rather than the actual assault on the city. The painting is a magnificent summation of Delacroix's mature style: Count Baldwin reins in his horse with a gesture appropriate to an Arab chief; the central group, enlarged, as in the *Battle of Taillebourg*, but without loss of reality, is united in a complex mass. A dreary sadness fills the picture, conveyed by a half-light that Delacroix found in Veronese's paintings (*see* §II BELOW). As the new barbarians, the Christians arrive in the city, their pennons and winged helmets fluttering against the smoking sky, while the infidel, imploring at their feet, have all the beauty and pathos of the Greeks in the foreground of the *Massacres at Chios*. The *Entry of the Crusaders* was Delacroix's last medieval subject on a large scale.

The work of Delacroix's mature years was largely dominated by mural decoration. Through his friend Adolphe Thiers, who had become Ministre du Commerce et Travaux Publics, he received a commission in 1833 to decorate the Salon du Roi in the Palais-Bourbon (now Assemblée Nationale), Paris, and the library of the Chambre des Députés (begun 1838) in the same building. In 1840 he decorated the cupola and half-dome in the library of the Senate in the Palais du Luxembourg. Further commissions came in rapid succession: the paintings for the chapel of Saints-Anges in St Sulpice (1849; *see* §5 BELOW), the ceiling of the Galerie d'Apollon in the Musée du Louvre (1850) and the Salon de la Paix in the Hôtel de Ville (1851; destr. 1871), all in Paris.

As the Salon du Roi in the Palais-Bourbon was a dark room with many doors and windows, Delacroix realized that his paintings there would have to have a strong effect of relief. His decoration represents the components of the State—Industry, Agriculture, Justice and War—above friezes depicting related subjects. On the piers dividing the room he painted allegories of the rivers of France. For the five small cupolas of the library in the Chambre des Députés, painted in 1845–7, he chose subjects traditional for the divisions of a library: Philosophy, Natural History, Theology, Literature and Poetry. In the half-domes, his depiction of the dawning of civilization and its collapse—*Orpheus Bringing the Art of Peace to Primitive Greece* and *Attila and his Hordes Overrunning Italy and the Arts*—epitomizes the sense of a precarious balance between civilization and barbarism, which was so often the subject of his work and which reached its apotheosis in the ceiling of the Galerie d'Apollon in the Louvre. In this case, it has been suggested that the scheme may be indebted to a cyclical concept of history held by Delacroix's friend the painter Paul Chenavard, which was an elaboration of a view first proposed by Giambattista Vico, whose *Scienza nuova* (Naples, 1725) had been translated from the Italian in 1827 by Jules Michelet.

The mural commission for the library of the Senate comprised paintings for a cupola, pendentives and a half-dome, prepared, as was Delacroix's habit, on canvas in the studio. The cupola

decoration is loosely based on Canto 4 of Dante's *Inferno* and depicts great figures of antiquity, forming four groups symbolizing the achievements of the human spirit and all represented in a continuous landscape: Dante and Virgil; Orpheus; Socrates, Aspasia and Alcibiades; and a group of distinguished Romans that includes Marcus Aurelius, Portia, Trajan and Julius Caesar.

Delacroix's painting in the Galerie d'Apollon was part of the restoration of the room that had been begun just after the Revolution of 1848. After a fire in 1661, the gallery had been redecorated under the supervision of Charles Le Brun using the sun symbolism often chosen as a compliment to Louis XIV. The decorative scheme had never been completed, and the central panel of the ceiling remained empty. Delacroix, whose sympathies for Le Brun were limited, nonetheless chose to adopt the original scheme, a combat between Apollo and the serpent Python, after which Victory descends to crown Apollo, and Iris unfurls her scarf as a symbol of the triumph of Light over Darkness.

During the 1840s an increasing preoccupation with his health led Delacroix to nurse his strength and to spend more time in the country. He rented a house at Champrosay, near Fontainebleau, and also spent part of several summers at Nohant, Indres, with the composer Chopin and the writer George Sand. In 1843 his set of lithographs illustrating Shakespeare's *Hamlet* appeared, and he completed the series from Goethe's play *Goetz von Berlichingen* (1771). Around this time he also painted several pathetic subjects from literature, including the familiar theme of the *Shipwreck of Don Juan* (1840; Paris, Louvre) from Byron's poem *Don Juan* (begun 1818) and several subjects from Shakespeare's *Romeo and Juliet* (*Romeo Bids Juliet Farewell*; priv. col.), *Macbeth* (*Macbeth and the Witches*, 1825; London, Wildenstein's; *Lady Macbeth Sleepwalking*, 1850; on dep. Ottawa, N.G.) and *Othello* (*Othello and Desdemona*, 1849; Ottawa, N.G.). In 1844 he depicted Marcus Aurelius, one of his moral heroes, in *Marcus Aurelius on his Deathbed* (Lyon, Mus. B.-A.). This gives a prominent place to his son Commodus, already a very unpromising young man, and sounds the ever-present note of pessimism as the spectator

ponders the reign of tyranny that is to follow. Delacroix was not altogether pleased with the picture, a feeling apparently shared by the jury of the 1845 Salon. When the government wished to acquire it for the Musée des Augustins in Toulouse, Delacroix requested that the *Sultan of Morocco and his Retinue* (1845; Toulouse, Mus. Augustins) be sent in its place.

The stoic resignation of Marcus Aurelius and the spiritual isolation of the poet Torquato Tasso in *Tasso Imprisoned in the Madhouse at Ferrara*, the latter a subject painted by Delacroix in 1824 (Zurich, Stift. Samml. Bührle) and in 1839 (Winterthur, Samml. Oskar Reinhart), were qualities that he also found in certain religious subjects. For example, his first commission for a church mural, the *Pietà* (1844) in St-Denis-du-St-Sacrement, Paris, is a continuation of his own distinctive vein of pathos combined with formal qualities derived from Rosso Fiorentino. Throughout his later career he returned to religious themes of suffering and isolation, though not always in response to a commission.

5. Later years, c. 1850–1863

From his early years Delacroix, like Gericault, was attracted by the savagery of wild animals; a note made in Morocco mentions a scene of fighting horses. Among the precedents for this kind of imagery was the antique group of a *Lion Attacking a Horse* (Rome, Mus. Conserv.), said to have been particularly admired by Michelangelo and copied in stone (1740; Rousham Park, Oxon) by Peter Scheemakers. George Stubbs used the theme in a naturalistic setting in several paintings (e.g. *Horse Attacked by a Lion*, 1770; London, Tate) of which Gericault made at least one copy (1820/21; Paris, Louvre). In Delacroix's versions of the subject, he was able to synthesize the classical with the exotic, with his studies of Ecorché (Fr. flayed bodies), with the example of English art and with the work of Rubens, of whose paintings of hunts he owned engravings by Pieter Claesz Soutman. On 25 January 1847 he described two of them in detail, making clear how important to him were the formal values of movement, variety and unity. Of his three great lion hunts, there remain a fragment (1855; Bordeaux, Mus. B.-A.) and two complete

paintings (1858; Boston, MA, Mus. F.A.; 1861; Chicago, IL, A. Inst.). The one in Chicago is the most spacious and free in handling, and its circular, dancelike movement suggests a perpetual struggle, one of the underlying themes in which, however, form and content are inseparable.

After Delacroix's brief interest in the events of 1848—Théophile Thoré, in his review of the Salon of 1848, implied that Delacroix had begun to paint a pendant to *Liberty Leading the People*, and he became joint president of the new Assemblée Générale des Artistes—he soon retreated to Champrosay, where he began his great series of flower paintings, of which two finally appeared at the Salon of 1849: *Basket of Fruit in a Flowergarden* (Philadelphia, PA, Mus. A.) and *Basket of Flowers Overturned in a Park* (New York, Met.). In 1850 he began work on sketches for his great commission to decorate the chapel of Saints-Anges in St Sulpice, Paris, which was to occupy him until 1861. The subjects for the walls were *Heliodorus Driven from the Temple* and *Jacob Wrestling with the Angel* and, for the ceiling, *St Michael Defeating the Devil*. *Heliodorus* derives, in theme and treatment, from the work of Raphael, a constant inspiration; *Jacob Wrestling* combines, as do the best of Delacroix's pictures, references to all that he had learnt from his study of nature and the Old Masters, resulting in a work that was to remain a touchstone for succeeding generations of artists.

II. Working methods and technique

Although his critics were chiefly concerned by Delacroix's apparent indifference to technique, very much more than by the nature of his subject-matter, Delacroix himself was more consistently exercised by problems of technique than almost any other artist of the 19th century. An early *Nude Study* (c. 1820; priv. col., see Johnson, 1981–9, no. 4), for example, reveals a correctness in the handling of the transparent glazes, similar to that in David's paintings, with a revealing preference for softly dramatic effects of chiaroscuro. However, from an early age he preferred the works of Gros and Pierre-Paul Prud'hon to those of Guérin and Anne-Louis Girodet. While *Dante and Virgil* (see

fig. 21 above), his earliest Salon painting, is Neoclassical in the sculptural quality of the figures and their parallel relationship to the picture-plane, the handling is strikingly bold when compared with the refined finish of a painting by David or Ingres. Delacroix admired the emphatic handling of paint in the works of Gericault and Gros, in which shadows are so loaded that they become dense and dark. The drops of water on some of the foreground figures in *Dante and Virgil* appear to be pure pigment. It has been suggested, following Delacroix's pupil Pierre Andrieu (1821–92), that these originated from a study of prismatic colour and particularly from a study of the nereids in Rubens's *Landing of Marie de' Medici at Marseille*, one of which Delacroix had copied (*see* §I, 2 above). In the *Massacres at Chios* (1824), he seemed concerned to depart from the sculptural relief of the figures in *Dante and Virgil* and, according to his *Journal*, to be pursuing something like a synthesis of the techniques of Michelangelo and Velázquez. He even mentioned Ingres as a painter whose soft and melting impasto had some of the qualities he was seeking; these qualities he also found in the paintings of Raphael, whose contour was always a model for him. The influence of Delacroix's friends Charles Soulier (who had first taught him the techniques of watercolour) and Thales Fielding, his new knowledge of Constable's work and the example of Bonington combined to lead him in the direction of lighter tonality and liveliness of surface. A group of pastel studies (Paris, Louvre, Cab. Dessins) for the *Death of Sardanapalus* reveals the extent to which he was seeking a pale tonality combined with a startling variety of hue, to be achieved by a literal translation of the pastel technique into the handling of oil paint, something that was later practised by Jean-François Millet, Degas and van Gogh. In Delacroix's work this approach can be seen in the application of graphic techniques of coloration, most memorably in the still-life of hat and staff in the foreground of *Jacob Wrestling with the Angel* in St Sulpice, Paris. Bonington's brilliant work in watercolour and gouache seems to have had the effect of brightening Delacroix's palette, particularly for his smaller pictures: the

use of bright impasto in the *Execution of the Doge Marino Faliero* is a good example. Many years later, when working on the decorations in the library of the Palais-Bourbon, Paris, Delacroix thought about the effect of white ground in watercolour, in which the transparency of the medium allows maximum luminosity. He attempted to achieve a similar luminosity (rather like the Pre-Raphaelites in Britain) by using a white oil ground, a practice that became commonplace with the Impressionists. In the course of his mural decorations he experimented, as did Ingres's pupils, with a number of mixtures, most commonly using a combination of oil and wax. The only time he used the fresco technique was at Valmont, yet the resulting pale luminous quality was one he valued and was able to achieve in other works by the increasing use of pale grounds and translucent pigment. Related to his work in pastel is the technique of *flochetage*, which implies a visible interweaving of brushstrokes. This is particularly associated with his later work; it is found in some landscapes of the 1850s (e.g. *Ovid among the Scythians*, 1859; London, N.G.) and is most noticeable in the murals in St Sulpice. Delacroix had used it earlier in his *Pietà* for St Denis-du-St-Sacrement, Paris, and in the *Entry of the Crusaders into Constantinople* (1840), in which the comparatively blond tonality was achieved, as at St Sulpice, by a mixture of wax and turpentine as well as by a thoughtful application of principles learnt from Veronese.

Repeatedly in his *Journal* Delacroix insisted on the necessity of applying scientific principles to the resolution of technical problems. For this reason, there is little doubt that he was aware of, if not influenced by, the theory of colour proposed by Michel-Eugène Chevreul. For the practising artist, the most significant of Chevreul's ideas was that a colour seen alone will appear to be surrounded by a faint ring of its complementary colour. One of Delacroix's North African sketchbooks contains a note on colour that may be derived from Chevreul (see Joubin), indicating that a half-tone should be made not by adding black but rather the complementary of the colour. Delacroix seems to have applied this principle while working on the *Entry of the Crusaders*, as a

sheet of preparatory studies (Paris, Louvre, Cab. Dessins) shows a colour circle bearing notes on primary colours and their complementaries. However, a new clarity of light and atmosphere in the painting was due primarily to the influence of Veronese, who, as Delacroix noted in his *Journal*, was able to paint brightly without violent contrasts of value (Johnson, 1963). In fact, as Delacroix worked on his large decorative schemes, Veronese was often in his thoughts, precisely because the Venetian artist's work was a splendid example of luminosity and also because his mastery of large, simple forms was a way of achieving an essential clarity of composition in work intended to be seen from a great distance. Delacroix developed a range of brushstrokes partly, presumably, as a result of his interest in the technique of pastel and partly because of his general interest in Venetian art. Critics sometimes suggested the influence of Tintoretto, whose free brushwork and handling of highlights and folds are all comparable with Delacroix's own.

The chief sources of information about Delacroix's technique are the reminiscences of his assistants, Gustave Lassalle-Bordes (1814–68), Louis de Planet (1814–75) and Pierre Andrieu. He had few pupils in any conventional sense, although after receiving his first decorative commission in 1833 he opened a studio for assistants, whom he regarded as employees. His practice cannot be compared with a Renaissance workshop; although Planet's *St Theresa* (untraced) was warmly praised by Baudelaire at the Salon of 1846, none of the artists appears to have absorbed any influence from Delacroix's own practices, nor did they show any marked success in pursuing a career. However, Planet, in his memoirs, indicated that Delacroix was conscientious in teaching the preparatory techniques of mural decoration. Planet recorded in detail the transfer of drawing to canvas, the preparation in grisaille and the supervision of the work. Occasionally he assisted Delacroix in the preparation of such easel paintings as *Marcus Aurelius on his Deathbed*. The memoirs contain a detailed discussion of Delacroix's technique of drawing, one by which he sought to assert the masses first of all. Delacroix drew continually,

copying engravings daily, almost as a musician practises scales. His working drawings, in pencil, black chalk or pen and ink, are generally loose, animated and exploratory. He constantly pursued 'relief', as he called it, which he found above all in Rubens's work, and thought this could best be obtained in drawing by using oval shapes he called *boules*. This was a long-established technique found in Leonardo's work, for example, or some of the pen-and-ink drawings of Raphael, and later used by Gros and Gericault. Delacroix's preoccupation with mass also extended to paint, and Planet explained how the drawing technique could also be applied to the grisaille preparation. Delacroix taught his pupils to attend to these and to use pure tones placed beside one another in a certain order. He stressed the importance of reflections and taught the composition and arrangement of colours on a palette and how to arrange them on the canvas. The order was carefully prescribed: Planet's notes on his master's advice for painting flesh tones are based on observations from nature and are similar to the notes Delacroix occasionally made for himself.

In 1850 Lassalle-Bordes returned to his home in the south of France, and Planet, from Toulouse, a little later. Delacroix's principal assistant on later commissions was Andrieu, who also left an account of their working practices. He described, for example, the 'van Dyck palette' used during the decoration of the library in the Senate of the Palais du Luxembourg, a limited and traditional arrangement to which Delacroix added ultramarine and viridian green. Delacroix generally used a prepared palette on which the colours were in a fixed order, though they could be modified according to the requirements of the picture. It is evident from his work that he increasingly moved towards the use of bright, pure colour of a pale tonal range and in which, as in the work of the Impressionists, the contrasts are of hue rather than of tone. His use of a contour slightly separated from the coloured area it encloses is derived from the work of the Venetians, especially Veronese; this particular use of outline, not usually associated with Delacroix, was also found in the work of Millet and Degas. As the range of Delacroix's style and brushwork reveals, the technical experimentation was unceasing. However, it was his use of colour at the service of his imagination, rather than in pursuit of a documentary and scientific realism, that provided resources for artists of a younger generation, Odilon Redon and Gauguin being the keenest followers of his example. For an illustration of Delacroix's.

III. CHARACTER AND PERSONALITY

Delacroix's work had much to do with his character; this is the essence of his romanticism that, as Baudelaire argued, lay neither in subject-matter nor in style but in a way of feeling. Delacroix's first wish had been to write, and several short pieces survive from 1817: a novella set in the time of William the Conqueror and a sombre drama entitled *Victoria*. They perhaps owed their initial inspiration to the ruins at Valmont Abbey, where he first felt the lure of the past. His parents died when he was young, and all that he inherited was a lawsuit. Poor, proud and dispossessed, he nevertheless contrived, in a Parisian way, to live a rather grand social life. He was a frequent guest at François Gérard's salon, and there are numerous descriptions in his *Journal* of dinner parties, concerts and visits to the opera. He was deeply pessimistic; the range of his subjects makes clear his predilection for pathos, if not tragedy, and there are few exceptions to this in his work. He therefore found Shakespeare a particularly rich source of inspiration, especially subjects taken from *Hamlet*, with whose principal character he probably felt some affinity; an early *Self-portrait* (1829; Paris, Louvre) is sometimes thought to represent him as this character. His active social life was often a source of ironic and contemptuous comment, and as he grew older, he felt an increasing need for periods of solitude or to be in the company of his closest friends. One of the most valued was Chopin, 'a man of rare distinction, the truest artist I have ever met'. The two enjoyed discussing the principles of musical composition, and on one occasion Chopin explained the use of counterpoint in music. In spite of his acknowledged role as leader of the Romantic movement

in painting, Delacroix maintained that even in that domain he was a pure 'classique', valuing balance, order and clarity above all. His tastes in music were largely for works by 18th-century composers, while in literature he liked Voltaire and admired Jean Racine but could spend days happily reading Alexandre Dumas *père*. His early interest in writing found expression in the consistently literary character of his work, but he also began to publish some of his writings on aspects of art, the first appearing in 1829. He published articles on Poussin, Gros, Raphael, Michelangelo and Prud'hon but, like Joshua Reynolds, excluded some of his favourite artists from his essays. His thoughts on art, although occasionally theoretical—as in his consideration of the Paragone (the question of the relative qualities of the different arts)—were always discussed with some particular painterly problem in mind. He even began work on a dictionary of art, but this project was never completed.

In a mood of high spirits accompanying the favourable reception of *Dante and Virgil* and its purchase by the State, Delacroix began to keep a journal in 1822. His diaries break off in 1824, and when he resumed them in 1847, 23 years later, the tone is far more serious, with extended passages discussing such aesthetic issues as the relative qualities of Beethoven and Mozart, both of whom he found 'modern'. Nor was he afraid to describe his moods of melancholy. The journal, which conveys something of the range and spaciousness of his art, is written with transparent honesty and good sense.

In spite of his official success and his social position, he admitted to having a wish for *gloire*. He was, not surprisingly, sensitive to criticism, and it must have been painful to his dignity to have made so many fruitless visits to the Académie des Beaux-Arts when seeking election to its ranks; he was eventually successful, on the eighth attempt, in 1857. His election, which allowed him to teach at the Ecole des Beaux-Arts, marked the point at which he began systematically to arrange his thoughts on the art and artists of the past. He frequently changed his choice of favourite artists, but his interests generally reflected problems of

composition. The 'darkness' he found in Spanish art attracted him when he was working on the *Massacres at Chios*, while Veronese's 'splendid afternoon light' delighted him as he painted the *Entry of the Crusaders into Constantinople*.

In the course of painting the *Massacres at Chios*, Delacroix reflected on the 'Romantic' label that had been attached to his name: 'If by romanticism they mean the free manifestation of my personal impressions, my effort to get away from the types eternally copied in the schools, my dislike of academic recipes, then I admit that not only am I romantic but also that I have been one since I was fifteen.'

IV. Critical reception and posthumous reputation

From the outset, the critics at the Salons found Delacroix's works challenging. His restless pursuit of forms and techniques appropriate to an art tied to his own imaginative response to literature could not fail, at times, to appear unorthodox. *Dante and Virgil*, in many ways a conventional painting, struck Delécluze, a former pupil of David, as 'a daub', when it was shown at the Salon of 1822, though he acknowledged its energy of form and colour. He felt that Delacroix and his friends were 'Shakespeareans', borrowing English techniques and dealing in extravagant and exotic subject-matter. Though he never denied Delacroix's gifts, he did not find them much to his taste, though he tried to judge them on their own terms. He was offended by what seemed a deliberate pursuit of ugliness in the *Massacres at Chios*: the cadaverous hues, so satisfactory to Delacroix, were unpleasing, and the suffering depicted seemed to exceed the limits of artistic propriety. Nonetheless, he conceded that the artist had vigour and a true sense of colour. Charles Paul Landon, who, like Delécluze, had received a traditional training, found that the *Massacres* turned ugliness into a system. Stendhal, who would have liked to have admired Delacroix, found that he could not, though he praised a sense of movement in which he thought he discerned the influence of Tintoretto. In short, an older generation of

critics, who judged Delacroix's work by the standard of moderation, and of Nicolas Boileau's *L'Art poétique* (Paris, 1674), were affronted by what they saw as a cult of misery and ugliness. For Auguste Jal and Adolphe Thiers, on the other hand, occasional faults of execution did not conceal the evidence of a rich imagination, and both were touched by the beauty of the conception. Delacroix, not averse to having publicity surrounding his work, had deliberately chosen the subject of a massacre for its ability to arouse considerable interest. The scale and dramatic incident of his treatment, combined with such a subject, made public notice inevitable. It is clear from contemporary comments, and not only those that were hostile, that Delacroix was perceived as setting out to subvert Neo-classical practice. The artist Arnold Scheffer (1795–1858), not unsympathetic to the painting, wrote that it was, more than any other work, in opposition to tradition and that Delacroix was taking as much trouble not to arrange his picture as David's pupils took to arrange theirs. Delacroix's position as an *enfant terrible* was established. The critics most sympathetic to Delacroix's work in the 1820s were Jal, a former naval officer, and Thiers, who later became a government minister in the July Monarchy. Thiers (sometimes thought to have been prompted by his friend Gérard) wrote in particularly glowing terms about *Dante and Virgil*, in which he recognized spiritual affinities with Michelangelo and Rubens, and he announced to his readers that Delacroix had 'received genius'.

Although neither the *Execution of the Doge Marino Faliero* nor the *Agony in the Garden* (1824–7; Paris, St-Paul-St-Louis) could be thought to have anything of the disturbing character of the *Massacres*, they both attracted strongly worded criticism. Writing for *Le Globe*, Louis Vitet, although a strong sympathizer with the Greek cause, seems to have had no particular sympathy for the new school and took Delacroix to task for an excessively literary treatment in *Marino Faliero*. In fact, as was often the case, the chief burden of his criticism fell on what he felt were faults of drawing and colour. Delécluze, too, complained of the treatment of the subject, the drawing and particularly the prominent position of the dazzling white staircase, finally dismissing the work as a 'brilliant sketch'. Once again Jal took for a virtue what Vitet had seen to be a fault; the design that Vitet found too mannered was for Jal charming in that it recalled medieval wood-engravings. Jal, with some prescience, added that Delacroix would not always retain the small-scale and mannered appearance of *Marino Faliero*, of which he had so many imitators. As for the *Agony in the Garden*, Jal found the figure of Christ too human, while Delécluze disliked Christ's stoic resignation. Almost all critics, however, found the angels appealing, Delécluze remarking that they looked like pretty English schoolgirls.

On the other hand, the *Death of Sardanapalus* stirred up a roar of indignation that, however, did not include Stendhal or Victor Hugo. On this occasion, Jal shared Delécluze's view that the picture lacked unity. However, he subsequently wrote of Delacroix's gifts in terms that anticipated Baudelaire, expressing his view that his execution was almost savage, that Dante would have understood him and that his palette was rich and terrible. *Liberty Leading the People*, shown at the Salon of 1831, was probably the most discussed of Delacroix's submissions. Delécluze and Landon were doubtful of its merits, the former admiring the concept but finding it exaggerated, the latter appreciating the composition but intensely disliking the figure of Liberty. The greatest enthusiasm was expressed by the young poet Heinrich Heine, who found in it 'the real appearance of the July days' (*Französische Maler: Gemäldeausstellung in Paris, 1831*; Hamburg, 1834). Victor Schoelcher, writing for the newly founded journal *L'Artiste*, whose editor Achille Ricourt was a friend of Delacroix's, mentioned the painter's 'transformation through the brush of the ugly into an object of beauty'. The young Gustave Planche objected to the alliance of fact and allegory but within two years was writing with approval about the painting for that very reason.

During the July Monarchy, reviews of Delacroix's work continued to be mixed, and Planche's sympathies moved away from Delacroix as he looked for a less purely Romantic artist. Jal

and Thiers ceased to publish art criticism. However, Delacroix's cause was taken up by several young critics: Maurice-Alexandre Decamps (1804–52), brother of the painter, Alexandre-Gabriel Decamps; Théophile Thoré; Théophile Gautier; and Charles Baudelaire, the critic whose name, more than any other, is linked with Delacroix's. In his poem *Les Phares*, Baudelaire characterized the artist as 'a lake of blood haunted by wicked angels', an extreme example of his tendency to stress the molochism, as he termed it, of Delacroix's imagination. On 30 May 1856 Delacroix admitted in his *Journal* that Baudelaire was right to claim that he found enjoyment in the terrible but he was anxious to disclaim any affinity with Edgar Allan Poe, whose incoherence and obscurity of expression were not at all to his taste. The 35 canvases Delacroix exhibited in 1855 at the Exposition Universelle in Paris created a favourable impression. The Salon of 1859, on the other hand, was somewhat unsatisfactory, and Philippe Burty referred to it as the painter's Waterloo. Maxime Du Camp's criticism was particularly wounding and Delacroix never again showed at the Salon.

Delacroix's posthumous reputation began almost immediately after his death in 1863. The studio sale organized by Burty six months after his death brought in 360,000 francs against an estimate of 100,000. In the following year Théophile Silvestre published *Eugène Delacroix: Documents nouveaux*, Burty began to prepare an edition of Delacroix's letters and Alfred Robaut had already embarked on his catalogue raisonné. During the 1860s the dealers Hector Brame and Paul Durand-Ruel bought a series of Delacroix's major works and sold them at great profit. For new generations of artists, he was the great liberator. Henri Fantin-Latour's group portrait, *Homage to Delacroix* (1864; Paris, Mus. d'Orsay), was a summation of the debt owed to Delacroix by such young artists as Manet, Puvis de Chavannes, Théodore Chassériau and Paul Signac. By 1880 his status was unassailable with artists, collectors and the general public. In that year, Henry James wrote that 'he belongs to the family of the great masters of the past—he had the same

large liberal way of understanding his business'. In the 20th century, substantial scholarship, both in England and France, has greatly increased the knowledge of his work, and the great retrospective held at the Louvre in 1963 on the centenary of his death confirmed his position as the only truly universal artist of the French school after Poussin.

Writings

P. Burty, ed.: *Lettres d'Eugène Delacroix* (Paris, 1878, rev., 2 vols, 1880)

E. Faure, ed.: *Eugène Delacroix: Oeuvres littéraires*, 2 vols (Paris, 1923)

A. Joubin, ed.: *Journal d'Eugène Delacroix*, 3 vols (Paris, 1932/R 1981; Eng. trans., ed. W. Pach, London, 1938)

—: *Correspondance générale d'Eugène Delacroix*, 5 vols (Paris, 1935–8) [essentially supersedes Burty's edn]

A. Dupont, ed.: *Lettres intimes: Correspondance inédite* (Paris, 1954)

L. Johnson, ed.: *Eugène Delacroix: Further Correspondence, 1817–1863* (Oxford, 1991)

Bibliography

early sources

T. Silvestre: *Eugène Delacroix: Documents nouveaux* (Paris, 1864)

A. Moreau: *E. Delacroix et son oeuvre* (Paris, 1873)

A. Robaut: *L'Oeuvre complet de Eugène Delacroix: Peintures, dessins, gravures, lithographies* (Paris, 1885/R New York, 1969) [cat. rais.]

M. Tourneux: *Eugène Delacroix devant ses contemporains: Ses écrits, ses biographes, ses critiques* (Paris, 1886)

P. Signac: *D'Eugène Delacroix au néo-impressionnisme* (Paris, 1899/R 1964)

L. Delteil: *Ingres et Delacroix* (1908), iii of *Le Peintre-graveur illustré (XIXe et XXe siècles)* (Paris, 1906–26/R New York, 1969)

L. de Planet: *Souvenirs de travaux de peinture avec M. Eugène Delacroix*, ed. A. Joubin (Paris, 1929)

general

T. Silvestre: *Histoire des artistes vivants: Etudes d'après nature* (Paris, 1856); expanded edns, 1878, 1926 as *Les Artistes français*

P. Andrieu: *Musée de Montpellier: La Galerie Bruyas* (Paris, 1876)

N. M. Athanassoglou-Kallymer: *French Images from the Greek War of Independence, 1821–1830* (New Haven and London, 1989)

monographs and exhibition catalogues

E. Moreau-Nélaton: *Delacroix raconté par lui-même*, 2 vols (Paris, 1916)

R. Escholier: *Delacroix, peintre, graveur, écrivain*, 3 vols (Paris, 1926–9)

L. Johnson: *Delacroix* (London, 1963) [best short account; fundamental for colour theory]

Mémorial de l'exposition Eugène Delacroix organisée au Musée du Louvre à l'occasion du centenaire de la mort de l'artiste (exh. cat., ed. M. Sérullaz; Paris, Louvre, 1963)

R. Huyghe: *Delacroix ou le combat solitaire* (Paris, 1964; Eng. trans., London, 1963)

F. A. Trapp: *The Attainment of Delacroix* (Baltimore and London, 1971)

L. Rossi Bortolatto: *L'opera pittorica completa di Delacroix* (Milan, 1972) [summary cat. of paintings]

De David à Delacroix: La Peinture française de 1774 à 1830 (exh. cat., ed. F. J. Cummings, R. Rosenblum and A. Schnapper; Paris, Grand Pal., 1974–5); Eng. edn as *David to Delacroix: French Painting, 1774–1830: The Age of Revolution* (Detroit, MI, Inst. A.; New York, Met., 1975), pp. 377–84 [important for context]

L. Johnson: *The Paintings of Eugène Delacroix: A Critical Catalogue*, 6 vols (Oxford, 1981–9) [supersedes all previous accounts; vols 5 and 6 deal with public decorations]

Eugène Delacroix, 1798–1863: Paintings, Drawings and Prints from North American Collections (exh. cat. by L. Johnson and others, New York, Met., 1991)

T. Wilson-Smith: *Delacroix: A Life* (London, 1992)

Copies créés de Turner à Picasso: 300 oeuvres inspirées par les maîtres du Louvre (exh. cat., ed. J.-P. Cuzin and M.-A. Dupuy; Paris, Louvre, 1993), pp. 234–71

specialist studies

L. Rudrauf: *Eugène Delacroix et le problème du romantisme artistique* (Paris, 1942)

L. Horner: *Baudelaire, critique de Delacroix* (Geneva, 1956)

L. Johnson: 'The Formal Sources of Delacroix's *Barque de Dante*', *Burl. Mag.*, c (1958), pp. 228–32

M. Sérullaz: *Les Peintures murales de Delacroix* (Paris, 1963) [excellent plates, especially of details]

G. P. Mras: *Eugène Delacroix's Theory of Art* (Princeton, 1966)

J. J. Spector: *The Murals of Eugène Delacroix at Saint-Sulpice* (New York, 1967)

H. Bessis: 'L'Inventaire après décès d'Eugène Delacroix', *Bull. Soc. Hist. A. Fr.* (1969), pp. 199–222

J. J. Spector: *Delacroix: The Death of Sardanapalus* (London, 1974)

G. Doy: 'Delacroix et Faust', *Nouv. Est.*, 21 (May–June 1975), pp. 18–23

H. Toussaint: *La Liberté guidant le peuple de Delacroix*, Les Dossiers du département des peintures (Paris, 1982)

F. Haskell: 'Chios, the Massacres and Delacroix', *Chios: A Conference at the Homereion in Chios, 1984*, pp. 335–58

M. Sérullaz: *Dessins d'Eugène Delacroix*, 2 vols, Paris, Louvre, Cab. Dessins cat. (Paris, 1984)

N. M. Athanassoglou-Kallymer: *Eugène Delacroix: Prints, Politics and Satire, 1814–1822* (New Haven and London, 1991)

T. Wilson-Smith: *Delacroix: A Life* (London, 1992)

E. Davies: *Portrait of Delacroix* (Edinburgh, 1994)

COLIN HARRISON

Delafontaine, Pierre-Maximilien

(*b* Paris, *c.* 1774; *d* Paris, *bur* 3 Dec 1860). French painter, bronze-founder and collector. He was born into a family of bronze-founders. He studied in Jacques-Louis David's atelier and on David's arrest in 1794 accompanied him on his way to prison and with 16 of his fellow students signed an address to the National Convention calling for his master's release. He exhibited for the first time at the Salon of 1798 both the full-length *Portrait of a Man Skating*, or the portrait of *Bertrand Andrieu* (Paris, Hôtel de la Monnaie), a rather stiff and awkward treatment of the subject in comparison with, for instance, Gilbert Stuart's *Skater* (1782; Washington, DC, N.G.A.), and the *Deluge* (Gray, Mus. Martin), inspired by the poems of Salomon Gessner (1730–88) (the episode in which Phanor carries the fainting Semira). Delafontaine considered this painting to be his masterpiece. At the Salon of 1799 he showed the portrait of *Alexandre Lenoir*, a somewhat gauche, full-length depiction of the creator of the Musée des Monuments Français (Paris, Louvre). The portrait of *Bichat* (*c.* 1800; Versailles, Château) dates from the same period.

He exhibited again in the Salons of 1801 and 1802, but his career as a painter was interrupted in 1804: on the reverse of a drawing, the *Death of General Marceau* (Chartres, Mus. B.-A.), he

explained 'sketch of a painting I was to execute for the Government until I was forced by circumstances to give up painting after a long illness and to succeed my father in the manufacture of bronzes in 1804'. He resumed the direction of his father's foundry until 1840, when it passed into the hands of his son Augustin-Maximilien. Delafontaine became one of the most skilful bronze-chasers in Paris (e.g. sconces in gilded bronze in the tabernacle of the chapel of the Holy Trinity, château of Fontainebleau, and bronzes in the chapel of Dreux). He regularly worked with François-Honoré-Georges Jacob (1770–1841), a cabinetmaker, and played an important role in furniture and the decorative arts during the Empire and the Restoration. He also cast two statues by François Rude, *Aristaeus* and *Eurydice* (both Dijon, Mus. B.-A.).

Delafontaine collected paintings and drawings by contemporary artists (e.g. Merry Joseph Blondel, who married Delafontaine's daughter in 1832, David, François Granet, Pierre Révoil, Lancelot Turpin de Crissé), which were sold in Paris on 6 February 1861. Several items were bought back by the family and bequeathed in 1932 to the Musée Baron Martin in Gray and to the Musée des Arts Décoratifs in Paris (including the famous *Raphael's Casino in Rome* by Jean-Auguste-Dominique Ingres). He left his manuscript reminiscences to the Bibliothèque de l'Institut de France; they constitute an important source for David and his circle.

Unpublished sources

Paris, Bib. Inst. France, MS. 782–4 [autobiographical fragments]

Bibliography

A.-P. de Mirimonde: 'Pierre-Maximilien Delafontaine: Elève de David', *Gaz. B.-A.*, n.s. 5, xlviii (Oct 1956), pp. 31–8
De David à Delacroix: La Peinture française de 1774 à 1830 (exh. cat., ed. F. J. Cummings, R. Rosenblum and A. Schnapper; Paris, Grand Pal., 1974–5); Eng. edn as *David to Delacroix: French Painting, 1774–1830: The Age of Revolution* (Detroit, MI, Inst. A.; New York, Met.; 1975), pp. 382–3
P. Durey: 'XIXe siècle: Peintures et dessins de 1800 à 1870', *Rev. Louvre*, 5–6 (1980), pp. 299–300

MARIE-CLAUDE CHAUDONNERET

Delaistre, François-Nicolas

(*b* Paris, 9 March 1746; *d* Paris, 23 April 1832). French sculptor. He was a pupil of Félix Lecomte and of Louis-Claude Vassé. He won the Prix de Rome in 1772 and, after a year at the Ecole Royale des Elèves Protégés, completed his training at the Académie de France in Rome between 1773 and 1777. It was there that he probably first met the architect Pierre-Adrien Pâris, for whom he later worked and who owned several of his terracotta models (Besançon, Mus. B.-A. & Archéol.). His best-known work, the group *Cupid and Psyche*, was originally executed in Rome (later marble version; Paris, Louvre); it is a graceful, rather precious treatment of a theme popular with Neo-classical sculptors, made for the collector Pierre-Marie Gaspard Grimod, Comte d'Orsay.

Delaistre was approved (*agréé*) by the Académie Royale in 1785. Under the *ancien régime* he was especially active as a religious sculptor. He exhibited in 1787 a group of the *Virgin and Child* for St Nicolas-des-Champs, Paris (plaster; destr.), and later executed a statue of *St Teresa* for the church at Meung (Loiret) and four *Evangelists* and eight *Angels* (1789–90), based on drawings by Pâris, for Orléans Cathedral.

The Revolution put an end to Delaistre's career as a religious sculptor and, although he exhibited regularly at the Salon between 1785 and 1824, he received relatively few commissions. Most notable were a low relief of *Astronomy* (stone, 1792–3; untraced) for the Panthéon, Paris, a statue of *Phocion* (marble, 1804 Salon; untraced) for the chamber of the Sénat in the Palais du Luxembourg, Paris, a bust of *Veronese* (marble, 1804–6; Paris, Louvre) and a statue of *Joseph Bonaparte* (marble, 1805–8; Versailles, Château). His models (1808; untraced) for the reliefs of the Colonne de la Grande Armée, Place Vendôme, Paris, were rejected. Throughout his career he was an accomplished portrait sculptor with works ranging in date from the bust of *Jacques–Philibert Varenne de Fenille* (1782; Bourg-en-Bresse, Mus. Ain.) to that of *Empress Marie-Louise* (1813; Fontainebleau, Château).

Bibliography

Lami

PHILIPPE DUREY

Delaroche

French family of artists, dealers, collectors and arts administrators. (1) Gregoire-Hippolyte Delaroche was one of the most prominent dealers and art experts in Paris at the end of the 18th century and the beginning of the 19th. His brother-in-law Adrien-Jacques Joly (1795–1849) was curator of the Cabinet des Estampes at the Bibliothèque Nationale in Paris. Gregoire-Hippolyte had two sons who were active as artists. Jules-Hippolyte Delaroche (*b* Paris, 7 April 1795; *d* Versailles, 1849) trained under David but eventually turned from painting to arts administration. (2) Paul Delaroche became one of the most important and renowned history painters in France in the first half of the 19th century.

(1) Gregoire-Hippolyte Delaroche

(*b* ?Paris, *c*. 1750; *d* Paris, *c*. 1824). Dealer and collector. He specialized in the sale of Old Master paintings but on at least one occasion (1798) he launched a scheme, together with Alexandre-Joseph Paillet, to set up a permanent exhibition and to hold regular auctions of paintings; this probably included contemporary art and was based on the methods of the painter–dealer Jean-Baptiste-Pierre Le Brun. Paillet was also Delaroche's partner in many of the sales of collections that Delaroche directed. When the Mont de Piété, a pawnbroking scheme set up by the State, was re-established in 1797, Delaroche and Paillet held official positions in connection with the sale of what presumably were unredeemed collections. Their premises were at 24–25, Rue Vivienne. Among important sales of collections they conducted were those of Robit and Tolozan (both 1801) and Choiseul-Praslin (1808). As a rule, the sales with which they were involved contained a high proportion of works by Flemish artists and others from northern Europe, and this presumably was the main area of their expertise. However, they also compiled a scholarly catalogue—unrelated to a sale—of the collection of Prince Giustiniani, which required considerable knowledge of Italian art. In 1812 Delaroche brought out a second edition without Paillet's collaboration. His own private collection was sold at auction in 1824 (24–6 April).

LINDA WHITELEY

(2) Paul (Hippolyte) Delaroche

(*b* Paris, 17 July 1797; *d* Paris, 4 Nov 1856). Painter and sculptor, son of (1) Gregoire-Hippolyte Delaroche. Though he was offered a post in the Bibliothèque Nationale by his uncle, Adrien-Jacques Joly, he was determined to become an artist. As his brother Jules-Hippolyte was then studying history painting with David, his father decided that Paul should take up landscape painting, and in 1816 he entered the Ecole des Beaux-Arts to study under Louis-Etienne Watelet (1780–1866). Having competed unsuccessfully for the Prix de Rome for landscape painting, he left Watelet's studio in 1817 and worked for a time with Constant-Joseph Desbordes (1761–1827). In 1818 he entered the studio of Antoine-Jean Gros, where his fellow pupils included Richard Parkes Bonington, Eugène Lami and Camille Roqueplan.

Delaroche made his début at the Salon in 1822 with *Christ Descended from the Cross* (1822; Paris, Pal. Royale, Chapelle) and *Jehosheba Saving Joash* (1822; Troyes, Mus. B.-A. & Archéol.). The latter work clearly showed the influence of Gros, and it was greatly praised by Géricault. At the same Salon, Delacroix exhibited *Dante and Virgil in Hell* (1822; Paris, Louvre), a highly influential painting, which could be said to mark the arrival of Romanticism in Paris, challenging the dominance of Neo-classicism. Delaroche's response to this conflict of influences was to steer a course between the two currents, unwilling to opt for full-blooded Romanticism for fear of jeopardizing his public standing. Such a compromise can be seen in one of his entries for the Salon of 1824, *Joan of Arc in Prison* (1824; Rouen, Mus. B.-A.; sketch and reduced replica, London, Wallace), and it was the distinguishing feature of his subsequent works. In 1828 he exhibited the *Death of Queen Elizabeth*, the first of a series of paintings from English history that traded on the growing French interest in English culture; it established the artist's reputation. Centred upon the very masculine figure of the dying Queen, the picture's obsessive attention to details, such as the rendering of different rich materials, creates a grotesque contrast between the shrivelled, haggard monarch and her resplendent surroundings.

In 1830 Delaroche was commissioned to paint the *Storming of the Bastille*, a large and important work for the Hôtel de Ville (destroyed when the Hôtel was burnt down during the Commune in 1871). He had great success at the 1831 Salon exhibiting, among other works, the *Children of Edward: Edward V, King of England, and Richard, Duke of York, in the Tower of London* (1831; Paris, Louvre) and *Cromwell Opening the Coffin of Charles I* (1831; Nîmes, Mus. B.-A.). These and other works exhibited that year, such as *Cardinal Richelieu Dragging Cinq-Mars and de Thou in the Wake of his Barge* (1829; London, Wallace), greatly impressed contemporary artists; Delaroche was hailed as the leader of the contemporary French school of history painting. Combining scrupulous accuracy in historical detail with a glossy finish, his highly theatrical compositions often resemble waxworks or stage tableaux; for many he made wax or plaster models to help him achieve the best arrangement of the figures. Sometimes he took bronze casts from successful models, such as the head of Charles I from *Cromwell Opening the Coffin of Charles I*. His sculptures were sufficiently accomplished for him to be invited to produce a work for the Champs-Elysées, but the Revolution of 1830 prevented this scheme from being realized.

In 1832 Delaroche was elected a member of the Académie des Beaux-Arts, and the following year he became a professor at the Ecole des Beaux-Arts, where his pupils included Thomas Couture and Jean-Léon Gérôme. In 1833 he received his first commission for a religious work when he was asked to decorate the central nave of the Madeleine in Paris. Having never produced any paintings of this kind, and aware of his lack of knowledge of the great religious works of the past, he travelled to Italy from 1834 to 1835 to study early frescoes in Tuscany and elsewhere. When he returned to France he was told that he was expected to collaborate with Jules-Claude Ziegler; he felt that any such arrangement would ruin his proposed scheme and withdrew from the commission altogether. At the Salon of 1834 he had exhibited one of his most acclaimed pictures, the *Execution of Lady Jane Grey* (1834;

London, N.G.). His first major religious work was a Salon entry of 1837, *St Cecilia* (1836; London, V&A). This change of subject and the painting's austere manner were ill received, and after 1837 Delaroche ceased exhibiting altogether. Much of his time over the next few years was taken up by his most famous work, *The Hemicycle* (also known as the *Artists of all Ages*), for the Ecole des Beaux-Arts. This monumental work, a 27 m encaustic panorama, included over 70 painters, sculptors and architects, an international group ranging from antiquity up to the 18th century; among them are Pheidias, Raphael, Leonardo and Inigo Jones. Assisted by four students, Delaroche worked on the project from 1837 to 1841; the final result proclaims its origins in Raphael's *School of Athens* (1508–11; Rome, Vatican, Stanza della Segnatura) and Ingres's *Apotheosis of Homer* (1827; Paris, Louvre; see fig. 55). In 1855 the work was severely damaged by fire; Delaroche started the restoration himself and it was completed after his death by Robert-Fleury. A second huge project for the Palais de Justice was never carried out.

Delaroche spent 1843 to 1844 in Italy, developing an interest in early Italian painting, which encouraged him to attempt a series of religious works (*Virgin and Child*, 1844; London, Wallace); religious themes dominated his later works. He also turned from English to French history, both distant (*Charlemagne Crossing the Alps*, 1847; Versailles, Château) and more recent (*Napoleon Abdicating at the Palace of Fontainebleau*, 1845; Leipzig, Mus. Bild. Kst.). Throughout his career Delaroche had occasionally painted portraits, such as *Marquis de Pastoret* (c. 1829; Boston, MA, Mus. F.A.). From 1840 these became an increasingly important part of his output; among his sitters were such august figures as *Pope Gregory XVI* (1844; Paris, Louvre). At the time of his death Delaroche was working on a series of four scenes from the Life of the Virgin; only the *Virgin Contemplating the Crown of Thorns* (1856; see Delaborde, pl. 84) was finished. Having ceased to exhibit in 1837, the last of his paintings to be seen in public was *The Hemicycle*.

Bibliography

E. de Mirecourt: *Les Contemporains No. 72: Paul Delaroche* (Paris, 1856)

H. Delaborde: *Oeuvre de Paul Delaroche, reproduit en photographie par Bingham, accompagné d'une notice sur la vie et les ouvrages de Paul Delaroche, par Henri Delaborde; et du catalogue raisonné de l'oeuvre, par Jules Goddé* (Paris, 1858)

E. de Mirecourt: *Les Contemporains No. 119: Delaroche, Decamps* (Paris, 1871)

J. R. Rees: *Horace Vernet, Paul Delaroche* (London, 1880), pp. 54–88

Historical Illustrations by Paul Delaroche, with a Brief Memoir of the Artist and Historical Descriptions from Holinshed, Carlyle, Froude, Merle d'Aubigné and other writers (London, 1883) [incl. memoir by Delaborde]

E. de Lalaing: *Les Vernet, Joseph, Carle et Horace: Géricault et Delaroche* (Lille and Paris, 1888), pp. 215–38

N. D. Ziff: *Paul Delaroche: A Study in French Nineteenth Century History Painting* (New York, 1977)

J. Ingamells: *The Wallace Collection: Catalogue of Pictures II, French Nineteenth Century* (London, 1986), pp. 98–116

Demarne, Jean-Louis

(*b* Brussels, ?1752; *d* Batignolles, Paris, 24 Jan 1829). French painter. He went to Paris at the age of 12 after the death of his father, who had been in Brussels as an officer in the service of the Emperor of Austria. Having spent eight years studying history painting with Gabriel Briard (1729–77), he entered the Prix de Rome in 1772 and 1774 but failed to win. Thereafter he concentrated on landscape and genre painting, in which he was greatly influenced by such 17th-century Dutch masters as Aelbert Cuyp, the van Ostade brothers, Adriaen van de Velde and Karel Dujardin, all artists enjoying a tremendous vogue and high prices in Paris at that time. Demarne was made an associate (*agréé*) of the Académie Royale in 1783 but did not become a full member. He seems to have cared little for official honours and later, in 1815, was unwilling to seek membership of the Institut de France. He was, however, awarded the Légion d'honneur at the Salon of 1828.

Demarne was a very commercially minded artist and in the 1780s not only exhibited at the official Salon but also sent work to the Exposition de la Jeunesse and the Salon de la Correspondance. His output was considerable, and the difficulty of dating and identifying specific paintings is compounded by their repetitious nature (especially after 1815) and their imprecise titles. He was particularly fond of painting village and town fairs and road scenes. His first depiction of a fair appeared at the Salon of 1785, and dozens of similar works followed; the *Village Fair* (1814; Paris, Louvre) and the *Parish Feast* (Brussels, Mus. A. Anc.) are scenes of animated activity with numerous subordinate anecdotal incidents. His road scenes appeared from 1799 and were at times rectilinear and rigid, as in *Road with a Stagecoach* (Paris, Louvre). Occasionally he diversified into historical scenes, for example the *Return of Cincinnatus* (1795; untraced), and Troubadour-style pictures that have fanciful monuments inserted into them.

Largely apolitical, Demarne did not participate in the French Revolution and was only marginally involved in Napoleon's patronage of the arts. He painted the figures for the *Meeting of Napoleon and Pius VII at Fontainebleau* (Versailles, Château), for which Alexandre-Hyacinthe Dunouy (1757–1841) produced the landscape. Demarne also sometimes contributed figures to the landscapes of Lancelot-Théodore Turpin de Crissé, César van Loo, Georges Michel and Louis-Léopold Boilly. He had a devoted array of admirers, and his work was eagerly collected. In 1817 the Comte de Nape held 13 of his works and the Empress Josephine four. He was also very popular in Russia, and many of his best works were bought by Russian aristocrats, much to the regret of French collectors.

Bibliography

Comte de Nape: 'Jean-Louis Demarne: Notice sur la vie et sur quelques-uns de ses ouvrages', *Rev. Univl. A.*, xxi (1865), pp. 269–99

J. Watelin: *Le Peintre J. L. Demarne, 1752–1829* (Paris, 1962)

French Painting, 1774–1830: The Age of Revolution (exh. cat., ed. P. Rosenberg; Paris, Grand Pal.; Detroit, MI, Inst. A.; New York, Met.; 1974–5), pp. 392–6

SIMON LEE

Depaulis, Alexis-Joseph

(*b* Paris, 30 Aug 1792; *d* Paris, 15 Sept 1867). French medallist. He entered the Ecole des Beaux-Arts, Paris, in 1813 and trained there under Bertrand Andrieu, for medal making, and Pierre Cartellier, for sculpture. Early in his career he contributed to the medallic history of Napoleon I's reign (*Conquest of Illyria*; *French Academy at Rome*; *Orphanage of the Legion of Honour*) and to James Mudie's *National Medals* (*George III*; *Return of Napoleon*; *British Army in the Netherlands*; *Charge of the British at Waterloo*). He was responsible for a number of the portraits in the *Galerie métallique des grands hommes français*, including those of *Antoine Arnaud* (1817), *Pierre Jolyot de Crébillon*, *Jacques Amyot* (1819), *Abbé Suger* and *Bayard* (1822), also for *Martin Luther* (1821), among others, in the *Series numismatica universalis virorum illustrium* by Amédée Pierre Durand (1789–1873). Depaulis's later work became increasingly ambitious in scale and in relief. His monumental commemorative medals for the *Bombardment of the Fort of St Jean d'Ulloa* (1838), the *Battle of Isly* (1844) and the *Capture of Sebastopol* (1855) were much admired by contemporaries. In these medals, as in his later piece celebrating the *Suez Canal* (1864), he re-established the technical supremacy enjoyed by French engravers at the Paris Mint.

Bibliography

Bellier de La Chaviguerie–Auvray; Forrer

C. Gabet: *Dictionnaire des artistes de l'école française au XIXe siècle* (Paris, 1834), pp. 200–201

MARK JONES

Dequevauviller

French family of engravers. (Nicolas-Barthélemy-) François Dequevauviller (*b* Abbeville, 1745; *d* ?Paris, *c.* 1807) trained under Jean Daullé and is considered to have been one of his best pupils. He was a particularly good interpreter—second only to Nicolas de Launay—of Niclas Lafrensen, or Nicolas Lavreince (1737–1807). Two of his finest works are engravings after this artist: *Gathering in a Salon* (1783–4) and *Gathering at a Concert* (Paris, Bib. N. cat. no. 63), both of which represent extremely detailed interiors. His other genre scenes after Lafrensen, *Awakening of the Dressmakers*, *Retiring of the Dressmakers*, the *Dancing School* and *Le Contretemps* (Paris, Bib. N. cat. nos 64, 66, 65 and 67 repectively), all date to 1784–6. Dequevauviller was also an engraver of illustrations for some of the best-known publications of the time, including the *Tableaux ... de la Suisse* (1780–86; Paris, Bib. N. cat. nos 15–34) of Jean-Benjamin de La Borde, the *Voyage ... de Naples et de Sicile* (1781–86; Paris, Bib. N. cat. nos 36–50) of Saint-Non and the *Voyage pittoresque de la Grèce* (1782; Paris, Bib. N. cat. nos 51–5) of the Comte de Choiseul-Gouffier. He also contributed to a number of albums of collections of Old Master paintings, such as Jacques Couché's *Galerie du Palais Royal* (1786–1808; Paris, Bib. N. cat. nos 69–79) and Jean-Baptiste Wicar's *La Galerie de Florence* (1789–1807; Paris, Bib. N. cat. nos 87–92). Dequevauviller married a member of an illustrious family of engravers, Marguerite-Angélique-Scolastique de Poilly, and their son François Jacques Dequevauviller (*b* Paris, 1783; *d* Paris, *c.* 1848) also became an engraver. François studied first with his father and then with Auguste-Gaspard-Louis Boucher-Desnoyers (1779–1857). His engraved portraits include that of *Charles Ferdinand d'Artois, Duc de Berry*, after Bourdon (*c.* 1820; Paris, Bib. N. cat. no. 12), and he provided numerous plates for, among other works, the *Voyage pittoresque et historique de l'Espagne* (1806–20; Paris, Bib. N. cat. nos 1–4). He engraved for several albums of museum collections, including S.-C. Croze-Magnan's *Musée français* (1803–9; Paris, Bib. N. cat. no. 14), to which his father had also contributed.

Bibliography

E. Dacier: *La Gravure en France au XVIIIe siècle: La Gravure de genre et de moeurs* (Paris, 1925), p. 105

Inventaire du fonds français: Graveurs du dix-huitième siècle, Paris, Bib. N., Cab. Est. cat., vii (Paris, 1951), pp. 34–60; vi (Paris, 1953), pp. 261–6

M.-E. HELLYER

Deseine [De Seine]

French family of artists. The brothers (1) Claude-André Deseine and (2) Louis-Pierre Deseine, both sculptors, came from a family of carpenters. Their younger brother, Louis-Etienne Deseine (b 1756), became an architect, and their sister, Madeleine-Anne Deseine (1758–1839), was a painter and draughtsman as well as a sculptor; among her works is a bust of *Louis-Pierre Deseine* (terracotta, 1807; Paris, Carnavalet).

(1) Claude-André Deseine

(b Paris, 6 April 1740; d Petit Gentilly, Val-de-Marne, 30 Dec 1823). Sculptor. Although deaf and mute, he studied from 1775 at the Académie Royale, Paris. He subsequently pursued a moderately successful career as a portrait sculptor, working in a style that combined Neo-classical sobriety with a personal ability to capture an expressive likeness. Among his earlier works, his bust of *Pierre Victor Besenval de Bronstatt* (plaster; Paris, priv. col.) and a statuette of *Jean-Jacques Rousseau* (untraced) were exhibited at the Salon de la Correspondance of 1782. During the French Revolution he made a number of busts of Republican leaders, including *Honoré Gabriel Riqueti, Comte de Mirabeau* (plaster, 1791; Rennes, Mus. B.-A. & Archéol.), *Le Peletier de Saint-Fargeau* (marble, 1793; Bourges, Mus. Berry), *Jean-Paul Marat* (1793; untraced) and *Maximilien Robespierre* (terracotta, 1793; Visille, Mus. Révolution Fr.). In 1797 he executed a bust of *Napoleon Bonaparte* (untraced), but he seems to have retired from artistic life c. 1801.

Bibliography

G. Le Châtelier: 'Deseine le sourd muet', *Rev. Gen. Ens. Sourds Muets*, iii (1903)

F. Le Châtelier: *Louis Le Châtelier et Elizabeth Durand, leurs ascendants, leurs descendants* (Nancy, 1972)

P. Bordes: 'Le *Mirabeau* de Claude-André Deseine', *Rev. Louvre*, ii (1976), pp. 61–6

(2) Louis-Pierre Deseine

(b Paris, 30 July 1749; d Paris, 11 Oct 1822). Sculptor, brother of (1) Claude-André Deseine. Like his brother, he studied at the Académie Royale, where he was a pupil of Louis-Philippe Mouchy

and Augustin Pajou. In 1780 he won the Prix de Rome, and from 1781 to 1784 he was in Rome at the Académie de France, where he absorbed the principles of Neo-classicism and showed an interest in sketching scenes from popular life (sketchbook in Paris, Louvre). Both these tendencies, the idealizing and the realistic, were to remain a feature of his work, finding resolution in his fine portrait sculptures.

Following his return to Paris, in 1789 Deseine became Premier Sculpteur to Louis-Joseph de Bourbon, Prince de Condé, having earlier executed for him marble statues of *Bacchus* and *Hebe* (Chantilly, Mus. Condé). In 1791 he was received (reçu) as one of the last members of the Académie Royale, presenting the marble statuette *Mucius Scaevola Enduring Pain* (Paris, Louvre). He maintained an active practice as a portrait sculptor, producing busts of *Louis XVI* (plaster; Paris, Carnavalet) and the *Dauphin* (later Louis XVII; marble, 1790; Versailles, Château) and of contemporary political figures such as *Jean-Sylvain Bailly* (plaster, 1789), the lawyer *J.-A. Thouret* (plaster, 1791; both Paris, Carnavalet) and *François-Armand Saige* (marble, 1789; Bordeaux, Mus. A. Déc.). He also provided posthumous portraits, such as those for the Musée des Monuments Français, Paris, of *Michel Eyquem de Montaigne* (marble, 1819; Bordeaux, Mus. A. Déc.) and *Johann Joachim Winckelmann* (terracotta, 1800, Versailles, Orangerie; marble, 1819, Toulouse, Mus. Augustins). He also produced monumental works for many of the major sculptural projects of the Directory and the Empire, including statues of *Prudence* for the Senate (1803–5; untraced), *Michel de l'Hospital* for the Palais Bourbon (stone, 1807–11; in situ) and *Jean Portalis* for the Conseil d'Etat (marble, 1808–12; Versailles, Château). He was less successful as a sculptor of funerary monuments; in his tombs for *Jean-Baptiste de Belloy* (marble, 1808; Paris, Notre-Dame) and *Louis-Antoine-Henri de Bourbon, Prince de Condé and Duc d'Enghien* (marble, 1816–22; château of Vincennes, Queen's Chapel), for instance, he concentrated on the elaboration of the individual figures to the detriment of the compositional design. His religious works include five plaster

reliefs illustrating the *Passion of Christ* (1801–5) and a plaster *Entombment* (1807) for St Roch, Paris, which show the influence of Italian Renaissance prototypes.

An ardent polemicist, Deseine defended the Académie Royale when it was on the point of being dissolved in 1790–91, and he strongly supported its re-establishment in 1816. During the Revolution, on finding himself excluded from the Panthéon building project by Antoine Quatremère de Quincy, he conducted a polemical campaign against him, and he was also one of those falsely considered to have been responsible for the downfall of Alexandre Lenoir, because of his attacks in 1802–3 on the Musée des Petits Augustins.

Bibliography

G. Le Châtelier: *Louis-Pierre Deseine statuaire* (Paris, 1906)

J. Thirion: 'Le Monument funéraire du Cardinal de Belloy à Notre-Dame de Paris', *Bull. Archéol. Cté Trav. Hist. & Sci.*, iii (1967), pp. 227–52

A.-M. de Lapparent: *Louis-Pierre Deseine, statuaire, 1749–1822: La Vie, son oeuvre* (diss., Paris, Ecole Louvre, 1985)

ANNE-MARIE DE LAPPARENT

Devéria

French family of artists.

(1) Achille(-Jacques-Jean-Marie) Devéria

(*b* Paris, 6 Feb 1800; *d* Paris, 23 Dec 1857). Painter, lithographer and stained-glass designer. He was a pupil of Louis Lafitte (1770–1828) and, like him, specialized in illustration, which formed the greater part of his output until 1830 (e.g. his illustrations to Goethe's *Faust*, 1828). His experience in the art of the vignette influenced his numerous lithographs (over 3000), most of which were issued by his father-in-law, Charles-Etienne Motte (1785–1836). Devéria was an excellent portrait artist, and his lithographs included portraits of Victor Hugo, Alexandre Dumas (père), Prosper Mérimée, Franz Liszt and numerous other artists and writers whom he entertained in his Paris studio in the Rue de l'Ouest.

Devéria chronicled the taste and manners of the Romantic era in a series of brilliantly coloured lithographs entitled *The Times of the Day* (c. 1829), which depicted the day of an elegant Parisienne in 18 detailed scenes, for example *Five o'Clock in the Morning, Annette Boulanger* (Paris, Carnavalet). Baudelaire believed that the series showed all 'the morals and aesthetics of the age'. In 1831–9 Devéria portrayed his friends wearing elaborate fancy dress in another series of coloured lithographs, *Historical Costumes* (125 plates). Most of his lithographs consisted of pseudo-historical, pious, sentimental or erotic scenes, and these images, disseminated in vast numbers by the new medium of lithography, fed the dreams and fantasies of a generation. Béraldi (1886) felt that such commercial output was devoid of artistic merit, but Farwell (1977) demonstrated how several of Devéria's erotic prints foreshadowed similar paintings by Courbet and Manet by 20 to 30 years, for example a suite of lithographs *Six Female Nudes Studied from Life* (1829).

Devéria was a regular contributor of religious paintings to the Salon. The monumental *Apotheosis of St Clotilda* (1851; Paris, St-Roch) is one of his few surviving works of this type. He also participated in the French 19th-century revival of stained glass. He designed a large number of windows depicting saints for the Sèvres factory and the figures of monarchs for the Henry II staircase in the Louvre, Paris (1840–41). He also designed glass for the church at Sèvres (1839–47) and the chapels of the royal residencies at Dreux (1841), Eu (1841–2) and Notre-Dame-d'Auray in Carheil (1847).

Foucart (1987) described Devéria's painting as 'colourful, happy and animated'. The sense of movement is particularly well expressed in the lively gestures of the ascending saint in *Apotheosis of St Clotilda*. A passion for colour is a feature in his work, not only in the lithographs but also in his stained glass for Versailles, the magnificent colour of which accords perfectly with the richness of the architecture. In his choice of subject-matter Devéria was less Romantic than Géricault and Delacroix and rarely depicted grave or tragic themes. Devéria ended his career as

curator of the Cabinet des Estampes in the Bibliothèque Nationale, Paris, which has examples of most of his work and an important collection of documents left at his bequest.

(2) Eugène(-François-Marie-Joseph) Devéria

(b Paris, 22 April 1805; d Pau, 3 Feb 1865). Painter, brother of (1) Achille Devéria. He was a pupil of Anne-Louis Girodet and Guillaume Lethière but was greatly influenced by his brother. Despite differences of taste and temperament—Eugène had an official career and painted on a grand scale—the brothers remained close until Eugène went to Avignon in 1838. He first exhibited at the Salon of 1824 and had his first success with the Birth of Henry IV (1827; Paris, Louvre). He approached this well-worn subject (made fashionable by the Restoration and usually portrayed in engravings or small-scale works) with unusual panache. The ambitious scale, the crowds of people painstakingly depicted in period costume and the rich colours revealed his desire to raise the subject to the rank of history painting. With Delacroix and Louis Boulanger, Devéria was hailed as a champion of the Romantic movement and the successor to Veronese and Rubens.

The success of the Birth of Henry IV brought Devéria numerous official commissions. He was asked by the Direction des Musées Royaux to decorate the Salle d'Amasis in the Louvre with the mural Puget Presenting Louis XIV with his 'Milos of Croton' in the Gardens of Versailles (1832) and was one of several artists called by Louis-Philippe to decorate the Musée de l'Histoire de France at Versailles. In the Oath of King Louis-Philippe before the Chamber of Deputies (1836) he depicted the new alliance between the sovereign and his subjects, and with this history painting joined the tradition of David and Baron François Gérard.

Devéria was one of the few Romantic painters (apart from Delacroix and Théodore Chassériau) to produce religious works, for example his five canvases of the Life of Christ (a sixth by Achille) for the church at Fougères, Brittany (1835), and two paintings of the Life of St Genevieve for Notre-Dame-de-Lorette, Paris (1835). His most important decorative work was for Notre-Dame-des-Doms,

Avignon (1838–40), for which he devised an elaborate programme, though only part was realized. The chapels of the Virgin and St Charlemagne were decorated in encaustic painting and fresco and completed by four large oil paintings depicting scenes from the Litanies of the Virgin (1851–6).

Devéria's Romantic style was a synthesis of various elements, combining the influence of Rubens and Veronese with that of his contemporaries. His work is distinguished by vivid colours, robustly modelled forms (which recall the work of Ingres) and a painstaking attention to detail in the depiction of costume and landscape, characteristic of nascent Orientalism. He was also a skilled portrait painter. His best works are of his family and friends; the intimate charm and engaging character of these works rely on his evident sympathy for his models, for example the portraits of his sister-in-law Céleste Devéria (1837; Pau, Mus. B.-A.) and Eugène and Achille Devéria (1836; Versailles, Château).

In 1841 Devéria settled in Pau, in the Pyrenees, where he painted village scenes and portraits of local worthies. His conversion to Protestantism in 1843 led to a break with his brother. In his last paintings he remained faithful to the historical vein that had brought him success in 1827. He sent to the Salon the Death of Jane Seymour (1847; Valence, Mus. B.-A. & Hist. Nat.), Cardinal Wolsey and Catherine of Aragon (1859; Le Havre, Mus. B.-A.) and Christopher Columbus Being Received by Ferdinand and Isabella (1861; Pau, Mus. B.-A.).

Bibliography

H. Béraldi: Les Gravures du XIXe siècle, v (Paris, 1886)

M. Gauthier: Achille et Eugène Devéria (Paris, 1925)

P. Gusman: 'Achille Devéria, illustrateur et lithographe romantique (1800-1857)', Byblis, vi (1927), pp. 34–40

J. Lethève and J. Adhémar: Inventaire du fonds français après 1800, vi (Paris, 1953)

The Cult of Images: Baudelaire and the Nineteenth-century Media Explosion (exh. cat., ed. B. Farwell; Santa Barbara, U. CA, A. Mus., 1977)

P. Comte: 'La Naissance d'Henri IV de Devéria', Rev. Louvre (1981), pp. 137–41

R. Rapetti: 'Eugène Devéria et le décor de la chapelle de la
 Vierge à la cathédrale d'Avignon', *Bull. Soc. Hist. A. Fr.*
 (1984), pp. 207–27
Achille Devéria: Témoin du romantisme parisien
 (exh. cat., ed. D. Morel; Paris, Mus. Renan-Scheffer,
 1985)
B. Foucart: *Le Renouveau de la peinture religieuse en
 France (1800–1860)* (Paris, 1987)
*The Charged Image: French Lithographic Caricature,
 1816–1848* (exh. cat. by B. Farwell, Santa Barbara, CA,
 Mus. A., 1989)
*Autour de Delacroix: La Peinture religieuse en Bretagne
 au 19ème siècle* (exh. cat., essay P. Bonnet, Vannes,
 Mus. B.-A., 1993)

DOMINIQUE MOREL

Devosges [Devosge], (Claude-)François, III

(*b* Gray, Haute-Saône, 25 Jan 1732; *d* Dijon, 22 Dec
1811). French painter, draughtsman and teacher.
He was descended from a dynasty of sculptors. At
the age of 14 he was painting for the Carmelite
convent and the church at Gray; he then moved
to Paris, where for some years he studied sculp-
ture with Guillaume Coustou. Having lost the
sight of one eye in a cataract operation, Devosges
was obliged to give up sculpture, but he contin-
ued with his painting, living at the home of
Jean-Baptiste-Henri Deshays, Boucher's son-in-law.
During this period Devosges refused an invitation
to go to Russia to teach drawing to the future Tsar
Paul I. In 1760 he moved to Burgundy, where he
painted and also illustrated the writings on law
by Claude-Philibert Fyot de La Marche, by then
many years premier président of the Parlement of
Bourgogne.

Around 1764 Devosges became tutor to a society
of artists who used to hire a life model. He
founded in Dijon in 1765 a free school of drawing
that was open to everyone, and with assistance
he obtained a subsidy for it from the States of
Burgundy, which in 1775 established a Rome schol-
arship, awarded every four years. During the
French Revolution, Devosges managed to keep
the school running; he tried to keep safe the
region's works of art and from 1792 kept an inven-
tory of those that had been seized. He was par-
ticularly noted for his qualities as a teacher:
among his pupils were Pierre-Paul Prud'hon and
François Rude, both of whom benefited from his
teaching and his example.

The few paintings by Devosges that have sur-
vived include the *Assumption of the Virgin* (Dijon,
Mus. Magnin) and a portrait (Langres, Mus. Du
Breuil St-Germain) of the sculptor *Edmé Gaulle*
(1762–1841). Devosges is, however, best known as
an artist from his drawings, many of which have
been preserved, the majority at the Musée Magnin,
Dijon, to which they were bequeathed by Anatole
Devosges (1770–1850), his son and successor as
director of the school. François Devosges favoured
the serious-minded, classicizing trends in subject-
matter, composition and facture that were appar-
ent in France towards the middle of the 18th
century. Some of his biblical scenes take their
inspiration from Raphael, Poussin and Eustache Le
Sueur. His mythological and pastoral scenes, on
the other hand, are in a modified version of
Boucher's idiom, although with an atmosphere
of sensibility rather than of voluptuous pleasure.
Some of his figures, such as *Zephyrus and Flora*,
possess the frozen grace of the art of Pompeii.
Devosges's improvised works display the 'passion,
the sensual ardour' (Quarré; see 1961 exh. cat.) of
his contemporary Jean-Honoré Fragonard.

Bibliography

Thieme–Becker
L. Fremiet-Monnier: *Eloge de M. Devosges, fondateur et
 professeur de l'Ecole de dessin, peinture et sculpture
 de Dijon* (Dijon, 1813)
A. Bougot: 'François Devosges', *Rev. Bourguignonne Ens.
 Sup.*, ii (1892), pp. 297–378
M. Imperiali: 'François Devosges: Créateur de l'Ecole de
 dessin et du Musée de Dijon', *La Révolution en Côte-
 d'Or*, 3 (Dijon, 1927) [whole issue]
P. Quarré: 'Remarques sur les dessins de François Devosge',
 An. Bourgogne, xiii (1941), pp. 114–24
*Une Ecole provinciale de dessin au XVIIIe siècle:
 L'Académie de peinture et sculpture de Dijon* (exh.
 cat., Dijon, Mus. B.-A., 1961) [introduction by
 P. Quarré]
S. Laveissière: *Dictionnaire des artistes et ouvriers d'art de
 Bourgogne* (1980), i of *Dictionnaire des artistes et
 ouvriers d'art de la France par provinces* (Paris, 1980–),
 pp. 168–74

CELIA ALEGRET

Diaz (de la Peña), (Virgilio) Narcisse [Narcisso]

(*b* Bordeaux, 21 Aug 1807; *d* Menton, 18 Nov 1876). French painter. After the death of his Spanish parents he was taken in by a pastor living in Bellevue (nr Paris). In 1825 he started work as an apprentice colourist in Arsène Gillet's porcelain factory, where he became friendly with Gillet's nephew Jules Dupré and made the acquaintance of Auguste Raffet, Louis Cabat and Constant Troyon. At this time he executed his first oil paintings of flowers, still-lifes and landscapes. Around 1827 Diaz is thought to have taken lessons from the Lille artist François Souchon (1787–1857); perhaps more importantly, he copied works by Pierre-Paul Prud'hon and Correggio in the Louvre, Paris, and used their figures and subjects in such later paintings as *Venus and Adonis* and the *Sleeping Nymph* (both Paris, Mus. d'Orsay). He soon became the friend of Honoré Daumier, Théodore Rousseau and Paul Huet. Diaz's pictures exhibited at the Salon from 1831 to 1844 derive from numerous sources, including mythology, as in *Venus Disarming Cupid* (exh. Salon 1837; Paris, Mus. d'Orsay), and literature, as in *Subject Taken from Lewis's 'The Monk'* (exh. Salon 1834; possibly the picture in the Musée Fabre, Montpellier, entitled *Claude Frollo and Esmerelda*). His other themes include a fantastical Orientalism inspired by his admiration for Alexandre-Gabriel Decamps and Eugène Delacroix, as in *Eastern Children* (Cincinnati, OH, Taft Mus.) and such genre scenes as *In a Turkish Garden* (Boston, MA, Mus. F.A.); these are all the more theatrical in that Diaz never travelled in the East. Nevertheless, they display his skill as a colourist and his ability to render light.

From 1835 Diaz regularly stayed in the Forest of Fontainebleau. Although Decamps's influence persisted, Diaz sought greater precision in his composition and executed numerous studies of tree trunks inspired by Théodore Rousseau. In *Ferry Crossing with the Effect of the Setting Sun* (exh. Salon 1837; Amiens, Mus. Picardie) he used the sombre tones of Dutch 17th-century landscapes but alleviated them with chiaroscuro and an effect of transparency. According to Silvestre, Diaz presented his first Fontainebleau subject, *View of the Gorges of Apremont* (untraced), at the Salon of 1837. From 1844 the brilliance of Diaz's flecked colours intensified. The lyricism of his unfinished technique can be appreciated in the numerous landscapes that he executed in the Forest of Fontainebleau, such as the *Pack in the Forest of Fontainebleau* (exh. Salon 1848; Copenhagen, Ordrupgaardsaml.) and the *Forest of Fontainebleau* (1859; U. Rochester, NY, Mem. A.G.). His minutely detailed studies, which recall Dutch painting (e.g. *Study of a Silver Birch*; Paris, Mus. d'Orsay), were executed on the spot and then used to compose finished pictures in the studio. Diaz turned increasingly to gypsy subject-matter, as in *The Gypsies* (exh. Salon 1850–51; Paris, Mus. d'Orsay), using the Forest of Fontainebleau and its foliage, bathed in a shimmering light, as a background for picturesque and imaginary scenes.

In an attempt to satisfy the 19th-century vogue for the *fête galante*, Diaz produced numerous genre scenes and pictures featuring fantastical characters and allegorical nudes. Although such works as *The Clown* (Phoenix, AZ, A. Mus.), after Antoine Watteau's *Gilles* (1720–21; Paris, Louvre), represent Diaz's interpretation of 18th-century painting, the quality of his mythological groups (e.g. *Venus with Cupid on her Knee*, 1851; Moscow, Pushkin Mus. F.A.) suffered from his overabundant production. Diaz's poetical style and technique inspired a number of epithets among Salon critics, from Théophile Thoré's 'heaps of precious stones' to Charles Baudelaire's 'nauseating sweeties and sugary stuff' on the subject of the *Lamentations of Jephthah's Daughter* (exh. Salon 1846; St Petersburg, Hermitage). In response to these criticisms, Diaz executed a picture 4 m in height in 1855; the *Last Tears* (priv. col.) is in a drier style, with heavy contours. It symbolizes souls departing from earth and shedding their last tears before attaining eternal bliss. The last pictures that Diaz sent to the Salon, such as *Don't Enter* (exh. Salon 1859; Paris, Mus. d'Orsay), marked a return to the laboured qualities of his earlier work.

Diaz often reused the same compositions, with the centre of the foreground occupied by a clearing, a pond or a path, framed by rows of trees that disappear into the distance and direct the eye

24. Narcisse Diaz: *Heights of Le Jean de Paris*, 1867 (Paris, Musée d'Orsay)

from the centre of the picture towards secondary gleams of light, as in the *Pond under the Oaks* (Paris, Mus. d'Orsay). Diaz's late landscapes express a tormented aspect of nature and a realism that, by way of Rousseau, recalls Salomon van Ruysdael. The light came to have a more tragic quality, as in the leaden sky of the *Heights of Le Jean de Paris* (1867; Paris, Mus. d'Orsay, see fig. 24), and the composition became more grandiose in the series of landscapes executed towards the end of his life (e.g. the *Threatening Storm*, 1870; Pasadena, CA, Norton Simon Mus.). These works have nothing of the anecdotal about them, with their almost total disregard for the human figure and for civilization, as in *Undergrowth* (1874; Reims, Mus. St-Denis). In 1863 Diaz had met Claude Monet, Auguste Renoir, Alfred Sisley and Frédéric Bazille, who admired his brilliant colours, and his late landscapes may have influenced the Impressionists.

Bibliography

T. Silvestre: *Histoire des artistes vivants français et étrangers* (Paris, 1861), pp. 163–78

J. Claretie: 'Notice biographique', *Exposition des oeuvres de N. Diaz* (exh. cat., Paris, Ecole N. Sup. B.-A., 1877)

——: *Peintres et sculpteurs contemporains*, i (Paris, 1882)

Narcisse Diaz de la Peña, 1807–1876 (exh. cat., Paris, Pav. A., 1968)

P. Miquel: *Le Paysage au XIXe siècle*, ii: *L'Ecole de la nature* (Maurs-la-Jolie, 1975), pp. 282–319

VALÉRIE M. C. BAJOU

Doyen, Gabriel-François

(*b* Paris, 20 May 1726; *d* St Petersburg, 13 March 1806). French painter. In 1748 he won second place in the Prix de Rome competition and subsequently became a pupil of Carle Vanloo at the Ecole Royale des Elèves Protégés, Paris. In 1752 he arrived to complete his artistic education at the Académie de France in Rome, where he discovered the art of Raphael and of Domenichino, as well as that of such Baroque masters as Pietro da Cortona, Luca Giordano and Francesco Solimena. He also stayed in Parma and visited Venice, Bologna and Turin. His experiences in Italy confirmed him in his life-long vocation for large-scale history painting.

In 1756 Doyen returned to Paris and began to paint the *Death of Virginia* (exh. Salon 1759; Parma, G.N.), a huge work (*c.* 4×7 m) recalling the great Italian decorative paintings of the 16th and 17th centuries, yet innovative in its use of a subject from Livy and its combination of antique costumes and setting with rich late Baroque colouring. The picture won high praise from the critics, Denis Diderot in particular. Doyen was immediately approved (*agréé*) as an associate member by the Académie Royale and received (*reçu*) as a full member in the same year. The painting was bought by Philippe de Bourbon, Duke of Parma (*d* 1765) as the first acquisition for his newly founded gallery in Parma. Doyen then turned to Homer, a fashionable source since the publication in 1757 of the Comte de Caylus's *Tableaux tirés d'Homère et de Virgile*, and over 20 years produced a series of paintings of vast dimensions: the tumultuous and poetic *Venus Wounded by Diomedes* (exh. Salon 1761; St Petersburg, Hermitage), the systematically dramatic *Andromache Hiding Astyanax from Ulysses* (exh. Salon 1763; Arkhangel'skoye Pal.) and finally *Mars Defeated by Minerva* (exh. Salon 1781; Poitiers, Mus. B.-A.). In the last-named canvas Doyen took up a favourite theme, that of the Homeric battle. But to the public at the 1781 Salon, discovering a new and more austere type of painting in Jacques-Louis David's *Belisarius Receiving Alms* (Lille, Mus. B.-A.), the overcharged ardour, the confusion of the principal action to the detriment of the harmony of the whole and the freedom of the brushwork in Doyen's picture must have seemed old-fashioned. Doyen nevertheless continued to work in this vein in the 1780s, exhibiting the clamorous *Priam Demanding the Body of Hector from Achilles* (Paris, Louvre, on dep. Algiers, Mus. N. B.-A.) at the Salon of 1787.

Doyen also worked on a number of important decorative projects. After the death of Carle Vanloo in 1765, he was given the task of completing the decoration of the Chapelle Saint-Grégoire in the church of the Invalides, Paris. Vanloo had left only bare indications for the project, but Doyen's seven scenes from the *Life of St Gregory* (completed 1772) are probably the outstanding masterpieces of large-scale decorative painting in late 18th-century France. Also in 1772 he produced a *Triumph of Amphitrite* for the dining-room of the Petit Trianon, Versailles. However, the powerful drawing and the amplitude of the forms were not in accord with fashionable Neo-classical taste, and it appears that the work was not hung.

Unlike his contemporary Jean-Baptiste-Henri Deshays, Doyen had little experience of religious painting apart from the Rubensian *Adoration of the Magi* (Mitry-Mory, Seine-et-Marne, parish church), painted in 1766 for Mme de Pompadour's château of Bellevue, and another picture of the same subject (Darmstadt, Hess. Landesmus.). It was nevertheless in this field that he produced his masterpiece, *St Geneviève and the Miracle of the Victims of Burning-sickness (Le Miracle des Ardents)* (exh. Salon 1767; Paris, St Roch), hailed by the Salon critics as one of the most brilliant paintings of the century. Doyen prepared for the picture not only by making numerous drawings and sketches (e.g. Paris, Louvre, and Bayonne, Mus. Bonnat) but also by travelling to Flanders to study the great compositions of Rubens. In addition, he doubtless drew on his memories of the work of Guercino and Mattia Preti. The powerful composition and intense colouring of *St Geneviève* had an impact on contemporaries such as François-Guillaume Ménageot, whose *Chaste Susanna* (1779; Douai, St Pierre) was clearly inspired by Doyen's painting. The realistic studies Doyen made from dying patients in the hospices for the afflicted figures that writhe in the lowest portion

of the composition anticipate the procedures of Jean-Antoine Gros and Théodore Gericault by 50 years. In its vigorous romanticism Doyen's picture was in striking contrast to the conventional classicizing quality of Jean-Marie Vien's *St Denis Preaching the Faith in France*, which was also painted for St Roch (*in situ*) and was shown in the same Salon. It is, however, a measure of the stylistic uncertainties of the 1760s that neither Diderot nor the general public was able to decide between the respective merits of the two artists. A further important commission for a religious painting followed in 1773, the *Last Communion of St Louis* for the high altar of the chapel of the Ecole Militaire, Paris (*in situ*). This is a meditation on the death of a hero pervaded by memories of Poussin's *Death of Germanicus* (Minneapolis, MN, Inst. A.), the acknowledged prototype of the genre.

Doyen became a fashionable painter and was well received at court; he was appointed Premier Peintre to the Comte d'Artois (later Charles X) in 1773 and to the Comte de Provence (later Louis XVIII) in 1775. The town of Reims commissioned from him ephemeral decorations for the celebrations of the coronation of Louis XVI in 1774, and in 1775 he executed a great commemorative painting in the tradition of Nicolas de Largillierre, *Louis XVI Being Received as Grand Master of the Order of the Saint Esprit* (Versailles, Château).

In 1791 and 1792 Doyen was involved with his pupil Alexandre Lenoir in the formation of the famous storehouse of works of art in the recently suppressed convent of the Petits Augustins, Paris, the purpose being to save and catalogue works threatened by the unsettled events of the French Revolution. However, in 1792 he accepted an invitation from Catherine II to settle in Russia and took up an appointment as a professor at the Imperial Academy in St Petersburg. After Catherine's death, he continued to work for Paul I, executing a number of portraits and decorative works, among them a ceiling (destr.) in the Winter Palace, St Petersburg. The lyricism of his inspiration as well as the freedom of his technique and the amplitude of his forms made Doyen one of the most innovative history painters of his period.

Bibliography

D. Diderot: *Salons* (1759–81); ed. J. Seznec and J. Adhémar (Oxford, 1957–67, rev. 1983)

H. Stein: *Le Peintre Doyen et l'origine du Musée des Monuments français* (Paris, 1888)

M. Hérold: 'A propos du *Miracle des Ardents* de Gabriel-François Doyen (1726–1806)', *Rev. Louvre*, 2 (1968), pp. 65–72

M. Sandoz: *Gabriel-François Doyen (1726–1806)* (Paris, 1975)

Diderot et l'art de Boucher à David: Les Salons, 1759–1781 (exh. cat., ed. M.-C. Sahut and N. Volle; Paris, Hôtel de la Monnaie, 1984–5)

NATHALIE VOLLE

Drolling [Drelling; Drölling]

French family of painters. Both (1) Martin Drolling and his son (2) Michel-Martin Drolling were portrait painters; whereas the father expanded his range by concentrating on bourgeois domestic interiors, the son produced a number of history paintings on mythological and religious subjects. Another of Martin Drolling's three children by his second wife, Louise-Elisabeth (née Belot), was Louise-Adéone Drolling (*b* Paris, 29 May 1797; *d* before 1831), otherwise known as Mme Joubert; she also practised as a painter.

(1) Martin Drolling

(*b* Oberbergheim, nr Colmar, *bapt* 19 Sept 1752; *d* Paris, 16 April 1817). After receiving initial training from an unknown painter in Sélestat, Drolling moved to Paris, where he attended courses at the Académie Royale. He supplemented his education there by studying Flemish and Dutch Old Masters in the collection at the Luxembourg Palace. From the Flemish school he derived his own rich impasto, while the Dutch was to influence him in his meticulous, supremely descriptive and unsentimental style of painting as well as his choice of subject-matter: unfussy bourgeois interiors and frank portraits. Drolling first exhibited at the Salon de la Correspondance in 1781 and again in 1782 and 1789. After the French Revolution he was able to participate in the Salon at the Louvre, despite the fact that he had never become

a member of the Académie Royale. He exhibited from 1793 to 1817, although the majority of his works extant today were shown after 1800. From 1802 to 1813 he was employed by the Sèvres porcelain manufactory, and many of his designs were engraved.

Drolling's works are often compared with those of his contemporary Louis-Léopold Boilly on account of their high finish and depiction of a solidly bourgeois world, though Drolling's compositions are less anecdotal and his choice of themes often more banal. He has much in common with the German and Scandinavian minor masters of the period (e.g. Carl Gustav Carus, Johannes Jelgerhuis and Georg Friedrich Kersting), but his productions lack the emblematic content of works by Caspar David Friedrich, which they resemble in style. Drolling's tendency to reduce his subject-matter to a mundane domestic level is seen in *A Young Lady (Queen Hortense) Brings Relief to a Family that has Experienced Misfortune* (Caen, Mus. B.-A.) and in the more successful *Interior of a Dining-room* (1816; Paris, priv. col.) and *Interior of a Kitchen* (1815; Paris, Louvre). A preparatory drawing for the latter work also exists (Paris, Louvre). No symbolic meanings are invested in *Interior of a Kitchen*, although occasionally Drolling did choose to illustrate a particular theme or moral.

A good collection of Drolling's portraits survives, the best examples of which testify to his great skill in this area. That of *Michel Belot* (1791) and the *Self-portrait* (c. 1791; both Orléans, Mus. B.-A.) are particularly fine.

Bibliography

French Painting, 1774–1830: The Age of Revolution (exh. cat., ed. F. Cummings, R. Rosenblum and P. Rosenberg; Detroit, MI, Inst. A.; New York, Met.; Paris, Grand Pal.; 1974–5), pp. 398–9

M. O'Neill: *Orléans, Musée des Beaux-arts, catalogue critique: Les Peintures de l'école française des XVIIe et XVIIIe siècles*, cat. (Orléans, 1977), pp. 49–54

Au temps de Watteau, Fragonard et Chardin: Les Pays-Bas et les peintres français du XVIIIe siècle (exh. cat., ed. C. Lauboutin and A. Scottez; Lille, Mus. B.-A., 1985)

JOSHUA DRAPKIN

(2) Michel-Martin Drolling

(*b* Paris, 7 March 1786; *d* Paris, 9 Jan 1851). Son of (1) Martin Drolling. The pupil of his father, he also studied in David's studio in 1806. He obtained the Prix de Rome in 1810 with the *Anger of Achilles* (Paris, Ecole N. Sup. B.-A.). After his stay in Rome he exhibited the *Death of Abel* (Leipzig, Mus. Bild. Kst.) in the Salon of 1817. He decorated two ceilings in the Musée Charles X in the Louvre and obtained two commissions from the Musée d'Histoire at Versailles: the *Tours States-General* (1836) and the *Alexandria Convention* (1837). His genre scenes show that while his style was generally colder, he inherited his father's love of Dutch art and use of thinly applied, porcelain-like paint, contrasting effects of light and meticulous detail. His figures were either half-length with a landscape background in the English manner (*Portrait of Manuel*, 1819; Brest, Mus. Mun.) or full-length and set in countryside, with the charming naivety of Pierre Duval Le Camus.

Drolling also attempted history painting (the *Separation of Hecuba and Polyxenas*, 1824; Le Puy, Mus. Crozatier) and allegory (*Strength*, 1818, Amiens, Mus. Picardie; *Prudence*, 1819, Bordeaux, Mus. B.-A.). These are works of a rigid, ponderous and ossified Neo-classicism. He was also involved in the decoration of Notre-Dame-de-Lorette (1823–36) in Paris, producing *Christ among the Doctors* (*in situ*), which is old-fashioned in comparison to the work of Victor Orsel in the same church and reveals Drolling as a frigid and enfeebled follower of David. The many students at his studio in the Ecole des Beaux-Arts included Paul Baudry, Jules Breton and Jean-Jacques Henner.

Bibliography

C. Gabet: *Dictionnaire des artistes français au XIXe siècle* (Paris, 1831), p. 224

P. Grunchez: *Les Concours des Prix de Rome: Catalogue* (Paris, 1986), pp. 94–5

MARIE-CLAUDE CHAUDONNERET

Dubufe

French family of painters. Both (1) Claude-Marie Dubufe and his son (2) Edouard Dubufe were best

known as portrait painters, though they worked in other genres as well. Edouard's wife and son were also artists, specializing in portrait busts and decorative painting respectively.

(1) Claude-Marie Dubufe

(b Paris, 1790; d La Celle-Saint-Cloud, 24 April 1864). His father, a chef d'institution, educated him for a career in the diplomatic service. At the age of 19 he was nominated vice-consul and was on the point of leaving for America when David (who had given Dubufe some instruction) persuaded his father to allow him to train as a painter. Dubufe received no further support from his father and paid for his lessons with David by playing the violin in an orchestra. He made his Salon début in 1810 with A Roman Allowing his Family to Die of Hunger rather than Touch a Sum of Money Entrusted to his Keeping; like Achilles Protecting Iphigenia (Salon of 1812) and Christ Calming the Tempest (Salon of 1819), this picture has disappeared. His earliest surviving composition, Apollo and Cyparissus (1821; Avignon, Mus. Calvet), exhibited in 1822, is elegantly mannered in a style inspired by Girodet but did not appeal much to the critics. He then painted the first of a number of sentimental genre pictures in the manner of The Surprise (exh. RA 1828; London, N.G.), of which the most famous, Souvenirs and Regrets (Pasadena, CA, Norton Simon Mus.), were widely known through many engraved versions.

In 1828, following the example of Gericault and other French painters at the time, Dubufe sent two pictures, the Temptation in the Garden of Eden and the Expulsion from Paradise, to Britain and to America on a touring exhibition; this was a financial success. He continued to send more pictures to the Salon into the early 1830s when he began to devote himself entirely to portraits. His early portraits, like Mme Dubufe (1820; Paris, Louvre), are painted in the thin, careful, straightforward manner of David. His later work is softer and more idealized and recalls the bland mannerism of Apollo and Cyparissus without the freshness of his early work. He had, however, a huge fashionable appeal. He exhibited over 150 portraits

at the Salon, mostly during the July Monarchy. After 1848 he attempted to extend his range by exhibiting an allegorical figure of the Republic (surely an unrecorded entry for the competition of 1848) and appears to have limited his practice as a portrait painter. In his later years he also painted the peasant girls and picturesque views of Normandy. In 1859, when the revival of mythology begun by a younger generation of Prix de Rome winners was well established, Dubufe returned to the inspiration of his youth by exhibiting a Greek Woman Leaving her Bath and a Birth of Venus (both untraced). None of these late works matched the popularity of his portraits.

Bibliography

De David à Delacroix (exh. cat., Paris, Grand Pal., 1974), pp. 401–2

(2) (Louis-)Edouard Dubufe

(b Paris, 31 March 1820; d Versailles, 11 Aug 1883). Son of (1) Claude-Marie Dubufe. He was trained by his father and then by Paul Delaroche. He first appeared at the Salon in 1839 with the Annunciation, a Huntress and a portrait, winning a third class medal. He followed this in 1840 with an episode in the life of St Elisabeth of Hungary, which won him a second class medal; in 1844 he won a first class medal with Bathsheba and a genre scene set in the 15th century (all untraced).

By the mid-1840s Dubufe seemed firmly established in the sentimental Romanticism associated with Cibot and Ary Scheffer. Baudelaire noted in 1845 that he appeared to have chosen a different path from his father's lucrative profession; in fact, he closely followed the pattern of his father's career, from a relatively unprofitable beginning in history painting into the rich world of fashionable portraits, inheriting the aristocratic sitters relinquished by his father in the early 1850s. Edouard's portraits before 1850 (e.g. Unknown Woman; Autun, Mus. Rolin) have a sharp, bright quality that recalls Delaroche. His later work is softer and more idealized. As with his father, it is difficult to assess Dubufe's range as a portrait painter, but there is an interesting group of works in Versailles (Château), including a memorable portrait of Rosa

Bonheur with one arm round a bull's head, exhibited in 1857, and a darker, more intense portrait of *Harpignies* sketching *en plein air*, exhibited in 1877; these are striking images of fellow artists but perhaps not as typical as the glittering, featureless portraits of the *Empress Eugénie* in Versailles and Compiègne. As a portrait painter, he shared fashionable Paris in the Second Empire with F. X. Winterhalter.

In 1866 Dubufe attempted to break new ground by exhibiting an immense composition, 12 m long, on the theme of *The Prodigal Son*, which did not please the critics. It was bought by A. T. Stewart, the American delegate at the Exposition Universelle of 1867, who sent it to an exhibition tour of America. It was shown for the last time at the Columbian Exposition in Chicago in 1893 and then disappeared.

In 1842 Dubufe married Juliette Zimmermann, daughter of the pianist, Pierre Zimmermann. She was a sculptor specializing in portrait busts, and she exhibited at the Salon between 1842 and 1853. Their son, (Edouard Marie) Guillaume Dubufe (1853–1909), broke with family tradition by becoming a successful decorative painter, inspired by the contemporary fashion for the art of the Rococo. His work can be seen in Paris at the Hôtel de Ville, the Sorbonne, the Palais de l'Elysée and the Comédie–Française.

Bibliography
Thieme–Becker

JON WHITELEY

Ducis, (Jean-)Louis

(*b* Versailles, 14 July 1775; *d* Paris, 3 March 1847). French painter. Around 1795 he entered the studio of Jacques-Louis David, where he was a member of the group of artists from southern France known as the 'parti aristocratique' (Pierre Révoil, Fleury Richard, Comte Auguste de Forbin and François-Marius Granet), who were among the first to paint small-scale pictures of French history. Ducis remained a friend of Granet throughout his life (e.g. *Portrait of Mme Granet*, Aix-en-Provence, Mus. Granet). He exhibited regularly in the Salon

between 1804 and 1838, winning a medal for history painting in 1808. He rapidly acquired a considerable reputation with scenes of sentimental mythology such as *Orpheus and Eurydice* (exh. Salon 1808; untraced), in part due to his links with the poet Jean-François Ducis (his uncle) and with his brother-in-law, the actor François Joseph Talma. (He exhibited *Talma's Débuts* (Paris, Mus. Comédie-Française) at the Salon of 1831.) Josephine and her daughter Hortense were among his patrons; at Malmaison the Empress owned four portraits by Ducis of children, probably the two youngest sons of Hortense and the elder daughters of her son, Eugène Beauharnais (untraced). For Napoleon Ducis executed a stiff composition, halfway between a group portrait and a history painting, *Napoleon and his Family at Saint-Cloud* (exh. Salon 1810; Versailles, Château). In 1811 he stayed in Naples, where he painted portraits of the royal family.

Ducis was still in favour during the Restoration. In 1814, in a letter to the Minister of the Maison du Roi listing the names of artists worthy of the King's attention (Paris, Archv. N., O³ 1389), the Director of Museums cited Ducis as an 'educated man of refined taste'. During the same period Ducis was entrusted with the restoration of the ceiling paintings in the apartments of Louis XIV in the château of Versailles. He received a commission from the Maison du Roi, *Louis XVIII Watching the Return of Troops from Spain from the Balcony of the Tuileries* (exh. Salon 1824; Versailles, Château), a history painting composed like a genre scene, the figures shown from behind and against the light, their costumes and accessories rendered with the detailed precision of a goldsmith. He also executed a portrait of *Charles X* (Cambrai, Mus. Mun.).

Ducis owed his fame to his Troubadour style paintings. These small, technically brilliant paintings were popular with the public and were frequently reproduced on porcelain. Far from being an erudite painter like most of the Troubadour artists, he knew how to please his public with easily read anecdotes, and he did not hesitate to repeat his most successful compositions. This was the case with the *Arts under the Empire of Love*, in which

Poetry, Sculpture, Painting and Music were represented allegorically by four pairs of lovers, who evoked the artistic life of former times. In the Salon of 1814 he exhibited *Tasso Reading his Verses to Eleonora d'Este*, which was acquired by Queen Hortense, who had already bought *Tasso in the House of his Sister Cornelia in Sorrento* (exh. Salon 1812; both Arenenberg, Napoleonmus.). To this composition symbolizing Poetry he added *Properzia de' Rossi and her Last Bas-relief* (Sculpture), *Van Dyck Painting his First Picture* (Painting) and *Mary Stuart Making Music with David Rizzio* (Music). The series (exh. Salon 1822; Limoges, Mus. Mun.) was bought by the Maison du Roi. Ducis repeated it for the Duchesse de Berry (untraced). This 'poem in four cantos', as it was called by the critics, propounded the idea of 'chivalry' in a mythical era of love, poetry and reverie, when Woman was seen as the protectress of the arts and the instigator of noble actions by men.

Throughout his career Ducis displayed a constant preoccupation with costume and picturesque detail, seen, for example, in *Flight of Bianca Capello* (exh. Salon 1824; Cherbourg, Mus. Henry). His Troubadour paintings lacked the archaeological purpose that was so important to Richard and Révoil but prefigured the sparkling and colourful works of Richard Parkes Bonington and Eugène Devéria. The decline of Troubadour painting began in 1824, and henceforth the critics, while they continued to appreciate the freshness of colouring and the delicacy of Ducis's work, stressed that the public were tiring of his repetition of the same characters and costumes. In 1831, when his career was in decline, Ducis became Director of the Ecole de Dessin in Cambrai. He was made Chevalier of the Légion d'honneur in 1832.

Bibliography

E. J. Delécluze: *Louis David: Son école et son temps* (Paris, 1855), pp. 49–52

C. de Beaumont: 'Jean-Louis Ducis, peintre (1775–1847)', *Réun. Soc. B.-A. Dépts*, xxiv (1900), pp. 520–47

M.-C. Chaudonneret: *Fleury Richard et Pierre Révoil: La Peinture troubadour* (Paris, 1980), pp. 43–4

MARIE-CLAUDE CHAUDONNERET

Ducreux, Joseph

(*b* Nancy, 26 June 1735; *d* Paris, 24 July 1802). French painter, pastellist and engraver. He lived in Paris from 1760 and from 1762 kept a list of his works. Among the portraits he completed in his early years were those in pastel of the well-known connoisseurs *Pierre-Jean Mariette*, the *Comte de Caylus* and *Ange-Laurent de la Live de July* (all untraced), which apparently were copies after Maurice-Quentin de La Tour. Ducreux has traditionally been seen as de La Tour's favourite pupil, while Jean-Baptiste Greuze is supposed to have initiated him into oil painting. From his age, it can be assumed that by the time Ducreux reached Paris he had already acquired a grounding in his art.

In 1769 Ducreux was selected to paint Louis XVI's future wife, Marie-Antoinette, in Vienna. The official portrait he made (untraced) survives only in the engraving (1771) by Charles Eugène Duponchel (1748–80). Two surviving portraits of the future queen (both priv. col.) are conventional and not very expressive. Ducreux spent two years at the Austrian court. While there he also received a commission to paint the portrait of *Emperor Joseph II* (c. 1769; untraced; engr. 1793 by Louis-Jacques Cathelin, 1739–1804) and became a member of the Vienna Kunstakademie. Then he returned to Paris, where Marie-Antoinette's patronage ensured him work at the court. He painted portraits of the sisters of Louis XVI (all untraced) and received many commissions from the nobility. Only rarely did Ducreux go beyond conventional patterns in expression and pose. To some degree his pastels, for example the portrait of the poet *Jacques Delille* (priv. col.) or that of *Gen. Pierre Choderlos de Laclos* (Versailles, Château), have the same quality of an unfinished drawing that characterizes those of de La Tour.

Ducreux's portrait of the *Abbesse Louise Claude de Bourbon Busset* (1779; Lignières, Château Ussé) is one of his best works of this period. In 1783 Ducreux, who was never a member of the Académie Royale (and so could not exhibit in the official Salons), exhibited some of his works in a 'counter-exhibition', the Salon de la

Correspondance, and presented a portrait of the founder of that institution, *M. Pahin de la Blanchérie* (untraced). He also exhibited a portrait of the singer *Marie Fel* (untraced), de La Tour's long-time companion, and one of *Benjamin Franklin* (untraced), as well as a *Self-portrait, Smiling* (Paris, Louvre). Like de La Tour, Ducreux regularly painted self-portraits. One of them (Paris, Mus. Jacquemart-André) closely follows the pattern of de La Tour's *Self-portrait* now in the Musée de Picardie, Amiens. Ducreux attached special artistic importance to his self-portraits; in 1791 in London, where he fled during the Revolution, he engraved and published three of them.

Not a success in London, Ducreux returned in 1793 to Paris, where he exhibited work at the Salon, then open to all artists. His association with Jacques-Louis David made it easier for him to continue an official career. In the 1790s he produced a portrait drawing of *Louis XVI* (untraced) and the expressive portrait of *Robespierre* (priv. col.). In his last years the former Hôtel d'Angiviller, where Ducreux lived from 1797, became a focal point for lovers of art and music. Works he produced during this period include the sympathetic pastel portrait of the composer *Melhul* (Paris, Louvre).

Bibliography
Thieme–Becker
P. Dorbec: 'Joseph Ducreux', *Gaz. B.-A.*, n. s. 2, xxxvi (1906), pp. 199–216
R. Crozet: 'Un Pastel inédit de Joseph Ducreux', *Rev. A.* [Paris], vi (1956), pp. 117–18
G. Lyon: *Joseph Ducreux (1735–1802), Premier Peintre de Marie Antoinette: Sa vie et son oeuvre* (Paris, 1958)

CATHRIN KLINGSÖHR-LE ROY

Dumont

French family of sculptors. The first in a long line of sculptors was Pierre Dumont (*d* ?1737), who was a member of the Accademia di S Luca, Rome, and sculptor to Leopold, Duke of Lorraine (*reg* 1697–1729), for whom he provided decorative work in, among other places, Nancy (1719; destr.). The career of his son François Dumont, was cut short by a tragic accident. François's son Edme Dumont, grandson (1) Jacques-Edme Dumont and great-grandson (2) Augustin-Alexandre Dumont were all winners of the Prix de Rome for sculpture.

Bibliography
G. Vattier: *Une Famille d'artistes: Les Dumont (1660–1884)* (Paris, 1890)

(1) Jacques-Edme Dumont

(*b* Paris, 10 April 1761; *d* Paris, 21 Feb 1844). In 1777 he was admitted to the Ecole des Elèves Protégés. As a student of Augustin Pajou, he won the Prix de Rome in 1788, by which time he had already executed a number of independent works, including the relief of the *Discovery of the Relics of SS Gervase and Protase* (marble, 1783; Sées Cathedral). He was in Italy from 1788 to 1793 and then returned to France in the hope of receiving commissions from the Revolutionary Convention. In this he was disappointed and turned instead to the production of statuettes and medallions (e.g. Lons-le-Saunier, Mus. B.-A.; Semur-en-Auxois, Mus. Mun.). He fared better under the Consulate and the Empire, receiving commissions for, among other works, a monumental statue of *Louis IV* (1801; St Denis Abbey); a statue of *General François-Séverin Marceau* (untraced; sketch models Paris, Louvre); and a seated statue of *Jean-Baptiste Colbert* (stone, 1808; Paris, Pal. Bourbon). He continued in official favour during the Restoration, producing a monument to *Chrétien-Guillaume de Malesherbes* (1819; Paris, Pal. Justice) and a statue of *General Charles Pichegru* (destr. 1830). He was also active as a portrait sculptor. Examples of his work in this genre are the tenderly realistic bust of his mother, *Marie-Françoise Berthault* (plaster; Paris, Louvre) and the severely Neo-classical bust of the *Empress Marie-Louise* (1810; priv. col.).

Bibliography
Souchal
G. Hubert: 'Deux maquettes de Jacques-Edme Dumont', *Rev. des A.*, 3 (1951), pp. 181–3
J. Pontefract: *Inventaire des collections de sculpture moderne . . . du Musée de Semur-en-Auxois* (1970–71)

(2) Augustin-Alexandre Dumont

(*b* Paris, 4 Aug 1801; *d* Paris, 27–28 Jan 1884). Son of (1) Jacques-Edme Dumont. He entered the Ecole des Beaux-Arts, Paris, in 1818, won the Prix de Rome for sculpture in 1823 and spent the next seven years in Italy, producing works such as the *Infant Bacchus Nurtured by the Nymph Leucothea* (1830; Semur-en-Auxois, Mus. Mun.). He returned to France shortly after the July Revolution of 1830; a succession of public commissions followed, including one for the statue of *Nicolas Poussin* for the Salle Ordinaire des Séances in the Palais de l'Institut de France, Paris (1835; *in situ*). The government of the Second Republic commissioned from him a statue of *Maréchal Thomas Bugeaud de la Piconnerie* (*c.* 1850; version, Versailles, Château). As well as the various large public sculptures of historical figures that he produced for provincial centres under the Second Empire, he executed a number of portrait sculptures, such as that of the naturalist *Alexander von Humboldt* (1871; Versailles, Château). Many of the public monuments that Dumont designed were destroyed under the Commune (1871); he was prevented by illness from producing any work after 1875.

Bibliography

DBE

G. Vattier: *A. Dumont: Notes sur sa famille, sa vie et ses ouvrages* (Paris, 1885)

La Sculpture française au XIXe siècle (exh. cat. by A. Pingeot, Paris, Grand Pal., 1986)

☐

Dupré, Augustin

(*b* Saint-Etienne, Loire, 6 Oct 1748; *d* Armentières, 30 Jan 1833). He began his career chasing and engraving the ornament on arms, first in Saint-Etienne and then as an apprentice in Paris. A lucky commission from the Spanish ambassador enabled him to establish his own workshop and to set up as a goldsmith. In 1776 he was asked to execute a jetton for the Corps des Marchands. The exhibition of his design for this medal, which depicts Hercules vainly attempting to break a bundle of sticks, along with others, established his reputation as a medallist and brought him an official commission for the medal representing the *Subterranean Junction of the Escaut and the Somme* (1782). In 1783, through his acquaintance with Benjamin Franklin, he gained the commission for a medal celebrating *American Liberty*. This enormously successful work was followed by further commissions from the government of the United States for medals of *Benjamin Franklin* (1784–6), *Nathaniel Green* (1787), *Daniel Morgan* (1789) and *John Paul Jones* (1789). This celebration of the American Revolution was, in retrospect, a long rehearsal for Dupré's flowering as the medallist who was most in tune with and best expressed the spirit of the French Revolution. His medal for the *Federation of the 14 July* (1790), executed on his own initiative and to his own design, was sold in thousands and, adopted as the type for the Monneron brothers' money medals, it circulated throughout France.

Advised and assisted by Jacques-Louis David, Dupré launched an attack on the system for minting coins in France, alleging a superfluity of incompetent engravers in the provincial mints, deploring the hereditary nature of most of the posts in the monetary administration and demanding an open competition for the post of Graveur-Général. In the spring of 1791 there was a competition for new designs for the coinage, a competition that Dupré, strongly supported by David, won. In July he won a further competition, for the post of Graveur-Général, and for the next few years he was occupied with engraving the dies first for the Revolutionary and then for the Republican coinage. Napoleon Bonaparte's arrival in power spelt the end of Dupré's career, however. His unflattering medallic portrait of *Napoleon as First Consul*, executed to commemorate the erection of a statue to Joan of Arc, reveals his antipathy to the new regime, which ejected him from his post in 1803.

Bibliography

J. F. Loubat: *The Medallic History of the United States of America* (New York, 1878)

C. Saunier: *Augustin Dupré* (Paris, 1894)

MARK JONES

Dupré, Jules

(*b* Nantes, 5 April 1811; *d* L'Isle-Adam, Val-d'Oise, 6 Oct 1889). French painter. He began his career in Creil, Ile de France, as a decorator of porcelain in the factory of his father, François Dupré (*b* 1781), and later worked at the factory founded by his father in Saint-Yrieix-la-Perche, Limousin. It was in this region of central France that Dupré became enchanted by the beauty of nature. He went to Paris to study under the landscape painter Jean-Michel Diébolt (*b* 1779), who had been a pupil of Jean-Louis Demarne. Dupré began to see nature with a new awareness of its moods, preferring to paint alone and *en plein air*. He was fascinated by bad weather, changes of light and sunsets. Many of his paintings depict quiet woodland glades, often with a pond or stream (e.g. *Plateau of Bellecroix*, 1830; Cincinnati, OH, A. Mus.). In 1830–31 he associated with other young landscape painters, including Louis Cabat, Constant Troyon and Théodore Rousseau (see col. pl. XXXIV and fig. 70), and with them sought inspiration for his study of nature in the provinces, exhibiting the finished paintings at the annual Salons. In 1832 he visited the region of Berry with Cabat and Troyon, and in 1834 he was among the first French landscape painters to visit England. He spent time in London, Plymouth and Southampton and painted several views of these cities (e.g. *Environs of Southampton*, exh. Salon 1835; priv. col., see Aubrun, no. 69). While in England he met, and was influenced by, Constable, Turner and Richard Parkes Bonington. He travelled to the Landes and the Pyrenees with Rousseau in 1844, and they also explored the forests of the Ile de France in search of motifs. Dupré also painted in Normandy, Picardy and Sologne. Although he was a member of the Barbizon school, he did not visit the Forest of Fontainebleau as frequently as did others of the group, preferring instead to settle in 1849 in the village of L'Isle-Adam, north of Paris, where he remained for much of his life.

Dupré's approach to nature falls somewhere between realism and Romanticism. For him nature was majestic, and he was fascinated by the alliance of the ephemeral and the eternal. He searched for the mystery of creation by examining the permanence of a natural world dominated by trees, which he saw as a significant element linking heaven and earth. This mystical vision was in part influenced by the paintings of such 17th-century Dutch masters as Meindert Hobbema and Jacob van Ruisdael. One of his most representative works is *The Floodgate* (c. 1855–60; Paris, Mus. d'Orsay), with its tormented conception expressed in shifting chiaroscuro and thick, powerful handling of paint, which shape the natural world of light, trees and plants supporting human beings and animals. Despite his independent temperament, his career was successful, and his work was received with enthusiasm during his lifetime. He was made Chevalier de la Légion d'honneur in 1849 and was awarded several medals at the Salons and at the Exposition Universelle in 1867 in Paris, where he showed 13 paintings. In later years he spent summers at Cayeux-sur-Mer and executed paintings inspired by its coastline (e.g. *The Headland*, c. 1875; Glasgow, A.G. & Mus.). In these works his feeling for the tragic character of nature is heightened as much by his technique as by his lyrical conception. He also painted watercolours (e.g. the *Duck Pond*, c. 1833; Paris, Louvre). He was admired by the Impressionist painters and by their dealer Paul Durand-Ruel for his perception of atmosphere and the rendering of reflections of light, although his popularity declined somewhat in the first half of the 20th century.

Bibliography

Bellier de La Chavignerie–Auvray
L. Delteil: *J. F. Millet, Th. Rousseau, Jules Dupré, J. Barthold Jongkind*, i of *Le Peintre-graveur illustré (XIXe et XXe siècles)* (Paris, 1906–30/R New York, 1969)
M. M. Aubrun: *Jules Dupré, 1811–1889: Catalogue raisonné de l'oeuvre peint, dessiné et gravé*, 2 vols (Paris, 1974–82)
M. Laclotte and J.-P. Cuzin, eds: *Petit Larousse de la peinture*, 2 vols (Paris, 1979)

ANNIE SCOTTEZ-DE WAMBRECHIES

Durand-Brager, (Jean-Baptiste-)Henri

(*b* Château de Belnoe, nr Dol, 21 May 1814; *d* Paris, 25 April 1879). French painter. Originally intended

for a naval career, he travelled widely while still a youth. By the time he decided to seek artistic instruction in the atelier of Eugène Isabey, he had already sailed along most of the Atlantic coast of Africa. In 1840 his spirit of adventure and growing artistic ambitions were both served by his appointment as artist on an official mission charged with the return of Napoleon's ashes from St Helena to France. An illustrated album documenting the expedition was published the following year. His subsequent career is a model of the times in its fusion of the wanderer's urge with the artist's commitment to visual record.

Durand-Brager was awarded the Légion d'honneur in 1843 and valuable commissions soon followed, in which his naval experience and artistic skills were called upon. Prominent works of those years were *The Combat between the French Frigate Niémen and the English Frigates Arethusa and Amethyst* (1844; Bordeaux, Mus. B.-A.) and two large canvases showing the bombardment of Mogador and its capture (1845; Versailles, Château). Durand-Brager was a participant in the latter action. Commissions from both the tsar and the Austrian emperor are indicative of his international reputation for creating military panoramas with a conviction based on personal experience.

FRANK TRAPP

Duret, François-Joseph [Francisque]

(*b* Paris, 19 Oct 1804; *d* Paris, 26 May 1865). French sculptor. Son of a sculptor of the same name (1729–1816) and a pupil of F.-J. Bosio, he entered the Ecole des Beaux-Arts in 1818 and won the Prix de Rome in 1823. Among his works executed at the Académie de France in Rome is *Orestes Mad* (marble, *c.* 1825; Avignon, Mus. Calvet), a colossal head modelled after the Antique that is at the same time a self-portrait, and *Mercury Inventing the Lyre* (marble; destr.), an elegant statue much praised at the 1831 Salon. Journeys from Rome to Naples resulted in *Neapolitan Fisherboy Dancing the Tarantella* (bronze, exh. Salon 1833; Paris, Louvre), which was executed on his return to Paris

and was one of the earliest Neapolitan genre subjects in French 19th-century art. In this work Duret reconciled classical form with modern subject-matter and the freedom of modelling allowed by working in bronze. Its popularity led to reduced-scale bronze editions by the founder P.-M. Delafontaine, who also reproduced in this fashion Duret's *Grape-picker Extemporizing* (bronze, 1839; Paris, Louvre).

Duret's interest in genre subjects and the melancholy Romanticism shown in such works as *Chactas Meditating at Atala's Tomb* (bronze, 1836; Lyon, Mus. B.-A.) were abandoned after 1840, as he increasingly devoted himself to working in marble on monumental commissions from the State. He was less at ease working with marble than with his favoured lost-wax method of bronze casting but sought to animate his statues by careful attention to expression and costume, anxiously aspiring after a classical grand manner. He ranged from commemorative statues, such as *Casimir Perier* (1833; Paris, Pal.-Bourbon), *Molière* (1834; Paris, Inst. France) and *Chateaubriand* (1854; Paris, Inst. France), to religious and symbolic works, characterized by ample drapery. This underlines the stances in the low reliefs of the *Stations of the Cross* (1851–2; Paris, Ste Clothilde) and adds to the severity of *Christ Revealing Himself to the World* (marble, 1840; Paris, La Madeleine). Duret's many other commissions include the statues of *Comedy* and *Tragedy* (marble, 1857) at the Théâtre-Français in Paris and the allegorical stone relief *France Protecting her Children* (stone, 1857; Paris, Louvre, Pavillon Richelieu), a rigorously Neo-classical work whose sole concession to modernity is the inclusion of a steam engine. In his Raphaelesque statue of the *Archangel Michael* (1860) for the Fontaine Saint-Michel, Paris, Duret returned to the use of bronze. He was appointed a professor at the Ecole des Beaux-Arts in 1852. Among his pupils were J.-B. Carpeaux, Henri Chapu and Jules Dalou.

Bibliography

Lami

C. Blanc: 'Francisque Duret', *Gaz. B.-A.*, xx (1866), pp. 97–118

The Romantics to Rodin: French Nineteenth-century
 Sculpture from North American Collections (exh. cat.,
 ed. P. Fusco and H. W. Janson; Los Angeles, CA, Co.
 Mus. A., 1980–81), pp. 247–8
A. Le Normand: La Tradition classique et l'esprit
 romantique: Les Sculpteurs à l'Académie de France à
 Rome de 1824 à 1840 (Rome, 1981)
La Sculpture française au XIXème siècle (exh. cat., ed.
 A. Pingeot; Paris, Grand Pal., 1986)

ANTOINETTE LE NORMAND-ROMAIN

Duval Le Camus, Pierre

(b Lisieux, 14 Feb 1790; d Saint-Cloud, 29 July
1854). French painter. A pupil of Jacques-Louis
David, he pursued an uninterruptedly smooth
career, which was almost banal in its lack of devi-
ation in inspiration or style. He showed regularly
in the Salon between 1819 and 1853, immediately
gaining attention with his first exhibited paint-
ing, the Game of Piquet between Two Invalids
(exh. Salon 1819; Detroit, MI, Inst. A.). Far from
being an innocent genre scene, it alludes to the
plight of the veterans of Napoleon's armies during
the Restoration. It is one of the few paintings by
Duval Le Camus in which a political meaning is
suggested. His interiors generally depict a famil-
iar and anonymous reality in the tradition of
Martin Drolling, although he was less skilful than
Drolling in the rendering of objects and effects.
Duval Le Camus was a guileless and unaffected
narrator. Throughout his career he executed genre
scenes in the Dutch style, showing a genuine
talent as a popular storyteller (e.g. Gossiping
Porter and Little Chimney Sweep; both Narbonne,
Mus. A. & Hist.). Unlike Louis-Léopold Boilly he did
not seek to amuse but to be sincere. Duval Le
Camus depicted the games and minor dramas of
childhood several times with the simplicity of
Chardin (e.g. The Reprimand; ex-Duchesse de
Berry priv. col.; drawing, Montpellier, Mus. Fabre).

Duval Le Camus's portraits belong to the same
tradition as his interiors. The figure is placed in
an interior (e.g. M. Courtin; Lisieux, Mus. Vieux-
Lisieux) or a landscape (e.g. Artist in a Landscape;
Bordeaux, Mus. A. Déc., and Returning from the
Fields; exh. Salon 1831; Orléans, Mus. B.-A.) with a

naive, poetic simplicity. The integration of the
figure into the landscape by means of luminous
contrasts recalls the small-scale portraits that
were fashionable in Europe around 1790, but
Duval Le Camus's sitters, somewhat awkwardly
composed in the manner of François Sablet, lack
the elegance of 18th-century conversation pieces.

Duval Le Camus was prolific, and his success
did not wane despite the repetitiveness of his sub-
jects. He was honoured and respected, obtaining
the Légion d'honneur and becoming mayor of
Saint-Cloud. In 1844 he was vice-president of
the Fondation du Baron Taylor, which brought
together artists such as Adrien Dauzats, Hippolyte
Sebron (1801–79), Oscar Gué (1809–77), Claude-
Marie Dubufe and Edouard Dubufe. The num-
ber of prints made after his works testifies to his
popularity.

His son, Jules Alexandre Duval Le Camus (b
Paris, 5 Aug 1814; d Paris, 23 June 1878), was also
a painter. He was taught by his father, Paul
Delaroche and Drolling and won second prize in
the Prix de Rome of 1838. He painted mainly reli-
gious and historical subjects, including Jacques
Clément (destr. World War I), which was bought
by the State.

Bibliography
H. Béraldi: Les Graveurs du XIXe siècle, ii (Paris, 1889),
 pp. 81–2
H. Hamel: 'Pierre Duval Le Camus, 1790–1854', Pays Ange,
 ix (1979), pp. 21–7
V. Dunifer: 'Two Veterans Playing "Piquet": A Genre
 Painting with Disguised Political Content', Ksthist.
 Tidskr., liv/4 (1985), pp. 170–80

MARIE-CLAUDE CHAUDONNERET

Espercieux, Jean-Joseph

(b Marseille, 22 July 1757; d Paris, 6 May 1840).
French sculptor. The son of a carpenter, he moved
to Paris in 1776 and entered the studio of Charles-
Antoine Bridan. He also attended, on an irregular
basis, the studios of the sculptors Jean-Joseph
Foucou, Pierre Julien and Philippe-Laurent Roland,
but he seems to have been chiefly influenced by
David. His career is obscure before the French

Revolution, in which he played an active role as one of the presidents of the Société Républicaine des Arts, attracting attention through his speeches in favour of patriotic subjects and the use of antique costume. From 1793 he was a regular exhibitor at the Salon, principally showing portrait busts. Although he was a Republican of strong convictions, the climax of his career came during the Consulate (1799–1804) and the Empire (1804–14), when he received a number of state commissions, including a bust of *Cicero* (plaster, 1803; Fontainebleau, Château), a statue of *Mirabeau* (plaster, 1804–5; untraced) for the Palais du Luxembourg, Paris, and a relief of *The Victory of Austerlitz* for the Arc de Triomphe du Carrousel, Paris (marble, 1810; *in situ*). Particularly successful were the allegorical reliefs for the Fontaine de la Paix in the Marché Saint-Germain, Paris (marble, 1810; now Paris, Rue Bonaparte).

Espercieux's popularity gradually diminished after the Restoration in 1815, although his statue of *Philoctetes* (marble, 1814–19; Compiègne, Château) was bought by the State, and he received commissions for a statue of *Sully* for the Pont de la Concorde, Paris (marble, 1816–17; Rosny-sur-Seine) and a decorative relief for the Arc de Triomphe de l'Etoile, Paris (stone, 1830; *in situ*). His last Salon appearance was in 1836 with the marble statue *Young Greek Preparing to Enter the Bath* (Avignon, Mus. Calvet), a work based on a model made in 1806 and a belated proclamation of his unshakable faith in Neo-classicism.

Bibliography

Lami

H. Jouin: *David d'Angers: Sa vie, son oeuvre, ses écrits et ses contemporains*, 2 vols (Paris, 1878), pp. 175–89

PHILIPPE DUREY

Etex, Antoine

(*b* Paris, 20 March 1808; *d* Chaville, Seine-et-Oise, 14 July 1888). French sculptor, painter, etcher, architect and writer. The son of a decorative sculptor, he entered the Ecole des Beaux-Arts, Paris, in 1824 as a pupil of Charles Dupaty (1771–1825), moving in 1825 to the studio of James Pradier.

Ingres also took an interest in his education, and Etex's gratitude towards him and Pradier was later expressed in projects for monuments to them (that to Pradier not executed, that in bronze to Ingres erected Montauban, Promenade des Carmes, 1868–71).

Etex failed three times to win the Prix de Rome, but in the aftermath of the Revolution of 1830 his Republican sympathies gained him a government scholarship that enabled him to spend two years in Rome. There he sculpted the intensely tragic group *Cain and his Children Cursed by God*, the plaster version of which (Paris, Hôp. Salpêtrière) was one of the great successes of the 1833 Paris Salon. During this period Etex asserted the Republican views that were to earn him the distrust of many of his fellow artists and of the establishment but also gain him the support of the influential critic and politician Adolphe Thiers. He behaved in Romantic fashion as a misunderstood artist, but nevertheless displayed a remarkable tenacity in forwarding his pet projects, including, for instance, schemes for sculptures representing *Napoleon Scaling the World* and the *Genius of the 19th Century* (drawings, Paris, Carnavalet), both intended for the Place de l'Europe, Paris, on which he worked from 1839 until 1878.

On his return to Paris in 1832, Etex received regular state commissions for nearly 30 years beginning with a prestigious contract for two stone high-reliefs for the Arc de Triomphe de l'Etoile: the *Resistance of 1814* and the *Peace of 1815* (1833–6), which although composed in a classical pyramidal shape are full of Romantic expressive force. He subsequently executed monumental marble statues for the Galeries Historiques at the château of Versailles (1837) and in Paris at the church of La Madeleine (1838), the Luxembourg Palace (1847) and the church of the Invalides (1852). Among his other state commissions were the bas-reliefs for the statue of *Henry IV* in the Place Royale, Pau (bronze, 1848), the statue of *General Lecourbe* in the Place de la Liberté, Lons-le-Saunier (Jura) (bronze, 1852–7), and the equestrian monument to *Francis I* in the Place François 1er, Cognac (bronze, 1864).

Etex also produced a number of important allegorical works, including the statue originally called *Poland in Chains* but renamed *Olympia* when it was purchased by Louis-Philippe's government (marble, 1848; Versailles, Château), the group of the *City of Paris Praying for the Victims of the Cholera Epidemic of 1832* (marble, 1848–52; Paris, Hôp. Salpêtrière) and the group *Maternal Sorrow* (marble, 1859; Poitiers, Parc de Blossac). All these works display Etex's characteristic combination of Neo-classical form, derived from Pradier, with Romantic intensity of emotion, qualities also apparent in the most striking of his tombs, that of the *Raspail Family* (marble, 1854; Paris, Père-Lachaise Cemetery). Tirelessly active, he also produced a large number of portrait busts and medallions of his contemporaries, including, most notably, a colossal bust of *Pius IX* (marble, 1862; Rome, Vatican Pal.), as well as painting such pictures as the *Death of the Proletarian* (1854; Lyon, Mus. B.-A.), etching a suite of 40 plates called *La Grèce tragique* and producing designs for the reconstruction of the Paris Opéra (exh. Salon 1861). He also transposed a number of paintings as bronze reliefs. These included a version (untraced) of his own *The Medici* (1831; Montauban, Mus. Ingres), versions of Géricault's major works for his tomb in Père-Lachaise cemetery, Paris (bronze; *in situ*), and of Ingres's *Apotheosis of Homer* (Paris, Louvre) for his monument in Montauban.

Of his numerous writings on art, which included a review of the Exposition Universelle of 1855 and lives of Paul Delaroche, Pierre-Jean David d'Angers, Pradier, Ary Scheffer and others, his most ambitious work was the *Cours élémentaire de dessin*, in which he stressed the harmony that should exist between painting, sculpture and architecture.

Writings

Revue synthétique de l'Exposition Universelle de 1855 (Paris, n.d.)

Cours élémentaire de dessin, appliqué à l'architecture, à la sculpture, à la peinture, ainsi que tous les arts industriels (Paris, 1859)

Souvenirs d'un artiste (Paris, 1877)

Bibliography

Lami

P. E. Mangeant: *Antoine Etex* (Paris, 1894)

The Romantics to Rodin: French Nineteenth-century Sculpture from North American Collections (exh. cat., ed. P. Fusco and H. W. Janson; Los Angeles, CA, Co. Mus. A., 1980–81), pp. 250–54

A. Le Normand-Romain: 'Le Séjour d'Etex à Rome en 1821–1832: Un Carnet de dessins inédits', *Bull. Soc. Hist. A. Fr.* (1981, pub. 1983), pp. 175–88

La Sculpture française au XIXème siècle (exh. cat., ed. A. Pingeot; Paris, Grand Pal., 1986)

B. Chenique: 'Une Oeuvre inspirée par André Chénier: Le Damalis d'Etex au Musée de Lille', *Rev. Louvre*, xl/1 (1990), pp. 26–36

ANTOINETTE LE NORMAND-ROMAIN

Fabre, François-Xavier, Baron

(*b* Montpellier, 1 April 1766; *d* Montpellier, 16 March 1837). French painter, printmaker and collector. He was taught by the painter Jean Coustou (1719–91) in Montpellier before entering, in 1783, the studio of David, to whose artistic principles he remained faithful all his life. His career as a history painter began brilliantly when, in 1787, he won the Prix de Rome for *Nebuchadnezzar Ordering the Execution of Zedekiah's Children* (Paris, Ecole N. Sup. B.-A.). This early success was consolidated by the four years he spent at the Académie de France in Rome and by the enthusiastic reception of his *Death of Abel* (1790; Montpellier, Mus. Fabre) at the Salon of 1791.

In 1793 his royalist sympathies forced him to move to Florence, where the poet Vittorio Alfieri and his mistress the Countess of Albany, estranged wife of the Young Pretender, introduced him to the artistic and social life of the city (see fig. 25). In the years preceding the French invasion of Tuscany in 1799, he worked for members of the cosmopolitan aristocracy of the region, including the Swede Gustaf Armfelt and the 3rd Lord Holland and his circle. He turned increasingly to producing society portraits, often in landscape settings, as in *Allen Smith Seated above the Arno* (1797; Cambridge, Fitzwilliam). Fabre survived the various political upheavals of his time without mishap, changing his patrons and the nature of

25. François-Xavier Fabre: *Portrait of Vittorio Alfieri*, 1793 (Florence, Galleria degli Uffizi)

manuscripts; his collection was further enriched by those of Alfieri and the Countess of Albany. After the Countess's death, in 1824, Fabre donated his collection to the city of Montpellier (resulting in the foundation of the Musée Fabre); the library and school of fine art in Montpellier were also created at his instigation. The title of Baron was conferred upon him by Charles X.

Although he was only a mediocre printmaker, his numerous drawings, of which there are about 500 examples in the Musée Fabre and in the Uffizi, Florence, show him to be an expressive and dynamic as well as a meticulous and accurate draughtsman. His paintings are characterized by a sound technique, a precise line and a delicacy of detail that borders on preciousness. They also show a certain stiffness and an occasionally defective perspective. The combination of elegance, realism and precision in his portraiture can be seen in the various paintings of Alfieri and of the Countess of Albany (e.g. Montpellier, Mus. Fabre; Florence, Uffizi) and in that of *Canova* (1812; Montpellier, Mus. Fabre). The *Vision of Saul* (1803; Montpellier, Mus. Fabre) and the *Judgement of Paris* (1808; Dayton, OH, A. Inst.) are good examples of his achievements in religious and mythological painting. The former was commissioned by the Countess of Albany and inspired by Alfieri's tragedy *Saul* (1784). Its style is firmly within the French Neo-classical tradition: the composition and use of dramatic gesture owe much to Poussin, of whose work Fabre assembled a fine set of prints; the meticulous technique and careful illumination of the central figure against a dark background show the influence of early David. *Oedipus at Colonus* (1808) and *Death of Narcissus* (1814), both in the Musée Fabre, exemplify his treatment of mythological subjects in landscape settings. Fabre is one of the most interesting representatives of French Neo-classicism and its links with Italy.

his production as conditions demanded. His portraits include *Lucien Bonaparte and his Wife* (1808; Rome, Mus. Napoleonico), *Maréchal Clarke, Duke of Feltre* (1810; Nantes, Mus. B.-A.) and *Mme Clarke with her Children* (1810; Paris, Mus. Marmottan).

Fabre was a prominent figure in Florentine society, being a member of the Academy, teacher of art and collector and dealer. He nevertheless remained in contact with French artists, notably Girodet, and with artistic bodies in Paris, becoming a corresponding member of the Institut in 1804. His voluminous correspondence is in the Bibliothèque Municipale at Montpellier. Changing fashions and bad health due to gout gradually forced him to abandon history painting and to concentrate on portraiture, landscape and printmaking (both etching and aquatint). He also intensified his activity as a collector, amassing an important group of 16th- and 17th-century Italian paintings, Poussin's *Landscape with Venus and Adonis*, drawings and paintings by his French contemporaries, as well as prints, books and

Bibliography

P. de Baudicour: *Le Peintre-graveur français*, ii (Paris, 1859–61/R Paris, 1967), pp. 319–25

L. G. Pelissier: 'Les Correspondants du peintre Fabre (1808–1834)', *Nouv. Rev. Rétro.*, iv (1896)

—: 'Le Fonds Fabre-Albany à la Bibliothèque de
Montpellier', *Centbl. Bibwsn*, xvii (1900)
A. Joubin: 'Comment fut fondé le Musée de Montpellier',
Ren. A. Fr. & Indust. Luxe (June 1926), pp. 237–45
P. Marmottan: 'La Jeunesse du peintre Fabre', *Gaz. B.-A.*, xv
(Feb 1927), pp. 93–113
F. Boyer: *Le Monde des arts en Italie et la France de la
révolution et de l'empire* (Turin, 1969)
P. Bordes: 'Girodet et Fabre, camarades d'atelier', *Rev.
Louvre*, vi (1974), pp. 393–9
—: 'François-Xavier Fabre, peintre d'histoire', *Burl. Mag.*,
cxvii (1975), pp. 91–8; cxviii (1975), pp. 155–61
*Actes du colloque: Florence et la France. Rapports sous la
révolution et l'empire: Florence, 1977* [with papers by
P. Bordes, pp. 187–208, and L. Pellicer, pp. 159–86]
L. Pellicer: 'François-Xavier Fabre et les sources littéraires
antiques', *Bull. Assoc. Guillaume Budé*, no. 4 (1983),
pp. 378–98
—: *Le Peintre François-Xavier Fabre (1766–1837)* (diss.,
U. of Paris-Sorbonne, 1983)
François-Xavier Fabre (exh. cat., Spoleto, Palazzo Racani-
Arroni; Florence, Uffizi; 1988)

LAURE PELLICER

Feuchère, Jean-Jacques

(*b* Paris, 26 Aug 1807; *d* Paris, 25 July 1852). French
sculptor, painter, decorative artist and collector.
Son of the chaser Jacques-François Feuchère (*d*
1828) and a pupil of Jean-Pierre Cortot and Claude
Ramey, he first exhibited at the Salon of 1831. Over
the ensuing decade he won the reputation, later
shared with his pupil Jean-Baptiste Klagmann
(1810–67), of leader in the small-scale, domestic
sculpture industry. He modelled statuettes in a
variety of historical styles, though he preferred a
Renaissance idiom, working for bronze-casters
such as M. Vittoz (*fl c.* 1840) and Victor Paillard
(*fl* 1840–51), and producing models for the gold-
smith François-Désiré Froment-Meurice (1802–55).
One of his early Romantic subjects, a seated figure
of *Satan* brooding after his expulsion from par-
adise, went through numerous editions from *c.*
1833 (bronze cast, 1850; Los Angeles, CA, Co. Mus.
A.), its Michelangelo-inspired posture prefiguring
Jean-Baptiste Carpeaux's *Ugolino* (bronze version;
Paris, Mus. d'Orsay) and Auguste Rodin's *Thinker*
(bronze version; Paris, Mus. Rodin). Feuchère

contributed to many of the sculptural projects of
the July Monarchy: a marble relief of the *Crossing
of the Bridge at Arcola* (1834) for the Arc de
Triomphe; a statue of *St Theresa* (1837–9) for La
Madeleine; three allegorical figures in bronze
(1838) for the fountains in the Place de la
Concorde; and designs for 12 Victories for
Napoleon's funeral car (1840). He was a member
of the hashish-smoking circle of the Hôtel
Pimodan; Charles Baudelaire, a fellow member,
regretted Feuchère's sacrifice of his talent to com-
mercialism. However, at his early death, the sculp-
tor was found to have sunk his considerable
earnings in a remarkable private art collection,
including paintings by Leonardo, Raphael and
other Italian masters, as well as paintings by
various Dutch masters and contemporary French
artists.

Bibliography
Lami
J. Janin: *Notice sur J. Feuchère* (Paris, 1853)
Romantics to Rodin (exh. cat., ed. P. Fusco and H. W.
Janson; Los Angeles, Co. Mus. A., 1980)
H. Hawley: 'Some Intimate Sculptures of Feuchère', *Bull.
Cleveland Mus. A.*, lxviii/3 (1981), pp. 75–83
P. Ward-Jackson: 'A.-E. Carrier-Belleuse, J.-J. Feuchère and
the Sutherlands', *Burl. Mag.*, cxxvii (1985), pp. 147–53

PHILIP WARD-JACKSON

Flandrin

French family of artists. Jean-Baptiste-Jacques
Flandrin (1773–1838), an amateur painter who spe-
cialized in portraits, had seven children, of whom
(1) Auguste Flandrin, (2) Hippolyte Flandrin and (3)
Paul Flandrin became artists.

(1) (René-)Auguste Flandrin

(*b* Lyon, 6 May 1801; *d* Lyon, 30 Aug 1842). Painter
and printmaker. He attended the Ecole des Beaux-
Arts in Lyon from 1817 to 1823, studying drawing
and painting under Fleury Richard and Alexis
Grognard (1752–1840). He produced engraved title-
pages for musical romances and lithographic
scenes of Lyon, such as the *Ruins of the Roman
Aqueduct at Lyon* (1824; Paris, Bib. N.). In 1833 he

moved to Paris, where he worked in Ingres's studio for a year. He then moved back to Lyon and in 1838 spent a few weeks in Rome. On his return, he set up a studio in Lyon where such artists as Louis Lamothe (1822–69) and Joseph Pognon studied. As well as landscape lithographs (e.g. *View of the Bridge at Beauregard on the Sâone*, 1834; Paris, Bib. N.), he also painted historical scenes, such as *Savonarola Preaching at S Miniato* (1836; Lyon, Mus. B.-A.), and portraits, such as *Dr S. des Guidi* (1841; Lyon, Mus. B.-A.), which shows the influence of Ingres.

(2) Hippolyte(-Jean) Flandrin

(*b* Lyon, 23 March 1809; *d* Rome, 21 March 1864). Painter and lithographer, brother of (1) Auguste Flandrin. He was initially discouraged from fulfilling his early wish to become an artist by Auguste's lack of success, but in 1821 the sculptor Denys Foyatier, an old family friend, persuaded both Hippolyte and Paul to train as artists. He introduced them to the sculptor Jean-François Legendre-Héral (1796–1851) and the painter André Magnin (1794–1823), with whom they worked copying engravings and plaster casts. After Magnin's death, Legendre-Héral took the brothers to the animal and landscape painter Jean-Antoine Duclaux (1783–1868). Hippolyte and Paul had both learnt the techniques of lithography from Auguste at an early age, and between the ages of 14 and 19 Hippolyte produced a number of lithographs, which he sold to supplement the family income. Many reflected his passion for military subjects (e.g. *Cossacks in a Bivouac*, *c.* 1825; Paris, Bib. N.). In 1826 the two brothers entered the Ecole des Beaux-Arts in Lyon, where Hippolyte studied under Pierre Révoil. Showing a precocious talent, he was soon advised to move to Paris, and having left the Ecole des Beaux-Arts in Lyon in 1829, he walked to the capital with his brother Paul; together they enrolled in the studio of Ingres. After several unsuccessful attempts, Hippolyte won the Grand Prix de Rome in 1832 with *Theseus Recognized by his Father* (1832; Paris, Ecole N. Sup. B.-A.), despite having suffered from cholera during the competition. His success was all the more spectacular given the general hostility to Ingres; Hippolyte was

the first of his pupils to be awarded this prestigious prize. Hippolyte arrived in Rome in 1833; Paul joined him there in 1834. After first working on such subjects as *Virgil and Dante in Hell* (1836; Lyon, Mus. B.-A.), Hippolyte developed a taste for religious works during this stay. From 1836 to 1837 he worked on *St Clare Healing the Blind* for the cathedral in Nantes, winning a first-class medal at the 1837 Salon, and in 1838 he painted *Christ Blessing the Children* (Lisieux, Mus. Vieux-Lisieux), which was exhibited at the 1839 Salon.

In 1838 Hippolyte returned to France; the following year he received a commission to decorate the Chapelle Saint-Jean of St Séverin in Paris with murals depicting the *Life of St John*. Unveiled in 1841, they won him the Croix de Chevalier. The encaustic painting technique resulted in a subdued colour scheme well suited to the Neo-classical austerity of the style. Soon after completing this project, he was one of several artists employed by the Duc de Luynes at the Château Dampierre; with Paul's assistance, he decorated its Great Hall with a series of semi-nude female figures in a graceful 'Etruscan' style. State commissions for murals continued; in 1842 he painted *St Louis Dictating his Laws* for the Chambre des Pairs of the Paris Sénat and began work on a series of biblical scenes for St Germain-des-Prés in Paris. The first, placed in the sanctuary, were executed between 1842 and 1846; the largest depict *Christ on the Road to Calvary* and the *Entry of Christ into Jerusalem*. Set on gold backgrounds, both pictures are highly dramatic despite the use of an emotionally restrained Neo-classical style. From 1846 to 1848 he decorated the Chapelle des Apôtres and the choir, also designing its stained-glass windows. From 1856 onwards he worked on the nave, work eventually finished after his death by Paul. This was the largest part of the commission, consisting of 20 separate panels showing scenes from the Old Testament and New Testament—the *Parting of the Red Sea*, the *Annunciation*, the *Adoration of the Magi*, the *Crucifixion* etc—each surmounted by a prophet or other biblical figure. Though occasionally harking back to Giotto, Flandrin's work was chiefly influenced by Raphael. In 1864 he was also asked to decorate the

transepts of the church; these were completed after his death by his pupil Sébastien Cornu.

By this time receiving more commissions than he could execute, Hippolyte was able to specialize in religious scenes; the revived popularity of large-scale church decoration in mid-19th-century Paris meant that there was no shortage of such work. In 1847 he had refused an offer to decorate St Vincent-de-Paul in Paris, in deference to his master Ingres, who had begun and then abandoned the project shortly before. It was then passed to François-Edouard Picot, but when the 1848 Revolution brought about a change in the Paris administration, the new mayor Armand Marast tried once again to persuade Flandrin to take up St Vincent-de-Paul. Finally a compromise was reached; Picot painted the choir and Flandrin the nave. The resulting works, executed from 1849 to 1853, largely consist of two friezes 39 m long and only 2.7 m high. Rather than break them up into smaller panels, Flandrin painted two processions of figures. On the one side are confessors, church doctors, martyred saints and apostles; on the other side are penitents, virgin saints and martyrs. Both friezes have a gold background, reminiscent of mosaics.

In 1853 Flandrin was elected a member of the Académie des Beaux-Arts; the following year he executed two allegorical murals of *Agriculture* and *Industry* for the Conservatoire National des Arts et Métiers in Paris. Returning to Lyon in 1855, he decorated St Martin d'Ainay as part of an overall restoration of the church. In 1857 he was appointed professor at the Ecole des Beaux-Arts in Paris, and in 1863, though in poor health, he moved to Rome. Though primarily known as a religious painter, he also painted numerous portraits; early works, such as *Mme Vinet* (1841; Paris, Louvre), are cold but elegant. His portrait of *Emperor Napoleon III* (1861–2; Versailles, Château) was disliked by the sitter.

(3) (Jean-)Paul Flandrin

(*b* Lyon, 28 May 1811; *d* Paris, 8 March 1902). Painter and lithographer, brother of (1) Auguste Flandrin and (2) Hippolyte Flandrin. Always very close to his brother Hippolyte, Paul followed much the same training, studying under Legendre-Héral,

Magnin and Duclaux. Like Hippolyte, he was taught lithography by Auguste. He studied at the Ecole des Beaux-Arts in Lyon (1826–8) and in 1829 moved to Paris, where he enrolled in the studio of Ingres. The two brothers soon became Ingres's favoured pupils, and in 1832, the year that Hippolyte won the Prix de Rome, Paul won a prize for historical landscape, though he failed in the Prix de Rome competition the following year. Finding the separation from his brother painful, in 1834 he moved to join Hippolyte. Once in Rome, he soon discovered his vocation as a landscape painter. Ingres arrived as Director of the Académie de France in 1835, and Paul, among other artists, received a commission to make copies of the works in the Vatican. Although not a prizewinner, he was closely connected with the Villa Médici and often accompanied the students on their trips to the country. In 1837, fleeing a cholera epidemic in Rome, Paul and Hippolyte visited Padua, Venice, Verona, Mantua and other places. Joined by Auguste in 1838, the three brothers visited Livorno, Milan, Pisa and Florence.

Returning to France in 1839, Paul made his Salon debut that year with two landscapes, the *Sabine Mountains* (1838; Paris, Louvre) and *Nymphée* (1839; Angers, Mus. B.-A.), winning a second-class medal. In 1840 he helped Hippolyte decorate the Chapelle Saint-Jean of St Séverin in Paris, and in 1842 he was commissioned to decorate the Chapelle des Fonts-Baptismaux in the same church; he worked on this until 1845. He often travelled to Brittany, Dauphiné, Normandy and Provence in search of subjects, producing paintings such as the *Dauphiné Valley above Voreppe* (c. 1845; Aix-en-Provence, Mus. Granet). After helping Hippolyte on the decorations for St Paul in Nîmes (1847–9), he remained there to paint the landscape. His pictures are clearly in the classical tradition of Claude and Poussin; some, such as the melancholy *Solitude* (1857; Paris, Louvre), feature figures in antique dress.

State recognition of his work came in 1859 with a commission for the *Flight into Egypt* (1861; Orléans, Mus. B.-A.). In 1862 he painted with Corot and that year and the next worked at Fontainebleau on such landscapes as *At the*

Waterside (1868; Bordeaux, Mus. B.-A.). During the Franco-Prussian War he stayed in Angers; in 1876, having lost his hard-won public esteem, he was forced to open a drawing school for girls. He received a commission to produce a cartoon for a tapestry for the Escalier Chagrin in the Sénat in 1878. Through much of the 1880s he worked outside Paris; he continued to paint until the end of the century, although his work was almost completely neglected—a neglect further compounded by the glittering reputation of his brother Hippolyte. Although Paul was not an innovator in the field of landscape painting, his canvases are invariably very appealing.

Bibliography

DBF

J.-B. Poncet: *Hippolyte Flandrin* (Paris, 1864)

H. Delaborde: *Lettres et pensées d'Hippolyte Flandrin* (Paris, 1865)

M. De Montrond: *Hippolyte Flandrin* (Paris, 1865)

H. L. Sidney Lear: *A Christian Painter of the Nineteenth Century, Being the Life of Hippolyte Flandrin* (London, Oxford and Cambridge, 1875)

E. Montrosier: *Peintres modernes: Ingres, Hippolyte Flandrin, Robert-Fleury* (Paris, 1882), pp. 49–72

F. Bournand: *Trois artistes chrétiens: Michel-Ange, Raphael et Hippolyte Flandrin* (Paris, 1892), pp. 293–382

L. Masson: *Hippolyte Flandrin* (Paris, 1900)

G. Bodinier: *Un Ami angevin d'Hippolyte et Paul Flandrin: Correspondance de Victor Bodinier avec Hippolyte et Paul* (Angers, 1912)

M. Audin and E. Vial: *Dictionnaire des artistes et ouvriers d'art de la France: Lyonnais*, 2 vols (Paris, 1918)

Hippolyte, Auguste et Paul Flandrin: Une Fraternité picturale au XIXe siècle (exh. cat. by J. Foucart, B. Foucart and others, Paris, Mus. Luxembourg, 1984–5; Lyon, Mus. B.-A.; 1985) [full bibliog.]

Flers, Camille

(*b* Paris, 15 Feb 1802; *d* Annet-sur-Marne, 27 June 1868). French painter and pastellist. The son of a porcelain-maker, he first learnt painting in the studio of a porcelain decorator. After a period as a theatre decorator and a dancer, he became a pupil of the animal painter Joseph François Pâris (1784–1871). He devoted himself to landscape painting and became one of the precursors of *plein-air* painting. Referring to himself as a 'romantique-naturaliste', he was a member of the new Naturalist school of landscape painting that emerged in the 1830s in opposition to the official classicism of the Ecole des Beaux-Arts. He was one of the first to paint *sur le motif* (from life) in the forest of Fontainebleau, and he also made frequent visits to Barbizon, joining that group of artists known as 'le groupe de Marlotte'. His works consist largely of views of Normandy and the Paris environs; he concentrated on thatched cottages, farmyards, prairies, ponds and riverbanks. He made his début at the Salon in 1831 with a *View of the Village of Pissevache, Bas-Valais* and continued to exhibit there until 1863. His early style of the 1830s and 1840s is characterized by splashes of thick paint, a roughly textured paint surface, a bright palette and a range of lively tones, as in *Prairie* (1831; Paris, Resche). Between 1850 and 1860 he painted a series of images of rivers and ponds with boats and fishermen. These were executed in a style very close to that of Jules Dupré, with whom he was working at the time. The surface of these paintings is smooth, the touch more discrete with a dominantly light-coloured tonality, as in *Landscape: The Environs of Paris* (1854; Paris, Louvre). Flers was also noted for his pastels, which he exhibited at the Salon from 1843, especially in the 1840s. In 1846 he published his theories of drawing in pastel in the journal *L'Artiste*, and these did much to revive interest in the medium. In common with other artists associated with Barbizon, in the early 1860s Flers experimented with making clichés-verre.

Writings

'Du pastel: De son application au paysage en particulier', *L'Artiste*, 4th ser., vii (1846), pp. 113–16

Bibliography

Bellier de La Chavignerie–Auvray; *DBF*

P. Miquel: *Le Paysage français au XIXe siècle, 1824–1874: L'Ecole de la nature*, ii (Maurs-La-Jolie, 1975), pp. 142–57

L. Harambourg: *Dictionnaire des peintres paysagistes français au XIXe siècle* (Neuchâtel, 1985)

ATHENA S. E. LEOUSSI

Forster, François

(*b* Le Locle, Switzerland, 22 Aug 1790; *d* Paris, 24
June 1872). French engraver of Swiss birth. He
came to Paris in 1805, studied with the engraver
Pierre-Gabriel Langlois (1754–1810), and in 1813
entered the Ecole des Beaux-Arts. He won the
Deuxième Grand Prix de Rome for graphic art in
1809 and the Première Grand Prix in 1814 with
the work *An Academy* (1814; Paris, Bib. N.). In 1828
he became a naturalized French citizen and in
1844 was elected to the Académie des Beaux-Arts.
He was one of the most outstanding engravers of
his time, producing prints from a wide variety of
paintings. He went to Italy and made a number of
plates from Renaissance masterpieces, for example
Christ in the Tomb (1814; Paris, Bib. N.) after
Andrea del Sarto, and the *Three Graces* (1841;
Paris, Bib. N.) after Raphael. He also engraved the
work of more contemporary artists: the *Sleep of
Endymion* (1820; Paris, Bib. N.) after Anne-Louis
Girodet (see col. pl. XV), and *Aeneas and Dido*
(1828; Paris, Bib. N.) after Pierre Guérin (see fig.
48). He also engraved a number of portraits,
including *Wellington* (1818) after François Gérard,
and *Queen Victoria* (1846; both Paris, Bib. N.) after
Franz Xavier Winterhalter. Forster provided plates,
after Achille Déveria, for Auguste de Chambure's
Napoléon et ses contemporains (Paris, 1824) and
for Ennio Quirino Visconti's *Iconographie anci-
enne* (Paris, 1823).

Bibliography

DBF

H. Béraldi: *Les Graveurs du XIXe siècle*, vi (Paris, 1887),
 pp. 142–9

Inventaire du fonds français après 1800, Paris, Bib. N.,
 Dépt. Est. cat., viii (Paris, 1954), pp. 114–16

Foucou, Jean-Joseph

(*b* Riez, Alpes de Haute-Provence, 7 June 1739; *d*
Paris, 1815). French sculptor. He studied at the
Ecole de Peinture et Sculpture in Marseille before
entering the Paris studio of Jean-Jacques Caffiéri
after 1760. In 1769 he won the Prix de Rome and
joined the Ecole des Elèves Protégés before spend-
ing the years 1771 to 1775 at the Académie de
France in Rome. On his return to Paris his work
hesitated between two stylistic tendencies, as is
illustrated on the one hand by the four Baroque
reliefs of scenes from the *Life of St Louis* in the
chapel of the Château Borély, Marseille (1772–8; *in
situ*), or by the flamboyant bust of the dramatist
Jean-François Regnard (marble, exh. 1779 Salon;
Paris, Comédie-Fr., foyer), and on the other hand
by the more modern, gently classicizing statue of
a *Bacchante* (marble, 1777; versions, Marseille,
Mus. B.-A., and Paris, Louvre), which was once erro-
neously attributed to Clodion.

Foucou's career began slowly, and his first
attempt to become a full member of the Académie
Royale in 1785 failed, though he was received
(*reçu*) later the same year on submission of a
second *morceau de réception*, a marble statuette
of a *River God* (Paris, Louvre). His involvement in
the decoration of Marie-Antoinette's dairy at
Rambouillet, in conjunction with Pierre Julien
and Claude Dejoux, brought him in 1787 the royal
commission for a statue of the soldier *Bertrand
Duguesclin* in the series of Illustrious Frenchmen
devised by the Comte d'Angiviller (plaster, exh.
1789 Salon: marble, exh. 1799 Salon; Versailles,
Château). This successful piece was a spirited pre-
Romantic image of heroic action, mixed with the
picturesque medievalism of the Troubadour style.

Foucou continued to work during the French
Revolution; he was involved with the decoration
of the Panthéon in 1792–3, and in 1796 he under-
took restoration work for Alexandre Lenoir's
Musée des Monuments Français. He exhibited reg-
ularly at the Salons between 1799 and 1814 and
was involved, in a subordinate capacity, in the
great building projects of the Empire (1804–14),
including decorative sculpture for the Arc de
Triomphe du Carrousel, Paris (1808), and for the
Colonne de la Grande Armée, Place Vendôme, Paris
(1806–10).

Bibliography

Lami

Autour du néo-classicisme (exh. cat., Paris, Gal. Cailleux,
 1973), no. 68

PHILIPPE DUREY

Foyatier, Denys

(*b* Bussières, nr Lyon, 22 Sept 1793; *d* Paris, 19 Nov 1863). French sculptor. He began his career as a self-taught wood-carver, going on in 1813 to study sculpture in Lyon with Joseph Chinard and then with Joseph-Charles Marin. In 1817 he entered the Ecole des Beaux-Arts in Paris as a pupil of François-Frédéric Lemot. He first exhibited at the Salon in 1819 and from 1823 was in Rome for three years, his study of antique sculpture there confirming the stylistic predisposition of his Neo-classical training. In Rome he produced the model for his statue of *Spartacus* (marble; Paris, Louvre), which, when exhibited at the Paris Salon of 1830, aroused the enthusiasm of critics as well as of the public: the gladiator breaking his chains became the symbol of the revolution of that year. This success gained him many commissions for monumental sculpture, including marble statues of *Faith* (1830; Paris, Notre-Dame-de-Lorette), *Prudence* (1834; Paris, Pal.-Bourbon), *Cincinnatus* (1834; Paris, Jard. Tuileries) and *St Matthew* (1845; Paris, St Vincent-de-Paul). None of these figures has the epic spirit that animates *Spartacus*, and it was in small-scale works of more intimate character, such as the marble group *Young Girl Playing with a Kid* (1831; Lyon, Mus. B.-A.) and *Siesta* (marble, 1848; Paris, Louvre), and in his portrait busts that his talent was most apparent. The great work of the last years of his life is the monumental bronze equestrian statue of *Joan of Arc* in the Place du Martroi, Orléans (1855).

Bibliography
Lami
Y. de La Genardière: *Denys Foyatier: Artiste statuaire, 1793–1863* (diss., Paris, Ecole Louvre, 1973)
Y. DE LA GENARDIÈRE

Fragonard

French family of artists. (1) Jean-Honoré Fragonard developed, from his beginnings as a pupil and follower of François Boucher, into the most brilliant and versatile artist in 18th-century France. He wielded brush, chalk and etcher's needle with extraordinary virtuosity, effortlessly varying his touch as he produced a succession of consummate masterpieces on themes from religion, mythology, genre and landscape. Uniquely, after promising beginnings as a history painter, he turned away from the Académie Royale and 'high art' and concentrated on lesser genres, more sympathetic to his spontaneous temperament. His independence of official circles led to a lack of securely datable projects, and much of his output can be dated, or even attributed, only tentatively. He had little direct influence on French painting, but his oeuvre shows many of the preoccupations of later artists with problems of style, subject-matter and conception. His only pupils of note were his sister-in-law Marguerite Gérard and his son (2) Alexandre Evariste Fragonard, who from an early age was noted as a draughtsman; during the Empire he began to work as a decorative painter and sculptor and also provided designs for the Sèvres porcelain factory. Subsequently he took up history painting, concentrating on Troubadour subjects. His son Théophile Fragonard (1806–76) also worked as a painter for Sèvres.

(1) Jean-Honoré Fragonard

(*b* Grasse, 4 April 1732; *d* Paris, 22 Aug 1806). Painter, draughtsman, printmaker and museum official.

1. Life and work

(i) Early work and years in Italy, to 1761. He was the only child of François Fragonard (1699–1781) and Françoise Petit, who both came from families of shopkeepers and glove-makers in Grasse. In 1738 the family moved to Paris, where, on the advice of François Boucher, Fragonard spent some time as a pupil of Jean-Siméon Chardin. He entered Boucher's own studio *c.* 1749 and probably remained there for about a year. Boucher was then at the height of his fame, and Fragonard doubtless assisted the overworked master on important commissions, such as large tapestry designs. He also made numerous copies after paintings by Boucher, such as *Hercules and Omphale* (untraced; c L62), and by Rembrandt, such as *Girl with Broom* (untraced; c L19). In 1752 Fragonard entered the

competition for the Prix de Rome, relying on Boucher's influence to overcome the stipulation that all candidates had to be pupils at the Académie Royale. His winning entry, *Jeroboam Sacrificing to the Idols* (Paris, Ecole N. Sup. B.-A.), in fact shows little of Boucher's teaching but is rather painted in the grand manner of Carle Vanloo, whose influence can be seen in the colouring, the geometrical composition and the concern for expressive detail at this moment of high drama.

On 20 May 1753 Fragonard entered the Ecole Royale des Elèves Protégés, of which van Loo was Director. He remained there until 1756, and from this period two important paintings survive. The first, *Psyche Showing her Sisters Cupid's Presents* (1754; London, N.G.), has clear echoes of the prize painting but is more light-hearted, with great delight taken in the accessories, shimmering plate and jewels and billowing draperies of pink, white and gold. The second, *Christ Washing the Disciples' Feet*, was commissioned on 17 May 1754 by the Confrérie du Saint-Sacrement for their chapel in Grasse Cathedral (1755; *in situ*). It is austere in its setting and simple composition and reminiscent of van Loo's picture of the same subject (1742; Le Mans, Mus. Tessé).

In addition to these important history paintings, the years 1754–5 marked the beginning of Fragonard's career as a decorative painter. For an unknown patron, he executed four scenes from country life, on subjects painted many times by Boucher: *Harvester*, *Woman Gathering Grapes*, *Gardener* and *Shepherdess* (all Detroit, MI, Inst. A.). Boucher's influence is even more apparent in the mythological paintings from this period, such as the pendants *Jupiter and Callisto* and *Cephalus and Procris* (c. 1755; Angers, Mus. B.-A.).

In December 1756 Fragonard arrived in Rome. He remained there for five years, but little is known of his activities. He must have made a large number of copies; one of the few securely documented is *St Paul Regaining his Sight* (untraced), after Pietro da Cortona's painting in the church of the Cappuccini, Rome. He also made several large and sober red-chalk drawings of draped figures (e.g. the group in Montpellier, Mus. Atger) and painted his first amorous subject, the *Kiss*

Won (c. 1759–60; New York, Met.), commissioned by the Bailli de Breteuil. Towards the end of 1758 he met Hubert Robert, who introduced him to new subjects and techniques: no doubt encouraged by Charles-Joseph Natoire, the two artists sketched constantly in the open air, and so similar in style are their many red-chalk drawings that their authors have often been confused. Fragonard spent the summer of 1760 at the Villa d'Este, as the guest of Robert's patron, the Abbé de Saint-Non, and he made a number of marvellously evocative red-chalk drawings of the park and gardens (e.g. ten sheets, Besançon, Bib. Mun.). In 1761 Fragonard accompanied Saint-Non and Robert on their tour of Italy, when they visited Naples and the north. Saint-Non described the journey in a diary (see Rosenberg and Brejon de Lavergnée), while Fragonard recorded the itinerary in copies of paintings and monuments in black or red chalk (71 of these drawings are in London, BM).

(ii) Paris and official success, 1761–5. After his return to Paris in 1761, Fragonard worked principally for collectors until he presented his *morceau d'agrément* to the Académie. Cuzin (1987) has suggested that he worked up a number of sketches made in Italy into oil paintings, a typical example being the *Gardens of the Villa d'Este* (c. 1762–3; London, Wallace), for which he made a preparatory drawing on the spot and an etching (see 1987–8 exh. cat., no. 66). Works of this period also show other Italian influences, notably that of Boucher's idol Giovanni Benedetto Castiglione, whose drawings Fragonard would have seen in Consul Smith's collection in Venice. He found a parallel source of inspiration in works by northern European artists, notably Jacob van Ruisdael, which resulted in a series of landscapes, among them the *Watering Place* (priv. col., c 110). During this period, perhaps c. 1763–4, he made two masterpieces: *Rinaldo in the Gardens of Armida* and *Rinaldo in the Enchanted Forest* (both priv. col., c 95–6). While ostensibly derived from Tasso's *Gerusalemme liberata*, these intensely operatic canvases were probably inspired by performances of Jean-Baptiste Lully's *Armide* in 1761 or 1764.

26. Jean-Honoré Fragonard: *Coresus and Callirhoë*, 1765 (Paris, Musée du Louvre)

On 30 March 1765 Fragonard was approved (*agréé*) by the Académie Royale, on the strength of his painting *Coresus and Callirhoë* (Paris, Louvre; see fig. 26). The unusual subject, from Pausanias' *Description of Greece*, tells how the poet Coresus calls upon Bacchus to avenge his unrequited love for Callirhoë: the god spreads universal madness and as the price of calming the frenzy, demands Callirhoë's life. At the last moment, Coresus kills himself instead. Fragonard's mastery of composition, the expression of individual participants and the richness of colouring were all commended when the picture was exhibited at the Salon of 1765: Denis Diderot was ecstatic. It was bought by the Marquis de Marigny for the Crown, which also commissioned a pendant (never executed). Almost overnight, Fragonard came to embody the hopes of the French school and seemed to be about to restore the fortunes of history painting: Marigny announced to Natoire that 'on espère qu'il contribuera beaucoup à nous consoler de la perte de M. Deshays' (see 1987–8 exh. cat., p. 152).

(iii) **Work for collectors and decorative painting, 1766–72.** Fragonard was by now celebrated and, had he followed the traditional path of the history painter, might have become Premier Peintre du Roi and Director of the Académie. Instead, he never sought to be received (*reçu*) at the Académie and seldom exhibited at the Salon, preferring the unofficial forum of the Salon de la Correspondance (1778–9, 1781–3, 1785–6). His contemporaries accused him of compromising his artistic integrity by pandering to the frivolous tastes of collectors. Certainly,

he supplied an eager market with rapidly brushed paintings on a variety of themes. Even the few works he did show at the Salon of 1767, such as the *Swarm of Putti* (Paris, Louvre), probably intended as a ceiling decoration, and the *Head of an Old Man in Profile* (Muncie, IN, Ball State U., A.G.), were far from being *grandes machines*, as such critics as Diderot were quick to lament. The change in direction is symbolized in *The Swing* (1767; London, Wallace), known from Nicolas de Launay's engraving as *Les hazards heureux de l'escarpolette*. It is a small painting, commissioned by the Baron de Saint-Julien to show his mistress being pushed in a swing by a bishop, while he himself looks on.

The *Head of an Old Man in Profile* heralded a completely new genre, the *figure de fantaisie*, of which some 15 by Fragonard survive, all dating from *c.* 1768–72. Although many of the sitters are identifiable, they are usually dressed in vaguely Spanish costume and are painted with such virtuosity that they are more fantasy than portrait. That of the *Abbé Richard de Saint-Non* (1769; Paris,

Louvre; see fig. 27) was apparently painted from life, in only an hour, in long, fluent strokes of extraordinary boldness. Despite their technical brilliance, these pictures convey a wide variety of moods, from the studious concentration of the philosopher *Denis Diderot* (*c.* 1769; Paris, Louvre) to the haughty flamboyance of the *grands seigneurs François-Henri, Duc d'Harcourt* (*c.* 1770; priv. col., C 176) and his brother *Anne-François d'Harcourt, Duc de Beuvron* (*c.* 1770; Paris, Louvre).

In addition to these easel paintings, Fragonard executed a number of decorative commissions for important patrons. The first of these (?1769–70; Paris, Carnavalet) was made in collaboration with Boucher and Jean-Baptiste Le Prince for a room in the *hôtel particulier* of the engraver Gilles Demarteau in Paris; another (1773–5; destr.) was for the dancer Marie-Madeleine Guimard (1743–1816). However, in scale and quality, the most important of these projects and the crowning achievement of Fragonard's career, indeed the greatest decorative ensemble produced in 18th-century France, was the *Progress of Love* (1771–2; New York, Frick). This series was commissioned by Mme du Barry for the salon en cul-de-four of her new pavilion at Louveciennes. Although described in 1772 as an 'hommage à l'amour', the precise sequence of the panels has never been satisfactorily explained: the principal scenes show *The Meeting, The Pursuit*, the *Lover Crowned* and *Love Letters*. The decorative scheme was completed by a ceiling panel simulating a cloudy sky by Jean-Bernard Restout and by four circular overdoors (untraced) by François-Hubert Drouais. Mme du Barry quickly rejected Fragonard's paintings: they may have referred too overtly to her amorous adventures; or their luxurious opulence of colour may have clashed with the elegant severity of Claude-Nicolas Ledoux's architecture. Certainly, by 1774 they had been replaced by ostensibly Neo-classical designs (two in Paris, Louvre and two in Chambéry, Préfecture) by Joseph-Marie Vien.

(iv) Further travels and late works, 1773–88. On 5 October 1773 Fragonard set off on his second journey to Italy, as artist-companion to the financier Jacques-

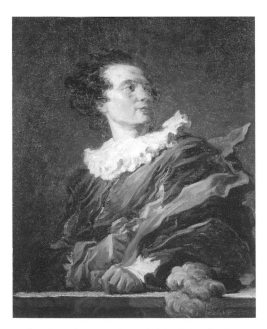

27. Jean-Honoré Fragonard: *Abbé Richard de Saint-Non*, 1769 (Paris, Musée du Louvre)

Onésyme Bergeret de Grancourt, Saint-Non's brother-in-law. Fragonard drew constantly as the party travelled south through France and Italy, arriving in Rome two months later; he soon rediscovered his old haunts. He made landscapes, some in red chalk, but increasingly in brown wash, for example the *Umbrella Pines at the Villa Pamphili* (Amsterdam, Rijksmus.); and genre scenes and portraits, such as the *Woman of Santa Lucia* (New York, Mr & Mrs Eugene Victor Thaw priv. col., see 1987–8 exh. cat., no. 192). Fragonard also met the young François-André Vincent, whose work of this period resembles his own. Bergeret's caravan travelled to Naples in spring 1774 and continued to Vienna, Prague and the southern German states, arriving in Paris in September 1774. Unfortunately, the return was marred by a dispute with Bergeret over the ownership of Fragonard's drawings, which apparently led to an acrimonious court case.

In Paris, Fragonard continued to produce paintings and drawings of modest size for collectors, among them *figures de fantaisie*, genre and religious subjects and anecdotal scenes. He embarked on his religious paintings with as little seriousness as Boucher; and, apart from the early altarpiece at Grasse, none was commissioned by the Church or a religious foundation. Indeed, the most notable, the *Adoration of the Shepherds*, was hung as a pendant to the erotic subject *The Bolt* (both *c.* 1776; Paris, Louvre) by the Marquis Louis-Gabriel de Véri. The only new departure in subject-matter was a series of decorative landscapes, the largest and most impressive of which is the so-called *Fête at Saint-Cloud* (*c.* 1775–80; Paris, Banque de France). These continued the tradition of Antoine Watteau's *fêtes champêtres* and stylistically mark a development of the leafy airiness of *The Swing* and the Louveciennes panels.

During the 1780s Fragonard became increasingly interested in mythological subjects, no longer painted in the manner of Boucher but in a smooth chiaroscuro, also favoured by Jean-Baptiste Greuze at this period. The heightened eroticism of such works as the *Fountain of Love* (*c.* 1785; London, Wallace) indicates that Fragonard was sensitive to the new mood of sentimental Neoclassicism that was becoming popular among

Parisian collectors. Another theme that appeared with increasing frequency during these years was scenes of family life, perhaps reflecting his own domestic happiness, and portraits of his wife and children, in particular the enchanting and gently humorous *Alexandre-Evariste Fragonard Dressed as Pierrot* (*c.* 1785–8; London, Wallace). He had married Marie-Anne Gérard in 1769, and her sister Marguerite Gérard was his pupil and collaborated with him on a number of paintings, the identity of which is still debated. Fragonard's final notable activity of this decade was a series of book illustrations that are unique in the history of French art in being impossible to engrave satisfactorily. For whereas the final series of illustrations for La Fontaine's *Contes* (Paris, Petit Pal.) was commissioned by the publisher Pierre Didot, those for Ariosto's *Orlando furioso* (dispersed; see Mongan, Hofer and Seznec) and Cervantes's *Don Quixote* (dispersed; see 1987–8 exh. cat., pp. 508–9) are so rapidly drawn in black chalk, with brown wash so freely applied, that they were probably made for the artist's own pleasure.

(v) Final years, 1789–1806. For unknown reasons the Fragonard family left Paris at the end of 1789 and returned to Grasse, taking with them the *Progress of Love*, which was installed in the house of their cousin Alexandre Maubert. In 1790, in order to make the decoration fit into its new home, Fragonard added one large panel, the *Reverie*, five of cupids in various activities (e.g. *Love Pursuing a Dove*) and four of *Hollyhocks* (all New York, Frick). These were probably the last pictures he painted: after his final move to Paris in 1792, he seems to have confined himself to administrative tasks at the Palais du Louvre. During the French Revolution he successfully avoided both emigration and imprisonment and was appointed to various bodies formed to oversee the creation of a national museum in the Louvre. On the recommendation of Jacques-Louis David, he was appointed a member of the Conservatoire des Arts on 16 January 1794, becoming its president a year later. He was thus in charge of the new museum, which was rapidly expanding with paintings stolen from churches and private collections both

in France and abroad. During the summer of 1797 Fragonard was given the title Inspector of the Transportation of Works of Art and oversaw the establishment of a new museum of the French school at Versailles. He continued in this post until 1800, and ended his life in relative obscurity.

2. Posthumous reputation

Apart from Marguerite Gérard and his son, Alexandre-Evariste, Fragonard had no pupils of note. However, as the 19th century progressed, his preoccupations became the concerns of all intelligent artists: particularly the role of history painting, indeed the very notion of subject-matter, which came to take second place to considerations of conception and style. On his death, which was not widely reported, it was principally Fragonard's Neo-classical works that were most admired. However, during the 1840s, the stylistic freedom and imaginative supremacy of the Rococo were championed by left-wing critics and writers, such as Théophile Thoré. Fragonard's paintings and drawings were bought by young intellectuals for small sums: Hippolyte Walferdin, for example, formed a great collection of Fragonard paintings and drawings and in 1849 gave the *Music Lesson* (*c.* 1755; Paris, Louvre) to the Musée du Louvre, to stay there only as long as France remained a republic. However, the undemanding subject-matter and obviously attractive colours of the paintings soon brought them to the attention of the middle classes, especially bankers and financiers such as the Rothschilds, and they soon became the province of the rich. The taste for Fragonard followed closely that for Boucher and Watteau, and crossed the Atlantic, so that the *Progress of Love* now decorates a room in the Frick Collection in New York. Following the Goncourt brothers, scholarly interest in Fragonard has attempted to establish a chronology for his oeuvre, and, more recently, to distinguish his work from that of close associates and imitators.

Bibliography

E. de Goncourt and J. de Goncourt: 'Fragonard', *Gaz. B.-A.*, xviii (1865), pp. 32–41, 132–62; also in *L'Art du dix-huitième siècle* (Paris, 1873, rev. 3/1882), pp. 241–342

R. Portalis: *Honoré Fragonard: Sa vie, son oeuvre* (Paris, 1889)

A. Tornézy: 'Bergeret et Fragonard: Journal inédit d'un voyage en Italie', *Bull. Soc. Antiqua. Ouest*, xvii (1894), pp. 1–431; as booklet (Paris, 1895)

P. de Nolhac: *J.-H. Fragonard, 1732–1806* (Paris, 1906) [includes cat. of paintings sold at auction between 1770 and 1805]

E. Mongan, P. Hofer and J. Seznec: *Fragonard Drawings for Ariosto* (London, 1945)

C. Valogne: 'Fragonard, mon grand-père, par Théophile Fragonard', *Lett. Fr.* (17 Feb 1955), pp. 1, 9

G. Wildenstein: *Fragonard aquafortiste* (Paris, 1956) [complete illus. cat. of etchings]

F.-M. Biebel: 'Fragonard et Mme du Barry', *Gaz. B.-A.*, lvi (1960), pp. 207–26

G. Wildenstein: *The Paintings of Fragonard: Complete Edition* ([London, 1960])

A. Ananoff: *L'Oeuvre dessiné de Jean-Honoré Fragonard (1732–1806)*, 4 vols (Paris, 1961–70)

W. Sauerländer: 'Über die ursprüngliche Reihenfolge von Fragonards *Amours des bergers*', *Münch. Jb. Bild. Kst*, n. s. 2, xix (1968), pp. 127–56

D. Wildenstein and G. Mandel: *L'opera completa di Fragonard* (Milan, 1972)

Drawings by Fragonard in North American Collections (exh. cat. by E. Williams, Washington, DC, N.G.A.; Cambridge, MA, Fogg; New York, Frick; 1978–9) [indispensable discussion of technique of drgs]

Fragonard (exh. cat. by D. Sutton, Tokyo, N. Mus. W.A.; Kyoto, Mun. Mus. A.; 1980)

Y. Cantarel-Besson: *La Naissance du Musée du Louvre*, 2 vols (Paris, 1981)

J.-P. Cuzin: 'De Fragonard à Vincent', *Bull. Soc. Hist. A. Fr.* (1981), pp. 103–24

Diderot et l'art de Boucher à David: Les Salons, 1759–1781 (exh. cat., ed. M.-C. Sahut and N. Volle; Paris, Hôtel de la Monnaie, 1984–5), pp. 204–16

J.-P. Cuzin: 'Fragonard dans les musées français: Quelques tableaux reconsidérés ou discutés', *Rev. Louvre*, 1 (1986), pp. 58–66

P. Rosenberg and B. Brejon de Lavergnée: *Panopticon italiano: Un diario di viaggio ritrovato, 1759–61* (Rome, 1986) [reproduces Fragonard's drgs made on journey]

J.-P. Cuzin: *Fragonard: Vie et oeuvre; Catalogue complet des peintures* (Paris, 1987; Eng. trans., New York, 1988) [c]

Fragonard (exh. cat. by P. Rosenberg, Paris, Grand Pal.; New York, Met.; 1987–8)

J.-P. Cuzin: 'Fragonard: Un Nouvel Examen', *Rev. A.*, 80
(1988), pp. 83–7

M. D. Sheriff: *Fragonard: Art and Eroticism* (Chicago and
London, 1990)

J. H. Fragonard e H. Robert a Roma (exh. cat. by
C. Boulot, J.-P. Cuzin and P. Rosenberg, Rome, Villa
Medici, 1991)

*Fragonard et le dessin français dans les collections du
Petit Palais* (exh. cat. by J.-L. de Los Llanos, Paris, Petit
Pal., 1992–3)

COLIN HARRISON

(2) Alexandre-Evariste Fragonard

(*b* Grasse, 26 Oct 1780; *d* Paris, 10 Nov 1850). Painter,
sculptor and draughtsman, son of (1) Jean-Honoré
Fragonard. Having been taught by his father and
by David, he attracted notice at an early age
and was considered the equal of Jean-Baptiste
Isabey and of Hilaire Ledru (1769–1840) in his draw-
ings. He made his début at the Salon of 1793 with
Timoleon Sacrificing his Brother (drawing; un-
traced); later he exhibited genre subjects similar
to those of J. A. Vallin (1760–after 1831) and Jean-
Baptiste Mallet, which were frequently reproduced
in prints. During the Revolution he produced sev-
eral allegories, such as the *French Republic* (draw-
ing; Grasse, Mus. Fragonard). He executed many
drawings during the Consulate and the Empire;
these are Neo-classical frieze compositions in
which he made use of strongly contrasted lighting
effects (e.g. the *Child Pyrrhus at the Court of
Glaucias*, 1814; Paris, Louvre). He developed an offi-
cial career as sculptor and painter during the
Empire. He took part in a competition for the Peace
of Amiens in 1801 (painting; Paris, Bib. Thiers),
after which he received several commissions. He
sculpted the pediment of the Palais Bourbon in
Paris (destr. in the Revolution of 1830 and replaced
by that of Jean-Pierre Cortot). Also for the Palais
Bourbon, in 1810 he was commissioned to paint
trompe-l'oeil grisailles to decorate the Salle des
Gardes and the salon behind the peristyle (now
destr. or hidden by the later false ceiling). In 1812
he was entrusted with the composition and exe-
cution of bas-reliefs for the obelisk that was to be
built on the Pont Neuf, Paris, in memory of the
Prussian campaign (not executed).

Fragonard also worked for the Sèvres porcelain
factory during the Empire. He executed sketches
(Sèvres, Mus. N. Cér.) for the column celebrating
the German campaign (Versailles, Château). He
produced models for the plinths of the Cordelier
Vases in the Galerie d'Apollon in Saint-Cloud
(1809), which were decorated with six plaques
painted to resemble cameos and based on medals
commemorating French victories in the Prussian
campaign. He obtained further official commis-
sions during the Restoration and was made
Chevalier de la Légion d'honneur in 1817. He
worked again in the Palais Bourbon, decorating
the vault of the Salle des Séances with geometric
motifs and allegories representing the 86 départe-
ments of France. (The Revolution of 1830 put an
end to this project.) He made drawings for the
Coronation of Charles X (Paris, Louvre) and
received a commission to paint the ceilings of the
Musée Charles X in the Louvre (*Francis I and
Bayard*, 1819; *Francis I and Primaticcio*, 1827; both
in situ).

In the 1820s Fragonard turned to history paint-
ing and became involved in the Troubadour
movement. In contrast to the meticulous paint-
ings of Jean-Antoine Laurent and Pierre Révoil,
he achieved considerable freedom by means of
a broader technique, a livelier touch and a vivid
sense of setting. He brought the amplitude of
history painting to such Troubadour themes as
*Raphael Adjusting the Pose of his Model for the
Virgin and Child* (1820; Grasse, Mus. Fragonard),
Bernard Palissy Burning his Furniture (Sèvres,
Mus. N. Cér.), the *Entry of Joan of Arc into Orleans*
(1822; Orleans, Mus. B.-A.), the *Burghers of Calais*
(exh. Salon 1822; Arras, Mus. B.-A.) and *Maria-
Theresa Presenting her Son to the Hungarians*
(exh. Salon 1822; Grasse, Mus. Fragonard).

Fragonard showed a taste for artificial and
dramatic lighting, and he often repeated the
motif of foreground figures silhouetted against
and screening a background brightly illuminated
by a diagonal fall of light. He usually chose sub-
jects from the history of the French monarchy, but
he also combined ancient and contemporary
history to create a modern legend, as in *Vivant
Denon Replacing the Bones of El Cid in his*

28. Alexandre-Evariste Fragonard: *Boissy d'Anglas Saluting the Head of the Deputy Féraud* (Paris, Musée du Louvre)

Tomb (Saint-Quentin, Mus. Lécuyer), which celebrates Denon and the cultural policies of the Empire but is at the same time a meditation on medieval heroes. After the Revolution of 1830, lacking work, Fragonard submitted *Mirabeau before Dreux-Brézé* and *Boissy d'Anglas Saluting the Head of the Deputy Féraud* (both Paris, Louvre; see fig. 28) to a competition for the decoration of the Salle des Séances in the Chambre des Députés (1830–31). He subsequently received a commission for the Musée Historique in the château of Versailles, the *Battle of Marignan, 14 September 1515* (1836). Fragonard exhibited until 1842 and also executed a number of religious paintings (e.g. *Flight into Egypt*; Strasbourg Cathedral). He made many drawings for lithography, including several series for Baron Taylor's *Voyages pittoresques*.

Writings

Recueil de divers sujets dans le style grec (Paris, 1815)

Bibliography

J. Renouvier: *Histoire de l'art pendant la révolution* (Paris, 1863), pp. 197–200
P. Marmottan: *L'Ecole française de peinture, 1789–1830* (Paris, 1886), pp. 266–8
H. Béraldi: *Les Graveurs du XIXe siècle*, ii (Paris, 1889), pp. 160–62
P. Jary: 'Les Peintures murales du Palais-Bourbon', *Bull. Soc. Hist. A. Fr.* (1928), pp. 39–41
G. Wildenstein: *Fragonard aquafortiste* (Paris, 1956)
K. Simons: 'Vivant Denon et le romantisme: A propos d'un tableau d'Alexandre Evariste Fragonard', *Rev. Inst. Napoléon*, 132 (1976), pp. 55–65
M.-C. Chaudonneret: 'Le Concours de 1830 pour la Chambre des Députés: Deux Esquisses d'Alexandre Evariste Fragonard au Louvre', *Rev. Louvre*, 2 (1987), pp. 128–35
 MARIE-CLAUDE CHAUDONNERET

Français, François-Louis

(*b* Plombières-les-Bains, Vosges, 17 Nov 1814; *d* Plombières-les-Bains, 18 May 1897). French painter

and printmaker. After attending several courses in drawing in Plombières-les-Bains, he went to Paris at the age of 14 to study. He first worked as a copyist, produced caricatures and drew from models at the Académie Suisse. In 1831 he decided to study painting and completed his first landscapes, painting mainly in the environs of Paris and at Meudon with Paul Huet, who was his adviser for several years. In 1834 he entered the workshop of Jean Gigoux and met Henri Baron, who remained his faithful friend. He also studied at the Louvre where he developed a lifelong admiration for the work of Claude. From 1834 he lived at Barbizon, and after 1835 he often painted in the Forest of Fontainebleau, where he met Louis Cabat and also Corot, who became his adviser and introduced him to Théodore-Caruelle d'Aligny. Français also made the acquaintance of Narcisse Diaz and of the landscape painter Auguste-Paul-Charles Anastasi (1820–89), who became his friend. In 1837 he exhibited for the first time at the Salon in Paris, showing *Under the Willows* (1837; Tours, Mus. B.-A.), a composition in which the figures were painted by Baron. He exhibited regularly at the Salon until 1896. Between 1836 and 1840 his style was above all a skilful but eclectic mixture of various contemporary trends in landscape painting. He also took up printmaking early in his career, and in 1835 he produced some engravings for Jacques-Henri Bernardin de Saint-Pierre's *La Chaumière indienne* and for Alain-René Lesage's *Gil Blas*. After 1838 his lithographic production was considerable and included such important commissions as that to illustrate Bernardin de Saint-Pierre's novel *Paul et Virginie*. With his friends Baron and Célestin Nanteuil (1813–73), he produced *Les Artistes anciens et modernes* (3 vols; 1848–62), a collection of lithographs after paintings by contemporary artists. Among the prints were those done after Corot's *Landscape, Sunset* (1840; Metz, Mus A. & Hist.), Diaz's *Bathers* (1847) and several of his own paintings.

From 1844 Français regularly visited Marly and Bougival, where, with Baron and Nanteuil, he acquired a boat nicknamed 'La Grenouillère' by the inhabitants of the area. Henceforth he signed his paintings *Français, élève de Bougival*. In 1846 he made his first journey to Italy and remained there for three years, although he had intended to stay for only a few months. He lived in Genoa (1846), Pisa (1846), Florence (1846–7), Rome (1846–9), Frascati (1847), Ariccia (1848) and Tivoli (1848–9). He executed mainly gouache studies in the Borghese Gardens and at Tivoli (e.g. *View of Tivoli*, 1850; Lille, Mus. B.-A.). During these years his style came to fruition, he began to paint in the closely set strokes that would be a feature of his later, better-known works, and his palette became more luminous, due probably to his work in watercolour (e.g. *Fountain at Ariccia*, 1848; Paris, Mus. d'Orsay). After returning to France, he travelled and painted in such regions as Marly, Vaux-de-Cernay, Saint-Cloud and Sèvres, where he painted with Constant Troyon. From 1850 he also frequented Honfleur and, with Corot, Courbet, Eugène Boudin and Johan Barthold Jongkind, painted the town and its environs (e.g. *Sunset near Honfleur*, 1859). In 1852 he travelled to Crémieu with Corot, Charles-François Daubigny and Auguste Ravier. At this time his preferred sites were Saint-Cloud, Plombières-les-Bains and the banks of the Loire, where he painted mainly forest interiors and scenes of riverbanks in a style more realistic than the classicism of his Italian period. Having acquired a passion for the light of the Mediterranean regions, he returned to Italy twice more, staying at Naples in 1858–9 and at Capri and Pompeii in 1864–5. In the 1850s and 1860s he also visited Alsace, Belgium, Switzerland and the Alps.

While Français always remained a much sought-after painter at the beginning of the 1860s, reviews of his work were much less favourable. His painting the *Sacred Wood* (Lille, Mus. B.-A.) was exhibited at the Salon of 1864 in Paris and elicited hostile reactions. Although Corot admired it, Français's patron Alfred Hartmann, an industrialist from Alsace, compared it to 'a chicory dish seasoned with cream' (letter from Hartmann to Rousseau, 17 April 1864; Paris, Louvre, Cab. Dessins). The picture evokes an antique idyll and was painted after sketches done at Vaux-de-Cernay and Tivoli. Français executed other neo-classical landscapes in the same manner, in which mythological characters are introduced into realistic

landscape settings painted from sketches made in Italy or France (e.g. *Orpheus*, 1863; Paris, Mus. d'Orsay). After 1873 he spent his winters in Nice, returning each spring to Vaux-de-Cernay and to Plombières-les-Bains in the summer. In 1875 he made a further trip abroad, visiting Algeria. In 1878, six years after he received the commission, he completed *Expulsion from the Garden* and the *Baptism*, painted decorative panels (*in situ*) for the font in La Trinité, Paris. At this time his work developed towards poetic naturalism. He executed a large number of self-portraits, some of them in pastels, and he also produced numerous pen-and-ink drawings, enhanced by sepia, that convey a certain melancholy. In the paintings of his later years (e.g. *View of Antibes*, 1895; Strasbourg, Mus. B.-A.) there is a return to a colouring similar to that present in his works *c.* 1858.

Throughout Français's career he retained a taste for detail inherited from his master Gigoux, and his works typically display a slightly mannered meticulousness. He rapidly acquired a considerable reputation and, once he had achieved financial success, he was much sought after. Outside France he also exhibited in Geneva (1857, 1858 and 1861) and at the two International Exhibitions of 1862 and 1874 in London. In 1890 he was appointed a member of the Institut de France. In 1901, four years after his death, a monument was erected to his memory at Plombières-les-Bains, and in 1905 his workshop, which he had presented to his native town, became the Musée Louis Français.

Prints

with H. Baron and C. Nanteuil: *Les Artistes anciens et modernes*, 3 vols (Paris, 1848–62)

Bibliography

A. Gros: *François-Louis Français: Causeries et souvenirs par un de ses élèves* (Paris, 1902)
P. Miquel: *Le Paysage français au XIXe siècle, 1824–1874: L'Ecole de la nature*, iii (Maurs-la-Jolie, 1975), pp. 608–45
François-Louis Français, Plombières-les-Bains, 1814–1897: Illustrateur romantique (exh. cat. by R. Conilleau, Plombières-les-Bains, Mus. Louis Français, 1981)
Aquarelles, dessins et gravures de François-Louis Français (exh. cat., Région Lorraine, 1982–3)

Tradition and Revolution in French Art, 1700–1880: Paintings and Drawings from Lille (exh. cat., London, N.G., 1993)

LAURENCE PAUCHET-WARLOP

Francia, (François-)Louis(-Thomas)

(*b* Calais, 21 Dec 1772; *d* Calais, 6 Feb 1839). French painter and engraver. The son of the director of the Military Hospital in Calais, Francia was intended for the legal profession; his talent as an artist was recognized early, and he was permitted to attend the local drawing school where, at the age of 16, he was awarded all of the prizes. He retained a passionate loyalty to Calais and to its art school, vigorously protesting in 1835 against plans to exclude pupils under ten years of age from the drawing class; such crusades were characteristic of this energetic man.

Because of the political upheavals of 1790, Francia chose to go to London rather than to Paris. There he found employment as a drawing-master in a Hampstead school. Although he spoke no English, he was befriended by Joseph Charles Barrow (*fl* 1789–1802) who, when he opened his own drawing school in 1792, appointed Francia as an assistant. Francia soon became a member of the group of young artists including Turner and Thomas Girtin who worked in the evenings at Dr Thomas Monro's Academy. He was a founder-member of the sketching society named the Brothers. Its origins, membership and purpose ('establishing by practice a school of Historical Landscape, the subjects being original designs from poetick passages') are recorded in Francia's hand and signed by him in the minutes of the first meeting, 20 May 1799, on the reverse of a watercolour *Landscape Composition—Moonlight* (London, V&A). He exhibited with the Associated Artists in Water-Colours, a rival organization to the Old Water-Colour Society, from its foundation in 1808.

While his earliest work was either topographical illustration or picturesque scenery in the manner of Girtin (whose dot-and-dash technique is much in evidence in *Cottages in a Valley*, 1805; London, V&A), Francia quickly developed a facility in the dramatic rendering of light effects by broad

washes, placing the best of his work on a par with that of Cotman. Francia's original and liberal approach to current aesthetic theory can be gauged from the interesting series of aquatints that he published in 1810 in 'imitation' of his own and other artists' landscape sketches, entitled *Studies of Landscape by T. Gainsborough, J. Hoppner RA, T. Girtin, Wm. Owen RA, A. Callcott, A. S. Owen, J. Varley, J. S. Hayward and L. Francia, Imitated from the Originals by L. Francia* (1810).

In 1817 Francia returned to Calais; he had already established himself as a marine painter exhibiting regularly at the Royal Academy. He concentrated on this genre (almost exclusively in watercolour) for the latter part of his life. Francia was employed briefly as secretary to the British Consul in Calais. His home became a port of call for visiting British artists; he found a patron in the expatriate Beau Brummell (1778–1840) and gathered around him a group of artists, including Eugène Isabey, Jules Collignon (*d* 1850), Louis Tesson (*fl* 1841–67) and his own son, Alexandre Francia (1813–84), also an accomplished professional landscape and marine artist. His most celebrated protégé, Richard Parkes Bonington, was in Calais for only a brief period but remained a close friend. Francia was undoubtedly instrumental in passing to a whole generation of French watercolourists a fluency in watercolour and, at his best, a crispness and confidence in composition. The tension between sharply defined hulls and riggings and the liquid squiggles that suggest the lazy recessive lines of rutted cart tracks in the *Banks of a Canal* (London, V&A), and the combination of transparent washes and brilliant dashes of gouache, are typical of Francia's most influential work. By 1830, however, his style of representing the coastline between Calais and Le Havre and his records of spectacular shipwrecks must have seemed outdated. In his last years he lacked patronage and, while retaining his acerbic humour, he died a disappointed and harassed man.

Bibliography

E. Le Beau: *Notice sur Louis Francia* [c. 1839–40] [mem. by a contemp.]

Louis Francia 1772–1839 and his Son Alexandre (exh. cat. by A. Reed and S. Smith, London, Anthony Reed Gal., 1985)

M. Pointon: *The Bonington Circle: English Watercolour and Anglo-French Landscape, 1790–1855* (Brighton, 1985)

——: *Bonington, Francia and Wyld* (London, 1985)

Louis Francia (exh. cat., Calais, Mus. B.-A., 1989)

MARCIA POINTON

Franque, Jean-Pierre

(*b* Le Buis, Drôme, 11 Aug 1774; *d* Paris, 28 March 1860). French painter. He and his twin brother, Joseph-Boniface Franque (1774–1833), who was also a painter, were the sons of a modest farmer and, according to a local story, their youthful talent was such that the provincial government paid for them to study in Grenoble. They enrolled at the Ecole Gratuite in Grenoble and stayed for about two years (1786–8), training to become engravers. During the revolutionary period, the twins' education was taken over by the Département de la Drôme. In 1792 their case was discussed at the National Assembly in Paris, which placed them in David's atelier and provided a pension for four years. David agreed to educate them but refused payment, writing to the President of the Assembly, 'I am overjoyed to be chosen to be the first teacher of these youths who could be called children of the nation since they owe everything to her.' The two brothers were considered very promising students, and David asked Jean-Pierre to assist him in the execution of the *Intervention of the Sabine Women* (1796–9; Paris, Louvre; see fig. 17). Jean-Pierre also became involved with les Primitifs and the mysterious Maurice Quaï (1779–1804), who reacted against Davidian principles and advocated a return to 'primitive' 15th-century Italian art. Franque demonstrated his independence from David in the selection of the subject for his 1806 Salon début, the *Dream of Love Induced by the Power of Harmony* (destr.). In the spring of 1807 he was one of the 26 painters who entered a sketch (untraced) for the competition for a large painting representing Napoleon on the battlefield of Eylau, a competition won by Gros. In 1810 Franque

produced *Allegory of the Condition of France before the Return from Egypt* (Paris, Louvre). This complex picture is a peculiar mixture of the allegorical, symbolic and historical, and depicts a seated Napoleon implored by a personification of France to come to her aid. An inscription within the work reads, 'France, suffering under an unhappy government, summons from the bosom of Egypt the hero on whom her destiny depends.' With its crystalline light effects and imaginative composition, this work is related to the Ossianic subject-matter of Girodet and Gérard. Franque's work is often reminiscent of the brilliant polished finish of Gérard's paintings.

Franque continued with large-scale religious and mythological pictures that tend to be very emphatic with exaggerated poses and glossy colour, for example the *Conversion of St Paul* (exh. Salon 1819; original untraced, version in Dijon, Mus. B.-A.) and *Jupiter Sleeping in the Arms of Juno on Mount Ida* (exh. Salon 1822; Montauban, Mus. Ingres). After 1830 he became involved with the restoration of the Musée d'Histoire, Versailles, and painted many bland historical portraits that did nothing to enhance his reputation. (More than sixty of these are at the château of Versailles.) For his services he was rewarded with the Légion d'honneur in 1836, and he continued to work on official projects until his death.

The Franque brothers sometimes collaborated on works (e.g. *Hercules and Alcestis*, exh. Salon 1814; untraced), but their careers diverged after 1812, when Joseph went to Italy as the protégé of Napoleon's sister Elisa Bacciochi, becoming professor of drawing at the Carrara academy in 1814. With the fall of Napoleon he went to Naples and there became director of the academy until his death in November 1833. He was a portrait painter of considerable ability, often portraying the Bonapartes and Bacciochis, for example the very tender *Marie-Louise Watching the Sleeping King of Rome* (exh. Salon 1812; Versailles, Château). Even when in Italy he continued to work for French patrons, for example the *Duc de Berry* (Naples, Accad. B.A.). His last Salon exhibit was *Scene during the Eruption of Vesuvius* (1827; Philadelphia, PA, Mus. A.), a frantic depiction of panic, with figures climbing over one another to escape the lava.

Bibliography

French Painting, 1774–1830: The Age of Revolution (exh. cat., Paris, Grand Pal.; Detroit, MI, Inst. A.; New York, Met.; 1975–6), pp. 419–22

D. Rosenthal: 'Joseph Franque's *Scene during the Eruption of Vesuvius*', *Bull. Philadelphia Mus. A.*, lxxv/324 (1976), pp. 2–15

G. Levitine: *The Dawn of Bohemianism: The Barbu Rebellion and Primitivism in Neoclassical France* (University Park, PA, 1978)

SIMON LEE

Froment(-Delormel), (Jacques-Victor-) Eugène

(*b* Paris, 17 June 1820; *d* Paris, 1 March 1900). French painter, designer and printmaker. He was a pupil of Jules Jollivet, Pierre Lecomte and Eugène-Ammanuel Amaury-Duval, for whom he also acted as executor. From 1857 to 1885 he worked mainly as a designer for the Sèvres manufactory. He exhibited regularly at the Paris Salon from 1842 to 1880; from 1864 he could exhibit his works at the Salon without having to undergo selection by the jury. Heavily influenced by the style of Ingres's pupils, and especially Amaury-Duval, Froment painted a *Virgin* (1846; Autun, St Jean) that recalls the contemporary work of Ingres for the stained-glass windows in the chapel of St Ferdinand at Dreux. In the same year he painted *St Peter Healing a Lame Man at the Door of the Temple* in the church at Pégomas.

Froment's genre scenes, with their pleasant, decorative symbolism, are often close to the works of Jean-Léon Gérôme and Jean-Louis Hamon, or his friend Henri-Pierre Picou (1824–95). He did many engravings to illustrate such works as Louis Ratisbonne's *La Comédie enfantine* (Paris, 1860) and Victor Hugo's *Livre des mères* (Paris, 1861). He also did some mural decorations in the chapel of St Joseph in Autun Cathedral, as well as decorating the chapel of St Martin-les-Autun at the seminary at Autun, in collaboration with Alfred de Curzon, in 1855–6.

Bibliography

J. Rerolle: 'Eugène Froment: Artiste peintre, sa vie, son oeuvre', *Mém. Soc. Eduenne*, xxviii (1900), pp. 339–47

La Tradition d'Ingres à Autun (exh. cat. by G. Vuillemot, Autun, Mus. Rolin, 1971)

G. Vuillemot: 'Carnets d'Eugène Froment et album romain d'Amaury-Duval', *Rev. Louvre*, 6 (1972), pp. 497–8

A. DAGUERRE DE HUREAUX

Gagneraux, Bénigne

(*b* Dijon, 24 Sept 1756; *d* Florence, 18 Aug 1795). French painter and engraver. He was one of the most important artists to emerge from François Devosge's school of art in Dijon. His reputation, like that of his fellow Dijonnais artist Pierre-Paul Prud'hon, is based on a number of Neo-classical works of a pleasingly poetic character, which Devosge had encouraged (see col. pl. XII). In 1776 he became the first artist from the Dijon art school to win the Prix de Rome with his painting of an uplifting moral subject, *Manius Curius Dentatus Refusing the Presents of the Samnites* (Nancy, Mus. B.-A.). The Dijon academy was very quickly recognized as one of the most important outside Paris. As a student there Gagneraux was directed towards examples from antiquity, the Italian Renaissance and the work of Poussin. During his four-year study period in Rome (1779–81) he worked on a copy (Dijon, Pal. Justice) of Raphael's *School of Athens* (Rome, Vatican, Stanze Raffaello) to fulfil his obligation to the States of Burgundy which sponsored him. He spent most of his life in Italy, working in the company of Anton Raphael Mengs, Johan Tobias Sergel and Henry Fuseli in the 1770s and with Antonio Canova, Gavin Hamilton, Goethe and Jacques-Louis David in the 1780s. In 1784 he was recognized as an artist of exceptional talent by Gustav III of Sweden, who visited Gagneraux's studio and bought the large painting *Blind Oedipus Commending his Family to the Gods* (Stockholm, Nmus.). This subject, which was subsequently taken up by many painters, was unusual for its time. David, however, had produced *Blind Belisarius Begging for Alms* (Lille, Mus. B.-A.) in 1781, which was similar in subject, sentiment and style. In common with contemporary history painters in Paris, Gagneraux showed an interest in dramatic subjects, clear and legible gestures and expressions and stark, austere settings. *Oedipus* was a turning-point in his career. As a direct consequence of the picture's success, he began to receive commissions from the King of Sweden and members of the court circle. One of the first of these was for a group portrait commemorating the meeting between Gustav III and Pope Pius VI in the Vatican (Stockholm, Nmus.). It was completed in 1785 and a copy (Prague, N.G., Sternberk Pal.), commissioned by the Pope, was done in 1786. It displayed Gagneraux's competence as a portrait painter and his ability to mass a large group on a grand scale. He took certain liberties with the architecture in an attempt to idealize it and with the positions of the main figures, which imitated those of the most revered antique statues shown in the background. This imaginative reconstruction of a solemn occasion, in which there was no attempt at absolute historical accuracy, was characteristic of Gagneraux's approach. Sandström pointed out the duality in Gagneraux's works, showing how disciplined studies from Egyptian statues and Greek vases in his notebooks were given as much attention as the paintings of more imaginative, fantasy subjects, such as the *Magician* (1790–95; Milan, Ambrosiana) or *Phaethon Terrified by the Sign of the Lion* (1790–95; Mâcon, Mus. Mun. Ursulines). The *Phaethon* is interesting not only for the surprisingly dynamic movement and rich, intense colouring but also for the unusual experimental technique employed. It is painted on gilded paper and laid down on panel, producing exciting light effects in certain areas.

In the last decade of his life Gagneraux showed an impressive range of subjects and great versatility in technique. He produced two large paintings of the *Battle of Senef* (1787–8) and *Crossing the Rhine* (1789–90). These were commissioned by the States of Burgundy and intended as the first in a series of six to decorate the ducal palace in Dijon in homage to the governor and his ancestors (now reinstalled in Dijon, Mus. B.-A., Salon Condé). These turbulent, confused battle scenes, influenced by those of Leonardo da Vinci, Raphael and Le Brun, were unrivalled until Napoleon

commissioned similar scenes at the turn of the century. In 1787 Gagneraux painted a ceiling in the Villa Borghese, Rome, with *Jupiter and Antiope* (Rome, Gal. Borghese, room 18), which was at the time considered to be one of his best works and of which he painted a replica (untraced) in 1789 during his stay in Naples. He was most at ease with such mythological or allegorical subjects, and they dominated his works of the late 1780s and early 1790s. Examples include *Psyche Awakened by Love*, painted for the Palazzo Altieri, Rome (1790; *in situ*, Sala Pompeiana), and *Psyche Carried by Zephyrs to the Palace of Love* and *Hebe Giving Drink to the Eagle of Jupiter* (both 1792; Norrköping, Löfstad Slott), which were commissioned by Baron Evert Taube, a member of the King of Sweden's retinue. For this type of subject Gagneraux chose cool pastel colours and gave the figures softer forms and sweeter expressions, more appropriate to the textual source. This was the story of Cupid and Psyche from Apuleius' *Golden Ass*, which was popular among artists in the second half of the 18th century for decorative and easel painting alike. In 1792 he received a commission for *Soranus and Servilia* (Dijon, Mus. B.-A.) from the daughters of Louis XV; this unusual subject marked a return to his earlier type of history painting. Finally, in 1792, he published a collection of 18 of his own line-engravings, some recording his own earlier paintings, others original works. They were among the first of such collections, pre-dating the engravings made by Tommaso Piroli (*d* 1824), after John Flaxman's illustrations for the *Iliad*, by one year. Flaxman and Gagneraux knew each other and both studied Greek vases and engravings of antiquities, for example the *Antichità di Ercolano* (1757–96) and those in the collection of Sir William Hamilton.

The last years of Gagneraux's life were troubled by illness and by the Italians' hostility towards the French in Rome during the aftermath of the French Revolution. His studio was ransacked and his brother Claude was hounded out of Rome. Gagneraux himself eventually left in February 1793, intending to go to Sweden. He stopped in Florence, where he was made an 'accademico professore' and in 1794 he was appointed History

Painter to the King of Sweden. He died in Florence after falling from a window. This was regarded as suicide rather than accident. In 1796 his brother mounted an exhibition of his work in Dijon.

Bibliography

H. Baudot: 'Eloge historique de Bénigne Gagneraux', *Mém. Acad. Sci., A. & B.-Lett. Dijon*, liii (1845–6, rev. 2/1889), pp. 173–219

P. Quarré: 'Les Artistes bourguignons à Rome au XVIIIe siècle', *Société française de littérature comparée, Actes du troisième congrès national: Dijon, 1959*, pp. 19–26

S. Laveissière: *Dictionnaire des artistes et ouvriers d'art de Bourgogne* (Paris, 1980), pp. 222–5

B. Sandström: *Bénigne Gagneraux (1756–1795): Education, inspiration, oeuvre* (diss., Stockholm U., 1981)

Bénigne Gagneraux (1756–1795): Un Peintre bourguignon dans la Rome néo-classique (exh. cat., ed. S. Laveissière; Rome, Acad. France; Dijon, Mus. B.-A.; 1983)

HELEN WESTON

Galimard, (Nicolas-)Auguste

(*b* Paris, 25 March 1813; *d* Montigny-lès-Corneilles, nr Paris, 16 Jan 1880). French painter, writer and lithographer. He was given his first art lesson by his uncle, Nicolas-Auguste Hesse, in Paris, then moved to the studio of Jean-Auguste-Dominique Ingres. According to Auvray in the *Dictionnaire général*, he also studied with the sculptor Denys Foyatier. Like a number of Ingres's pupils, Galimard was involved in decorating the newly built or newly restored churches of the July Monarchy and the Second Empire. At his first Salon in 1835 he exhibited *Three Marys at the Tomb*, a *Châtelaine of the 15th Century* and a portrait of his cousin, *Mme Lefèvre* (all untraced). The following year he exhibited one of his first attempts at glass painting, *The Queen of the Angels* (broken by a gust of wind during the exhibition), and a painting, *Liberty Leaning on Christ Flanked by the Apostles James and John* (untraced), a subject indicating sympathy with the social ideology of Charles Fourier or Saint-Simon. In 1848 and 1849 he exhibited a series of cartoons for his first major project, the decoration of the medieval church of St Laurent in Paris, then undergoing restoration by Victor Baltard. When the

church was remodelled and extended in 1866–7, Galimard again supplied designs for decorating the choir. None of this remains, but his windows in the south aisle of St Clothilde, Paris, Théodore Ballu's Gothic Revival masterpiece, finished in 1859, provide a good indication of his talent for organizing areas of strong colour in large, simple shapes. According to Auvray's account, Galimard also supplied windows for St Phillipe-du-Roule, Paris, for the church at Celle-Saint-Cloud and elsewhere.

As a painter Galimard is difficult to assess: surviving paintings by him are rare. His *Supper at Emmaus* in St Germain-l'Auxerrois, Paris, is too black to see. His *Ode* of 1846 (Paris, Louvre), however, survives in good condition. This half-length figure of a muse, inspired, it seems, by Nicolas Boileau's *Art poétique* (Paris, 1674), has the soulfulness, the exaggerated purity of form, the strong local colour and enamelled finish common in the work of Ingres's followers. His *Juno* (exh. Salon 1849; Narbonne, Mus. A. & Hist.) is a more eccentric figure, sharply outlined in profile like a character on a Greek vase, with little sense of academic modelling. *Leda and the Swan* (untraced), commissioned by Napoleon III as a present for William I, King of Württemberg, and submitted by the artist to the Exposition Universelle of 1855, was refused by the jury on the grounds of its indecency. Galimard retaliated by holding a private exhibition. It reappeared at the Salon of 1857, and in 1863 Galimard exhibited a drawing of the picture.

Galimard was the author of articles and reviews in *L'Artiste*, *La Patrie* and *La Revue des deux mondes*, published under the names of 'Judex' and 'Dicastes'. He also published lithographs after his own designs for stained glass (1854; Paris, Bib. N., Cab. Est.), a life of the lithographer Hyacinthe Aubry-Lecomte and a review of the Salon of 1849. He based his criticism on the absolute superiority of religious art (pagan and Christian), and, although not unsympathetic to Théodore Rousseau or Eugène Delacroix, he took Ingres as his ideal. His nickname, 'Pou mystique' ('mystic louse'), reflects the amused contempt felt by some of his contemporaries towards the religious and artistic idealism of Ingres's pupils.

Writings

Chapelle Saint-Paul: Peintures, murales, exécutées à la cire dans l'Eglise Saint-Sulpice, par Martin Drölling (Paris, n.d.)

Les Grands Artistes contemporains: Aubry-Lecomte (Paris, 1860)

Les Peintures murales de Saint Germain-des-Prés (Paris, 1864)

Bibliography

Bellier de La Chavignerie–L. Auvray, p. 601

B. Foucart: *Le Renouveau de la peinture religieuse en France (1800–60)* (Paris, 1987)

JON WHITELEY

Galle, André

(*b* St Etienne, Loire, 15 May 1761; *d* Paris, 21 Dec 1844). French medallist. He first worked in Lyon as an engraver of dies in a button factory, becoming its owner in 1786. In 1790 enthusiasm for the French Revolution inspired him to produce a medal for the Fédération. He followed this with a trial piece for the proposed bell-metal coinage, bearing a portrait of the *Marquis de Mirabeau* as the French Demosthenes, and in the following year another piece, representing *French Liberty* (in imitation of Augustin Dupré's *American Liberty*). Galle was sent to Paris to take part in the deliberations on the new coinage; there he worked for Dupré at the Mint, while studying sculpture under Antoine-Denis Chaudet. His opportunity came when Dominique-Vivant Denon began to produce his medallic history of Napoleon's reign. Galle's numerous contributions included the *Conquest of Upper Egypt*, the *Arrival of General Bonaparte at Fréjus*, the *Battle of Friedland* and the *Battle of Jena*, while his coronation portrait of *Napoleon* (1806) was much admired. After the Bourbon Restoration Galle was soon reconciled with the new regime and received a number of important commissions, including a medal for the *Entry of Louis XVIII into Paris in 1814* (ordered in 1816 and completed in 1822); at the same period he executed portraits of contemporaries such as *Jacques-Louis David*, *Henry Grattan* and *Matthew Boulton*. Galle was elected to the Institut de France

in 1819 and was made a Chevalier of the Légion d'honneur in 1825. In 1828 he invented an articulated chain of the kind later used in bicycles and devoted much of the rest of his life to its manufacture.

Bibliography

Forrer

Biographie des hommes vivants, iii (Paris, 1817), pp. 202–3

C. Gabet: *Dictionnaire des artistes de l'école française au XIXe siècle* (Paris, 1834), pp. 184–5

J. M. Darnis: 'André Galle', *Bull. Club Fr. Médaille*, li/lii (1976), pp. 160–72

MARK JONES

Gamelin, Jacques

(*b* Carcassonne, 3 Oct 1738; *d* Carcassonne, 12 Oct 1803). French painter, draughtsman and engraver. He was employed as a book-keeper in Toulouse by Nicolas-Joseph Marcassus, Baron de Puymaurin, who (on the strength of marginal drawings in the ledgers) sent him to study with Pierre Rivalz and then to Paris to the studio of the history painter Jean-Baptiste Deshays. He failed to win the Prix de Rome in 1763 and 1764, but Puymaurin's generosity enabled him to go to Rome. There he completed his training within the circle of such independent French artists as Laurent Pécheux, who was influenced by the Neo-classicism of Anton Raphael Mengs, and of Italian painters such as Marco Benefial, Domenico Corvi and, later, Giuseppe Cades. In 1770 he travelled to Naples and the following year he was elected to the Accademia di S Luca, Rome, as a battle painter. The most important work of these years is in the gallery of the Palazzo Rondanini, Rome, where in 1772 he decorated the vault with the *Fall of Phaëthon*, a painting in oil on canvas. Its effects of sublimity and terror are akin to contemporary work by Henry Fuseli.

In 1774 Gamelin returned to France, where despite recurrent financial troubles and the disruptive effects of the French Revolution he was a sought-after and prolific painter in his native Languedoc. He was at first based in Toulouse, where he became a member of the Académie in 1776. He painted a number of large compositions for the churches of Montréal and Narbonne (both in the département of Aude) as well as five works (1783; Carcassonne Cathedral; Narbonne, Hôtel-Dieu) for the Abbey of Fontfroide, near Narbonne. He also engraved the *Nouveau recueil d'ostéologie et de myologie* (1779), an anatomical work in which he combined realist observation and macabre imagination in a style reminiscent of Francisco de Goya. It was, however, a financial failure and in 1780 he was obliged to accept the directorship of the Académie of Montpellier. Further financial difficulties led him to renounce this post to settle in Narbonne, where he remained from 1782 to 1796. He worked for the cathedral, for the Pénitents Blancs and the Pénitents Bleus, painting for the latter order four scenes from the *Life of St Louis* (1783–5; Narbonne, Hôtel-Dieu), as well as for churches in the area, including those at Gruissan, Sallèles and Perpignan. Besides religious canvases he painted portraits, such as those of the *Children of Baron de Puymaurin* (1775; Carcassonne, Mus. B.-A., Toulouse, Mus. Augustins) and of *Frion* (1796; Perpignan, Mus. Rigaud); lively genre scenes in the Flemish style, including the *Toper and his Family* (1789; Carcassonne, Mus. B.-A.); and scenes evoking the ancient Roman world, for instance the *Vestal Virgins* (Carcassonne, Mus. B.-A.). He continued to paint battle scenes throughout his career: during the French Revolution he followed the Republican armies in the Roussillon campaign, depicting the *Battles of the Pyrenees* (1793; Narbonne, Mus. A. & Hist.; Béziers, Mus. B.-A.), and was also an organizer of Revolutionary celebrations. He was involved in the foundation of the museum in Carcassonne, saving the treasures of local monasteries and churches and in particular his own canvases. In 1796 he returned to settle in Carcassonne, where he became a professor at the Ecole Centrale. In addition to the *Nouveau recueil d'ostéologie* Gamelin produced more than 100 other prints (e.g. Toulouse, Mus. Dupuy) and was a prolific draughtsman (e.g. *Fire in the Temple of Vesta*, 1787; Toulouse, Mus. Dupuy; *Cavalry Skirmish*; Paris, Louvre). His son Jacques-François Gamelin (1774–1871) was a painter of minor talent.

Bibliography

Note sur les honneurs funèbres rendus à Jacques Gamelin, et éloge funèbre de Jacques Gamelin peintre d'histoire (Carcassonne, 1803)

R. Portalis and H. Béraldi: *Les Graveurs du dix-huitième siècle*, ii (Paris, 1881), pp. 231–2

Jacques Gamelin, 1738–1803 (exh. cat. by J. Hahn, O. Michel and G. Sarraute, Paris, Gal. Joseph Hahn, 1979) [with bibliography]

O. Michel: 'Huit tableaux du peintre languedocien Jacques Gamelin, 1738–1803', *Rev. Louvre*, xxxiv (1984), pp. 359–66

Le portrait toulousain de 1550 à 1800 (exh. cat. by J. Penent, Ch. Peligny and J.-P. Suzzoni, Toulouse, Musèe des Augustins, 1987), pp. 147–162, no. 97–103

Toulouse et le Néo-Classicisme: Les artistes toulousains de 1775 à 1830 (exh. cat. by J. Penent and J.-P. Suzzoni, Toulouse, Musée des Augustins, 1989), pp. 9–23, 59–63, 82, no. 1–19, 72–80, 102

O. Michel and J.-F. Mozziconacci: *Jacques Gamelin, 1738–1803*, ii of *Les collections du Musée des Beaux-Arts de Carcassonne* (Carcassonne, 1990) [with bibliog.]

OLIVIER MICHEL

Garneray [Garnerey]

French family of artists. Among the many pupils of the painter (1) Jean-François Garneray were his three sons (2) Louis Garneray, (3) Auguste Garneray and Hippolyte(-Jean-Baptiste) Garneray (*b* Paris, 23 Feb 1787; *d* Paris, 7 Jan 1858); a daughter, about whom little is known, seems to have worked most closely with Auguste. Hippolyte was a painter and engraver, producing landscapes of Brittany and Normandy (examples in La Rochelle, Mus. B.-A.; Douai, Mus. Mun.; Paris, Louvre).

(1) Jean-François Garneray

(*b* Paris, 1755; *d* Auteuil, 11 June 1837). Painter. He was one of Jacques-Louis David's earliest pupils, probably entering his studio in 1782. He worked with David on portrait commissions, most notably on *Dr Alphonse Leroy* (1783; Montpellier, Mus. Fabre), where he was responsible for the clothing and hands, but inexplicably he (or more likely David) chose a pose that seems to deny the sitter a left hand. He did not make his Salon début until 1791; during the French Revolution he drew and painted many important figures, including *Joseph Barra* and *Charlotte Corday* (both untraced; engraving of *Barra* by Pierre-Michel Alix after Garneray, 1794; Paris, Mus. Carnavalet). Garneray was evidently present at Corday's trial, as he recorded how she posed impassively when she realized her portrait was being drawn. The portrait of a deputy to the Convention, *Jean-Baptiste Milhaud* (c. 1794; Paris, Louvre), has also been attributed to Garneray on the basis of his signed and dated miniature copy (1794; Paris, Louvre), although it was previously given to David because of a false inscription; later even Garneray's authorship was disputed (see 1989 exh. cat.). After the Revolution, Garneray continued his successful portrait practice and also moved into historical genre. Many of his portraits, for example *Citizen Ol and his Wife* (exh. Salon 1801; Paris, priv. col.), have a Dutch quality, then much in vogue, while his excursions into historical genre indicate both a nostalgia for the *ancien régime* and some relationship with the Troubadour style (e.g. *Diane de Poitiers Asking Francis I to Pardon her Father*, 1817; the *Duc de Montansier Taking the Young Dauphin, Son of Louis XIV, into a Peasant's Cottage*, 1827; both untraced). Towards the end of his life he also produced numerous paintings of church interiors, again invoking a profound debt to Dutch art.

Bibliography

Bellier de la Chavignerie–Auvray

P. Chaussard: 'Notice historique et inédite sur M. Louis David', *Le Pausanias français: Etat des arts du dessin en France à l'ouverture du XIXe siècle: Salon de 1806* (Paris, 1806), p. 154

J. Renouvier: *Histoire de l'art pendant la Révolution*, i (Paris, 1863), pp. 210–12

G. Brière: 'Sur David portraitiste', *Bull. Soc. Hist. A. Fr.* (1945–6), pp. 172–3

David et Rome (exh. cat., ed. A. Senllaz, V. van de Sandt and R. Michel; Rome, Acad. France, 1981–2), pp. 168–72

La Révolution française et l'Europe, 1789–1799 (exh. cat., ed. J. R.Gaborit and others; Paris, Grand Pal., 1989), ii, pp. 493–4

SIMON LEE

(2) (Ambroise-)Louis Garneray

(b Paris, 19 Feb 1783; d Paris, 11 Sept 1857). Painter, illustrator and museum keeper, son of (1) Jean-François Garneray. He studied briefly with his father, before embarking as an apprentice on the frigate La Forte. After narrowly avoiding capture by the English in the Ile-de-France in 1799, he worked briefly as a draughtsman for a boatbuilder in Mauritius and then returned to sea on an expedition to chart the coast of Madagascar. His short but picturesque career at sea ended when he was taken prisoner by the English in 1806. During his confinement in a prison-ship in Portsmouth, Garneray learnt English and made an income by painting portraits. In 1814 he returned to France, took lessons in aquatint from Philibert-Louis Debucourt and was appointed marine painter to Louis de Bourbon, Duc d'Angoulême (1775–1844). He also painted for Charles, Duc de Berri, and exhibited the first of many shipping scenes in 1815. His collaboration with Etienne Jouy on Vues des côtes de France dans l'océan et dans le Mediterranée (Paris, 1823), illustrating the ports of France, gave him the opportunity to travel along the French coasts from 1820 to 1823, drawing the views that he later engraved to illustrate the text. In 1827 he was sent to Greece to paint a work commemorating the Battle of Navarino (exh. Salon 1831; Versailles, Château).

In 1832, at his own request, Garneray was made keeper of the Musée de Beaux-Arts, Rouen. In this capacity he published the first catalogue of the collection and set up a society to support the museum; he resigned in 1837 following a reprimand for overspending his account. In 1841, again at his request, he was given a place in the Sèvres manufactory, providing models for the painters to copy on to porcelain. He then spent much of his time at Nice (where he had a house), painting marines for Sèvres and for the Salon in Paris. In 1851 he published a colourful memoir, Les Scènes maritimes, which ran to several editions. Some of his paintings, also, are autobiographical, for example Prison Hulks at Portsmouth (London, N. Mar. Mus.) and the Battle of the Kent and the Confiance (La Rochelle, Mus. B.-A.). Most, however, are simple views of boats at sea, filled with light and movement, as in Fishing (Rouen, Mus. B.-A.), which he presented to the museum at Rouen in 1832; it shows a boat heaving on a swell against a windswept sky in a manner that recalls the early work of Turner, whose marine paintings he must have known.

Bibliography

Marseille et les grands ports français vus par Louis Garneray (exh. cat., Marseille, Mus. Mar., 1984)

(3) Auguste(-Simon) Garneray

(b Paris, 1785; d Paris, March 1824). Painter, printmaker, illustrator and designer, son of (1) Jean-François Garneray. He studied with his father and with Jean-Baptiste Isabey. He was appointed Peintre du Cabinet to Queen Hortense, Josephine's daughter, a title he retained after the fall of the Bonapartes, when Caroline, Duchesse de Berri, appointed him her drawing-master. From 1808 until his death he exhibited many portraits (e.g. Queen Hortense in her Boudoir, 1811; Paris, priv. col., see Praz, fig. 162), miniatures and vignettes. He also painted landscapes and illustrated books (Mme de Genlis's La Duchesse de la Vallière, 1805; Mme Cottin's Mathilde, 1804; the works of Molière and others). Apart from a few lithographs dated 1819, his prints consist entirely of etchings of theatrical costumes, many of which were published in his series Receuil des costumes de tous les ouvrages dramatiques représentés avec succès sur les grands théâtres de Paris (Paris, 1819–22). He designed costumes for the Académie Royale de Musique, the Opéra and the Théâtre-Français, all in Paris.

Garneray is remembered chiefly for his interior scenes in watercolour. These recall the more familiar work of Isabey, although Garneray's subject is the room itself and Isabey's work has a more pronounced human focus. Garneray's best-known interior, the Music Room at Malmaison (Malmaison, Château N.), was begun in 1812 and was finished by his sister in 1832. Others are illustrated and discussed by Praz, including a group dated too late to be by Garneray that may be by his sister.

Bibliography

M. Praz: *An Illustrated History of Interior Decoration* (London, 1964), p. 196

The Age of Neo-classicism (exh. cat., ACGB, 1972), pp. 704–5

JON WHITELEY

Garnier, Etienne-Barthélemy

(*b* Paris, 24 Aug 1759; *d* Paris, 15 Nov 1849). French painter. Although he was given a sound Classical education to prepare for the magistrature, he found a painter's career more alluring. Despite his late start, he had an impeccable record of success in competition with the pupils of Jacques-Louis David, whose influence he mostly resisted. Trained by Louis-Jacques Durameau, Gabriel-François Doyen and Joseph-Marie Vien, he won second place in the Prix de Rome competition in 1787 with *Death of Sedecius* (Le Mans, Mus. Tessé) and first place in 1788 with a strenuously rhetorical *Death of Tatius* (Paris, Ecole N. Sup. B.-A.). Although his stay in Italy was abruptly ended by the Roman crisis of 1793, he completed before his return to Paris the course work and other pictures, including an academic study of *St Jerome* (Troyes, Mus. B.-A. & Archéol.) and several Classical subjects.

While in Italy, Garnier began work on his masterpiece, the *Family of Priam*, for which he completed a painted sketch (Mâcon, Mus. Mun. Ursulines) in 1792. On the strength of this he obtained a government grant and a studio in the Louvre where he completed the huge, full-scale version (4.2×5.96 m; Angoulême, Mus. Mun.) eight years later, exhibiting it at the Salon of 1800. This depiction of the grief at Hector's death in combat with Achilles (as described in the *Iliad*), with its high, panoramic view, isolated groups and episodic action, is unlike anything David had painted by 1792; however, the fragmentation, which disturbed critics in 1800 and which was perhaps inspired by Greek art, was later echoed in David's *Leonidas at Thermopylae* (1814; Paris, Louvre).

The success of Garnier's picture established his reputation, and he was included in several major enterprises in the Empire and Restoration. With Pierre-Paul Prud'hon and Léonor Merimée (1757–1836) he was commissioned to decorate the ceiling of the Salle de Diane in the Louvre, where he painted an accomplished but stiff picture of *Hercules with the Deer with the Golden Horns* (*in situ*) in a tympanum. He was included in the group of painters who provided pictures for the sacristy in the church of St Denis, Paris, for which he painted the *Burial of Dagobert I* (*in situ*). In 1808 he painted *Napoleon Studying a Map of Europe in his Study* (Versailles, Château), and in 1810 he was included among the select group competing for the Prix Décennal. His success continued under the Restoration: *Eponina and Sabinus* (Angers, Mus. B.-A.), exhibited in 1814, was bought by Louis XVIII.

Garnier was inevitably drawn into the Restoration commissions for religious pictures, exhibiting in 1827 his *Virgin of Sorrows* (Nantes Cathedral), commissioned for the Madeleine, Paris, but he was too old to keep up with the newer, softer fashions in religious art. His career received a check in 1829, when he failed in his candidature for the directorship of the Académie de Rome, in competition with Horace Vernet. Charles X compensated him with the Légion d'honneur and a pension of 2000 francs. He continued to paint, exhibiting in 1847 his large *Marriage Procession of Napoleon and Marie-Louise in the Tuileries Gardens* (Versailles, Château), completed after 30 years.

As President of the Académie des Beaux-Arts, Garnier delivered eulogies on such painters as Anne-Louis Girodet, Charles Meynier, Antoine-Jean Gros, Carle Vernet, François-Xavier Fabre and Charles Thévenin (1764–1838), some of whom were younger and more supple artists than himself. At his last Salon, in 1848, Garnier exhibited *Christ Falling under the Weight of his Cross* (Paris, Louvre), a cramped, crowded, mannered composition, out of step with the early Italian style preferred in contemporary religious art. He was at his best painting the conventional passions and gestures of Greek and Roman mythological characters and was less convincing in his attempts to depict historical figures (e.g. *Henry IV Visiting the*

Louvre, exh. Salon 1819; Versailles, Château). Garnier died the last survivor—but also the most forgotten artist—of his generation.

Bibliography

J. Bottineau: 'Le Décor de tableaux à la sacristie de l'ancienne abbatiale de Saint-Denis (1811–1823)', *Bull. Soc. Hist. A. Fr.* (1973), pp. 255–81
De David à Delacroix (exh. cat., Paris, Grand Pal., 1974), pp. 423–5

JON WHITELEY

Gatteaux

French family of medallists.

(1) Nicolas-Marie Gatteaux

(*b* Paris, 2 Aug 1751; *d* Paris, 24 June 1832). He was the son of a locksmith and trained as a gem-engraver under Delorme and de Gros before obtaining a position at the Paris Mint in 1773. Among his early medals were those for the *School of Medicine and Surgery* (1774), the *Death of Louis XV* (1775) and the *Coronation of Louis XVI* (1776). In 1781 he was made Médailleur du Roi and engraved a medal for the *Birth of the Dauphin*. He contributed three medals to the series commemorating the American Revolution—*Horatio Gates*, *Anthony Wayne* and *John Stewart*—and during the same period executed portraits of *Jean-Frédéric, Comte de Maurepas* (1781), *Jean le Rond d'Alembert* (1785) and *Joseph-Jérôme le François de Lalande* (1787). His *Abandonment of Privileges* (1789) was the first of a number of medals produced during the French Revolution, and his portrait of *Franz Joseph Haydn* (1802) was very highly regarded. Among his pupils were Bertrand Andrieu, Nicolas-Guy-Antoine Brenet (1770–1846) and his son (2) Jacques-Edouard Gatteaux.

(2) Jacques-Edouard Gatteaux

(*b* Paris, 4 Nov 1788; *d* Paris, 9 Feb 1881). Son of (1) Nicolas-Marie Gatteaux. He trained with his father and also studied sculpture and modelling under Jean-Guillaume Moitte. In 1809 he won the Prix de Rome for medal-engraving. In Rome he formed a friendship with Jean-Auguste-Dominique Ingres and executed a medal commemorating the *Villa Medici*, the home of the Académie de France in Rome. On his return to Paris in 1813 he contributed first to Vivant Denon's medallic history of Napoleon I's reign and then, from 1816, to the *Galerie métallique des grands hommes français*. For the latter he executed 17 portrait medals, including those of *Pierre Corneille, Victor Riqueti, Marquis de Mirabeau, Michel Eyquem de Montaigne* and *Armand-Jean du Plessis, Cardinal de Richelieu*. Among his official commissions were the coronation medals of *Charles X* (1824) and *Louis-Philippe* (1830), and the *Marriage of the Prince Royal* (1837). Gatteaux also executed a number of portrait busts, including posthumous ones of *François Rabelais* (Versailles, Château) and *Michelangelo* (Paris, Louvre), as well as statues. He was notable among French medallists of the first half of the 19th century in executing all but one of his 289 medals from his own designs. The exception was that for the *Ecole des Beaux-Arts*, after a drawing by Ingres. Elected a member of the Académie des Beaux-Arts in 1845, the younger Gatteaux was an influential teacher, whose most famous pupil was Eugène Oudiné. His fine collection of works of art went, after his death, to the Louvre and to the Ecole des Beaux-Arts.

Bibliography

DBF; Lami
Biographie des hommes vivants, iii (Paris, 1817), p. 231
F. M. Meil: *Notice sur N.-M. Gatteaux* (Paris, 1832)
C. Gabet: *Dictionnaire des artistes de l'école française du XIXe siècle* (Paris, 1834), pp. 294–5
J. F. Loubat: *The Medallic History of the United States* (New York, 1878)
J. M. Darnis: 'Jacques-Edouard Gatteaux', *Bull. Club Fr. Médaille*, lviii (1978), pp. 194–201

MARK JONES

Gautherot, Pierre [Claude]

(*b* Paris, 1769; *d* Paris, July 1825). French sculptor and painter. He studied sculpture with his father, Claude Gautherot (1729–1802); throughout his life he was known as both Pierre and Claude, signing his work with his surname only. He initially

specialized in portrait busts of well-known figures such as *Voltaire, Anne-Robert-Jacques Turgot* and *Jean-Sylvain Bailly* (all untraced). In 1787 he entered the studio of Jacques-Louis David and became his close friend. Thereafter he devoted himself completely to painting, initially choosing his subjects from his sculptural practice, as in his copies of portraits of *Voltaire* (after Nicolas de Largillierre) and *Turgot* (after Joseph Ducreux) (both 1790; St Petersburg, Hermitage). Delécluze's description of Gautherot in David's studio in 1796 and 1797 mentions that he was an avid Republican and that he wore a blond, powdered wig to disguise a skin disease. At the Salon of 1799 he exhibited *Pyramus and Thisbe* (Melun, Mus. Melun) and a year later another version of that subject (Bagnères-de-Bigorre, Mus. A.). At the Salon of 1802 he treated the fashionable subject of the *Funeral Procession of Atala* (untraced; see Lemonnier, p. 366), taken from the sensationally successful novel by François-René, Vicomte de Chateaubriand. In a scene full of pathos, the mournful cortège has Père Aubry with head bowed, followed by the Indian Chactas carrying the lifeless Atala.

Gautherot painted numerous scenes commemorating Napoleon's military triumphs, including *Napoleon Haranguing his Troops at Lech, 12 October 1805* (exh. Salon 1808; untraced) and *The Emperor Wounded before Regensburg* (exh. Salon 1810; Versailles, Château). In 1809 he was an unsuccessful candidate for admission to the Institut de France. Contemporaries observed that Gautherot's work was weakly coloured, but that his composition and draughtsmanship were extremely proficient. At the Restoration he managed to slip effortlessly from Napoleonic to Bourbon patronage and in 1817 received from Louis XVIII a commission for a *St Louis Curing the Plague-stricken Soldiers in his Camp* (untraced; oil sketch, Paris, Louvre) for the chapel of the Tuileries Palace, Paris.

Bibliography

Bellier de La Chavignerie–Auvray

E. J. Delécluze: *Louis David: Son école et son temps* (Paris, 1855), pp. 49–53

F. Benoit: *L'Art français sur la révolution et l'empire* (Paris, 1897), p. 310

H. Lemonnier: '*L'Atala* de Chateaubriand et *L'Atala* de Girodet', *Gaz. B.-A.*, 4th ser., xi (1914), pp. 365–6

SIMON LEE

Gavarni, Paul [Hippolyte-Guillaume-Sulpice Chevalier]

(*b* Paris, 13 Jan 1804; *d* Paris, 24 Nov 1866). French lithographer and painter. He was one of the most highly esteemed artists of the 19th century. Like Daumier, with whom he is often compared, he produced around 4000 lithographs for satirical journals and fashion magazines, but while Daumier concentrated on giving a panoramic view of public life, it was said of Gavarni that his work constituted the 'memoirs of the private life of the 19th century'. He specialized in genre scenes, in which the protagonists are usually young women, treating them as little dramatic episodes drawn from the light-hearted life of bohemia, dear to the Romantics.

Gavarni was initiated into the art of precision drawing while still very young, being apprenticed to an architect and then to a firm making optical instruments. He was also a pupil at the Conservatoire des Arts et Métiers. His first lithograph appeared when he was 20: a miscellany that accorded well with the taste of the time. His second work, the album *Etrennes de 1825: Récréations diabolico-fantasmagoriques*, also dealt with a subject then in fashion, diabolism. The pattern was set: all his life Gavarni produced works that would have been considered superficial if the delicacy of his line, his beautiful light effects and the wit of the captions he himself composed had not gained him admirers who found his prints both popular in their appeal and elegant. Gavarni also enjoyed writing, producing several plays now forgotten.

From 1824 to 1828 Gavarni stayed in Tarbes in the Pyrénées, where he worked for a geometrician; but he constantly made drawings, especially of local costumes, which he later published in Paris. On this trip he acquired his pseudonym, the 'cirque de Gavarnie'. Back in Paris he had his first taste of success with his contributions to fashion magazines. He was himself extremely elegant and

sophisticated, and he adored women. He personified the dandy figure sought out by the Romantics and expressed his personal tastes in his drawings. In March 1831 Balzac introduced him to the paper *La Caricature*, owned by the Republican Charles Philipon, where he joined a team of young graphic artists, most notably Daumier, Jean-Jacques Grandville and Joseph Traviès, who were to raise the status of satirical lithography to new heights. Like them, he produced a few political caricatures directed against Charles X prior to the 1830 Revolution and a few satires against the monarchy in 1832, but he made a speciality of ball and carnival scenes, portraits of actresses and prints of costumes and fancy dress.

In 1833, encouraged by the speed of his success, Gavarni founded his own magazine, *Le Journal des gens du monde*, where, surrounded by artist and writer friends, including Nicolas-Toussaint Charlet, Achille Devéria, Théophile Gautier and Alexandre Dumas, he combined the roles of editor-in-chief, graphic designer and journalist. The magazine was a commercial failure and closed after seven months and eighteen issues. From 1834 he began working on Philipon's principal satirical journal, *Le Charivari*, and after 1837 became a regular contributor both to this and to *L'Artiste*, which since 1831 had been reporting on the art world. It was for *Le Charivari* that he made his main series of lithographs: *The Letter-box*, *Husbands Avenged*, *Students*, *Clichy* (1840–41) (the Parisian debtors' prison to which he had been sent in 1835), *The Duplicity of Women in Matters of the Heart* (1840) and *The Life of a Young Man* (1841). In 1841–3 he made the 'Lorettes' famous: they were young women of easy virtue who haunted the new district around Notre-Dame-de-Lorette in Paris, to which businessmen and numerous intellectuals had been moving.

From the very start of his career in 1829, Gavarni's prints had been published by Tilt in England, where they had been fairly successful. He stayed in England in 1847 and 1851, discovering the wretchedness of the working-class districts of London. There he published his *Gavarni in London* (1849). He began drawing in quite a different way, with greater social commitment and greater

bitterness. It was also at this time, no doubt largely under English influence, that he worked in watercolour. On his return to France he published in *Le Paris* the long suite *Masques et visages* over the course of a year and at the rate of a lithograph a day (1852–3). The suite included several series: *The English at Home*, *A Tale of Politicking*, *The Sharers*, *Lorettes Grown Old* and *Thomas Vireloque*. This is perhaps his most important achievement. In it his graphic work is seen at its most lively. His line has become more tense and vigorous, the sense of contrast and movement greater, and the theme (the contrast between appearance and reality) more serious. He became moralistic and critical, often acrimoniously so, and his later work was not a popular success. The image created in the 1830s of a cheerful bohemia in which the lower orders of the bourgeoisie still mingled with the people had disappeared before the confrontation of the working class with the *nouveaux riches*. Gavarni superimposed on his habitual themes a profound disenchantment that owed much to his own aging, in such images as *The Emotionally Sick* (1853). He became increasingly reclusive, abandoning lithography in 1859 to concentrate on his garden, only to see it destroyed by the encroachment of the railways.

Gavarni was praised by the critics of his time: Balzac, Gautier, Sainte-Beuve and Jules Janin. Edmond and Jules de Goncourt, who befriended him after 1851, and of whom he made a lithograph portrait, helped to sustain his reputation after his death. They contrasted the elegance of Gavarni's themes favourably with what they considered the triviality of Daumier. This contrast obscured the more fundamental political division implicit in their work between a bourgeoisie faithful to its popular origins and one proud of its rise. For the latter Gavarni was a less dangerous artist than Daumier, although for later generations he appears less representative of the broad popular current that swept across France in the 19th century.

Bibliography

J. Armelhault and E. Bocher: *L'Oeuvre de Gavarni* (Paris, 1873)

E. de Goncourt and J. de Goncourt: *Gavarni: L'Homme et l'oeuvre* (Paris, 1873)

H. Beraldi: *Les Graveurs du XIXe siècle: Guide de l'amateur d'estampes modernes* (Paris, 1885–92), vii, pp. 5–82

The Studio (1904) [issue dedicated to Daumier and Gavarni]

P.-A. Lemoisne: *Gavarni: Peintre et lithographe*, 2 vols (Paris, 1924)

Inventaire du fonds français après 1800, Paris, Bib. N., Cab. Est., viii (Paris, 1954), pp. 465–581

Paul Gavarni, 1804–1866 (exh. cat. by G. Schack, Hamburg, Ksthalle, 1971)

The Charged Image: French Lithographic Caricature 1816–1848 (exh. cat. by B. Farwell, Santa Barbara, CA, Mus. A., 1989)

MICHEL MELOT

Gayrard, Raymond

(*b* Rodez, Aveyron, 25 Oct 1777; *d* Paris, 4 May 1858). French sculptor and medallist. He trained in Paris as a goldsmith with Jean Baptiste Claude Odiot before turning to the engraving of medals; about 1808 he joined the workshop of the gem-engraver and medallist Romain-Vincent Jeuffroy. In 1819 he showed his first work of sculpture, a marble statue in Neo-classical style of *Cupid Testing his Arrows* (untraced), at the Paris Salon. In 1823 he became medal-engraver to Charles X, and he remained a prolific engraver of commemorative and portrait medallions throughout his life. He competed unsuccessfully in the competition (1829) for allegorical sculpture for the pediment of the church of the Madeleine, Paris. That same year, however, he received an official commission for two seated marble statues representing the *Power of the Law* and *Universal Suffrage* for the courtyard of the Chambre des Députés, Palais Bourbon, Paris; these ponderous and academic works were not put in place until 1860. Gayrard was largely excluded from major state commissions during the July Monarchy (1830–48) because of his pro-Bourbon sympathies. Instead, he began to devote himself to religious statuary and funerary monuments in a Neo-classical style; among these works is the tomb of his friend *Denis-Antoine-Luc Frayssinous*, minister of ecclesiastical affairs under Charles X (marble, 1844; St Geniez, Aveyron, parish church). He was also a portraitist, and produced several busts and medallions of private clients (examples in Rodez, Mus. Fénaille), as well as small-scale groups of children and animals with moralizing themes, as in *Child, Dog and Serpent* (marble, exh. Salon 1841; Paris, priv. col.). Under the Second Empire (1851–70) Gayrard was much in demand as a medallist, but he received only one official commission, a bust of *Napoleon III* (marble, 1854; Paris, Acad. N. Médec.). His son and pupil Paul Gayrard (1807–55) was also a sculptor, producing popular family groups and statuettes of actors and animals.

Bibliography
Bénézit; Forrer; Lami; Thieme–Becker

J. Duval: *Raymond Gayrard* (Paris, 1859, rev. Rodez, 1902)

HÉLÈNE DU MESNIL

Gechter, (Jean-François-)Théodore

(*b* Paris, 1796; *d* Paris, 11 Dec 1844). French sculptor. Like Antoine-Louis Barye, Gechter was a pupil of François-Joseph Bosio and Baron Gros. His first Salon exhibits in 1824 had heroic Classical and mythological subjects. After 1830 he followed the example of Barye in turning to small-scale sculpture, usually including animals, but without Barye's zoological bias. After being shown at the Salon in 1833, his *Combat of Charles Martel and Abderame, King of the Saracens* (Meaux, Mus. Bossuet) was commissioned in bronze by the Ministry of Commerce and Industry. Although occasionally—as in *The Engagement (Egyptian Expedition, 1798)* (exh. Salon, 1834; untraced)— Gechter treated recent history, his predilection was for elaborately costumed battle or hunting scenes from the medieval or Renaissance period. Usually such pieces, with their frozen groupings, their emphasis on costume and their intricacy, belong to the genre known as Troubadour. Exceptionally Gechter could strike a more emotive note in his statuettes, as in *Death of Tancred* (bronze, exh. Salon 1827; silvered bronze, e.g., Paris, Louvre) or *Wounded Amazon* (bronze, exh. Salon 1840; untraced). Gechter received several

important public commissions: a marble relief of the *Battle of Austerlitz* (1833–6) for the Arc de Triomphe; marble allegories of the Rhine and the Rhône for one of the fountains in the Place de la Concorde (1839); a *St John Chrysostom* (marble, 1840) for the Madeleine; and a marble statue of *Louis Philippe* in coronation robes, commissioned in 1839 (Versailles, Château).

Bibliography

Lami

The Romantics to Rodin (exh. cat., ed. P. Fusco and
 H. W. Janson; Los Angeles, CA, Co. Mus. A., 1980)
G. Schiff: 'The Sculpture of the "Style Troubadour"',
 A. Mag., lviii/10 (1984), pp. 102–10

<div align="right">PHILIP WARD-JACKSON</div>

Gérard, François(-Pascal-Simon), Baron

(*b* Rome, 4 May 1770; *d* Paris, 11 Jan 1837). French painter and illustrator.

1. Life and work

He spent most of his childhood in Rome. His talent as an artist revealed itself early and during this period he acquired a love of Italian painting and music, which he never lost. In 1782 his family returned to Paris, where, through the connections of his father's employer Louis-Auguste le Tonnelier, Baron de Breteuil, Minister of the King's Household, Gérard was admitted to the Pension du Roi, a small teaching establishment for young artists which had been founded by the Marquis de Marigny. After 18 months he entered the studio of the sculptor Augustin Pajou, where he remained for two years, before transferring to that of the painter Nicolas-Guy Brenet. He became a pupil of David in 1786 and quickly found special favour with his master.

In 1789 Gérard competed for the Prix de Rome and his entry, *Joseph Revealing himself to his Brethren* (Angers, Mus. B.-A.), was placed second; the winner was Girodet. He did not submit in 1790, being preoccupied with his father's illness and death—after which he returned to Italy with his mother and two younger brothers. Back in Paris by mid-1791 he became David's assistant in

29. François Gérard: *Psyche Receiving Cupid's First Kiss*, 1798 (Paris, Musée du Louvre)

the painting of the *Death of Le Pelletier de Saint Fargeau* (destr.) in 1793 and the following year won first prize in the National Convention's competition on the theme of its historic session of *10th of August 1792* (prize drawing, Paris, Louvre; unfinished canvas, London, priv. col.). Although the project lapsed, his success secured him lodgings and a studio in the Louvre. The design was much praised by David—its composition was inspired by his own *Oath of the Jeu de Paume* (never completed) and through his influence Gérard was spared military service, though only at the cost of sitting on the Revolutionary Tribunal. (He avoided most, if not all, of its sanguinary sessions by feigning illness.)

On the death of his mother in 1793, Gérard married her sister and assumed responsibility for his youngest brother. He urgently needed to earn a living and worked for the publisher Pierre Didot

the elder illustrating luxury folio editions of La Fontaine's *Les Amours de Psyché et de Cupidon* (1797), the works of Virgil (1798) and Racine (1801) and *Les Amours pastorales de Daphnis et Chloé* (1800). He was greatly assisted financially by the miniature painter Jean-Baptiste Isabey who commissioned his *Belisarius* (ex-Duke of Leuchtenberg priv. col., Munich), which, having taken only 18 days to paint, brought him acclaim at the Salon of 1795. Immediately afterwards Isabey sold it to Caspar Meyer, Ambassador of the Batavian Republic, at a profit, which he donated to the artist. He also commissioned the superb portrait of himself and his four-year-old daughter (1795; Paris, Louvre; see col. pl. XIII) which drew attention to Gérard at the Salon of 1796.

Gérard's reputation and success were based on his work as a portrait painter. *Isabey and his Daughter* was widely praised for its superb naturalism, rivalled only by David's *Mme Sériziat and her Son* (exh. Salon 1795; Paris, Louvre). There followed *Larevellière-Lépeaux* (1797; Angers, Mus. B.-A.) and *Comtesse Regnault de Saint-Jean-d'Angély* (exh. Salon 1799; Paris, Louvre), in which personal expressiveness was couched in precise definition of form and soft yet subtle colour. These portraits met with almost universal approval and led in turn to commissions from Bonaparte, his family and entourage, culminating in the official *Napoleon in his Imperial Robes* (Versailles, Château, incl. other versions) and *Mme Récamier* (Paris, Carnavalet), both completed in 1805. On the strength of these, Gérard became the most fashionable portrait painter of his day, surpassing even David. His productivity at this time was phenomenal: between 1800 and 1815 he produced approximately fifty full-length and forty bust-length portraits.

Gérard did not forsake history painting. *Belisarius* was followed in 1798 by *Psyche Receiving Cupid's First Kiss* (Paris, Louvre; see fig. 29)—a development of his illustrations to La Fontaine—in which the cool smoothness of the two figures contrasts strongly with the carefully observed landscape setting. This painting was the sensation of the Salon of 1798, and as a result Gérard was commissioned in 1800 to execute one of two paintings (Girodet did the other) on

Ossianic themes for the Salon Doré at Malmaison. His uncharacteristically ethereal *Ossian Evoking Phantoms* (1801; original lost; versions at Hamburg, Ksthalle; Malmaison Château N.) was followed by the *Three Ages* (Chantilly, Mus. Condé; see fig. 30), shown at the Salon of 1808; in an unusual interpretation, an old man, a baby and a youth are grouped in complex symmetry around the central figure of a woman. In all three pictures a tendency towards the allegorical and anecdotal is pronounced, as is Gérard's interest in landscape (an interest probably absorbed from Girodet and his circle in Rome).

Corinna at Cape Misenum (1819; Lyon, Mus. B.-A.) was commissioned at the suggestion of Madame Récamier by Prince Augustus of Prussia in memory of Madame de Staël and shown at the Salon of 1822. Although the treatment of the figures remains classical, Gérard's propensity for elevating eyes and exaggerating gestures in the manner of Greuze is much in evidence, while passionate emotion and the wildness of the setting lend the picture a romantic aspect well in advance of its time. *St Theresa* (Paris, Infirmerie Marie-Thérèse), a rare venture into religious subject-matter, was conceived in a similarly romantic vein. Painted in 1827, its lachrymose mysticism is well attuned to the *Génie du Christianisme* (1802) of Chateaubriand, whose wife founded the institution for which it was commissioned.

Gérard returned to classical themes intermittently throughout his career but in order to cater for the increasing interest of the French in their own history, many of his history paintings depicted more recent subjects. In 1810 he exhibited the enormous *Battle of Austerlitz* (Versailles, Château; figures, Paris, Louvre), commissioned by the Emperor and incorporated into the ceiling of the Salle du Conseil d'Etat at the Tuileries in the form of a fictive tapestry being unrolled by winged female figures representing Victory, Fame, Poetry and History. It was removed after the fall of the Empire and replaced by the *Entry of Henry IV into Paris* (exh. Salon 1817; Versailles, Château), an allegory of the Bourbon Restoration and one of Gérard's most successful history paintings. On several occasions thereafter he was commissioned

30. François Gérard: *Three Ages*, exh. Salon 1808 (Chantilly, Musée Condé)

to paint large-scale contemporary history pictures, for example the *Coronation of Charles X* (1827–9; Versailles, Château) and the *Duc d'Orleans Accepting the Lieutenancy-general of the Kingdom* (1834; Versailles, Château). Under the July Monarchy, Gérard resumed work on four allegorical pendentives at the Panthéon, originally commissioned in 1820 but not completed until 1836, and in recognition of his work as a history painter, Louis-Philippe envisaged the creation of a Salle Gérard at the Louvre.

The consistent success of Gérard, particularly as a portrait painter, coupled with his political moderation and circumspection, brought him many honours. Chevalier of the Légion d'honneur from its inception in 1802, he became Premier Peintre to Empress Josephine in 1806, professor at the Ecole des Beaux-Arts in 1811 and a member of the Institut in 1812. Through the influence of Talleyrand, he secured the commission for a full-length portrait of *Louis XVIII* (exh. Salon 1814; Versailles, Château) at the Restoration, became Chevalier of the Order of St Michel in 1816 and Premier Peintre to Louis XVIII in 1817. Two years later he was ennobled.

2. Style and influence

In his early years Gérard was markedly influenced by David. This is evident in his illustrations to *Psyché*, where he made much use of nudity, figures seen in profile, archaeological detail, strong diagonal shadow and shallow space; or in the *Three Ages*, where the woman was inspired by the figure of Hersilia in David's *Sabine Women* (Paris, Louvre).

His contemporary history pictures show the influence of both David and Gros. His technique always retained its polished quality; indeed, it became more finical than David's own and was thus, by the closing years of his career, greatly at variance with that of Delacroix and his romantic followers. His mature pictures have a grace and independence from the antique which distance him from his master, as do his softer colours and liking for landscape settings. In the case of *Psyche Receiving Cupid's First Kiss*, the finesse of the figures, the clarity of definition and the lack of colour complexity led to his being the only contemporary artist admired by Les Primitifs, while Ingres was much influenced by his *Ossian* in the composition of his *Dream of Ossian* (1813; Montauban, Mus. Ingres) and by some of his portraits.

In portraiture Gérard was a leader from the late 1790s, rivalling David himself for Court favour and even influencing his style. Typical of the free brushwork and superb control of tone in his portraits is *Mme Lecerf* (1794; Paris, Louvre). At the height of his success, the brilliant characterization of his sitters, as striking as that of his English contemporary, Sir Thomas Lawrence (whom he greatly admired), began to decline through sheer pressure of work; a number of his later portraits are repetitious and uninspired. This is hardly surprising in view of the extent of his oeuvre: over thirty history paintings, more than eighty full-length portraits and innumerable half-lengths and busts. Many of the portraits are in private collections and are known only through prints or the series of 84 freely handled reductions, originally made by Gérard as a record and now at Versailles. He had hardly any pupils but, because of the demands on his time, was compelled to employ assistants, notably Charles de Steuben (1788–1856), Paulin Guérin and Marie-Eléonore Godefroid (1778–1849).

Bibliography

C. Lenormant: *François Gérard: Peintre d'histoire* (Paris, 1846, 2/1847)

H. Gérard, ed.: *Oeuvre du baron Gérard, 1789–1836*, 3 vols (Paris, 1852–7)

—: *Correspondance de François Gérard* (Paris, 1867) [with an essay on Gérard by A. Viollet-le-Duc]

Lettres addressées au baron François Gérard (Paris, 1880)

G. Hubert: 'L'Ossian de François Gérard et ses variantes', *Rev. Louvre* (1967), pp. 239–48

The Age of Neo-classicism (exh. cat., London, RA; London, V&A; 1972), pp. 66–9, 351–2

A. Latreille: *François Gérard (1770–1837): Catalogue raisonné des portraits peints par le baron François Gérard* (diss., Paris, Ecole Louvre, 1973)

French Painting, 1774–1830: The Age of Revolution (exh. cat., Paris, Grand Pal.; Detroit, MI, Inst. A.; New York, Met.; 1974–5), pp. 431–9

Le Néo-classicisme français: Dessins des musées des province (exh. cat., ed. J. Lacambre and others; Paris, Grand Pal., 1974–5), pp. 61–6 [on Gérard's illustrations for Didot]

R. Kaufmann: 'François Gérard's *Entry of Henry IV into Paris*: The Iconography of Constitutional Monarchy', *Burl. Mag.*, cxvii (1975), pp. 790–805

M. Moulin: 'François Gérard: Peintre du *10 août 1792*', *Gaz. B.-A.*, (May–June, 1983), pp. 197–202

—: 'Daphnis et Chloé dans l'oeuvre de François Gérard, 1770–1837', *Rev. Louvre*, xxxiii/2 (1983), pp. 100–09

PAUL SPENCER-LONGHURST

Gérard, Marguerite

(*b* Grasse, 28 Jan 1761; *d* Paris, 18 May 1837). French painter. After the death of her mother in 1775 she left Grasse to join her elder sister Marie-Anne and her sister's husband Jean-Honoré Fragonard in their quarters in the Louvre in Paris. Marguerite became Fragonard's protégé and lived for the next 30 years in the Louvre, where she was exposed to the greatest art and artists of the past and present. By 1785 she had already established a reputation as a gifted genre painter, the first French woman to do so, and by the late 1780s came to be considered one of the leading women artists in France, the equal of Adelaide Labille-Guiard, Anne Vallayer-Coster and Elisabeth Vigée-Lebrun.

Since she was excluded from exhibiting at the Académie Royale, which allowed only four women members, her work was popularized through engravings by Gérard Vidal, Robert de Launay and her brother Henri Gérard. As a woman, Marguerite Gérard was also deprived of the academic training and study of the nude essential to the professional history painter. However, her informal

31. Marguerite Gérard: *Bad News*, exh. Salon 1804 (Paris, Musée du Louvre)

apprenticeship to Fragonard and her study of the paintings by Dutch 17th-century masters in private and royal collections enabled her to develop a meticulous and sentimental genre style that appealed to both the public and the critics throughout her long career. After the Revolution the Salons were opened to women and Gérard exhibited from 1799 to 1824, winning a Prix d'Encouragement in 1801 and a Médaille d'Or in 1804.

Gérard was also an accomplished portrait painter, specializing at first in small-scale, freely brushed portraits of friends and later in larger, more finished portraits, closer in style to her genre scenes. More than 300 genre scenes and 80 portraits, including several miniatures, have been documented. Since she worked chiefly in oil on canvas, preferring to make preliminary sketches in oil, very few drawings can be reliably attributed to her.

Gérard's genre paintings present an idealized vision of the private world of bourgeois and upper-class women of her period. The embodiments of perfect womanhood, her subjects are depicted in romantic or maternal roles, accompanied by pets and servants and enjoying a leisurely, protected life occupied with their children, their correspondence, their music and drawing. *Bad News* (exh. Salon 1804; Paris, Louvre; see fig. 31) is typical of this genre. Unlike her subjects, Marguerite Gérard never married. She pursued her career as an artist for over 50 years and was an astute businesswoman, often lending money to aristocrats at high rates of interest.

The myth that Gérard and Fragonard were lovers has been disproved: she referred to him as her 'good little father' and continued to live with Mme Fragonard for 17 years after the master's death. However, the question of her artistic collaboration with Fragonard during the 1780s remains controversial. Some scholars believe that Fragonard's hand is visible in many works signed by Gérard during the first decade of her career, while others cannot imagine this master of dynamic, spontaneous brushwork painting in the precise, controlled manner of his student. Since Fragonard scholars are still at odds over the style and quantity of his output in the 1780s, agreement over the attribution of many well-known pictures including the *Stolen Kiss* (c. 1785; St Petersburg, Hermitage) and the *First Steps of Childhood* (c. 1780–83; Cambridge, MA, Fogg) has yet to be reached.

Gérard maintained a level of technical competence and ingratiating sentimentality in her paintings that assured her success. Her ability to reproduce textures and surfaces with *trompe l'oeil* precision and her preference for a glittering palette of silvery colours enhanced by glazes made her genre scenes unique. Gérard's canvases are precursors of the idyllic domestic genre scenes beloved by the public from the 19th century onwards, yet they also convey a sense of the splendid isolation that was the norm for the most fortunate, educated women of her time.

Bibliography

J. Doin: 'Marguerite Gérard', *Gaz. B.-A.* (1912), pp. 429–30
G. Levitine: 'Marguerite Gérard and her Stylistic Significance', *Baltimore Annu.*, iii (1968)

S. W. Robertson: 'Marguerite Gérard', *French Painting 1774–1830: The Age of Revolution* (exh. cat., Paris, Grand Pal.; Detroit, MI, Inst. A.; New York, Met.; 1974–5), pp. 440–41

—: 'Marguerite Gérard', *Women Artists, 1550–1950* (exh. cat., Los Angeles, CA, Co. Mus. A., 1976–7), pp. 197–8

—: 'Marguerite Gérard et les Fragonard', *Bull. Soc. Hist. A. Fr.* (1977), pp. 179–89

—: *Marguerite Gérard, 1761–1837* (diss., New York U., 1978) [includes complete cat. rais., master bibliog., bibliographies of source and sale materials, biog. outline, etc]

Fragonard (exh. cat. by P. Rosenberg, Paris, Grand Pal.; New York, Met; 1987–8), pp. 573–7

J. P. Cuzin: *Jean-Honoré Fragonard: Life and Work* (New York, 1988), pp. 216–24, 338–40

SARAH WELLS ROBERTSON

Gericault [Géricault], (Jean-Louis-André-) Théodore

(*b* Rouen, 26 Sept 1791; *d* Paris, 26 Jan 1824). French painter, draughtsman, lithographer and sculptor. He experienced the exaltation of Napoleon's triumphs in his boyhood, reached maturity at the time of the empire's agony and ended his career of little more than 12 working years in the troubled early period of the Restoration. When he died, he was known to the public only by the three paintings he had exhibited at the Salon in Paris, the *Charging Chasseur* (1812; Paris, Louvre), the *Wounded Cuirassier Leaving the Field of Battle* (1814; Paris, Louvre) and the *Raft of the Medusa* (1819; Paris, Louvre), and by a handful of lithographs.

The work that Gericault left behind is a fragment, difficult to comprehend or fit into the conventional framework of art history. Primarily he sought a pictorial form with which to represent contemporary experience with dramatic emphasis and visual truth. The dangers that beset him on this search were, on the one side, the style-lessness and banality of 'picturesque' realism and, on the other, the stilted artifice of over stylization. Between these two temptations, the Romantic and the Neo-classical, he sought for a middle way: a grand style capable of expressing modern subjects.

I. LIFE AND WORK

1. Training and early work, before 1814

Gericault was born into a family of the provincial middle class, business-minded, newly enriched by revolution and war and far removed from intellectual or artistic interests. In 1796 his parents moved to Paris, where the boy, a far from brilliant student, attended the Lycée Imperial. At his mother's death in 1808 he came into a comfortable annuity that allowed him, at the age of 17, to plan his future according to his own wishes. An irresistible, precocious vocation for art marked him out as unusual in his family. His widowed father, the very model of a good bourgeois, who was to remain his lifelong companion and housemate, raised objections, but the young Gericault refused to be swayed from his decision.

By his own choice, Gericault's early studies were casual and without clear direction, foreshadowing in their changes of course some of the dilemmas that he was to face in later life. Following a personal impulse, he initially sought the advice of a fashionable outsider, Carle Vernet, the specialist of equestrian subjects and modish genres. Vernet seems to have regarded Gericault as a clever boy with a taste for art but without serious professional prospects. He allowed him the run of his studio, to rummage and to copy as he pleased, but apparently made no effort to teach him in any systematic way. Few traces survive from this earliest period (1808–9): a youthful *Self-portrait* (c. 1808; Paris, Denise Aimé-Azam priv. col., see Eitner, 1983, p. 8), a work of exuberant amateurishness, some paintings of horses, inspired by engravings after Vernet, and a sketchbook filled with a profusion of fantasy drawings of horses (Bazin, ii, pp. 334–55).

In 1810 Gericault left Vernet's casual guidance for a more disciplined course of studies under Pierre Guérin, a rigorous classicist and conscientious teacher who had organized his studio as a private academy in imitation of David's. Here Gericault proved to be a difficult student who, impatient with his master's routines, persevered in regular attendance for only about six months. Guérin recognized the talent of his unruly

disciple but warned the other, more docile students against imitating this turbulent nonconformist who possessed, unlike them, the 'stuff of three or four painters' (Clément, p. 25). While in Guérin's studio, Gericault is known to have painted the posing model and can be presumed to have submitted to the other regular exercises of academic training, but virtually nothing of his early school work has been preserved or, at any rate, identified. The very sparse scattering of works that can be dated within the short period of his apprenticeship (1810–11) shows few, if any, traces of Guérin's influence.

In 1811 Gericault took his further education into his own hands, removing himself from Guérin's studio to the galleries of the Louvre, recently transformed into the Musée Napoléon and filled with the art looted from Flanders and Italy. Setting up his easel before paintings by Rubens, van Dyck, Rembrandt, Titian, Caravaggio, Pier Francesco Mola and Salvator Rosa—a wide and for its time unorthodox choice of models—he discovered a richness and vitality in Renaissance and Baroque painting that completed his disenchantment with the reasoned compositions of Davidian classicism. He persisted in his copying of the masters for about four years (c. 1811–15), a remarkably sustained effort compared to the brevity of his studies with Vernet and Guérin. Like the vanguard painters of the later 19th century, he developed as an essentially self-trained artist whose school was the museum. Guided by intuitive affinities, he found his teachers among the masters of the past and gradually defined his individuality through his choice of models. Far from stifling his spontaneity, copying seems to have encouraged his love of heavy pigment and sensuous brushwork. After his death, some 62 of his copies of the masters were found in his studio.

When Gericault began his study of art, Neoclassical history painting had already started its decline into sterile routine. The public and the artists themselves were growing weary of the stilted pantomime, the endless parade of antique beauty and nobility, enacted by stock figures draped and helmeted à l'antique. The time was ripe for change. Napoleon, whose interests were

32. Théodore Gericault: *Charging Chasseur*, exh. Salon 1812 (Paris, Musée du Louvre)

not served by far-fetched mythologies, personally intervened to give a national and modern direction to history painting by commissioning prominent artists to record the victories and ceremonies marking his reign. At his instigation, history painting was divided into two official categories of equal rank, the classical and the national. At the Salons, these presented a contrast that was bound to impress artists of Gericault's temperament: on the one side, classical nudity and the pallor of ideal beauty; on the other, scenes of the most urgent modernity, violent action and colour. Gericault strongly favoured the painters of national—that is, modern military—subjects, particularly Antoine-Jean Gros, whose influence at this stage helped to obliterate the last traces of Guérin's instruction.

Barely 21 years old, an unknown, largely self-taught beginner, Gericault brashly presented himself at the Salon of 1812 with his *Charging Chasseur* (see fig. 32), a work of provocative size

(2.92×1.94 m) that surprisingly held its own among the exhibition's grand performances. A dashing improvisation, rapidly worked up into a picture of Salon format, it was indebted to Gros in its modernity and use of colour, and beyond this immediate influence it hinted at that of Rubens, whose work Gericault had recently copied at the museum. Though designated a 'portrait' at the Salon, in fact it went beyond the traditional schemes of portraiture, history or genre. The *Chasseur* spurring his horse into the glare of battle was not intended as the likeness of an individual but as an embodiment of the spirit of France in arms on the eve of the Russian campaign. The picture's originality and vigour of execution drew attention to its young author. Gericault was awarded a gold medal at the Salon's close.

The years following this precocious success were troubled and, on the surface, unproductive. Gericault continued his self-training, copied at the Louvre and painted the nude in Guérin's studio. Renouncing the ambitious monumentality and

33. Théodore Gericault: *Wounded Cuirassier Leaving the Field of Battle*, exh. Salon 1814 (Paris, Musée du Louvre)

drama of the *Chasseur* for the time being, he indulged a more personal bent by painting intimate studies of thoroughbred horses in the imperial stables of Versailles (*Twenty-four Horses in Rear View*, c. 1813–14; Paris, Vicomte de Noailles priv. col., see Eitner, 1983, p. 35) and producing a series of small, brilliantly vivid oil studies of cavalrymen (*Three Mounted Trumpeters*, c. 1814; Washington, DC, N.G.A.). A large number of swiftly but precisely pencilled sketches related to these paintings fill the pages of his sketchbooks of the time (e.g. the Chicago Album, Chicago, IL, A. Inst.). These private works, of small scale and delicately realist execution, were apparently not intended to be translated into larger, exhibitable works. They mark the first of several episodes of stylistic relaxation that regularly followed his more strenuous efforts: temporary lapses into a refined descriptive realism and fluent handling that cost him little effort.

2. Salon of 1814 and experiments with Neo-classicism, 1814–17

For the Salon of 1814, held shortly after Napoleon's abdication, Gericault reverted to a grand style and heroic dimensions. His *Wounded Cuirassier Leaving the Field of Battle* (see fig. 33) was planned as a pendant to the *Charging Chasseur* of 1812, which he showed again on this occasion. The ponderous figure of the defeated soldier, solidly sculptural in its metal armour and earthbound weight, lacked the painterly brilliance and dashing modernity of the earlier picture. Neither portrait nor history, the *Wounded Cuirassier* suited none of the recognized categories of subject-matter. It had the puzzling aspect of a fragment torn from its context, isolated, magnified and made to stand for something larger than a particular incident: the wounded straggler, a dark presence among the timid offerings of this first Salon of the Restoration, signified the fall of an empire. The *Wounded Cuirassier* failed to please the critics. Gericault himself was dissatisfied. The picture nonetheless marked an advance on his way towards an art of monumental format and energetic expression. It was followed by other military subjects, of similar style and mood, though of smaller

format and entirely private purpose, among them a *Mounted Hussar Trumpeter* (*c.* 1814–15; Williamstown, MA, Clark A. Inst.) and the two versions of the *Portrait of a Carabinier* (both *c.* 1815; Paris, Louvre, and Rouen, Mus. B.-A.), powerful evocations of military valour in defeat.

Gericault's work up to this point had been part of the current of national modernity, one of the two mainstreams that constituted the French school of the time. To the other, the Neo-classical, he owed nothing, despite his brief studies with Guérin. The collapse of the empire in the spring of 1814 did not immediately cause him to change direction. In the course of that year, he bought a commission in the Mousquetaires Gris, a splendidly uniformed royal cavalry of ceremonial rather than military character. This unexpectedly involved him in a brief spell of active service at the time of Napoleon's return from Elba in April 1815, when the Musketeers covered the flight of Louis XVIII to Belgium. Released from service at the frontier, Gericault spent the Hundred Days in hiding.

This inglorious end of Gericault's military adventure interrupted the course of his work and seems to have given him a distaste for the military spectacles that until then had preoccupied him. After the Battle of Waterloo (1815), he may have concluded that the modern, national vein in French art, inextricably involved with the Napoleonic era, was now exhausted. Upsets in his private life, the start of a clandestine love affair with a close relative, may also have contributed to his need for a change. Some time early in 1815 he made an abrupt change in his work, not only abandoning his favourite modern subject-matter but also radically reforming his style. With sudden determination, he turned to the only alternative at hand, the Neo-classical grand style, and with characteristic energy struggled to master an idiom that he had previously avoided. For nearly two years, he inflicted on himself the rigours of the kind of academic regimen that he had earlier refused to accept from Guérin. The progress of this self-training can be followed in the pages of the so-called Zoubaloff Sketchbook (Paris, Louvre), in compositional exercises, and in numerous practice drawings after engravings. By inborn talent a colourist and realist, he deliberately thwarted his more spontaneous tendencies, replaced colour with sharp light–dark contrasts, painterly effect with contour design and, in his treatment of the human figure, limited himself to a vocabulary of rough stereotypes, harsh to the point of crudity and entirely indifferent to natural appearance.

The style Gericault distilled from this self-inflicted ordeal, his 'antique manner', had little to do with conventional classicism, though he used it to express Classical themes. His very personal intent was to gain greater expressive force: more important than the increase in control was the increase in dramatic intensity that his effort at discipline brought him. Unlike his earlier, more casual realism, this new, highly artificial manner lent itself to resonant statements. Romantic in its intensity, borrowed from the tradition of Michelangelo rather than that of David, it expanded his range to include fantasies of terror, cruelty and lust (e.g. the pen-and-wash drawing of an *Executioner Strangling a Prisoner, c.* 1815; Bayonne, Mus. Bonnat). There can be no doubt that the main purpose of these efforts was to prepare himself for painting on a monumental scale. For the time being, he tested his grand style in works of modest size (e.g. the portrait of *Alfred Dedreux, c.* 1815–16; New York, Met.) and in a series of oil studies of heroic male nudes (e.g. Rouen, Mus. B.-A.; Bayonne, Mus. Bonnat; Brussels, Mus. A. Mod.), culminating in the *Nude Warrior with Spear* (*c.* 1815–16; Washington, DC, N.G.A.). Some of these studies were probably painted by way of rehearsal for the academic Prix de Rome competition of 1816, in which Gericault participated in the hope of winning a stipend for the Villa Medici in Rome. He failed the second round of the contest, precisely that of the study of the live model, and was thus disqualified from competing in the final, decisive trial. From this period of stylistic reorientation also comes the erotic and boldly carved *Satyr and Nymph* (*c.* 1815–16; Rouen, Mus. B.-A.), one of Gericault's few sculptures and an indication of his considerable talent for this medium.

Despite his failure in the competition, Gericault was determined to go to Rome, partly to further

his self-education, partly to escape the torments of an unavowable love affair. He arrived in Florence in October 1816 and the following month left for Rome. Overwhelmed by the works of Michelangelo, he 'trembled before the masters of Italy' (Clément, p. 82), began to doubt his own ability and only gradually recovered from this shock. His newly acquired 'antique manner' had by then lost some of its initial harshness; his irrepressible virtuosity was beginning to reassert itself, despite the obstacles he had put in its path. With superb assurance, he drew a series of erotic fantasies based on Classical themes in pen, wash and white heightening: *Leda and the Swan*, *Centaur Carrying off a Woman* (both 1816–17; Paris, Louvre) and *Satyr and Nymph* (1817; Princeton U., NJ, A. Mus.).

After his long effort of stylistic discipline, Gericault felt the need for fresh experience. Equally impressed by the drama of Italian popular life and the greatness of Italian art, he conceived the idea of treating observations gathered in the streets of modern Rome in an elevated style reminiscent of Michelangelo or Raphael. An event of the Roman carnival of 1817, the traditional race of the riderless Barberi horses in the Corso, gave him the motif he wanted. He began by recording the *Start of the Race of the Barberi Horses* (1817; Baltimore, MD, Walters A.G.), as he had witnessed it in the Piazza del Popolo, and the *Recapture of the Horses at the Finish* (1817; Lille, Mus. B.-A.), both turbulent and diffuse crowd scenes in modern settings. In a series of studies he then gradually reduced the panoramic spectacle to a few clearly articulated groups, arranged these in a balanced frieze and stripped the figures of their modern costumes (e.g. *Four Youths Holding a Running Horse*, 1817; Rouen, Mus. B.-A.). The final preparatory design of the *Race of the Barberi Horses* (1817; Paris, Louvre), ready for the transfer to a large canvas, projected a severely stylized composition of athletes struggling with horses, in a setting of undefined location and a time neither ancient nor modern.

Having reached this point, Gericault suddenly abandoned his project and returned to France, a year earlier than planned. He may have begun his painting in the hope of making an appearance at the Salon of 1817 with a work surpassing his previous entries in ambition and careful preparation. Had he carried out his compositional design, he would have produced a work without parallel in its time and probably incomprehensible to Salon audiences: a painting of heroic format and grand style that had no clearly identifiable subject and made no clear reference to history or myth, literature or common reality.

3. The 'Raft of the Medusa' and stay in England, 1817–21

After his return to Paris in the autumn of 1817, Gericault continued briefly to experiment with timeless heroic subjects, composing a *Cattle Market* (oil sketch, Cambridge, MA, Fogg), another contest of men and animals. He also toyed with the subject of a *Cavalry Battle*, which he alternately cast in an antique version (c. 1818; Bayonne, Mus. Bonnat) and a modern version (c. 1818; Paris, Louvre). On a larger scale, he improvised a cycle of three mural-sized Italianate landscapes, signifying *Morning* (1818; Munich, Neue Pin.), *Noon* (1818; Paris, Petit Pal.) and *Evening* (1818; New York, Met.). But in the politically charged atmosphere of Paris the timeless visions that had absorbed him in Rome began to fade. His interest in the drama of contemporary life reawakened. Turning his Italian experience to new advantage, he conceived the idea of representing exemplary acts of courage or endurance, taken from the history of the recent wars, with the stylistic elevation with which he had treated Classical themes. Searching for suitable subjects, he followed the news of the day and tried his hand at work of small format and wholly modern character, among them a series of drawings dealing with a sensational crime, the *Murder of Fualdès* (1818; Rouen, Mus. B.-A., Dijon, Mus. B.-A., Lille, Mus. B.-A., and Paris and London, priv. cols, see 1991–2 exh. cat., pls 210, 214–15). The new medium of lithography, recently introduced to France and used mainly for journalistic or illustrative work, offered him a chance to reconcile realistic observation with stylistic discipline in a series of military subjects, as in *Retreat from Russia* (1818; Paris, Bib. N.). It also allowed him to achieve on a small scale

that union of the grand and the natural that he hoped to realize in the more ambitious format of a Salon painting.

The crowning result of these various efforts was the *Raft of the Medusa* (Paris, Louvre; see col. pl. XIV) with which Gericault caused a sensation at the Salon of 1819. The huge canvas (4.91×7.16 m) represents the aftermath of a shipwreck that, three years earlier, had violently agitated public opinion in France. Gericault was initially attracted to this subject because of its sensational actuality and controversiality, but, in the course of giving it pictorial form, he gradually progressed from reportorial realism to a broadly humanitarian statement, putting the emphasis not on the scandalous circumstances of the disaster but on the suffering and struggle of men abandoned to the forces of nature. The problem he had set himself was the extremely difficult one of treating a contemporary occurrence in the exalted language of monumental art: the newspaper story of the wreck of a government frigate and the shameful abandonment of its crew was to be raised to the tragic power of Michelangelo's *Last Judgement* or Dante's *Inferno*.

Before deciding on his composition, Gericault explored the successive episodes of the underlying narrative: the outbreaks of mutiny and cannibalism on the raft, the victims' first, inconclusive sighting of the distant rescue vessel and the final rescue of the few survivors. He finally chose the moment of highest suspense between hope and despair—the shipwrecked men's desperate effort to be seen by their rescuers—because it offered the most dramatic pictorial effect and expressed the particular significance he wished to give to the event. Once he had found this motif, he gradually developed its compositional form in a series of contour drawings, after which he translated it, by means of several oil studies, into the painterly terms of light and colour. For the execution of the final canvas, he posed studio models in the predetermined positions and painted all the figures directly from the life. To maintain his emotional tension and remind himself of the horror of his subject, he had medical friends furnish him with portions of cadavers on which he based several

studies of *Severed Heads* (c. 1819; Stockholm, Nmus.) and still-lifes composed of *Dissected Limbs* (1818–19; Montpellier, Mus. Fabre). The *Medusa* was badly hung at the Salon and met with a mixed reception. The critics blamed or praised it for what they supposed to be its political tendency while ignoring its artistic significance.

Disappointed and exhausted after what had been the most strenuous effort of his career, Gericault suffered a nervous collapse in the autumn of 1819. During his convalescence, he made arrangements to have the *Raft of the Medusa* exhibited to the paying public in London in 1820. He had personal reasons for absenting himself from Paris for a time. In 1818, while he was at work on his picture, his mistress—the young wife of an elderly uncle—had given birth to their child. Relaxing in England, during part of 1820 and all of 1821, he renounced the grand manner and, indulging the other side of his artistic personality, played the part of the leisured amateur. He had no projects other than some lithographic experiments and spent the early part of his stay in London in undemanding occupations. Where Rome had roused him to attempt the grandiose, timeless and monumental, London revived his taste for the natural, modern and elegant. With a new lightness of touch, he drew or painted in watercolour horsemen, farriers, waggoners and the animals at the zoo. Struck by the spectacle of slum life, he drew studies of the poor whom he observed in London streets and used some of these for a series of lithographs, *Various Subjects Drawn from Life and on Stone* (London, 1821), which, as a group, constitute the most original work of his English stay. In the *Epsom Downs Derby* (Paris, Louvre), his only highly finished oil painting of this period, he deliberately imitated a popular English type of racing picture, playing in masterly fashion with borrowed foreign conventions. Painted in London in 1821, it is the modern English counterpart to his antique Roman *Race of the Barberi Horses*.

4. Late works, 1821–4

When Gericault returned to Paris, in the last days of 1821, his health had begun to fail. Frequently

ill with what seems to have been a tubercular infection, he suffered from what appeared to his friends as a physical and moral fatigue. A barely concealed urge to self-destruction seemed to guide his conduct. Repeated riding accidents succeeded in breaking what remained of his health, and ruinous speculations and reckless expenditures brought him to the edge of want. His artistic powers were unimpaired, but instead of focusing them on major projects, he spent them on a multitude of enterprises of short duration and small ambition. He had lived most of his life in financial security, without giving much thought to the saleability of his work. The loss of part of his fortune in 1822 forced him to work for the market and to appeal to the tastes of collectors and dealers. This accounts for his large production, in 1822–3, of finished watercolours and small oil paintings of pleasing subjects: horse genres, for the most part, romantic exotica and illustrations of popular, mainly Byronic, literature.

The few works that rise above this level of refined but minor accomplishment all had some private significance and evidently drew on deeper resources of emotional energy. The great achievement of Gericault's last years was not another grand Salon picture but a series of ten portraits of insane men and women, probably the patients of a medical acquaintance, Dr Etienne-Jean Georget (1795–1828), a pioneer of psychiatric medicine, who was the original owner of these paintings. The five surviving portraits of the series (all c. 1822) represent victims of various delusions or 'monomanias': *Kleptomania* (Ghent, Mus. S. Kst.), *Gambling Mania* (Paris, Louvre), *Manic Envy* (Lyon, Mus. B.-A.), *Delusion of Military Command* (Winterthur, Samml. Oskar Reinhart) and *Kidnapper* (Springfield, MA, Mus. F.A.). What purpose these portraits were to serve is unknown. They were painted in a spirit of severe objectivity and may have been intended as a record of Georget's clinical studies. Of hypnotic intensity and boldly spontaneous execution, they have a powerful realism that is entirely unaffected by romantic sentiment or artistic dramatization. They secure Gericault a place in the vanguard of 19th-century realism, though in their time they remained virtually

unknown. They were among the last of his works to reach a wider public and emerged from obscurity only after 1900.

In 1823 Gericault's illness became acute. Aware that he might die, he regretted his many unfinished projects and the waste of his talent on petty enterprises. On his sickbed, his ambition to paint subjects from modern life on a hugely monumental scale returned to him with full force. Too weak for their actual execution, he nevertheless busied himself with the preliminaries for several large compositions, among them the drawings for the *Opening of the Doors of the Spanish Inquisition* (1823; Paris, priv. col., see Eitner, 1983, p. 271) and for the *African Slave Trade* (1823; Paris, Ecole N. Sup. B.-A.), subjects of intense political interest to liberal Frenchmen of the period. Though realized only in drawings, their conception equals that of the *Raft of the Medusa* in ambition and surpasses it in stylistic unity. Amid the seemingly directionless variety of Gericault's late works, the *Portraits of the Insane* and these last monumental projects give strong hints of future possibilities. Had his life not been cut short, his late work would not appear as a subsidence but as the preparation for a new start.

II. POSTHUMOUS REPUTATION

After Gericault's death, an auction dispersed his works the following November. This contained some 220 paintings, mostly studies or sketches, and 16 large lots of drawings and watercolours that included a number of sketchbooks and may have comprised a total of 1600 to 1800 individual sheets. Save for some gifts to friends and relatives, this constituted the bulk of his life's work, as he had sold very little. The *Medusa* entered the Louvre later that year, the *Charging Chasseur* and the *Wounded Cuirassier* in 1848. But, despite the very limited public visibility of his work, his posthumous reputation among artists was great, and his influence, both on the later Romantics (Delacroix) and on the Realists (Courbet), was longlasting. For all its experimental variety, Gericault's work has the coherence of an assertive, unconforming individualism. It stands apart by its

freedom from the aesthetic and sentimental stereotypes of his time; there is very little in it of religious or conventionally patriotic subject-matter, even less of past history and literature, and not a trace of amusing anecdote or humour. He took his material mainly from the direct—largely visual—experience of reality or from an empathetic reconstruction of reality, but in giving it form he remained aware of the traditions of art and was able to give his evocations of reality a symbolic resonance. In dealing with contemporary events, he responded to their broadly human aspects rather than to national or partisan interests and at the same time tended to see in them reflections of his own fate. His keenest experience of life was associated with athletic or heroic exertion. The drama of all his larger compositions is generated by conflict, often in the form of physical contest, as in the recurring image of fiery horses mastered by athletes, but sometimes, as in the *Raft of the Medusa*, by an heroic self-assertion in the face of overwhelming adversity.

Bibliography

C. Clément: *Géricault: Etude biographique et critique* (Paris, 1868, rev. 3/1879/R with additions, New York, 1974)

L. Rosenthal: *Géricault* (Paris, 1905)

L. Delteil: *Géricault* (1924), xviii of *Le Peintre-graveur illustré* (Paris, 1906–30)

G. Oprescu: *Géricault* (Paris, 1927)

K. Berger: *Géricault und sein Werk* (Vienna, 1952)

D. Aimé-Azam: *Mazeppa, Géricault et son temps* (Paris, 1956, rev. 3/1980)

L. Eitner: *Géricault: An Album of Drawings at the Art Institute of Chicago* (Chicago, 1960)

The Graphic Art of Géricault (exh. cat. by K. Spencer, New Haven, CT, Yale U. A.G., 1969)

L. Eitner: *Géricault's 'Raft of the Medusa'* (London, 1972)

P. Grunchec: *Tout l'oeuvre peint de Géricault* (Paris, 1978)

Géricault: Tout l'oeuvre gravé et pièces en rapport (exh. cat., Rouen, Mus. B.-A., 1981)

P. Grunchec: *Géricault: Dessins et aquarelles de chevaux* (Lausanne, 1982)

L. Eitner: *Géricault: His Life and Work* (London, 1983)

G. Bazin: *Théodore Géricault: Etude critique, documents et catalogue raisonné*, 6 vols (Paris, 1987–94)

Géricault, 1791–1824 (exh. cat. by L. Eitner and S. A. Nash, San Francisco, CA, F.A. Museums, 1989)

Géricault (exh. cat. by S. Laveissière, B. Chenique and R. Michel, Paris, Grand Pal., 1991–2)

LORENZ EITNER

Gibelin, Esprit-Antoine

(*b* Aix-en-Provence, 17 Aug 1739; *d* Aix-en-Provence, 23 Dec 1813). French painter, draughtsman, sculptor, medallist and writer. He first trained under Claude Arnulphy at Aix, leaving for Rome *c.* 1761. He remained in Italy for ten years, studying the works of Raphael and other Old Masters as well as Polidoro da Caravaggio, whose monochrome frescoes Gibelin later imitated in France. In 1768 he won a prize at the Accademia di Belle Arti, Parma, with his *Achilles Fighting the River Scamander* (*in situ*; preparatory drawing in Stockholm, Nmus.). On his return to Paris in 1771 he was commissioned to execute a large number of monochrome frescoes as well as two paintings, *The Blood-letting* (1777; preparatory drawing at Poitiers, Mus. B.-A.) and *Childbirth*, for the new Ecole de Chirurgie, now the Faculté de Médecine (*in situ*). His works made over the next few years include the *Genius of War* and *Mars* for the pediments of the two south wings of the Ecole Militaire, Paris, and a painting of *St Francis Preaching*, which he donated to the Capuchin Monastery (now the church of St Louis d'Antin) on the Chaussée d'Antin (*in situ*).

During the French Revolution Gibelin was a staunch Republican, and he was elected colonel of the militia in Aix-en-Provence in 1789, remaining in that city for several years. By 1795 he was back in Paris, where he obtained lodgings in the Louvre, later transferring to the Sorbonne. In the course of the next 12 months he was made an associate member of the Institut de France and a director of a new school of painting at Versailles. He exhibited only three times at the Salon (1795, 1804, 1806) before returning in 1808 to Aix, where he was entrusted with reorganizing its academy.

An erudite artist, Gibelin wrote a number of essays on art, notably *La Nécessité de cultiver les arts d'imitation*. He also designed and executed medals, among which was one struck to honour the French Constitution (1795) and another in honour of American Liberty (drawing and terra-

cotta model at Chauny, Mus. N. Coopération Fr.-Amér.). Among his works as a sculptor is the terracotta low relief of *Jephthah's Daughter* (Aix-en-Provence, Mus. Arbaud) while, as an engraver, his prints include the *Public Good* and the allegorical *Coalition* and *Unison* (both *c.* 1800). Several albums also survive of Gibelin's drawings executed in Rome and Paris (France, priv. col.).

Writings

Discours sur la nécessité de cultiver les arts d'imitation (1799)

Mémoire sur la statue antique surnommée le 'Gladiateur Borghèse' (1806)

Observations critiques sur un bas-relief antique conservé dans l'hôtel de ville d'Aix et sur la mosaïque découverte près des bains de Sextius (1809)

Bibliography

Bellier de La Chavignerie-Auvray; Thieme–Becker

T.-B. Emeric-David: *Vie des artistes anciens et modernes* (Paris, 1872)

Autour de David: Dessins néo-classiques du Musée des beaux-arts de Lille (exh. cat., Lille, Mus. B.-A., 1983), pp. 104–5

ANNIE SCOTTEZ-DE WAMBRECHIES

Gigoux, Jean(-François)

(*b* Besançon, 6 Jan 1806; *d* Paris, 11 Dec 1894). French painter, lithographer, illustrator and collector. The son of a blacksmith, he attended the school of drawing in Besançon. He left for Paris and in 1828–9 frequented the Ecole des Beaux-Arts while executing various minor works. He made his début at the Salon in 1831 with a number of drawings. He established himself at the Salons of 1833 and 1834 with such sentimental compositions as *Henry IV Writing Verses to Gabrielle*, *St Lambert at Versailles*, *Count de Comminges*, *Fortune-telling* and such portraits as *Laviron* and *The Blacksmith* (1886; unless otherwise stated, all works are in Besançon, Mus. B.-A. & Archéol.; many drawings in Lille, Mus. B.-A. and Rouen, Mus. B.-A.). His portrait of the *Phalansterist Fourier* (1836) confirmed the success he had achieved as a history painter with the *Last Moments of Leonardo da Vinci* (1835).

In 1836 Gigoux travelled to Italy with his students Henri Baron and François-Louis Français. His friendships with Hygin-Auguste Cavé, the Directeur des Beaux-Arts, and with the influential Charles Blanc advanced his career and made it easier for him to obtain commissions, producing numerous portraits and religious subjects. He executed several works for the Musée d'Histoire at Versailles, including the *Capture of Ghent* and *Charles VII*. The subject-matter of the *Death of Manon Lescaut* (1845; destr.) and *Israelites in the Desert* (1845; Ivry-sur-Seine, Dépôt Oeuvres A.) reflects a period when Gigoux was out of favour: in addition to rejections from the Salon in 1837, 1840 and 1847, he attracted much adverse criticism. In 1848 and 1849 he drew various portraits and sold to Charles Blanc his painting *Antony and Cleopatra Testing Poisons on Slaves*, which had been refused for the Salon in 1837 (Bordeaux, Mus. B.-A.).

Unlike his friend Théophile Thoré, Gigoux supported the Empire and became involved in official art, producing such works as *Galatea and Pygmalion* (1857) and *Napoleon Visiting the Bivouacs on the Eve of Austerlitz* (1857). He executed two vast compositions, later destroyed, for the Conseil d'Etat in Paris, the *Grape Harvest* (1853) and *Harvest* (1855), and the *Flight and Rest in Egypt*, *Entombment* and *Resurrection* for a chapel in SS Gervais and Protais in Paris (*in situ*). Among his later works are *Poetry of the Midi* (1867; Narbonne, Mus. A. & Hist.) and *Father Lecour* (1875), which continued his earlier academic style.

Between 1830 and 1850 Gigoux executed a large number of lithographs of such contemporary figures as *Arsène Houssaye*, *Eugène Delacroix*, *Xavier Sigalon*, *François Gérard* and *Antoine-Louis Barye* and his friends *Pierre-Jean David d'Angers* and *Mme de Balzac* and her daughter. After 1850 these became more fluid, as in *Julia, the Beautiful Englishwoman* and *Memory*. He also illustrated various publications, including Petrus Borel's *Champavert, contes immoraux* (1833) and *Lettres d'Abailard et d'Héloîse* (Paris, 1839), and enjoyed a great success with Alain-René Le Sage's *Gil Blas* (1835). Gigoux was also involved in Jules-Gabriel

Janin's *La Normandie* (Paris, 1844) and *Les Français peints par eux-même* (Paris, 1840) among other works. Gigoux was a major collector of paintings, prints and drawings from the Renaissance onwards and owned works by such artists as Dürer, Chardin, Hogarth, Gericault and David. Apart from a few sales and donations to the Louvre and to the Ecole des Beaux-Arts, he left the major part of his collection to the town of Besançon.

Writings

Causeries sur les artistes de mon temps (Paris, 1885)

Bibliography

A. Estignard: *Jean Gigoux: Sa vie, ses oeuvres, ses collections* (Paris and Besançon, 1895)

H. Jouin: *Jean Gigoux et les gens de lettres à l'époque romantique* (Paris, 1895)

P. Brune: *Dictionnaire des artistes et ouvriers d'art de la Franche-Comté* (Paris, 1912)

R. Marin: *Le Peintre Jean Gigoux (1806–1894)* (MA thesis, Paris, U. Paris IV, 1987)

Jean Gigoux, dessins, peintures, estampes: Oeuvres de l'artiste dans les collections des musées de Besançon (exh. cat., Besançon, Mus. B.-A. & Archéol., 1994)

RÉGIS MARIN

Girardet, Edouard(-Henri)

(*b* Le Locle, Switzerland, 30–31 July 1819; *d* Versailles, 5 March 1880). Swiss painter and engraver. He was the son of the engraver Charles-Samuel Girardet (1780–1863) and the brother of the painters and engravers Karl Girardet (1813–71) and Paul Girardet (1821–93). At an early age he joined his brother Karl in Paris, studying painting with him and attending the Ecole des Beaux-Arts. He had practised the techniques of wood-engraving from the age of nine and concentrated increasingly on the graphic arts after 1835. In 1836 he started work as a draughtsman for Jacques-Dominique-Charles Gavard's *Les Galeries historiques de Versailles* (Paris, 1838–49), a project that continued for the next 12 years. He made his début at the Salon in 1839 with the *Communal Bath* (1839; Neuchâtel, Mus. A. & Hist.), and he continued to submit works until 1876. These included such genre paintings as the *Paternal*

Blessing (1842; Neuchâtel, Mus. A. & Hist.) and a number of engravings and aquatints after such artists as Paul Delaroche, Horace Vernet and Jean-Léon Gérôme. Several of these engravings were published by the firm of Adolphe Goupil. In 1844 Girardet and his brother Karl were commissioned by the Musées Nationaux de Versailles to travel to Egypt to paint a historical scene from the Crusades. Girardet responded with the *Capture of Jaffa* (1844; Versailles, Château). He also travelled to England and frequently visited Switzerland, though most of his time was spent in France. In 1857 he finally settled in Paris and devoted himself largely to copperplate-engraving.

Bibliography

DBF

H. Béraldi: *Les Graveurs du XIXe siècle*, vii (Paris, 1888), pp. 154–6

G. Vapereau: *Dictionnaire universel des contemporains* (Paris, 1858, rev. 6/1893)

□

Girodet (de Roussy-Trioson) [Girodet-Trioson], Anne-Louis

(*b* Montargis, Loiret, 29 Jan 1767; *d* Paris, 9 Dec 1824). French painter.

1. Life and work

(i) Before c. 1795: Paris and Rome. Girodet was named 'de Roussy' after a forest near the family home, Château du Verger, Montargis. He took the name Trioson in 1806, when he was adopted by Dr Benoît-François Trioson (*d* 1815), his tutor and guardian and almost certainly his natural father. Girodet took lessons with a local drawing-master in 1773 and by 1780 was studying architecture in Paris, where he became a pupil of the visionary Neo-classical architect Etienne-Louis Boullée. Boullée persuaded Girodet to study painting under Jacques-Louis David, and Girodet joined David's atelier in late 1783 or early 1784. He belonged to the highly successful first generation of David's school, which included Jean-Germain

34. Anne-Louis Girodet: *Hippocrates Refusing the Gifts of Artaxerxes*, 1792 (Paris, Université de Paris V, Faculté de Médecine)

Drouais, François-Xavier Fabre, François Gérard, Antoine-Jean Gros and Jean-Baptiste-Joseph Wicar. David's pupils showed great stylistic uniformity, based on a close emulation of his elevated Neo-classicism, and Girodet's early compositions are distinguishable from those of his contemporaries only by their slight quirkiness and excessive attention to detail.

Girodet's competition paintings for the Prix de Rome from 1786 to 1789 show David's influence in their austerity and formal economy, their subordination of colour to line and the sculptural plasticity of the figures. No prize was awarded in the competition of 1786, and when Girodet tried again in 1787 with *Nebuchadnezzar Putting to Death the Children of Zedekiah* (Le Mans, Mus. Tessé) Fabre denounced him for cheating and he

was disqualified. Girodet's reaction to this was extreme, displaying the unpleasant temperament which later developed into vindictiveness, paranoia, arrogance and hatred of criticism that soured his relationships with both patrons and fellow artists. To his abiding hatred of Fabre he was to add jealousy of Gérard and an openly contemptuous attitude to David.

Girodet was placed second in the Prix de Rome of 1788 with the *Death of Tatius* (Angers, Mus. B.-A.), and finally won in 1789 with *Joseph Recognized by his Brothers* (Paris, Ecole N. Sup. B.-A.), which shows a more sensuous and yielding treat-ment of the figures. In the same year he painted a *Deposition* (1789; Church of Montesquieu-Volvestre, Haute-Garonne) commissioned by a Capuchin convent. This vast canvas

(3.35×2.35 m) was thought to have been destroyed during the Revolution but was rediscovered in 1953. It is of considerable importance in that it was painted at a period notably unsympathetic to the production of religious paintings. It is a night scene, set in the interior of a cave, and demonstrates an early strain of Romanticism in Girodet's art. He had a lasting interest in sepulchral subjects, which permitted melancholy introspection: most notable was his *Burial of Atala* (1808; Paris, Louvre).

Girodet's departure for the Académie de France in Rome was delayed by the outbreak of the Revolution of 1789, and since like David he was an avowed Republican, he made drawings of the fall of the Bastille and its aftermath (Paris, Bib. N., Est. B6 Rés.41). Girodet arrived in Italy in 1790 and stayed until 1795 although his studies were disrupted by ill-health and political upheaval. In addition to drawings from the Antique and several accomplished landscape paintings he produced two major compositions in Rome. In 1791 he transformed a compulsory *pensionnaire*'s life-study exercise into an original and impressive mythological painting, the *Sleep of Endymion* (Paris, Louvre; see col. pl. XV). In many respects this was the most successful painting of his career; when it was sent to the Paris Salon of 1793 it made his reputation. It demonstrates Girodet's ideas concerning originality, creativity and individuality. He claimed that the idea of the Zephyr and the depiction of the goddess Diana as a moonbeam were entirely his creations, and in thus stressing the role of imagination, he was opposing the imitative basis of Neo-classicism. He was at pains to point out how little *Endymion* resembled the paintings of David and how much it represented his own unique, poetic vision. David had considered Girodet to be his most talented and promising pupil. However, when in Rome Girodet embarked on a deliberate refutation of David's precepts: the elongated figure of Endymion exudes eroticism. The moonlit setting and *sfumato* effects are influenced by Leonardo and Correggio, and the painting exhibits the eclecticism and complexity against which David had warned him before he left for Rome.

In 1792, as a homage to his guardian Trioson, Girodet painted *Hippocrates Refusing the Gifts of Artaxerxes* (U. Paris V, Fac. Médec.; see fig. 34), which adheres more closely to Neo-classical precepts although still incorporates bizarre and recherché elements, particularly in its illustration of Johann Kasper Lavater's physiognomic theories. Apart from *Endymion* and *Hippocrates*, the most important paintings produced by Girodet in Italy were the *Giuseppe Favrega, Doge of Venice* (1795; Marseille, Mus. B.-A.) and *Self-portrait Aged 28* (1795; Versailles, Château).

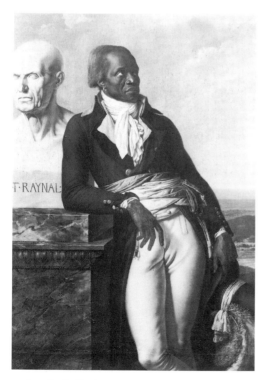

35. Anne-Louis Girodet: *Jean-Baptiste Belley*, 1797 (Versailles, Musée National du Château de Versailles et du Trianon)

(ii) From c. 1795: Paris. On his return to Paris in 1795 Girodet drew the illustrations for Pierre Didot's editions of Virgil (1798) and Racine (1801) and also made his name as a portrait painter. His

36. Anne-Louis Girodet: *Ossian and the French Generals*, 1802 (Malmaison, Château National de Malmaison)

three-quarter-length portrait of *Jean-Baptiste Belley* (1797; Versailles, Château; see fig. 35), the black Deputy to the Convention from Saint Domingue (now Haiti), is one of the outstanding portraits of the Revolutionary period. Belley, an ex-slave, is shown leaning against a bust of the Abbé Raynal, a prominent campaigner against slavery who had died in 1796.

In 1799 Girodet was awarded a Prix d'Encouragement and a state commission for the 'patriotic' subject of the assassination of the French plenipotentiaries at Rastatt. His conditions for undertaking the commission were extravagant and it was abandoned. This was the first of many official commissions that he never executed, or finished years after the agreed date. His disinclination to undertake such work was due to his preference for subjective themes allowing imaginative scope and, after 1815, to his improved financial position.

In 1799 also, Girodet was guilty of a more disruptive professional impropriety. The fashionable actress Anne Françoise-Elisabeth Lange commissioned him to paint her portrait. Sitter and artist

37. Anne-Louis Girodet: *Burial of Atala*, 1808 (Paris, Musée du Louvre)

argued, Girodet destroyed the original portrait and replaced it at the Salon with an allegorical rejoinder satirizing Lange with complex and highly detailed symbolism. This scurrilous painting, *Mlle Lange as Danaë* (Minneapolis, MN, Inst. A.), caused a scandal, ruined Lange's career and disgraced Girodet. The portrait is ethically and stylistically at odds with David's standards and employs an exaggerated Mannerism derived from Bronzino.

Surpassing *Mlle Lange* in extravagance, eclecticism and complexity of effect was Girodet's next major painting, the *Apotheosis of French Heroes who Died for the Country during the War for Liberty*, more commonly known as *Ossian and the French Generals* (Malmaison, Château N.; see fig.

36). It was commissioned in 1800 by Charles Percier and Pierre-François Fontaine to decorate the Salon Doré of Napoleon's country retreat at Malmaison and was based on James Macpherson's Ossianic legends. Gérard was also working on an Ossianic subject for Malmaison. In an effort to outdo Gérard and prove his own originality Girodet spent 15 months on a highly complex politico-allegorical work which combined Ossianic figures with the ghosts of generals killed in the wars of the Revolution. Girodet intended it as a topical allusion to the Treaty of Lunéville (1801) but by the time it was shown in the Salon of 1802 the political climate had changed with the Peace of Amiens (March 1802), and the work that Girodet

saw as his masterpiece met with incomprehension. Napoleon disliked the painting, David saw it as evidence of Girodet's insanity and critics termed it 'the fruits of a mind in delirium'. It confirms Girodet's claim to originality but demonstrates also his tendency to produce works of an ephemeral interest. Forty named figures are included in *Ossian and the French Generals*, although the composition is relatively small (1.92×1.84 m). The baroque accumulation of figures and the extravagance of the conception marks a complete break with Neo-classical composition.

Girodet's interest in Ossianic subjects continued with his *Death of Malvina* (Varzy, Mus. Mun.), painted c. 1802, and with a number of illustrations to the *Poems of Ossian* including a series of eight also dated c. 1802 at the Musée de Montargis. After the failure of the *Ossian* painting, Girodet produced a number of portraits including those of *Doctor Larrey* (Paris, Louvre) and *Charles-Marie Bonaparte* (Ajaccio, Mus. Fesch; replica of 1805, Versailles, Château), both shown at the Salon of 1804. In the Salon of 1806 he showed the *Deluge* (Paris, Louvre), which he insisted had nothing to do with the biblical event and was again intended to demonstrate originality. He felt that the small scale of *Ossian* had contributed to its failure and compensated with the monumental *Deluge* (4.31×3.41 m) showing five full-length figures linked in agonized contortions on a slippery rock. The treatment of the figures combines the influence of David with that of Michelangelo. Many critics found the work unnecessarily horrific, but it won the Prix Décennal of 1810, beating David's *Intervention of the Sabines* which came second. In 1807 Girodet produced two portraits that offer proof of his excellence in the genre; those of *An Indian* (Montargis, Mus. Girodet) and *Chateaubriand* (Saint-Malo, Château). The following year he had his greatest success since *Endymion* with the *Burial of Atala* (Paris, Louvre; see fig. 37), inspired by Chateaubriand's novel *Atala* (1800), a key work of the Catholic Revival in France. Girodet's painting perfectly matched the poetic and exotic tone of Chateaubriand's text, and the *Burial of Atala* was one of the most

popular works of the Salon of 1808. Also dated 1808 is an undistinguished Napoleonic work commissioned by Vivant Denon, *Napoleon Receiving the Keys to Vienna* (Versailles, Château). More successful and original was a second Napoleonic work, the *Revolt at Cairo* (Versailles, Château), one of the outstanding works of the Salon of 1810, and an important example of early Romantic orientalism.

From 1808 Girodet was involved with a series of decorative allegorical and mythological paintings for the Empress Josephine at the château of Compiègne. These occupied him intermittently until 1821 but are mediocre in execution. In 1812 he was commissioned to paint 36 portraits of *Napoleon in his Coronation Robes* for the imperial courts. By 1814 he had completed 26 (e.g. Montargis, Mus. Girodet; Barnard Castle, Bowes Mus.). In 1815 Dr Trioson died, leaving Girodet a considerable inheritance. From this point until his death he produced little of note, concentrating on portraits, such as *The Violinist Boucher* (1819; Versailles, Château), and *Hector Becquerel* (1820; Montargis, Mus. Girodet), and on drawings illustrating Anacreon and Virgil. He spent an increasing amount of time composing didactic poems about painting (e.g. *Les Veillées* and the epic *Le Peintre*) and writing discourses on aesthetics. He made a last attempt to attract attention at the Salon of 1819 with *Pygmalion and Galatea*, which he hoped would equal *Endymion* in its erotic, enchanting effects, but the work was unexceptional and made little impact. His last two exhibited works, at the Salon of 1824, were portraits of the Vendée generals *Bonchamps* and *Cathelineau* (both Cholet, Mus. A.), originally commissioned in 1816. The 1824 exhibition was the first of the great Romantic Salons, overtly opposed to Neo-classicism. Girodet had anticipated significant elements of Romanticism with his insistence on originality and individualism, his deviation from Classical sources and ideals, and his liking for the irrational and extreme. In the latter part of his career, however, he became reactionary and conservative in his politics and his art and was intolerant of Romantic painting which he considered careless and 'unfinished'.

2. Working methods and technique

Girodet's innovative theories and themes were not matched by any appreciable stylistic or technical developments. His style remained recognizably influenced by David although his ingenious artificial atmospheric effects (the glaucous moonlight of *Endymion*, the golden lighting of *Mlle Lange*, *Ossian and the French Generals* lit by meteors, and the *Deluge* by lightning) differed significantly from David. In Italy he had started painting at night and continued this unusual practice throughout his career using a system of artificial light set up by his pupil Antoine Claude Pannetier (1772–1859). His Romantic, subjective themes, allied to academically correct execution, resulted in his work attracting contradictory classifications, ranging from 'icy Neoclassicism' to 'visionary Romanticism'. A survey of his oeuvre reveals an unusual eclecticism covering the major preoccupations of the time. Girodet systematically researched his subjects and made numerous preparatory drawings. His oil sketches were used mainly to establish effects of lighting and atmosphere and show little of the detail of the finished works, as exemplified by the sketches for *Mlle Lange* (Montargis, Mus. Girodet) and *Ossian and the French Generals* (Paris, Louvre). The preliminary drawings and his literary illustrations, particularly those for the *Aeneid*, demonstrate his outstanding draughtsmanship.

Girodet accepted his first pupils on the strength of the reputation he had made with *Endymion*. Although his atelier was fashionable, it was generally recognized that he was not a successful teacher. His originality and individuality, which he considered crucial to his own work, were not teachable. Instead, his pupils concentrated on imitating his refined academicism, exaggerating the smooth finish and highly descriptive appearance of his canvases. They assisted him on major commissions such as the portraits of Napoleon and produced copies and replicas of his work. This has sometimes led to confusion of attribution, but Pérignon's catalogue (1825) is a reliable guide to original works.

Girodet's followers rarely distinguished themselves, and his most outstanding pupils were Léon Cogniet, Alexandre Colin (1798–1875), Théodore Gudin, Achille and Eugène Devéria, Pierre Delorme, Henri-Guillaume Chatillon (1780–1856) and Hyacinthe Aubry-Lecomte. Many of his pupils were involved in the new process of lithography, using it to make reproductions of Girodet's work, such as Aubry-Lecomte's numerous prints of Girodet's illustrations and paintings, including a suite of 16 lithographs of the principal heads from *Ossian and the French Generals*. The Musée Girodet at Montargis has an important collection of Girodet's paintings and drawings.

Writings

Oeuvres posthumes de Girodet-Trioson, peintre d'histoire: Suivies de sa correspondance, précédées d'une notice historique, ed. P. A. Coupin (Paris, 1829) [contains the epic didactic poem *Le Peintre* and its embryonic form, *Les Veillées*]

Bibliography

Catalogue des tableaux, esquisses, dessins, et croquis de M. Girodet-Trioson, peintre d'histoire, membre de l'Institut (sale cat. by M. Pérignon; Paris, 11–25 April 1825)

J. Adhémar: 'L'Enseignement académique en 1820: Girodet et son atelier', *Bull. Soc. Hist. A. Fr.* (1933), pp. 270–83

G. Levitine: *Girodet-Trioson, an Iconographic Study* (diss., Harvard U., 1952)

——: 'L'Ossian de Girodet et l'actualité politique sous le Consulat', *Gaz. B.-A.*, n. s. 6, xlviii (1956), pp. 39–56

Girodet (exh. cat., ed. J. Pruvost-Auzas; Montargis, Mus. Girodet, 1967) [reviewed by J. de Caso, *A. Bull.*, li (1969), pp. 85–9 and P. Ward-Jackson, *Burl. Mag.*, cix (1967), pp. 660–63]

G. Levitine: 'Girodet's New Danaë: The Iconography of a Scandal', *Minneapolis Inst. A. Bull.*, lviii (1969), pp. 69–77

P. Bordes: 'Girodet et Fabre, camarades d'atelier', *Rev. Louvre*, vi (1974), p. 393

De David à Delacroix: La peinture française de 1774 à 1830 (exh. cat., ed. P. Rosenberg; Paris, Grand Pal., 1974), pp. 447–54

Le Néo-classicisme français: Dessins des musées de Provence (exh. cat., ed. A. Sérrulaz, J. Lacambre and J. Vilain; Paris, Grand Pal., 1974), pp. 68–77

Ossian (exh. cat., ed. H. Toussaint; Paris, Grand Pal., 1974)

G. Bernier: *Anne-Louis Girodet, Prix de Rome 1789* (Paris, 1975) [excellent plates]

S. Nevison Brown: *Girodet: A Contradictory Career* (diss., U. London, 1980)

N. MacGregor: 'Girodet's Poem *Le Peintre*', *Oxford A. J.*, iv/1 (1981), pp. 26–30

Girodet, dessins de Musée, Montargis (exh. cat. by J. Boutet-Loyer, Montargis, Mus Girodet, 1983)

STEPHANIE NEVISON BROWN

Gleyre, (Marc-)Charles(-Gabriel)

(*b* Chevilly, nr Lausanne, 2 May 1806; *d* Paris, 5 May 1874). Swiss painter and teacher, active in France. While many of his pictures appear academic in technique and subject, they often treat subjects that are new or imaginatively selected in a manner that betrays varied artistic influences. With his contemporaries Paul Delaroche and Thomas Couture, he helped to create the *juste-milieu* compromise style of painting. Adept in classical and biblical subjects, Gleyre also ventured into historical iconography, employing Swiss rather than French historical events, as well as genre motifs and sometimes obscure original themes. His influence was immense through his art and his teaching, which helped to form the Néo-Grec school of the Second Empire.

Gleyre's earliest artistic training was in the decorative arts in Lyon, where he was sent after the death of his parents. In 1825 he went to Paris, where he enrolled in the studio of Louis Hersent and augmented his education with classes in watercolour under R. P. Bonington. Having perfected his drawing technique, Gleyre set out for Rome in 1828. (He was not eligible to compete for the Prix de Rome because of his Swiss nationality.) Gleyre lived in abject poverty during his six years in Rome, but the stay was extremely valuable as it permitted him to study closely the major Classical and Renaissance monuments, which remained crucial sources for his art and theory throughout his life.

In 1834 Horace Vernet, Director of the Académie de Rome, recommended Gleyre to accompany an American traveller, John Lowell jr, on an extensive trip to the Near East, serving both as companion and artistic recorder. The two remained together for more than nineteen months, visiting Greece, Turkey, Rhodes, Egypt and Sudan. Gleyre produced a mass of drawings and watercolours at virtually every important site; immediate, sometimes remarkably spontaneous, and always brilliantly coloured, they reveal Gleyre as a draughtsman of exceptional talent and also provide a unique record of significant archaeological sites (some no longer extant), costumes and exotic Near Eastern and North African physiognomies (e.g. *Turkish Woman ('Angelica')*, *Smyrna*, 1834; Lausanne, Pal. Rumine). The majority of these works are in the Lowell Institute, Boston (on loan to Boston, MA, Mus. F.A.). They were not well known to Gleyre's contemporaries, and Gleyre himself, although having spent more time in the Near East than most other Orientalist painters of the period, rarely made use of them in his later paintings. In November 1835 Gleyre, almost blind from ophthalmia, decided to withdraw from the assignment, finally returning to Paris in 1838.

Gleyre's first efforts on his return to France were in a decidedly academic manner. His most important commission at that time was for the decoration of the stairway of the château de Dampierre, where he worked with the Flandrin brothers and Ingres for the Duc de Luynes. After the murals were completed in 1841, some were intentionally effaced on the orders of Ingres, who was responsible for the overall decorative scheme; the reason for this was never wholly explained. Gleyre's first genuine success was with *Evening*, or *Lost Illusions* (1843; Paris, Louvre; see col. pl. XVI), which became the sensation of the Paris Salon of 1843. This sombre allegory of the human condition, deriving from memories of Egypt but wedded to classical iconography, typifies Gleyre's approach in its dreamy, romantic air, but also with its tightly controlled technique and sense of traditional composition, at once appealing to both academic and romantic tastes. The painting was bought by the government, thrusting on the painter an uncomfortable celebrity. In 1845 Gleyre won a first-class medal in the Salon with his *Parting of the Apostles* (Montargis, Mus. Girodet) and also embarked on a curious series of

paintings depicting primeval history in accord with contemporary literary and scientific interest in ancient history (e.g. *The Elephants*, *c.* 1849; Lausanne, Pal. Rumine). However, in 1849, at the height of his career, Gleyre withdrew from exhibiting in the French Salons because of his Republican ideals which clashed with the policies of Louis Napoleon. Gleyre also refused official French commissions and declined the Légion d'honneur, a measure of his staunch independence.

Despite his increasing reclusiveness and misanthropy, in the 1850s Gleyre received various commissions from the city of Lausanne for works depicting aspects of local history. His *Major Davel* (Lausanne, Pal. Rumine, destr.) represented the last moments of the Vaudois hero before his execution in 1723 in a manner that established a universal symbol of political freedom and courage. The *Romans Passing under the Yoke* (1858; Lausanne, Pal. Rumine), commissioned as a pendant, illustrates the Helvetic victory over the Roman legions and demonstrates Gleyre's resourcefulness in dealing with a vast composition of over 50 figures based on a historical event. Both works achieved the status of Swiss national icons and were reproduced in virtually every medium, but neither canvas was shown in France during his lifetime.

Gleyre's later works are marked by a search for new subjects from traditional classical and biblical sources. The most significant is *Pentheus* (Basle, Kstmus.), completed in 1864 on a commission from the city of Basle. The composition is unusually dynamic, with strong, diagonal movement, dramatic lighting and animated figures. Gleyre's last completed canvas, the *Return of the Prodigal Son* (1873; Lausanne, Pal. Rumine), illustrates a well-known theme, but in a manner that is unusually tender and poetic: the son is shown being welcomed home by his mother rather than, as was traditional, his father. Gleyre also added unusually revealing gestures and expressions, as well as exotic details, which enliven the time-worn subject.

A crucial aspect of Gleyre's career was his activity as a teacher. In 1843 he took over from Delaroche one of the most famous ateliers in Paris,

which had belonged to Jacques-Louis David and Antoine-Jean Gros, maintaining it until the outbreak of the Franco-Prussian War in 1870. In many ways Gleyre's atelier was a unique institution. It was run like a republic, in which each student had an equal voice in the daily activities and the general programme. Gleyre refused to accept payment for his efforts but requested instead a contribution for the rent and modelling fees. Gleyre offered practical instruction in drawing and painting, as well as theory, providing the customary correction of student work twice a week. Because of the liberal regime that prevailed in the atelier, as well as Gleyre's well-founded reputation as a solid, conscientious teacher, the atelier was among the most popular in Second Empire Paris. His most important pupils included the Impressionists Claude Monet, Auguste Renoir, Alfred Sisley and Jean-Frédéric Bazille, who all attended briefly in 1863. Gleyre also trained more conservative French painters, such as Jean-Léon Gérôme and Jean-Louis Hamon, and two generations of Swiss artists, including Albert Anker, Auguste Bachelin, Albert de Meuron (1823–97) and Edmond de Pury (1845–1911).

Bibliography

C. Clément: *Gleyre: Etude biographique et critique* (Geneva, 1878) [incl. cat. rais.]

Charles Gleyre ou les illusions perdues (exh. cat., Winterthur, Kstmus., 1974)

W. Hauptman: 'Allusions and Illusions in Gleyre's *Le Soir*', *A. Bull.*, xl (1978), pp. 321–30

L. F. Robinson: *Marc-Charles-Gabriel Gleyre* (diss., Baltimore, Johns Hopkins U., 1978)

Charles Gleyre, 1806–1874 (exh. cat., New York U., Grey A.G., 1980)

W. Hauptman: 'Delaroche's and Gleyre's Teaching Ateliers and their Group Portraits', *Stud. Hist. A.*, xviii (1985), pp. 79–119

WILLIAM HAUPTMAN

Gois, Etienne-Pierre-Adrien

(*b* Paris, 31 Jan 1731; *d* Paris, 3 Feb 1823). French sculptor. A pupil of the painter Etienne Jeaurat and then of René-Michel Slodtz, he won the Prix

de Rome in 1757 and, after a period at the Ecole Royale des Elèves Protégés, was at the Académie de France in Rome from 1761 to 1764. On his return to France he was accepted (agréé) by the Académie Royale in 1765 and received (reçu) as a full member in 1770 on presentation of a marble bust of *Louis XV* (Versailles, Château), a work made under the direct influence of Jean-Baptiste II Lemoyne. He had a successful official career, and was made a professor at the Académie Royale in 1781. He sculpted two marble statues for the series of 'Grands Hommes' commissioned by Charles-Claude de Flahaut de la Billarderie, Comte d'Angiviller, director of the Bâtiments du Roi: *Chancellor Michel de l'Hôpital* (exh. Salon 1777; Versailles, Château), of whom he later executed a bust for the Galerie des Consuls in the Tuileries, Paris (marble, exh. Salon 1801; Paris, Louvre), and *President Mathieu Molé* (exh. Salon 1789; Paris, Louvre). The two statues, generously draped, have the highly expressive features characteristic also of Gois's portrait busts, such as *Chevalier Guilleaumeau de Fréval* (marble, 1770; Cardiff, N. Mus.), *Daniel-Charles Trudaine* (marble, 1778–9; Chaalis, Mus. Abbaye) and his masterpiece, the *Portrait of the Artist's Father* (terracotta, 1760; Dijon, Mus. B.-A.).

Gois was a prolific artist. He was responsible for, among other works, the sculptural decoration of the Hôtel des Monnaies, Paris, including the Grande Salle and the stone pedimental sculpture of the façade (model, exh. Salon 1771), and for the funerary monument (marble; Paris, Notre-Dame-des-Victoires) to Louis XV's secretary, *Jean Vassal*, who died in 1770. This is an attractive work comprising a draped portrait medallion, weeping cherubim and smoking urns. He executed for the Palais de Justice a statue of *Justice* (plaster version, exh. Salon 1785; in situ; terracotta version, Paris, Louvre). He also produced small-scale commemorative monuments such as that to *Abbé Nicolas de La Pinte de Livry* (marble and bronze; Paris, Inst. France) and widely collected statuettes in a classicizing manner. He continued to work during the French Revolution, presenting at the 1793 Salon an elaborate plaster model for a monument to *Voltaire* (Paris, Carnavalet).

Gois was an artist much appreciated by his contemporaries. He was a fine portrait sculptor, working both in the grand manner developed by Jean-Baptiste II Lemoyne and Augustin Pajou and in slighter, more fashionable genres; he reflected in a small but not untalented way the great artistic currents of the second half of the 18th century. He was also known for his drawings, some of which were exhibited at the Salon. His son, Edme-Etienne-François Gois (b Paris, 1765; d St Leu-Taverny, Val-d'Oise, 1836), was a sculptor of historical subjects and portraits.

Bibliography
Lami
'Le Sculpteur Gois et l'Abbé de Livry', *Mag. Pittoresque* (1885), p. 32
M. Furcy-Raynaud: *Inventaire des sculptures exécutées au XVIIIe siècle pour la direction des bâtiments du roi* (Paris, 1927), pp. 156–6

GUILHEM SCHERF

Graillon, Pierre-Adrien
(b Dieppe, 19 Sept 1807; d Dieppe, 14 Dec 1872). French sculptor and painter. Employed in infancy in chalk-quarries and subsequently as a cobbler in Rouen and Paris, he returned to his native town in 1827, where he married and attended drawing-school while earning a living in local ivory and alabaster workshops. In 1836 he went to work in the Paris studio of Pierre-Jean David d'Angers. After his return to Dieppe in 1838, his reputation steadily increased as a sculptor in ivory, unbaked clay, terracotta, wood and alabaster. His small reliefs, figures and groups representing sailors, fisher-folk, vagrants and scenes from local life were appreciated by his more unassuming compatriots and acquired by tourists. Graillon retained the manner of a man of the people, and in his sculpture and paintings a deliberate roughness of treatment is allied to a strong formal sense and an instinct for natural grouping. He generally avoided the historical and exotic subjects that were the mainstay of the 19th-century statuette industry and was exceptional among contemporary sculptors in his preference for the ordinary

local theme. A strain of romantic 'misérabilisme' in his work finds allegorical expression in the group *Misery* (terracotta, 1854; Dieppe, Château–Mus.), and there are echoes of earlier genre painters like David Teniers II, particularly noticeable in the relief of *Card-players* (terracotta, 1849; Rennes, Mus. B.-A. & Archéol.). Remarkably (in that they are little more than seaside souvenirs), Graillon's works anticipate the subjects and treatment of the Realists. He felt occasional dissatisfaction with his modest status. According to David d'Angers, this was exacerbated by a visit paid to him in 1858 by Napoleon III. In the following year, Graillon executed a life-size statue of *Abraham Duquesne* (bronze, Dieppe, Château–Mus.). After his death, his two sons, César (1831–?c. 1900) and Félix (1833–1893), continued to work in their father's idiom.

Bibliography

Lami
A. Bruel, ed.: *Les Carnets de David d'Angers* (Paris, 1958)
P.-A. Graillon (exh. cat., Dieppe, Château–Mus., 1969)

PHILIP WARD-JACKSON

Grandville, J(ean-)J(acques) [bapt. Gérard, Jean-Ignace-Isidore]

(*b* Nancy, 15 Sept 1803; *d* Vanves, 17 March 1847). French caricaturist and illustrator. He was the son of the miniaturist Jean-Baptiste Gérard (1766–1854), and his paternal grandparents were actors known as 'Gérard de Grandville', the source of his pseudonym. He began to draw when very young and published his first lithograph, the *Cherry Seller*, in Nancy in 1825. From the start he copied the style of the little satirical scenes that had been popularized by the English and French satirical magazines of the period such as the *Nain jaune*. He went to Paris in 1825 and worked initially for the lithographer Mansion [pseud. of Léon-André Larue] (1785–1834) and with Hippolyte Lecomte on *Costumes* (1826). He published further series of *Theatre* colour lithographs in the English manner, *Sundays of a Paris Bourgeois* (1826) and *Every Age Has its Pleasures* (1827), for Langlumé. He had considerable success in 1829 with his album *Today's*

Metamorphoses for the publisher Bulla, in which animals appeared dressed as humans: his penchant for fantasy was already obvious. A new series for Bulla in 1830, *Journey for Eternity*, was not as successful and was cut short after nine plates had been published.

In 1829 Grandville went to work for the satirical journal *La Silhouette*, where he met Charles Philipon. Deeply committed to the Republican movement, he published caricatures attacking Charles X and is said to have taken an active part in the Revolution of 1830. Grandville became one of the main illustrators for *La Caricature*, the satirical magazine launched by Philipon on 4 November 1830. In 1832 the paper crowned him 'roi de la caricature'. In order to pay legal costs arising from government attempts to suppress *La Caricature*, Philipon decided to sell large and violently political lithographs under the title the *Monthly Association* (1832). Grandville was responsible for 17 of the 24 prints published in this series. When Philipon founded the first illustrated

38. J. J. Grandville: *The Wolf as Shepherd*, from *The Fables of Jean de La Fontaine*, ed. 1887 (Paris, Bibliothèque Nationale)

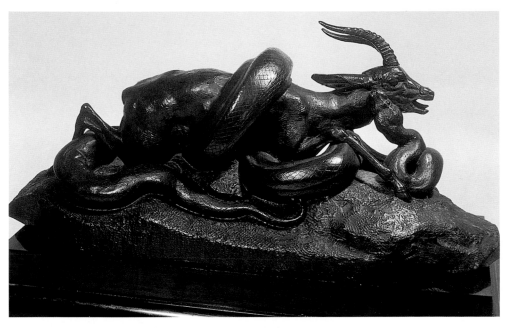

I. Antoine-Louis Barye: *Boa Strangling a Stag* (Paris, Musée du Louvre)

II. Théodore Chassériau:
Toilet of Esther, 1841, exh.
Salon 1842 (Paris, Musée
du Louvre)

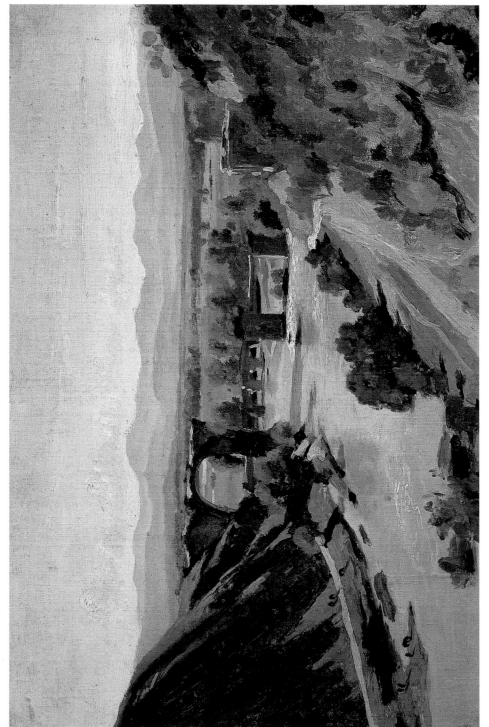

III. Camille Corot: *Bridge at Narni*, 1826 (Paris, Musée du Louvre)

IV. Thomas Couture: *Romans of the Decadence*, completed 1847 (Paris, Musée d'Orsay)

V. Honoré Daumier: *Rue Transnonain, le 15 avril 1834*, from *Association mensuelle*, 1834 (Paris, Bibliothèque Nationale)

VI. Jacques-Louis David: *Lictors Bringing Brutus the Bodies of his Sons*, 1789 (Paris, Musée du Louvre)

VII. Jacques-Louis David: *Coronation of Napoleon in Notre-Dame*, or *Le Sacre*, 1805–7 (Paris, Musée du Louvre)

VIII. David d'Angers: Niccolò Paganini, 1830–33 (Angers, Galerie David d'Angers)

IX. Alexandre-Gabriel Decamps: *Defeat of the Cimbrians*, 1833 (Paris, Musée du Louvre)

X. Eugène Delacroix: *Death of Sardanapalus*, 1827 (Paris, Musée du Louvre)

XI. Eugène Delacroix: *Liberty Leading the People*, 1830 (Paris, Musée du Louvre)

XII. Bénigne Gagneraux: *Strength Conquered by Love* (Turin, Galleria Sabauda)

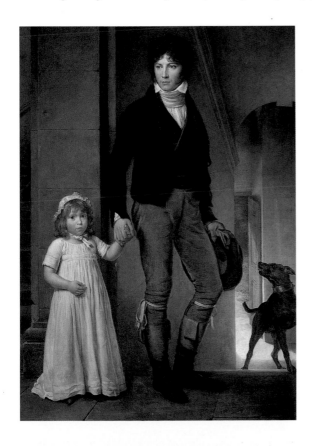

XIII. François Gérard: *Isabey and his Daughter*, 1795 (Paris, Musée du Louvre)

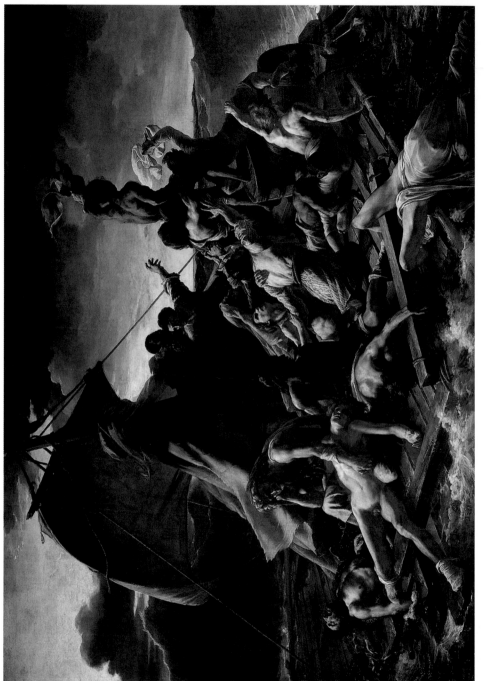

XIV. Théodore Gericault: *Raft of the Medusa*, exh. Salon 1819 (Paris, Musée du Louvre)

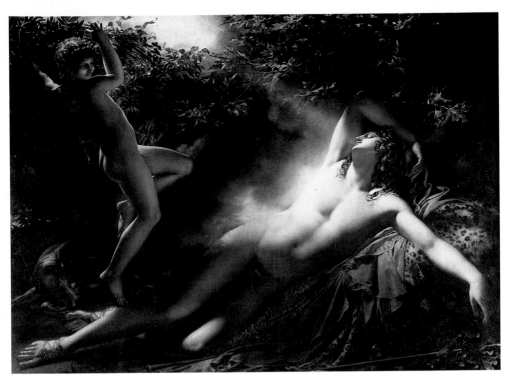

XV. Anne-Louis Girodet: *Sleep of Endymion*, 1791 (Paris, Musée du Louvre)

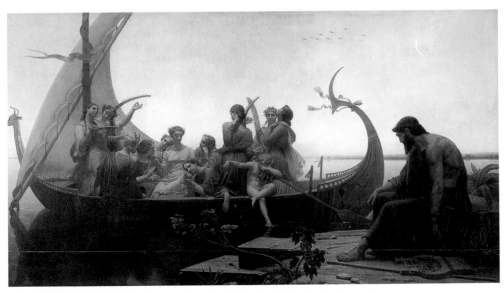

XVI. Charles Gleyre: *Evening* or *Lost Illusions*, 1843 (Paris, Musée du Louvre)

XVII. J. J. Granville: *The Wolf and the Lamb; The Cricket and the Ant; The Rat of the City and the Rat of the Country;* illustration from *The Fables of Jean de la Fontaine*, edition of 1887 (Paris, Bibliothèque Nationale)

XVIII. Antoine-Jean Gros: *Bonaparte Visiting the Victims of the Plague at Jaffa, 11 March 1799*, 1804 (Paris, Musée du Louvre)

XIX. Pierre Guérin: *Clytemnestra Hesitating before Stabbing the Sleeping Agamemnon*, exh. Salon 1817 (Paris, Musée du Louvre)

XX. François-Joseph Heim: *Charles X Distributing Prizes after the Salon of 1824*, 1825 (Paris, Musée du Louvre)

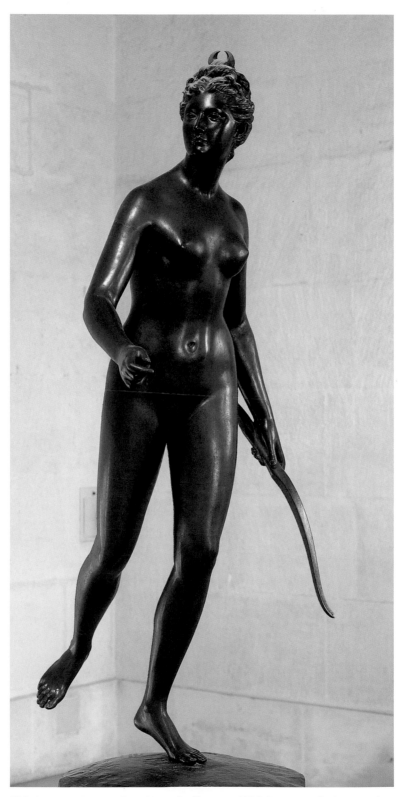

XXI. Jean-Antoine Houdon: *Diana the Huntress*, 1790 (Paris, Musée du Louvre)

XXII. Jean-Auguste-Dominique Ingres: *Vow of Louis XIII*, 1824 (Montauban Cathedral)

XXIII. Guillaume Lethière: *Peace Treaty of Leoben, signed on 18 April, 1797*, 1806 (Versailles, Château)

XXIV. Prosper Marilhat: *Syrian Arabs on a Journey,* 1844 (Chantilly, Musée Condé, Château de Chantilly)

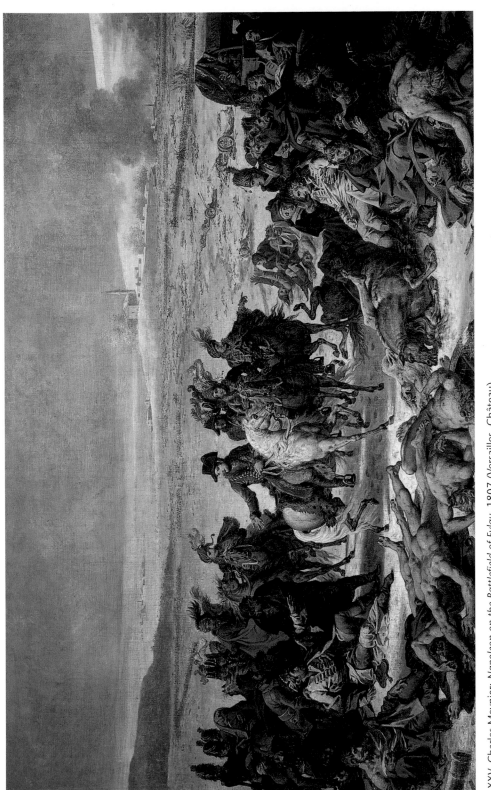

XXV. Charles Meynier: *Napoleon on the Battlefield of Eylau*, 1807 (Versailles, Château)

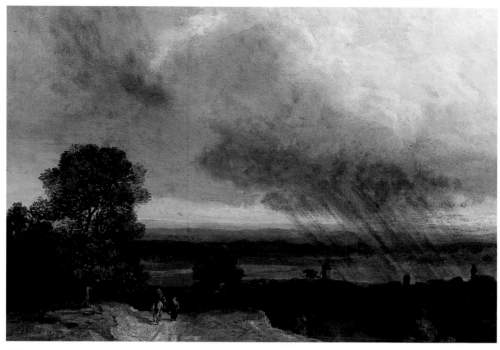

XXVI. Georges Michel: *Landscape outside Paris,* after 1830 (Lille, Musée des Beaux-Arts)

XXVII. James Pradier: *Sappho,* exh. Salon 1852 (Paris, Musée d'Orsay)

XXVIII. Pierre-Paul Prud'hon: *Justice and Divine Vengeance Pursuing Crime*, exh. Salon 1808 (Paris, Musée du Louvre)

XXIX. Pierre-Joseph Redouté: *The Thory Rose (Rosa centifolia bullata)* from *Les Roses* (Paris, 1817–24) (Paris, Bibiothèque du Musée National d'Histoire Naturelle)

XXX. Jean-Baptiste Regnault: *Three Graces*, 1794 (Paris, Musée du Louvre)

XXXI. Pierre Révoil: *Captivity of Joan of Arc* (Rouen, Musée des Beaux-Arts)

XXXII. Hubert Robert: *Imaginary View of the Grand Gallery of the Louvre in Ruins*, 1796 (Paris, Musée du Louvre)

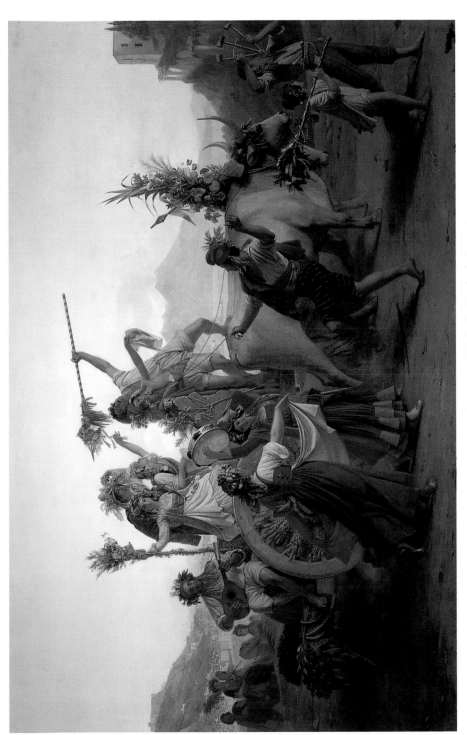

XXXIII. Léopold Robert: *Return from the Pilgrimage to the Virgin with a Bow*, 1827 (Paris, Musée du Louvre)

XXXIV. Théodore Rousseau: *Avenue of Chestnut–trees*, 1841 (Paris, Musée du Louvre)

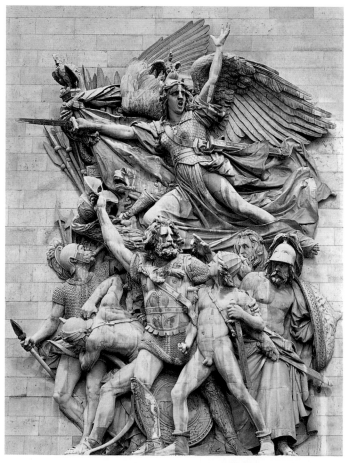

XXXV. François Rude: *'La Marseillaise'*, 1833–6 (Paris, Arc de Triomphe)

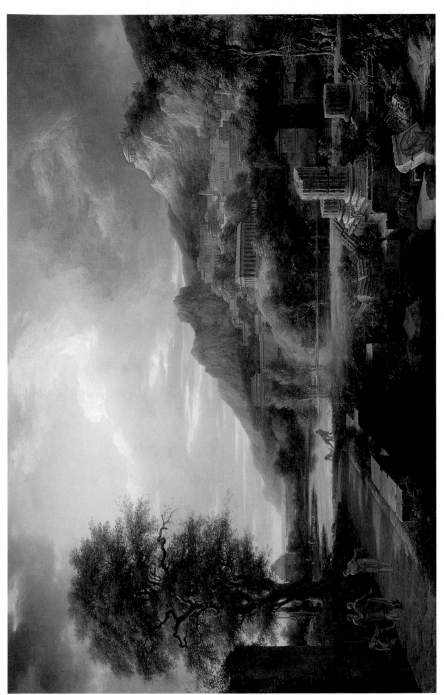

XXXVI. Pierre-Henri Valenciennes: *Ancient City of Agrigentum*, 1787 (Paris, Musée du Louvre)

XXXVII. Horace Vernet: *The Battle of Isly* (Paris, Musée des Arts d'Afrique et d'Oceanié)

XXXVIII. Joseph-Marie Vien, *Cupid Seller*, 1763 (Fontainebleau, Musée du Château de Fontainebleau)

XXXIX. Elisabeth-Louise Vigée Le Brun: *Madame Vigée Le Brun and her Daughter*, 1789 (Paris, Musée du Louvre)

XL. François-André Vincent: *Zeuxis Choosing the Most Beautiful Girls of Crotone as his Models*, 1789 (Paris, Musée du Louvre)

daily paper, *Le Charivari*, in 1832, Grandville contributed *c.* 100 designs, but after press censorship was reintroduced in 1835 and political subjects were forbidden, his contributions to *Le Charivari* became scarce. Of the team of illustrators at *La Caricature* and *Le Charivari*, he was, with Honoré Daumier and Joseph Traviès, the most politically committed, and his prints, which intermingle realism and fantasy for the sake of caricature, are among the most powerful published at that time, especially in defence of freedom of the press. In the *Resurrection of Censorship: 'And on the Third Day it rose again'* (1832) the Comte d'Argout, the government censor and a frequent victim of Grandville's attacks, is depicted ascending, like the risen Christ, from the tomb, clutching an enormous pair of scissors, while various newspaper editors sleep on unconcerned. Grandville's venom and fertile imagination were more distinctive than the style of his lithographs; he was more a draughtsman than a lithographer and preferred to have his drawings transferred on to stone by the specialized lithographers employed by Philipon such as Auguste Desperet (*d* 1865), Marie-Alexandre Menut-Alophe (1812–83), Joseph Traviès and Jacques Guiaud (1811–76). The largest collection of Grandville's original drawings is in the Musée des Beaux-Arts, Nancy.

After 1835 Grandville preferred to concentrate on book illustration, on which he had a profound effect; not only did he extend its repertory of subjects to include dream-like, imaginary scenes, but he also gave precedence to image over text, which became no more than an accessory or accompaniment. His later designs were usually reproduced in wood-engravings. In 1842 he published *Scènes de la vie privée et publique des animaux*, with a text by Balzac, and in the same year *Petites Misères de la vie humaine*. In the former he satirized contemporary society through portraits of its leading figures and types lightly disguised as animals and set in appropriate, if bizarre, contexts. Published in instalments from 1843 and together in 1844, his most important work is *Un Autre Monde*, a series of fantastic compositions around which his friend the *Charivari* journalist Taxile Delord (1815–77) wove an appropriate text, drawn up along lines indicated by Grandville himself. In this original and disturbing book Grandville abandoned the logic of the conscious mind to depict the world of dreams, in which perspective, viewpoint, shape and size undergo peculiar metamorphosis and distortion.

Grandville was also able to produce a more conventional style of illustration, for example for *Jérôme Paturot* (Paris, 1846) or in his *Don Quichotte de la Manche*, which was published in Tours in 1848 after his death. He was involved in illustrating *c.* 50 works, many of them literary classics by such authors as La Fontaine (Paris, 1838; see fig. 38 and col. pl. XVII), Daniel Defoe (Paris, 1840), Jean de La Bruyère (Paris, 1845) and Boccaccio (Paris, 1846). He returned to word and image games with the series *Animated Flowers* (1846–7) and *The Stars* (1849), a posthumous publication. A few days before his death he sent *Magasin pittoresque* two particularly fantastic and dream-like drawings, which were published in July 1847 and which well encapsulate the boldness of a visual imagination that anticipated the Surrealists. The writers André Breton and Georges Bataille saw him as a prophetic artist, and, although he shares something with the nonsense worlds of his contemporaries Edward Lear and Lewis Carroll, he really belongs to a later, post-Freudian age.

Bibliography

J. Adhémar and J. Lethève: *Inventaire du fonds français après 1800*, ix, Paris, Bib. N., Cab. Est. (Paris, 1955), pp. 326–43

P. Kaenel: 'Autour de J. J. Grandville: Les Conditions de production socio-professionnelles du livre illustré "romantique"', *Romantisme*, xliii (1984), pp. 45–61

A. Renonciat: *La Vie et l'oeuvre de J. J. Grandville* (Paris, 1985)

P. Kaenel: 'Le Buffon de l'humanité: La Zoologie politique de J. J. Grandville (1803–1847)', *Rev. A.* [Paris], lxxiv (1986), pp. 21–8

Grandville: Dessins originaux (exh. cat. by C. F. Getty and S. Guillaume; Nancy, Mus. B.-A.; Paris, Carnavalet; 1986–8)

The Charged Image: French Lithographic Caricature, 1816–1848 (exh. cat. by B. Farwell, Santa Barbara, Mus. A., CA, 1989)

MICHEL MELOT

39. François-Marius Granet: *Trinità dei Monti and Villa Medici*, 1808 (Paris, Musée du Louvre)

Granet, François-Marius

(*b* Aix-en-Provence, 17 Dec 1775; *d* Malvalat, 21 Nov 1849). French painter and museum official. The son of a master mason, he revealed an early talent for drawing in his copies of his father's collection of prints after François Boucher and Joseph Vernet. After studying with an unidentified Italian landscape painter, he became a pupil of J.-A. Constantin at the free drawing academy in Aix-en-Provence. One of his fellow pupils was Auguste de Forbin, the painter and future Director-General of the Musées Royaux. In 1793 Granet left Aix with the local Société Populaire to assist in the siege of Toulon. He worked as a draughtsman with the artillery battery; his autobiography provides a vivid account of his experiences during the siege

and destruction of the town. On a subsequent tour of duty he was employed to paint republican motifs on ships in the naval base at Toulon.

Granet made his first journey to Paris in 1796. He studied in the Louvre, where he was encouraged by Fragonard, and in his memoirs he recorded his admiration for works of the Dutch and Flemish schools, mentioning in particular how he copied the *Prodigal Son* by Teniers (1644; Paris, Louvre). He made some money by painting mural decorations, most notably in the apartments belonging to the Marquis de Senneval and, on a visit to Provence in 1797, in the Château de la Barben, which belonged to Forbin's brother. On his return to Paris in 1798 he joined Forbin as a pupil of Jacques-Louis David, but he was soon forced to leave

the studio because of lack of money. David's encouraging remarks to the young Provençal artist were recorded by Delécluze: 'This one will be a colourist; he likes chiaroscuro and beautiful effects of light'. Delécluze also noted that Granet associated with the 'aristocratic' group of painters from southern France in David's studio, including Fleury Richard and Pierre-Henri Révoil. Whereas the classical doctrines of David made little impact on Granet's work, his contact with these fellow pupils was crucial to his development; he shared their Catholic faith as well as their enthusiasm for medieval and royalist subjects.

Granet's first Salon success, the *Little Cloister of the Feuillants* (1799; untraced), an interior of a monastery in the Rue Saint-Honoré, Paris, marked the emergence of a theme that was to dominate

his work. According to Delécluze, Granet had been working for several years in the Capuchin monastery in the Rue de la Paix, with Gros, Ingres, Bartolini and Girodet painting in neighbouring cells. Granet observed that it was the study of Flemish art that had opened his eyes to the potential of his subject, although he was probably also influenced by the dramatic displays of medieval and Renaissance sculpture in Alexandre Lenoir's Musée des Monuments Français in the Petits-Augustins convent.

In 1802 Granet set out for Rome with Forbin, visiting Pisa, Siena and Florence en route. The French chargé d'affaires, François Cacault, introduced him to Cardinal Fesch, who became his patron, but during his first years in Rome he made a living selling picturesque views of ancient

40. François-Marius Granet: *Inquisition Scene* (Dunkirk, Musée des Beaux-Arts)

monuments (e.g. *Trinità dei Monti and Villa Medici*, 1808; Paris, Louvre; see fig. 39). His sketchbooks (Aix-en-Provence, Mus. Granet) contain numerous views of ruins and cloisters, and his first important canvas from Rome was the *Crypt of S Martino in Monte* (1802; Montpellier, Mus. Fabre). Granet remained in Rome until 1824, and during this time his working method became firmly established. The essential starting point was an awe-inspiring architectural motif, usually the interior of a church or monastery. A historical, literary or religious subject was then grafted on to his experience of the atmosphere and light effects of a particular site (e.g. *Inquisition Scene*; Dunkirk, Mus. B.-A.; see fig. 40). Describing this process in his autobiography, Granet recalled how the *Painter Stella in Prison* (exh. Salon 1810; Moscow, Pushkin Mus. F.A.) was inspired by a visit to the former prisons of the Capitol, which reminded him of a passage in Félibien's *Entretiens* about the false imprisonment of the painter Jacques Stella. Granet was able to gain access to the prisons, and the picture was produced on the spot with models posing for the main figures.

Granet's work is often described as repetitious, yet, although he tended to re-use certain compositional formulae, his feeling for dramatic chiaroscuro and his skilful articulation of massive architectural forms relieve his work from the anecdotal features associated with many other exponents of the Troubadour style. These qualities are particularly apparent in the painting that sealed his official success, the *Choir of the Capuchin Church in Rome* (1814; New York, Met.). Dominated by the elaborate perspective view of the vault, the monks are silhouetted against a strong central light source; through his sensitive depiction of light, Granet achieved a convincing harmony between figures and setting. Admired by Pius VII and Charles IV, the picture was bought off the easel by Caroline Murat, the Queen of Naples, who ceded it to her brother, Louis Bonaparte. Granet exhibited a larger version of this subject at the Salon of 1819 (probably the version in Cardiff, N. Mus.). The demand for this particular painting led Granet to produce at least 13 further variants (e.g. Buckingham Palace, Royal Col.), and his success

earned him the Cross of the Légion d'honneur (1819) and the ribbon of the Order of St Michael (1822). The compositional format of the *Choir of the Capuchin Church in Rome* formed the basis for another major work, the *Lower Church of the Basilica of S Francesco at Assisi* (exh. Salon 1822; Paris, Louvre). This was followed by a succession of paintings developing his melancholy monastic themes, which were exhibited regularly at the Salon. He also painted events in the lives of famous artists, including *Domenichino at the Villa of Cardinal Aldobrandini* (exh. Salon 1822; untraced) and *Poussin on his Deathbed Receives the Blessing of Cardinal Massimo* (exh. Salon 1834; first version, Aix-en-Provence, Mus. Granet).

A rigorous study of nature remained the basis for Granet's work. Throughout his career he produced a large number of landscape sketches; many of these were painted on his travels through Italy (he was particularly attracted to Assisi and the Roman Campagna) and, after 1824, in the Ile de France and the countryside around Aix (e.g. *Montagne Sainte-Victoire*; Aix-en-Provence, Mus. Granet). Working in oils or watercolour on paper he developed an accomplished and fluid style, simplifying the forms of the landscape and capturing subtle effects of outdoor light. These landscapes are among his most successful achievements.

In 1826 Forbin offered Granet a post as a curator at the Louvre. He was elected to the Institut in 1830 and in 1833 was appointed curator of Louis-Philippe's newly established Musée Historique at Versailles. For this museum, Granet was commissioned to paint a number of works depicting contemporary events, including *Louis-Philippe Bestowing the Biretta to Cardinal de Cheverus in the Chapel of the Tuileries, 10 March 1836* (exh. Salon 1837; Versailles, Château). In spite of his continued official recognition in the 1830s, Granet's work was no longer fashionable and his Salon submissions attracted little attention. He became an isolated figure, cutting himself off from all but his closest friends; he later observed that his pictures had a 'sad character which repels the men of our era'. Following the death of his wife in 1847 Granet returned to his property, 'Le Malvallat', at Malvalat near Aix. He decided to

retire there after the Revolution of 1848, and he died the following year. Granet had been nominated an honorary Director of the Musée d'Aix in 1844 and, apart from 199 drawings that were bequeathed to the Louvre, he left his studio and collection, totalling more than 500 works, to this museum, since known as the Musée Granet.

Writings

'Vie de Granet', Le Temps (28 Sept–28 Oct 1872) [posth. pubd autobiography; MS., Aix-en-Provence, Mus. Arbaud; Eng. trans. in 1988–9 exh. cat.]

Bibliography

A. de la Fizelière: Granet (Paris, n.d.)

E.-J. Delécluze: Louis David: Son école & son temps (Paris, 1855)

H. Gibert: Catalogue du Musée d'Aix (Aix-en-Provence, 1862)

H. Pontier: Musée d'Aix comprenant le Musée Granet (Aix-en-Provence, 1900)

E. Ripert: François-Marius Granet, 1775–1849: Peintre d'Aix et d'Assise (Paris, 1937)

François-Marius Granet (exh. cat., Nice, Gal. Ponchettes, 1970)

De David à Delacroix: La Peinture française de 1775 à 1830 (exh. cat., Paris, Grand Pal., 1974), pp. 454–6

Granet: Paysages de l'Ile de France, aquarelles et dessins dans les collections du Musée Granet (exh. cat., Aix-en-Provence, Mus. Granet, 1984)

F. Pupil: Le Style Troubadour ou la nostalgie du bon vieux temps (Nancy, 1985)

Granet: Paysages de Provence (exh. cat., Aix-en-Provence, Mus. Granet, 1988)

François-Marius Granet: Watercolours from the Musée Granet at Aix-en-Provence (exh. cat., New York, Frick, 1988–9)

I. N. Daguerre and D. Coutagne: Granet, peintre de Rome (Aix-en-Provence, 1992)

JOHN LEIGHTON

Greuze, Jean-Baptiste

(b Tournus, 21 Aug 1725; d Paris, 21 March 1805). French painter and draughtsman. He was named an associate member of the Académie Royale de Peinture et de Sculpture, Paris, in 1755 on the strength of a group of paintings that included genre scenes, portraits and studies of expressive heads (têtes d'expression). These remained the essential subjects of his art for the next 50 years, except for a brief, concentrated and unsuccessful experiment with history painting in the late 1760s, which was to affect his later genre painting deeply. Though his art has often been compared with that of Jean-Siméon Chardin in particular and interpreted within the context of Neo-classicism in general, it stands so strikingly apart from the currents of its time that Greuze's accomplishments are best described, as they often were by the artist's contemporaries, as unique. He was greatly admired by connoisseurs, critics and the general public throughout most of his life. His pictures were in the collections of such noted connoisseurs as Ange-Laurent de La Live de Jully, Claude-Henri Watelet and Etienne-François, Duc de Choiseul. For a long period he was in particular favour with the critic Denis Diderot, who wrote about him in the Salon reviews that he published in Melchior Grimm's privately circulated Correspondance littéraire. His reputation declined towards the end of his life and through the early part of the 19th century, to be revived after 1850, when 18th-century painting returned to favour, by such critics as Théophile Thoré, Arsène Houssaye and, most notably, Edmond and Jules de Goncourt in their book L'Art du dix-huitième siècle. By the end of the century Greuze's work, especially his many variations on the Head of a Girl, fetched record prices, and his Broken Pitcher (Paris, Louvre) was one of the most popular paintings in the Louvre. The advent of modernism in the early decades of the 20th century totally obliterated Greuze's reputation. It was only in the 1970s, with Brookner's monograph, Munhall's first comprehensive exhibition of the artist's work, increased sale prices, important museum acquisitions and fresh analyses of his art by young historians, that Greuze began to regain the important place that he merits in the history of French art of the 18th century.

1. Life and work

(i) Training and early years, to 1755. Greuze was the sixth of nine children of a roofer (whom the artist would later describe as an architect and property

developer) named Jean-Louis Greuze (1697–1769) and his wife, Claudine Roch. He was baptized Jean Greuze. Although he later signed his portrait of the model *Joseph* (Paris, Louvre) *J. Greuze* and affixed the initials *J. G.* to his *Filial Piety* (St Petersburg, Hermitage), in the mid-1750s he adopted the name Jean-Baptiste, by which he is generally known.

According to tradition, Greuze's talents were so developed by the age of eight that he was able to deceive his father into believing that the drawing he had executed for him after an engraving was a print. Surviving versions of a *Portrait of an Old Woman* (priv. col., see 1976–7 exh. cat., no. 1) and a canvas depicting *St Francis in Ecstasy* (Tournus, La Madeleine) suggest that Greuze had some sort of training in his home town and began painting there. In the late 1740s he went to Lyon, where he studied with Charles Grandon (*c.* 1691–1762), a successful portrait painter. Around 1750 the latter went to Paris to join his son-in-law, the composer André Grétry, and it was probably in his mentor's company that Greuze arrived in the capital. There he studied drawing at the Académie Royale with Charles-Joseph Natoire and, according to Melchior Grimm, painted small pictures to make a living. One of these may be a *Triumph of Galatea* (Aix-en-Provence, Mus. Granet) in the style of François Boucher. Greuze won the favour of the sculptor Jean-Baptiste Pigalle and of the painter Louis de Silvestre, who had been named director of the Académie in 1752. Supported by Pigalle, the young artist presented some of his work to the Académie, including the *Family Bible Reading* (Paris, Hottinguer priv. col., see 1976–7 exh. cat., no. 2), and executed in public a brilliant portrait of *Silvestre* (Munich, Alte Pin.) to dispel rumours that some of his work had been done by others. On the strength of what he showed, Greuze was named an associate member (*agréé*) of the Académie on 28 June 1755, in the category of 'peintre de genre particulier'. The records of the event noted that '. . . Greuze will go to the director, who will tell him what he should do for his reception piece'. He did not, however, present his *morceau de réception* for another 14 years.

Later in 1755 Greuze exhibited at the Salon for the first time. Critics, while remarking on the Dutch character of his art and of the resemblances to the paintings of Chardin, hailed 'the new athlete' with enthusiasm. But despite the acclaim, regrets were expressed over such a talented 'young man' (he was already 30 years old) devoting himself to lowly genre subjects. Nevertheless, the popular *Family Bible Reading* was acquired, along with two other canvases, by La Live de Jully.

(ii) **The Italian journey, 1755–7.** On 22 September 1755, not long after the closing of the Salon, Greuze left Paris for Italy as the guest of Louis Gougenot, Abbé de Chezal-Benôit, a historian, theorist and collector whose acquaintance Greuze had made probably through Pigalle. Greuze later claimed that he had paid his own expenses throughout the trip. However, Gougenot noted in his travel-journal—illustrated with watercolours by Greuze (Paris, Soucy priv. col.)—that after a friend had abruptly declined to travel with him 'I proposed to M. Greuze . . . to accompany me, covering all his expenses throughout the trip. He accepted this offer as a piece of good luck.' Greuze painted a sympathetic portrait of *Gougenot* (Dijon, Mus. B.-A.) that was shown in 1757, but he had nothing to do with his patron following his return to Paris. After stopping to see his family in Tournus, where he would not return for many years, Greuze and Gougenot crossed the Alps in perilous conditions, visited monuments and collections in Turin, Genoa, Parma, Modena, Bologna and Florence, and arrived in Rome on 28 January 1756, having previously visited Naples. In Rome, Gougenot was at a loose end when Greuze threw himself into his work, but he patiently paid for the artist's materials as well as for the models whom Greuze hired and dismissed on erratic whims. Gougenot finally set off alone for Paris four months later, Greuze declaring that he wished to remain in Italy, in order—according to the Abbé Jean-Jacques Barthélémy—to profit from the 'piquant riches of the sites and ruins of Rome' and from the example of the paintings of Raphael, which 'might enable him to rise above himself'.

From Versailles, the Marquis de Marigny, Louis XV's Surintendant des Bâtiments, sent instructions that Greuze should be given lodgings and working space in the Palazzo Mancini, home of the Académie de France in Rome, and commissioned two paintings from him for the Marquise de Pompadour, his sister. Instead of responding to Marigny's generous and flattering offer, Greuze put off executing the commissions until long after his return to Paris; the works were *Simplicity* (1759; Fort Worth, TX, Kimbell A. Mus.) and *Young Shepherd Holding a Flower* (1761; Paris, Petit Pal.). Greuze was more concerned with completing the extraordinary set of paintings that he rushed back to Paris to exhibit at the Salon of 1757 as 'Four Pictures in Italian Costume': *Broken Eggs* (New York, Met.), *Neapolitan Gesture* (Worcester, MA, A. Mus.), *Indolence* (Hartford, CT, Wadsworth Atheneum) and *The Fowler* (Warsaw, N. Mus.). Employing the highly finished, minutely detailed execution he had learnt from looking at works by the Dutch masters in Paris, Greuze presented in these two sets of pendants—the first horizontal, the second vertical—theatrical evocations of contemporary Italian life, fraught with moral undertones and sardonic wit. Innocence and naivety are contrasted with sin and deceit in the first pair; sloth and lust are memorably conjured up in the second. In addition to painting these four major canvases in a period of 15 months, Greuze executed portraits, including those of the French ambassador to the Holy See, the *Comte de Stainville* (later the Duc de Choiseul) and of the *Comtesse de Stainville* (both untraced), and some figural compositions such as the *Neapolitan Sailor* (London, Wallace) as well as a great many drawings, including an ensemble depicting regional costumes that were later engraved by the Moitte family. He even found time for a romantic involvement with a member of the noble Pignatelli family. Jean-Honoré Fragonard, who was at the Académie at that time, called Greuze 'an amorous cherub'.

The effect of the Italian sojourn on Greuze's development continues to be debated. Sauerländer saw reminiscences of Michelangelo's *Ignudi* (Rome, Vatican, Sistine Chapel) in the pose of *The Fowler* and of the *Laokoon* (Rome, Vatican, Mus. Pio-Clementino) in the gesture of the son in the *Father's Curse* (Paris, Louvre); there is evidence that Greuze drew after antique sculpture (e.g. *Female Torso after the Antique*; U. Warsaw, Lib.), and a carefully depicted foliated capital appears in the foreground of *Neapolitan Gesture*. These amount, however, to no more than superficial ornaments on an artistic manner that Greuze had evolved earlier in France. Like his French contemporaries in Rome, Fragonard and Hubert Robert, Greuze was more interested in the picturesque details of contemporary life than in the august examples of the ancient past or the monuments of the Renaissance.

(iii) Success in France, 1757–65. On 27 April 1757 Natoire, then director of the Académie de France in Rome, informed Marigny that Greuze had left for Paris. His intention to visit Venice seems not to have been fulfilled. Always adept at self-promotion, Greuze must have felt that it was more important to show the products of his Italian trip at the Salon that summer than to study Titian or the work of his Venetian contemporaries. In Paris he exhibited over a dozen works, including the 'Four Pictures in Italian Costume', portraits of *Pigalle* (untraced) and of *Gougenot* (Dijon, Mus. B.-A.), and the Rembrandtesque and sombre *Boy with a Lessonbook* (Edinburgh, N.G.).

Soon after his return from Rome, Greuze became involved with Anne-Gabrielle Babuti (1732–after 1812), the beautiful and wealthy daughter of a Paris bookseller. After a tempestuous courtship they were married on 3 February 1759 at St Médard, the bride bringing Greuze a dowry of 10,000 livres. They had three daughters, one of whom died in infancy. Mme Greuze's flagrant infidelities and meddlings in her husband's affairs were to turn their marriage into a private nightmare and a public scandal. It was also in 1759 that Greuze befriended the German engraver and dealer Jean-Georges Wille, whose *Journal* provides valuable references to the artist. In 1763 he sat for one of Greuze's finest portraits (Paris, Mus. Jacquemart-André).

41. Jean-Baptiste Greuze: *Marriage Contract*, 1761 (Paris, Musée du Louvre)

Denis Diderot spoke of Greuze for the first time, and with a certain familiarity, in his *Salon* of 1759. The critic saw in Greuze's genre scenes the visual equivalent of his own sentimental dramas, an embodiment of his call for a new seriousness in painting and the perfect occasion for his own idiosyncratic criticism, which depended to a large degree upon the emotive power of a painting's subject-matter. Relations between the *philosophe* and the artist developed over the ten years from 1759, culminating in a separation: Diderot spoke of 'my friend Greuze' in 1761; two years later he addressed him as 'tu' and in 1763 he opened his long article on *Filial Piety* with the exclamation, 'That is really my man, that Greuze!'. By 1767, when relations between Greuze and Diderot had deteriorated (the latter was then referring to the former as 'my late friend Greuze'),

Diderot intervened with Catherine II to have her rescind her invitation to Greuze to come to Russia, using Mme Greuze as the reason.

If Greuze's showings at the Salon of 1759 appealed because of the exotic details of the Italian subjects, those of 1761 were devoted to themes of family life and depictions of idealized girls: *Silence!* (London, Buckingham Pal., Royal Col.), showing a nursing mother disciplining an unruly child, the *Wool Winder* (New York, Frick) and the *Sleeping Knitter* (San Marino, CA, Huntington Lib. & A.G.). Portrait subjects included several aristocrats, among them the artist's early patron, *Ange-Laurent de La Live de Jully* (Washington, DC, N.G.A.), shown playing a harp and surrounded by his avant-garde Neo-classical furniture. Critical reactions to these works were muted, Diderot saying merely, 'the Greuzes are

not marvellous this year'. Nevertheless, the Salon of 1761 brought Greuze phenomenal success with the *Marriage Contract* (Paris, Louvre; see fig. 41)—more familiarly known as *L'Accordée de village*—in which the artist alluded to a crucial detail of his own marriage two years earlier by showing an old father handing over a dowry to his timid son-in-law. Further portrait subjects among Greuze's 20 entries that year included the artist himself (untraced), his father-in-law *François Babuti* (Paris, David-Weill priv. col., see 1976–7 exh. cat., no. 26) and *Mme Greuze as a Vestal Virgin* (untraced). The *Marriage Contract*, painted on commission for Marigny, was the only work from the minister's collection to be acquired after his death by Louis XVI. It received a delirious popular and critical reception; even the demanding connoisseur Pierre-Jean Mariette pronounced it 'the painter's

masterpiece'. Greuze's reputation had reached its zenith. At the Salon of 1763 he provided what was interpreted as a dramatic sequel to the *Marriage Contract*: *Filial Piety* (St Petersburg, Hermitage), in which a paralysed old man is shown being cared for by several generations of loving family members. The picture drove Diderot, in an exceptionally long article, to announce that with it Greuze had created a new genre of painting, what he called 'moral painting', that would finally replace the artificialities of Boucher's tradition. Despite the critical acclaim, the high price Greuze set on the painting and its depressing subject-matter held up its sale for some time, until Catherine II of Russia purchased it in 1765. In that same year Greuze exhibited at the Salon the *Girl Weeping over her Dead Bird* (Edinburgh, N.G.), a pathetic subject inspired by Catullus that pro-

42. Jean-Baptiste Greuze: *Septimius Severus Reproaching Caracalla*, 1769 (Paris, Musée du Louvre)

voked from Diderot a celebrated text analysing it as a symbol of the loss of virginity. Portrait subjects included the collector *Claude-Henri Watelet* (Paris, Louvre), the sculptor *Jean-Jacques Caffiéri* (New York, Met.) and *Jean-Georges Wille* (Paris, Mus. Jacquemart-André).

(iv) The crisis of 1767–9. After several years of such professional success and relative happiness at home, Greuze's peace was disturbed in 1767 when he received a letter from Charles-Nicolas Cochin II, secretary of the Académie Royale, informing him that because he still had not presented his reception piece after 12 years (it was normally expected within six months after an artist was named an associate member), he would not be permitted to exhibit at the Salon that year. Cochin explained that his colleagues felt that such a highly regarded artist as Greuze ought to be an academician. Greuze's reply to Cochin's courteous letter was

later described by Diderot as 'a model of vanity and impertinence'.

Privately Greuze made the decision at this time to abandon genre painting and to enter the grand arena of history painting. He perhaps thought that his skills were equal to those of any of his contemporaries working in that field, or he realized that he could reach the highest posts and honours of the Académie only as a history painter. He also perhaps relished the idea of surprising everyone when he finally presented the long-awaited *morceau de réception*. For the next two years Greuze doubled his efforts. He undertook an unusual variety of religious and historical subjects, including *Lot and his Daughters* (Paris, Louvre), *Cimon and Pero* (Paris, Louvre; Cambridge, MA, Fogg), *Aegina Visited by Jupiter* (New York, Met.), *Vespasian and Sabinus* (Chaumont, Mus. Mon.), the *Funeral of Patroclus* (Paris, priv. col., see 1976–7 exh. cat., no. 66) and the *Death of Brutus* (Bayonne,

43. Jean-Baptiste Greuze: *Father's Curse*, c. 1777 (Paris, Musée du Louvre)

44. Jean-Baptiste Greuze: *Punished Son, c.* 1777 (Paris, Musée du Louvre)

Mus. Bonnat), a subject that Diderot had suggested to him. He made fresh studies from ancient sculpture and casts, and he looked at the example of Nicolas Poussin's paintings for guidance—both for composition and for a new painterly manner, flatter and matt. By the summer of 1767 Greuze had chosen the subject for his Académie painting, Septimius Severus rebuking his son Caracalla for having attempted to assassinate him, and had painted the first version of it (untraced) that Grimm and Diderot saw and admired. Writing to the sculptor Etienne-Maurice Falconet, the latter extolled Greuze's *tour de force* in changing genres and lauded the composition, with its 'broad, naked background, with so great a silence that it seems the voice of Septimius Severus reverberates in the emptiness of the apartment'. Two years later, however, Diderot described the final version of the picture as 'worth nothing'.

Diderot's reaction was echoed by Greuze's fellow members of the Académie Royale when he presented *Septimius Severus Reproaching Caracalla* (Paris, Louvre; see fig. 42) to them on 23 July 1769. After examining the picture with its unexpected, and unannounced, historical subject, and keenly aware of the artist's acerbic attitude towards them, his colleagues first voted to elect Greuze as an academician but then voted separately on his classification. In a majority of twenty-one to nine they received him 'with the same rights as his associateship, that is to say as a genre painter'. To humiliate him further, Greuze was

informed of this condition only after taking his oath of membership. Enraged, the artist initially sought to remove his painting but then left it there in the hope that he would be vindicated by the public who would view it shortly at the Salon. Unfortunately, his hopes were dashed, as *Septimius Severus* was greeted with an avalanche of negative criticism. The artist spoke back, in vain, in a letter published in the *Avant-Coureur* on 25 September. In vain, too, he attempted to resign from the Académie, but he did at least dissociate himself from the organization, not exhibiting at the Salon again until 1800. His only consolation lay in flight, so he returned to his native Tournus, where his father died on 10 October.

(v) Late years, after 1769. The remaining 36 years of Greuze's life were far from easy, but they saw a continual artistic growth, a deepening humanity in his outlook and a ceaseless daring in the face of adversity. While he did not exhibit at the Salons of the Académie, he occasionally attended its meetings when his vote could count, such as at that of 28 September 1770 concerning the admission of female members. His work appeared at the Salon de la Correspondance in 1779, 1782, 1783 and 1785, at the Salon de l'Encouragement des Arts in 1790, at the Société des Arts in Montpellier in 1779, and at the Salon des Arts in Lyon in 1786. More importantly, Greuze managed to embarrass the Académie and tease the critics by staging private exhibitions in his studio in the Louvre that coincided with the biennial Salons. Numerous distinguished foreigners made a point of visiting Greuze, including Gustav III of Sweden (1771), Joseph II of Austria (1777) and the Grand Duke Paul Petrovitch, son of Catherine II (1782). Greuze also publicized himself in the press, announcing the publications of the numerous reproductive engravings of his works by artists including Jean-Jacques Flipart, Carlo Antonio Porporati (1741–1816), Jean Massard, René Gaillard (d 1790) and Jean-Charles Le Vasseur. The sale of such prints brought the artist wealth, but his fortune was decimated by the onerous settlement he was obliged to give his wife at the time of their divorce in 1792.

In his late years Greuze executed a certain number of important works depicting scenes of contemporary life, in which he mixed realistic observation with the grand manner of history painting. These include the *Twelfth-night Cake* (1774; Montpellier, Mus. Fabre), the *Charitable Woman* (1775; Lyon, Mus. B.-A.) and the *Drunkard's Return* (c. 1780; Portland, OR, A. Mus.). The masterpieces of his old age, however, are the majestic pendants, the *Father's Curse* (Paris, Louvre; see fig. 43) and the *Punished Son* (Paris, Louvre; see fig. 44). In these the family discords that Greuze had known all his life are intensified to an expressionistic degree but at the same time elevated through the clarity and beauty of their formal presentation. Two important history paintings date from this period—*Innocence Carried Off by Cupid* (before 1786; Paris, Louvre) and *St Mary of Egypt* (c. 1800; Norfolk, VA, Chrysler Mus.)—as well as a great number of portraits and self-portraits (e.g. Paris, Louvre; Marseille, Mus. B.-A.), and many drawings.

Greuze's activities during the French Revolution remain obscure. He treated a very few Revolutionary subjects, but he did execute some notable portraits during those years, including that of *Jean-Nicolas Billaud-Varenne* (Dallas, TX, Mus. A.). During these difficult times the artist produced a quantity of versions of his ever-popular *Head of a Girl* and may even have sold some he knew he had never painted. These unfortunate productions continue to mar his reputation to this day. In 1793 he joined the Commune Générale des Arts, led by Jacques-Louis David and Jean-Bernard Restout. He certainly applauded the dissolution of the old Académie Royale, returning after its reorganization to exhibit at the Salons of 1800, 1801 and 1804. He died in his studio in the Louvre, still attended by his unmarried elder daughter, Anne-Geneviève (1762–1842), whom he called his Antigone. He is buried in the cemetery of Montmartre, Paris.

2. Working methods and technique

From his early *Family Bible Reading* to his late *Drunkard's Return*, Greuze's programme in developing a multi-figured composition remained the

same. He proceeded from rough compositional schemes to studies of individual figures, heads, hands and accessories. Few drawings for portraits are known, however, though the artist did execute some that were notable. He experimented only once with printmaking, preferring to turn over the production of reproductive engravings after his paintings to specialists. His earliest surviving works, such as the *Triumph of Galatea*, were painted in the manner of Boucher, with lush, fluid brushstrokes and a light palette. By 1755, when he dated his portrait of *Joseph* (Paris, Louvre), his debt to Rembrandt in his use of dark coloration and dramatic lighting was remarked upon by a contemporary. In his portraits Greuze continued to follow the manner of Rembrandt and of Anthony van Dyck, but many of his early figural compositions, such as the *Broken Eggs* or the *Wool Winder*, with their highly finished technique, recall the work of the popular 17th-century Dutch masters Gerrit Dou and Frans van Mieris (i). By the late 1760s, however, Greuze's study of Poussin led him to adopt a flatter, broader handling of form and a somewhat murky palette. In the 1780s he was employing panel supports for his portraits, with brilliant translucent effects. Despite his disdain for the study of anatomy, Greuze had a perfect innate knowledge of it, and anatomical faults are to be weighed carefully in pondering any Greuze attribution. He rarely signed his paintings.

Bibliography

D. Diderot: *Correspondance, 1741–84*; ed. G. Roth, 16 vols (Paris, 1955–70)

——: *Salons* (1759–81); ed. J. Adhémar and J. Seznec, 4 vols (Oxford, 1957–67, rev. 1983)

J.-G. Wille: *Journal* (1759–93); ed. G. Duplessis as part of *Mémoires et journal*, 2 vols (Paris, 1857)

E. de Goncourt and J. de Goncourt: *L'Art du dix-huitième siècle*, i (Paris, 1880), pp. 289–360

J. Martin and C. Masson: *Catalogue raisonné de l'oeuvre peint et dessiné de J.-B. Greuze* (Paris, 1908)

L. Hautecoeur: *Greuze* (Paris, 1913)

W. Sauerländer: 'Pathosfiguren im Oeuvre des Jean-Baptiste Greuze', *Walter Friedlaender zum 90. Geburtstag* (Berlin, 1965)

A. Brookner: *Greuze: The Rise and Fall of an Eighteenth-century Phenomenon* (London, 1972)

Jean-Baptiste Greuze, 1725–1805 (exh. cat. by E. Munhall, Hartford, CT, Wadsworth Atheneum; Dijon, Mus. B.-A.; 1976–7)

S. Laveissière: 'Jean-Baptiste Greuze', *Dictionnaire des artistes et ouvriers d'art de Bourgogne* (Paris, 1980)

E. Munhall: 'Jean-Baptiste Greuze', *Diderot et l'art de Boucher à David: Les Salons, 1759–1781* (exh. cat., ed. M.-C. Sahut and N. Volle; Paris, Hôtel de la Monnaie, 1984–5), pp. 217–67

EDGAR MUNHALL

Gros, Antoine-Jean, Baron

(*b* Paris, 16 March 1771; *d* Meudon, Hauts-de-Seine, 25 June 1835). French painter. He was one of the most honoured and respected painters during the reigns of Emperor Napoleon I, King Louis XVIII and King Charles X. For these monarchs he executed large paintings of contemporary history and allegory, although he was also known as a painter of mythological subjects and of portraits in a Romantic vein.

1. Paris and Italy, 1785–1800

He received his first lessons in drawing from his parents, the miniature painters Jean-Antoine Gros and Madeleine-Cécile Durand, who lived in the Rue Neuve-des-Petits Champs, in the commercial district of Paris popular with such painters. He also frequented the studio of Elisabeth-Louise Vigée Le Brun. However, his earliest paintings show no obvious trace of any influence prior to that of David, whose studio he entered as a pupil in 1785. At this time, inspired by his visits to the race-course in the Bois de Boulogne, he developed his lifelong passion for drawing horses. In 1787 he entered the Académie Royale de Peinture et de Sculpture and progressed steadily through the competitions, winning the Prix de Torse in 1791 and becoming a final competitor for the Prix de Rome in 1792 with *Antiochus Attempting to Prevent Eleazar from Eating an Impure Dish* (Saint-Lô, Mus. B.-A.). *Bather* (Besançon, Mus. B.-A. & Archéol.), executed as a pupil of David, is usually dated to this period as well because of the academic style of the figures, although there is a strong naturalism akin to Rubens that makes it unusual

for its time. Gros's formal education ended in 1793, due to the bankruptcy and death of his father, and, like other artists in the tumult of the French Revolution, he turned to portrait painting for an income. In January 1793 he left for Italy, having obtained a passport issued at the request of David. Augustin Pajou, whom he had met through Vigée-Le Brun, accompanied him part way and introduced him to contacts in Montpellier, where he paused long enough to paint two portraits (e.g. *Paul François des Hours de Calviac*, 1793; Lyon, priv. col., see G. Delestre, pl. 3) before continuing by way of Marseille and Genoa to Florence. Again Gros supported himself by painting portraits and by giving lessons to the writer Count Niemcewicz, who remained a lifelong friend and patron and through whom Gros met other Polish exiles. He probably intended to go to Rome, but with the uprising there in 1793 against the French and the closing of the Académie de France, it was not a secure city for French artists. He therefore returned to Genoa, where, for a time, he shared lodgings with Anne-Louis Girodet. Before Girodet left for France, the two artists painted portraits of each other (both Versailles, Château) and exchanged them as tokens of friendship. In 1796 in Genoa, Gros was introduced to Josephine, who had heard of his skill in painting horses and his desire to paint a portrait of Napoleon to commemorate his victories. That year he met Bonaparte in Milan and painted a lively head-and-shoulders study (Paris, Louvre), which was used as a model for his portrait of *Bonaparte on the Bridge at Arcole, 17 November 1796* (1801; Versailles, Château). The success of this work established his reputation among Napoleon's occupying forces in Italy, resulting in further commissions for portraits and a position on the committee set up to inspect works of art from the conquered cities of Italy and to remove them to the Musée du Louvre. This period of relative security ended abruptly when Napoleon left on his Egyptian campaign, and Gros was confined in Genoa for two months because of the Austrian siege. After the evacuation of the city, he returned to Paris in October 1800.

Even before the siege, Gros had been restless to return home. He was aware of the revival of painting in France after the disasters of the French Revolution and wanted to move away from portraits into more ambitious subject-matter. Turning to history painting, he looked to the Classical world for possible subjects. His interest in horses made him think of painting *Alexander Taming Bucephalus* (sketch, Paris, priv. col., see G. Delestre, pl. 21). He then considered a subject from the poetry of Ossian, sketched a composition from ancient Greek history (*Timoleon at Corinth*, 1798; Paris, Louvre, Cab. Dessins).

2. First Empire and Restoration commissions, 1801–20

On his return to Paris, Gros painted *Sappho at Leucadia* (Bayeux, Mus. Gérard). In this work, lit by eerie, greenish moonlight, he depicted Sappho throwing herself from the top of a cliff. Despite its bizarre colour, critics were impressed by the painting when it appeared at the Salon of 1801. Its strong light effects, sharp contours and the melancholy subject link it to paintings by Girodet and other pupils of David, and it would probably have been the type of picture that Gros would have continued to paint during the First Empire had he not been drawn into Napoleon's propagandist programme of painting contemporary events. On 25 April 1799 Napoleon had announced a competition for a painting to celebrate the victory of General Andoche Junot against the vastly superior forces of the Turks and Arabs 17 days earlier at Nazareth. In March 1801 the conditions for the competition were published, and in December a jury unanimously awarded the prize to Gros on the basis of his sketch (Nantes, Mus. B.-A.), a tumultuous panorama painted with lively brushstrokes that reminded some of his contemporaries of the Rococo style. The sketch was intended as a preliminary work for a large painting, over 8 m long, of the Battle of Nazareth, but the project was halted by Napoleon, who appeared to have had second thoughts about honouring Junot. By way of compensation, Gros received a commission to paint a picture recording the fearless encouragement given by Napoleon to his staff to assist the victims of the plague at Jaffa during the Syrian campaign in 1799. Using a fragment of the canvas

45. Antoine-Jean Gros: *Christine Boyer*, 1800 (Paris, Musée du Louvre)

intended for the *Battle of Nazareth*, Gros painted *Bonaparte Visiting the Victims of the Plague at Jaffa, 11 March 1799* (1804; Paris, Louvre; see col. pl. XVIII) in time for the Salon of 1804, where it had an overwhelming success with his fellow artists, the critics and the public. Unlike the episodic *Battle of Nazareth*, the painting is tightly organized in the manner of David's work, with Napoleon occupying the central position. Gros, however, added a vivacity of colour and a naturalism not commonly found in the work of other history painters at that time. In 1806 he received a commission from Joachim Murat, Napoleon's brother-in-law, to paint the *Battle of Aboukir* (Versailles, Château). For this work he used another portion of the canvas that had originally

been intended for the *Battle of Nazareth*, and for the figure of Junot on a rearing horse he substituted that of Murat, swinging his sabre in the midst of the battle.

The Battle of Eylau, in Silesia, took place on 8 February 1807 between the combined forces of Russia and Prussia and those of France. Two months later, Napoleon, then Emperor, announced a competition to commemorate not the battle itself but the appalling aftermath when, lamenting the extent of the casualties, he brought medical aid to the wounded Russian soldiers. Gros won the competition with his painting *Napoleon on the Battlefield at Eylau, February 1807* (1808; Paris, Louvre), in which he emphasized the presence of the Emperor on the battlefield the day after the fighting and the role of the French in attending to the wounded Russians, who are prominently displayed in the foreground. The competition was intended to provide evidence of the French victory (which was not certain) and, as in *Bonaparte Visiting the Victims of the Plague at Jaffa*, to establish the reputation of the Emperor as a humane conqueror. Gros adapted a print of *Henry IV* by Gravelot for the central motif of his composition, linking the reputation of the Bourbon monarch as the father of his people with the myth of Napoleon (Herbert, pp. 52–75). When it appeared at the Salon of 1808, the painting confirmed Gros's reputation and led to a further series of paintings celebrating the Emperor's military career: the *Capture of Madrid*, the *Battle of the Pyramids*, both shown at the Salon of 1808, and the *Battle of Wagram* shown at the Salon of 1810 (all Versailles, Château). None of these quite equalled the huge successes of his earlier paintings, but they reinforced his position as the most effective painter of imperial propaganda and as one of the leading painters of the period.

During the Empire, Gros was constantly employed in painting portraits of imperial society and, in particular, of the military. He was clearly familiar with the work of such 18th-century English portrait painters as Reynolds and Gainsborough, whose poses inspired that of *Lieutenant Legrand* (1810; Los Angeles, CA, Co. Mus. A.), in which the figure stands cross-legged beside

his horse. The elegiac mood in the portrait of the first wife of Lucien Bonaparte, *Christine Boyer* (1800; Paris, Louvre; see fig. 45), also owes something to English portraiture: the woman gazes at a rose carried along by a stream through wild parkland. The painting has a literary and melancholic element, common to French painting of *c.* 1800–20.

Gros's role as Napoleon's propagandist brought him two commissions outside his normal range. Following the Concordat (1801), the Saint-Denis Abbey was refurbished, and there was to be a series of paintings for the reconsecrated sacristy. The restitution of the abbey, in which many of the kings of France were buried, marked an act of reconciliation between the Emperor and past and present royal dynasties, and this is depicted allusively in *Charles V Received by Francis I at the Abbey of Saint-Denis (1540)* (1811; Paris, Louvre). In the painting the two monarchs lay aside their former hostilities and visit the royal tombs at Saint-Denis.

This theme was treated more ambitiously in 1812, when Gros was commissioned to paint images of *Clovis*, *Charlemagne*, *Louix IX* and *Napoleon*, representing four dynasties, for the central cupola of the Panthéon. He worked on the frescoes (*in situ*) from 1814, when the Bourbons were restored to the throne. At this time he was ordered to substitute *Louis XVIII* in place of *Napoleon*. During the Hundred Days (1815), he restored the image of Napoleon to the cupola, but when the French leader was defeated at Waterloo, Gros was asked to reinstall the painting of *Louis XVIII*. Although his paintings celebrating the achievements of Napoleon were removed from public exhibition during the Restoration, he was nevertheless the most honoured painter in France. In 1814 he was appointed Portrait Painter to Louis XVIII, and in 1815 he was given a seat in the Institut de France. In 1819 he was made Chevalier of the Order of St Michel and later, in 1828, Officer of the Légion d'honneur. He received many commissions from Louis XVIII, among them the *Departure of Louis XVIII from the Tuileries on the Night of 19–20 March, 1815* (1816; Versailles, Château), painted to

46. Antoine-Jean Gros: *Hercules and Diomedes*, 1835 (Toulouse, Musée des Augustins)

commemorate the King's flight from Paris. The *Embarkation of the Duchesse d'Angoulême at Pauillac* (1819; Bordeaux, Mus. B.-A.) was commissioned by the Chambre des Députés as a pendant to the *Departure of Louis XVIII*. Both were rare excursions by the artist after 1815 into the field of contemporary history.

3. Mythological paintings and late works, 1821–35

David went into exile in 1816, and Gros subsequently taught many of his pupils and, like David, was successful in preparing them for the Prix de Rome. In his own work, the depiction of academic figures assumed renewed importance, and he rejected themes from modern life in favour of paintings based on ancient myths. He exhibited *Bacchus Consoling Ariadne on the Island of Naxos* (1821; Ottawa, N.G.) at the Salon of 1822, and *Cupid Stung by a Bee* (Toulouse, Mus. Augustins) at the Salon of 1833. In *Acis and Galatea* (Norfolk, VA, Chrysler Mus.), shown at the Salon of 1835,

there is a strong debt to the academic figure painting he taught in his life classes: the figure of Acis is based on the antique statue of the *Crouching Venus* (Florence, Uffizi). In 1824 he finally completed the series of frescoes for the cupola of the Panthéon, for which he was made Baron by Charles X. In 1827 he painted the allegory *Charles X Presenting the New Museum to the Arts* (removed in 1830; Versailles, Château) on the ceiling of one of the rooms in the Musée Charles X, a recently completed part of the Louvre. He also executed a large painting for the ceiling of the Musée des Antiquités Egyptiennes depicting *Humanity Imploring Europe in Favour of the Greeks: The Genius of France Thrusting Forward to Protect them* (1830; *in situ*). This was a topical subject, referring to the Greek War of Independence (1821–9) and the wave of philhellenism that drew French sympathies to the Greek side.

Gros's contemporaries were generally disappointed with these late works. It is doubtful that they would have been admired at any time, but in the late 1820s and 1830s they were, in addition, unfashionable. His paintings of Napoleon, which were shown again to the public during the July Revolution of 1830, reminded critics of his earlier talent for evoking the heroism of modern times. Despite the fact that his paintings were given positions of honour at Versailles in the Musée Historique, established by Louis-Philippe, he was reluctant to return to his former subject-matter. In 1835 he agreed to add strips (Cleveland, OH, Mus. A.) to enlarge the *Battle of the Pyramids* but refused to paint a scene of the Battle of Iena for the new museum. Perhaps sensing that he had sacrificed too much of his natural talent in painting characterless depictions of the human figure, he composed *Hercules and Diomedes* (1835; Toulouse, Mus. Augustins; see fig. 46), a large picture with a subject more in keeping with the Rubensian vigour of his earlier work and with the talent he had for painting horses. He sent it, along with *Acis and Galatea*, to the Salon of 1835. At best the critics were mildly appreciative. On 25 June 1835 he drowned himself in the River Seine. At the time, it was said that he did so because of his

failure at the Salon, but contemporaries also hinted at domestic difficulties. His marriage in 1809 to the painter Augustine Dufresne (1789–1842), who was 18 years younger than he, had not been a happy one.

4. Influence

Although nothing Gros painted in the last 20 years of his life left any lasting mark on French art, he was one of the most influential artists of the 19th century, primarily for the Romantic tendencies in his work that inspired younger painters and sculptors. Apart from teaching a generation of pupils that included Richard Parkes Bonington, Paul Huet, Antoine-Louis Barye, Paul Delaroche and Thomas Couture, he was admired by many younger artists who worked in other studios. Delacroix was profoundly affected by Gros's early work, despite his belief that modern life offered little to inspire the artist. Géricault, however, who had made his public début ten years earlier than Delacroix, when the Empire was at its height, assimilated Gros's talent for endowing modern subjects with the timeless pathos of ancient drama, particularly when the subject-matter had as its main theme the power and passion of the horse in motion.

Bibliography

J. B. Delestre: *Gros et ses ouvrages* (Paris, 1845); rev. as *Gros: Sa vie et ses ouvrages* (Paris, 1867)

E. Delacroix: 'Peintres et sculpteurs modernes, III: Gros', *Rev. Deux Mondes*, xxiii (1848), pp. 649–73; also in *Oeuvres littéraires*, 2 vols, ed. E. Fauré (Paris, 1923), pp. 163–200

E.-J. Delécluze: *David, son école et son temps* (Paris, 1855/R 1983)

C. Blanc: *Histoire des peintres: Ecole française*, iii (Paris, 1865), pp. 1–32

J. Tripier-Lefranc: *Histoire de la vie et de la mort du baron Gros* (Paris, 1880)

G. Dargenty: *Le Baron Gros*, Les Artistes célèbres (Paris and London, 1887) [trilingual text]

Gros, ses amis, ses élèves (exh. cat., intro. Duc de Trévise; Paris, Petit Pal., 1936)

G. Delestre: *Antoine-Jean Gros, 1771–1835*, Col. Maîtres A. (Paris, 1951)

R. Herbert: 'Baron Gros's *Napoleon* and Voltaire's *Henri IV*, *The Artist and the Book in France: Essays in*

Honour of Jean Seznec, ed. F. Haskell, A. Levi and
R. Shackleton (Oxford, 1974), pp. 52–75

C. Millard: 'Baron Gros's *Portrait of Lieutenant Legrand*',
Bull. LA Co. Mus. A., xx/2 (1974), pp. 36–45

C. Sells: 'The Death of Gros', *Burl. Mag.*, cxvi (1974),
pp. 266–70

J. H. Rubin: 'La Sépulture romantique de Christine Boyer
et son portrait par Antoine-Jean Gros', *Rev. Louvre*
(1975), pp. 17–22

——: 'Gros and Girodet', *Burl. Mag.*, cxxi (1979), pp. 716–21

E. Lilley: 'Consular Portraits of Napoléon Bonaparte', *Gaz.
B.-A.*, n. s. 5, cvi (1985), pp. 143–56

A. Boime: *Art in an Age of Bonapartism, 1800–1815,
A Social History of Modern Art*, ii (Chicago, 1990),
pp. 3–95, 300–02

JON WHITELEY

Gudin, (Jean-Antoine-)Théodore, Baron

(*b* Paris, 15 Aug 1802; *d* Boulogne-sur-Seine, 12
April 1880). French painter and printmaker. He
studied under Anne-Louis Girodet and Antoine-
Jean Gros at the Ecole des Beaux-Arts in Paris,
which he entered on 30 January 1817. With the
emergence of the Romantic movement he inter-
rupted his Neo-classical training to become a dis-
ciple and friend of Delacroix and Gericault. Like
Delacroix, he first exhibited at the Salon in 1822,
and his submission included the depiction of an
eminently Romantic subject, *Episodes from a
Shipwreck* (sold, Paris, 7 Dec 1973). However, his
greatest success of the 1820s, which established
him as a marine painter, was the *Fire on the Kent*,
which he exhibited at the Salon of 1827. Following
this direction he cultivated his talent for histori-
cal naval subjects on a large scale, becoming
France's leading painter of sea battles. His style is
characterized by the faithful rendering of water,
the use of impasto and the careful execution
of motifs.

From the beginning of his career Gudin's work
was appreciated by both the public and the critics,
and he received numerous state, royal and private
commissions, becoming a baron under Louis-
Philippe. He sold his paintings to the most
eminent members of French society, such as the
Baron de Rothschild, as well as to such foreign sov-
ereigns as King Leopold I of Belgium and the Tsar.

Gudin participated in many military expeditions.
He was appointed an official artist to the Algerian
expedition in 1830 and returned with many paint-
ings that he exhibited at the Salon from 1831
onwards, such as *Hurricane at the Roadstead of
Algiers, 7 January 1831* (1835; Paris, Louvre). He
also painted other military subjects that glorified
French valour, particularly French naval victories
over the British. During the 1830s Louis-Philippe
commissioned Gudin to paint 97 large scenes illus-
trating the most glorious episodes of French naval
history to decorate the galleries at Versailles, 41
of which were shown at the Salon between 1839
and 1848. To this commission belong such works
as *Capture of the English Corvette 'Le Vimiejo' by
a Section of the Imperial Flotilla, 8 May 1804* and
Battle of Chio in 1681 (both Versailles, Château).
This project seems to have drained his inspiration
as from then on his work became very repetitive.
In 1841 Gudin was commissioned by Tsar Nicholas
I (*reg* 1825–55) to paint the ports of Russia and
visited Warsaw and St Petersburg.

From the late 1840s into the 1860s Gudin con-
tinued to paint historical subjects while also pro-
ducing some genre scenes, such as a *Scottish
Hunting Party* (exh. Salon 1849). He also enjoyed
the patronage of Napoleon III whom he joined on
his campaigns to Italy and Algeria. Among the
commissions from Napoleon III was the *Arrival of
the Queen of England at Cherbourg* (exh. Salon
1861). After the Franco-Prussian War of 1870–71
Gudin retired to Scotland, where he raised money
to support his wounded compatriots. As well as
Paris, Gudin exhibited his work in London, and
his paintings appeared intermittently at the Royal
Academy between 1837 and 1873 and at the British
Institution. In London he understandably showed
his coastal scenes (e.g. *Dutch Coastal Scene*, 1846;
London, Wallace) rather than his historical paint-
ings. He also produced illustrations for such books
as Eugène Sue's *Histoire de la marine française*
(1835) and Mme de Staël's *Corinne ou l'Italie*
(1841–2).

Writings
E. Beraud, ed.: *Baron Gudin: Souvenirs, 1820–70* (Paris,
1921)

Bibliography

Bellier de La Chavignerie–Auvray; *DBF*

Inventaire du fonds français après 1800, Paris, Bib. N.,
 Dépt. Est. cat., ix (Paris, 1960), pp. 442–4

E. H. H. Archibald: *Dictionary of Sea Painters* (Woodbridge,
 1980, 2/1989)

ATHENA S. E. LEOUSSI

Guérin, (Jean-Baptiste-)Paulin

(*b* Toulon, 24 March 1783; *d* Paris, 16 Jan 1855).
French painter. He was the son of a locksmith who
fled from Toulon, which was in revolt against
Jacobin rule, to Marseille in 1793. Although
intended to follow his father, Guérin decided at 13
to study drawing, attending the Ecole des
Bernardines, which had opened in Marseille in
1793. There he met Augustin Aubert (1781–1857),
who became his adviser and lifelong friend. Guérin
went to Paris in October 1802 and for about ten
years lived in poverty and isolation, executing a
number of self-portraits as he could not afford mod-
els (e.g. *Self-portrait*, 1804; Toulon, Mus. Toulon).
In 1805 he was admitted as an apprentice to the
studio of François- André Vincent where he met
Auguste Heim and Horace Vernet. Although his
studies under Vincent were free, he had to leave in
order to provide money for his family in Marseille.
He became a full-time assistant to François Gérard,
painting accessories and drapery in his portraits.

In 1810 Guérin exhibited his first portraits at the
Salon in Paris, and in 1812 he showed his first large
composition there, *Cain after the Death of Abel*
(Toulon, Mus. Toulon), which was critically
acclaimed. Auguste, Comte de Forbin, became a
friend and protector, obtaining portrait commis-
sions for Guérin and employing him at Versailles.
Guérin married his niece Maria, and, financially
secure at last, began a series of history paintings
and portraits, including *Louis XVIII* (1819) and
Charles X (1827; Toulon, Mus. Toulon); his depic-
tions of *Caroline, Duchesse de Berry* and *Félicité de
Lamennais* were particularly well received. His
mythological paintings, such as *Anchises and
Venus* (1822; Toulon, Mus. Toulon), were strongly
influenced by Jacques-Louis David and the cult of
languid beauty espoused by Johann Joachim

Winckelmann, and derived from antique vases and
bas-reliefs. Although he employed colour, light and
composition to give his pictures a strongly linear
quality, Guérin's brand of Neo-classicism is tem-
pered by the use of *sfumato*, which also distin-
guishes the increasingly Romantic atmosphere of
Pierre-Paul Prud'hon's and Anne-Louis Girodet's
paintings. A symbolic luminism suffuses many of
his religious paintings, as in the *Holy Family* (exh.
1833; Paris, priv. col.). Other religious works include
St Anne (exh. 1833; Le Castellet, church) and *St
Catherine of Alexandria* (exh. 1833; Paris, St Roch).

In 1828 Guérin was appointed director of
drawing and painting at the Maison Royale de St
Denis, Paris. Remaining loyal to the Bourbons, he
had little contact with Louis-Philippe and contin-
ued painting portraits of Parisian society. In 1836
he opened a studio in the Quai Malaquais where
Vincent Courdouan (1810–93) was among his
pupils. Guérin trained his daughter Isabelle, son
Félix (1825–65) and nephew Jean-Pierre Philibert
(1805–46), all of whom became painters. Praised
by Théodore Géricault, François-Marius Granet
and Jean-Auguste-Dominique Ingres, Guérin was
the official painter to the royal family and aris-
tocracy during the reigns of Louis XVIII and
Charles X. Following in the 18th-century French
tradition of Jean-Baptiste Greuze in particular, and
influenced by the great English portrait painters
Joshua Reynolds and Thomas Gainsborough,
Guérin inherited a mild version of the Neo-classi-
cal aesthetic yet achieved a distinctly personal
style that made him one of the most prominent
portrait painters of the Restoration.

Bibliography

A. Alauzen: *La Peinture en Provence du XIVe siècle à nos
 jours* (Lausanne, 1962)

*La Peinture en Provence dans les collections du Musée de
 Toulon du XVIIe au début du XXe siècle* (exh. cat. by J.
 Forneris and others, Toulon, Mus. Toulon, 1985)

JEAN-ROGER SOUBIRAN

Guérin, Pierre(-Narcisse), Baron

(*b* Paris, 13 March 1774; *d* Rome, 16 July 1833).
French painter, draughtsman and teacher. He was

one of the most successful French painters working in the Neo-classical style at the end of the 18th century and the beginning of the 19th. He especially admired the art of Poussin and David, and derived inspiration from Greek mythology and from the Classical themes of the plays of Jean Racine. At the Salons in Paris he exhibited elegant compositions painted in a carefully controlled manner and with arresting chiaroscuro. He was never a prolific artist and, owing to ill-health, painted even less in his later years, devoting himself instead to teaching and to the directorship (1822–8) of the Académie de France in Rome.

1. Early years and Salon success, 1774–1805

His talent for drawing was apparent at an early age and his father, an ironmonger with a shop on the Pont-au-Change, enrolled him at the Académie Royale de Peinture et de Sculpture in Paris in 1785. As required, his application was supported by a member of the Académie, in this case Hugues Taraval, who would have become his first master had he not died that year. Guérin then transferred to the studio of Nicolas-Guy Brenet and remained with him for five years before becoming a pupil of Jean-Baptiste Regnault, with whom he appears to have had a close and influential relationship. Guérin's lively manner of drawing, in which he

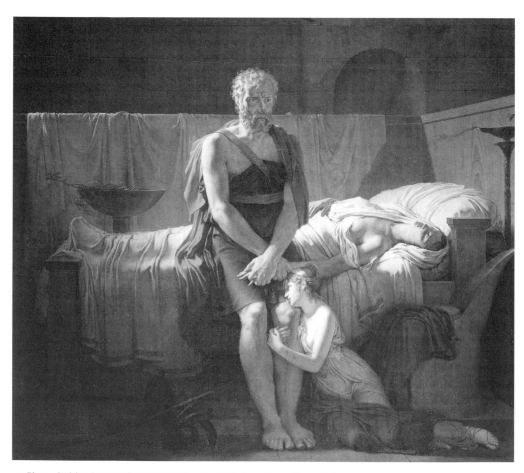

47. Pierre Guérin: *Return of Marcus Sextus,* exh. Salon 1799 (Paris, Musée du Louvre)

combined a chalky *sfumato* with sharp contours, is similar to that of Regnault. His choice of subjects—sometimes dramatic or violent, sometimes graceful or erotic—is also reminiscent of Regnault. He made his début at the Salon of 1795 with a large wash drawing, *Coriolanus Pleading his Cause before the Roman People is Condemned to Death by a Tribune of the People and Defended by the Young Men of Rome who Drive Back the Aediles Sent to Arrest him*, and a painting, *Geta Assassinated on the Orders of Caracalla* (both destr.). The title of the drawing gives a clear idea of Guérin's complex and violent contrasts of pose and gesture that are frequently seen in the works of other late 18th-century artists. The painting, which depicts a scene of horrific violence, survives only as a preparatory drawing (Cambridge, Fitzwilliam). Such subjects as these were not favoured by David, who preferred to represent the drama either before or after the principal action, but they were encouraged by the academic tradition in other studios and in the Académie, where themes of violence allowed young artists to demonstrate their skills in composition, chiaroscuro, figure painting and the recording of gesture and physiognomy.

During the 1790s Guérin progressed through the system at the Académie, which was transformed into a state institution in 1793. He was briefly conscripted into the army but through the intervention of Regnault was released from duty after four months, which enabled him to return to Paris to participate in the competitions that were an important part of the curriculum. In 1796 he won the prize for painting the best half-length figure and graduated to the competition for the Prix de Rome, reintroduced in 1797 after an interval of four years. As no awards had been made during that time, the prize was given to Guérin, Pierre Bouillon (1776–1831) and Louis André Gabriel Bouchet (1759–1842). The subject set, the *Death of Cato*, was chosen to give them ample opportunity to demonstrate the skills they had developed as painters of dramatic narrative. In Guérin's painting of the theme (Paris, Ecole B.-A.) he shows his mastery of academic art in his portrayal of the reactions registered on the faces

of the spectators, in the rendering of eloquent gestures and in the forceful treatment of light and shade falling on the half-nude figure of Cato. The geometry of parallel lines and the frieze-like arrangement of the figures are also clear evidence of the artist's interest in Poussin and David. Lack of public funds and unrest in Rome prevented Guérin from leaving for Italy, and in the interim he followed the stipulated course-work in Paris, completing, as his final submission, the *Return of Marcus Sextus* (Paris, Louvre; see fig. 47), which he sent to the Salon of 1799. The composition originally began as a picture of the blind Belisarius returning home to find his wife dead and his daughter in mourning. One of Guérin's fellow artists, however, advised him to select another character, as Belisarius had already appeared in works by David (*Belisarius Receiving Alms*, 1781; Lille, Mus. B.-A.) and Francois Gérard (*Belisarius*, 1795; ex-Duke of Leuchtenberg; Munich, priv. col.; for illustration see *A.Q.* [Detroit], xxxvi/3 (Autumn 1973), p. 162, fig. 14). Guérin then painted the grief-stricken hero's eyes as open, gave him an invented name and recast him as one of the Romans sent into exile by Lucius Cornelius Sulla (*reg* 82–81 BC). The painting was outstandingly successful, and his contemporaries were quick to draw a comparison between the fate of émigrés during the Reign of Terror (1793–4) and Guérin's imaginary victim of civil war in ancient Rome. At a time when Robespierre and Sulla were often compared, it is difficult to believe that Guérin did not intend the allusion. Some saw the success of the painting as an attempt by Guérin to diminish David's reputation, although the influence of David's *Andromache Mourning Hector* (exh. Salon 1783; Paris, Ecole N. Sup. B.-A., on dep. Paris, Louvre) is very pronounced, not only in the relationship of the figures but also in the smoking candelabrum, an emblem of recent death, which gives a particular significance to the dramatic contrasts of light and shade in both pictures.

Guérin was a theatre enthusiast, and although his paintings have often been described as theatrical, they are not actual depictions of scenes from plays as such. His interest in the plays of Jean

Racine was probably inspired, in the first instance, not by seeing them performed but rather by Pierre Didot's well-known illustrated edition of them (Paris, 1801). *Phaedra and Hippolytus* (1802; Paris, Louvre), Guérin's earliest major composition that reflected his love of the theatre, ostensibly illustrates a passage from Racine's *Phèdre* (1677). He painted it to be shown as part of an exhibition for which there was to be an admission charge, a scheme that he devised with three of David's pupils—Gérard, Anne-Louis Girodet and Gioacchino Giuseppe Serangeli (1768–1852)—in imitation of the profitable exhibition of David's *Intervention of the Sabine Women* (1799; Paris, Louvre). Their show, advertised to open in 1801, was never held, probably because the artists, aware of a recent number of similar failed exhibitions, realized that the French public was reluctant to pay to see works of art when entrance to the Salon and the Musée du Louvre was free. Guérin, however, completed his painting and sent it to the Salon of 1802, where it was received as successfully as was the *Return of Marcus Sextus*. The composition is derived from a well-known Roman fresco (Naples, Mus. Archaeol. N.) from Herculaneum showing Phaedra and Hippolytus, although Guérin painted his in a more contemporary, academic manner. The telling use of light and shade conveying contrast of character, the effective repertory of gestures and the elegant figure-drawing all forcefully combine to represent the elements of guilt, vengeance and innocence that are expressed throughout Racine's play in a series of dramatic confrontations. Critics were puzzled by the moment depicted in the painting, which was at variance with the incidents in Act IV of the play that were actually cited in the catalogue. Guérin, though, was aware that the concerns of art and literature were not identical. In order to overcome the difficulty confronting artists when they had to deal with a sequence of events or with scenes that depended on the written or the spoken word, Guérin encapsulated time by combining several themes and characters into a single dramatic instance.

With the reopening in 1801 of the Académie de France in Rome, Guérin was given permission to take up his position as a student at the Villa Medici. While there his situation was unusual, for by now he was one of the most well-known artists in France. In 1803, shortly before his departure for Italy, he had been made a member of the Légion d'honneur and when he arrived he was allowed an independence that was not permitted the other students. Partly because of ill-health, he spent much of his time in Naples, going there for the first time in the spring of 1804, and visiting Herculaneum, Pompeii, Paestum and other Classical sites on a romantic voyage of exploration that confirmed his taste for the Antique without noticeably affecting the direction of his art. When he returned to Rome he continued to work on a composition begun before leaving Paris, *Shepherds at the Tomb of Amyntas* (1805; Paris, Louvre), an elegiac painting inspired by one of Salomon Gessner's *Idyllen* (1756). In February 1805 he returned to Naples for one month, where he completed the painting and met Mme de Staël, who was keenly interested in his use of literary themes.

2. Later years: painting and teaching, 1806–33

On his return to Paris in November 1805 after only 22 months in Italy, Guérin, along with other successful French artists, painted themes of propaganda glorifying the regime as part of the programme set up by Emperor Napoleon I. *Bonaparte Pardoning the Rebels at Cairo* (Versailles, Château), which appeared at the Salon of 1808, is a well-ordered recollection of his friend Antoine-Jean Gros's painting of *Bonaparte Visiting the Victims of the Plague at Jaffa*, on 11 March 1799 (1804; Paris, Louvre). Guérin received one further commission for a painting of this type: the *Death of Marshal Lannes* (Valenciennes, Mus. B.-A.), but he did not complete it. His work did not have the elements of realism that were present in the paintings of Gros and David. The subjects of Gessner's *Idyllen*, which inspired *Offering to Aesculapius* (Paris, Louvre), exhibited in 1804, and *Shepherds at the Tomb of Amyntas*, better suited his talent for painting elegant, idealized figure compositions with pathetic or dramatic themes. In 1810 he exhibited *Andromache and Pyrrhus* (Paris, Louvre),

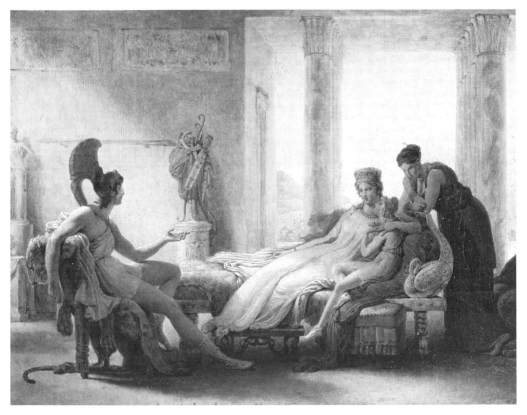

48. Pierre Guérin: *Aeneas Recounting the Misfortunes of Troy in the Presence of Dido*, exh. Salon 1817 (Paris, Musée du Louvre)

another painting inspired by Racine's work. It followed the same elegant, schematized formula used in *Phaedra and Hippolytus*, where strong yet simple gestures and clear-cut expressions convey the sense of the spoken word. He also exhibited *Aurora and Cephalus* (Paris, Louvre), a new type of picture, the themes of which derived from ancient mythology. In the painting the subject of Dawn permitted him to introduce an extreme contrast of light and shade, an effect inspired by Girodet's *Sleep of Endymion* (exh. Salon 1793; Paris, Louvre; see col. pl. XV), in which the male figure was the model for Guérin's sleeping Cephalus. Works of this type, illustrating ancient myths and painted with strong chiaroscuro, were fashionable among David's pupils in the first two decades of the 19th century

and were popular with collectors. Guérin's *Aurora and Cephalus* originally belonged to the Italian collector Giovanni Battista Sommariva, and a replica of it was painted in 1811 for Prince Nikolay Yusupov (1794–1849), along with a pendant, *Iris and Morpheus* (both St Petersburg, Hermitage).

The two aspects of Guérin's art, the dramatic and the charming, were again evident in the paintings he sent to the Salon of 1817: the sinister, emotionally charged *Clytemnestra Hesitating before Stabbing the Sleeping Agamemnon* and the immensely popular *Aeneas Recounting the Misfortunes of Troy in the Presence of Dido* (both Paris, Louvre; see col. pl. XIX and fig. 48), the latter inspired by Virgil's *Aeneid*. He also exhibited a posthumous portrait of *Henri de la*

Rochejaquelein (Cholet, Mus. A.), Commander-in-Chief of the Royalist army in the Vendée during the French Revolution. Although portraits are comparatively rare in his oeuvre, this was one of several of Vendéen generals that were commissioned by Louis XVIII for an antechamber of the château of Saint-Cloud. By depicting Rochejaquelin in a moment of dramatic action as he fires his pistol in the face of the Republican bayonettes, Guérin blurred the distinction between history painting and portraiture. In the early 1820s he briefly became interested in lithography, a process that was suited to his talent for drawing in black chalks, but he produced only four prints: *Le Paresseux* (1820), *Le Vigilant* (1821), *Qui trop embrasse mal étreint* and *Le Repos du monde*.

After 1817 he never again showed at the Salons, as teaching had become increasingly important to him. In 1815 he had been elected to the Institut de France and in 1816 was appointed Director of the Académie de France in Rome. Ill-health prevented him from taking up the directorship but he was reappointed in 1822. When he left for Rome he took with him a sketch (Angers, Mus. B.-A.) for his most ambitious composition so far, a scene in which the violent death of Priam at the hands of Pyrrhus is set against a background of lurid flames. The demands of his position at the Académie prevented him from making progress with the huge composition, and he could only resume work on it in earnest after he returned to Paris in late 1828. He was awarded a baronetcy by Charles X and became an Officer of the Légion d'honneur, but his health deteriorated and, without informing his friends, he accompanied Horace Vernet back to Rome, where he died in 1833. He was buried in Trinità dei Monti, near the Villa Medici. Although he painted very little in his last 15 years, the unfinished *Death of Priam* (Angers, Mus. B.-A.) indicates a direction in his work that was taken up in the 1820s by those who had been his pupils. Many notable painters who worked during the Restoration (1814–30) and the reign of Louis-Philippe (1830–48) were trained in his studio, among them Gericault, Delacroix, Ary Scheffer, Léon Cogniet and Xavier Sigalon, all associated with the Romantic movement. They belonged to a generation that was not as exclusively devoted to subjects from the Antique as Guérin's had been but they learnt from him ways of transforming other non-Classical literary subjects into their own particular forms of expression.

Bibliography

E. Delécluze: *Louis David: Son école et son temps* (Paris, 1855)

A. Soubies: *Membres de l'Académie des beaux-arts depuis la fondation de l'Institut*, i (Paris, 1909), pp. 128–33

H. Lapauze: *Histoire de l'Académie de France à Rome*, ii (Paris, 1924), pp. 155–83

J. Bottineau: 'Les Bergers au tombeau d'Amyntas par Pierre Guérin', *Rev. Louvre*, xxiii (1973), pp. 355–60

J. Rubin: 'Guérin's Painting of *Phèdre* and the Post-Revolutionary Revival of Racine', *A. Bull.*, lix (1977), pp. 601–18

J. Bottineau: 'La Jeunesse de Pierre Guérin: Etude de quelques dessins', *Rev. Louvre*, xxxix (1989), pp. 300–09

S. Ginzburg: 'Sulla fortuna di Pierre-Narcisse Guérin come "peintre d'expression"', *Ric. Stor. A.*, xl (1990), pp. 5–22

JON WHITELEY

Guichard, Joseph(-Benoît)

(*b* Lyon, 14 Nov 1806; *d* Lyon, 31 May 1880). French painter. He was a close friend of Paul Chenavard, both at school and at the Ecole des Beaux-Arts, Lyon, where he trained (from 1819) as a designer. He was taught painting by Pierre Révoil and drawing by the sculptor Jean-François Legendre-Héral (1796–1851), in whose atelier he met Paul and Hippolyte Flandrin. In 1827 he went to Paris and entered Ingres's studio where he was joined by the Flandrin brothers in 1829. He also attended the Ecole des Beaux-Arts and copied exhibits in the Louvre. In 1833 he exhibited at the Salon with the huge *Dream of Love* (Lyon, Mus. B.-A.). It was praised by the critics, but its debt to Delacroix, whose work Guichard had been studying surreptitiously, infuriated Ingres, and Guichard was obliged to leave his studio. In November 1833 he travelled to Italy, where he copied Daniele da Volterra's *Deposition* (Rome, Trinità dei Monte) and frequented the salon of Horace Vernet. He left Italy for Paris in 1835, the year of Ingres's arrival there.

For the next 30 years Guichard received regular commissions from the state. In 1845 he painted the *Adoration of the Shepherds* and the *Deposition* for the chapel of St Landrin, St Germain l'Auxerrois, Paris; in 1848 *Moses Making Water Spring from the Rock* for the chapel of St Joseph, SS Gervais and Protais, Paris; and the *Dead Christ Surrounded by the Holy Women* for Notre-Dame de Passy (untraced). In 1849 he worked beside Delacroix in the Galerie d'Apollon in the Louvre, where he painted the voussoir with the *Awakening of the Earth* (*in situ*) after a drawing by Charles Le Brun. His studio was frequented by Félix Bracquemond, Henri Fantin-Latour and Berthe Morisot. Guichard's career in Paris was wrecked by financial and domestic problems and in 1862 he returned to Lyon where he succeeded Michel Génod (1796–1862) as a teacher of the painting class at the Ecole des Beaux-Arts, although he resigned after quarrelling with the staff in 1871. In 1879 he was made Director of the Musées de Peinture et Sculpture in Lyon, and he also acted as art critic for the *Courrier de Lyon*. Towards the end of his life he turned to Impressionism, producing a series of small paintings that are marked by a loose painterly style, delicate colour and a control of light and shade (e.g. *Dance at the Préfecture* and *Young Girl at her Mirror*; both Lyon, Mus. B.-A.).

Writings

Les Doctrines de Mr Gustave Courbet, maître peintre (Paris, 1862)

Bibliography

R. Chazelle: *Joseph Guichard: Peintre lyonnais* (diss., U. Lyon, 1956)

MADELEINE ROCHER-JAUNEAU

Guillaume, Jean-Baptiste-Claude-Eugène

(*b* Montbard, Côte d'Or, 4 July 1822; *d* Rome, 1 March 1905). French sculptor and writer. Having attended drawing school in Dijon, he entered the Ecole des Beaux Arts, Paris, in 1841. He won the Prix de Rome in 1845 and during his stay in Rome produced several works that were enthusiastically received by the Académie. These included

the marble statue of *Anacreon* (exh. Salon 1852; Paris, Mus. d'Orsay), the hedonistic Classical subject and precise execution of which betray Guillaume's debt to his master, James Pradier. Another piece from his years in Rome, *The Reaper* (bronze, 1849; Paris, Mus. d'Orsay), while not going so far as to infringe Classical conventions, frees the representation of labour from traditional poetics.

Guillaume returned to Paris to pursue a successful career as an official sculptor. His identification with the regime of Napoleon III was confirmed by his series of five marble portrait busts and a marble statue of *Napoleon I* (some at Arenenberg, Napoleonmus), destined for the Pompeian villa of Prince Napoléon-Jérôme Bonaparte. He was involved in virtually every major scheme of sculptural decoration for the public buildings of the Second Empire (1851–70), including the Paris Opéra, to which he contributed one of the façade groups, *Instrumental Music* (Echaillon stone, 1865–9). Guillaume was Director of the Ecole des Beaux Arts (1864–78) and played a prominent part in public life, becoming a member of the Commission on Public Instruction in 1866 and Inspector General of Drawing Instruction in 1872.

Writings

Discours et allocutions (Paris, n. d.)
Essai sur la théorie du dessin et de quelques parties des arts (Paris, 1896)

Bibliography

Lami
A. M. Wagner: *Jean-Baptiste Carpeaux, Sculptor of the Second Empire* (New Haven, 1986)

PHILIP WARD-JACKSON

Harriet, Fulchran-Jean

(*b* Paris, 1776; *d* Rome, 1805). French painter and draughtsman. He began his career in 1793 by winning second prize in the Prix de Rome with an entry that was praised by his teacher, David, and by Prud'hon. He exhibited portraits and subjects taken from ancient history in the Salons between

1796 and 1802. Harriet took part in the 'Pre-Romantic' movement made famous by his fellow disciples of David, Pierre Guérin and Anne-Louis Girodet. *Oedipus at Colonus* (1798–9; priv. col., see 1974 exh. cat., no. 97) is typical of this development in Neo-classicism. Harriet combined precise drawing of draperies, strong effects of light and symbolically divided landscape (the arid section on the left prefigured Caspar David Friedrich) with static, symmetrical composition. At the same time he won the 1798 Prix de Rome with the *Fight between the Horatii and the Curiatii* (Paris, Ecole N. Sup. B.-A.). He went to Rome, probably in 1802, where he undertook a vast heroic composition, *Horatius Cocles* (untraced), which, according to his contemporaries Landon and Wicar, was a masterpiece, although it was still unfinished when he died.

Harriet died very young and very few of his works are known. These include a charmingly naturalistic *Portrait of a Child* (1797; exh. Salon, ?1802; Orléans, Mus. B.-A.) and a *Portrait of Marat* (Versailles, Mus. Lambinet). Several of his designs were reproduced: for example *The Days of 9 Thermidor and of 31 May* (etched by J.-J. F. Tassaert; Paris, Carnavalet), in which he showed himself to be an impassioned witness of his times. Although always loyal to the example of David, Harriet had a rich and original talent, which is evident in his acerbic caricature from the Consulate period, *Parisian Tea, Supreme Style* (coloured etching by Adrien Godefroy (1777–1865); Paris, Carnavalet).

Bibliography

J.-B. Wicar: 'Nouvelles littéraires', *Mag. Enc.*, vi (1805), pp. 375–8
C. P. Landon: *Annales du Musée et de l'école moderne des beaux-arts: Ecole française moderne*, i (Paris, 2/1832), pp. 375–8
De David à Delacroix (exh. cat., Paris, Grand Pal., 1974), pp. 478–81
P. Grunchec: *Le Grand Prix de peinture: Les Concours des Prix de Rome de 1797 à 1863* (Paris, 1983), p. 135
P. de la Vaissière: 'Un Adolescent malléable, durci par la Révolution: Le Peintre Fulcran-Jean Harriet', *Gaz. B.-A.*, ci (April 1983), pp. 141–4

PASCALE MÉKER

Haudebourt-Lescot [née Lescot], (Antoinette-Cécile-)Hortense

(*b* Paris, 14 Dec 1784; *d* Paris, 2 Jan 1845). French painter. At the age of seven Hortense Lescot became a pupil of Guillaume Lethière, a family friend and popular history painter who was appointed director of the Académie de France in Rome in 1807. She followed him to Rome in 1808 and remained there until 1816, depicting the customs and costumes of the Italian peasantry in veristic detail. This experience abroad, rare for a woman artist, was a decisive influence on her art which in its picturesque and anecdotal images of everyday Italian life prefigured the work of the genre specialists J.-V. Schnetz and Léopold Robert. She married the architect Louis-Pierre Haudebourt (1788–1849) in 1820.

Haudebourt-Lescot exhibited more than 100 easel paintings in the Salons from 1810 to 1840, winning second-class medals in 1810 and 1819 and a first-class medal in 1827. She received a number of government commissions. Even after her marriage, her production of sentimental genre scenes with domestic, moralizing, religious, amorous, humorous and literary themes did not slacken. Although she painted historical genre scenes, her reputation was based on exotic Italianate paintings and quaint domestic portrayals. These works were popularized by numerous prints made after them, and it is through reproductions that such works as the *Fair at Grottaferrata* (exh. Salon 1814), the *Notary Public* (exh. Salon 1817), the *Art Dealer* (exh. Salon 1824), the *First Step* (exh. Salon 1819) and the *Happy Family* (exh. Salon 1824) are still known (engravings in Paris, Bib. N.). Haudebourt-Lescot was also an accomplished portrait and watercolour painter; her *Self-portrait* (1825; Paris, Louvre) is particularly notable.

Bibliography

A. Valabrègue: 'Mme Haudebourt-Lescot', *Lett. & A.* (1887), pp. 102–3
S. W. Robertson: *A. C. H. Haudebourt-Lescot, 1784–1845* (MS., New York U., Inst. F.A., 1973)
S. W. Robertson and I. Julia: 'A. C. H. Haudebourt-Lescot', *French Painting, 1774–1830: The Age of Revolution* (exh. cat., Paris, Grand Pal.; Detroit, MI, Inst. A.; New York, Met.; 1974–5), pp. 486–7

L. Nochlin: 'A.-C.-H. Haudebourt-Lescot', *Women Artists, 1550–1950* (exh. cat., Los Angeles, CA, Co. Mus. A., 1976–7), pp. 218–19

SARAH WELLS ROBERTSON

Hédouin, (Pierre-)Edmond(-Alexandre)

(*b* Boulogne-sur-Mer, 16 July 1820; *d* Paris, 12 Jan 1889). French painter, printmaker and illustrator. He studied engraving and lithography under Célestin Nanteuil (1813–73) from 1835 and in 1838 entered the Ecole des Beaux-Arts in Paris, where he studied under Paul Delaroche. He made his Salon début with a peasant genre scene in 1842 and at the Salon of 1846 was singled out for praise by Baudelaire for his powerful handling of colour.

Hédouin's Orientalist work dates from a visit made to Algeria in the company of Adolphe Leleux in 1847. Sketches executed during this trip provided the themes of finished paintings throughout his subsequent career (*Café at Constantine*, 1868; Narbonne, Mus. A. & Hist.). Hédouin's pleasing, realistic scenes of French, Spanish and Arab peasant life were much to the taste of Second Empire officialdom, and a number of the artist's works were acquired by the State during his own lifetime: for example, *The Gleaners* (1857; Paris, Mus. d'Orsay) and the *Sheep Market at St Jean de Luz* (1863; Valenciennes, Mus. B.-A.). In 1861 he painted decorative panels and medallions on the theme of the Liberal Arts for the Galeries des Fêtes in the Palais Royal in Paris (*in situ*) and later executed schemes in the style of Watteau for the foyer of the Théâtre Français (*in situ*) and for the old Hôtel de Ville (destr. 1871).

Hédouin's interest in printmaking dates from the early 1840s, when he provided lithographs for *L'Artiste*. Around 1845 he abandoned lithography for etching and became one of the founder-members of the Société des Aquafortistes in 1863. His later years were devoted principally to engraving copies of Old Master paintings (Boucher, David Teniers II and Henry Raeburn), and to illustrating the literary works of Sterne (*Le Voyage Sentimental*, 1875), Rousseau (*Confessions*, 1881), Janin and Molière (1888).

Hédouin was awarded medals for painting at the Salons of 1848, 1855 and 1857, and for engraving in 1868 and 1872, when he was also made Officier of the Légion d'honneur.

Bibliography

T. Gautier: *Les Beaux-arts en Europe* (Paris, 1856)
H. Béraldi: *Les Graveurs du XIXe siècle*, viii (Paris, 1889), pp. 68–74
J. Adhémar, J. Lethève and F. Gardey: *Bibliothèque nationale: Inventaire du fonds français*, x (Paris, 1958), pp. 163–76

JANE MUNRO

Heim, François-Joseph

(*b* Belfort, 16 Jan 1787; *d* Paris, 30 Sept 1865). French painter. His father, Joseph Heim (*fl* 1781–after 1788), a decorative painter and drawing-master in Alsace, intended Heim for a career in mathematics but, recognizing his skill in drawing, sent him instead to the studio of François-André Vincent in 1803. He won second prize in the competition for the Prix de Rome in 1806 with *Return of the Prodigal Son* (untraced) and took the prize with *Theseus, Conqueror of the Minotaur* (Paris, Ecole N. Sup. B.-A.) in 1807. *Theseus* is characterized by the elongated forms, simple outlines and theatrical light effects that recur in extreme form in the audaciously mannered *Arrival of Jacob in Mesopotamia* (Bordeaux, Mus. B.-A.), painted in Rome and exhibited in the Salon of 1812; in the *Robe of Joseph Shown to Jacob* (exh. 1817; Paris, Louvre); and in the two works on the theme of Titus (exh. 1819; both Paris, Louvre), painted as overdoors for the château of Versailles. The imperial government rewarded him by commissioning a picture very different from his academic work, the *Defence of Burgos* (1813; Versailles, Château), which he painted in the panoramic manner of L. F. Lejeune (1775–1848), but with a better sense of atmosphere and composition. The empire fell too soon to allow Heim to build on his successful beginning as a battle painter. The Restoration government gave him a less promising theme from recent history, the *Recovery of the Royal Bones from Saint-Denis in*

1817 (1822; Saint-Denis, Abbey), which Heim painted with a memorable range of light effects, culminating in the eerie silhouette of Saint-Denis against a moonlit cloud.

The mannerism of Heim's early work gave way to a greater naturalism and energy in drawing and painting the human figure, evident in the *Destruction of Jerusalem by the Romans* (exh. Salon, 1824; Paris, Louvre) and in the *Victory of Judas Maccabaeus* (*c.* 1824; Dijon, Mus. Magnin), for which there is a brilliant, typically explosive sketch in the Musée Bonnat, Bayonne. There was, however, little demand for violent pictures of ancient history; the State, Heim's chief patron, had more use for religious, decorative and commemorative works. Heim was drawn into all three fields and became a master in each. His early works on Old Testament themes, encouraged perhaps by his interest in Jewish history, prepared him for the commissions that the Prefect of the Seine handed out to artists in the Restoration. Heim painted at least ten major works for churches in Paris and elsewhere in this period, beginning with the *Martyrdom of SS Cyr and Juliette* of 1819 for the transept of SS Gervais et Protais, Paris (*in situ*), a rhythmic composition of big, clear, well-drawn figures, and ending with two large grisailles in 1828, the *Adoration of the Magi* and the *Presentation in the Temple* in the apse of St Germain-des-Prés, in which the energy and expression of the earlier work gave way to a quieter, frieze-like elegance. Heim rarely showed at Salons after this. His major religious works in the churches of Notre-Dame-de-Lorette (1836), St Sulpice (1845) and St Séverin (1849) were not framed pictures but large decorative murals in the manner of the work in St Germain. His secular decorative work began with a commission to paint the ceiling of the eighth room in the Musée Charles X with *Vesuvius Receiving Fire from Jupiter to Destroy the Towns of Herculaneum, Pompeii and Stabiae*, with six scenes of desolation in the frieze. The allegorical ceiling *Renaissance of French Art*, which he painted on commission in the Louvre in 1833, is less energetic and more elegant than the other, in keeping with the subject but also with the general tendency in Heim's art away from the dynamism he admired in Michelangelo. In 1844 he decorated the conference room in the Chamber of Deputies with four compositions, twelve allegorical figures and twelve medallions.

Heim developed a speciality in painting large group portraits, following the success of *Charles X Distributing Prizes after the Salon of 1824* (1825; Paris, Louvre; see col. pl. XX), exhibited in 1827, skilfully composed with 108 recognizable celebrities. He followed this with *Richelieu Receiving the First Academicians* (1833), the *Duc d'Orléans Receiving Deputies in 1830* (1834), *Andrieux Reading in the Comédie Française* (1847; all Versailles, Château) and others. The success of these compositions relied on a vast output of preparatory portrait drawings, of which he exhibited 64 at his last Salon in 1859 (e.g. *Comte de Nieuwerkerke*, 1859; Paris, Louvre). Like Abel de Pujol, whose career followed a similar course, Heim spent his whole life working for the Church and State. He rarely worked for private patrons. In 1855 he received a special *grande médaille* as his reward. Apart from Ingres, he was the only surviving artist of his generation who was still respected in the Second Empire.

Bibliography

M. de Saint-Santin [P. de Chennevières]: 'M. Heim', *Gaz. B.-A.*, xxii (Jan 1867), pp. 40–62

P. Lafond: 'François-Joseph Heim', *Gaz. B.-A.*, n. s. xvi (Dec 1896), pp. 441–5; xvii (Jan 1897), pp. 27–36

De David à Delacroix: La Peinture française de 1774 à 1830 (exh. cat., Paris, Grand Pal., 1974), pp. 483–6

L'Art en France sous le Second Empire (exh. cat., Paris, Grand Pal., 1979), pp. 447–8

B. Foucart: *Le Renouveau de la peinture religieuse en France (1800–1860)* (Paris, 1987), pp. 179–82

JON WHITELEY

Helman, Isidore-Stanislas-Henri

(*b* Lille, 1743; *d* Paris, ?1806–9). French engraver and printseller. One of the first pupils at the free school of drawing in Lille, he studied under Louis-Jean Guéret (*fl* 1767–77) and Louis-Joseph Watteau. He completed his training in the Paris studio of

Jacques-Philippe Lebas and is considered one of his best pupils. By 1777 his reputation as an engraver of genre scenes was well established. Among his most successful works are those he engraved after Jean-Michel Moreau for the second *Suite d'estampes pour servir à l'histoire des modes et du costume en France*, which illustrates the life of a fashionable young mother (e.g. *N'ayez pas peur, ma bonne amie*, 1776; Paris, Bib. N. cat. no. 29; *Les Délices de la maternité*, 1777; Bib. N. cat. no. 30; *L'Accord parfait*, 1777; Bib. N. cat. no. 31), and those for the third suite, on the theme of a man about town (e.g. *Le Souper fin*, 1781; Bib. N. cat. no. 53). (Both suites were republished with a text by Restif de La Bretonne in 1789 as the *Monument du costume*, a title often used for the first edition.) Helman also engraved genre subjects after Pierre-Antoine Baudouin, Jean Duplessis-Bertaux (1747–1819), Nicolas Lavreince, or Niclas Lafrensen (1737–1807), and Jean-Baptiste Le Prince.

Helman was not only a talented engraver but also an astute businessman. One of his profitable commercial ventures was the *Conquêtes de l'empereur de la Chine* (1783; Bib. N. cat. nos 54–77), a suite of folio reductions of drawings made by French missionaries, including Jean-Denis Attiret (1702–68), for Qianlong, emperor of China from 1736 to 1796. These were engraved under the direction of Charles-Nicolas Cochin (ii), but as the emperor had stipulated that all the proofs should be returned to China only a very few copies remained in France, in the hands of the royal family. Taking advantage of their rarity, and of the general interest in Chinese subjects, Helman produced his suite and was so encouraged by its success that he undertook two more Chinese suites, the *Abrégé historique des principaux traits de la vie de Confucius* (Bib. N. cat. nos 83–106) and the *Faits mémorables des empereurs de la Chine* (Bib. N. cat. nos 111–34).

Helman is best known, however, for his *Principales journées de la révolution* after Charles Monnet (1732–1808) (Bib. N. cat. nos 142–56). Published between 1790 and 1802, these represent in grisly detail the 15 most important days of the French Revolution, including the decapitation of Louis XVI.

Throughout his life Helman engraved book illustrations, contributing one or more plates to twenty different publications, including three for Jean-Benjamin de La Borde's *Tableaux . . . de la Suisse* (1780–86; Bib. N. cat. nos 38–40) and four after Jean-Baptiste Hilair for the Comte de Choiseul-Gouffier's *Voyage pittoresque de la Grèce* (1782; Bib. N. cat. nos 49–52). In 1775 he became engraver to Louis-Philippe-Joseph, Duc de Chartres, later Duc d'Orléans (Philippe-Egalité). In 1784 he became a member of the Académie des Arts, Lille.

Bibliography

Inventaire du fonds français: Graveurs du XVIIIe siècle, Paris, Bib. N., Dépt. Est. cat., xi (Paris, 1970), pp. 267–302

L'Image de la révolution française (exh. cat., ed. C. Hould; Québec, Musée du Québec, 1989) [incl. reprs of seven of the *Principales journées de la révolution*]

M.-E. HELLYER

Hennequin, Philippe-Auguste

(*b* Lyon, 1762; *d* Leuze, nr Tournai, 12 May 1833). French painter. He was precociously talented and by the age of 15 had been Donat Nonnotte's pupil at the Académie des Beaux-Arts at Lyon and had arrived in Paris. There he worked for a time in Jacques-Louis David's studio, from which he was expelled after being accused of theft. He completed his studies at the Académie Royale de Peinture in 1784 and visited Rome at the expense of an English patron named Mills. Because of masonic connections he was forced to flee in 1789, returning to Lyon. His politics tended towards Jacobinism, and during the Revolution he was appointed to a commission entrusted with saving works of art. After the fall of Robespierre in 1794 he fled to Paris, where he suffered imprisonment and narrowly avoided the guillotine.

In 1798 Hennequin exhibited *Paris Tearing himself from Helen's Arms* and in 1799 was commissioned to paint the *Triumph of the French People, 10th August 1792* (fragment, Rouen, Mus. B.-A.). In 1800 he painted a ceiling for the Salle des

Antonins in the Louvre with the *French Hercules* (*in situ*) and also won first prize for the *Remorse of Orestes* (damaged; Paris, Louvre). Vivant Denon commissioned him to paint for Napoleon the *Battle of Quiberon* (exh. Salon 1804; Toulouse, Mus. Augustins), *Distribution of the Crosses of the Légion d'Honneur* (Versailles, Château) and *Battle of the Pyramids* (exh. Salon 1806; Versailles, Château). Exiled from France by the restoration of the Bourbon monarchy, he went to live in the southern Netherlands, first in Brussels, then in Liège, where he became director of the new Athénée des Arts, and finally (1819) in Tournai, where he taught at the Académie. In 1831 his post was abolished; he died in poverty. His *Mémoires*, not published until 1933, reveal a genuine talent for writing.

Hennequin was a Neo-classical painter of the generation of François Gérard, Anne-Louis Girodet and Antoine-Jean Gros. His pictures have frieze-like compositions and figures derived from Classical sculpture. Their subjects are taken from the great deeds of ancient or contemporary history, from heroic mythology, or are allegories representing the virtues or alluding to contemporary personalities. However, his sharp, incisive drawing celebrates the human frame of bone and muscle; the folds of the draperies are stiff and the movements awkward; everything vibrates with tension.

Hennequin occasionally painted landscapes; his *Ancient Dance* (Tournai, Mus. B.-A.) shows groups of people in a space organized in receding parallel planes, punctuated by the verticals of medieval towers and ovoid trees, the whole enveloped in a vague, misty atmosphere. His religious paintings, from the Belgian period, are passionately expressive. In his *St John on Patmos* (1814; Liège, St Jean Evangéliste) the saint, whose disproportionately large hands and feet are characteristic of Hennequin, raises his face to the sky in a violently contrasted chiaroscuro. Hennequin's bust-length portraits, such as the *Conseiller de Saint-Martin* (between 1811 and 1819; Liège, Mus. B.-A.), are intensely expressive of character and mood, in spite of a neutral background. The full-length portrait of *Dominique-Catherine*

de Pérignon, Maréchal de France (1804; Versailles, Château), against a background of mountains and sky, is Neo-classical in composition but animated by a wholly Romantic passion.

Writings

J. Hennequin, ed.: *Mémoires* (Paris, 1933)

Bibliography

A.-M. Benso: *Hennequin, la vie et l'oeuvre* (diss., U. Lille III, 1975)
J. Benoît: *Philippe-Auguste Hennequin, 1762–1833* (Paris, 1994)

CELIA ALEGRET

Henriquel-Dupont [Henriquel, Louis-Pierre]

(*b* Paris, 13 June 1797; *d* Paris, 20 Jan 1892). French draughtsman and engraver. From 1812 to 1815 he studied painting at the Ecole des Beaux-Arts, Paris, and in the studio of Pierre Guérin, after which, with a view to commercial prospects, he devoted himself to the graphic arts and studied under Charles-Clément Bervic, who made him copy the masterpieces of engraving from the 16th and 17th centuries. He competed unsuccessfully for the Prix de Rome for graphic art in 1816 and 1818 and in the latter year established his own studio, where he produced engravings from works by Alexandre Desenne (1785–1827) and Achille Déveria for such books as La Fontaine's *Fables* (Paris, 1819) and Voltaire's *La Pucelle d'Orléans* (Paris, 1820). His style, formed by his training in the classic works of the past, gradually grew less severe, influenced by such English engravers as William Woollett. His friendship with Ingres, which began in the late 1820s, and his engraving of the *Abdication of Gustav Vasa* (1831; Paris, Bib. N.) were instrumental in winning him critical acclaim. In the 1840s and early 1850s he made engravings after, among other works, Paul Delaroche's (*see* DELAROCHE (2)) *Hémicycle* for the Ecole des Beaux-Arts (1853; Paris, Bib. N.), for which he was awarded the medal of honour at the 1853 Salon. He subsequently devoted himself increasingly to religious work and

portraits, producing, for example, the *Deposition* (1855; Paris, Bib. N.) after Delaroche and *Jean-Baptiste Dumas* (1884; Paris, Bib. N.). In 1863 he was appointed Professor of Graphic Arts at the Ecole Nationale des Beaux-Arts and in 1871 was elected President of the Académie des Beaux-Arts, of which he had been a member since 1849.

Bibliography

DBF

G. Vapereau: *Dictionnaire universel des contemporains* (Paris, 1858, rev. 6/1893)

Inventaire du fonds français après 1800 (Paris, Bib. N., Dépt. Est. cat., x (Paris, 1958), pp. 281–92

☐

Hersent, Louis

(*b* Paris, 10 March 1777; *d* Paris, 2 Oct 1860). French painter and printmaker. His parents sent him to Baron Jean-Baptiste Regnault's studio where he made rapid progress. In 1797 he won second place in the Prix de Rome with the *Death of Cato* (untraced) behind the joint winners, Pierre Bouillon (1776–1831), Pierre Guérin and Louis André Gabriel Bouchet (*fl* 1797–1819). In 1798, seriously ill, he withdrew from the competition and left the studio. His parents put him into commerce where he lasted 18 months, painting on Sundays, until his kinsman, M. Crouzet, director of the military academy at St Cyr, gave him a post as drawing-master to the students. He made his Salon début in 1802 with *Narcissus* (Arras, Mus. B.-A.). He sent *Achilles Receiving Briseis* (untraced) to the Salon of 1804 and then extended his range with the *Aerial Tomb* and *Atala in the Arms of Chactas* (1806; untraced), derived like Anne-Louis Girodet's famous version (but two years before Girodet) from Chateaubriand's story *Atala* (1801). *Atala* won Hersent a gold medal in the Salon of 1806. To an academic figure painter like Hersent, American Indians were as good a subject as ancient Greeks and had the advantage of being more interesting. Many of his mature pictures were painted with an academic sense of light and shade and composition, but using modern heroes in place of Greeks and Romans,

and sentiment and anecdote in place of history. This mixed genre, neither history nor daily life, was popular with the new aristocracy of the First Empire. The Empress Josephine bought *Fénelon Returning a Cow to a Family of Peasants* (exh. 1810; Malmaison, Château N.), and the government commissioned him to paint the *Crossing of the Bridge of Landshut* (Versailles, Château) at the request of the Prince d'Eckmuth. Hersent returned to the Indian theme in 1814 with *Las Casas Rent by Savages* (untraced).

Collectors at the Restoration court were even more enthusiastic about Hersent's paintings, encouraged, in part, by a royalist tendency in his choice of subjects. *Louis XVI Distributing Charity to the Poor in the Winter of 1788* (exh. Salon, 1817; Versailles, Château; see fig. 49), an apocryphal episode, composed in the manner of Antoine-Jean Gros's *Bonaparte Visiting the Victims of the Plague at Jaffa, 11 March 1799* (1804; Paris, Louvre; see col. pl. XVIII), was commissioned in 1816 for the Tuileries and awarded the prize given by Louis XVIII in 1817 for the best genre painting at the Salon. In the *Death of Dr Bichat* (exh. 1819; U. Paris V, Mus. Hist. Médec), he translated the heroic deathbed scenes of Poussin and David into a touching anecdote from modern life. In 1819 the Duc d'Orléans (the future King Louis-Philippe) commissioned eight pictures from young artists through the intermediation of François Gérard. The *Abdication of Gustav Vasa* (destr. 1848), commissioned from Hersent, was a sensational success at the Salon of 1819, a forerunner of many similar historical pictures painted in the 19th century in Düsseldorf, Antwerp, Paris and elsewhere. Hersent painted several other pictures for the Duc d'Orléans, which were hung in the Galerie du Palais-Royal, a prototype of the Musée Historique at Versailles; illustrating the history of the palace, these paintings were destroyed in the sack of 1848. Louis XVIII, who was more attracted by the anecdotal side of Hersent's art, commissioned *Ruth Requesting Boaz to take her in Protection* as a gift for the miniature painter Lizynka Rue, later Mme de Mirbel (1796–1849), with a punning reference to her name, but gave it instead to Mme de Cayla, who had taken her place in the King's favour by the time the

picture was completed. *Monks on St Gothard Taking Care of a Family Attacked by Brigands* (exh. 1824; Mortagne, Mairie) was commissioned for the King by the Comte d'Artois (later Charles X), who thought the subject would appeal to the King's piety and to his interest in attractive young women. Considering his close links with the Duc d'Orléans, it is surprising that Hersent was not much involved in the Musée Historique at Versailles. But he continued to paint many portraits during the July Monarchy, especially of the Orléans family.

Hersent also practised lithography, illustrating Auguste, Comte de Forbin's *Voyages dans le Levant* (1819) and the *Fables de La Fontaine* and reproducing a handful of his own pictures. His best-known works were reproduced by other artists in large, popular editions. In 1822 he was elected to the Institut. He succeeded Girodet as a professor at the Ecole des Beaux-Arts in 1825 and opened his own teaching studio. Charles Gleyre, Paul Chenavard and Jacques-Raymond Brascassat were among his pupils. In 1821 he married Louise-Marie-Jeanne Mauduit (1784–1862), a successful painter who had her own teaching studio for women artists.

Bibliography

G. Hédiard: *Louis Hersent: Les Maîtres de la lithographie* (Paris, 1901)
De David à Delacroix: La Peinture française de 1774 à 1830 (exh. cat., Paris, Grand Pal., 1975), pp. 486–8

JON WHITELEY

49. Engraving after Louis Hersent: *Louis XVI Distributing Charity to the Poor in the Winter of 1788*, 1817 (Versailles, Musée National du Château de Versailles et du Trianon)

Hervier, (Louis-Henri-Victor-Jules-François) Adolphe

(*b* Paris, 1818; *d* Paris, 18 June 1879). French painter, draughtsman and printmaker. He was first taught by his father, Marie-Antoine Hervier (*fl c.* 1810–20), a successful miniature painter and former pupil of David, and he later studied under Léon Cogniet and Eugène Isabey. From the start his work had an individual style. His work first appeared at the Salon in 1849 but, according to Philippe Burty (sale catalogue, Paris, Hôtel Drouot, 26 Feb 1876), was exhibited there only eight more times, with 23 rejections. Gautier, the Goncourt brothers, Champfleury, Corot and Rodolphe Bresdin praised his work, but their admiration brought him little money, and he was forced to paint backgrounds for other artists, such as the military painter Edouard Armand-Dumaresq (1826–95).

A skilled draughtsman with a lively style, Hervier learnt to etch about 1840 and became a gifted printmaker. His etchings, which are frequently small, resemble sketchbook pages with their innovative use of various printmaking techniques and their fresh ideas. He published several different editions of his prints in his lifetime, and in 1888 the editor and bookseller L. Joly compiled a posthumous *Album Hervier*, containing 43 plates drawn and etched by the artist between 1840 and 1860. His figure style, which, like Daumier's, has elements of caricature, gives expressive life to the peasants and workers he frequently portrayed, for example in *Market at Caen* (*c.* 1860; Dijon, Mus. B.-A.). His paintings are solidly constructed, with considerable sensitivity to effects of light, perhaps a reflection of the time he spent working around Barbizon with artists such as Charles Jacque. In the last two decades of his life Hervier sacrificed some of his early vigour for a broader, more facile approach, notably in his watercolours. Several sales of Hervier's work were held during his lifetime, though none was very successful.

Bibliography

T. Gautier: *Les Beaux-arts en Europe*, ii (Paris, 1857), pp. 158–9

P. Hamerton: 'Modern Etching in France', *F.A. Q.*, ii (1864), pp. 83–4, 102

H. Beraldi: *Les Graveurs du XIXème siècle*, viii (Paris, 1889), pp. 110–16

E. de Goncourt and J. de Goncourt: 'Le Salon de 1852', *Etud. A.* (1893), pp. 89–90

R. Bouyer: 'Petits maîtres oubliés, I: Adolphe Hervier', *Gaz. B.-A.*, xvi (1896), pp. 61–72

R. Marx: 'Cartons d'artistes, maîtres et petits maîtres du XIXème siècle: Adolphe Hervier, 1819–1879', *Image* (1896–7), pp. 18–23

A. Baudin: *Recherches sur la vie et l'oeuvre du peintre français, Adolphe Hervier (1819–1879), avec le catalogue des oeuvres peintes et dessinées* (MA thesis, U. Lille, 1972)

J. van der Noort: *Catalogue Raisonné* of Hervier's Prints and Watercolours (in preparation)

JAMES P. W. THOMPSON

Hesse

French family of artists.

(1) Nicolas-Auguste Hesse

(*b* Paris, 28 Aug 1795; *d* Paris, 14 June 1869). Painter and lithographer. He initially studied under his brother, the painter Henri-Joseph Hesse (1781–1849), and then, in 1810, under Antoine-Jean Gros. In 1811 he entered the Ecole des Beaux-Arts in Paris, winning the Prix de Rome in 1818 with *Philemon and Baucis Receiving Jupiter and Mercury* (1818; Paris, Ecole N. Sup. B.-A.). He then went to Rome, where ill-health prevented him from fully devoting himself to painting. Nevertheless he produced a number of works on Classical and mythological subjects while in Italy and exhibited at the Salon for the first time in 1824. He rapidly established himself as an important official painter, receiving numerous State commissions. In 1827 he exhibited the *Foundation of the Sorbonne College around the Year 1256*, which now decorates the chapel of the Sorbonne. The Duchesse Caroline de Berry employed Hesse in 1829 to decorate the chapel at the château at Rosny, near Paris. The same year, he painted the allegorical figures *Theology* and *History* for the Ancienne Salle du Conseil d'Etat in the Louvre. He won a first-class medal at the Salon of 1838 for *Christ at the Sepulchre* (1838; Périgueux Cathedral; reduced variant version, 1845; Paris,

Louvre) and *General Meeting of the Etats-Généraux on 23 June 1789* (1838; Amiens, Mus. Picardie). The latter was installed in the Chamber of Deputies. He worked for King Louis-Philippe in 1846, decorating his château at Corbeil in Brittany, and in 1848 he won the competition to provide a symbolic representation of the Republic for the Galerie des Fêtes in the Hôtel de Ville in Paris (destr. 1871).

A large portion of Hesse's output was devoted to decorating churches, and in 1835 he provided an *Adoration of the Shepherds* for the nave of Notre-Dame de Lorette in Paris. Among his other commissions in Paris were decorations for the chapel of the Virgin at Notre-Dame de Bonne-Nouvelle (1840), for the choir of St-Pierre-de-Chaillot (1843) and for Ste-Elisabeth-du-Temple (1852). He also designed stained-glass windows (1849) for the chapel of the Virgin at St-Eustache, Paris, and for Ste-Clotilde (also in Paris) in 1853. On account of these numerous commissions for churches and public monuments, Hesse exhibited at the Salon comparatively infrequently, though he continued to send works until 1868. His subjects were invariably historical or religious, executed in an academic style characteristic of the official art of the Second Empire. He also turned his hand to lithography, producing works of a similar tone and style to his paintings; a typical example is *Annibale Carracci after a Self-portrait* (1825; Paris, Bib. N.). In 1840 Hesse was awarded the Légion d'honneur, and in 1863 he succeeded Delacroix as a member of the Académie des Beaux-Arts.

Bibliography

DBF; Hoefer

A. Soubies: *Les Membres de l'Académie des Beaux-Arts*, 4 vols (Paris, 1905–17), iii, pp. 32–4

Inventaire du fonds français après 1800, Paris, Bib. N., Cab. Est. cat., x (Paris, 1930), p. 381

(2) Alexandre-Jean-Baptiste Hesse

(*b* Paris, 30 Sept 1806; *d* Paris, 7 Aug 1879). Painter, nephew of (1) Nicolas-Auguste Hesse. He was the son of Henri-Joseph Hesse. He entered the studio of Jean-Victor Bertin in 1820, enrolling at the Ecole des Beaux-Arts the following year. He then travelled in France, visiting the Midi in 1825. In 1830 he visited first Rome, where he met Horace Vernet, Director of the Académie Française, and then Venice. In 1833 he exhibited *Funeral Honours Rendered to Titian after his Death at Venice during the Plague of 1576* (Paris, Louvre) at the Salon, where he won a first-class medal. The same year he returned to Italy, where he made copies of Renaissance masterpieces in Florence and Venice. In 1836 he received a State commission to paint *Henry IV Brought back to the Louvre after his Assassination* (1836; Versailles, Château), which was destined for the Galerie d'Apollon in the Louvre.

In 1842 Hesse exhibited the large work *Adoption of Godefroy de Bouillon in 1097 by the Emperor Alexius Comnenus* (1842; Versailles, Château), which had been commissioned by the State two years previously and for which he was made a Chevalier de la Légion d'honneur that year. Like his uncle, he took part in the 1848 competition to provide an allegorical figure of the Republic. Apart from his Salon paintings he worked on a number of church decorations in Paris, including the chapel at St Séverin (1852) and the church of St Gervais–St Protais (1864–7). He continued to exhibit at the Salon until 1861. His painting was most notable for its intense colours, earning him the name 'the last Venetian'. He travelled regularly and was in Rome again from 1845 to 1857 and in Belgium in 1870. He was elected a member of the Académie des Beaux-Arts in 1867, succeeding Ingres, and in 1869 was made Officier de la Légion d'honneur.

Bibliography

DBF

E. Bellier and L. Auvray: *Dictionnaire général des artistes de l'école française*, 3 vols (Paris, 1868–85)

P. Nicard: *Alexandre Hesse: Sa vie et ses ouvrages* (Paris, 1883)

□

Hoin, Claude(-Jean-Baptiste)

(*b* Dijon, 25 June 1750; *d* Dijon, 16 July 1817). French painter, teacher and museum administrator. The son of a prominent doctor in Dijon, he

began his career there under the architect Claude-François Devosge II (1697–1777). He received a sound training in the principles of allegory and composition, which he put to good use in his earliest known work, the wash drawing of a filial *Allegory in Honour of Jean-Jacques-Louis Hoin* (1769; Dijon, Mus. B.-A.). Although he remained in lifelong contact with his first teacher and with the provincial bourgeois milieu of his youth, Hoin went to Paris in 1772 or 1773. There, under Jean-Baptiste Greuze, he immediately began copying portraits of young girls 'to improve the delicacy of his touch' (Portalis). In 1776 he was made a corresponding member of the Dijon Académie, and, although he was not a member of the Académie Royale in Paris, two years later he joined the académies of Lyon, Rouen and Toulouse. The fine pastel *Portrait of a Young Girl* (Toulouse, Mus. Augustins) was his *morceau de réception* for Toulouse. In 1779 he first exhibited at the Salon de la Correspondance in Paris; in 1782 he exhibited a gouache of his parents' tomb (Dijon, Mus. B.-A.), and the following year he followed up with a series of pastel portraits and various miniatures. His official career had progressed in the meantime: in 1779 he was made professor of drawing at the Ecole Royale Militaire, and late in 1785 he was named official painter to the Comte de Provence (later Louis XVIII). He continued to paint simple genre scenes, allegories and actresses in costume. These gouaches, which he produced throughout the 1780s, were straightforward in composition, though occasionally he executed works of greater complexity, such as *La Danse champêtre* and *La Conversation galante* (both 1784; Vienna, Albertina). Miniatures he executed around this time include the *Duchesse de La Trémoille and her Son* (1788; priv. col., see 1963 exh. cat., pl. ix)—two tiny profile busts in a landscape setting—and *Madame Elisabeth and the Dauphin* (1793; Paris, Louvre).

Following the outbreak of the French Revolution Hoin moved back to Dijon, joining the local Société Populaire des Arts in 1794. Although he stayed in Paris for a short period, exhibiting at the open salons of 1800 and 1801, he returned to Dijon in 1804 with his new wife, Amélie, to take up the position of professor of drawing at the Lycée. He made a modest living in this post, while waiting for the directorship he had been promised of the recently created Musée des Beaux-Arts to fall vacant. This finally happened early in 1811, and he took up the post immediately. Soon afterwards Hoin suffered the deaths of his wife and his old friend and teacher Devosge, and he devoted the last six years of his life to the museum's administration and expansion. He bequeathed to it several fine works of his own, including some of the most attractive examples: large chalk portrait studies on blue paper of which the best, *Head of a Child* (1791) and *Young Girl in a Black Hat* (n.d.; both Dijon, Mus. B.-A.), have a vivacity that makes a refreshing change from the studied quality of many of the more formal works he produced during his career, for example the *Allegory in Honoured Memory of Legouz de Gerland* (1776, Dijon, Mus. B.-A.).

Bibliography

R. de Portalis: 'Claude Hoin', *Gaz. B.-A.*, n.s. 2, xxii (1899), pp. 441–61; xxiii (1900), pp. 10–24, 203–16, 293–309
Claude Hoin (exh. cat., intro. P. Quarré; Dijon, Mus. B.-A., 1963)

JOSHUA DRAPKIN

Houdon, Jean-Antoine

(*b* Versailles, 25 March 1741; *d* Paris, 15 July 1828). French sculptor. He was the foremost French sculptor of the second half of the 18th century and one of the outstanding portrait sculptors in the history of art. Although he created a number of works on Classical themes, he is best known for his remarkably vivid busts and statues of his famous contemporaries, many of which exist in several versions.

1. Paris and Rome, to 1768

Houdon's father was concierge to the Comte de Lamotte, whose Paris hôtel housed the Ecole Royale des Elèves Protégés. This newly established institution trained the winners of the Grand Prix of the Académie Royale de Peinture et de

Sculpture before they were sent to the Académie de France in Rome. It was his proximity to some of the best artists in France that encouraged Houdon's vocation. He trained in the studios of René-Michel Slodtz, Jean-Baptiste Lemoyne and Jean-Baptiste Pigalle, and won the Académie's third prize for sculpture in 1756 and the Grand Prix (Prix de Rome) in 1761. He subsequently spent three years at the Ecole des Elèves Protégés before leaving for Rome in 1764.

Surviving works from Houdon's years in Rome attest to the variety of his interests. Like all students at the Académie de France he was obliged to make copies of antique sculptures. His plaster bust of a *Vestal* (Gotha, Schloss Friedenstein) is a severe composition with the head covered with a veil. He made a marble version of this work in 1788 (Paris, Louvre) and continued to be inspired by its source, the statue of a *Vestal* (or *Pandora*) in the Museo Capitolino in Rome, in a number of reductions produced throughout his career (e.g. bronze version, exh. Salon 1777; untraced). His bust of a *Peasant Girl of Frascati* (plaster version, Gotha, Schloss Friedenstein; later marble versions, Paris, Mus. Cognacq-Jay and St Petersburg, Hermitage) is a finely idealized head after the Antique. The plaster statuette of a *Priest of the Lupercalia* (Gotha, Schloss Friedenstein) is reminiscent of Bernini's statue of *Apollo* in the group *Apollo and Daphne* (Rome, Gal. Borghese). A commission for a statue of *St John the Baptist* for S Maria degli Angeli (plaster; Rome, Gal. Borghese) was the occasion for the production of Houdon's famous statue of a *Flayed Man* or *Ecorché au bras tendu* (plaster version, Gotha, Schloss Friedenstein; later and modified bronze version, Paris, Ecole N. Sup. B.-A.). It bears witness to Houdon's other great source of inspiration—study from nature. A statue of *St Bruno*, also for S Maria degli Angeli (marble; *in situ*), was clearly a response to René-Michel Slodtz's *St Bruno* (1744) in St Peter's. Where Slodtz's statue is dynamic, almost agitated, in character, Houdon's is sober, an image of contemplation and introspection, in which the asceticism of the face is emphasized by the striking vertical pleats of the saint's habit.

2. Paris and Gotha, 1768–79

Houdon returned to Paris in 1768 and was approved (*agréé*) by the Académie Royale on presentation of a recumbent statue of *Morpheus*, god of dreams. He exhibited a monumental plaster version of this ambitious work at the 1771 Salon (Gotha, Schloss Friedenstein) and was received (*reçu*) as a full member of the Académie in 1777 on presentation of a smaller marble version (Paris, Louvre). The 1771 Salon was also the first occasion when Houdon showed portraits of identified sitters, among them a terracotta bust of *Denis Diderot* (Paris, Louvre). The writer is depicted lightly idealized in the antique manner, with short hair and no draperies, his lips slightly parted. In this bust Houdon experimented with a new manner of treating the eyes, perhaps inspired by Bernini, to which he remained faithful for the rest of his career: a small isthmus of marble left within the excavated socket to catch the light represents the sparkle of the pupil.

In 1771 and again in 1773 Houdon travelled to Gotha in Saxony, where the Francophile Herzog and Herzogin were among the first collectors of his sculpture. In 1773 he showed at the Paris Salon profile medallion portraits *all'antica* of *Ernest Ludwig II, Herzog von Saxe-Gotha* and of *Maria Charlotte, Herzogin von Saxe-Gotha* (bronzed plaster; Gotha, Schloss Friedenstein). At the same Salon he also exhibited a characterful bust, made after drawings, of another important collector of his works, *Catherine the Great* (marble version, St Petersburg, Hermitage; plaster version, Schwerin, Staatl. Mus.). Russian patronage was to be important to Houdon. In particular he received commissions for four funerary monuments for members of his family from Prince Dmitry Alekseyevitch Galitzin, Russian Ambassador to France. Two of these were executed in marble (St Petersburg, Mus. Sculp., and Moscow, Don Monastery Cemetery) and were shown at the 1773 Salon. A third exists only as a terracotta model (exh. Salon 1777; Paris, Louvre). The two marbles are in the form of Neo-classical stelae with mourning figures in relief and anticipate the design of Houdon's monument for the *Heart of Victor Charpentier, Comte d'Ennery* (marble, 1781; Paris, Louvre). The

50. Jean-Antoine Houdon: *Rousseau*, 1778 (Paris, Musée du Louvre)

terracotta represents a programmatic composition of the kind advocated by Diderot, and maybe conceived as a small cenotaph, made for personal reflection—such as a Vanity—rather than a model for a large monument, never, in fact, executed.

The great series of Houdon's portrait busts began in earnest with his exhibits at the Salons of 1775 and 1777, when he showed works that are among his most successful, both from the point of view of psychological penetration and in the exceptional mastery of his handling. They included busts of the Garde des Sceaux, the *Marquis de Miromesnil* (marble versions, London, V&A, and New York, Frick), of the Contrôleur Général des Finances, *Anne-Robert-Jacques Turgot* (marble; Lantheuil, Calvados, Château), of the composer *Willibald von Gluck* (plaster; Weimar, Thüring. Landesbib.) and the singer *Sophie Arnould* (marble; Paris, Louvre), as well as Houdon's four marble masterpieces, the busts of the *Comtesse de Cayla* (New York, Frick), the

Baronne de la Houze (San Marino, CA, Huntington A.G.) and Louis XVI's aunts *Mme Victoire* (London, Wallace) and *Mme Adélaïde* (Paris, Louvre). Also noteworthy were the terracotta busts of the children of the architect Alexandre-Théodore Brongniart (Paris, Louvre). Houdon later made portraits of his own children at different ages, such as those of *Sabine Houdon* (plaster; Paris, Louvre).

If the Salons of 1775 and 1777 established Houdon as a portrait sculptor without rivals, he nevertheless continued to work also on a monumental scale. In 1776 he executed for the Herzog von Saxe-Gotha a large plaster statue of *Diana the Huntress* (Gotha, Schloss Friedenstein). In this, the goddess is depicted as if running forward, her bow in her hand. It is a reinterpretation of the art of antiquity in which Houdon, while choosing to depict the figure completely nude, also chose to show its anatomical details without idealization. Diana is given apparent movement by a slight twist to the torso, which gives the figure both its dynamism and its sensuality. The statue exists in a number of other large-scale versions: a marble of 1780 (Lisbon, Mus. Gulbenkian), a terracotta of c. 1781 (New York, Frick) and two bronzes cast by Houdon himself, one of 1782 (San Marino, CA, Huntington A.G.) and the other of 1790 (Paris, Louvre; see col. pl. XXI).

3. From the Salon of 1779 to the French Revolution

At the Salon of 1779 Houdon inaugurated his impressive gallery of portraits of famous men, modelled both from life and posthumously. This was a theme that he continued up to his last Salon in 1814, and places him firmly within the historicist current of the age of Louis XVI. Houdon's originality (he was always keen to exploit the commercial possibilities of his works) lay in creating different bust types of his illustrious subjects. Thus Voltaire, Rousseau (see fig. 50), D'Alembert, Franklin, Washington and others were depicted in contemporary costume and hairstyles, but also with their hair dressed in the Roman manner and their shoulders naked or covered with antique drapery.

Also in 1779 Houdon received his only official commission from the Bâtiments du Roi, a statue

51. Jean-Antoine Houdon: *Voltaire Seated*, exh. Salon 1781 (Paris, Bibliothèque Nationale)

in period costume of the 17th-century soldier the *Maréchal de Tourville* (marble; Versailles, Château). This was intended as part of the series of statues of *Illustrious Frenchmen* designed to decorate the Grande Galerie of the Louvre, Paris. The statue of Tourville was exhibited at the 1781 Salon together with one of Houdon's greatest masterpieces, his statue of *Voltaire Seated* (see fig. 51). The latter was a private commission from the writer's niece Mme Denis. It exists in a number of versions, including the original plaster containing Voltaire's heart (Paris, Bib. N.), two marbles, shown at the Salon (Paris, Mus. Comédie Fr.), and a variant made for Catherine the Great (St Petersburg, Hermitage). The pose of the Voltaire statue, which shows him seated in a Louis XVI-style armchair, is related to the concept of the *Illustrious Frenchmen*. But the imprecise nature of the costume, a sort of dressing-gown that implies Classical drapery, and the head shown wigless but

decorated with a philosopher's headband, suggest a heroization responding, but with a greater care for 'decency', to Pigalle's infamous statue of *Voltaire Nude* (1776; Paris, Louvre).

Such was Houdon's celebrity by this time that Thomas Jefferson, Ambassador of the United States to France, suggested to him a scheme for a monumental statue of *George Washington* for the Capitol at Richmond, VA. Hoping to execute a bronze equestrian statue, the apogee of the sculptor's art, Houdon went to the USA in 1785. There he executed a bust portrait of *Washington* taken from life but lightly idealized *all'antica* (terracotta; Mount Vernon, VA). Unfortunately, Washington refused to be represented in the heroic antique mode and Houdon had to content himself with making a marble standing statue showing him in contemporary costume (Richmond, VA, Capitol), which he signed in 1788. The only Classical reference is the plough behind the figure of Washington, an allusion to the retirement of Cincinnatus.

4. After 1789

Houdon, who by the late 1780s had portrayed the king, the royal family and the high aristocracy as well as the men of the Enlightenment, continued his activity unabated during the early years of the Revolution. He executed busts of such political figures as *Lafayette*, *Necker*, *Barnave*, *Bailly*, *Mirabeau* and *Dumouriez*, which exist in a number of versions. Nevertheless, later he was in less demand. It is significant that he was not involved in the new sculptural decorations of the Panthéon, Paris, and he failed in his ambition to execute a monument in honour of Rousseau. He did execute a number of important works under the Empire, including a herm bust of *Napoleon as Emperor* (terracotta, 1806; Dijon, Mus. B.-A.), a statue of *Cicero* (plaster, 1804; Paris, Bib. N.) for the chamber of the Senate, and monumental marble statues of *Général Joubert* (c. 1812; Versailles, Château) and *Voltaire* (c. 1812; Paris, Panthéon), the latter this time depicted standing.

Houdon was an artist of remarkable range and calibre who dominated with ease the sculptors of his generation. His output covers all the genres,

except perhaps that of the terracotta model for the consumption of private collectors. Even this taste was catered for late in his career with the half-nude female statuettes he made on the theme of *Winter* ('La Frileuse', Paris, Louvre). He executed portraits from life and posthumously, sometimes, as in the case of his busts of *Rousseau* and *Mirabeau*, using death masks. He produced outdoor statuary, such as his fountain for the Duc d'Orléans's park at the Plaine Monceau. This consisted of a marble figure of a *Bather* (New York, Met.) on to whose shoulders water was poured by a lead *Negress* (destr. 1790s). There was also sculpture for interior settings, including marble female statues representing *Winter* and *Summer* (c. 1783–5; Montpellier, Mus. Fabre) made for the rich collector Girardot de Marigny, as well as decorative low reliefs, such as the one made for Ste Geneviève, Paris (untraced). He was a superb handler of marble—perhaps only Augustin Pajou's works show a comparable finesse of touch—commercially shrewd in the production of plaster versions of his works (and equally so in the diffusion throughout Europe of copies of his portraits of the Parisian élite), and also an expert bronze-founder in the best French tradition. Although he failed in his ambition to execute an equestrian statue, he did produce bronze versions of a number of his statues, including *Winter* ('L'Hiver', 1787; New York, Met.), *Diana the Huntress* and its pendant of *Apollo* (1790; Lisbon, Mus. Gulbenkian) and the *Écorché*, as well as superb bronzes of his busts, such as that of *Rousseau* (1778; Paris, Louvre). It was of this last activity that he was most proud. In a memoir written in 1794 Houdon summed up his career thus: 'I have given myself over to only two studies, which have filled my whole life . . . anatomy and the casting of statues'.

Bibliography

Lami
G. Giacometti: *La Vie et l'oeuvre de Houdon*, 2 vols (Paris, 1928)
W. Sauerländer: *Jean-Antoine Houdon: Voltaire* (Stuttgart, 1963)
L. Réau: *Houdon*, 2 vols (Paris, 1964)
H. H. Arnason: *The Sculptures of Houdon* (London, 1975) [with extensive bibliog.]

GUILHEM SCHERF

Hoüel, Jean-Pierre-Louis-Laurent

(*b* Rouen, 28 June 1735; *d* Paris, 14 Nov 1813). French painter and engraver. He was born into a family of prosperous artisans and at the age of 15 was sent to the drawing academy in Rouen run by Jean-Baptiste Descamps (?1715–91). Presumably Descamps introduced him to the art of 17th-century Dutch and Flemish artists. Descamps also recommended his promising pupil to the Paris engraver Jacques-Philippe Le Bas, whose studio Hoüel entered in 1755. While in Paris Hoüel taught engraving to the celebrated amateur Blondel d'Azincourt (who had inherited a superb collection from his father Blondel de Gagny). This marked Hoüel's entry into cultivated high society, including the circle of the enlightened patron and hostess Mme Geoffrin.

Hoüel developed an interest in landscape painting early in his career. In 1758 he published a book of landscape engravings, consisting of six engravings after drawings by Boucher, and in 1764 he studied with the landscape and battle painter Francesco Casanova. In 1768 he painted six views of properties belonging to Etienne-François, Duc de Choiseul as overdoors for the music-room of his château at Chanteloup, of which four have survived (Tours, Mus. B.-A.). These works indicate his study of 17th-century northern landscape painting. Such views of estates were relatively rare in 18th-century French art.

At the suggestion of Hoüel's influential patrons, the Directeur des Bâtiments, the Marquis de Marigny, arranged a place for him at the Académie de France in Rome. He arrived in Rome in 1769 and within a month was given permission to accompany the Marquis d'Havrincourt on a trip to Naples. Hoüel became fascinated by the landscape, antiquities and customs of southern Italy, which they visited in the company of the antiquarian Baron d'Hancarville. During his Italian sojourn, Hoüel produced many gouache drawings (Paris, Louvre; Besançon, Mus. B.-A. & Archéol.), which he

exhibited at the Paris Salons of the early 1770s. These exhibits aroused widespread public interest.

In 18th-century France there was relatively little demand for the non-ideal, topographical landscape painting produced by Hoüel. However, there was a market for lavishly illustrated travel books, which Hoüel hoped to exploit through writings, illustrations and engravings of his own travels. He obtained permission to make an extended trip to Sicily, Lipari and Malta from 1776 to 1779, avoiding Naples and southern Italy, already covered by the Abbé Richard de Saint-Non in his book *Voyage pittoresque ou description des Royaumes de Naples et de Sicile* (1781–7). Hoüel published four large volumes between 1782 and 1787, *Le Voyage pittoresque des isles de Sicile, de Malte et de Lipari*. They contain 264 aquatint plates and a long explanatory text. The final publication, much more than just an antiquarian travel book, is a study of the physical and human antiquity and geography of the islands. Hoüel's main intention was to render topography, but he also developed a rare sensitivity to the general effects of nature. He often employed delicate washes of watercolours to reproduce the most subtly observed effects of light and atmosphere. His preparatory drawings were generally made on the spot, while the figures and animals, which enliven the published plates, were added at the time of engraving. Hoüel helped finance his project by selling the drawings after his return to Paris in 1780: Louis XVI acquired 46 (Paris, Louvre), while Catherine II of Russia purchased over 500, of which 260 survive (St Petersburg, Hermitage).

Because Hoüel was involved in the Revolution, the period of Revolution and Empire was a less productive time for him. However, he did publish designs for a triumphal column (1802) and his entry for the competition of 1806 for a public monument at the Madeleine (pubd 1807). He also prepared two illustrated treatises on elephants as well as producing many drawings of animals, which suggest he had further treatises in mind.

Writings

Le Voyage pittoresque des isles de Sicile, de Malte et de Lipari, 4 vols (Paris, 1782–7)

Histoire des éléphants de la ménagerie nationale et relations de leur voyage à Paris (Paris, 1798)

Histoire naturelle des deux éléphants mâle et femelle du museum de Paris, venus de Hollande en France, en l'an VI (Paris, 1803) [drgs for these two treatises on elephants repr. in Vloberg, pls XXVI–XXVII]

Bibliography

M. Vloberg: *Jean Hoüel* (Paris, 1930)

PHILIP CONISBEE

Huë, Jean-François

(*b* Saint-Arnoult-en-Yvelines, 1 Dec 1751; *d* Paris, 26 Dec 1823). French painter. He was a pupil of Joseph Vernet and was admitted to the Académie Royale in 1780, his first exhibit, two years later, being *An Entrance to the Forest of Fontainebleau* (Compiègne, Château). He spent some time (1785–6) in Italy, where he painted historical landscapes in the manner of Claude Lorrain, as well as views of Tivoli and of Naples, such as *Cascade* (Tours, Mus. B.-A.) and *Tivoli* (Cherbourg, Mus. Henry). Huë's greatest claim to fame, however, was the continuation of the series of the *Ports of France*, started by Vernet; in 1791 he went to Brittany, where he painted the *Port of Brest* (three versions), the *Port of Saint-Malo* and the *Port of Lorient*, which he was to paint again when he returned there in 1801 (Paris, Pal. Luxembourg; Paris, Mus. Mar.; Cherbourg, Mus. B.-A.). He also produced historical paintings, such as the *Conquest of the Island of Grenada in 1779* (Versailles, Château) and especially depictions of Napoleonic victories on both land and sea, including the *French Army Crossing the Danube*; the *French Army Entering Genoa*; and *Napoleon Visiting the Camp at Boulogne* (all Versailles, Château). Huë was strongly influenced by Vernet, showing in his paintings the pre-Romanticism that was already apparent in his master's works; but he made even greater play with the effects of light reflected in water and the picturesque aspect of his scenes.

Bibliography

Thieme–Becker

NICOLE PARMANTIER-LALLEMENT

52. Paul Huet: *Breakers at the Tip of Granville*, 1853 (Paris, Musée du Louvre)

Huet, Paul

(*b* Paris, 3 Oct 1803; *d* Paris, 9 Jan 1869). French painter, draughtsman and printmaker. From an early age he painted *en plein air*, especially in Paris and its environs, in the Parc Saint-Cloud and the Ile Séguin. In 1818 he studied briefly in the studio of Pierre Guérin and from 1819 to 1822 he was tutored by Antoine-Jean Gros. In 1820 he also attended the Ecole des Beaux-Arts, and in 1822 he painted the nude figure at the Académie Suisse. Although his first works show the influence of Antoine Watteau and Jean-Honoré Fragonard (e.g. *Elms at Saint-Cloud*, 1823; Paris, Petit Pal.), the major influence was to be that of the English landscape painters, especially after his meeting in 1820 with Richard Parkes Bonington. They became close friends and often painted together in Normandy, and it is sometimes difficult to decide to whom to attribute certain of their works. At the Salon of 1824 in Paris, Huet discovered the work of Constable, and this marked a turning-point in his career: his palette became darker and his paint thicker. He quickly began to show a new sensitivity to the landscape, as is evident in *Sun Setting behind an Abbey* (1831; Valence, Mus. B.-A. & Hist. Nat.), inspired by one of Victor Hugo's poems. Huet was considered to be an innovator in the depiction of landscape in a Romantic vein, and by 1830 he had become one of the leading painters in this manner. Having made his début at the Salon in 1827, he continued to exhibit there until 1869. He also exhibited in 1834 at the Exposition des Beaux-Arts in Lille, where he received a gold medal for his painting *Landscape: Evening* (Lille, Mus. B.-A.), an evocative composition of a woman by the bank of a stream. In 1841 he was made Chevalier de la Légion d'honneur and in 1855 showed at the Exposition Universelle in Paris, where *Flood at Saint-Cloud* (Paris, Louvre) was successfully received.

Huet travelled widely in the French provinces and was particularly fond of Normandy. In 1818, 1821, 1825 and 1828 he visited Trouville and Fécamp and, in 1829, Calais. At various times in the 1830s he was in Honfleur and Rouen, where he advised Théodore Rousseau. From 1822 he painted and sketched in the forest of Compiègne, and in 1833 he was one of the first to become interested in the region of the Auvergne. That year he also made his first trip to Avignon and Aigues-Mortes in the south of France, and he returned there in 1836. From 1838 he spent many winters at Nice, where he painted watercolours bathed in light. He also did several pen-and-ink drawings of coastal rocks (e.g. *Rocks at Nice*; Lille, Mus. B.-A.), a favourite subject of his. In 1841–3 he made an extensive tour of Italy, and in 1849 he began to paint in the forest of Fontainebleau. He returned to Normandy in the 1850s and 1860s, visiting such places as Trépont (1853) and Etretat (1868). He visited London in 1862 and Belgium and the Netherlands in 1864 to see the works of Rembrandt and Rubens. On all of his trips he painted and sketched extensively in watercolour, pastel and pencil. He was especially adept at painting in watercolour, a medium that he had mastered at an early age and to which he lent his own innovative quality. Throughout his career he was primarily concerned with interpreting variations in atmosphere, expressing the moods of nature and seeking out the contrasts of light and shade that occur in forests, storms and floods (e.g. *The Abyss: Landscape*, 1861; Paris, Louvre). He applied his paint in a thick impasto to enable him to render the play of light (see fig. 52). His style of landscape painting influenced the work of the members of the Barbizon school, as well as that of the Impressionists. He was a close friend of Delacroix, and he also knew the writers Alphonse de Lamartine, Charles-Augustin Sainte-Beuve, Victor Hugo, Jules Michelet and the sculptor David d'Angers. He also produced wood-engravings and lithographs (e.g. *The Heron*, 1833) in which he experimented with contrasts of light and dark and of tones, and in 1831 he contributed illustrations to *Voyages pittoresques et romantiques dans l'ancienne France* (Paris, 1820–78) by Baron Isidore-Justin-Séverin Taylor and Charles Nodier. His son René-Paul Huet (*b* 1844) was also a painter and was his pupil.

Bibliography

L. Delteil: *Le Peintre-graveur Paul Huet*, vii (Paris, 1911)

R.-P. Huet: *Paul Huet: D'après ses notes, sa correspondance, ses contemporains* (Paris, 1911)

P. Miquel: *Paul Huet: De l'aube romantique à l'aube impressionniste* (Paris, 1962)

Paul Huet (exh. cat., Rouen, Mus. B.-A., 1965)

P. Miquel: *Le Paysage français au XIXe siècle, 1824–1874* (Maurs-la-Jolie, 1975), pp. 194–247

LAURENCE PAUCHET-WARLOP

Ingres, Jean-Auguste-Dominique

(*b* Montauban, 29 Aug 1780; *d* Paris, 14 Jan 1867). French painter. He was the last grand champion of the French classical tradition of history painting. He was traditionally presented as the opposing force to Delacroix in the early 19th-century confrontation of Neo-classicism and Romanticism, but subsequent assessment has shown the degree to which Ingres, like Neo-classicism, is a manifestation of the Romantic spirit permeating the age. The chronology of Ingres's work is complicated by his obsessive perfectionism, which resulted in multiple versions of a subject and revisions of the original. For this reason, all works cited in this article are identified by catalogue raisonné number: Wildenstein (w) for paintings; Naef (N) for portrait drawings; and Delaborde (D) for history drawings.

I. LIFE AND WORK

1. Montauban, Toulouse and Paris, 1780–1806

His father, Jean-Marie-Joseph Ingres (1755–1814), a decorative painter and sculptor as well as an amateur musician, taught him the basics of drawing and also the violin. In accord with contemporary academic practice, Ingres devoted much of his attention to copying from his father's collection of prints after such masters as Raphael, Titian, Correggio, Rubens, Watteau and Boucher; none of

Revoil. Signed and/or dated works from this period are scarce. It was in David's studio that the principles of the German theorist Johann Joachim Winckelmann and his apotheosis of Greek art became part of Ingres's artistic credo and that he first became aware of the beauty inherent in the work of such Italian painters as Giotto, Masaccio, Fra Angelico and Perugino. During the next five years Ingres found his own eclectic balance of these stylistic contradictions, to which he added a personal elevation of Raphael as the ultimate classical ideal. He trained his eye to be as acute as David's and sought an even greater degree of historical authenticity.

In 1801 Ingres won the Prix de Rome with the *Envoys of Agamemnon* (w 7, 1801; Paris, Ecole N. Sup. B.-A.), which John Flaxman described as the best painting he had seen from the modern French school. Subsequently Flaxman's illustrations to Homer and Dante became a staple in Ingres's artistic diet, reinforcing his natural proclivity for abstract linearity. *Venus Wounded by Diomedes* (w 28, c. 1804–6; Basle, Kstmus.) was painted in direct emulation of Flaxman. Ingres could not immediately claim his prize as the Académie de France in Rome had yet to be funded by the government. He was given a small bursary and studio space and a share of available government portrait and copy commissions. In July 1803 he received the commission for a portrait of *Bonaparte as First Consul* (w 14, 1804; Liège, Mus. B.-A.) for the city of Liège, the first acknowledgement that he was becoming one of the leading portraitists of his time.

At the end of 1805 funds were made available for the Prix de Rome stipends. However, Ingres delayed his departure until the last possible moment, submitting five portraits to the Salon of 1806 just before it opened: a *Self-portrait Aged 24* (w 17, 1804; Chantilly, Mus. Condé); portraits of *Philibert Rivière*, *Mme Philibert Rivière* and *Mlle Caroline Rivière* (w 22–4, 1806; all Paris, Louvre) and a portrait of *Napoleon I on the Imperial Throne* (w 27, 1806; Paris, Mus. Armée). An additional incentive for him to remain in Paris was his engagement in June 1806 to Julie Forestier (*b* 1789), a painter and musician.

53. Jean-Auguste-Dominique Ingres: *Oedipus and the Sphinx*, 1808 (Paris, Musée du Louvre)

these copies survives. The earliest known drawings, some signed *Ingres fils*, are portrait sketches and miniatures of family members and Montauban acquaintances (N 1–8). He studied at the academy in Toulouse with the history painter Guillaume-Joseph Roques and the sculptor Jean-Pierre Vigan (*d* 1829): only a selection of school drawings remains and some records of prizes for excellence in 'composition', 'figures and antique', 'rounded figure' and 'life studies'. He studied landscape painting with Jean Briant (1760–99) and continued his musical training. His entry into the Paris studio of David in 1797 brought him into contact with the most talented artists of his generation—among David's former students still frequenting the studio were Jean-Germain Drouais, François-Xavier Fabre, Anne-Louis Girodet and Antoine-Jean Gros; studying at the same time as Ingres were Lorenzo Bartolini, Etienne-Jean Delécluze, Auguste Forbin, François-Marius Granet, Jean-Pierre Granger (1779–1840), Charles Langlois, Fleury Richard and Pierre

2. Rome, 1806–10

En route to Rome, Ingres stayed briefly with Lorenzo Bartolini's family in Florence, where he received letters with news of the adverse criticism his paintings had received at the Salon. After his arrival in Rome in October 1806, he discovered that even David had found his *Napoleon* 'unintelligible'. Stunned, Ingres realized that he could not leave Rome until he had proved himself to the Parisian art establishment. On 26 December 1806 he moved into the small pavilion of S Gaetano in the grounds of the Villa Medici (home of the Académie de France from 1803). It had a magnificent view of Rome and gave him the privacy he needed to work. A series of landscape drawings and small oil paintings records his response to the city (see 1960 exh. cat.).

In 1807 Ingres began two history paintings. Pen-and-ink sketches (Montauban, Mus. Ingres, 867.2302, 2303) show the evolution of the *Venus Anadyomene* (W 257, completed 1848; Chantilly, Mus. Condé), which was inspired by Botticelli's *Birth of Venus* (Florence, Uffizi). In a letter (Feb 1806) he stated his intention of painting a half life-size *Antiochus and Stratonice*, later (29 May) mentioning that he was going to invite Lucien Bonaparte to his studio to see it as soon as it was finished, although it was not until 1808 that the meeting actually took place (portrait drawing of *Lucien Bonaparte*, N 45; New York, priv. col.). The relationship between the wealthy patron and the ambitious young artist soured, however, when Bonaparte requested Ingres's services not as a history painter but as a copyist. Ingres executed few portraits during these early years in Rome. He continued to work on the *Antiochus and Stratonice* (W 232; Chantilly, Mus. Condé; see fig. 56) for the next 30 years, until he finished it for Ferdinand-Philippe, Duc d'Orléans, in 1840; the *Venus* remained unfinished until 1848. These works set a characteristic pattern of procrastination in a search for perfection.

In 1808 Ingres prepared three compositions, all focusing on his expertise with the nude figure, for the annual *envoi* to the Ecole in Paris. The first, now known as the Valpinçon *Bather* (W 53, 1808; Paris, Louvre), is a female bather seen from behind and is derived from the study of a *Half-length Bather* (W 45, 1807; Bayonne, Mus. Bonnat); both of these seem inspired by the nudes of Flaxman and Bronzino and reveal for the first time the cool sensuality that became characteristic of Ingres's vision. The second *envoi* was *Oedipus and the Sphinx* (W 60, 1808; Paris, Louvre; see fig. 53). A third painting, *Reclining Woman* (later called the *'Sleeper of Naples'*, W 54, 1808; lost in 1815), was listed in the Villa Medici catalogue of 1808 but was not sent to Paris, being bought by Joachim Murat, King of Naples. The criticism of the paintings for their unorthodox stylizations and departure from academic propriety left Ingres puzzled and angry at the lack of appreciation for his talents.

During his last two years at the Villa Medici, Ingres continued to establish potentially useful connections. Among fellow winners of the Prix de Rome, for instance, was Jacques-Edouard Gatteaux with whom he formed a lifelong friendship and through whom he was introduced to Charles Marcotte d'Argenteuil (1787–1864). The resultant portrait (W 69, 1809; Washington, DC, N.G.A.) clearly reveals what a congenial spirit Ingres found his sitter to be. Commissions from several other French government officials followed, and Ingres's income in Rome was assured.

3. Italy, 1811–15

Encouraged by the steadiness of commissions in Rome, in November 1810 Ingres took an apartment at 40 Via Gregoriana at the end of his tenure at the Villa Medici. Living near by was Granet, of whom there are several portrait drawings (e.g. N 86, 1812; Aix-en-Provence, Mus. Granet), and the two painters had free government studios in the church of S Trinità dei Monti. Ingres was still completing his last *envoi*, the large-scale *Jupiter and Thetis* (W 72, 1811; Aix-en-Provence, Mus. Granet), a subject he had first considered in 1806. He envisioned a 'divine painting' that would convey the full beauty of the god-like forms and expressions. His Jupiter is a masterly image of male power; the sensuous curves and pliant posture of Thetis express eloquently the sensual intimacy between the two immortals. To Ingres's distress,

54. Jean-Auguste-Dominique Ingres: *Tu Marcellus eris*, fragment cut from a version of *Virgil Reading from the 'Aeneid' before Augustus and Livia*, 1813–14 (Brussels, Musées Royaux d'Art et d'Histoire)

the painting was severely criticized: in his attempt to reconcile prevailing taste and the classical spirit, he failed to see how unorthodox his painting was in combining an intimate love theme with a massive scale and in introducing wildly manneristic exaggerations of contour and proportion.

For the next two years Ingres devoted himself to three monumental decorative paintings: *Romulus Victorious over Acron* (w 82, 1812; Paris, Ecole N. Sup. B.-A.) and the *Dream of Ossian* (w 87,

1813; Montauban, Mus. Ingres), both for the Palazzo di Monte Cavallo, and *Virgil Reading from the 'Aeneid' before Augustus and Livia* (w 83, 1812; Toulouse, Mus. Augustins) for the residence of General François de Miollis (1759–1828), the French lieutenant-governor who oversaw the renovation of Monte Cavallo (the pontifical palace on the Quirinal was being made into the residence of the King of Rome). The programme was an ambitious mixture of painting and sculpture in the

Neo-classical style: its theme was the parallel between Roman and Napoleonic history. Antonio Canova oversaw the selection of artists, which included the Danish sculptor Bertel Thorvaldsen. This commission marked the acceptance of Ingres as a history painter. *Romulus Victorious over Acron* was one of three antique battle scenes for the salon of the Empress. Ingres followed Plutarch's *Life of Romulus* closely, striving for archaeological correctness. The archaisms of the work's stylized composition and the flat colouring were intended to imitate an antique low relief. The *Dream of Ossian*, begun in 1812 in collaboration with Jose Alvarez y Priego, was intended as an oval ceiling decoration for the Emperor's bedroom. (When Ingres bought it back in the 1830s he began to rework it into a rectangular format; it was in his studio with its perimeters unfinished at his death.) *Virgil Reading from the 'Aeneid' before Augustus and Livia*, a night scene painted for General Miollis's bedroom in the Villa Aldobrandini, is perfectly attuned to the traditional Neo-classical approach to subject-matter: action is frozen, emotion is held in check, gestures tell all. (It too was repurchased, reworked and left unfinished: see below.)

The large commissions were completed by May 1813. Having firmly established his reputation in Rome, Ingres looked to secure a place in Paris. He set to work on an ambitious plan for the Salon of 1814, at which he hoped to outshine the popular historical genre painters. In a letter of July 1813 he mentioned plans to send two *grands tableaux*, two portraits, a painting of the *Interior of the Sistine Chapel* (W 91, 1814; Washington, DC, N.G.A.), which had been commissioned in 1812 by Marcotte, and a small painting of *Raphael and La Fornarina* (W 86, 1813; untraced). Neither of the *grands tableaux* was completed: *Tu Marcellus eris* (W 128; Brussels, Musées Royaux A. & Hist.; see fig. 54) is a fragment of the three central figures from a revised *Virgil Reading* cut down (at a later date) from the composition Ingres intended to send to this Salon; it is uncertain what the second *tableau* was to have been. The *Interior of the Sistine Chapel* was finished in summer 1814 and was sent to the Salon accompanied only by another historical genre piece, *Don Pedro of Toledo Kissing the Sword of Henry IV* (W 101, exh. Salon 1814; untraced). It was hardly the *tour de force* that Ingres intended. *Raphael and La Fornarina* reached Paris just days before the Salon closed.

While preparing for the Salon, on 4 December 1813 Ingres married Madeleine Chapelle (1782–1849), beginning 36 years of personal security and happiness. A series of portraits shows his contentment within this new family circle (N 98–111). Another diversion from preparations for the Salon was a summons to Naples, where he spent February to May 1814, painting the *Grande Odalisque* (W 93, 1814; Paris, Louvre) as a pendant to the 'Sleeper of Naples'. A full-length oil portrait of *Caroline Murat, Queen of Naples* (W 90, 1814) and the *Sleeper* were lost from the palace in May 1815 with the fall of the Murat régime, but a series of portrait drawings of the family remains (N 116–21). He also painted two smaller Troubadour style love scenes for Caroline Murat—the *Betrothal of Raphael* (W 85, 1813; Baltimore, MD, Walters A.G.), which Ingres boasted he completed in just 20 days, and the first version of *Paolo and Francesca* (W 100, c. 1814; Chantilly, Mus. Condé).

4. Rome, 1815–20

As the withdrawal of the Napoleonic forces from Italy cut off avenues of financial support, Ingres was forced to turn to drawing portraits of tourists and later a host of new officials of the French Restoration government. Eventually these connections led to new historical commissions, but in the meanwhile he was distressed by having to waste time on such portraits. In contrast to these, many of the portrait drawings Ingres did of friends are exquisite in the loving detail he lavished on them. One of the most intimate, and a perfect example of the type, is his portrait of the *Guillon-Lethière Family* (N 140, 1815). In the winter of 1816–17 Ingres received a commission from the Alba family for three small paintings with subjects taken from Spanish history. For *Philip V and the Marshal of Berwick* (W 120, 1818; Madrid, Pal. Liria, Col. Casa de Alba), a scene from 18th-century Alba family history, Ingres raided the Gobelins tapestry series the *Story of the King* for stylistic prototypes. The

figures, diminutive in comparison with his other work, are subordinated to the props of the scene, dressed in period costumes, each playing their assigned role. The subject—the Spanish king rewarding a loyal subject—is purely anecdotal, and Ingres had little personal commitment to it. The subject of the second painting moved Ingres from disinterest to disgust. The *Duque de Alba at Ste Gudule, Brussels* (W 102, 1816–17; Montauban, Mus. Ingres) had as its 'hero' the man who led the Catholic campaign in the Low Countries against the Protestant Reformation and who was responsible for the slaughter of hundreds of innocent people. At first Ingres had in mind a horizontal composition with the protagonist receiving honours from the archbishop. Infra-red photographs reveal that the original format of the canvas was identical with that of a drawing (D 216; ex-Paul Rosenberg & Co., New York) done as a model. Then he switched to a vertical format in order to put as much distance as possible between the viewer and the Duque, the latter becoming almost a speck on the horizon in a long view down the nave of Ste Gudule. Even that did not ease his scruples, and in 1819 Ingres abandoned the canvas. The third painting never reached the drawing phase.

Ingres made concerted efforts to build up connections with the new French Restoration circles in Rome. Commissions were not only smaller but less frequent than in the glorious days of the Empire. It may be fortuitous, or it may reflect a political astuteness for which Ingres does not often receive credit, that the paintings he sent to the first Restoration Salon (1814) were particularly appropriate to a post-Napoleon environment: the *Sistine Chapel* (W 91) and *Don Pedro of Toledo* (W 101). He lost no time in ingratiating himself with the new leadership. He enjoyed the friendship of three diplomatic secretaries, Gabriel de Fontenay (1784–1855), Artaud de Montor and Augustin Jordan (1773–1849), and profited from their acquaintance in many ways. He drew their portraits, made gifts of drawings of his latest genre subjects, and even made a rare venture into printmaking, transforming the portrait of the ambassador *Mgr de Pressigny* (N 170; priv. col.)

into an etching, which he hand-tinted. Mgr de Pressigny (1745–1823) was soon replaced by Pierre-Louis-Casimir, Comte (later Duc) de Blacas, a man of independent fortune, powerfully connected to the inner circle of government. Ingres's relationship with this patron yielded two exquisite Bourbon cabinet pictures for Blacas's personal collection, *Henry IV Playing with his Children* (W 113, 1817; Paris, Petit Pal.), a classic of the Restoration Troubadour style that shows Henry IV down on his knees in a cosy domestic scene, and its pendant, the *Death of Leonardo da Vinci* (W 118, 1818; Paris, Petit Pal.), which depicts the artist dying in the arms of Francis I.

In July 1816 Charles Thévenin (1764–1838), the new director of the Académie de France, began successfully to lobby the Direction des Beaux-Arts in Paris on Ingres's behalf. In January 1817 Blacas chose Ingres as one of the artists for the renovation and the decoration of Trinità dei Monti, the focus of the French colony in Rome. *Christ Giving the Keys to St Peter* (W 132; Montauban, Mus. Ingres) was completed in March 1818 for a fee of 3000 francs. Ingres certainly knew the versions of the subject by Raphael (tapestry cartoon, 1515; London, V&A) and Poussin (*Ordination*, 1639–40; Belvoir Castle, Leics), but while they included all twelve Apostles, Ingres reduced the number to six, while retaining the symbolic position of Judas, who stands apart from the others. (Characteristically, he retouched the painting in the 1840s when the Dames du Sacré-Coeur exchanged it with the French government for a copy.) The Comte de Blacas acted as an intermediary in the acquisition by Louis XVIII of *Roger Freeing Angelica* (W 124, 1819; Paris, Louvre), Ingres's first sale to the State and also the first work by him to enter a public collection (by 1824 it had been moved to the Musée du Luxembourg, Paris). With his confidence as a history painter re-established by these commissions, Ingres sent *Roger Freeing Angelica* to the Salon of 1819 with the *Grande Odalisque*. James-Alexandre, Comte de Pourtalès-Gorgier, acquired the latter from the Salon, as he had *Raphael and La Fornarina* in 1814, but critics and public alike found the arbitrariness of the odalisque's anatomical structure shocking and found so little

55. Jean-Auguste-Dominique Ingres: *Apotheosis of Homer*, 1827–33 (Paris, Musée du Louvre)

to interest them in the *Angelica* as to misidentify the scene as representing Perseus and Andromeda. Ingres felt that the three public exhibitions of his work in 1806, 1814 and 1819 had ridiculed him in Paris, and he determined to stay in Italy.

5. Florence, 1820–24

In August 1820 Ingres moved to Florence, where he hoped to renew contact with Bartolini and to explore the artistic and architectural wealth of the city. Bartolini had become a famous sculptor, and the friendship did not survive. Immediately after his installation at Bartolini's home, Ingres finished a variant of the *Sistine Chapel* (w 131, 1820; Paris, Louvre). He made a copy of Titian's *Venus of Urbino* (w 149, 1822; Baltimore, MD, Walters A.G.) for Bartolini to use as a model for his *Recumbent Venus* (1822; Montpellier, Mus. Fabre)

and did a portrait of *Bartolini* (w 142, 1820; Paris, Louvre). He also copied a painting in the Uffizi that he believed to be a self-portrait by Raphael (w 163; Montauban, Mus. Ingres), drew the churches of Florence and the gardens and visited Lucca, Siena and Pisa. In 1821 Ingres did two portrait commissions, *Count Nicolas Dmtrievitch de Gouriev* (w 148; St Petersburg, Hermitage) and *Mlle Jeanne Gonin* (w 147; Cincinnati, OH, Taft Mus.). The Gonin family became lifelong friends, their household being a model of Ingres's ideal world: a patriarchal merchant husband, a devoted wife, clever children and a wide circle of worthy friends and relatives.

One of the commissions Ingres had 'in progress' when he arrived from Rome was from the Comte de Pastoret (1791–1859) for a small history painting of the *Entry into Paris of the*

Dauphin, the Future Charles V (w 146, 1821; Hartford, CT, Wadsworth Atheneum) derived from that of 1358 by Jean Froissart. The figure welcoming the Dauphin was one of Pastoret's relatives. The medieval prototypes Ingres sought in developing the painting are to be found in the vignettes from the *Grandes Chroniques de France* (Paris, Bib. N., MS.fr.6465), which Ingres traced from Bernard de Montfaucon's *Les Monumens de la monarchie française* (Paris, 1729–33, iii, pl. XXII and XXXIX). He also borrowed from Jean Fouquet's *Reception of the Emperor Charles IV* (*Grandes Chroniques*, fol. 419) and Franz Pforr's *Entry of Rudolf I of Habsburg into Basle in 1273* (1808–9/10; Frankfurt am Main, Städel. Kstinst). Though finished in 1821 and listed in the Salon catalogue for 1822, the *Entry into Paris* was not shown until two years later, when it received critical acclaim.

Shortly after his arrival in Florence, Ingres received word from Thévenin of a government commission for a religious painting on a grand scale. The official request was for a painting for the choir of Montauban Cathedral; Ingres's response was a plan for a confrontation at the Salon of 1822. The mayor had asked for a work that would show the King placing the royal family of France under the protection of the Virgin at the time of her Assumption. At first Ingres protested that these were two distinct subjects; later he realized the concept was perfect for the Raphaelesque solution he found in the *Vow of Louis XIII* (w 155, 1824; see col. pl. XXII). His representation of the Virgin and Child is a reversal of the *Madonna of Foligno* (1511–12; Rome, Pin. Vaticana) by Raphael. His image of Louis XIII is from a painting of the same name by Philippe de Champaigne (1637–8; Caen, Mus. B.-A.). Ingres had these borrowings firmly in place with an oil sketch by 1822 (w 156; Montauban, Mus. Ingres), but he failed to deliver the painting for two more years because once again his grandiose intentions inhibited his ability to realize the dream. In late 1821 Ingres mentioned that he expected to cover the cost of personally bringing his *Vow* to Paris by finishing a painting begun in 1807, the *Venus Anadyomene*. By January 1822 he had found a buyer for the work, Jacques-Louis Leblanc (1774–1846), a man

of patience who advanced funds against the intended purchase and yet never questioned that the *Vow* would take precedence over his commission. By December 1823 the *Vow* had progressed to the point where Ingres expected to bring it to Paris by the spring. However, it was not until November 1824 that he arrived.

6. Paris, 1824–34

The *Vow of Louis XIII* appeared at the Salon on 12 November 1824. Its favourable reception was essentially a tribute to the long-absent artist. Also, the work was sufficiently orthodox in its presentation of traditional values to stand against such Romantic incursions as Delacroix's *Massacre at Chios* (1824; Paris, Louvre; see fig. 22). In early 1825 Ingres received the Cross of the Légion d'honneur, was invited to attend the coronation of Charles X and was elected to the Académie des Beaux-Arts. By July Ingres was installed in a two-room studio with his prints, books, earlier canvases and drawings to inspire, and distract, him. In November 1825 he opened a studio for students, foremost among whom were Eugène-Ammanuel Amaury-Duval, Paul Chenavard, Armand Cambon (1819–85), Raymond Balze (1818–1909) and Paul Balze (1815–84), Auguste Flandrin and Hippolyte Flandrin, Henri Lehmann, Franz Adolph von Stürler (1802–81) and Sébastien Cornu. One of the first fruits of his new place as champion of the classical tradition was a commission from the Bishop of Autun for a monumental religious subject, the *Martyrdom of St Symphorian* (w 212, 1827–34; Autun Cathedral). Shortly afterwards he received the commission for the *Apotheosis of Homer* (w 168, 1827–33; Paris, Louvre; see fig. 55) for the ceiling of one of the nine rooms dedicated to Egyptian and Etruscan antiquities in the Musée Charles X (now Musée du Louvre) to be inaugurated in 1827. The transport of the *Vow of Louis XIII* to Montauban was delayed by Ingres's efforts to keep the work in Paris at one of the more prestigious churches. Abandoning that plan, he kept it for several months so that the engraver Luigi Calamatta could make a drawing of it. The painting was unveiled in the city hall in Montauban on 12 November 1826, the only time Ingres ever returned to his birthplace. On his way

back to Paris, he stopped in Autun, where he made studies of the old Roman wall for the *St Symphorian*: an oil sketch (w 202, 1827; New York, priv. col.) was completed by February, by which time a watercolour study of *Homer* (D 178, Lille, Mus. B.-A.) was also well advanced.

During this ten-year period in Paris Ingres carefully manipulated his connections with French society: portrait drawings from this time onwards were exclusively for friendship and/or favour (the two were often linked) and never directly for money. His oil portraits of *Mme Marcotte de Sainte Marie* (w 166, 1826; Paris, Louvre) and *Comte Amédée-David de Pastoret* (w 167, 1826; Chicago, IL, A. Inst.) were sent to the Salon of 1827. A portrait of *Charles X* (w 206, 1829; Bayonne, Mus. Bonnat) was followed by paintings that mark the passage from the Restoration to the bourgeois government of the July Monarchy (1830): both the founder and director of the *Journal des Débats* (*Louis-François Bertin*, w 208, 1832; Paris, Louvre) and Louis-Philippe's prime minister (*Comte Louis-Mathieu Molé*, w 225, 1834; priv. col.) symbolized the new age. Painfully aware that the work he had produced during the previous two decades was virtually unknown in France, Ingres was determined to launch prints of his work soon after his arrival in Paris. James Pradier bought engraving rights to *Virgil Reading the 'Aeneid'* and *Raphael and La Fornarina* in February 1825; Pierre Sudre (1783–1866) bought lithographic rights for the *Grande Odalisque* in 1826; Théodore Richomme (1785–1849) had engraving rights to *Henry IV Playing with his Children* and Charles-François Sellier to the *Death of Leonardo*. These contracts ended financial need, yet Ingres's fussing over the details of how these prints were done, coupled with obsessive reworking of earlier compositions in replicas and revisions from 1828 to 1833, resulted in a marked decline in his artistic output.

The deadline for the Louvre commission, the *Apotheosis of Homer*, was linked to the opening of the 1827 Salon. While Ingres was still laying in preliminary contours on the canvas, the other artists agreed they could be ready in time. Though in place when the Salon opened, the painting was finished only in grisaille; Ingres eventually completed it for the opening of the Salon of 1833. He was now ready to take up again the *Martyrdom of St Symphorian*, depicting the moment at which the young Christian is led out of the city gate to be beheaded. Although the format had been resolved by February 1827, and Ingres listed it in the Salon catalogue of that year, it was not shown until the Salon of 1834; its discordances of space, perspective, emotion and colour were deemed contrary to academic practice, and the painting was damned as an unsuccessful marriage of Raphael and Michelangelo. Profoundly discouraged, Ingres decided to abandon the Paris art scene. He requested, and received on 5 July 1834, the directorship of the Académie de France in Rome. His Paris studio was abruptly closed. He swore that he would neither submit his works to public exhibition nor undertake government commissions ever again; henceforth he would do only small paintings for friends.

7. Rome, 1835–41

Ingres replaced Horace Vernet as director at the Villa Medici. He and his wife soon gathered round them an intimate circle of young artists, including the composer Ambroise Thomas (1811–96), the architect Victor Baltard, the painter Hippolyte Flandrin and the sculptor Pierre-Charles Simart. At first Ingres buried himself in administrative details. In January 1836 his direct superior Adolphe Thiers asked him to return to Paris to work on paintings for the church of La Madeleine. Ingres politely declined; but he did have a new project in mind, the *Odalisque with Slave* (w 228, Cambridge, MA, Fogg), which he completed in 1839, part token of his friendship with Marcotte, and part repayment for Marcotte's advance in 1825 to Calamatta for engraving the *Vow*. Ingres also had another commitment. In 1834 Ferdinand-Philippe, Duc d'Orléans, eldest son of Louis-Philippe and a prominent Parisian art collector, had commissioned an *Antiochus and Stratonice* (see fig. 56) as an unlikely pendant to Paul Delaroche's *Death of the Duc de Guise* (1834; Chantilly, Mus. Condé). Ingres had begun work on this subject in 1807 and had reconsidered it several times in the 1820s.

56. Jean-Auguste-Dominique Ingres: *Antiochus and Stratonice*, 1834–40 (Montpellier, Musée Fabre)

Despite a period of debilitating illness, Ingres continued to work as much as possible. He resumed painting in September 1837, and he was still involved with the *Antiochus* in January 1839; pressure for completion was being applied by Pradier, who had been promised reproduction rights. It was August 1840 before the painting was sent back to Paris. By then the simple cast of three in a narrow rectangular format had developed into a theatrical cast of characters in a room, the architecture of which was based on designs by Victor Baltard and mostly executed by the Balze brothers. The impressive array of auxiliary characters and the splendour of the room reflect Ingres's attempt to match the *juste-milieu* style of Delaroche. The Musée Ingres, Montauban, has more than 100 sheets containing over 300 drawings showing his search for the right balance of detail; there are over 40, for instance, for the position of the arm of Antiochus. Gatteaux delivered the painting to the Duc d'Orléans, who wrote personally to thank Ingres and included payment of 18,000 francs, nearly double the agreed price. The

Duc authorized a showing of the completed *Antiochus and Stratonice* each day in the most beautiful Salon of the Tuileries. Never had a work by Ingres excited such admiration.

8. Paris, 1841–55

In May 1841 Ingres returned to Paris, where he was received with acclaim following the favourable reception of the *Antiochus and Stratonice*. In November that year he began a portrait of *Ferdinand-Philippe, Duc d'Orléans* (w 239; Louveciennes, priv. col.), which was delivered to the Palais-Royal by May 1842. At the request of Queen Marie-Amélie (1782–1866), Louis-Philippe commissioned a religious painting for the chapel of the château at Bezy (*Christ among the Doctors*, w 302, completed 1862; Montauban, Mus. Ingres), and in June 1842 he purchased *Cherubini with the Muse of Lyric Poetry* (w 236, 1842; Paris, Louvre) for the State collection.

Ingres declined to reopen his studio on his return to Paris as he was assured of a secure income not only from such commissions as the *Golden Age*

(see below) but also from society portraits. At the end of June 1842 he was doing an oil sketch (w 238, Paris, priv. col.) for the portrait of the *Comtesse d'Haussonville* (w 248, completed 1845; New York, Frick) and was about to have his first sitting with the Baronne James de Rothschild (1805–86). Despite his many complaints about the inconvenience such portraits caused, he still gave them the same attention as his history paintings. With the accidental death of the Duc d'Orléans in July 1842, Ingres lost a patron who had shown him much respect and understanding. Shortly afterwards Louis-Philippe asked for a copy of his son's portrait (w 242, 1843; Versailles, Château), and within a year five more copies of the portrait, in varied formats, were requested. The Queen erected a memorial chapel dedicated to St Ferdinand at Dreux and commissioned designs for its stained-glass windows from Ingres. He completed his cartoons (in colour) for the 25 windows with incredible speed in August and September 1842 (Camesasca, 1971, no. 135a–q; Paris, Louvre). In November 1843 he received a request for stained-glass window designs for the royal chapel of St Louis at Dreux, which held the tombs of the Orléans family (Camesasca, 1971, no. 136a–h; Paris, Louvre), and the designs were completed by June 1844.

Meanwhile in 1843 Ingres had begun work on the largest commission of his career. The Duc de Luynes wanted pendant murals of the *Golden Age* and the *Iron Age* (unfinished; each mural 4.8 ×6.6 m) as the principal decorations of the Salon de Minerva, a large room on the second floor of the family château at Dampierre. The theme of the *Golden Age* was intended to compare 19th-century Paris with the ideal world at the beginning of time. The literary and artistic sources ranged from Ovid and Hesiod to Mantegna, Raphael, Agostino Carracci, Poussin, Watteau and Anton Raphael Mengs, and Ingres found further inspiration in Milton's *Paradise Lost*. The project was to occupy him for several years. When Gatteaux asked to see the work in progress in the summer of 1844 Ingres refused, as not even the Duc de Luynes had been admitted to the gallery.

In June 1845 Ingres brought the portrait of the *Comtesse d'Haussonville* to a remarkable conclusion. It attracted virtually all Parisian high society to his studio, including the sitter's brother, the Prince de Broglie (1785–1870), who immediately commissioned a portrait of his wife the *Princesse de Broglie* (w 272, 1853; New York, Met.). About this time Ingres did cameo portrait pendants in grisaille of the Queen and her daughter-in-law, the *Duchesse d'Orléans* (Camesasca, nos 141–2; Paris, Mus. A. Déc.). By the summer of 1845 the *Golden Age* was progressing steadily, and both Gatteaux and Marcotte were invited to see it in late October. By June 1847 *Christ among the Doctors* was well advanced, and Ingres had again taken up the *Venus Anadyomene* (begun 1807), now for Etienne Delessert (1735–1816). In October 1847 Henri-Eugène-Philippe-Louis, Duc d'Aumale (Louis-Philippe's fifth son), offered Ingres a commission for cartoons for the stained-glass windows of a chapel he wanted to restore in his château at Chantilly. The project was cut short by the Revolution of February 1848; Ingres also lost his client for *Christ among the Doctors*, when Louis-Philippe was deposed and his art collection dispersed.

In the opening months of 1848 social life in Paris halted, and Ingres found the solitude he needed to finish the *Venus Anadyomene* and the portrait of *Baronne James de Rothschild* (w 260, priv. col.). Delessert dared to complain of irregularities in the Venus's proportions, and the work was sold in an instant to Frédéric Reiset (1815–91). Ingres excused himself from work on the murals at Dampierre that summer, claiming that the political climate made work impossible. In October he accepted an invitation to be on the Commission des Beaux-Arts, where, remembering his own painful entry into the artistic establishment, he abandoned his conservatism and argued for an open Salon. He was named vice-president of the Ecole des Beaux-Arts for 1849.

When his wife Madeleine died on 27 July 1849, Ingres seems to have felt that his own life had come to an end also. The families of his friends and students placed him under attentive care, and portrait drawings of this supportive circle show the artist being nurtured back into life (N 414–21). One of his disciples, Albert Magimel (1799–1877), suggested that Ingres should prepare his collected

works for publication in outline format (Magimel, 1851). Ostensibly a simple exercise in line reproduction based on tracings of his compositions from his portfolios, the project gave Ingres new life. By June 1851 he had returned to portrait painting, blocking in the portrait of the *Princesse de Broglie* and working on the first of two portraits of *Mme Moitessier* (W 266, 1851; Washington, DC, N.G.A.). As soon as Ingres finished the view of Mme Moitessier standing, he resumed work on a portrait of her seated (W 280, completed 1856; London, N.G.), which he had begun in 1844 as a double portrait of her and her daughter. At this time Ingres believed that his career was nearly at an end. He had abandoned the Dampierre commission in 1850, much to the disappointment of the Duc de Luynes. In July 1851 he donated his art collection to the museum at Montauban, and in October he resigned from the Ecole des Beaux-Arts. However, the beginning of the Second Empire and his marriage on 15 April 1852 to Delphine Ramel (1808–87; portrait drawing, N 427; Bayonne, Mus. Bonnat) rejuvenated him. Close friends realized how painful the loss of his first wife had been and how necessary a second wife was. The only disadvantage of the new marriage was the 'swarm of portraits' required for his extended family (N 428–32, 435–8, 441–2, 448).

In 1851 Guisard, the Directeur des Beaux-Arts, had asked Ingres to paint a subject of his choice for the State. The only stipulation was that Ingres submit a drawing for the approval of the government. Ingres rejected the offer, proposing instead to finish two works already under way in his studio. Guisard agreed, and paintings of the *Virgin with the Host* (W 276) and *Joan of Arc* (W 273; both Paris, Louvre) were delivered in 1854. Both works were repetitions of subjects that he had executed in the 1840s: a painting of the former had been commissioned by the future Tsar Alexander II (W 234, 1841; Moscow, Pushkin Mus. F.A.); the latter is based on his drawing (1844; Paris, Louvre) engraved in the second edition of Mannechet's *Le Plutarque français: Vies des hommes et femmes illustrés de la France* (Paris, 1844–7). An infra-red examination of the *Virgin with the Host* reveals that it began as a rectangular composition and

was changed into a circular one, with the paired columns becoming two angels and curtains. In Ingres's painting of *Joan of Arc* the heroine is shown surrounded by her pages and followers, among them Ingres, witnessing the coronation of King Charles VII in Reims Cathedral.

The *Apotheosis of Napoleon* (W 270, 1853; destr.) was one of only two exceptions to the pledge Ingres had made in 1834 never again to work on a monumental scale. In March 1853 he accepted a commission from the government of Napoleon III for a ceiling painting for the Salon Napoléon in the Hôtel de Ville in Paris. The work had to be completed by the end of the same year. It was delivered on time, but was destroyed in the fires of the Commune of 1871: an oil study (W 271; Paris, Carnavalet) remains of the composition together with several drawn versions (e.g. Paris, Louvre, RF 3608). It is also known through photographs taken at the Exposition Universelle (Paris, 1855), where all Ingres's important works were hung in a separate gallery. Paranoid as ever, he believed that he had been humiliated by the jury's decision to award gold medals to other artists in addition to himself, including one to Delacroix, 'the apostle of the ugly'. His anger was modified only slightly by being named Grand Officer of the Légion d'honneur, but he vowed again to abandon the public arena.

9. Paris, 1856–67

From 1856 Ingres's work was directed primarily towards a private audience. At his summer residence at Meung-sur-Loire he worked on two drawings: a watercolour of the *Birth of the Muses* (D 28, 1856; Paris, Louvre), painted in imitation of a fresco to ornament the cella of a little Greek temple for Prince Napoléon-Jérôme Bonaparte; and a drawing of *Homer Deified* (D 180; Paris, Louvre, RF 5273), 'reseen and redrawn' and meant to be the model for an engraving after his 1827 ceiling painting by Calamatta. Although he expected to finish it by the end of the summer, it was in progress for nine more years, when Ingres had it photographed by Charles Marville and sent signed copies of it in a limited edition to his friends. He also painted a number of late versions in oil of his

early subjects for private clients. For example, the *Turkish Bath* (w 312, completed 1863; Paris, Louvre) is an elaboration of his many earlier bather compositions. The canvas had been in the studio from the early 1850s, when Prince Anatole Demidov was listed as the client; by the time he considered it to be finished in 1859, however, it was claimed by Prince Napoléon-Jérôme. Much to Ingres's dismay, the painting was returned as Princesse Clotilde found it unsuitable for a family residence. Frédéric Reiset, Director of the Louvre and a friend of both Ingres and the Prince, averted disaster by negotiating an exchange for Ingres's *Self-portrait* of 1806. A photograph (see 1983–4 exh. cat., p. 125) records the *Turkish Bath* as it was then, nearly square in format. Once back in the studio it met the fate common to returned works. In his reworking Ingres increased the number of figures to 23 and gave the composition its circular format. The final painting was sold in 1863 to Khalil-Bey, the Turkish ambassador to France.

Ingres created a private gallery of his work for his wife. The collection (complete list in 1983–4 exh. cat., p. 252) included the *Antiochus and Stratonice* (w 322; Montpellier, Mus. Fabre), which he painted in watercolour and oil over a drawing on tracing paper (affixed to canvas in 1866), a technique that was also used in the *Martyrdom of St Symphorian* (w 319, 1865; Philadelphia, PA, Mus. A.). He gave away some of his works, again all reductions or variants of earlier subjects, as tokens of his friendship: Mme Marcotte (1798–1862) received a *Virgin with the Host with SS Helen and Louis* (w 268; London, priv. col.); Théophile Gautier received a reworked study for the *Apotheosis of Homer, Three Greek Tragedians, Aeschylus, Sophocles and Euripedes* (w 324; Angers, Mus. B.-A.). In 1861 several of Ingres's friends organized an exhibition of about 100 of his historical and portrait drawings in the Salon des Arts Unis, Paris. It was the first time Ingres had consented to let his drawings be shown, as he had previously felt that their popular appeal would distract from his paintings.

Christ among the Doctors was finished in 1862, after Ingres was released from his original contract of the 1840s and given the right to dispose of it as he pleased. A large exhibition of his work, organized by Armand Cambon, opened in Montauban on 4 May 1862; on 25 May Ingres became the first artist since Joseph-Marie Vien to be named Senator. His last will and testament was signed on 28 August 1866. In it he bequeathed to the city of Montauban his art collection (paintings, prints, drawings, plaster casts, antique fragments, terracottas) and illustrated art books, in addition to the contents of his studio (including the large paintings of *Christ among the Doctors* and the *Dream of Ossian*) and over 4000 of his study drawings. He left the huge canvas of *Virgil Reading the 'Aeneid'*, which had been in his Paris studio for reworking since the 1840s, to the Musée des Augustins, Toulouse. He made provision for his wife's financial security after his death by working closely with his dealer, Etienne-François Haro, to assemble a body of work from his studio for sale. Haro bought 31 oil studies for the history paintings and assorted drawn copies and studies for 50,000 francs. On 6–7 May 1867 the remaining contents of Ingres's studio were sold.

II. WORKING METHODS AND TECHNIQUE

Marjorie B. Cohn (intro. to 1983–4 exh. cat.) divided Ingres's working method into the generative phase (in which the original idea was conceived) and the extended and obsessive executive phase. The latter included not only the process of realizing the painting, but was extended by Ingres to include a lifetime of reworking favourite compositions in preparation for reproductive prints, in finished drawings and paintings for friends and clients, and in reductions to partial compositions, which were sent into the world, often decades after the original product, as works in their own right. These habits reflected Ingres's profound esteem for repetition as a means of understanding. He was very much governed by traditional Ecole des Beaux-Arts practices. He began with quick pen-and-ink sketches of a general idea and then explored all possible artistic prototypes for the composition. He worked next in a combination of life studies from the model for individual figures and detailed studies of archaeological

furnishings from his library of engraved models after antiquity and the Renaissance. He suited his style to the subject, imitating 15th-century primitive oil painting for Troubadour subjects, emulating fresco technique in oil for antique battle scenes, and used every conceivable drawing material on a wide variety of papers—charcoal for light and shadow studies, pen with ink or a sharp graphite for contour drawings. He was especially partial to working on a translucent tracing paper that aided his endless manipulations of the composition. Some of his drawings are built up of layers of paper types over one another as revision followed revision; other drawings were spontaneously completed in a few perfect contours.

Major history paintings were preceded by relatively finished drawings of the whole composition, by oil sketches of the whole and by detailed studies in oil of the individual figures. When faced with a new commission, Ingres assembled all possible relevant historical documentation, then slowly laboured to dominate the model with his own vision by rebuilding it from the ground up with studies from life. A good example of this approach is the *Golden Age* mural for the Duc de Luynes. In 1843 Ingres started on the commission, alternately working at the château at Dampierre (usually from June to October) and at the studio in Paris (November to June). He worked on the subject for several years (1843–8), especially in the quiet evening hours, making over 500 drawings. During the first year at Dampierre he had a model made of the major figures so that he could study the effects of light and shadow. As he was unable to work from the live model in the gallery, detailed drawings for the major figures were made in Paris. In such later paintings as *Antiochus and Stratonice* and *Odalisque with Slave*, which required elaborate interiors, Ingres began his studies from nature. He prepared the rough sketch on the canvas, and his students then worked on less important parts such as the architecture, mosaics, rugs and furniture, some of which might need repositioning if he decided to change the figures. Since the figures were completed by Ingres, he alone undertook to harmonize the ensemble with innumerable carefully applied layers of colour. His concern for the final touches extended to the last coats of varnish and the exact choice of frame.

A normal day consisted of work in the studio from nine to six, followed, preferably, by dinner and a quiet evening in preparation for the next day, but more often in Paris by the exigencies of social life. The time devoted to portraits was carefully scheduled and followed a set pattern. Ingres and the sitter met for an hour and a half in the morning, then broke for lunch. While the sitter relaxed, Ingres looked for mannerisms, gestures or opinions that could throw light on the sitter's character. They returned to the studio for a two-and-a-half hour session. At four the sitting was over, the drawing finished. Patience was essential as, regardless of the status of the sitter, the finished portrait might be delivered up to seven years later, or not at all.

Ingres wrote of his working habits, 'I force myself to press ahead by every sort of study, and each step further that I make in the understanding of nature makes me see that I know nothing. The more I reach toward perfection, the more I find myself . . . measuring . . . what I lack. I destroy more than I create' (letter, 24 Dec 1822). Justifying his obsessive reworking, he also noted 'if my works have a value and are deserving, it is because . . . I have taken them up twenty times over again, I have purified them with an extreme of research and sincerity' (Delaborde, 1870, p. 100).

III. CHARACTER AND PERSONALITY

Ingres was the staunchest, most conservative defender of the classical tradition, preaching an inflexible, if sometimes contradictory, doctrine of ideal beauty and the absolute supremacy of line and pure form over colour and emotion. He described himself as generally affable but with a 'white hot' temper if he felt himself wronged. His personality, like his art, was marked by a preference for the order of a familiar universe. He adjusted slowly to changes in daily habits and remained the worst sort of provincial traveller, comparing everything that was new to him unfavourably with the home equivalent.

According to Charles Blanc, Ingres's friend and biographer, 'In him genius is will Here was a man for whom invention was painful, but who bent his faults by a prodigious love of the beautiful' (1870, pp. 92–3). In times of stress, Ingres was likely to react with a whole variety of physical symptoms, for example boils and atrocious headaches during the last few months of 1833, while he was working on the *Apotheosis of Homer*. There were times, however, when the pleasures of work were sweeter than ever before: 'Every day I am shut away in my studio from morning to night. I am love struck by painting, I don't possess it, it possesses me' (letter, May 1827). He was not at all the 19th-century bohemian artist; he loved every bourgeois comfort and expected his wife to look after his domestic needs.

In a letter of 7 July 1862 to Hippolyte Fockedey (Naef, 1977–81, iii, p. 371) Victor Mettez described 'le Père Ingres' as 'choleric, impatient, obstinate, good, naive, righteous, lazy . . . by moments eloquent and sublime . . . an incredible mélange'. This 'mélange' was echoed in an intimate sketch of Ingres by the composer Charles Gounod: 'He had an enthusiasm which sometimes approached eloquence. He had the tenderness of a child and the indignations of an apostle. He was naive and sensitive. He was sincerely humble before the great masters, but fiercely proud of his own accomplishments' (*Mémoires d'un artiste*, Paris, 1896).

Ingres's passions for music (Gluck, Haydn, Mozart and Beethoven), for literature (Plutarch, Virgil, Homer, Shakespeare, Dante and Vasari) and the visual arts (Raphael and Michelangelo) were deep and lifelong. His friends were friends for life, unless they crossed him, and nothing pleased him more than his favourite music in the company of a select circle of friends. As a student, he was seen as too serious, intolerant of the usual studio antics; as a teacher, although he often acted as a father figure to his favourite students, he brooked no opposition: 'Discussion was, unfortunately, not possible with M. Ingres' (Amaury-Duval, 1878, 2/1924, p. 61). And M. Ingres he remained, even to his family and closest friends.

IV. Critical reception and posthumous reputation

Ingres alternated between pride and self-doubt, confidence and crisis. This insecurity was fuelled, and his development thwarted, both in early and mid-career, by constant harsh criticism. At first, he was considered too radical; later he was seen as representative of the moribund old guard. In one year only—1825—did he receive critical acclaim, when he was given the Cross of the Légion d'honneur, following the success of the *Vow of Louis XIII* that welcomed him back to France as champion of the classical style.

There is a marked difference between Ingres's posthumous reputation as a leading figure of his school and the difficulty he had establishing and holding that place during his lifetime. Equally ironic, given Ingres's absolute devotion to his calling as a history painter, is the fact that his portraits are now more widely appreciated than his history paintings. A retrospective exhibition of his work, including 587 paintings, drawings and oil sketches, was held in May 1867 at the Ecole des Beaux-Arts during the Exposition Universelle. It attracted 40,000 visitors.

Writings
R. Cogniet, ed.: *Ingres, écrits sur l'art: Textes recueillis dans les carnets et dans la correspondance d'Ingres* (Paris, 1947)
T. B. Brumbaugh: 'A Group of Ingres Letters', *J. Walters A.G.*, xlii–xliii (1984–5), pp. 90–96 [five letters, 1845–54]

Bibliography

general
E. Delécluze: *David, son école & son temps: Souvenirs de soixante années* (Paris, 1862)
E. A. Amaury-Duval: *L'Atelier d'Ingres* (Paris, 1878, 2/1924)
H. Lapauze: *Histoire de l'Académie de France à Rome*, 2 vols (Paris, 1924)
W. Friedlaender: *Von David bis Delacroix* (Bielefeld, 1930); Eng. trans. by R. Goldwater (Cambridge, MA, 1952)
David, Ingres, Géricault et leur temps (exh. cat., Paris, Ecole N. Sup. B.-A., 1934)
F. Lugt: *Ventes* (The Hague, 1938–64), iii, pp. 83–4, 563
J. Alazard: *Ingres et l'Ingrisme* (Paris, 1950)

P. Angrand: *Monsieur Ingres et son époque* (Lausanne, 1967)

The Age of Neo-classicism (exh. cat., foreword J. Pope-Hennessy; ACGB, 1972)

French Painting, 1774–1830: The Age of Revolution (exh. cat., preface P. Rosenberg; Paris, Grand Pal.; Detroit, MI, Inst. A.; New York, Met., 1974–5)

The Second Empire: Art in France under Napoleon III (exh. cat., ed. G. H. Marcus and J. M. Iandola; Philadelphia, PA, Mus. A.; Detroit, MI, Inst. A.; Paris, Grand Pal.; 1978–9)

catalogues raisonnés

H. Delaborde: *Ingres: Sa vie, ses travaux, sa doctrine, d'après les notes manuscrites et les lettres du maître* (Paris, 1870) [D]

D. Wildenstein: *The Paintings of J.-A.-D. Ingres* (London, 1954, rev. 2/1956) [W] [the most useful source for tracing provenance]

E. Camesasca: *L'opera completa di Ingres*, intro. by E. Radius (Milan, 1968); Fr. trans. with add. mat. as *Tout l'oeuvre peint d'Ingres*, intro. by D. Ternois (Paris, 1971)

H. Naef: *Die Bildniszeichnungen von J.-A.-D. Ingres*, 5 vols (Berne, 1977–81) [N]

monographs

A. Magimel, ed.: *Oeuvres de J.-A. Ingres, gravées au trait sur acier par A. Réveil, 1800–1851* (Paris, 1851)

C. Blanc: *Ingres: Sa vie et ses oeuvres* (Paris, 1870)

E. Gatteaux: *Collection des 120 dessins, croquis et peintures de M. Ingres classés et mis en ordre par son ami Edouard Gatteaux*, 2 vols (Paris, 1875)

L. Frölich-Bum: *Ingres: Sein Leben und sein Stil* (Vienna, 1911)

H. Lapauze: *Ingres: Sa vie, et son oeuvre* (Paris, 1911)

W. Pach: *Ingres* (New York, 1939)

P. Courtheon: *Ingres raconté par lui-même et par ses amis*, i: *Pensées et écrits du peintre*; ii: *Ses contemporains, sa postérité* (Geneva, 1947)

H. Naef: *Ingres. Rom* (Zurich, 1962)

R. Rosenblum: *Jean-Auguste-Dominique Ingres* (New York, 1967)

J. Whiteley: *Ingres* (London, 1977)

D. Ternois: *Ingres* (Paris, 1980)

museum and exhibition catalogues

Ingres (exh. cat., Paris, Gal. Martinet, 1861)

A. Cambon: *Catalogue du Musée de Montauban* (Montauban, 1885)

H. Lapauze: *Les Dessins de J.-A.-D. Ingres du Musée de Montauban* (Paris, 1901)

Portraits par Ingres et ses élèves (exh. cat. by C. Sterling, Paris, Gal. Jacques Seligmann, 1934)

A Loan Exhibition of Paintings and Drawings from the Ingres Museum at Montauban (exh. cat., intro. A. Mongan and D. Ternois; New York, Knoedler's, 1952)

Ingres et ses maîtres, de Roques à David (exh. cat. by P. Mesplé and D. Ternois, Toulouse, Mus. Augustins; Montauban, Mus. Ingres; 1955)

Rome vue par Ingres (exh. cat., ed. H. Naef; Lausanne, 1960; Zurich, 1962; Montauban, Mus. Ingres, 1973)

D. Ternois: *Montauban, Musée Ingres: Peintures, Ingres et son temps* (1965), xi of *Inventaire des collections publiques françaises* (Paris, 1957–)

Ingres Centennial Exhibition, 1867–1967: Drawings, Watercolors and Oil Sketches from American Collections (exh. cat., ed. A. Mongan and H. Naef; Cambridge, MA, Fogg, 1967)

Ingres et son temps: Exposition organisée pour le centenaire de la mort d'Ingres (exh. cat. by D. Ternois and J. Lacambe, Montauban, Mus. Ingres, 1967)

Ingres (exh. cat., ed. L. Duclaux, J. Foucart, H. Naef and D. Ternois; Paris, Petit Pal., 1967–8) [with excellent bibliog.]

Ingres in Italia: 1806–1824, 1835–1841 (exh. cat. by J. Foucart, Rome, Villa Medici, 1968)

M. Cohn and S. Siegfried: *Works by J.-A.-D. Ingres in the Collection of the Fogg Art Museum* (Cambridge, MA, Fogg, 1980)

Ingres (exh. cat. by M. Ikuta and others, Tokyo, N. Mus. W. A.; Osaka, N. Mus. A.; 1981)

In Pursuit of Perfection: The Art of J.-A.-D. Ingres (exh. cat., ed. P. Condon; Louisville, KY, Speed A. Mus.; Fort Worth, TX, Kimbell A. Mus.; 1983–4)

subject-matter and iconography

J. Alazard: 'Ce que J.-D. Ingres doit aux primitifs italiens', *Gaz. B.-A.*, ii (1936), pp. 167–75

E. King: 'Ingres as a Classicist', *J. Walters A.G.*, v (1942), pp. 69–113

A. Mongan: 'Ingres and the Antique', *J. Warb. & Court. Inst.*, x (1947), pp. 1–13

D. Ternois: 'Les Sources iconographiques de *l'Apothéose d'Homère*', *Bull. Soc. Archéol. Tarn-et-Garonne* (1954–5), 97–108

H. Naef: 'Paolo und Francesca: Zum Problem der schöpferischen Nachahmung bei Ingres', *Z. Kstwiss.*, x (1956), pp. 97–108

N. Schlenoff: *Ingres, ses sources littéraires* (Paris, 1956)

Ingres and the Comtesse d'Haussonville (exh. cat. by E. Munhall, New York, Frick, 1985)

specialist studies

H. Delaborde: 'Les Dessins de M. Ingres au Salon des Arts-Unis', *Gaz. B.-A.*, ix (1861), pp. 257–69

C. Blanc: 'Du Style et de M. Ingres', *Gaz. B.-A.*, xiv (1863), pp. 5–23

H. Schwarz: 'Die Lithographien J. A. D. Ingres', *Mitt. Ges. Vervielfält. Kst* (1926), pp. 74–9

Bull. Mus. Ingres (1956–)

E. Bryant: 'Notes on J. A. D. Ingres' *Entry into Paris of the Dauphin, Future Charles V*', *Wadsworth Atheneum Bull.*, 5th ser., iii (1959), pp. 16–21

M. J. Ternois: 'Les Oeuvres d'Ingres dans la collection Gilibert', *Rev. A.* [Paris], iii (1959), pp. 120–30

H. Naef: 'Un Tableau d'Ingres inachevé: *Le Duc d'Albe à Sainte-Gudule*', *Bull. Mus. Ingres*, 7 (1960), pp. 3–6

——: 'Ingres as Lithographer', *Burl. Mag.* (1966), pp. 476–9

Actes du colloque Ingres et son temps: Montauban, 1967

D. Ternois: 'Ingres et sa méthode', *Rev. Louvre*, iv (1967), pp. 195–208

——: 'Napoléon et la décoration du palais impérial de Monte Cavallo en 1811–13', *Rev. A.* [Paris], vii (1970), pp. 68–89

J. Connolly: *Ingres Studies: Antiochus and Stratonice, the Bather and Odalisque Themes* (diss., Philadelphia, U. PA, 1974)

Actes du colloque Ingres et le néo-classicisme: Montauban, 1975

C. Duncan: 'Ingres's *Vow of Louis XIII* and the Politics of the Restoration', *Art and Architecture in the Service of Politics*, ed. H. Millon and L. Nochlin (Cambridge, MA, 1978), pp. 80–91

M. Lader: 'Gorky, De Kooning and the "Ingres Revival" in America', *A. Mag.* (March 1978), pp. 94–9

S. Symmons: 'J. A. D. Ingres: The Apotheosis of Flaxman', *Burl. Mag.*, cxxi (1979), pp. 721–5

Actes du colloque Ingres et son influence: Montauban, 1980

M. Méras: 'Théophile Gautier critique officiel d'Ingres au Moniteur', *Bull. Mus. Ingres*, 47–8 (1980), pp. 205–19

S. Siegfried: *Ingres and his Critics, 1806–1824* (diss., Cambridge, MA, Harvard U., 1980)

P. Angrand: 'Le Premier Atelier de Monsieur Ingres', *Bull. Mus. Ingres*, 49 (1982), pp. 19–58 [with bibliog.]

F. Haskell: 'A Turk and his Pictures in Nineteenth-century Paris', *Oxford A. J.*, v/1 (1982), pp. 40–47

C. Ockman: *The Restoration of the Château of Dampierre: Ingres, the Duc de Luynes and an Unrealized Vision of History* (diss., New Haven, CT, Yale U., 1982)

A. D. Rifkin: 'Ingres and the Academic Dictionary: An Essay on Ideology and Stupefaction in the Social Formation of the Artist', *A. Hist.*, vi (1983), pp. 153–70

L. Ewals: 'Ingres et la réception de l'art français en Hollande avec des lettres inédites de David, Gérard, Ingres, Vernet, Delaroche, Decamps et Rousseau', *Bull. Mus. Ingres*, 53–4 (1984), pp. 21–42

A. Boime: 'Declassicizing the Academic: A Realist View of Ingres', *A. Hist.*, viii (1985), pp. 50–65

C. de Couossin: 'Portraits d'Ingres: Examen du laboratoire', *Rev. Louvre*, xxxiv (1985), pp. 197–206

P. Condon: *J.-A.-D. Ingres: The Finished History Drawings* (diss., Providence, RI, Brown U., 1986)

D. Ternois: 'La Correspondance d'Ingres: Etat des travaux et problèmes de méthode', *Archvs A. Fr.*, n. s., xxviii (1986), pp. 161–200

B. Ivry: 'Right under his Nose', *Connoisseur*, ccxx (1990), pp. 126–9, 156

PATRICIA CONDON

Isabey

French family of artists. (1) Jean-Baptiste Isabey was one of the leading portrait miniaturists associated with the Napoleonic era. His son (2) Eugène Isabey became one of Louis-Philippe's principal court painters; equally notable for his land- and seascapes, he represents a link between the artists of the Rococo revival and the birth of Romanticism.

(1) Jean-Baptiste Isabey

(*b* Nancy, 11 April 1767; *d* Paris, 18 April 1855). Painter, draughtsman and printmaker. He trained in Nancy with Jean Girardet (*d* 1778) and then with Jean-Baptiste-Charles Claudot (1733–1805), master of the miniaturist Jean-Baptiste Augustin. In 1785 he went to Paris, where he began by painting snuff-boxes. In 1786 he received lessons from the painter François Dumont, who had also studied with Girardet in Nancy, before entering the studio of David. Although he had received aristocratic commissions before the Revolution to paint portrait miniatures of the Duc d'Angoulême and Duc de Berry and through them of Marie-Antoinette, he did not suffer in the political upheavals that followed. He executed 228 portraits of deputies for a work on the Assemblée Législative and from 1793 exhibited miniatures and drawings in the Salon.

57. Jean-Baptiste Isabey: *Portrait of Napoleon as First Consul* (Versailles, Musée National du Château de Versailles et du Trianon)

Success came to him in 1794 with two drawings in the 'manière noire', *The Departure* and *The Return*. This type of drawing, using pencil and the stump to simulate engraving, was very fashionable in the last years of the 18th century and reached its peak with Isabey's *The Boat* (exh. Salon 1798; Paris, Louvre), an informal scene including a self-portrait, in which the artist exploited contrasts of light and shade with considerable success.

Isabey took an active part in Parisian artistic and social life and was much sought after by Mme de Staël and Mme Récamier for their salons. He commissioned a portrait of himself and his daughter from François Gérard (for additional information *see* GÉRARD, FRANÇOIS), and Boilly immortalized Isabey's own brilliant gatherings in the *Studio of Isabey* (1798; Paris, Louvre). At the school of Mme

Campan at Saint-Germain-en-Laye, Isabey taught drawing to Hortense de Beauharnais and through her was introduced to the Napoleonic court, where he rapidly established himself. He was one of the first chevaliers of the Légion d'honneur and in 1804 was appointed Dessinateur du Cabinet de l'Empereur, des Cérémonies et des Relations Extérieures. He also organized all the private and public festivities in the Tuileries, at Saint-Cloud and Malmaison. In his capacity as Dessinateur du Cabinet de l'Empereur he produced a watercolour (Paris, Bib. N.) for the frontispiece of a volume of Ossian's poems in Napoleon's library. In 1805 he was made Premier Peintre to the Empress, Josephine, and painted numerous portraits of her, notably the *Empress after the Divorce* (Paris, Louvre) and *Empress Josephine* (after 1803; Angers, Mus. Turpin de Crissé). He was on equally good terms with Napoleon's second wife, Marie-Louise, whom he painted in her wedding dress (large miniature, 1810; Vienna, Ksthist. Mus.) and with her son, François-Charles-Joseph, King of Rome (e.g. London, Wallace, 1815; Malmaison, Château N.). His portraits of Napoleon are equally numerous, including *Bonaparte at Malmaison* (exh. Salon 1802; Malmaison, Château N), *Portrait of Napoleon as First Consul* (Versailles, Château; see fig. 57) and the *Review for Quintidi* (exh. Salon 1804; Paris, Louvre). His miniatures of the Emperor and Empress became so famous that they were used to adorn many snuff-boxes.

In 1807 Napoleon appointed Isabey to succeed I.-E.-M. Degotti (*d* 1824) as principal decorator of the imperial theatres. Isabey also worked for the Sèvres factory, contributing to the decoration of the *Table des maréchaux* (1806; Malmaison, Château N.). During a stay in Vienna he executed 16 portrait miniatures of members of the Austrian imperial family (Vienna, Ksthist. Mus.), which he exhibited in the Salon of 1812. He returned to Vienna in 1814 to paint the plenipotentiaries of the Congress of Vienna. Isabey's work did not develop or change, and his popularity began to decline under the Restoration. He was almost forgotten during the July Monarchy, deriving a small pension from a post as assistant curator to the Musées Royaux in 1837. In 1853 Napoleon III

remembered that Isabey had been highly regarded by his mother and made him a commander of the Légion d'honneur.

Isabey's fame derived from his portrait miniatures, and within this genre he was considered the leader of a school. In watercolour he created a type of portrait that became extremely fashionable: a woman's face wearing a melancholy, stereotyped smile, framed by roses and wreathed in diaphanous veils fluttering in an imaginary breeze. These portraits, with their fresh, bright colouring, were highly prized by his aristocratic and middle-class clientele. During the Empire and the Restoration, Isabey endlessly repeated this formula, the gracefulness of which sometimes declined into mawkish vapidity. He also produced large drawings such as the *First Consul at the Factory of the Sévène Brothers in Rouen* and *Bonaparte at the Oberkampf Factory* (exh. Salon 1804; Versailles, Château), in which he treated historic events as elegant genre scenes. In the *Staircase of the Louvre* (Paris, Louvre), a large watercolour painted on ivory, he emulated porcelain in the quality of the detail and the sweet, refined colouring. Isabey also made a small number of portraits in oils, including *Napoleon I* (Nancy, Mus. B.-A.) and the *Comtesse de Boigne* (Chambéry, Mus. B.-A).

Isabey's graphic oeuvre is also significant. He was fascinated by drawing in the 'manière noire' when the fashion for this style had only just begun and was one of the first painters to use lithography. In 1818 he published with Godefroy Engelmann a series of small-scale examples of lithography in which he experimented with new ways of rendering effects of light. He also published *Voyage en Italie* (a set of 30 lithographs) and, in a more risqué manner, a collection of 12 *Caricatures de J. J.* (1818). He contributed to Baron Taylor's *Voyages pittoresques et romantiques dans l'ancienne France*, making felicitous use of monochrome printing.

Bibliography

P. Mantz: 'Jean-Baptiste Isabey', *L'Artiste* (6 May 1855), pp. 1–5

E. Taigny: *J.-B. Isabey: Sa vie et ses oeuvres* (Paris, 1859)

C. Lenormant: 'Jean-Baptiste Isabey', *L'Artiste* (1 March 1861), pp. 97–100

H. Béraldi: *Les Graveurs du XIXe siècle*, viii (Paris, 1889), pp. 151–6

G. Hédiard: *Les Maîtres de la lithographie: J.-B. Isabey* (Châteaudun, 1896)

Mme de Basily-Callimaki: *J.-B. Isabey, sa vie, son temps, 1767–1855: Suivi du catalogue de l'oeuvre gravée par et d'après Isabey* (Paris, 1909)

A. Francastel: 'Quelques miniatures d'Isabey', *Rev. Etud. Napoléoniennes*, ii (1918), pp. 120–28

M. Garçot: 'Jean-Baptiste Isabey, 1767–1855', *Pays Lorrain*, iv (1956), pp. 152–60

MARIE-CLAUDE CHAUDONNERET

(2) (Louis-)Eugène(-Gabriel) Isabey

(*b* Paris, 22 July 1803; *d* Lagny, 25 April 1886). Painter and printmaker, son of (1) Jean-Baptiste Isabey. He spent his earliest years in the Louvre among such artists as François Gérard and the Vernet family, and at 7 rue des Trois Frères at the foot of Montmartre. His first works, mostly landscapes in watercolour, painted on the outskirts of Paris, display an independent character that owes little to the influence of his father or the other artists among whom he had lived. In 1820 he travelled to Normandy with his father, Charles Nodier and Alphonse de Cailleux, the future director of the Louvre. In 1821 he visited Britain with Nodier and discovered British painting; it is uncertain whether Isabey ever met Richard Parkes Bonington (his father certainly knew him), but Bonington's free watercolour technique had a decisive influence on his development. Isabey's admiration for Géricault, the advice of his friends and a passionate temperament also helped to form his style, which was characterized by skilfully worked brushstrokes and a preference for impasto rather than glazing. Between 1821 and 1824 Isabey seems to have returned to Normandy several times, painting on the coast between Le Havre and Dieppe. At the Salon of 1824 he exhibited a series of seascapes and landscapes (untraced), which helped to establish his reputation.

Isabey made a second journey to England in 1825, where he met Delacroix, another important influence on his Romantic vision of landscape. He returned to the Normandy coast in 1826. In 1828

58. Eugène Isabey: *Return of the Ashes of Napoleon* (Versailles, Musée National du Château de Versailles et du Trianon)

he met Charles Mozin (1806–62) and Paul Huet, who became a close friend, at Trouville, and with them and Théodore Gudin he made famous the genre of Romantic seascape during the 1830s. In 1829 he visited the Auvergne and the Velay, where he made drawings of the region to accompany Charles Nodier's text in the Auvergne volumes of Baron Taylor's *Voyages pittoresques et romantiques dans l'ancienne France*. Isabey's 17 lithographs (1830–32) unify and dramatize the Auvergne sky, landscape and architecture with unusual verve and are among the finest illustrations in this great series (e.g. *Exterior of the Apse of the Church of St Nectaire*).

Isabey was chosen as official artist to accompany the French expedition to Algiers in 1830; he illustrated Denniée's *Précis historique et administratif de la campagne d'Afrique* (Paris, 1830). His enthusiasm quickly changed to disillusion, however, when the drawings and oil studies he brought back failed to sell, and the wide range of subjects he exhibited at the Salon of 1831 reflects the

hesitation and confusion he felt at that time. The success there of *The Alchemist* (untraced, see Miquel, no. 1301), then a fashionable subject, the novels of his friend Alexandre Dumas and a certain calculated ambition all encouraged him towards producing anecdotal genre pictures. During the July Monarchy his output alternated between marine subjects, both dramatic (e.g. *Battle of Texel*, 1839; Paris, Mus. Mar.) and placid (*Beach at Low Tide*, 1832, exh. Salon 1833; Paris, Louvre), and historicizing genre subjects—elegant scenes of opening nights in court dress and elaborate re-creations of 16th- and 17th-century ceremonial, often in a maritime setting (e.g. *Arrival of the Duke of Alba at Rotterdam*, 1844; Paris, Louvre). He became one of Louis-Philippe's principal court painters and recorded several important episodes in the life of the July Monarchy (e.g. *Return of the Ashes of Napoleon*; Versailles, Château; see fig. 58).

Between 1833 and 1850 Isabey's style fluctuated between the smooth painting loved by the dealers and the thicker impasto found in his large

exhibition pieces. At the same time he was producing numerous quickly executed landscape drawings. After 1844, in vast paintings such as the *Disembarkation of Louis-Philippe at Portsmouth on 8 October 1844* (1844; Paris, Louvre, on dep. Versailles, Château), his palette became brighter and his brushwork gained a glimmering quality that was constant from 1850. A journey to Brittany in 1850 marked the start of a free but more compact style in his seascapes, and at the same time he produced a series of *Scenes in the Park*, in which the study of drapery was enriched by a golden Venetian colouring. In the summer of 1856 he moved to Varengeville, near Dieppe, where he produced watercolours of the local cottages and countryside (e.g. Paris, Louvre, Cab. Dessins), which are among his most uninhibited and original works. The increasingly exuberant colour of his paintings of the 1860s and 1870s was applied to scenes of violence, massacres, duels and looting (e.g. *Duel in the Time of Louis XIII*, 1863; Compiègne, Château). He continued to produce marine views, but his boats were now usually painted from models in his studio rather than from life.

From Varengeville, Isabey travelled to Le Havre in 1859 and then to Honfleur with Eugène-Louis Boudin, on whose coastal views he had an important influence. During 1862 he spent some time in Le Havre, Honfleur and Trouville, where he was joined by his pupil, Johan Barthold Jongkind. In his later years he stayed often in Varengeville, working primarily for dealers and exhibiting little at the Salon.

In his costume pieces Isabey did not merely seek to pursue historical truth for its own sake but became both the creator and the victim of the fantasies of the French upper classes, to whom he offered a pleasantly decorative, if artificial, image of their ancestors. He kept alive the elegant frivolity of the world of his father and his father's friends, the Cicéri, and helped to transmit it to the artists of the Rococo revival, such as Adolphe Monticelli. Similarly, in his freshly painted watercolour seascapes he stood between and helped to bridge the worlds of Bonington and Boudin.

Bibliography

G. Hédiard: *Eugène Isabey: Etude, suivie du catalogue de son oeuvre* (Paris, 1906)

A. Curtis: *Catalogue de l'oeuvre lithographiée d'Eugène Isabey* (Paris, 1939)

Eugène Isabey (exh. cat. by P. H. Schabacker and K. H. Spencer, Cambridge, MA, Fogg, 1967)

P. Miquel: *Eugène Isabey et la marine au XIXe siècle, 1803–1886*, 2 vols (Maurs-la-Jolie, 1980)

PIERRE MIQUEL

Jacquand, Claudius [Claude]

(*b* Lyon, 11 Dec 1803; *d* Paris, 2 April 1878). French painter, designer and printmaker. In 1821 he entered the atelier of Fleury Richard in the Ecole des Beaux-Arts, Lyon. He exhibited for the first time at the Lyon Salon of 1822, in 1824 receiving a first-class medal at the Paris Salon for a *Prison Courtyard* (untraced). He lived in Lyon until his mother's death in 1836, when he settled in Paris. During the 1830s his pictures sold well: Louis-Philippe bought seven paintings for Versailles, and commissioned cartoons of the *Death of the Duc d'Orléans* (1847) for the stained-glass windows of the Chapelle St Ferdinand at Dreux. Although the fall of Louis-Philippe in 1848 deprived Jacquand of official commissions, financial mismanagement of the family polish factory obliged him to earn his living from painting. Between 1852 and 1855 he lived in Boulogne-sur-Mer where he decorated the Salle d'honneur in the Hôtel de Ville. He also obtained the commission for several paintings (1852–4) for Notre-Dame, Roubaix. Government commissions gradually returned: he was asked to decorate the chapel of the Virgin in St Philippe du Roule, Paris (1858–60), and the chapel of St Bernard, St Bernard de la Chapelle, Paris (1867). Jacquand also painted the archivolt of the chapel of the Virgin, St Martin d'Ainay, Lyon (1863).

For his easel paintings Jacquand chose subjects that he knew would appeal to the emotions of his public, for example *Sick Savoyard Child* (1822; untraced) and *Young Girl Being Cared for by Nuns in Hospital* (1824; priv. col.). He was not a history painter, rather a painter of historical anecdote, and he sometimes chose fanciful settings and

anachronistic costumes, but he had a gift for selecting the right moment to represent. He was an eclectic reader and adroitly visualized precise literary descriptions as in his *Death of Adelaide de Comminges* (1831; priv. col.) after Froissard and the *Fifth of March at Perpignan* (1837; priv. col.) after Alfred de Vigny. He also made lithographs for Lyon magazines. Jacquand's concentration on meticulous detail was the fruit of his training in Lyon and his study of 17th-century Dutch painting.

Bibliography

D. Richard: 'Claudius Jacquand "cet habile artiste"', *Bull. Mus. Ingres*, xiv (1980), pp. 23–9

MADELEINE ROCHER-JAUNEAU

Jacque, Charles(-Emile)

(*b* Paris, 23 May 1813; *d* Paris, 7 May 1894). French painter, printmaker and illustrator. In 1830 he worked briefly for an engraver who specialized in cartography, and in that year he produced his first etching, a copy of a head after Rembrandt. From 1831 to 1836 Jacque served in the infantry, seeing action in the siege of Antwerp in 1832. During military service he found time to sketch scenes of army life and is reputed to have submitted two works to the Salon of 1833 in Paris. In 1836 he went to London where he found employment as an illustrator. He was back in France in 1838 and visited his parents in Burgundy, where he became enamoured of the countryside.

Jacque's graphic works in the early 1840s include caricatures published in *Le Charivari* in 1843 and a number of vignettes and illustrations that appeared in the publications of the firm Curmer. More significant, however, are his etchings; this medium was beginning to undergo a revival in popularity at the time, to a large extent through Jacque's efforts. Working in etching and drypoint, he produced numerous small prints of rustic life, beggars, farm animals, cottages and landscapes. An auction of the works of Georges Michel in 1841 profoundly influenced Jacque, who began to emulate the older master, painting landscapes with windmills at Montmartre and later on the Clignancourt plains (e.g. *Herd of Swine*; priv. col., see Miquel, p. 547).

By 1843 Jacque was closely associated with the Realist movement. Although he had previously exhibited only prints at the Salon, in 1846 the State commissioned a painting showing a herd of cattle milling about a pond at twilight, *Herd of Cattle at the Drinking Hole* (Angers, Mus. B.-A.). Meanwhile, he had befriended Jean-François Millet (ii), and in the spring of 1849 the two artists, seeking to avoid an outbreak of cholera in the capital, moved their families to adjoining properties in Barbizon. Thereafter Jacque divided his time between Barbizon, by then an established artists' colony, Montrouge, where he maintained another studio, and Paris. He increasingly concentrated on painting, treating his rustic subjects, barnyard scenes and images of grazing livestock with an unerring though more descriptive realism than that of Millet. The works of this period are often small and painted on panel, such as the barn scene, *The Sheepfold* (1857; New York, Met.), and *Poultry* (Amsterdam, Hist. Mus.), one of many similar compositions in which fowl with brightly coloured plumage are shown against sunlit masonry walls. In the 1850s and 1860s Jacque continued to produce prints, often working in a larger format as in the etchings *The Sheepfold* (1859), *The Storm* (1865–6) and *Edge of the Forest: Evening* (1866).

In addition to his artistic endeavours, Jacque pursued numerous speculative ventures: he raised poultry and in 1858 published *Le Poulailler: Monographie des poules indigènes et exotiques*; he cultivated asparagus; and he invested in real estate. In the course of these activities Jacque alienated his fellow artists in Barbizon and still failed to attain financial security. In the 1870s he became involved with a factory at Le Croisic that produced Renaissance- and Gothic-style furniture, utilizing fragments of original pieces. Although he did not regularly participate in the Salon after 1870, he continued to paint, relying on various dealers for sales. He treated the same subjects, working in thicker impasto and relying increasingly on his palette knife. Many of his later works, including *Forest Pastures near Bas Bréan* (Montreal, Mus. F.A.), are marked by a sombre note bordering on

pathos. Jacque's position improved in his last years: he received a gold medal at the Exposition Universelle in 1889 and, outliving his Barbizon colleagues, he benefited from the Anglo-American vogue for landscape in the late 19th century. Working in Jacque's immediate circle were a brother, Léon Jacque (*b* 1828), and two sons, Emile Jacque (1848–1912) and Frédéric Jacque (*b* 1859).

Bibliography

J. M. J. Guiffrey: *L'Oeuvre de Charles Jacque: Catalogue de ses eaux-fortes et pointes sèches* (Paris, 1866)

H. Béraldi: *Les Graveurs du XIXe siècle* (Paris, 1885–92), viii, pp. 162–92

F. C. Emanuel: 'The Etchings of Charles Jacque', *The Studio*, xxxiv (1905), pp. 216–22

P. Miquel: *Le Paysage français au XIXe siècle, 1824–1874*, iii (Maurs-la-Jolie, 1975), pp. 532–63

Millet and his Barbizon Contemporaries (exh. cat. by G. Weisberg, Tokyo, Keio Umeda Gal., 1985), pp. 160–64

WILLIAM R. JOHNSTON

Jalabert, Charles(-François)

(*b* Nîmes, 1 Jan 1819; *d* Paris, 8 March 1901). French painter. Against the wishes of his father, a jeweller, he enrolled in the Ecole de Dessin of Nîmes, directed by Alexandre Colin (1798–1875). A promising pupil, he received the first prize in drawing in 1835 and in painting in 1836 and 1837. A year later he moved to Paris to work briefly for one of his father's associates who urged him to study at the Ecole des Beaux-Arts, where he entered the atelier of Paul Delaroche. He competed three times for the Prix de Rome, faring best with his first attempt in 1841, when he obtained a second prize. However, he submitted his entry of 1843, *Oedipus and Antigone* (Marseille, Mus. B.-A.), to the initial exhibition of the Amis des Arts in Nîmes, winning a gold medal.

Jalabert followed Delaroche to Italy, where he stayed at his own expense until 1846. In Rome in 1844 he began work on *Virgil, Horace and Varius in the House of Maecenas* (Nîmes, Mus. B.-A.), which he intended as the counterpart to the large history paintings sent home by Prix de Rome winners. Embodying all the characteristics of academic history painting, this idealized view of Virgil reading the *Georgics* to his patron launched the artist's career in France: it received a third-class medal at the Salon of 1847 and was purchased by the State.

With Delaroche's sponsorship, Jalabert was introduced to wealthy and influential patrons, including Achille Fould (1800–67) and Emile Pereire. He became associated with the dealer Adolphe Goupil, who popularized his stock through the distribution of prints. Goupil found a ready market for Jalabert's small figure paintings recalling his Italian sojourn, such as the *Peasant Girl* (untraced, see 1981 exh. cat., p. 43), a genre so successfully exploited by Léopold Robert and Ernest Hébert, for his Renaissance subjects, including *Romeo and Juliet* (untraced, see 1981 exh. cat., p. 52) and *Raphael's Studio* (untraced, see 1981 exh. cat., p. 53), and for his religious works. The avoidance of heroic themes from antiquity and the preference for anecdotal, often sentimental subjects from the more recent past were characteristic of Delaroche and his pupils.

Jalabert's official recognition included a commission in 1850 from the Sèvres Manufactory for paintings of the *Four Evangelists* (Sèvres, Mus. N. Cér.), which served as designs for the enamelled plaques presented to Prince Albert at the Great Exhibition of 1851 in London. At the Salon of 1853 Empress Eugénie purchased for her chapel in the Tuileries the *Annunciation* (destr.), originally commissioned by the State for Alès Cathedral. Jalabert won a first-class medal at the Salon of 1853 for *Orpheus* (Baltimore, MD, Walters A.G.); this painting, showing nymphs in a forest glade listening enraptured to the Thracian poet, was praised for the lyrical treatment of the subject and for the delicate nuances and harmonies of its execution. Following his exhibition of several paintings, including *Christ in the Garden of Olives* (Douai, Mus. Mun.), at the Exposition Universelle of 1855, Jalabert was awarded the Légion d'honneur. After a trip to Italy in 1857 with his pupil Adolphe Jourdan (1825–89) and Albert Goupil, his dealer's son, Jalabert embarked on two projects that proved ideally suited to his temperament: the ceiling decoration, *Night Unfurling her Veils*, for

a bedroom in Pereire's hôtel on the Rue du Faubourg St-Honoré (now the British Embassy) and another, *Homage to Aurora*, for the boudoir of Constant Say's hôtel on the Place Vendôme (now the Morgan Bank).

From the mid-1860s Jalabert devoted his time to portraiture. In 1864 a commission from Charles Asseline, the former secretary to Louis-Philippe, for portraits of *Louis-Philippe Albert d'Orléans, Comte de Paris* and *Isabelle, Comtesse de Paris* (1865; untraced, see 1981 exh. cat., p. 64), who were residing in exile in Twickenham, England, linked the artist with the house of Orléans. The following year, while in England, he painted portraits of the Comte's younger brother, *Robert d'Orléans, Duc de Chartres*, and *Françoise, Duchesse de Chartres* (1865; untraced). On a third trip in 1866 he received commissions for a series of portraits from Henri d'Orléans, Duc d'Aumale for various members of his family. These works, together with a posthumous portrait of *Marie-Amélie*, ordered by the Duc d'Aumale in 1880, are in the Musée Condé, Chantilly. Jalabert remained active until his death, dividing his time between Nîmes and Bougival.

Bibliography

T. Gautier: *Les Beaux-arts en Europe*, ii (Paris, 1855), pp. 8–9
C. Blanc: *Les Artistes de mon temps* (Paris, 1876), p. 474
E. Reinaud: *Charles Jalabert: L'Homme, l'artiste d'après sa correspondance* (Paris, 1903)
Charles-François Jalabert, 1819–1901 (exh. cat. by A. Jourdan, Nîmes, Mus. B.-A., 1981)

WILLIAM R. JOHNSTON

Jaley, Jean-Louis-Nicolas

(*b* Paris, 27 Jan 1802; *d* Neuilly, 30 May 1866). French sculptor. He was a pupil of his father, Louis Jaley (1763–1838), a medal engraver, and of Pierre Cartellier. In 1820 he entered the Ecole des Beaux-Arts, Paris, winning the Prix de Rome in 1827 with the relief *Mucius Scaevola before Porsenna* (Paris, Ecole N. Sup. B.-A.). His stay in Rome profoundly affected his style, which was influenced by the sculpture of antiquity and the paintings of Raphael. After his return to Paris, *c.* 1834, he con-

tributed sculpture to all the major state building projects of the July Monarchy (1830–48) and the Second Empire (1851–70), including statues of *Jean-Sylvain Bailly* and *Victor Riqueti, Marquis de Mirabeau* (both marble, 1833) for the Chambre des Députés, Paris, of *St Ferdinand* (stone, 1837–9) for the church of La Madeleine, Paris, and those representing *London* and *Vienna* (both stone, 1862) for the Gare du Nord, Paris (all *in situ*). Jaley also achieved contemporary renown for the elegant, Raphaelesque female nudes that he exhibited regularly at the Salon, with titles such as *Prayer* (marble, exh. Salon 1831; Paris, Louvre) and *Modesty* (marble, exh. Salon 1834; Paris, Min. Finances).

Bibliography

Lami
A. Le Normand: *La Tradition classique et l'esprit romantique* (Rome, 1981), pp. 218, 222

ISABELLE LEMAISTRE

Janet-Lange [Janet, Ange-Louis]

(*b* Paris, 26 Nov 1815; *d* Paris, 25 Nov 1872). French painter, illustrator and lithographer. On 5 October 1833 he entered the Ecole des Beaux-Arts in Paris, where he was a pupil of Horace Vernet, Ingres and Alexandre Marie Colin (1798–1875), but was most influenced by Vernet. He made his début at the Salon of 1836 with two paintings, a *Stud Farm* and *Post Stable* and continued to exhibit there until 1870. His subjects consist mostly of hunting scenes and episodes from contemporary French history. Among the latter are works depicting the Crimean War of 1853–6, (e.g. *Episode from the Battle of Koughil, Crimea*, exh. Salon 1859; Epinal, Mus. Dépt. Vosges & Mus. Int. Imagerie), Napoleon III's campaigns in Italy in 1859 (e.g. *Napoleon III at Solferino, 24 June 1859*, exh. Salon 1861; Versailles, Château, on dep. Rennes, Cercle Mil.) and the Mexican expedition of 1861 (e.g. the *Battle of Altesco in Mexico*, exh. Salon 1864). He also painted religious subjects, for example *Agony in the Garden* (exh. Salon 1839; Castelnaudary, Mus. Archéol. Lavragais).

In 1846 Marshal Nicolas-Jean Soult (1769–1851) commissioned Janet-Lange to make a series of

drawings of military uniforms, and these now form part of the archives of the French Ministry of War. He also produced a great number of drawings and lithographs, distinguished by their precision, for the magazine *L'Illustration* and for such other illustrated periodicals as the *Journal amusant* and the *Journal pour rire*. He contributed illustrations of oriental figures to the *Tour du monde* (1862–73), a periodical that was hailed by the critic Léon Lagrange in 1864 as the most lively illustrated publication produced by Hachette. Janet-Lange's illustrations for it were engraved on wood. In addition he illustrated such books as Augustin Thierry's *Histoire de la conquête de l'Angleterre* (1866). He also made a number of Bonapartist lithographs (e.g. *Louis-Napoleon Bonaparte Elected by 7,500,000 Votes*, 1852) chronicling and celebrating the policies and campaigns of Louis-Napoleon Bonaparte (later Napoleon III). Around 1847 he contributed a few cartoons for the publication *Code civil illustré* (1847).

Bibliography

Bellier de La Chavignerie–Auvray; Bénézit; Thieme–Becker
L. Lagrange: 'Les Illustrations du *Tour du monde*', *Gaz. B.-A.*, xvi (1864), pp. 179 83
H. Beraldi: *Les Graveurs du XIXe siècle*, viii (Paris, 1889), pp. 221–2
Inventaire du fonds français après 1800, Paris, Bib. N., Dépt. Est. cat., xi (Paris, 1960), pp. 247–55

ATHENA S. E. LEOUSSI

Janinet, Jean-François

(*b* Paris, 1752; *d* Paris, 1 Nov 1814). French printmaker. He was probably apprenticed to his father François Janinet, a gem-engraver from Burgundy. Between *c.* 1770 and *c.* 1772 he worked in the studio of Louis-Marin Bonnet, who had a considerable reputation as an engraver in the crayon manner and pastel manner. Their collaboration continued later with the production of coloured mounts with gilt decorations. Although Janinet began by executing engravings in the crayon manner, his reputation was based on his perfection of the process of colour printing with a series of plates and the subtle use of special mattoirs and thin layers of ink

imitating the tonal effects of brush-and-ink washes, watercolours or gouaches. In 1772 he published a small oval-print from several plates, *The Meeting* (*Inventaire de fonds français*, no. 2), after Clément-Pierre Marillier, with an inscription that asserted 'Cette Planché gravé à l'imitation du lavie en couleur par F. Janinet/le seul qui ait trouvé cette manière'. He was essentially a reproductive artist, and he left a copious oeuvre. His prints were rarely dated, but they can be classified according to his successive Paris addresses after 1780 (before then he frequently moved house). Between 1781 and 1787 he lived in the Place Maubert and between 1787 and 1792 in the Rue Hautefeuille. His later works were mainly published by the partnership of Esnauts and Rapilly. He seems to have found success and wealth early on. His career continued throughout the political upheavals of the French Revolution and changes in public taste. He tackled a wide variety of subjects: drawing books in the crayon manner such as *Principes de dessin d'après nature* (1773); genre scenes—which won him most renown—such as the *Pleasant Disarray* (1779; after Baudouin), the *Friendly Peasant Girl* (after Saint-Quentin), and his most popular works, after Lafrensen, *The Comparison* (1786), the *Difficult Confession* (1787) and *The Indiscretion* (1788). He also worked on mythological scenes such as the *Toilet of Venus* (1784; after François Boucher); small-scale portraits such as those of the milliner *Rose Bertin* and of *Queen Marie-Antoinette* (both 1787); portraits of actresses on stage, for example *Madame Dugazon in the Role of Nina* and *Mlle Contat* as Suzanne in Beaumarchais's *Le Mariage de Figaro*. In a similar vein was the set of 176 plates illustrating Le Vacher de Charnois's *Costumes et annales des grands théâtres de Paris* (1786–9), which Janinet took charge of and for which he made most of the engravings. During the Revolution Janinet was obliged to reproduce the austere allegories of Jean-Guillaume Moitte: *La Liberté* and *L'Egalité*, but he also produced a historical series from his own drawings, consisting of 52 plates in the wash manner: *Principaux événements depuis l'ouverture des Etats généraux*.

In addition to a number of fine Roman landscapes engraved after watercolours by Hubert

Robert, Janinet also executed two series of views of Paris, in colour, after the drawings of the architect Jean-Nicolas-Louis Durand, which record the appearance of many buildings now destroyed: *Vues des plus beaux édifices publics et particuliers de la ville de Paris* (c. 1787) as well as 63 new views in a circular format (1792). In 1810, in collaboration with his pupil J.-B. Chapuy, he engraved 83 plates in the wash manner for the *Vues des plus beaux édifices publics et particuliers de la ville de Paris et des châteaux royaux*. Janinet claimed to be a 'physicist', and this pretension led to an abortive ascent in a balloon on 11 July 1784, which engendered much mockery and many caricatures. Besides Chapuy, his pupils included Antoine Carrée and Charles-Melchior Descourtis; the latter became his equal in the reproduction of watercolours and was the author of the prints *Village Fair* and the *Village Wedding*. Janinet had a daughter, Sophie, who exhibited a number of prints in the wash manner, under her married name of Giacomelli, at the Salons between 1799 and 1804.

Bibliography

Portalis–Beraldi

M. Hébert and Y. Sjöberg, eds: *Inventaire du fonds français: Graveurs de XVIIIe siècle*, Paris, Bib. N., Dépt. Est. cat., xii (Paris, 1973), pp. 1–94

Regency to Empire: French Printmaking, 1715–1814 (exh. cat. by V. Carlson and J. Ittmann, Baltimore, MD, Mus. A.; Minneapolis, MN, Inst. A., 1984), p. 258

Graveurs français de la seconde moitié du XVIIIe siècle (exh. cat., Paris, Louvre, 1985)

MADELEINE BARBIN

Janmot, (Anne-François-)Louis

(*b* Lyon, 21 May 1814; *d* Lyon, 1 June 1892). French painter and poet. He belonged to the Lyon school of painting, characterized by idealistic and mystical tendencies similar to those of the Nazarenes and the Pre-Raphaelites. His Christian beliefs, which are very apparent in his art, were strongly influenced by neo-Catholic apologists. From 1831 Janmot studied at the Ecole des Beaux-Arts in Lyon. In 1833 he went to Paris, where he became a student of Victor Orsel at the Ecole des Beaux-Arts. He also attended Ingres's studios in Paris and Rome. His technique was deeply indebted to Ingres, but emotionally and intellectually he was more closely allied with Delacroix, whose enthusiasm for the literature of Dante and Shakespeare he shared. Janmot's style combined the precision of Ingres with the meditative devotion of Orsel. His predilection for heraldic compositions, based on symmetry and repetition, his use of profile and flattened form and his luminous colour were all influenced by a love of such early Italian painters as Giotto and Fra Angelico. Janmot's style has much in common with that of fellow Lyonnais and pupil of Ingres, Hippolyte Flandrin.

The majority of Janmot's paintings were commissions for churches. The *Resurrection of the Son of the Widow of Nain* (1840; Puget-Ville Church, Var) is indebted to Ingres's *Martyrdom of St Symphorien* (1884; Autun Cathedral). His *Agony in the Garden* (1840; Col. Ouillins) demonstrates his doctrinaire pro-Catholic beliefs, with such scenes as Savonarola and the Polish defence of the national religion in the background. Other religious works include *St Francis Xavier* (1843; Lyon, St Paul) and an *Assumption of the Virgin* (1844) for the Mulatière Church, Lyon. Janmot also executed murals, sometimes in fresco, as for example at St Polycarpe (1856; destr.), Lyon; St François de Sales (1859), Lyon; and St Etienne du Mont (1866), Paris. His fresco (1878–9) in the chapel of the Franciscains-de-Terre-Sainte, Lyon, was his last state commission.

Janmot's most ambitious work was a series of 18 allegorical paintings, 16 drawings (Lyon, Mus. B.-A.) and poetic verses called *La Poème de l'âme* on which he worked for over 40 years. The series traces the spiritual and physical history of a soul. Recurrent themes include maternal affection and divine and terrestrial love. *La Poème de l'âme* contains autobiographical references and allusions to such contemporary political events as the Revolution of 1848. It attracted the attention of Paul Chenavard, Delacroix and Baudelaire at the Paris Exposition Universelle of 1855, but it was not well received by the public. Janmot's personal and poetic approach to his subject-matter as well as

his pictorial imagination make him an important link between Romanticism and Symbolism. His work was admired by Pierre Puvis de Chavannes, Maurice Denis and Odilon Redon.

Writings

La Poème de l'âme (Paris, 1881, rev. Lyon, 1978)
Opinion d'un artiste sur l'art (Paris, 1887)

Bibliography

E. Hardouin-Fugier: Louis Janmot, 1814–1892 (Lyon, 1981) [with comprehensive bibliog.]

NADIA TSCHERNY

Jazet, Jean-Pierre-Marie

(b Paris, 31 July 1788; d Paris, 18 Aug 1871). French printmaker. He was trained by his uncle, Philibert-Louis Debucourt, and soon became one of his best pupils. At an early age he was successfully producing and selling prints and drawings of the subjects favoured by Debucourt, such as hunts, landscapes and genre scenes. He soon mastered the technique of aquatint, which became his speciality.

Jazet made his début at the Salon in 1817; by this time he was working exclusively on reproductive etchings after paintings. However it was not until the 1819 Salon when he exhibited Général Lasalle (1818; Paris, Bib. N.) after Antoine-Jean Gros and The Bivouac of Colonel Moncey (1819; Paris, Bib. N.) after Horace Vernet that his reputation became established. He was particularly fond of the work of Vernet, which he had first seen in 1816, and he later produced aquatints after such paintings as The Defence of the Clichy Barrier (1822; Paris, Bib. N.) and Judith and Holofernes (1838; Paris, Bib. N.). He also reproduced the works of such painters as Jacques-Louis David, Anne-Louis Girodet, Paul-Emile Destouches (1794–1874), Charles de Steuben (1788–1856) and Hippolyte Bellangé. He specialized in pictures depicting events of the First Empire, such as The Battle of Essling, 22 May 1809 (1831; Paris, Bib. N.) after Bellangé and The Battle of Waterloo (1836; Paris, Bib. N.) after de Steuben. These works gained him considerable popularity but he was also criticized for concentrating on such restricted subject-matter. The demand for his works led him to work over-hastily and occasionally to choose poor paintings. He was awarded the Légion d'honneur in 1846 and continued to exhibit at the Salon until 1865.

Bibliography

H. Beraldi: Les Graveurs du XIXe siècle (Paris, 1885–92), viii, pp. 223–34
Inventaire du fonds français après 1800 (Paris, Bib. N., 1930–), xi, pp. 284–309
For further bibliography see DEBUCOURT, PHILIBERT-LOUIS.

Jeuffroy, Romain-Vincent

(b Rouen, 16 July 1749; d Bas-Primay, nr Marly, 2 Aug 1826). French gem engraver and medallist. He trained in Rouen, where in 1764 he won a prize at the Académie, and in Italy he trained as a gem engraver under Johann Peter Pichler (1766–1807). On his return to France he was appointed Director of the Ecole de Gravure en Pierres Fines and was a founder-member of the engravers section of the Institut in 1803. From 1804 to 1819 he exhibited medals and gems at the Salon. His contributions to the series of Napoleonic medals organized by Baron Vivant Denon in 1804–15 included the medals for the Invasion of England (1804), the Coronation of Napoleon in Paris (1804), the Battle of Sommo-Sierra (1808) and the Battle of Moscow (1812). Examples of these are in the Cabinet des Médailles, Bibliothèque Nationale, Paris, as are a number of his gems, including pieces after the Antique and portraits of such contemporaries as Charles de Wailly (1729–98) and Antoine-François Fourcroy (1755–1809).

Bibliography

Thieme–Becker
E. Babelon: Histoire de la gravure sur gemmes en France (Paris, 1902), pp. 219–21
A. Soubies: Les Membres de l'Académie des Beaux-Arts depuis la fondation de l'Institut (Paris, 1904), pp. 206–9

MARK JONES

Johannot

French family of illustrators and painters. [Charles-Henri] Alfred Johannot (*b* Offenbach am Main, 21 March 1800; *d* Paris, 7 Dec 1837) and his brother Tony Johannot (*b* Offenbach am Main, 9 Nov 1803; *d* Paris, 5 Aug 1852) were born to a French Protestant family of paper-makers and in 1806 went to live in Paris with their father, François Johannot, who, despite financial ruin, was one of the first to try to import the new invention of lithography to France. Alfred and Tony were taught to draw by their father and their elder brother Charles (1795–1824), and they were thoroughly acquainted with the new techniques of illustration: lithography, woodcut and steel engraving. Between 1830 and 1850 French publishing was undergoing a complete change in taste and technique; books were being deluged with images, whether in the form of separately printed plates or more especially small vignettes integrated with the text. The Johannot brothers provided French publishers with thousands of illustrations for major publications of Romantic literature presented in demi-luxe editions for an increasingly large and cultivated public. Their technical virtuosity was allied to a fertile imagination, and they created a graphic style that, with its nervous and dramatic line, contrasting tones, movement, calculated distortion and extravagant expressiveness, could evoke the most powerful emotions. Some of the captions to their illustrations have become famous and reflect the drama of the images: 'Kill us then! I tell you I love him' (illustration by Tony for *La Châtelaine d'Orbec* by Lottin de Laval, 1832); or, 'She resisted: I killed her!' (illustration by Alfred for *Antony* by Alexandre Dumas, 1831).

The brothers rapidly became successful, and their output covers virtually all illustrated Romantic literature. Walter Scott was their first success (complete works with 88 steel-engraved vignettes, 1826), followed by Fenimore Cooper (complete works, 1827), Lamartine (1830), Chateaubriand (1832), Rousseau (1832) and Byron (1833). They were habitués of Romantic literary circles, especially Charles Nodier's at the Bibliothèque de l'Arsenal, and were the favourite illustrators of the great contemporary authors: Victor Hugo (*Notre-Dame de Paris*, 1831), Balzac (*La Peau de chagrin*, 1831), Charles Nodier (*Histoire du roi de Bohême et de ses sept châteaux*, 1830) and also Alfred de Vigny, George Sand, Alexandre Dumas and Jules Janin. They also worked together on periodical illustrations.

Collaboration between the two brothers was total, and their signatures often appear together or even joined. Tony is usually considered a more lively artist than Alfred, who died of consumption at the age of 37. After his death the rate of Tony's output, far from slowing down, seemed to accelerate, losing in quality what it gained in quantity, at a time when the tide of Romantic illustrated books had passed its peak. In 1836 Tony produced 1000 vignettes for J.-J. Dubochet's great edition of *Don Quixote*. He also illustrated the classics, Molière, Boccaccio and Ariosto, and his last work was a contribution to Victor Hugo's complete works (1856–9).

The Johannot brothers also painted, regularly sending to the Salons canvases scarcely known except in the successful reproductions that were made after them. They also painted watercolours (Rouen, Mus. B.-A.), and took part in decorating the church of Notre-Dame-de-Lorette, Paris (*Life and Deeds of St Hyacinth* by Alfred Johannot, 1836), and the Musée Historique at Versailles (late 1830s). However, the Johannot brothers are chiefly remembered as the representatives *par excellence* of the Romantic vignette.

Bibliography

H. Beraldi: *Les Graveurs du XIXe siècle: Guide de l'amateur d'estampes modernes* (Paris, 1885–92), viii, pp. 243–77

A. Marie: *Alfred et Tony Johannot, peintres, graveurs et vignettistes* (Paris, 1925)

Inventaire du fonds français après 1800, Bib. N., Cab. Est. cat., xi (Paris, 1960), pp. 406–48

G. Ray: *The Art of the French Illustrated Book, 1700 to 1914*, ii (New York, 1982), pp. 256–67

Histoire de l'édition française, iii (Paris, 1985), pp. 296–312

MICHEL MELOT

Jollain, Nicolas-René

(b Paris, 1732; d Paris, 1804). French painter. A pupil of Jean-Baptiste Marie Pierre, he finished second in 1754 in the Prix de Rome competition with his *Mattathias* (untraced). He was approved (*agréé*) at the Académie Royale in 1765. He was a precocious and original artist, whose works range from historical, allegorical and religious pictures to decorative and genre pieces and portraits. His work frequently divided contemporary critical opinion. His *Belisarius Begging Alms* of 1767 (untraced), for example, was considered well composed by Louis Petit de Bachaumont, who admired the motif of the child begging with an upturned soldier's helmet. Denis Diderot, on the other hand, dismissed the work as 'a bad sketch'. Jollain's particular aptitude was for religious subjects. At the Salon of 1769, for example, he exhibited *The Refuge* (untraced; oil sketch, British priv. col.), which depicts the founder of the Institute of Our Lady of Refuge in an attitude of devotional supplication; it was painted for the Order's convent chapel at Besançon, and the chapel itself appears in the background. Jollain's art was part of the mid-18th-century Baroque revival in French religious painting, and *The Refuge* has some affinity with Gabriel-François Doyen's *Miracle des Ardents* (1767; Paris, St Roch). Jollain's other religious commissions of this period include the *Entry of Christ into Jerusalem* (1771; untraced) for the Paris Charterhouse. He was received (*reçu*) as a history painter at the Académie in 1773 with the *Good Samaritan* (ex-St Nicolas-du-Chardonnet, Paris, 1972).

Jollain was adept at maintaining the smooth forms of the Rococo style while incorporating fashionable Neo-classical subject-matter or references. A subject from Herodotus, the *Indiscretion of Candaules, King of Lydia* (1775; Paris, Jean de Cailleux priv. col.), with its popular combination of antique and erotic elements, has the *déshabillé* Queen of Lydia in the foreground, with Candaules and his bodyguard, Gyges, appearing in the background as shadowy voyeurs. Shortly after, Jollain again reworked two common themes in the Rococo nude: *The Bath* and *La Toilette* (both Paris, Mus. Cognacq-Jay). In these very small pictures, both of which are painted on copper, Jollain

complemented his elegantly proportioned figures with exquisitely detailed accessories. Both were engraved in 1781 by Louis-Marin Bonnet, who augmented them with a blatant erotic charge bordering on the ridiculous. That year Jollain was himself commissioned to provide a companion piece for Hugues Taraval's *Waking of Cupid* for the Chambre de la Reine at the château of Marly. The result was his *Sleeping Child* (London, Wallace), a demonstration of the artist's ability to modify his style to suit specific demands and locations. In the same year he painted his *Christ Among the Doctors* (1781; Fontainebleau, Château) for the chapel at Fontainebleau. In 1788 he was made a curator of the Musée du Roi and in 1792, with François-André Vincent and Jean-Baptiste Regnault, he was a member of the commission for the formation of a Musée National.

Jollain could not have been prepared for the vitriolic critical assault that followed the open Salon of 1791. Among the works he exhibited were *Aeneas and Dido*, *Blind Oedipus Guided by Antigone* and *Susanna* (all untraced). His pictures were called 'detestable', 'sad' and 'daubs'. The severity of these criticisms resided in the perception of him as an archetypal Academician practising a smooth and gracious style that was associated with a privileged élite. Jollain's cause cannot have been helped by the presence in the same room of Jacques-Louis David's *Death of Socrates* (New York, Met.) and the *Lictors Bringing Brutus the Bodies of his Sons* (Paris, Louvre). He did not exhibit at the Salon again.

During the French Revolution and for a period soon after his death, Jollain was largely forgotten; but although his oeuvre is fragmentary and widely dispersed, he must be considered among the more able figures in the transition from the Rococo to the Neo-classical style in France.

Bibliography

Lettres analytiques, critiques et philosophiques sur les tableaux du Salon, l'an troisième de la liberté (Paris, 1791), pp. 44–5

M. Roland Michel: 'Concerning Two Rediscoveries in Neo-classical Painting', *Burl. Mag.*, cxix (1977) [adv. supplement, pp. i–vii]

French Eighteenth-century Oil Sketches from an English
 Collection (exh. cat. by P. Walch, Albuquerque, U. NM,
 A. Mus., 1980)

SIMON LEE

Jollivet, Pierre-Jules

(*b* Paris, 26 June 1794; *d* Paris, 7 Sept 1871). French
painter and lithographer. He first studied archi-
tecture with Jean-Jacques Huvé (1742–1808) and
Charles Famin and then turned to painting, enter-
ing the Ecole des Beaux-Arts in Paris on 11 May
1822. He remained there until 1825 and was a
pupil of François-Louis Dejuinne (1786–1844) and
of Antoine-Jean Gros. He became interested in lith-
ography very early on and in 1826 travelled to
Spain to work on the *Colección litographica de
cuadros del rey de España el señor Fernando VII*
(Madrid, 1826), a catalogue of the art collections
of Ferdinand VII, King of Spain, at the Museo
Real in Madrid. Jollivet contributed the first 18
plates to this publication and, on his return to
Paris, resumed painting. He specialized in paint-
ing history and genre subjects, and his journey
to Spain supplied him with numerous subjects
for the latter, which were much admired at the
Salon. He made his début at the Salon in 1831 with
the *House of the Alcalde, View of the Royal
Residence in Aranjuez, Taken Opposite the
Waterfall of the Tagus* and *Philip IV and his
Children*, after the work by Velázquez. He contin-
ued to paint and exhibit Spanish subjects there-
after, and these became one of the hallmarks of
his work. In the 1830s he was commissioned by
Louis-Philippe to paint a number of large histori-
cal compositions for the Musée Historique de
Versailles, and this led to such works as the *Battle
of Hooglede, 13 June 1794* (Salon 1836) and
*Godefroy de Bouillon Holding the First Assizes in
the Kingdom of Jerusalem, January 1100* (both
Versailles, Château). He also painted such religious
subjects as the *Massacre of the Innocents* (exh.
Salon 1845; Rouen, Mus. B.-A.), and he decorated
the chapels of such churches as St-Ambroise, St-
Antoine-des-Quinze-Vingts and St-Vincent-de-Paul,
all in Paris.

Bibliography
Bénézit; DBF; Thieme–Becker
G. Vapereau: *Dictionnaire universel des contemporains*
 (Paris, 1858, 5/1880)
Inventaire du fonds français après 1800, Paris, Bib. N.,
 Dépt. Est. cat., xi (Paris, 1960), pp. 457–8
B. Foucart: *Le Renouveau de la peinture religieuse en
 France, 1800–1860* (Paris, 1987), pp. 91–2

ATHENA S. E. LEOUSSI

Jouffroy, François

(*b* Dijon, 1 Feb 1806; *d* Laval, Mayenne, 25 June
1882). French sculptor. Son of a baker, he attended
the Dijon drawing school before enrolling at the
Ecole des Beaux-Arts in Paris in 1824. In 1832 he
won the Prix de Rome and was charged while in
Italy with the task of selecting earlier Italian
sculpture for inclusion in the cast collection of
the Ecole. Two of his works from the years imme-
diately after his return from Rome stand out from
contemporary production: the highly acclaimed
Girl Confiding her Secret to Venus (marble, exh.
Salon 1839; Paris, Louvre), depicting a naked girl
standing on tiptoe to whisper into the ear of a
herm bust of the goddess, a work recalling Roman
genre sculpture as well as the playful gallantry
of the 18th century; and the stone pediment for
the Institut des Jeunes Aveugles (1840), in the
Boulevard des Invalides, Paris, in which Jouffroy
rivalled Pierre-Jean David d'Angers in accommo-
dating present-day realities in monumental public
sculpture. During the Second Empire (1851–70)
Jouffroy participated in the decoration of major
public buildings, most conspicuously with the
stone groups *Marine Commerce* and *Naval Power*
(*c.* 1867–8) for the Guichets du Carrousel of the
Louvre and the façade group depicting *Harmony*
(Echaillon stone, 1865–9) for the new Paris Opéra.
Jouffroy's sculpture classes at the Ecole des
Beaux-Arts were attended by some talented stu-
dents, including Alexandre Falguière, Marius-Jean-
Antonin Mercié, Louis-Ernest Barrias, Augustus
Saint-Gaudens and António Soares dos Reis, but he
is said to have performed his duties there in an
increasingly perfunctory manner.

Bibliography

Lami

A. M. Wagner: *Jean-Baptiste Carpeaux, Sculptor of the Second Empire* (New Haven, 1986), pp. 68, 118, 224, 226–7, 229–30, 250

PHILIP WARD-JACKSON

Julien, Pierre

(*b* Saint-Paulien, Haute-Loire, 20 June 1731; *d* Paris, 17 Dec 1804). French sculptor. He studied in Le Puy with the minor sculptor Gabriel Samuel (1689–1758) and in Lyon with Antoine-Michel Perrache (1726–79), who in 1758 recommended him to Guillaume Coustou (ii) in Paris. In 1765 Julien won the Prix de Rome with the relief *Albinus Helping the Vestals to Flee the Gauls* (untraced). After three years at the Ecole Royale des Elèves Protégés he went to the Académie de France in Rome (1768–72). Among his works from this time is a reduced copy (marble; Versailles, Château) of the antique statue *Ariadne Abandoned*, then known as *Cleopatra*. In 1773 he returned to Coustou's studio and in 1776 suffered a humiliating check to his career when, on submission of his statue of *Ganymede* (marble; Paris, Louvre), he was refused admission to the Académie Royale (possibly at the instigation of his master). In 1779, however, he became a member of the Académie with the marble statue the *Dying Gladiator* (Paris, Louvre). He subsequently enjoyed a successful career, both working for private clients and receiving public commissions from the Bâtiments du Roi. The most important of his official sculptures were the two life-size, seated marble statues commissioned by the Comte d'Angiviller, director of the Bâtiments du Roi, for the series of 'Illustrious Frenchmen'. Reflecting contemporary critical pleas for historical accuracy, his well-received statue of *La Fontaine* (1783–5; Paris, Louvre) was represented in 17th-century costume, while that of *Poussin* (1789–1804; Paris, Louvre) cleverly depicted the painter in his nightclothes, permitting Julien to carve simplified monumental drapery that might pass for a Classical toga. Like most of his contemporaries Julien eclectically adopted Baroque, Rococo and Neo-classical

styles as alternative modes of expression. His terracotta statuette of *Silent Cupid* (exh. Salon 1785; New York, Met.) is fully Rococo in conception, while his most famous work, the group of a *Girl Tending a Goat* or *Amalthea* (marble, 1786–7; Paris, Louvre), executed for Marie-Antoinette's dairy at Rambouillet, modifies a typically Rococo conceit by using a model derived from the antique Capitoline *Venus*. Julien continued to exhibit at the Salons after the French Revolution and *c.* 1800 modelled a terracotta bust of Napoleon (untraced). He was made a member of the Légion d'honneur in the year of his death.

Bibliography

A. Pascal: *Pierre Julien sculpteur: Sa vie et son oeuvre, 1731–1804* (Paris, 1904)

M. Gagne: 'Une Esquisse de Julien', *Bull. Mus. France*, i (1929), p. 260

M. Benisovich: 'Pierre Julien at Rambouillet', *Burl. Mag.*, lxxix (1941), pp. 43–4

—: 'A Sculpture by Pierre Julien in the United States', *A. Q.* [Detroit], xii (1949), pp. 370–72

F. H. Dowley: 'D'Angiviller's "Grands Hommes" and the Significant Moment', *A. Bull.*, xxxix (1957), pp. 259–77

P. Guth: 'La Laiterie de Rambouillet', *Conn. A.*, 75 (1958), pp. 74–81

W. G. Kalnein and M. Levey: *Art and Architecture of the 18th Century in France*, Pelican Hist. A. (Harmondsworth, 1972)

J. D. Draper: 'New Terracottas by Boizot and Julien', *Bull. Met. Mus. A.*, xii (1977), pp. 141–9

M. P. Worley: 'Catalogue of the Works of Pierre Julien', *Gaz. B.-A.*, n.s. 6, cxii (1988), pp. 185–204

MICHAEL PRESTON WORLEY

Karpff, Jean-Jacques [Casimir]

(*b* Colmar, 12 Feb 1770; *d* Versailles, 24 March 1829). French painter, miniaturist and draughtsman. He had an early love for drawing and was given a rudimentary training under Joseph Hohr in Colmar. He travelled to Paris in 1790; there he became one of the first pupils of Jacques-Louis David. In his atelier, he acquired the name Casimir because 'Karpff' was found difficult to pronounce. In 1793 he toyed with the idea of travelling to Rome to complete his studies but decided to carry

on for a further two years under David. His training instilled a love for classical and mythological subjects, but most of his paintings on these subjects were without distinction. He always felt uneasy with colour, and soon learnt that it was wisest to restrict himself to monochrome painting and drawing. In 1795 he was called from Paris to Colmar to teach drawing at the newly founded art school; he also organized the local Republican festivals through his association with David. While in Colmar he drew portraits (untraced) of the poet *Théophile-Conrad Pfeffel* (1736–1809) and of *Général Jean Rapp* (1772–1821). In 1806 he was summoned to the château of Saint-Cloud to draw the portrait of the *Empress Josephine Bonaparte* (untraced), after she had been impressed by his portrait of Général Rapp; he never returned to Colmar. The portrait of the Empress won a gold medal at the 1809 Salon and drew from David the comment that 'the art of drawing could be extended no further'. The work made Karpff famous and sought after. Soon after its exhibition he was invited by the poet Victoire Babois (1760–1839) to live in Versailles, where he remained for the rest of his life. Among the numerous portraits he executed are *Portrait of the Artist's Father* (1789; Colmar, Mus. Unterlinden), the miniature of the *Mother of the Painter Auguste Bigand* (Avignon, Mus. Calvet) and the *Portrait of the Poet Victoire Babois* (Versailles, Château).

Bibliography

H. Lebert: 'J.-J. Karpff, dit Casimir', *Rev. Alsace* (July 1856), pp. 289–304

R. Ménard: *L'Art en Alsace-Lorraine* (Paris, 1876), p. 97

☐

Labille-Guiard [née Labille], Adélaïde

(*b* Paris, 11 April 1749; *d* Paris, 24 April 1803). French painter. Her father, Claude Labille (1705–88), was a haberdasher in Paris. She first trained (*c.* 1763) with the miniature painter François-Elie Vincent (1708–90), whose studio was next door to her father's shop. By 1769 she had obtained membership in the Académie de St Luc,

no doubt sponsored by Vincent, who was Conseiller to this Académie. In that year she married Louis-Nicolas Guiard, a financial clerk; the marriage was childless. In 1779 she obtained a legal separation from her husband. For some time between 1769 and 1774 she studied the technique of pastel with Maurice-Quentin de La Tour. She first exhibited her work at the Académie de St Luc in 1774, when she showed a life-size pastel *Portrait of a Magistrate* (untraced; see Passez, no. 1) and a *Self-portrait* in miniature (untraced; P 2). With the ambition of eventually becoming a member of the Académie Royale de Peinture et de Sculpture, she entered in 1776 the studio of her childhood friend François-André Vincent, in order to learn oil painting, a technique she had mastered by *c.* 1780. Following the suppression of the Académie de St Luc in 1776, artists who were not members of the Académie Royale had no venue in which to exhibit until the establishment of the Salon de la Correspondance in 1781. There Labille-Guiard exhibited in 1782 and 1783 a series of artists' portraits in pastel. Her subjects included leading members of the Académie Royale, such as *Joseph-Marie Vien* (1782; Montpellier, Mus. Fabre), from whom she had requested sittings as a means of developing her professional connections and demonstrating her talent. By then she had made her own studio and by 1783 had been teaching nine women students. In that year she was admitted to full membership of the Académie Royale, on the same day as Elisabeth-Louise Vigée Le Brun.

Labille-Guiard exhibited regularly at the salons from 1783 to 1800. Her sitters included members of the aristocracy, among them *Etienne-François, Duc de Choiseul* (1786; priv. col., P 66). In 1787 she was designated Peintre des Mesdames, official painter to Louis XVI's numerous aunts; her portraits of them included *Mme Adélaïde* (1787) and *Mme Victoire* (1788; both Versailles, Château; version of *Mme Adélaïde*, Phoenix, AZ, A. Mus.). The following year the Comte de Provence (the future Louis XVIII) commissioned her first large-scale history painting, the *Reception of a Knight of St Lazare by Monsieur, Grand Master of the Order*. She worked on this painting for over two years; in 1793 it was destroyed by order of leaders

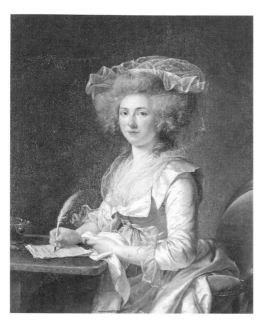

59. Adélaïde Labille-Guiard: *Portrait of a Woman*, c. 1787 (Quimper, Musée des Beaux-Arts)

of the French Revolution, who considered the subject unacceptable, and it is known only from a surviving oil sketch (Paris, Mus. N. Légion d'Honneur). She dedicated herself to winning equal privileges for women artists within the Académie. Beginning in 1785 she repeatedly petitioned for a studio in the Palais du Louvre, a request not granted until 1795; officials objected to the notion of her women students invading the male bastion of the Louvre. She took an active role in reforming the regulations of the Académie: on 23 September 1790 she addressed the assembled artists on offering wider admission to women, whose membership had been limited to four places at any one time.

When Labille-Guiard's royal and aristocratic commissions dwindled as a result of the Revolution, she sought new sitters among Revolutionary leaders; Maximilien de Robespierre and Alexandre de Beauharnais were among the radical politicians from whom she elicited commissions for portraits, shown at the 1791 Salon

(both untraced; P 120–22). In September 1791 both she and Jacques-Louis David received an ill-timed royal commission that had been approved by the Assemblée Nationale; each was to produce a painting depicting Louis XVI accepting the new constitution. Following the King's imprisonment and execution, the project was abandoned. From 1792 Labille-Guiard divided her time between Paris and a nearby village, Pontault-en-Brie. Throughout this period she continued to paint miniatures; her submissions to the Salon declined in number. In 1800 she married François-André Vincent, her former teacher and lifelong companion.

Labille-Guiard produced a relatively small oeuvre, comprising miniatures, pastels (1774–95) and oil paintings (c. 1780–1800). Her presentation of the sitter was direct and candid. Many of her works were half-lengths, with little or no elaboration of setting. Like the pastels of her teacher Quentin de La Tour, they featured subtly nuanced expressions, directness of gaze and informal poses or gestures, as in the portrait of the painter *Joseph-Benoît Suvée* (1783; Paris, Ecole N. Sup. B.-A.) or the actor *Dublin* (1799; Cambridge, MA, Fogg). In portraits of women she was able to depict detail, such as the patterns of lace, the sheen of fabric and the texture of hair, without overwhelming the character of the sitter, as in her *Portrait of a Woman* (c. 1787; Quimper, Mus. B.-A.; see fig. 59). Contemporaries praised her portraits as perfect likenesses. In royal commissions, and in the 1785 *Self-portrait with Two Pupils* (New York, Met.), the artist depicted full-length figures with more formality, elegant costuming and elaborate settings. She used a complex play of shadows to add immediacy and interest, particularly in the portrait of *Louise-Elisabeth de France, Duchesse de Parme, and her Son* (1788; Versailles, Château), where the sitter is shown on a canopied balcony, with strong sidelighting that casts a full shadow on the wall behind. Labille-Guiard preferred a restrained, sombre palette, with close harmonies of blue, grey or brown; the background often repeated the colour of the sitter's clothing. Her pastels were carefully blended, with little drawing apparent. She painted in oil with a miniature painter's precision and the high degree of finish

valued by the Académie at that period. From the start of her career the critical press fostered the notion of a continuing rivalry with Vigée Le Brun, contrasting the graceful, seductive quality of the latter's work with the supposedly masculine character of Labille-Guiard's painting. In fact, the two artists neither frequented the same social circles nor competed for the same clientele. Serious and hard-working, Labille-Guiard never enjoyed the celebrity or prosperity achieved by her supposed rival.

Bibliography

R. Portalis: 'Adélaïde Labille-Guiard, 1749–1803', *Gaz. B.-A.*, n. s., 2, xxvi (1901), pp. 353–67, 477–94; xxvii (1902), pp. 100–118, 325–47; also as *Adélaïde Labille-Guiard* (Paris, 1902)

M. Jallut: 'Le Portrait du prince de Bauffremont par Madame Labille-Guiard', *Rev. Louvre* (1962), pp. 217–22

J. G. von Hohenzollern: 'Das Bildnis der Marquise de La Valette von Mme Adélaïde Labille-Guiard', *Pantheon*, xxvi (1968), pp. 474–82

J. Cailleux: 'Portrait of Madame Adélaïde of France, Daughter of Louis XV', *Burl. Mag.*, cxi (1969), suppl., pp. i–vi

A.-M. Passez: *Adélaïde Labille-Guiard, 1749–1803: Biographie et catalogue raisonné de son oeuvre* (Paris, 1973) [P]

W. Chadwick: *Women, Art and Society* (New York, 1990)

KATHLEEN NICHOLSON

Lagrenée, Jean-Jacques [*le jeune*]

(*b* Paris, 18 Sept 1739; *d* Paris, 13 Feb 1821). French painter, designer and engraver, brother of Louis Lagrenée. He was a pupil of his brother, with whom he travelled to Russia, where he stayed from 1760 to 1762. Although in 1760 he had only obtained second place in the Prix de Rome competition, he received permission to stay at the Académie de France in Rome, where he spent the years 1763 to 1768. In Rome he discovered the works of antiquity and followed the example of Giovanni Battista Piranesi in drawing and engraving antique sculpture. He also painted a ceiling in the Palazzo Senatorio 'in the arabesque taste' (destr.). He was approved (*agréé*) by the Académie Royale in 1769. He exhibited regularly at the Salon

between 1771 and 1804 and he was as prolific as his elder brother.

Jean-Jacques Lagrenée devoted himself almost exclusively to history painting, but he also continued to execute decorative paintings. He sometimes worked in a light and gracious style, as in *Apollo Surrounded by the Muses*, painted in 1775 for the ceiling of the theatre of the Trianon, Versailles (*in situ*), and sometimes in the grand manner, as with *Winter*, an allegorical ceiling painting for the Galerie d'Apollon in the Louvre, Paris (*in situ*). The latter was Lagrenée's *morceau de réception*, presented when he became a full member of the Académie Royale in 1775. His contemporaries were struck by the monumentality of this work, which was influenced by the famous Galleria of the Palazzo Farnese, Rome, frescoed by Annibale Carracci and assistants.

Lagrenée's religious paintings are numerous but not innovative, as witness two oval canvases shown at the 1781 Salon, the *Baptism* and the *Wedding at Cana*, which form part of the last great cycle of religious paintings commissioned in the 18th century for the royal chapel at the château of Fontainebleau (*in situ*). Among his most remarkable works in this field is the *Presentation in the Temple* (1771; Versailles, Chapel of the Grand Trianon), in which the figures are arranged in a vast, light-filled architectural setting and the whole recalls the 17th-century classicism of Eustache Le Sueur and Sébastien Bourdon. *St John Preaching in the Desert* (1783; Grenoble, Mus. Peint. & Sculp.) is a brilliant stylistic variation on the painting of the same subject by Pier Francesco Mola (Paris, Louvre) then in the French royal collection, while a highly contemporary Neo-classical concern with archaeological accuracy is apparent in the *Finding of Moses* (1785; Chambéry, Préfecture). Lagrenée drew on past models in an eclectic fashion: in *David Taunting Goliath* (exh. Salon 1781; Caen, Mus. B.-A.), for instance, he turned to the Bolognese school for inspiration, whereas the slightly earlier *Holy Family in Egypt Destroying the Idols* (exh. Salon 1775; Rennes, Mus. B.-A. & Archéol.) is somewhat reminiscent of Giovanni Benedetto Castiglione and François Boucher.

Like his elder brother and like Jean-Marie Vien, Jean-Jacques Lagrenée painted fashionable antique genre scenes, such as the *Wedding in Ancient Times* (1776; Angers, Mus. B.-A.). He also received commissions for history paintings from Louis XVI's reforming Directeur-Général des Bâtiments du Roi, the Comte d'Angiviller. It is difficult to form an impression of these works exhibited at the Salon between 1777 and 1789, since some have been destroyed (e.g. *Albinus*, exh. Salon 1777), while others are rarely exhibited in the museums where they are stored. However, they seem to demonstrate a stylistic development from a somewhat theatrical eloquence to a more classical restraint. Among surviving works are the *Steadfastness of Jubellius Taurea* (exh. Salon 1779; Montpellier, Mus. Fabre), *Bacchus' Feast or Autumn* (exh. Salon 1783; Compiègne, Château), *Ulysses Arriving at Circe's Palace* (exh. Salon 1787; Tourcoing, Mus. Mun. B.-A.) and *Ulysses on the Isle of the Phaeaceans* (exh. Salon 1791; Narbonne, Mus. A. & Hist.). The archaizing style of the last-named work, as shown in the Pompeian décor, the frieze-like composition and the static quality of the figures, confirms the younger Lagrenée's complete adherence to the Neo-classical aesthetic of the 1780s and 1790s.

From 1785 to 1800 Jean-Jacques Lagrenée was artistic director of the Manufacture de Sèvres. Inspired by the friezes of Greek temples, Etruscan vases and Roman paintings, he created many new Neo-classical designs, such as the famous Etruscan service for Marie-Antoinette's dairy at the château of Rambouillet (e.g. cup and saucer, 1788; Sèvres, Mus. N. Cér.), which has no gold decoration but polychrome or black designs on yellow, purple and violet backgrounds. He was also interested in new techniques and he exhibited his experiments at the Salon. These included a *St John* painted on glass (1781; untraced), a painting on mirror glass of coloured figures on a black background (1796; untraced), a drawing in bistre heightened with gold (1798; untraced) and paintings in oils on glass plaques (1804; untraced). Little is known about his work in the first years of the 19th century; more generally, his entire oeuvre, often confused with that of his elder brother or of his nephew, François Lagrenée, still awaits scholarly rediscovery.

Bibliography

M. Sandoz: 'Jean-Jacques Lagrenée, peintre d'histoire (1739–1821)', *Bull. Soc. Hist. A. Fr.* (1962), pp. 121–33

NATHALIE VOLLE

Lami, Eugène(-Louis)

(*b* Paris, 12 Jan 1800; *d* Paris, 19 Dec 1890). French painter and lithographer. As a boy his health was so delicate that he was taught by a tutor at home. In 1815, after seeing some of his sketches, Horace Vernet took him into his studio. Overburdened with work himself, Vernet then sent him in 1817 to Antoine-Jean Gros's studio at the Ecole des Beaux-Arts, where he remained for three years, while also continuing to work with Vernet. While in Gros's studio he met Paul Delaroche, Théodore Gericault and R. P. Bonington. Although Bonington taught him the art of watercolour painting, Lami's early work was largely in the field of lithography. In 1819 he produced a set of 40 lithographs depicting the Spanish cavalry, which reflect his fascination for military subjects. These were published in Paris under the title *Manejo del Sable*. However, his largest project of this period was a set of lithographs called *Collections des uniformes des armées françaises de 1791 à 1814* (Paris, 1821–4), all of which (except for a few by Horace and Carl Vernet) were produced by Lami himself. A series of six lithographs representing characters from Byron designed by Gericault and Lami appeared in Paris in 1823, and in the same year he began a number of caricatures entitled *Contretemps* (Paris, 1824).

In 1824 Lami made his début at the Salon with the painting *Battle at Puerto da Miravete* (1823; Versailles, Château). In 1826 he travelled to London where he stayed until 1827, studying, among other things, the works of Joshua Reynolds and Thomas Lawrence. He returned to Paris where his acquaintance with the Marquis de Murinais led to the series of lithographs *La Vie de château* (Paris, 1828). After the July Revolution in 1830 Lami received a number of commissions from Louis-Philippe for military paintings for the château at Versailles, which the King intended to turn into a history

60. Eugène Lami: *Banquet in the Salle des Spectacles at Versailles in Honour of the Queen of England*, 1854 (Versailles, Musée National du Château de Versailles et du Trianon)

museum. He was also appointed drawing-master to the Duc de Nemours, which further tied him to the Orléans family. The period from 1830 until about 1838 was Lami's most prolific in terms of military paintings, all of which were characterized by a detailed, panoramic view set beneath a vast expanse of sky. These included *Battle at Claye, 27 March 1814* (1831) and *Battle of Wattignies* (1837; both Versailles, Château). In 1837 the museum at Versailles was inaugurated and Louis-Philippe was married. The colourful ceremonies that accompanied these events led to a change in Lami's work. He began to concentrate on the court of Louis-Philippe and bourgeois society; the result was such oil paintings as *Arrival of Queen Victoria at the Château of Eu* (1843; Versailles, Château). Mostly, however, he produced watercolours, such as the *Races at Chantilly* (1835; priv. col.; see Lemoisne, 1912, p. 106), and, except when depicting military scenes, this became his favoured medium.

After Louis-Philippe's fall in 1848 Lami followed him to England where he produced a number of watercolours depicting English society, such as *Costume Ball at Buckingham Palace* (1851; Windsor Castle, Royal Lib.). He returned to France in 1852 but, during the reign of Napoleon III, he never again achieved the official importance he had previously enjoyed. From 1856 he was occupied for some time as artistic adviser to Baron James Mayer de Rothschild (1792–1868) during his construction of a château at Boulogne and his transformation of that at Ferrières. In 1859 he painted a series of watercolours illustrating the works of Alfred de Musset such as *December Night* (1859; Malmaison, Château N.). At this time he became increasingly interested in producing historical watercolours depicting either important events or merely scenes from the past, such as *Festival at the Château of Versailles on the Occasion of the Marriage of the Dauphin in 1745*

(1861; London, V&A). (For an earlier example, see fig. 60.) During the Franco-Prussian War (1870–71) Lami fled to Pregny in Switzerland with the Rothschilds and only returned to Paris after the Commune. In 1879 he was the driving-force behind the foundation of the Société des Aquarellistes Français. Lami continued to work until his death.

Bibliography

P.-A. Lemoisne: *Eugène Lami* (Paris, 1912)

——: *L'Oeuvre d'Eugène Lami* (Paris, 1914)

□

Landelle, Charles(-Zacharie)

(*b* Laval, 2 June 1821; *d* Chennevières-sur-Marne, 13 Dec 1908). French painter. His father, a calligrapher and musician from Mayenne, moved to Paris in 1825 to take up a post as musician in the Tuileries. Ary Scheffer, whom Landelle met through his father's contact with the Orléans court, encouraged him to become a painter. He registered at the Ecole des Beaux-Arts on 2 October 1837 as a pupil of Paul Delaroche and made his debut at the Salon in 1841 with a *Self-portrait* (Laval, Mus. Vieux-Château). His first success, *Fra Angelico asking God for Inspiration* (exh. 1842; untraced), indicated a sentimental, religious tendency in his work, which alternated with pretty pictures of young girls. *Charity* (exh. 1843; Compiègne, Mus. Mun. Vivenel), commissioned by Antoine Vivenel (1799–1862), was followed by *Idyll* and *Elegy* (untraced), which were bought by the dealer Adolphe Goupil on the opening day of the 1844 Salon. The contract to buy also included Goupil's right of first refusal on the reproduction of all Landelle's future work. Subsequently, he painted the *Three Marys at the Tomb* (exh. 1845; Perpignan, Mus. Rigaud) in the pious manner of Ary Scheffer and a sweet, angelic *St Cecilia* (exh. 1848; Paris, St Nicolas-des-Champs), commissioned in 1845 by the Prefect of the Seine, in which elements of the early Renaissance art seen by Landelle on a trip to Italy in 1845 combined with the soft, pale style common among some of his colleagues from the studio of Delaroche. He also painted religious works for St Roch (1850), St Germain l'Auxerrois (1856) and St Sulpice (1875) churches in Paris. The competition for a figure of the 1848 Republic suited his talent as a painter of single, idealized figures, and his entry (Paris, Louvre), posed impressively like a Renaissance saint, was liked more than most.

Landelle achieved his greatest popularity during the Second Empire. Through the dealer Theo van Gogh, he was patronized by the Dutch King. Goupil, van Gogh, private collectors and the French government (acting on behalf of the Emperor) competed with each other to buy his *Femme Fellah* (destr. 1871), which was inspired by a visit to North Africa and exhibited in 1866. Landelle sold the original to Emperor Napoleon III and, according to his nephew, Casimir Stryenski, painted at least twenty copies for his rivals (example in Laval, Mus. Vieux-Château). Like his colleagues, Jean-Léon Gérôme and Charles Jalabert, Landelle abandoned an academic career at an early stage to concentrate on selling pictures with the powerful backing of Goupil, who had promoted his masters, Delaroche and Scheffer.

Bibliography

C. Stryenski: *Charles Landelle* (Paris, 1911)

B. Foucart: *Le Renouveau de la peinture religieuse en France (1800–1860)* (Paris, 1987), pp. 257–8

JON WHITELEY

Laneuville, Jean-Louis

(*b* Paris, 1748; *d* 1826). French painter. He was a pupil of his exact contemporary Jacques-Louis David, with whose work his own has frequently been confused. Nothing is known of his early training. David did not take on pupils until 1781, and Laneuville exhibited at the Salon de la Jeunesse in the Place Dauphine, Paris, from 1783 to 1789. He specialized in portraiture and during the French Revolution (1789–95) produced a sequence of paintings of deputies of the Convention, including *Bertrand Barère de Vieuzac* (1792–3; Bremen, Ksthalle), *Pierre-François-Joseph Robert* and *Joseph Delaunay* (both exh. Salon 1793; Versailles, Château) and *Jules-François Paré* (exh. Salon 1795;

Paris, Carnavalet). His approach was often similar to that of his master, and the *Barère* portrait was once attributed to David. Laneuville's portraits are characterized by monochromatic, neutral backgrounds, with the sitter usually seated, either turning his head as if momentarily disturbed or directly confronting the spectator. A thorough process of psychological probing is evident, and the tension of the image is increased by the highly detailed accessories and the sharp focus of the clothes. Traditionally the *Barère* portrait is deemed to show the politician standing before the Tribunal of the Convention on 4 January 1793, demanding the death of Louis XVI; Laneuville, however, confused both the date of the King's trial and the correspondence between the Gregorian and Revolutionary calendars, showing Barère resting his right hand on a sheet of paper dated 4 January 1792, Year II. At the Salon of 1796 Laneuville exhibited the portrait of the revolutionary *Thérèse Cabarrus, Citizeness Tallien, 'Our Lady of Thermidor'* (untraced); she is shown imprisoned at La Force holding her recently cut hair in preparation for her execution (although this did not take place). The painting hung for only a few days before being removed, since it was an uncomfortable reminder of the bloodiness of the Terror. Laneuville was also active on the fringes of politics; in 1791 he was elected one of the non-academic commissioners to judge the award of the Prix d'Encouragement, and in 1796 he was a signatory to a pro-government petition defending the acquisition of looted works of art.

Although Laneuville's known painted works are all portraits, there is some evidence of an interest in history painting. At the Salon de la Jeunesse of 1783 he exhibited a *Bathsheba* (untraced); his only known drawing is a *Tête d'expression* (1810; Paris, Louvre), possibly depicting Dido. He continued to exhibit at the Salon, in 1804 showing portraits of the harpist *François-Joseph Nadermann* and the architect *Pierre-François Fontaine* (both untraced). He also contributed to Napoleon's scheme to commemorate the marshalls of the army for the Palais des Tuileries, in 1805 painting *Jean-Mathieu Philibert, Comte Serurier, Maréchal de L'Empire* (Versailles, Château). In 1814 he painted *Count Nikolai Mikitich Demidoff* (untraced), adviser to the Emperor of Russia. He exhibited at the Salon until 1817, his last documented date.

Bibliography

P. Dorbec: 'David portraitiste', *Gaz. B.-A.*, 3rd ser., xxxvii (1907), pp. 316–17

G. Brière: 'Sur David portraitiste', *Bull. Soc. Hist. A. Fr.* (1945–6), p. 171

French Painting, 1774–1830: The Age of Revolution (exh. cat., ed. P. Rosenberg; Paris, Grand Pal.; Detroit, Inst. A.; New York, Met.; 1974–5), pp. 523–5

R. Michel: 'L'Art des Salons', *Aux armes et aux arts: Les Arts de la Révolution, 1789–1799*, ed. P. Bordes and R. Michel (Paris, 1988), pp. 60–61

J. F. Heim, C. Béraud and P. Heim: *Les Salons de peinture de la Révolution française (1789–1799)* (Paris, 1989), pp. 57, 256–7

SIMON LEE

Langlois, (Jean-)Charles

(*b* Beaumont-en-Auge, Calvados, 22 Aug 1789; *d* Paris, 24 March 1870). French painter and writer. A student at the Ecole Polytechnique in Paris, he enlisted in the army in 1807 and served in the battles at Wagram in 1809 and at Waterloo in 1815. He was briefly out of service after Waterloo and studied painting in the studio of Horace Vernet. The studio, fondly called La Nouvelle Athènes by its young denizens, was a hotbed of Bonapartism during the Restoration. Louis-Philippe, later King of France, was a frequent visitor there, and this may have assisted Langlois in receiving commissions during his reign. There is a drawing (1813–16; Paris, Ecole B.-A.) by Théodore Géricault of Langlois in the uniform of a grenadier with a cartridge box on his back. It was probably drawn in Vernet's lively environment where liberal politics, militarism, nationalism and art were as energetically mixed as they would be later in Langlois's paintings. The Salon catalogue of 1855 notes that Langlois also studied under Antoine-Jean Gros and Anne-Louis Girodet. He re-enlisted in 1819 and went to Spain with the French army sent by Louis XVIII to protect the Bourbon king of Spain, Ferdinand VII, in 1823 and to Algiers in 1830 to

defend French colonial interests in Algeria and Morocco. He was a military attaché in St Petersburg in 1832, where he painted a portrait of *Nicholas I and his Family* (untraced). His travels to Africa, Russia and, in 1855–6, to the Crimea were made to study the terrain of battlefields for his immense and accurate illustrations of France at war.

Langlois's Salon entries were, almost without fail, battle paintings and included depictions of the battles of Montereau in 1814 (Salon of 1831; Versailles, Château), Sidi Feruch in 1830 (Salon of 1834; untraced), Polotsk in 1812 (Salon of 1838), Smolensk in 1812 (Salon of 1839), Champaubert in 1814 (Salon of 1840) and Hoff in 1807 (Salon of 1849; all Versailles, Château). They were usually accompanied by lengthy catalogue descriptions quoting official reports, such memoirs as those of his superior officer Marshall Gouvion St-Cyr or bulletins of the Grande Armée. They were not intended to be traditional allegorical history paintings celebrating national glory but documentary accounts of the execution of predetermined battle plans. Nevertheless the French are depicted as victorious even in such dubious engagements as Eylau, Moscow and the crossing of the Beresine River.

The most innovative of Langlois's works are his battle panoramas, in which, if read from left to right, a series of paintings depicts the sequence of actions that led the French to victory in a particular engagement. Langlois informed his readers in the pamphlet on the Moscow panorama (1835; Versailles, Château) that his works generally have distinct phases: a beginning, a middle and an end, as in all the great battles planned by Napoleon. His other panoramas depicted the battles of Eylau (1846), Borodino (1850; Paris, Mus. Armée (Hôtel N. Invalides)), the Pyramids (1853), Sebastopol (1862) and Solferino (1868), for most of which he published pamphlets including maps of the battlefields, official contemporary accounts of the battles and careful descriptions of his own deployment of the troops. The panoramas, like the works of the popular poet Pierre Jean de Beranger, served to fan the flame of the Napoleonic legend in the 19th century.

Writings

Voyage pittoresque et militaire en Espagne (Paris, 1826–30)

Panorama de la bataille de la Moskowa (Paris, [1835])

Relation du combat et de la bataille d'Eylau (Paris, 1846)

Explication du panorama et relation de la bataille des pyramides, extraite en partie des dictées de l'empereur à Sainte-Hélène, et des pièces officielles (Paris, 1853)

Explication du panorama représentant la bataille et le prise de Sébastopol (Paris, 1862)

Explication du panorama et relation de la bataille de Solférino (Paris, 1868)

Bibliography

Thieme–Becker

E. C. Bouseul: *Biographie du Colonel Langlois, fondateur et auteur des panoramas militaires* (Paris, 1874)

G. Bapst: *Essai sur l'histoire des panoramas et des dioramas* (Paris, 1891); review by J. Guiffrey in *Nouv. Archvs A. Fr.*, 3rd ser., vii (1891), p. 398

G. Pinet: *Le Panthéon polytechnique* (Paris, 1910)

L. Bro: *Mémoires du Général Bro (1796–1844), recueillis, complétés et publiés par son petit-fils* (Paris, 1914)

D. Aimé-Azam: *La Passion de Géricault* (Paris, 1970), p. 166

NANCY DAVENPORT

Laurent, Jean-Antoine

(*b* Baccarat, 31 Oct 1763; *d* Epinal, 11 Feb 1832). French painter. A pupil of Jean-François Durand (1731–after 1778) in Nancy and later of the miniature painter J.-B. Augustin in Paris (*c.* 1785–6), he began his career as a porcelain and miniature painter. In the latter capacity he exhibited in the Salon between 1791 and 1800, after which he gave up miniatures in favour of small genre paintings, which he exhibited regularly until 1831. In 1806 he received a Prix d'Encouragement and in 1808 a first-class medal. In 1804, when he showed *Woman Playing the Lute* (acquired by the Empress Josephine; now Arenenberg, Napoleonmus.), he was hailed by Vivant Denon as a painter of 'very delicate and very distinguished talent' and as worthy of comparison with Gerrit Dou, Willem van Mieris and Gerard ter Borch (ii) (Paris, Archv. N., AF. IV 1050). He was highly regarded by Josephine, who bought six paintings from

him between 1804 and 1812. Her home at Malmaison also contained a small full-length portrait of the *Empress Josephine* (1806; Strasbourg, Mus. B.-A.), which owed much to his training as a miniaturist.

Of the Troubadour-style painters, Laurent was the most indebted to Dutch art. His paintings are generally very small and are extremely smooth and delicate in technique. Their shiny surface is accentuated by the support (wood or copper), which gives them the appearance of painting on porcelain. The critics were fascinated by the polished technique of his earliest works, which showed the influence of Dou and Mieris as much in their execution as in their composition. Laurent often repeated a motif favoured by the Dutch painters—a figure at a window—as in *Oboe Player* (exh. Salon 1806; Arenenberg, Napoleonmus.). Laurent's *The Prayer* (exh. Salon 1808; St Petersburg, Hermitage) is almost a pastiche of Mieris's *Soap Bubbles* (The Hague, Mauritshuis), which had briefly hung in the Louvre as part of Napoleon's war booty.

During the Restoration Laurent obtained a commission for the Galerie de Diane in Fontainebleau, *Clotilde Begging her Husband to Embrace Christianity Before Leaving for the Battle of Tolbiac* (exh. Salon 1819; *in situ*). The Duc d'Orléans (later King Louis-Philippe) bought the *Man in the Iron Mask in Prison* (exh. Salon 1814; untraced) and the *Childhood of Callot* (exh. Salon 1817; untraced). Laurent continued to paint the same type of picture, in which jewellery, decorative detail and carefully rendered textiles featured prominently (e.g. *Diploma*, exh. Salon 1819; Bourg-en-Bresse, Mus. Ain) until the public lost interest. One of his last works, *A Locksmith Trying to Make a Jay Bite his File* (1829; exh. Salon 1831; Paris, Louvre), is characteristic of this genre, which repetition ossified, and which, after 1824, exasperated many of the critics. Augustin Jal called it 'very polished, very finished, very proper and very bad'.

After selling the paintings remaining in his studio (11 March 1823), Laurent left Paris to settle in Epinal, where he established the Ecole des Beaux-Arts and the museum, of which he was curator until his death. He wrote the first catalogue of the museum (1829).

Bibliography

P. Marmottan: *L'Ecole française de peinture (1789–1830)* (Paris, 1886), pp. 269–70

H. Béraldi: *Les Graveurs du XIXe siècle*, iv (Paris, 1889), p. 65

J. Lejeaux: 'Jean-Antoine Laurent (1763–1832)', *Pays Lorrain* (April 1938), pp. 164–75

H. Haug: 'Musée des Beaux-Arts de Strasbourg: Un Portrait inconnu de l'Impératrice Joséphine', *Rev. des A.*, ii (1954), pp. 120–23

M. C. Chaudonneret: *Fleury Richard et Pierre Révoil: La Peinture troubadour* (Paris, 1980), pp. 41–3

MARIE-CLAUDE CHAUDONNERET

Lebarbier [Le Barbier], Jean-Jacques-François

(*b* Rouen, 11 Nov 1738; *d* Paris, 7 May 1826). French painter, illustrator and writer. He began his studies in Rouen and, at 17, won first prize for drawing at the city's Académie. Shortly afterwards he travelled to Paris, entering the Académie Royale de Peinture et de Sculpture as a student of Jean-Baptiste-Marie Pierre. In 1767–8 he was in Rome, a fact confirmed by a number of dated and inscribed drawings and paintings, including the pen, ink and wash drawing *Landscape Inspired by the Gardens of the Villa d'Este at Tivoli* (Paris, Ecole N. Sup. B.-A.). He was in Switzerland in 1776, where he spent several years drawing illustrations for Beát Zurlauben's *Tableau de la Suisse ou voyage pittoresque fait dans les treize cantons du Corps Helvétique* (Paris, 1780–86). In 1780, having returned to France, he was approved (*agréé*) by the Académie Royale and received (*reçu*) in 1785 with *Jupiter Asleep on Mount Ida* (Paris, Ecole N. Sup. B.-A.). Thereafter he regularly exhibited moralistic pictures at the Salon until 1814, including the *Canadians at the Tomb of their Child* (Rouen, Mus. B.-A.) and *Jeanne Hachette at the Siege of Beauvais* (Beauvais, Hôtel de Ville, destr. 1940) in 1781, *Aristoumenos and the Spartan Girls* (Paris, Louvre) in 1787 and pictures of *St Louis* and *St Denis* in 1812, both of which indicate his interest in depicting religious themes and incidents from earlier French history.

Lebarbier was swift to take up the increasingly fashionable Neo-classical style of Joseph-Marie Vien and Jacques-Louis David, and his works in this vein include the *Tomb of Sextus* (Angers, Mus. B.-A.). He also wrote a minor contribution to the literature of Neo-classicism, the treatise *Des Causes physiques et morales qui ont influé sur les progrès de la peinture et de la sculpture chez les Grecs* (1801). However, his drawing (1784; Paris, Carnavalet) of the Neo-classical hôtel (destr.) designed and built in the Chaussée d'Antin quarter of Paris for Mme Marie-Jeanne Thélusson by the architect Claude-Nicolas Ledoux shows that Lebarbier's artistic interests were not confined purely to painting and sculpture.

In 1786 Lebarbier painted cartoons for a set of four Beauvais tapestries on the theme of the *Four Parts of the World* (London, Osterley Park House, NT). His designs for two of the tapestries, *America* and *Europe*, emphasize the assistance given by France to American colonists during their struggle to throw off British rule. These designs reveal the warmth of Lebarbier's own republican sympathies, to which he gave free rein in his art during the French Revolution (1789–95). In 1786 he also began working on a series of illustrations for the *Works* of the Swiss poet and painter Salomon Gessner. While many of these attest to his Neo-classical bias, there are some, for example *Eraste*, that owe more to Jean-Baptiste Greuze's influence. Lebarbier worked on Gessner's illustrations until 1793, but he also provided designs for works by Ovid, Racine, Jean-Jacques Rousseau and Jacques Delille.

In 1790 the Assemblée Nationale approached Lebarbier to commemorate an early act of Revolutionary zeal; this resulted in *The Heroic Courage of the Young Desilles at the Nancy Affair, 30 August 1790* (Nancy, Mus. Hist. Lorrain). He also made a drawing of this same army officer, *Desilles Presented to Henry IV by Minerva in the Elysian Fields* (untraced; engr. by François Girard). By 1795, however, when the painting was shown at the Salon, the political climate had changed, and Antoine-Joseph-Marc Desilles was no longer seen as a hero but as a counter-revolutionary traitor. Lebarbier's portrait of the South American general *Francisco de Miranda* (1795; Caracas, Pedro Vallenilla Echeverria priv. col.) depicts another individual who was in turn fêted and hounded during the Revolution. Miranda (1756–1816) collected works of art, with Lebarbier acting as adviser and agent. Lebarbier's two daughters, Elise Bruyère (1776–1842) and Henriette, were both painters; Elise became a moderately successful portrait- and flower-painter.

Writings

Des Causes physiques et morales qui ont influé sur les progrès de la peinture et de la sculpture chez les Grecs (Paris, 1801)

Bibliography

J. Renouvier: *Histoire de l'art pendant la Révolution* (Paris, 1863)

G. W. Digby: 'A Set of Beauvais Tapestries Alluding to the War of American Independence', *Burl. Mag.*, xcii (1950), pp. 251–5

M. N. Benisovich: 'Le Général Francisco de Miranda et ses amis parisiens', *Gaz. B.-A.*, n.s. 5, lix (1962), pp. 345–51

J. Vergnet-Ruiz: 'Une Inspiration de Delacroix: La *Jeanne Hachette* de Lebarbier', *Rev. Louvre*, xxi/2 (1971), pp. 81–5

French Landscape Drawings and Sketches of the Eighteenth Century (exh. cat., intro R. Bacou; London, BM, 1977), p. 87

French Painting: The Revolutionary Decades, 1760–1830 (exh. cat., ed. A. Serullaz, H. Toussaint and J. Vilain; Sydney, A.G. NSW, Melbourne, N.G. Victoria, 1980), pp. 170–73

JOSHUA DRAPKIN

Lecomte, Hippolyte

(*b* Puiseaux, nr Fontainebleau, 28 Dec 1781; *d* Paris, 25 July 1857). French painter and lithographer. He was a pupil of Jean-Baptiste Regnault and Pierre-Antoine Mongin (1761–1827). He exhibited regularly at the Salon between 1804 and 1847 and received a first class medal as a genre painter in 1808. His reputation was based above all on his historical landscapes. Apart from a few contemporary subjects, for example the *View of Lake Garda* (exh. Salon 1806; Malmaison, Château N.), which shows the Empress Josephine abandoning her carriage in the face of enemy artillery, his

subjects were taken from an idealized view of the Middle Ages. With Alexandre Millin-Duperreux (1764–1843) he formed a connection between historical landscape and the Troubadour style. His works combine landscape and contrived light effects with the trappings of chivalry fashionable under the Consulate and the Empire (e.g. *Joan of Arc Receiving a Sword from the Hands of Charles VII*, exh. Salon 1808; Blois, Mus. Mun.; *Squire Blondel Telling Marguerite of Flanders of King Richard's Exploits*, exh. Salon 1810; Paris, Louvre, on dep. Tokyo, Fr. Embassy). His reputation was enhanced by *Two Crusaders Leaving for the Holy Land* (exh. Salon 1804; untraced), which was bought by Josephine for the gallery at Malmaison. He was one of the first landscape painters to turn to medieval history, but unlike most painters of historical landscape he emphasized the setting and tried to raise landscape to the level of history painting. The tiny brushstrokes, the stiff elongated figures standing out in the icy, almost unreal light and the bright, acid colours, in their naivety and awkwardness, are tinged with poetry, and these early works contributed to the vogue for mythic medieval imagery, which began with the novels of the Comte de Tressan.

In 1819 Lecomte obtained a commission for the Galerie de Diane at the château of Fontainebleau, *Charlemagne Crossing the Alps* (*in situ*), which depicts horses and figures dramatically illuminated in an imaginary landscape. His fantastic vision of the Alps is characterized by the dramatic contrast of the brutal whiteness of the peak with the shadows of the mountain pass. He started work at the Musée Historique de Versailles in 1836, painting town views and 20 battles from the reigns of Louis XIV through to Napoleon, emphasizing their strategic aspects. The compositions of the Louis XIV paintings are inspired by Adam Frans van der Meulen (e.g. *Capture of Le Catelet* and *Capture of Landrecies*; both *in situ*). Most of these battle paintings are repetitive, lacking conviction or individuality, perhaps because of the overwhelming influence of his father-in-law Carle Vernet. There is, however, no definite proof that they ever collaborated on a picture. The town views can be stereotyped, as in the *Capture of*

Pignerol, and the figures rather stiff, but they are more broadly painted than the highly coloured staffage of his Troubadour-style pictures. He also executed a number of historical paintings on contemporary themes, for example *Louis XVIII at Suze* (ex-Galerie de Diane, Fontainebleau, Château; Chambéry, Mus. B.-A.) and *English Prisoners Brought before Napoleon at Asthora* (Versailles, Château).

Lecomte also executed many lithographs showing his taste for picturesque detail and historical anecdote and costume, such as *Civilian and Military Costumes of the French Monarchy from 1200 to 1820* (380 lithographs) and *Theatre Costumes between 1610 and 1820* (104 lithographs), as well as illustrations for the fables of Jean de La Fontaine, possibly in collaboration with Carle and Horace Vernet.

Bibliography

P. Marmottan: *L'Ecole française de peinture, 1789–1830* (Paris, 1886), pp. 159–63

H. Béraldi: *Les Graveurs du XIXe siècle*, ix (Paris, 1889), pp. 74–5

A. Cox and A. Cox: 'Hippolyte Lecomte and the Rockingham Peasant Figures', *Connoisseur*, cxcv/785 (July 1977), pp. 195–200

MARIE-CLAUDE CHAUDONNERET

Lefèvre, Robert(-Jacques-François)

(*b* Bayeux, 24 Sept 1755; *d* Paris, 3 Oct 1830). French painter. He was the son of a Bayeux draper and originally worked as a law clerk before learning to paint, possibly in the studio of Pierre de Lesseline in Caen. Lefèvre quickly made a reputation for himself and established a sizeable practice in Normandy. About 1784 he went to Paris and entered the studio of Jean-Baptiste Regnault, where he formed a close friendship with the artist and critic Charles-Paul Landon.

Lefèvre's Salon début came at the open Salon of 1791, where he exhibited six paintings to great critical approval. At the 1795 Salon he showed a vibrant *Venus Disarming Love* in the style of Rubens (Fontainebleau, Château). The dislocation of patronage in the aftermath of the French

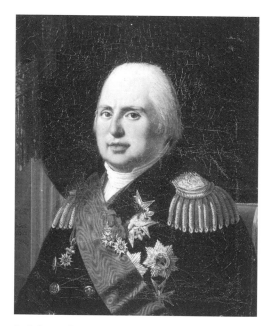

61. Robert Lefèvre: *Louis XVIII*, 1814 (Paris, Musée Carnavalet)

Revolution forced Lefèvre to undertake some book illustration, but with the rise of Napoleon his career as a portrait painter took off, and he became a well-known and prolific painter of portraits of the imperial family. In 1801 he painted *The First Consul and General Berthier at the Battle of Marengo* (untraced; coloured stipple engraving by Anthony Cardon), for which Carle Vernet painted the landscape and JOSEPH BOZE attempted to steal the credit. In the same year Lefèvre painted his fellow artist *Pierre Guérin* (Orléans, Mus. B.-A.), whom he had met at Regnault's studio, presenting the frail and dandyish Guérin directly in an elegant portrait that shows the crispness and clarity of which he was capable. He excelled in rendering the textures of rich fabrics, and his contemporaries dubbed him 'the French van Dyck'. Such portraits of his friends and associates have an intensity and vigour that is often lacking in his official commissions.

In 1804 Lefèvre painted *Napoleon as First Consul* for the Hôtel de Ville at Dunkirk (destr.

1817). The unusually high quality of this painting briefly prompted speculation that it had been copied from a work by David. Enjoying the protection of Dominique Vivant-Denon, the Director-General of Museums, Lefèvre became Napoleon's official portrait painter. His best-known image of the Emperor is that showing *Napoleon in Coronation Robes* (1806 and later versions), of which no fewer than 37 replicas were requested. The portrait exists in two forms. The first depicts Napoleon bare-headed, with his left hand resting on his sword hilt (e.g. Paris, Mus. N. Légion d'Honneur). The second has Napoleon crowned and extending his left arm downwards (e.g. Versailles, Château). The Emperor evidently approved of these for their good likenesses, but Lefèvre insisted on executing all of the many replicas himself, resulting in progressive loss of quality. Lefèvre was also much in demand in society and portrayed many of the beautiful and fashionable women of his age, among them *Pauline Bonaparte, Princess Borghese* (version, London, Apsley House). Here the Princess is shown elegant and relaxed, reclining on a cushion, a favourite device of Lefèvre's.

In 1814, in a bid to ingratiate himself with the restored Bourbon monarchy, Lefèvre painted a portrait of *Louis XVIII* 'done from memory' (1814; Paris, Carnavalet; see fig. 61). This ploy worked, and in 1816 he was named Premier Peintre du Roi, in which capacity he was to execute many portraits of the royal family. In 1826 he painted *Charles X in Coronation Robes* (Paris, Louvre) in the traditional format of French royal portraits. In the 1820s Lefèvre resumed history painting with *The Baptism of the Duc de Bordeaux* (1821; destr.); also in 1821 he painted an *Assumption* for the church at Fontenay-Le-Comte, Vendée (*in situ*). At the 1827 Salon he exhibited a *Crucifixion*, commissioned by the Missionary Fathers of Mount Valerian but never delivered (now Caen, Mus. B.-A.). His last work was an *Apotheosis of St Louis* for the cathedral of La Rochelle (*in situ*). In 1830, worn out by pressure of work and possibly unsettled by the events of the revolution of that year, during which he lost his titles, he committed suicide.

Bibliography

Lady Morgan: *France in 1829-30*, i (London, 1830), pp. 334-54 [contains description of visit to Lefèvre's studio]

Catalogue des tableaux et du cabinet de M. Robert Lefèvre (Paris, 1831) [incl. 'Notice historique']

G. Lavelley: *Le Peintre Robert Lefèvre: Sa vie, son oeuvre* (Caen, [1902])

M. T. Folguera: *Robert Lefèvre, 1755-1830* (diss., U. Paris, 1976)

SIMON LEE

Lehmann, (Charles-Ernest-Rodolphe-) Henri [Karl Ernest Heinrich Salem before naturalization (1846)]

(*b* Kiel, Holstein, 14 April 1814; *d* Paris, 30 March 1882). French painter and teacher of German origin. A pupil of his father, Leo Lehmann (1782-1859), and Ingres, whose studio he entered in 1831, Lehmann enjoyed a long and much honoured career. His work reflects his fervent admiration and emulation of Ingres, his respect for the art of the Nazarenes and his study of 17th-century Italian art. He exhibited regularly at the Salon from 1835, gaining first-class medals in 1840, 1848 and in 1855. He was represented by 20 works at the Exposition Universelle.

Lehmann's most celebrated large easel painting was the *Grief of the Oceanides at the Foot of the Rock where Prometheus Lies Enchained* (1851; Gap, Mus. Dépt.), which allowed him to exercise fully his talents for dramatic lighting and energetically posed nude figures. It was purchased by the State for 6000 francs. He was awarded many commissions for large-scale figure compositions including decorations for the newly enlarged Hôtel de Ville, Paris, in 1852 (destr. 1871), the church of Ste-Clotilde, Paris (1854), and the throne-room of the Palais du Luxembourg, Paris (1854-6). He produced portraits of many of the leading men and women of the period including Stendhal (1841; Grenoble, Mus. Stendhal), the Princess Belgiojoso (1844; ex-Marquis Franco del Pozzo d'Annone priv. col.) and his friend Franz Liszt (1840; Paris, Carnavalet), which is considered by many to be his most successful portrait. Lehmann concentrated on capturing Liszt's dramatic features and commanding gaze, isolating the composer's spare figure against a neutral background. He was also a prolific draughtsman.

Lehmann was awarded the Légion d'honneur in 1846 and was naturalized as a French citizen later that year. From 1875 until a year before his death, he taught at the Ecole des Beaux-Arts; his students included Camille Pissarro and Georges Seurat, who found his conservative regime unappealing.

Bibliography

Henri Lehmann (exh. cat., ed. M.-M. Aubrun; Paris, Carnavalet, 1983)

M.-M. Aubrun: *Henri Lehmann, 1814-1882: Catalogue raisonné de l'oeuvre*, 2 vols (Paris, 1984)

MICHAEL HOWARD

Leleux

French family of painters and printmakers. (1) Adolphe Leleux and his brother (2) Armand Leleux were both known mainly as painters of provincial rural life.

(1) Adolphe Leleux

(*b* Paris, 15 Nov 1812; *d* Paris, 27 July 1891). Adolphe was 25 before he decided to become a painter. He received no formal schooling in art apart from an apprenticeship in engraving with the printer Alexandre Vincent Sixdeniers (1795-1846). Though brought up in Paris, he often painted rural scenes. In 1835 he exhibited scenes from Picardy at the Salon and in 1838 followed with genre scenes of the rural poor. Beginning in 1838 he turned to Brittany for inspiration. Salon critics such as Théophile Gautier found a sincerity in his work that made his scenes 'almost real'. Gautier praised *The Roadmenders* (exh. Salon 1844; untraced) as 'one of the major works of the realist school'.

Adolphe exhibited his Breton scenes, and occasionally a Spanish theme (after a trip to Spain in 1843), at the Salons from 1835 until 1881. He received third-class medals in 1842 and 1843, a second-class medal in 1848 and the Légion d'honneur in 1855. Adolphe fought in the revolution of

1848 and later painted pictures such as *The Password* (1848; Versailles, Château), inspired by his experience on the barricades. Many of these paintings were engraved, the products of which were widely distributed, gaining Leleux a broad following; his images of the 1848 revolution became icons that entered the national consciousness. Adolphe quickly became a favourite of Napoleon III and his canvas of the *Fairground of St Fargeau* (1855; untraced) was purchased by the state for 3000 francs. He received commissions for a number of works, was invited to official gatherings and enjoyed a profitable career. In later years his style softened, and it was criticized for its lack of definition and focus. Gautier unsuccessfully urged Adolphe to return to scenes in the realist tradition. By the time he died he had fallen into obscurity.

(2) Armand Leleux

(*b* Paris, 1818 or 1820; *d* Paris, 1 June 1885). Brother of (1) Adolphe Leleux. He was trained by his brother. His early canvases also had Breton themes, although in his case the inspiration must have come from his brother, for he had never been to Brittany. Adolphe's official ties at court must have greatly assisted the development of Armand's career. In 1846 he was sent to Spain by the French government, probably in order to assess the state of the the arts there, to examine the collections and to study the people and customs of the country. In the same year he visited Switzerland; he returned there many times after his marriage to the Swiss painter Louise Emilie Giraud (1824–1885), who had studied in Paris at the atelier of Léon Cogniet, and he found many patrons and supporters of his work among her compatriots. In 1863 he also went to Italy. Like his brother, he became a favourite artist of Napoleon III and the court. His composition of *The Knitter* (1854; untraced) was purchased by Napoleon's wife, Empress Eugénie.

The locations of Armand's best-known canvases *The Clogmaker*, *Woman with a Lamp* and *The Forge* (all mid-1850s) were unknown by the 1990s, but they were frequently reproduced as engravings in periodicals of the time. These reproductions make clear that he was influenced by the realist painter François Bonvin and was capable of creating a direct, simple style that was easily understandable. This style, when it was used in the service of common work themes, led critics to regard him as an important contemporary realist. His scenes of rural Spain show a sensitivity to light and an exactitude very different from the frequently dour and dark tonality of his brother Adolphe's painting. Critics encouraged Armand to continue to paint in this mode, recognizing that he had a talent for depicting nature and the effects of sunlight in rich colours; but Armand preferred intimate scenes of family life, perhaps because they appealed to an upper middle-class market and afforded him a degree of financial security.

Armand first exhibited at the Salon in 1839, and his folklore scenes proved popular with the Salon jury. He was awarded a third-class medal in 1844, second-class medals in 1847 and 1848, a first-class medal in 1859 and the Légion d'honneur in 1850. This success generated numerous commissions for genre scenes both from patrons and from the French government. In 1867 Armand was selected for a committee studying popular costume for the Paris Exposition Universelle.

Bibliography

L. Nochlin: *Gustave Courbet: A Study of Style and Society* (New York, 1976), pp. 115–17
The Realist Tradition (exh. cat., ed. G. P. Weisberg; Cleveland, OH, Mus. A., 1980)
G. P. Weisberg: 'The Leleux: Apostles of Proto-realism', *A. Mag.*, lvi (Sept 1981), pp. 128–30

GABRIEL P. WEISBERG

Lélu, Pierre

(*b* Paris, 13 Aug 1741; *d* Paris, 9 June 1810). French painter, draughtsman and engraver. He was a pupil of Boucher and of Gabriel-François Doyen. He travelled to Italy for the first time *c.* 1761, making copies of works by Raphael, Domenichino and other celebrated artists. Around 1775 he travelled to Spain and Portugal, then back to Italy. In 1777 he was in Marseille, where he was made a

member of the academy. He then travelled to Paris, where he made the acquaintance of Michel-François Dandré-Bardon; in 1789 he made a third Italian journey.

At the 1793 Salon in Paris he exhibited a number of religious and historical scenes, including *Martha and Mary*, the *Entombment*, *Diomedes Wounding Venus*, *Pyrrhus Sacrificing Polyxena*, the *Death of Virginia* and *Cupid and Psyche*. He is known to have executed portraits of *Napoleon* and the *Marquis de Mirabeau*, among others, but did his finest work as an engraver, producing works such as *God Blessing the World* after Raphael (see Baudicour, no. 59) and *Virgin and Child* after Guercino (Baudicour, no. 67). On his death he left a large collection of works that was sold off in 1811; it included 460 drawings of Italian, French and Spanish monuments. He used pen and wash with verve and imagination, both to depict historical scenes, such as the *Vision of Abraham* (Orléans, Mus. B.-A.) and to record the appearance of interesting sites.

Bibliography

Bellier de la Chavignerie–Auvray; Thieme–Becker

P. de Baudicour: *Le Peintre-graveur français*, i (Paris, 1859), pp. 231–86]

J. Guiffrey and P. Marcel: *Inventaire général des dessins du musée du Louvre et du musée de Versailles*, ix (Paris, 1921), pp. 15–16

Autour de David: Dessins néo-classiques du musée des Beaux-Arts de Lille (exh. cat. by A. Scottez, Lille, Mus. B.-A., 1983), p. 160

ANNIE SCOTTEZ-DE WAMBRECHIES

Lemaire, (Philippe-Joseph-)Henri

(*b* Valenciennes, 9 Jan 1798; *d* Paris, 2 Aug 1880). French sculptor. He was a pupil of François-Dominique-Aimé Milhomme, then of Pierre Cartellier, and won the Prix de Rome in 1821. Throughout his career he remained faithful to the Neo-classical style current in his youth and exemplified in the statues he made in Rome for the Paris Salon, such as *Virgil's Ploughman* (marble, 1826; Paris, Tuileries Gardens) and *Girl with a Butterfly* (1827; Valenciennes, Mus. B.-A.).

After his return to Paris in 1826 Lemaire was principally occupied with official and semi-official monumental sculpture for successive regimes. In 1829 he executed a statue of the *Duc de Bordeaux* for the Duchesse de Berry (marble; Valenciennes, Mus. B.-A.), and during the July Monarchy (1830–48) he worked on sculpture for the Galeries Historiques at the château of Versailles, the Arc de Triomphe, and the Colonne de la Grande-Armée in Boulogne, among other projects. He was also involved in the decoration of several Paris churches, his most important work being the monumental stone relief of the *Last Judgement* on the pediment of La Madeleine (1829–34). Its success earned him an invitation to St Petersburg, where he executed models for two pedimental reliefs of the *Resurrection* and *St Isaac* for the church of St Isaac (bronze, 1838–41).

He continued to contribute sculpture to the major Paris building projects of the Second Empire (1851–70), executing work for the Palais de Justice, the Gare du Nord and the Cour Carrée of the Louvre, while for Lille he made a statue of *Napoleon I* (bronze, 1854; Entrepôts municipaux) and for Valenciennes a monument to the chronicler *Froissart* (marble, 1856; Jardin Froissart). Many of his plaster and terracotta models are in the Musée des Beaux-Arts, Valenciennes, and many drawings are kept in the Musée des Beaux-Arts, Rouen.

Bibliography

Lami

A. Le Normand: 'De Lemaire à Rodin: Dessins de sculpteurs du 19ème siècle', *Etudes de la Rev. Louvre*, i (1980), pp. 152–9

De Carpeaux à Matisse: La Sculpture française de 1850 à 1914 dans les musées et les collections publiques du Nord de la France (exh. cat., Calais, Mus. B.-A.; Lille, Mus. B.-A.; Arras, Mus. B.-A.; and elsewhere; 1982–3), pp. 242–5

La Sculpture française au XIXème siècle (exh. cat., ed. P. Durey; Paris, Grand Pal., 1986)

ANTOINETTE LE NORMAND-ROMAIN

Lemot, François-Frédéric, Baron

(*b* Lyon, 4 Nov 1772; *d* Paris, 6 May 1827). French sculptor. He studied drawing in Besançon before

travelling to Paris, where he became a pupil of Claude Dejoux. In 1790 he was awarded the Prix de Rome with a low relief of the *Judgement of Solomon* (Paris, Ecole N. Sup. B.-A.), but his studies in Rome were terminated in 1793, when he was conscripted into the French Revolutionary armies on the Rhine. In 1795 he was recalled to Paris to take part in a competition to sculpt a colossal statue of the *French People*, a project initiated by the wood-carver Jean-Louis David (father of David d'Angers) that came to nothing. Lemot made his Salon debut in 1801 with a *Bacchante* (untraced), which had already been acquired by Napoleon. In 1808 he executed a gilt-lead *quadriga* to crown the Arc de Triomphe du Carrousel, Paris; the sculpture, which incorporated the Horses of St Mark's, looted from Venice, was removed in 1815. The figure of Napoleon that had originally been intended to form part of it, was never executed. Between 1808 and 1810 Lemot sculpted a pediment (*in situ*) for the colonnade of the Musée du Louvre, Paris. It represented *Minerva and the Muses Paying Homage to Napoleon*, but in 1815 the bust of *Napoleon* was replaced by one of *Louis XIV*. Under the Bourbon Restoration Lemot was principally employed in reconstructing two equestrian statues of monarchs that had been destroyed during the Revolution (1789–95). The first, *Henry IV* (1816–18), for the parapet of the Pont Neuf, Paris, was based on the original by Giambologna and Pietro Tacca. The second statue was of *Louis XIV* (1820–25), and replaced the original by Martin Desjardins in the Place Bellecour, Lyon. Shortly before his death Lemot was rewarded for his services to the restored monarchy by being created a baron.

Bibliography

Lami

Lemoyne, Paul [Saint-Paul]

(*b* Paris, 1783; *d* Bordeaux, 29 May 1873). French sculptor. Having failed to win the Prix de Rome, he went to Rome at his own expense in 1809 or 1810, remaining for 50 years. There he frequented the studio of Canova and the Académie de France, becoming friendly with Ingres and later with a succession of its directors from Pierre Guérin to Victor Schnetz. In Rome he worked on several commissions from French patrons, including a plaster statue of *St Julitta at the Stake* (1827) for St Leu-St Gilles, Paris. He also regularly sent works of a Neo-classical style to the Paris Salons, exhibiting, for example, a statue of *Hope* at the 1827 Salon (marble, 1826; Paris, Louvre). He ceased to do so, however, after the critical failure of his colossal, vehemently expressive group *Medea* (marble; untraced) at the 1837 Salon.

Among Lemoyne's works in Rome, principally memorials executed for the French colony, are the bust on the monument to *Nicolas Poussin* (marble, 1829; S Lorenzo in Lucina)—a work assigned to him by Chateaubriand—and the monuments to *Claude Lorrain* (marble, 1835–40), *Guérin* (marble, 1836) and the landscape painter *Didier Boguet* (marble, 1840), all in S Luigi dei Francesi. It seems he stopped working as a sculptor c. 1840.

Bibliography

Lami

A. Le Normand: 'Paul Lemoyne: Un sculpteur français à Rome au XIXème siècle', *Rev. A.*, 36 (1977), pp. 27–41

ANTOINETTE LE NORMAND-ROMAIN

Lepoittevin [Poidevin], Eugène(-Modeste-Edmond)

(*b* Paris, 31 July 1806; *d* Paris, 6 Aug 1870). French painter and lithographer. A student of Louis Hersent and Auguste-Xavier Leprince, he was a prolific painter and lithographer and exhibited regularly in the Salons in Paris from 1831. He combined history, genre and landscape in his marine and pastoral narratives. The influence of Dutch painting is not only evident in his scale, topographical accuracy and attention to light and air but also in his choice of Dutch subjects, as in such works as *Van de Velde Painting the Effect of a Broadside Fired from the Ship of Admiral de Ruyter* (1846; see *Art-Union*, viii (1846), p. 100), the *Studio of Paul Potter* (1847; see *Art-Union*, ix (1847), p. 20) and the *Studio of van de Velde* (1854; see *A. J.* [London], vi (1854), p. 184). In these the Dutch painters are ironically depicted working in

nature, not in their studios. Lepoittevin's primary figures are often at the apex of a pyramid composed of healthy women and children, faithful domestic animals and other elements in spacious, horizontal formats. While some paintings (e.g. *Shipwrecked*, 1839; *Frankish Women*, c. 1842; both Amiens, Mus. Picardie) suggest the violence of the Romantic Sublime, others, such as the *Fisherman's Return* (1848; see *Art-Union*, x (1848), p. 84), are more sentimental. Beraldi divided Lepoittevin's graphic work into categories entitled marines, patriotic souvenirs and, apparently his most popular, *Albums de diableries*. Lepoittevin travelled and sketched in England, the Netherlands, France and Italy; his work attracted a pan-European bourgeois audience interested in well-composed and carefully costumed romances on a human scale, borrowed from wide-ranging sources in history, art history and literature yet rooted in observed nature.

Bibliography

Bénézit; Thieme–Becker
'The Living Artists of Europe, no. ix: Eugène Le Poittevin',
 Art-Union, viii (1846), pp. 100–01
H. Beraldi: *Les Graveurs du XIXe siècle*, ix (Paris, 1889),
 pp. 145–6
F. von Boetticher: *Malerwerke des neunzehnten
 Jahrhunderts*, ii (Dresden, 1895/R Leipzig, 1941),
 pp. 840–41
H. Mireur: *Dictionnaire des ventes d'art*, iv (Paris, 1911),
 p. 295
J. Robiquet: 'Pages d'albums de la Restauration', *La
 Renaissance*, xi (1928), pp. 386–8

NANCY DAVENPORT

Leprince, Auguste-Xavier

(*b* Paris, 28 Aug 1799; *d* Nice, 24 Dec 1826). French painter and lithographer. He was the son and pupil of the painter and lithographer Anne-Pierre Leprince and the elder brother of the painters Robert-Léopold Leprince (1800–47) and Gustave Leprince (1810–37). Leprince received a medal at his first Salon of 1819 for one of six entries, five of which were landscapes of 17th-century Dutch inspiration, which came possibly via the work of Jean-Louis Demarne. Leprince quickly learnt to

vary the contents of his paintings: at the Salon of 1822 his entries included three Paris street scenes, three portraits and two scenes on board a frigate. His numerous Paris street scenes usually depicted some well-known contemporary event, as in the *Restoration of the Barrière du Trône* (Paris, Carnavalet), which is one of a series. The *Embarkation of the Animals at the Port of Honfleur* (1823; Paris, Louvre) shows the successful application of Leprince's interest in R. P. Bonington, not only in its composition and content but also in its direct observation. The painting was purchased by Louis XVIII at the highly competitive Salon of 1824. Also reminiscent of Bonington is the small-scale contemporary history painting, *The Ordination* (1825; Angoulême, Mus. Mun.), again one of a series. In the last year of his short life Leprince showed himself to be a sensitive watercolour painter and lithographer, publishing a set of 12 lithographs entitled *Inconveniences of a Journey by Stage-coach*.

Bibliography

H. Beraldi: *Les Graveurs du XIXe siècle: Guide de
 l'amateur d'estampes modernes* (Paris, 1885–92), ix,
 pp. 146–7
A. Michel: *L'Histoire de l'art depuis les premiers temps
 chrétiens jusqu'à nos jours*, VIII, i (Paris, 1925),
 p. 106
Le Paysage français de Poussin à Corot (exh. cat. by
 H. Lapauze, C. Goonkowski and A. Fauchier-Magnan,
 Paris, Petit Pal., 1925), pp. 146–7

LORRAINE PEAKE

Leroy de Barde, Vicomte Alexandre-Isidore [Le Chevalier de Barde]

(*b* Montreuil, Pas-de-Calais, 15 Feb 1777; *d* Paris, 5 May 1828). French painter, active in England. An amateur virtuoso of still-life watercolour painting, Leroy de Barde appears to have been entirely self-taught. In 1792 he emigrated to England with his monarchist family to avoid the Revolution. The first mention of him as an artist is as an 'honorary' exhibitor at the Royal Academy exhibition of 1797 when he showed two watercolours, *Fruit* and *Grapes* (untraced). He styled himself 'Le

Chevalier de Barde' and signed his works thus. He also exhibited in Royal Academy exhibitions in 1800, 1801 and 1802 with various flower paintings and a composition of *Moths and Butterflies*. The paintings exhibited in 1800 are still in the Royal Academy: *Double Narcissus and Lilies of the Valley*, *Lilac Branch* and *Green Oak*.

In 1803 Leroy de Barde began an extensive series of watercolours representing natural curiosities from the Bullock Museum in Piccadilly, London. The Bullock Museum catalogue of 1814 contains descriptions of, and engravings (by Thomas Bewick) after, several of Leroy de Barde's watercolours. The series was exhibited again at the Salon of 1817 and was bought by Louis XVIII. These large watercolours are vivid and meticulous renditions of animal, vegetable and mineral subjects and include *Shells* (1803), *Collection of Birds, Snakes, Shells, Minerals and Antique Vases*, *Royal Tiger Choked by a Boa* (both 1814) and *Exotic Birds Assembled in Different Cases* (1810; all Paris, Louvre). The last mentioned in particular shows his remarkable handling of *trompe l'oeil* effects.

Around 1804 Leroy de Barde joined the newly formed Society of Painters in Water-Colour, but after the Bourbon restoration in 1814 he returned to France and accompanied Louis XVIII to Ghent during the Hundred Days. In 1816 and 1817 he executed large watercolour landscapes as decorations for the Comte de Montbrun's Château de Recques-sur-Course near Montreuil. Although Louis appointed him Premier Peintre d'Histoire Naturelle in 1816, these were probably the only major works he produced after 1815.

Bibliography

Catalogue of the Different Subjects Represented in the Large Watercolour Drawings by the Chevalier de Barde Now Exhibiting at Mr Bullock's Museum, the Egyptian Hall, Piccadilly, London (London, 1814)

A. Braquehay: *Un Peintre d'histoire naturelle, Leroy de Barde et son temps (1777–1829)* (Abbeville, 1896)

De David à Delacroix: La Peinture française de 1774 à 1830 (exh. cat., ed. P. Rosenberg; Paris, Grand Pal., 1974), pp. 528–31

STEPHANIE NEVISON BROWN

Lethière [Lethiers; Letiers], Guillaume [Guillon]

(*b* Sainte-Anne, Guadeloupe, 10 Jan 1760; *d* Paris, 21 April 1832). French painter. He was the illegitimate son of a white government official and a freed black slave. Although his real name was Guillon, as the third child of the family he called himself Letiers, Lethiers and finally, from 1799, when recognized by his father, Lethière. While accompanying his father to France in 1774 Lethière entered the studio of Jean-Baptiste Descamps at the Académie in Rouen, where he won a drawing prize for an *académie* in 1776 (Rouen, Bib. Mun.). In 1777 he went to Paris and enrolled at the Académie Royale de Peinture et de Sculpture, studying under Gabriel-François Doyen and winning a first-class medal in July 1782. Lacking influential friends and patrons, before the Prix de Rome of 1784 Lethière attempted to attract support by writing to Mme de la Palum (related by marriage to the Minister of Foreign Affairs, Charles Gravier, Comte de Vergennes), asking her to intercede in his favour with the Premier Peintre du Roi, Jean-Baptiste Pierre (Paris, Archv. N., A.N. 1. O 1917 2, item 91). In the Prix, Lethière won second prize with the *Woman of Canaan at the Feet of Christ* (Angers, Mus. B.-A.). With its theatrical gestures and delicacy of form, the picture is reminiscent of the religious works of both Doyen and Joseph-Marie Vien. His entry for the Prix de Rome in 1785, *Horatius Killing his Sister* (Providence, RI, Sch. Des., Mus. A.), displays many changes from that of the previous year, and Lethière turned to a Neo-classical composition deriving from Pierre Peyron and David. He was again unsuccessful in the competition, probably due to some kind of plot or favouritism concerning the eventual winner, Fréderic Jean-Baptiste Desmarais (1756–1813). In 1786 no prizes at all were awarded because the Académie jury found a disturbing 'similarity of styles' between the entries due to the overwhelming influence of David. Lethière had gravitated towards the Davidian style, and the poet and critic Jean-Baptiste Publicola Chaussard (1766–1823), in his *Pausanias français* (1806), wrote that, 'Although M Le Thiers had begun by being the pupil of M

Doyen, the school of David claimed him. Messieurs Le Thiers and Drouais were the first who walked with honour along the paths opened by this great master.' Lethière's painting for the Prix in 1786 is lost, but although he did not win, the diplomat and friend of Louis XVI, Armand-Marc, Comte de Montmorin, persuaded the Académie that he was worthy of the Roman *pension*. Lethière arrived in Rome and while there painted a copy of Ribera's *Deposition* (Dijon, Mus. B.-A.). (He also became one of the few friends of the difficult Jean-Germain Drouais.)

In 1791 Lethière returned to Paris and opened a teaching studio in competition to that of David, though ironically his own painting style was greatly indebted to that of his rival. From 1793 until his death he exhibited irregularly at the Salon. A committed revolutionary, in 1799 he painted the *Homeland in Danger* (Vizille, Mus. Révolution Fr.), a patriotic image of departing conscripts swearing to defend the nation and a direct response to the military threat posed by the allies of the Second Coalition against France (1798); see also *Peace Treaty of Loeben, signed on 18 April, 1797* (1805; Versailles, Château; see col. pl. XXIII). In 1801 he travelled to Spain as artistic adviser to Lucien Bonaparte, and an intimate relationship developed between Lethière's wife and Bonaparte, by whom she had an illegitimate son. Returning to Paris, the hot-tempered Lethière was involved in a fight with some soldiers. One was killed and another wounded, prompting the government to order Lethière's studio to be closed. Forced to quit Paris, Lethière and his family travelled in Europe until 1807, when, thanks to Lucien Bonaparte's influence, Lethière was appointed Director of the Académie de France in Rome. Ingres was one of his *pensionnaires* at the Académie, and the young artist produced a series of sympathetic pencil drawings of the family, for example *Mme Lethière and her Son* (New York, Met.). Removed from office at the Restoration, Lethière reopened his teaching studio in Paris, but his initial election to the Institut in 1816 was vetoed by Louis XVIII, either on the grounds of his attachment to the empire or because of some racial prejudice against the mulatto artist. In 1818 Lethière was finally elected

and also awarded the Légion d'honneur. A year later he became a professor at the École des Beaux-Arts. His studio attracted numerous students from the French colonies, such as Jean-Baptiste Gibert (1802–89), Benjamin de Rolland (1777–1855) and Jean-Abel Lordon (*b* 1801).

Lethière had ambitious plans for a series of four pictures concerning the great eras of ancient Rome: *Brutus Condemning his Son to Death*, the *Death of Virginia* (both Paris, Louvre), the *Death of Caesar* and the *Defeat of Maxentius by Constantine*. Eventually only *Brutus* and the *Death of Virginia* were executed. Painted in Rome in 1811, *Brutus* was shown at the Salon of 1812 in Paris and again in London in 1817. Both this and the *Death of Virginia* show Lethière's stubborn attachment to the increasingly outmoded canons established by David, and consequently his works were the butt of much sarcastic criticism. The *Death of Virginia* had an abnormally long gestation period. The point of departure was a drawing presented to the Salon of 1795, and Lethière appears to have worked intermittently on the subject until the definitive picture was exhibited at the Salon in 1831. Of the two paintings, contemporaries preferred the more severe and static *Brutus* to the turbulent and rhetorical *Virginia*, which has a seemingly inextricable arrangement of hands and arms woven into the crowd scene. Lethière also produced historical landscapes, an increasingly popular genre at the time. In 1818 he painted *Dido and Aeneas* (Tourcoing, Mus. B.-A.), a commission from the Bâtiments du Roi, in which he borrowed from Poussin and Claude but added some dramatic meteorological effects. Some historical landscapes were executed in collaboration with Jean-Joseph-Xavier Bidauld, with Bidauld painting the landscapes and Lethière adding the figures. Lethière also painted *St Louis Visiting the Plague-stricken of Carthage* (1822; Bagnères-de-Bigorre, Mus. A.), a medieval scene in the fashionable Troubadour style.

Lethière's interest in politics remained, and in 1822 he painted an allegory to celebrate the independence of Haiti, *The Oath of the Ancestors* (Port-au-Prince, Cathedral), in which the generals Alexandre Pétion and Jean-Jacques Dessalines are shown swearing the oath of union that led to the

nation's freedom. Yet for all the diversity of his later years, Lethière's true vocation was to adhere fervently to Neo-classical principles. The critic Gustave Planche, in his review of the Salon of 1831, said that Lethière was bound 'to die impenitently', and this helps explain why the artist's work slipped so quickly into obscurity.

Bibliography

F. Debret: *Funérailles de M. Guillon Lethière* (Paris, 1832)
T. Oriol: *Les Hommes célèbres de La Guadeloupe* (Basse-Terre, 1935), pp. 39–47
J. Patrice Marande: '*The Death of Camille*: Guillaume Lethière and the 1785 Prix de Rome', *Antol. B. A.*, iv/13–14 (1980), pp. 12–17
P. Bordes: '*La Patrie en danger* par Lethière et l'esprit militaire', *Rev. Louvre*, 4/5 (1986), pp. 301–6
B. Foucart, G. Capy and G. Flrent Laballe: *Guillaume Guillon Lethière* (Paris and Point-à-Pitre, 1991)

SIMON LEE

Lonsing, François-Louis

(*b* Brussels, 27 May 1739; *d* Léognan, Gironde, 11 April 1799). Flemish painter and engraver, active in France. He trained at the Antwerp Académie and under the painter Martin Geeraedts (1707–91); this Flemish training had a decisive influence on his style throughout his career. Early on he found a generous patron in Charles de Lorraine (1712–80), Governor of the Habsburg Netherlands, who paid for him to make a visit to Rome, where he remained for 17 years apparently without going through any significant artistic development. His only known works of that time are some reproductive engravings of mediocre quality, which the artist completed for the Scottish painter and dealer Gavin Hamilton. Lonsing left Rome in 1778 and spent a few years in Lyon, finally moving in 1783 to Bordeaux, where, until the Revolution (1789–95), he built up an important practice as a portrait painter. Among his portraits of the 1780s are those of *Maréchal de Mouchy* (Bordeaux, Mus. A. Déc.) and *Lt-Gen. de Larose* (Brussels, Mus. A. Anc.), both formal works that show Baroque influence. Like many artists, Lonsing lost his former patrons as a result of the Revolution. He moved to Paris, where he lived in poverty, although he produced an aquatint engraving of *Jean-Baptiste Lacombe* in 1794. Not until 1798 did he receive another major commission, from a prosperous merchant of Bordeaux: the painted double portrait of *J. B. Mareilhac and his Wife*, in which the young couple are depicted with their arms around each other in the grounds of Mareilhac's château, La Louvière, at Léognan near Bordeaux. This portrait, like the drawings and other portraits Lonsing completed during the Revolution, displays a Romantic sensibility. He was working on the decoration of the salon at La Louvière when he died.

Bibliography

Thieme–Becker
M. Meaudre de Lapouyade: *Un Maître flamand à Bordeaux: Lonsing* (Paris, 1911)
H. Duriot: 'Le Château de Louvière à Léognan', *Bull. Mém. Soc. Archéol. Bordeaux*, lxv (1963–9), pp. 291–302
O. Michel: 'L'Apprentissage romain de François Joseph Lonsing', *Mél. Ecole Fr. Rome: Moyen Age, Temps Mod.*, lxxxiv (1972), pp. 493–509

Loo, van, (Jules-)César(-Denis)

(*b* Paris, 20 May 1743; *d* Paris, 1 July 1821). French painter, son of Carle Vanloo. He studied with his father and, from 1757, at the Académie Royale, Paris. In 1767 he was approved (*agréé*) by the Académie, and in the same year was awarded a special bursary to study at the Académie de France in Rome, although his repeated attempts between 1764 and 1776 to win the Prix de Rome were all unsuccessful. In 1784 he was received (*reçu*) as a full member of the Académie Royale, on submission of *Landscape with a Storm* (untraced; formerly Paris, Louvre) and *Landscape by Moonlight* (Paris, Louvre), both in the manner of Joseph Vernet. He first exhibited at the Salon in 1785, showing his two *morceaux de réception* and another landscape, the *Temple of the Sibyl at Tivoli* (untraced); from then until 1817 he missed only the Salon of 1795. He is recorded in Rome in 1785 and probably returned to Paris in 1789, when he was appointed *adjoint au recteur* at the Académie.

In 1791 van Loo emigrated to Turin and, like his father before him, worked for the Piedmontese court. The first of his winter landscapes, a genre for which he became especially celebrated, was exhibited at the Salon of 1799, and was influenced not only by the Netherlandish masters of the 17th century, but also, more immediately, by Italian artists such as Francesco Foschi (*d c.* 1805) and the Piedmontese Giovanni Michele Granieri (*fl* 1736–78). The best of van Loo's snow scenes, such as the *Ruins of a Gothic Church* (1799; exh. Salon 1801; Fontainebleau, Château), show a careful finish combined with a strong sense of atmosphere, and place him among the most interesting and individual artists of the period. In addition to landscapes, he made at least one portrait, that of Louis XVI's secretary, the *Comte de Mirbel* (1780; Caen, Mus. B.-A.), and was the author of an open letter, *César van Loo aux amateurs des beaux-arts* (Paris, 1817).

Bibliography
French Painting, 1774–1830: The Age of Revolution (exh. cat., ed. F. J. Cummings, P. Rosenberg and R. Rosenblum; Paris, Grand Pal.; Detroit, MI, Inst. A.; New York, Met.; 1974–5), pp. 647–9

J.-F. Heim, C. Beraud and P. Heim: *Les Salons de peinture de la révolution française, 1789–1799* (Paris, 1989), p. 370

□

Lucas, François

(*b* Toulouse, 1736; *d* Toulouse, 17 Sept 1813). French sculptor. The son of Pierre Lucas (1691–1752), a founder-member of the Toulouse Académie, he became the leading sculptor of the Toulouse region during the late 18th century. Lucas began to exhibit in 1759, winning the Grand Prix de Sculpture at the Toulouse Académie in 1761 with his low relief *David and Abigail* (untraced). Three years later he became a professor at the Académie; his students included Jean-Marie-Joseph Ingres (1755–1814), the father of Jean-Auguste-Dominique Ingres. By 1774 Lucas was in Carrara sketching out his great marble low relief, the *Junction of the Canal des Deux-Mers* (l.17 m, 1775; between the

Canal du Midi and the Canal de Brienne). Most of his works are in the Musée des Augustins, Toulouse, which he helped to found. They include a terracotta statuette of *Zephyr*, a seated marble statue of *Louis XVI* (1777) in the dress of a Classical warrior, a marble low relief with the Genius of War carrying an urn, formerly part of the tomb of *Chevalier Dauvet* (Toulouse, St Jean), and portrait busts. The two elegant marble *Angels in Adoration* (1782) at the high altar of St Pierre-des-Chartreux, Toulouse, show how Lucas was inspired both by the traditions of 17th- and 18th- century French sculpture and by Italian classicism. Lucas also took part in work for the Tower of Illustrious Agenais (1806; Lacassagne, Château des Boéry), a two-storey octagonal pavilion in the Louis XVI style, for which he contributed four life-size terracotta statues: *Jules Scaliger*, *Théophile de Viau*, *Blaise de Montluc* and *Bernard Palissy*. Lucas was an avid collector of ancient medals and inscriptions; his valuable collection also went to the Musée des Augustins.

Bibliography
J. Momméja: 'Notes sur un canon en argent en 1646 et sur un amateur agenais du XVIIIe siècle: P.-F.-X. Daribeau de Lacassagne', *Réun. Soc. B.-A. Dépt.*, xxvii (1903), pp. 199–213

H. Rachou: 'Un Buste du musée des Augustins', *Bull. Soc. Archéol. Midi France*, 40 (1909–11), pp. 3–5, 173–4

[H. Rachou]: *Catalogue des collections de sculpture et d'épigraphie du musée de Toulouse* (Toulouse, 1912), pp. 369–70

B. Desazars de Montgailhard: *Les Artistes toulousains et l'art à Toulouse au XIXe siècle*, ii (Toulouse, 1925), pp. 157–60

'Classements parmi les monuments historiques', *Mnmts Hist. France*, ii (1956), pp. 238–9

P. Mesplé: 'L'Oeuvre toulousaine et régionale du sculpteur François Lucas', *Bull. Mus. Augustins* (July–Sept 1958)

—: 'L'Album de dessins de voyage d'Italie de François Lucas', *Bull. Soc. Archéol. Midi France*, xxviii (1962), pp. 75–84

R. Mesuret: *Les Expositions de l'Académie royale de Toulouse, de 1751–1791* (Toulouse, 1972), pp. 590–91 [list of works]

MICHAEL PRESTON WORLEY

Lucas de Montigny, Jean-Robert-Nicolas

(b Rouen, 9 Dec 1747; d Paris, 29 Jan 1810). French sculptor. He trained with Jean-Baptiste Pigalle and also from 1773 at the Académie Royale de Peinture et de Sculpture, Paris, but, despite his undoubted talents as a sculptor, he never became an academician. In 1777 he set up on his own in Paris and was soon in fashionable demand, producing portraits such as that of *Mlle d'Oligny* (terracotta, 1778; Paris, Mus. Cognacq-Jay). Portraits of actors, such as his bust of *Préville as Figaro* (patinated plaster, 1782) or the statuette of *Mme de Saint-Huberty as Dido* (plaster, 1784; both Paris, Louvre), show a responsive delicacy, but the uncompromising realism of his portraiture is seen at its best in the powerful busts of his patron Honoré Riqueti, Comte de Mirabeau, whom he sculpted in plaster in 1781 and 1790 (both in priv. cols) and in marble in 1791 (Aix-en-Provence, Mus. Arbaud). From 1781 to 1792 Lucas produced a series of plaster and terracotta statuettes of mythological subjects and historical characters, now all lost.

During the French Revolution (1789–95) Lucas de Montigny, though not an academician, was able to affirm his political sympathies by exhibiting at the Salon such works as his plaster statuette of *Voltaire* (1781; Geneva, Mus. Voltaire) and a colossal group of the *Execution of a Vestal Virgin Found to Be with Child* (exh. Salon 1804; untraced). During the First Empire (1804–15) he received a number of official monumental commissions, of which the only works to survive are four low reliefs for the column in the Place d'Austerlitz (now Place Vendôme), Paris. His portrait busts have sometimes been confused with those of Jean-Antoine Houdon.

Bibliography

Lami

U.-R. Dessaix: 'Un Portrait de Préville en Barbier de Séville', *Interméd. Chercheurs & Curieux*, xx (1887), p. 200

H. Marcel: 'Un Oublié, le statuaire Lucas de Montigny', *Rev. A. Anc. & Mod.*, vii/36 (1900), pp. 161–8

——: 'Essai sur l'iconographie de Mirabeau', *Rev. A. Anc. & Mod.*, ix/49 (1901), pp. 269–80

——: 'L'Exposition générale d'art provençal à Marseille, sculptures', *Gaz. B.-A.*, ii/1 (1906), pp. 258–9

——: 'Sur Quelques Ouvrages peu connus de Lucas de Montigny', *Rev. A. Anc. & Mod.*, xxv/143 (1909), pp. 105–11

M. Beaulieu: 'Le Théâtre et la sculpture française au XVIIIe siècle', *Jard. A.*, xv (1956), p. 171

H. Mercier: *Jean-Robert-Nicolas Lucas de Montigny (1747–1810), sculpteur*, 2 vols (diss., Paris, Ecole Louvre, 1973)

HUGUETTE MERCIER

Machy, Pierre-Antoine de

(b Paris, bapt 19 Sept 1723; d Paris, 10 Sept 1807). French painter and engraver. He was the son of a cabinetmaker and served his apprenticeship with Giovanni Niccolo Servandoni. He was approved (agréé) by the Académie Royale de Peinture, Paris, in 1755 and was received (reçu) three years later as a painter of architecture. He exhibited regularly at the Salon from 1757 to 1802. His views of the interiors of the Paris churches of Ste Geneviève and the Madeleine were painted from architectural plans and exhibited at the Salons of 1761 and 1763 respectively, earning Diderot's praise. At the Salon of 1763 de Machy also demonstrated his talent for painting contemporary events with a pair of pictures of the *Foire Saint-Germain* after the fire of 1762 (both Paris, Carnavalet) and a scene of the *Installation of Bouchardon's Statue of Louis XV* (untraced; engraved by Antoine François Hémery, b 1751), with the statue being placed on its pedestal in the Place Louis XV (now the Place de la Concorde). Later, however, de Machy suffered increasingly from comparison with other painters, especially those who, unlike himself, had studied in Italy. At the Salon of 1765 his *Inauguration of Ste Geneviève* and the *Building of the Halle au Blé* (both Paris, Carnavalet) were overshadowed by Servandoni's works, and in 1767 his pictures were totally eclipsed by the works of Hubert Robert, who had recently returned from Italy. At this exhibition Diderot found de Machy's pictures lacking in the quality of handling and Italian light effects that characterized Robert's painting.

De Machy continued to depict changes in the Parisian townscape in such works as the wash drawing of the *Demolition of the Hôtel Guénégaud*

in 1771 and the painting of the *Demolition of the Church of the Innocents in 1787* (both Paris, Carnavalet). The baptism of the Dauphin (Louis, son of Louis XVI) on 21 January 1782 occasioned two further pictures recording contemporary events, the *Arrival of the Queen at the Hôtel de Ville* for the baptism ceremony and the *Celebratory Firework Display at the Spanish Embassy*. He was made an adviser (*conseiller*) at the Académie Royale in 1775 and was appointed Professor of Perspective in 1786.

De Machy produced a number of decorative works. Dézallier d'Argenville's *Voyage pittoresque* (6/1778) records among others a background scheme in the church of St Roch, a set of paintings in the Palais-Royal and various *trompe l'oeil* effects in private garden locations. In the 1780s de Machy turned his talent for engraving to commercial use. At the Salon of 1781 he exhibited a set of views of Paris intended principally for engraving, colouring and sale by subscription. He continued to produce coloured prints after his own pictures and those of other artists, including an engraving (untraced) after a *Sleeping Child* by Murillo, inscribed and dated Madrid 1787.

After 1789 de Machy adapted his skills to revolutionary requirements, depicting the *Federation of the French* (14 July 1790), the *Festival of Unity* (10 Aug 1793), the *Festival of the Supreme Being* (8 June 1794) and *An Execution* (all Paris, Carnavalet). The less refined style of these later pictures and the profusion of badly drawn figures led Wilhelm to suggest that these works may have been painted by de Machy's son.

Bibliography

A. J. Dézallier d'Argenville: *Voyage pittoresque des environs de Paris* (Paris, 1728, rev. 6/1778)
J. Cain: *Guide explicatif du Musée Carnavalet* (Paris, 1903)
D. Diderot: *Les Salons, 1759–1781*, ed. J. Seznec and J. Adhémar, 4 vols (Oxford, 1957–67)
J. Wilhelm: 'Une Peinture révolutionnaire de l'atelier d'Antoine de Machy', *Bull. Mus. Carnavalet*, i (1961), pp. 12–13
P. de la Vaissière: 'La Fédération des Français peinte par P.-A. de Machy: Essai d'iconographie de la fête de juillet 1790', *Bull. Mus. Carnavalet*, ii (1975), pp. 16–30
JOSHUA DRAPKIN

Maindron, Etienne-Hippolyte

(*b* Champtoceaux, Maine-et-Loire, 16 Dec 1801; *d* Paris, 21 March 1884). French sculptor. He studied at the Ecole des Arts et Métiers in Angers and from 1827 at the Ecole des Beaux Arts, Paris. He was a student and later an assistant of Pierre-Jean David d'Angers. He also collaborated with Henri-Joseph-François Triqueti on the bronze doors of La Madeleine (1834–41). A number of Maindron's own works represent confrontations between Christianity and paganism. He won great acclaim for his statue *Velléda* (plaster, exh. Salon 1839, Angers, Mus. B.-A.; marble, Paris, Louvre). The subject, from Châteaubriand's *Les Martyrs*, is a Druidic priestess, consumed by her passion for a Roman Christian, Eudore; she represents both the Gallic spirit and the death wish of the pagan world.

Bibliography

Lami
Romantics to Rodin (exh. cat., ed. H. W. Janson and P. Fusco; Los Angeles, CA, Co. Mus. A., 1980)
PHILIP WARD-JACKSON

Mallet, Jean-Baptiste

(*b* Grasse, 1759; *d* Paris, 16 Aug 1835). French painter. A pupil of Simon Julien in Toulon, he was then taught by Pierre-Paul Prud'hon in Paris. He exhibited at every Salon between 1793 and 1827, obtaining a second class medal in 1812 and a first class medal in 1817. He executed very few portraits (*Chénier*, Carcassonne, Mus. B.-A., is an exception), preferring to paint nymphs bathing and graceful classical nudes such as the *Graces Playing with Cupid* (Arras, Abbaye St Vaast, Mus. B.-A.). He established his reputation with gouache genre scenes of fashionable and often libertine subjects, always elegant and refined, in the style of Louis-Philibert Debucourt and Louis-Léopold Boilly, and remarkable for the delicacy and brilliance of their brushwork: for example *At the Laundry Maid's* and the *Painful Letter* (both Paris, Mus. Cognacq-Jay). They reveal a knowledge of 17th-century Dutch painting in the treatment of details (transparent crystal, reflections on silk or satin) as well as the choice of

themes: *Military Gallant* (Paris, Mus. Cognacq-Jay). Mallet's meticulously precise paintings are one of the best records of fashionable French furnishings and interiors at the end of the 18th century and the beginning of the 19th. They were very popular and widely disseminated in prints.

During the Restoration Mallet adopted the Troubadour style, producing very small paintings with a porcelain-like quality, elegant details and an extremely refined treatment of contrasting light effects, for example *Education of Henry IV* (exh. Salon 1817; Pau, Mus. N. Château) and *Genevieve of Brabant Baptizing her Son in Prison* (exh. Salon 1824; Cherbourg, Mus. Henry). Mallet achieved a synthesis of his early amorous works, the Dutch style and Troubadour painting in the *Gothic Bathroom* (exh. Salon 1810; Dieppe, Château-Mus.), in which he combined a Gothic window, a rich lustre reminiscent of Gerrit Dou and a female nude, smoothly glazed in the manner of Adriaen van der Werff. He painted fewer outdoor scenes, such as *St John the Baptist as a Child Washing* (1820; Paris, Louvre), a family scene that is similar, in its intimist feeling and delicacy of lighting, to the style of Hortense Haudebourt-Lescot.

Bibliography

J. Renouvier: *Histoire de l'art pendant le Révolution* (Paris, 1863), pp. 188–90

P. Marmottan: *L'Ecole française de peinture (1789–1830)* (Paris, 1886), pp. 263–6

De David à Delacroix: La Peinture française de 1774 à 1830 (exh. cat., Paris, Grand Pal., 1974), pp. 532–5

MARIE-CLAUDE CHAUDONNERET

Marilhat, Prosper(-Georges-Antoine)

(*b* Vertaizon, Puy-de-Dôme, 26 March 1811; *d* Paris, 13 Sept 1847). French painter. He painted his first landscapes and family portraits at Thiers and in the Auvergne before moving to Paris in 1829. After working as the pupil of Camille Roqueplan he was engaged by Baron Karl von Hügel for an expedition to the Near East (1831–3), from which he brought back numerous studies. He visited Greece, Syria, Lebanon and Palestine, stayed in Egypt from October 1831 to May 1833 and returned by way of Rhodes and Corfu. Cairo, the villages of the Delta and Upper Egypt proved to be sources of inspiration for later works. At Alexandria he painted theatre sets and numerous court portraits (more than 80, according to Gérard de Nerval: 'Les Artistes français à l'étranger, par L. Dussieux', *L'Artiste*, x (15 March 1853), p. 60). Despite further trips to Italy (1835), the Midi, the Pyrenees (1836) and Normandy (1843), the Near East and the Auvergne remained his major themes. *Ezbekiyah Square* (1834; untraced, engraving in Paris, Bib. N.), the *Recollection of the Countryside near Rosetta* (1835; untraced, engraving in Paris, Bib. N.) and the illustration of the *Countryside near Luxor* published (Paris, 1835) by the engraver Léon de Joannis (*fl* 1808–50) brought him to the attention of the public. Although *Twilight* (1836; untraced, engraving in Paris, Bib. N.) was refused by the Salon in 1836, his pastel drawing of the *Villa Pamphili* (Paris, priv. col.) was engraved by Eugène Ciceri (Paris, Bib. N.).

During the late 1830s Marilhat concentrated on historical and poetical landscapes, influenced by Neo-classicism, by Théodore Caruelle d'Aligny particularly, and by his friend Corot. D'Aligny's influence is apparent, for example, in the *Pastoral Scene* (1837; Le Mans, Mus. Tessé). The press criticized the coldness and artifice of his compositions but praised his *Tomb of Sheik Abou-Mandour* (1837; untraced) and his *Delta* (1839; untraced). His collaboration in the production of 86 drawings for the *Journey from Syria* (1837) and the *Journey from Asia Minor* (1838), published by the archaeologist Léon de Laborde, confirmed his reputation as an Orientalist. From 1840 Marilhat returned to his Egyptian and Auvergnat subjects, though he now darkened his palette. His work also became more naturalistic as he began to depict subjects traditionally associated with the Barbizon painters, including the Forest of Fontainebleau and Chevreuse. The seven royal commissions executed between 1843 and 1845 are evidence of his fame at this time. The *Return from Château d'Eu* (1844; Versailles, Château) was commissioned after Queen Victoria's visit to Louis-Philippe in 1843 and executed with Eugène Lami. Marilhat's success

culminated in the exhibition of eight major works at the Salon of 1844, including *Recollections of the Banks of the Nile* (untraced), *Egyptian Town at Twilight* (1844; untraced, engraving in Paris, Bib. N.) and *Memories of the Area around Thiers* (1844; untraced, engraving in Clermont-Ferrand, Bib. Mun.). His commissioned individual and family portraits, particularly his graphite pencil drawings, are distinguished by a fine linear style reminiscent of Ingres that suggests the character and social status of the sitter, for example in *Mme Madieu* (1838; Paris, priv. col.). Marilhat lapsed into insanity and died aged 36. He left many unfinished paintings; when the contents of his studio were sold (13–15 Dec 1847) 281 works were listed.

Marilhat's stylistic development falls into five phases. His early picturesque landscapes (1828–31) give way to more balanced compositions (1831–5), notable for their vigorous colours and warm light. Between 1835 and 1839 Marilhat worked in an academic style. His mature works (1839–45), with their full forms and technical perfection, pleased his admirers despite their over-reliance on the effects of shadow. His last works (1846–7) show a marked decline in their conception and execution. Marilhat's Orientalist works present a vision of Egypt that is at once authentic and idealized. He depicted both the everyday life of the region and the grandeur of its ruins and mosques. He produced individual studies of typical characters—hookah smokers, Nubian warriors and fellah musicians—and integrated carefully grouped objects and figures into daguerreotype-like landscapes to produce a tranquil, meditative effect. Works such as *Syrian Arabs on a Journey* (1844; Chantilly, Mus. Condé; see col. pl. XXIV) suggest the immutable characteristics of the Near East. His French landscapes similarly combine naturalistic themes (forest edges, cattle pens, storm effects and rocks damp with water) with a treatment that is akin to the clarity and harmony of Poussin's work. The paintings suggest the influence of Claude Lorrain's golden skies and diffuse light, while their poetic atmosphere arises partly from references to Classical mythology and partly from Marilhat's vision of a world in which exuberant palm leaves, sleepy waters and twilight effects invite the viewer to fall into reverie. His colour, bright at first, was later softened into half-tones, though he remained a scrupulously precise draughtsman and his works have a documentary value. His watercolours rival those of John Frederick Lewis in their refinement.

Marilhat was, together with Delacroix and Alexandre-Gabriel Decamps, an important and influential figure in the development of French Orientalist painting. His numerous imitators included the painters Théodore Frère (1814–88) and Narcisse Berchère (1819–91), while Eugène Fromentin, captivated by his elegant style, modelled his works on Marilhat from 1843 to 1861. Reproductions of Marilhat's work by 46 engravers, and copies of his work by William Leighton Leitch (1804–83), William Forrest (1805–89) and Henry Warren (1794–1879), increased his reputation until 1886. Thereafter, though valued by Monet and Degas, his work suffered a period of obscurity until 1960, when it was rehabilitated. There is a large collection of prints after his paintings in the British Museum, London.

Writings

'Marilhat paysagiste: Fragments de ses lettres inédites', *Mag. Pittoresque*, xxiv (1856), pp. 347–50, 370–71, 403–4

Bibliography

T. Gautier: 'Prosper Marilhat', *Rev. Deux Mondes*, xxiii (1848), pp. 56–75

G. A. Delafoulhouze: 'Notice sur Prosper Marilhat, peintre de paysage', *Mém. Acad. Sci., B.-Lett. & A. Clermont-Ferrand*, iv (1862), pp. 27–49

H. Gomot: *Marilhat et son oeuvre* (Clermont-Ferrand, 1884)

M. Delotz: *Prosper Marilhat (1811–47): Visite chez son neveu* (Thiers, 1913)

R. Bonniot: 'Le Peintre auvergnat Prosper Marilhat (1811–47): Etude iconographique', *Auvergne Litt.*, cxci (1966), pp. 3–28

D. Menu: 'L'Orient de Prosper Marilhat d'après quelques inédits', *Inf. Hist. A.*, xviii (1973), pp. 62–9

—: 'Un Paysagiste français du XIXe siècle: Prosper Marilhat et l'Auvergne', *Auvergne Lit.*, ccxviii–ix (1973), pp. 159–76

—: 'Portraits et figures d'Orient à propos de dessins de Prosper Marilhat au Musée des Beaux-Arts de Lyon', *Bull. Mus. & Mnmts Lyon.*, v/2 (1973), pp. 21–33

——: 'Prosper Marilhat à l'époque romantique', *Médec. Fr.*, ccxliii (1973), pp. 25–40

——: 'L'Orient gravé d'après P. Marilhat', *Marseille*, xcvii (1974), pp. 47–56

——: *Prosper Marilhat (1811–47)*, 2 vols (diss., U. Dijon, 1979)

DANIÈLE MENU

Marillier, Clément-Pierre

(*b* Dijon, 28 June 1740; *d* Boissise, nr Melun, 11 Aug 1808). French draughtsman. Having first studied painting in Dijon, in 1760 he became Noël Hallé's pupil in Paris, but, needing to earn a living, by 1762 he had changed to a career as an illustrator. Like Charles Eisen, whose associate he became, he devoted himself mainly to illustrating the amorous poetry of such writers as François-Thomas de Baculard d'Arnaud (*Anecdotes et nouvelles*, 1767–75, later published as a collection in *Epreuves du sentiment*, Paris, 1775) and Claude-Joseph Dorat (notably the *Oeuvres complètes*, Amsterdam, 1772–3). He was at home with courtly and slightly erotic subjects, treated with wit and delicacy, but was less successful with the serious subjects he wanted to treat in the 1780s, including 150 drawings for the two-volume *L'Abrégé de l'histoire universelle en figures* (Paris, 1785–90) and the 300 drawings (some of which Marillier commissioned from Nicolas-André Monsiau) for the *Holy Bible* in 12 octavo volumes (Paris, 1789–1804). A contract that he signed with the publisher Defer de Maisonneuve shows that Marillier was to be paid 4000 livres for these 300 drawings. Such an output allowed him to live in some comfort at Boissise, where during the period of the French Revolution (1789–95) he found a role in organizing the national festivals in Melun.

Bibliography
R. Portalis: *Les Dessinateurs d'illustrations au XVIIIème siècle*, i (Paris, 1877), pp. 364–86

T. Lhuillier: 'Le Dessinateur Marillier: Etude biographique suivie d'un catalogue chronologique de son oeuvre', *Réun. Soc. B.-A. Dépts*, x (1886), pp. 368–404

G. N. Ray: *The Art of the French Illustrated Book, 1700 to 1914* (New York, 1986), p. 86 [examples of Marillier's original drgs]

CHRISTIAN MICHEL

Marin, Joseph-Charles

(*b* Paris, 1759; *d* Paris, 18 Sept 1834). French sculptor. He emulated the graceful Rococo style of his master, Clodion, and enjoyed a successful career, working largely for private patrons and exhibiting at the Paris Salon from 1791 to 1833. Most of his works are terracotta busts, statuettes and groups made in imitation of Clodion's erotic Rococo female figures, but with an added touch of realism and a more marked interest in varieties of texture. Among them are a *Bust of a Girl* (Paris, Mus. Jacquemart-André), the statuettes *Ganymede* and *Hebe* (Bayonne, Mus. Bonnat) and the *Young Girl with a Dove* (1791; Paris, Louvre). More severe is his group *Canadian Indians at their Infant's Grave* (1794; ex-Pierre Decourcelle priv. col., Paris). In 1801 he won the Prix de Rome for sculpture with the classicizing plaster bas-relief of *Caius Gracchus Leaving his Wife Licinia to Rejoin his Partisans* (Paris, Ecole N. Sup. B.-A.). This work and the bold and free terracotta sketch of *Roman Charity* (c. 1805; Besançon, Mus. B.-A. & Archéol.) show that Marin was able to produce original works in different styles. In 1805 he was made a professor at the Académie de France in Rome; in the same year he finished the marble tomb of *Pauline de Montmorin, Comtesse de Beaumont* (Rome, S Luigi dei Francesi), commissioned by François-René, Vicomte de Chateaubriand. Marin's most famous work is the marble *Bather* (1808; Paris, Louvre) in the Neo-classical style. His reputation was in decline before 1820, and he lived in some poverty towards the end of his life.

Bibliography
P. Bonnefon: 'Quelques Lettres inédites du sculpteur J.-C. Marin', *Chron. A. & Curiosité* (1901), 35, pp. 283–5; 36, pp. 290–92; 39, pp. 315–17; 41, pp. 331–2; (1902), 1, pp. 2–5; 2, p. 13; 3, pp. 1–20; 4, pp. 28–9; (1906), 6, p. 45; 7, p. 53; 10, pp. 77–8

Collection Pierre Decourcelle: Tableaux anciens,
aquarelles, pastels, dessins, sculptures de l'Ecole
Française (Paris, 1911), pp. 133–4
S. Rubenstein: 'French Eighteenth-century Sculpture in
the Collection of Mortimer Schiff', A. America, xii
(1924), pp. 67–75
P. Pradel: 'La Baigneuse de Marin', Mus. France, xiii (1948),
pp. 112–14
M. Quinquenet: Un Elève de Clodion: Joseph-Charles Marin
(Paris, 1948)
France in the Eighteenth Century (exh. cat. ed. D. Sutton;
London, RA, 1968), nos 810–12
R. Rosenblum: 'Caritas Romana after 1760: Some Romantic
Lactations', ARTnews Annu., xxxviii (1972), pp. 43–63
The Age of Neo-classicism (exh. cat., Council of Europe
14th exh.; London, 1972), no. 404
Skulptur aus dem Louvre: 89 Werke des französischen
Klassizismus, 1770–1830 (exh. cat., ed. J.-R. Gaborit;
Duisburg, Lehmbruck-Mus.; Karlsruhe, Städt Gal. Prinz-
Max-Pal.; Gotha, Schloss Friedenstein; 1989–90), pp.
128–9, 292, 318

MICHAEL PRESTON WORLEY

Mauzaisse, Jean-Baptiste

(b Corbeil, Seine-et-Oise, 1 Nov 1784; d Paris, 15
Nov 1844). French painter and lithographer. The
son of a poor organist, he entered the Ecole des
Beaux-Arts in Paris on 16 November 1803 as a pupil
of François-André Vincent. He first exhibited at
the Salon in 1812, with the painting Arab Weeping
over his Horse (Angers, Mus. B.-A.), which was a
great success and won him a first class medal. He
specialized in history subjects, particularly battle
scenes, as well as genre scenes and portraits (e.g.
portrait of the miniature painter Muneret, 1812;
Paris, Louvre). He also worked with Antoine-Jean
Gros on several of the latter's paintings.

Mauzaisse was commissioned to produce
various decorative paintings for public buildings.
He worked in the Louvre, where he executed
ceiling decorations in the gallery of antique jew-
ellery and elsewhere, and also a number of gri-
sailles in the vestibule of the Galerie d'Apollon.
These decorations tended to be allegorical, as in
Time and the Seasons (1822) for the jewellery
gallery (in situ), or mythological, as in Prometheus
Animating Man in the gallery of antiquities (in

situ). For the Salle Louis XVIII in the Louvre he
produced the ceiling painting Divine Wisdom
Giving Laws to the Kings and Legislators of the
Earth (1827; in situ). He received a few commis-
sions for religious paintings, such as the Martyr-
dom of St Etienne (1824; Bourges, Hôtel Jacques
Coeur) for the cathedral of Bourges, and St Clarus
Healing the Blind (1831) for the cathedral of
Nantes (in situ).

When Louis-Philippe declared the Château de
Versailles a national museum of French history,
Mauzaisse received numerous commissions to
paint portraits and battle scenes. These include
the full-length portrait of Comte Philippe d'Artois,
the Battle of Fleurus (1837) and Napoleon at Eylau
(all Versailles, Château). He was also one of the
earliest practitioners of lithography, in which
medium he produced such portraits as that of the
Director General of the French museums under
Napoleon, Baron Vivant Denon. In addition, he
made lithographs of historical subjects and genre
scenes, as well as illustrations for the publication
La Henriade, ornée de dessins lithographiques
avec les portraits (Paris, 1823) by F.M.A. de Voltaire.

Bibliography
Bellier de La Chavignerie–Auvray; Bénézit; Hoefer;
Thieme-Becker
C. Gabet: Dictionnaire des artistes de l'école française au
XIXe siècle (Paris, 1831)
P. Larousse, ed.: Grand Dictionnaire universel du XIXe
siècle, x (Paris, 1873), p. 1369
H. Beraldi: Les Graveurs du XIXe siècle, ix (Paris, 1889),
pp. 252–3

ATHENA S. E. LEOUSSI

Mayer, (Marie-Françoise-)Constance [la Martinière]

(b Paris, 1775; d Paris, 26 May 1821). French painter.
Constance Mayer's name is closely associated with
that of PIERRE-PAUL PRUD'HON, with whom she col-
laborated on many works often catalogued under
his name. She was one of an increasing number
of women artists who worked mainly as painters
of miniatures, portraits and genre scenes. In the
middle years of her career, under the impact of

Prud'hon's influence, she turned to allegorical subjects. She studied first under Joseph-Benoît Suvée and then Jean-Baptiste Greuze, whose sentimental subjects and soft handling left a deep and lasting impression on her work, but especially on the early Salon exhibition pictures of children and young girls. It was as a pupil of Suvée and Greuze that she signed her Salon submission of 1801, *Portrait of the Artist with her Father; He Points to a Bust of Raphael* (Hartford, CT, Wadsworth Atheneum), although that year she took lessons from Jacques-Louis David. His teaching accounts for the greater clarity, incisiveness and serious tone of the work. Despite the bust of Raphael and antique fragments on the studio wall in this painting, Mayer never really incorporated these models into her own work and remained closer in subject and sentiment to Greuze than to David.

In 1802 Mayer entered Prud'hon's studio as a pupil but soon became his friend, housekeeper, childminder and mistress. His wife, who was seriously unbalanced, was placed in a nursing home in 1803 and Prud'hon was given custody of the children. The usual distinction between teacher and pupil, master and assistant was not clearcut with Prud'hon and Mayer. Nor is it easy to assess their respective contributions to Salon paintings. Prud'hon normally produced the early drawings and sketches and Mayer then worked them up into paintings with varying degrees of assistance from Prud'hon. For the Salon exhibit of 1804, *Innocence Preferring Love to Wealth* (St Petersburg, Hermitage), he produced at least 12 sketches but she executed most of the painting and exhibited it under her name. A later allegory of a subject painted by Greuze in the late 1770s, *Innocence Drawn by Love and Followed by Regret* (priv. col., see J. Guiffrey: *L'Oeuvre de P. P. Prud'hon*, 1924, pp. 4–5), was begun by Mayer but finished by Prud'hon and catalogued under his name. Empress Josephine commissioned the *Sleep of Venus and Cupid, Disturbed by Zephyrs* (London, Wallace), which Mayer exhibited in 1806 and to which she added a pendant in 1808. These were both sold at later dates as Psyche subjects by Prud'hon.

The *Happy Mother* (exh. Salon 1810; Paris, Louvre) and the *Unfortunate Mother* (exh. Salon 1812; Paris, Louvre) are instances of the early 19th-century concern with motherhood, a much-debated subject since the novels of Jean-Jacques Rousseau and the pronouncements of Enlightenment thinkers of the mid-18th century. The *Happy Mother* is a powerful depiction of the pleasure of breast-feeding, while the *Unfortunate Mother* evokes a sense of loss, the mother shown mourning at the tomb of her dead child. Both paintings are set in wooded landscapes and emphasize the private nature of maternal experience. Adverse criticism of these attempts at serious subject-matter led Mayer to turn again to portraiture, mostly paintings of her women friends (e.g. *Mme Voiart*, exh. Salon 1814; Nancy, Mus. B.-A.). For the Salon of 1819 she returned to an allegorical subject, the *Dream of Happiness* (Paris, Louvre), showing a couple and child in a boat being taken down the River of Life by Love and Fortune. It was a happiness that Mayer never experienced. Although she had made a reputation for herself as an artist and had been given lodgings in the Sorbonne, she never had children of her own and became depressed and ill with her personal circumstances. When Prud'hon refused to contemplate the idea of remarriage should his wife's illness become fatal, Mayer cut her own throat with his razor. Prud'hon completed her painting The *Poverty-stricken Family* (M. G. Jakobi priv. col., see Weston, p. 16), a work much admired by Stendhal for its convincing depiction of despair. It was exhibited with her other works in 1822, in a posthumous exhibition which Prud'hon organized as a tribute to her.

Bibliography

C. Clément: *Prud'hon, sa vie, ses oeuvres, sa correspondance* (Paris, 1872)

C. Gueullette: 'Constance Mayer', *Gaz. B.-A.*, n.s. 1, xix (1879), pp. 476–90; xx (1879), pp. 525–38

J. Doin: 'Constance Mayer', *Rev. A. Anc. & Mod.*, xxix (1911), pp. 49–60

E. Pilon: *Constance Mayer (1775–1821)* (Paris, 1927)

H. Weston: 'The Case for Constance Mayer', *Oxford A. J.*, iii/1 (1980), pp. 14–19

HELEN WESTON

Ménageot, François-Guillaume

(*b* London, 9 July 1744; *d* Paris, 4 Oct 1816). French painter. He was the son of Augustin Ménageot (*d* 1784), an art dealer and adviser to Denis Diderot, and he studied with Jean-Baptiste-Henri Deshays and with François Boucher, whose bravura style and use of light, warm colours he adopted in his early works. He won the Prix de Rome in 1766 with *Tomyris Plunging the Head of Cyrus into a Bowl of Blood* (Paris, Ecole N. Sup. B.-A.). From 1769 to 1774 he was at the Académie de France in Rome. Having been approved (*agréé*) as a history painter by the Académie Royale in Paris in 1777, he exhibited at the Salon the *Farewells of Polyxena to Hecuba* (Chartres, Mus. B.-A.), a vast already Neoclassical work that was warmly received. His *morceau de réception* was a powerfully classicizing work entitled *Learning Resisting the Passage of Time* (1780; Paris, Ecole N. Sup. B.-A.). A year later he triumphed at the Salon with the *Death of Leonardo da Vinci in the Arms of Francis I* (Amboise, Hôtel de Ville). Ménageot was one of the painters who was involved in the return to the Grand Style: his compositions became more horizontal, the architecture more monumental, the drapery sculptural and the colouring increasingly cold. Works that bear witness to this development include *Astyanax Torn from the Arms of Andromache* (1783), *Cleopatra Paying her Last Respects to Anthony* (1785; both Angers, Mus. B.-A.), the *Continence of Scipio* (1787; Židlochovice Mus.) and *Meleager Implored by his Family* (1789; Paris, Louvre), the last being one of his most resolutely Neo-classical works.

Ménageot, however, had a predilection for gentle subjects (e.g. the *Adoration of the Shepherds* (versions in Paris, St Eustache; Villeneuve-sur-Yonne, church of the Assumption); for happy episodes from mythology or antiquity; for intimate scenes (e.g. the *Young Mother*, priv. col., see Willk-Brocard, fig. 41); and for caricature (examples in Montpellier, Mus. Atger). In 1787 he was appointed Director of the Académie de France in Rome, but with the upheavals of the French Revolution (1789–94), he resigned in 1792 and moved to Vicenza. Two *Self-portraits* of 1797 (Florence, Uffizi; Montpellier, Mus. Fabre) reveal a serious,

sad-looking man. Ménageot painted portraits, probably out of necessity (e.g. *Family Portrait*, 1801; Ferrara, Pin. N.). His few known works from this period show a change of mood, already seen in the *Virgin Commending St Teresa to the Protection of St Joseph* (1787; Quebec, Hôtel-Dieu) Such works as the *Virgin with Angels* (1797; Vicenza, Madonna del Monte), in which line was emphasised and which are reminiscent of Raphael, with an archaizing purism, heralded the 19th century. Returning to Paris in 1801, he was named a Chevalier of the Légion d'honneur in 1804 and was elected to the Institut de France in 1809. Paintings that he exhibited at the Salon of 1806 had little success, however (e.g. the *Deception of Venus* (untraced; known from an engraving by Charles P. J. Normand, see Willk-Brocard, fig. 57b); his *Marriage of Prince Eugène de Beauharnais and Princess Augusta of Bavaria* (1808; Versailles, Château) failed to please Napoleon. From 1809 to 1813 he designed costumes for the Opéra (drawings, Paris, Bib.–Mus. Opéra). Having been away from developments in Paris, he was unable to adapt to the new styles and devoted himself to his academic posts. An exquisite *Holy Family* (1804; St Petersburg, Hermitage) shows his true talent: Ménageot contributed to the development of Neo-classicism, imbuing his works with grace and an individual sensitivity that maintained the spirit of the 18th century; but he was overtaken by the movement that he had helped to establish. Having been forgotten, his importance should now be reconsidered.

Bibliography

N. Willk-Brocard: *François-Guillaume Ménageot (1744–1816)* (Paris, 1978) [with extensive bibliog.]
A.-C. Venturini: 'Ritratto di famiglia: Un dipinto inedito di François-Guillaume Ménageot, 1744–1816', *Mus. Ferrar.: Boll. Annu.*, 9/10 (1982), pp. 207–11

NICOLE WILLK-BROCARD

Mène, Pierre-Jules

(*b* Paris, 25 March 1810; *d* Paris, 21 May 1879). French sculptor. Having learnt to cast and chase bronze from his father, who was a metal-turner, he began his career by executing models for porcelain

manufacturers and making small-scale sculptures for the commercial market. He received his first professional lessons from the sculptor René Compaire and augmented these with anatomical studies and life drawings of animals in the Jardin des Plantes, Paris. From 1838 he regularly exhibited animal sculptures at the Salon. His statuettes and groups, such as *Flemish Cow and her Calf* (wax, 1845; Paris, Mus. d'Orsay), depicted the animal world with great physical precision. He even made sculptures of horses, such as *Ibrahim, an Arab Horse Brought from Egypt* (exh. Salon 1843), *Djinn, Barb Stallion* (exh. Salon 1849) and the *Winner of the Derby* (exh. Salon 1863). Mène was distinguished from other animal sculptors by his well-developed sense of business. He established his own foundry, where he formed a partnership with his son-in-law Auguste-Nicolas Cain, also an animal sculptor; they published a catalogue of their works, which could be ordered directly from the studio. The wide dissemination of reproductions of Mène's works ensured his popularity in France and abroad, especially in England.

Bibliography

Lami

J. Cooper: *Nineteenth-century Romantic Bronzes: French, English and American Bronzes, 1830–1915* (London, 1975)

LAURE DE MARGERIE

known today include a marble bust of *Louis-François de Bourbon, Prince de Conti* (1777; ex-Edouard Kann priv. col., Paris) and a terracotta *Bust of an Unknown Man* (1786; London, V&A). Another terracotta *Bust of an Unknown Man* (Lawrence, U. KS, Spencer Mus. A.), signed 'P.M.', is attributed to him and may be the portrait of the writer Jacob-Nicolas Moreau that Mérard exhibited at the Académie de St Luc in 1774. In addition to portraits he executed the tomb of *Louis-François de Bourbon* (marble, 1777–9; L'Isle-Adam, Val-d'Oise, St Martin). Mérard's works exemplify the late 18th-century taste for delicate, realistic portraiture, in contrast to Bouchardon's more classicizing and monumental style.

Bibliography

Lami

'Notes critiques sur les oeuvres de peinture et de sculpture réunies à l'exposition de cent pastels du XVIIIe siècle', *Bull. Soc. Hist. A. Fr.* (1908), pp. 176–7

P. Vitry: 'Exposition de cent pastels et des bustes du XVIIIe siècle', *Les Arts* [Paris], 82 (1908), p. 9

J. Maxon: 'A Bust Attributed to Pierre Mérard', *A.Q.* [Detroit], xv (1952), p. 337

F. H. Dowley: 'Toward an Attribution to Pierre Mérard', *Register* [Lawrence, U. KS], 4 (1954), pp. 17–18

T. Hodgkinson: 'French Eighteenth-century Portrait Sculptures in the Victoria and Albert Museum', *V&A Mus. Yb.*, 3 (1972), pp. 100–15

MICHAEL PRESTON WORLEY

Mérard, Pierre

(*b* ?Paris, *c.* ?1740; *d* Paris, 6 May 1800). French sculptor. A student of Edme Bouchardon, this little-known portrait sculptor was never a member of the Académie Royale de Peinture et de Sculpture, although in 1763 he was received (*reçu*) into the rival Académie de St Luc. He exhibited there in 1774 and later became one of its professors. After the French Revolution (1789–95) Mérard showed sculptures in the Salons of 1795, 1796 and 1799. His earliest known production is a wax medallion portrait of *Louis XV*, signed and dated 1771 (ex-Marquis de Menars sale, Paris, 1782). Mérard's materials were terracotta, plaster, marble and wax. The few works by Mérard that are

Meynier, Charles

(*b* Paris, 25 Nov 1768; *d* Paris, 6 Sept 1832). French painter and collector. His father intended that he should become a tailor, but he showed an early love for drawing and was allowed to study with the engraver Pierre-Philippe Choffard. He was a proficient student but nevertheless wished to become a painter, so his elder brother Meynier St-Phal, an actor at the Comédie-Française in Paris, paid for him to train from 1785 with François-André Vincent, who then enjoyed a considerable reputation. In 1789 he won the Prix de Rome for *Joseph Recognized by his Brothers* (1789; Paris, Ecole N. Sup. B.-A.), jointly with Anne-Louis

Girodet. The events of the French Revolution prevented him spending the usual five years in Rome, but his time there (till 1793) allowed him to make numerous studies of antique sculpture. He returned to Paris during the Reign of Terror and started to produce large Neo-classical works. In 1793 he entered a competition set by the Committee of Public Safety for the best work on a theme from the French Revolution. Taking the competition itself as his subject, he painted *France Encouraging Science and the Arts* (Boulogne-Billancourt, Bib. Marmottan), a classically inspired work in which the generalized features of the figures, with prominent noses and chins, are characteristic of his style. The painting won a prize, though not the first prize, which was won by François Gérard, and thereafter Meynier rapidly established a reputation. He made his début at the Salon in 1795. Under the First Empire he received several public commissions for works celebrating Napoleon's victories. In 1806 he produced a series of drawings (Paris, Louvre) for bas-reliefs and sculptures to ornament the Arc de Triomphe du Carrousel, Paris, the monumental entrance to the Tuileries that was built to celebrate Napoleon's victories of 1805. The arch was designed by Pierre-François Léonard Fontaine and Charles Percier, and Meynier's designs were sculpted by a team that included Pierre Cartellier, Clodion, Louis-Pierre Deseine, Jacques Philippe Le Sueur (1757–1830) and Claude Ramey. In 1808 he painted *Marshal Ney and the Soldiers of the 76th Regiment Retrieving their Flags from the Arsenal of Inspruck* [sic] (1808; Versailles, Château), one of 18 works commissioned in 1806 to illustrate Napoleon's German campaign. Other similarly large-scale works were commissioned from such artists as Antoine-Jean Gros, François Gérard and Girodet. The work, which depicts the retrieval in 1805 of three flags that had been lost in the campaign of 1800, was highly praised at the Salon of 1808. In 1807 he was one of 26 artists who entered the competition to paint a scene from the recently fought Battle of Eylau. His *Napoleon on the Battlefield of Eylau* (1807; Versailles, Château; see col. pl. XXV) won one of the two honourable mentions, though the

competition was won by Gros. In the foreground of this bloody battle scene he included numerous nude corpses, in rather slavish accordance with classical ideals.

In 1815 Meynier was elected to the Académie des Beaux-Arts. Following the Bourbon Restoration, he received many decorative commissions, most notably for the Louvre, Paris, where he painted two ceilings, *France Protecting the Arts* (1819) for the Salle Percier and the *Triumph of French Painting* (1822) for the Salle Duchâtel (the latter depicting the apotheosis of Nicolas Poussin, Charles Le Brun and Eustache Le Sueur). He returned to the Louvre in 1827 and painted the *Nymphs of Parthenope* for the Salle des Antiquités Egyptiennes. Together with Alexandre Abel de Pujol he decorated the Paris Bourse (1826) and in 1829 provided ceiling decorations for the Grand Salon of the Tuileries (Amboise, Mus. Mun.).

Though mainly known for his allegorical and history paintings, Meynier occasionally painted portraits (e.g. *Marshal Ney*; Versailles, Château) and religious works, such as the *Dedication of the Church of St-Denis* (1812) for the sacristy of that church in Paris. One of his last works was the Rubensian *Triumph of St Michael* (1828) for the chapel of the Boulard asylum in Saint-Mandé. Highly linear Neo-classical drawings form a further part of his oeuvre. He ran a painting studio open exclusively to women, his more distinguished pupils including Louise-Marie-Jeanne Hersent (1784–1862). After his death from cholera, a large sale was held of his art collection, comprised mostly of prints but including also paintings by Annibale Carracci, David Teniers, Jacques-Louis David, Anthony van Dyck and Simon Vouet. His prints were largely reproductions of well-known paintings, but there were a few originals, for example some by Albrecht Dürer and Giovanni Battista Piranesi.

Bibliography

Catalogue des tableaux, dessins et aquarelles, estampes anciennes et modernes provenant du cabinet et des ateliers de feu M. Meynier (Paris, 1832)

E. B. Garnier: *Funérailles de M. Charles Meynier* (Paris, 1832)

C. Deplace, ed: *Biographie universelle, ancienne et moderne*, 45 vols (Paris, 1843–58), xxviii, p. 173

P. Marmottan: *L'Ecole française de peinture (1789–1830)* (Paris, 1886), pp. 313, 330, 339, 452

French Painting, 1774–1830: The Age of Revolution (exh. cat. by F. J. Cummings, A. Schnapper and R. Rosenblum, Paris, Grand Pal.; Detroit, Inst. A.; New York, Met.; 1975), pp. 544–9

R. Michel: 'Meynier ou la métaphore parlementaire', *Rev. Louvre*, iii (1987), pp. 188–200

☐

Michallon, Achille (Etna)

(*b* Paris, 22 Oct 1796; *d* Paris, 24 Sept 1822). French painter and draughtsman. After the death of his father, the sculptor Claude Michallon (1751–99), and of his mother in 1813, he was brought up by his uncle, the sculptor Guillaume Francin (1741–1830). He drew from life at an early age and studied with Jacques-Louis David, Pierre Henri de Valenciennes and later Jean-Victor Bertin. For four or five years starting in 1808 Michallon may have received financial help from Prince Nicolay Yusupov after the latter had seen some of his works in David's studio. Although no works dating from this period are known, Michallon exhibited a *View of Saint-Cloud, Seen from the Vicinity of Sèvres* and a *Wash-house: Study from Life Executed at Aulnay* at the Salon of 1812. It is possible that two small landscapes, a *View of Sceaux* and a *Site in Ile-de-France* (both Albi, Mus. Toulouse-Lautrec, on loan to Gray, Mus. Martin), date from 1812–15. Their panoramic perspective, spare composition, realistic depiction of weather conditions and the picturesque quality of a figure disappearing into the distance suggest that Michallon was familiar with the work of 17th-century landscape artists.

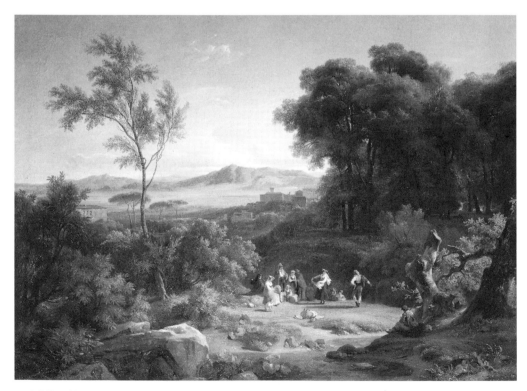

62. Achille Michallon: *Landscape Inspired by the View of Frascati*, 1822 (Paris, Musée du Louvre)

In 1814 Michallon travelled to Vichy, and in 1815 he drew the fortifications erected around Paris; these views, which follow the 18th-century tradition of topographical landscapes, were published in aquatint in *Les Environs de Paris fortifié*. Three of Michallon's landscapes, representing the *Château of Versailles*, the *Château of Meudon* and the *Château of Vincennes* (all ex-New York, Wildenstein's; see 1982 exh. cat., pp. 30–31), recall the Rationalist tendency in landscape painting, in which an accurate description of architecture is combined with a northern European influence, visible particularly in the realistic treatment of the foreground.

In 1817 Michallon won the Prix de Rome, organized that year for the first time, for the *Woman Struck Down* (Paris, Louvre) and *Democritus and the People of Abdera* (Paris, Ecole N. Sup. B.-A.). Before leaving for Italy, he executed a series of sepia wash drawings (nine in Paris, Bib. N.) in Dieppe, Saint-Valéry-en-Caux and Fécamps for Baron Isidore-Justin-Séverin Taylor's *Voyage pittoresque de la France*. Michallon left for Rome in 1818 at the same time as Léon Cogniet, whom he befriended. Little is known of the early part of his stay, although there is a drawing of the *Villa Medici* (Paris, Louvre) dated 1818, which is similar to a landscape in the Musée des Beaux-Arts in Orléans. While in Rome Michallon executed the *Death of Roland* (exh. Salon 1819; Paris, Louvre), a commission for the Diana Gallery at Fontainebleau. Two sketches (Strasbourg, Mus. B.-A.; Orléans, Mus. B.-A.) show an ideal-istic landscape with an air of fiery intensity in the style of Salvator Rosa. Also at the Salon of 1819 he exhibited a *View of Lake Nemi* (ex-Gal. La Scala, Paris), in which the influence of such Italianate painters as Frederik de Moucheron and Nicolaes Berchem can be seen in the light and the arrangement of the foreground. Michallon executed several studies representing Rome and its surroundings, including the *Sabine Hills* (Detroit, MI, Inst. A.) and a *View of the Colosseum* (Paris, Louvre).

In 1819 and 1820 Michallon travelled through southern Italy and Sicily. He made numerous drawings and painted studies of architectural subjects, such as the *Temple of Neptune at Paestum* and the *Forum of Pompeii*, and of picturesque characters, such as *Countrywoman, near Rome* (all Paris, Louvre). He also executed landscapes without figures, such as the *Island of Ischia* (Phoenix, AZ, A. Mus.) and *Eruption of Vesuvius by Night* (Paris, Louvre), in which he displayed his skill at observing atmospheric conditions and the time of day. Some of his drawings were engraved in Gigaud de la Salle's *Le Voyage pittoresque en Sicile* (1822–6) and in *Vues d'Italie et de Sicile* (Paris, 1826).

Michallon returned to France in 1821, travelling through Florence, Bologna, Venice and the Swiss Alps. On his return to Paris he opened a studio that was frequented by Jean-Baptiste-Camille Corot. He executed several pictures based on his memories of Italy (e.g. *Landscape Inspired by the View of Frascati*, 1822; Paris, Louvre; see fig. 62); in these he combined the classicism of historical landscape, in which the organization of elements was sometimes artificial, with a study of changing nature. In such dramatic subjects as *Landscape with a Man Frightened by a Snake* (Barnard Castle, Bowes Mus.) and *Philoctetes on the Island of Lemnos* (1822; Montpellier, Mus. Fabre), Michallon suggested the violence of the passions depicted and foreshadowed the new approach to landscape painting that flourished from the 1830s. In his last compositions, such as those executed in the Forest of Fontainebleau (1821–2; untraced), Michallon became more sensitive to nature's melancholy and the dramatization of natural elements, without moving away from Poussinesque models. He died of pneumonia, and his paintings and drawings were sold in Paris in 1822.

Bibliography

P. Miquel: *L'Ecole de la nature*, ii of *Le Paysage français au XIXe siècle, 1824–1874* (Maurs-la-Jolie, 1975), pp. 76–85

D. G. Cleaver: 'Michallon et la théorie du paysage', *Rev. Louvre*, 5–6 (1981), pp. 359–66

Consulate—Empire—Restoration: Art in Early Nineteenth Century France (exh. cat., New York, Wildenstein's, 1982)

Achille-Etna Michallon (exh. cat. by V. Pomarède, B. Lesage and C. Stefani, Paris, Louvre, 1994)

VALÉRIE M. C. BAJOU

Michel, Georges

(*b* Paris, 12 Jan 1763; *d* Paris, 7 or 8 June 1843).
French painter. He came from a humble back-
ground, his father being an employee at the
market of Les Halles in Paris. At an early age, a
farmer general, M. de Chalue, took an interest in
him and found him a place with the curate of
Veruts, on the plain of Saint-Denis, north of Paris.
It was here that he first developed a love of the
countryside. In 1775 he was apprenticed to a
mediocre history painter called Leduc, but he pre-
ferred to go off and sketch out of doors. In order
to assist him, M. de Berchigny, Colonel in the
Hussars, engaged him in his regiment garrisoned
in Normandy and arranged for him to take lessons
in art. He remained there for more than a year
and then returned to Paris, where he worked with
M. de Grammont-Voulgy, who was Steward to the
brother of Louis XVI. In 1789 Grammont-Voulgy
took him to Switzerland, and Michel also visited
Germany, where he stayed with the Duc de Guiche.

Some time between 1783 and 1789, Michel met
the dealer Jean-Baptiste-Pierre Le Brun, who autho-
rized him to copy the 17th-century Dutch paint-
ings that were in his shop. In 1790 he probably met
the painter Lazare Bruandet. The two of them
became friends, painted at Romainville, north-east
of Paris, and in the Bois de Boulogne and shared a
dissolute lifestyle. In 1791 he exhibited for the first
time at the Salon in Paris, showing two small land-
scapes and *Horse and Animal Market*. He contin-
ued to exhibit regularly there but was ignored by
the critics because his style was not yet well defined
and his paintings were considered too similar to
those of the Dutch masters. Around 1800 he was
employed by the Musée du Louvre to restore
Flemish and Dutch paintings by Rembrandt,
Ruisdael and Meindert Hobbema, and it was in this
capacity that he developed a true understanding
of technique. In 1808 he decided to set up a studio
and to give lessons, although he closed it a year
later, as he disliked teaching. In 1813 he opened
a shop adjacent to his studio in the Rue de Cléry
and sold furniture and paintings. Discouraged by
numerous refusals, he exhibited for the last time
at the Salon of 1814. After the death in 1820 of the
last surviving of his eight children, he left Paris to
stay for a year at Condé-sur-l'Escaut in Picardy.
After his return he began to lead a reclusive life
and gradually withdrew from the art world.
Because of his self-imposed artistic isolation, he
had to rely solely on the patronage of Baron d'Ivry,
who purchased almost his entire output. During
the July Revolution of 1830, the two men fell out
over political differences, and d'Ivry became one
of Michel's principal imitators, even pretending
that the artist was dead.

Michel always painted within a small area lim-
ited to the surroundings of Paris. He commented
that 'Whoever cannot paint within an area of four
leagues is but an unskilled artist who seeks the
mandrake and will only ever find a void' (Sensier).
His preferred locations were Montmartre, where
he was inspired by the famous windmills, the
plains of Saint-Denis, the villages of Vaugirard,
Grenelle, Montsouris, Romainville and Le Pré-
Saint-Gervais. He executed small *plein-air* studies:
often these were drawings heightened with water-
colour wash, which were then used as preliminar-
ies for paintings worked up in the studio. His career
may be divided into three phases. The first, until
c. 1808, includes the period of his collaboration
with Jean-Louis Demarne and Jacques-François
Swebach, artists who often executed the staffage
of his landscapes. These works recall those by the
lesser 18th-century masters of northern Europe.
Typical of this period is *Animals at the Drinking
Trough*, also known as *The Storm* (*c.* 1794–5;
Nantes, Mus. B.-A.). From 1808 he developed a more
personal vision, in which light and the treatment
of the sky and space became his principal concerns.
Paintings of this period (e.g. the *Plain of Saint-
Denis*, Paris, Carnavalet) are more unified compo-
sitionally, with vast expanses of landscape and
wide perspectives under stormy skies. The wind-
mills are often the sole accents punctuating the
compositions. After 1830 he was at the peak of his
talent, his style becoming even more lyrical and
visionary. His brushstrokes are broader and his
paint thicker. He reinforced the dramatic tension
by accentuating the heaviness of the skies and the
constrasts of light and dark. The mood is one of
unrest, and the inclusion of Man confronted by the
immensity of Nature and its forces is a theme later

used by Romantic painters. Works from this last period include the *Environs of Montmartre* (Paris, Louvre), *The Storm* (*c*. 1830; Strasbourg, Mus. B.-A.) and *Two Windmills* (The Hague, Rijksmus. Mesdag). *Landscape outside Paris* (Lille, Mus. B.-A.; see col. pl. XXVI) is also typical. Various tiny figures, including a horse and rider and two travellers on foot, move through a vast landscape with a sunlit horizon. In the darker mid-ground can be seen a windmill and a thunderstorm.

Michel had little interest in fame, and, with the exception of a few early paintings, his works are unsigned. He said: 'The painting must please without the aid of a name or a label. We should do what our ancestors did: they did not sign [their works], but their talent was their signature' (Sensier, p. 17). He was important as a precursor of the works of the Barbizon school. In 1841, two years before Michel's death, the contents of his studio, consisting of more than 1000 studies and 2000 drawings, were put up at auction, and the Barbizon painter Charles Jacque acquired several of his works, which were of great inspiration to him. Jules Dupré also encountered Michel's art at that time.

An independent artist who never achieved success in his lifetime, Michel's role today is recognized by critics as crucial in the evolution of 19th- and 20th-century landscape painting. However, literature on him remains sparse. The only known facts about his life were collected and published (1873) by Alfred Sensier, his first biographer, and his study is still the principal source of information about the artist.

Bibliography

A. Sensier: *Etude sur Georges Michel* (Paris, 1873)

J. Bouret: *L'Ecole de Barbizon et le paysage français au XIXe siècle* (Neuchâtel, 1972), pp. 25–32

P. Miquel: *Le Paysage français au XIXe siècle, 1824–1874: L'Ecole de la nature*, ii (Maurs-la-Jolie, 1975), 4–11

C. Parsons and N. McWilliam: '"Le Paysan de Paris": Alfred Sensier and the Myth of Rural France', *Oxford A. J.*, vi/2 (1983), pp. 38–58

H. P. Bühler: 'Der Ruisdael vom Montmartre: Georges Michel, 1763–1843', *Die Weltkunst*, lvi/22 (1986), pp. 3614–18

LAURENCE PAUCHET-WARLOP

Milhomme, François-Dominique-Aimé

(*b* Valenciennes, 20 Aug 1758; *d* Paris, 24 May 1823). French sculptor. He was trained in the Valenciennes studio of the local sculptor Pierre-Joseph Gillet (1734–1810) and later became the pupil in Paris of André-Jean Lebrun (1737–1811) and Christophe-Gabriel Allegrain. In the 1790s, during the French Revolution, he executed decorative sculpture and also produced models for the goldsmith Robert Joseph Auguste or his son Henry Auguste. In 1801, at the age of 43, he won the Prix de Rome with the bas-relief *Caius Gracchus Leaving his Wife Licinia to Dispute in the Forum with the Consul Opimius* (plaster; ex-Mus. B.-A., Valenciennes; untraced). He shared the prize with Joseph-Charles Marin. His herm bust of *Andromache Mourning Hector* (tinted plaster, 1800; Paris, Louvre) reveals a delicate Neo-classical sensibility that was developed during his years at the Académie de France in Rome after 1802 to 1809. During this period he produced his finest works, including a statue of *Psyche Abandoned by Cupid* (marble, 1806; Compiègne, Château), in which a form derived from antique sculpture was given a recognizably modern sentiment, and a colossal seated statue of *General Lazare Hoche* (marble, 1808; Versailles, Château) based on the Ludovisi *Mars* (Rome, Mus. N. Romano), in which the heroic nudity of the original is perhaps a little incongruous for an official monument. On his return to Paris in 1809 he exhibited numerous portrait busts, both contemporary and historical, such as those of the actor *François-Joseph Talma* (exh. Salon 1812; untraced) and of *Henry IV* (plaster, exh. Salon 1814; untraced). He also executed a small number of full-length statues, including an unusual one of *Jean-Baptiste Colbert* (marble, 1820; Versailles, Château). He made models for several monuments that were not executed. Among those large-scale works that were carried out is the impressive figure of *Sorrow* (marble, 1816) for the tomb of *Pierre Gareau* in Père Lachaise Cemetery, Paris.

Bibliography

Lami

Nouvelles Acquisitions du Département des Sculptures (1980–1983), Paris, Louvre cat. (Paris, 1984), pp. 72–3

La Sculpture française au XIXe siècle (exh. cat., ed. A.
 Pingeot; Paris, Grand Pal., 1986)

GÉRARD HUBERT

Millet, Jean-François

(b Gruchy, nr Gréville, 4 Oct 1814; d Barbizon, 20
Jan 1875). French painter, draughtsman and
etcher. He is famous primarily as a painter of peas-
ants. Although associated with the Barbizon
school, he concentrated on figure painting rather
than landscape except during his final years. His
scenes of rural society, which nostalgically evoke
a lost golden age, are classical in composition but
are saturated with Realist detail. Millet's art,
rooted in the Normandy of his childhood as well
as in Barbizon, is also indebted to the Bible and
past masters. His fluctuating critical fortunes
reflect the shifting social and aesthetic lenses
through which his epic representations of peas-
ants have been viewed.

1. Life and work

Born into a prosperous peasant family from
Normandy, Millet received a solid general educa-
tion and developed what became a lifelong inter-
est in literature. After studying with a local
portrait painter, Bon Du Mouchel (1807–46), he
continued his professional training in Cherbourg
with Lucien-Théophile Langlois (1803–45), a pupil
of Antoine-Jean Gros. The talented young artist
received a stipend from the city of Cherbourg and
went to Paris where he entered the atelier of the
history painter Paul Delaroche. Frustrated and
unhappy there, Millet competed unsuccessfully
for the Prix de Rome in 1839 and left the Ecole
des Beaux-Arts. One of the two portraits that he
submitted to the Salon of 1840 was accepted. In
1840 Millet moved back to Cherbourg and set
himself up as a portrait painter, returning the fol-
lowing year to Paris.

Millet's early years (c. 1841–8) were dominated
by portraiture, which represented the most lucra-
tive (and often the only) means for a 19th-century
artist to earn a living, especially in the provinces.
Such early portraits as his Self-portrait (c. 1840–41)
and the touching effigy of his first wife, Pauline-

Virginie Ono (1841; both Boston, MA, Mus. F.A.),
are characterized by strongly contrasted lighting,
dense, smooth brushwork, rigorous simplicity and
directness of gaze. The beautiful black conté
crayon study of his second wife, Catherine Lemaire
(c. 1848–9; Boston, MA, Mus. F.A.), with its sensi-
tive crayon strokes and monumentality, heralds a
new phase in Millet's artistic evolution, which
coincided with his move to Barbizon in 1849. After
1845 Millet painted few portraits, although he con-
tinued to make portrait drawings. During the
1840s Millet struggled to survive financially in
Paris, lost his first wife in 1844 and failed to
achieve critical recognition. In addition to por-
traits, he produced pastoral subjects and nudes
during the 1840s. Around 1848 Millet became
acquainted with several of the Barbizon artists,
notably Théodore Rousseau who became a close
friend. Through an arrangement with Alfred
Sensier (1815–77), Millet was able to guarantee his
family's livelihood.

Millet's epic naturalist style, which surfaced in
the peasant scenes he painted after he settled in
Barbizon, coincided with the Revolution of 1848
and his escape from the city. From 1849 Millet spe-
cialized in rural genre subjects, which melded
together current social preoccupations and artis-
tic traditions. In the aftermath of the Revolution
these subjects took on socio-political connota-
tions. Rural depopulation and the move to the
cities made the peasant a controversial subject. At
the Salon of 1850–51, Millet attracted the atten-
tion of both conservative and liberal critics with
The Sower (1850; Boston, MA, Mus. F.A.). The pow-
erful, striding peasant, exhibited in the same year
as Gustave Courbet's controversial Stonebreakers
(destr.) and Burial at Ornans (Paris, Mus. d'Orsay;
see fig. 10), imbued the common man with a sort
of epic grandeur. Millet's Sower represents the
endless cycle of planting and harvesting and phys-
ical toil with dignity and compassion. To conser-
vative critics, there was something distinctly
disquieting about this hulking, monumental
peasant with his forceful gesture and coarse,
unidealized features. To progressive critics,
however, the art of Millet and Courbet signalled
change and the coming of age of the common man

as a subject worthy of artistic representation. Yet, ironically, Millet himself was a pessimist who held little hope for reform. In fact, his paintings of peasants often portray archaic farming methods in nostalgic colours and sometimes allude to biblical passages, as in *Harvesters Resting (Ruth and Boaz)* (1850–53; Boston, MA, Mus. F.A.). Millet made numerous preparatory studies for this painting, which he considered his masterpiece and which won him his first official recognition at the Salon of 1853. In this monumental, classicizing harvest scene, Millet paid homage to his heroes, Michelangelo and Nicolas Poussin. The critic Paul de Saint-Victor (1825–81) perceptively described Millet's *Harvesters* as 'a Homeric idyll translated into the local dialect' (*Le Pays*, 13 Aug 1853).

In 1857 Millet exhibited *The Gleaners* (Paris, Mus. d'Orsay) at the Salon. This grandiose canvas represents the summation of Millet's epic naturalism. Three poor peasant women occupy the foreground of the composition, painfully stooping to gather what the harvesters have left behind as they were entitled to by the commune of Chailly. In the background Millet painted with chalky luminosity the flat, fruitful expanse of fields with the harvest taking place. The painting was attacked by conservative critics, such as Saint-Victor, who characterized the gleaners as 'the Three Fates of pauperdom' (*La Presse*, 1857). The three impoverished women, like the figure in *The Sower*, raised the spectre of social insurrection and belied government claims about the eradication of poverty. However, Millet's painting was defended by leftist critics for its truth and honesty. The Realist critic Jules-Antoine Castagnary noted the beauty and simplicity of the composition despite the misery of the women and evoked Homer and Virgil. The monumental, sculptural figures, with their repetitive gestures, are in fact reminiscent of the Parthenon frieze, and the painting itself, despite its apparent naturalism, is composed with mathematical precision. *The Gleaners*, like Millet's other canvases, both reflects and transfigures the realities of rural life by filtering them through the lenses of memory and past art.

The Angelus (1857–9; Paris, Mus. d'Orsay; see fig. 63), which was commissioned by Boston artist Thomas Gold Appleton (1812–84), exemplifies Millet's fluctuating critical reputation. Its widespread vulgarization and unusually specific subject-matter verging on the mawkish have made it Millet's most popular painting. A young farmer and his wife, silhouetted against the evening sky, pause as the angelus tolls, the woman bowed in prayer, the man awkwardly turning his hat in his hands. In 1889 the painting was the object of a sensational bidding war between the Louvre and an American consortium that bought it for the unprecedented sum of 580,650 francs. Billed as the most famous painting in the world, *The Angelus* was triumphantly toured around the USA. In 1890 Hippolyte-Alfred Chauchard acquired the painting for 800,000 francs, and it entered the Louvre in 1909. However, by that date Millet had fallen out of fashion and the painting became a subject of derision. *The Angelus*, with its rigid gender differentiation, later became a veritable obsession for the Surrealist artist Salvador Dalí.

During the 1860s Millet continued to exhibit peasant subjects, most often single figures. Successful and financially secure, he enjoyed a growing reputation, enhanced by the retrospective of his work held at the Exposition Universelle of 1867 in Paris. In 1868 he was awarded the Légion d'honneur. From 1865 Millet turned frequently to pastels and devoted himself increasingly to landscape painting although he never abandoned the human figure. In particular, he completed the monumental series the *Four Seasons* (1868–74; Paris, Mus. d'Orsay), commissioned by Frédéric Hartmann (d 1881) for 25,000 francs. These landscapes, with their loose, painterly brushwork and glowing colour, form the connecting link between the Barbizon school and Impressionism. In 1870 Millet exhibited at the Salon for the last time. At a public sale held in 1872 his works fetched high prices. In 1874 Millet was commissioned to paint murals illustrating the life of St Geneviève for the Panthéon, Paris, which he was unable to carry out. One of his last completed works is the horrifying but hauntingly beautiful *Bird Hunters* (1874; Philadelphia, PA, Mus. A.), which represents an

63. Jean-François Millet: *The Angelus*, 1857–9 (Paris, Musée d'Orsay)

apocalyptic nocturnal vision recollected from his childhood—an elemental drama of light and dark, of life and death. Severely ill, Millet married his second wife, Catherine, in a religious ceremony on 3 January 1875 and died on 20 January. He was buried at Barbizon next to Rousseau.

2. Working methods and technique

Millet was an exceptional draughtsman whose drawings have perhaps withstood the test of time better than his paintings. His varied graphic oeuvre ranges from rapid preparatory studies (most often in black crayon) to carefully finished pastels, which he sold to collectors for high prices during the last decade of his career. Drawings, which enabled Millet to perfect his compositions, were the building blocks for his paintings. Millet worked in the traditional manner, sometimes producing numerous preparatory studies for a single painting. In particular, he was a master of light and dark, as such nocturnal scenes as *Twilight* (black conté crayon and pastel on paper, *c.* 1859–63; Boston, MA, Mus. F.A.) attest. Millet's drawings, in their predilection for the expressive effects of black and white, foreshadow those of Georges Seurat and Odilon Redon.

Technically it is Millet's pastels, many of which were commissioned by the collector Emile Gavet

(1830–1904), that are the most innovative. Although he had worked in pastel as early as the mid-1840s, Millet turned to the medium with increasing regularity after 1865 and developed an original technique in which he literally drew in pure colour. Beginning with a light chalk sketch, he applied the darks, then rubbed in the pastels to create the substructure and finally built up the surface with mosaic-like strokes of colour. He soon lightened his technique and experimented with different coloured papers, which he allowed to show through in the finished composition. Millet's pastels, in their marriage of line and colour, point forward to Impressionism and Edgar Degas. With typical modesty, Millet referred to his pastels simply as *dessins*.

Although printmaking was never a central activity for Millet, he created in the 1850s and 1860s a series of etchings that often reproduced motifs from his paintings. Millet, like other artists of his generation, was part of the general revival of printmaking in the mid-19th century. He probably began etching about 1855, although Melot (1978) has suggested that he may have begun earlier. Alfred Sensier urged Millet to create a series of etchings from his own designs for commercial publication in the hopes of expanding the market for his art. Millet's etchings, such as *Woman Churning Butter* (1855–6; Delteil, no. 10), illustrate his technical skill with the etching needle although they are generally less forceful than his preparatory drawings. In some instances, however, Millet's etchings anticipate his paintings as in the case of *The Gleaners*. *Woman Carding Wool* (1855–6; D 15) is one of the most monumental images that Millet created in the etching medium.

Millet's work illustrates the complexity of the Realist enterprise at mid-century. His art is a dialogue between past and present—radical in its humanitarian social creed but traditional in technique and classicizing in composition. Millet's rural subjects are drawn from contemporary social reality but interpreted in a highly personal manner. His art influenced Impressionist and Post-Impressionist painters, notably Camille Pissarro and Vincent van Gogh, who idolized Millet and copied a number of his compositions. Even if the peasant no longer strikes the same sympathetic chords for the 20th-century viewer, one cannot help but be moved by the humble majesty of Millet's ageless figures who fill the gap between earth and sky. The retrospective exhibitions held in Paris and London (1975–6) and Boston, MA (1984), provided comprehensive overviews of Millet's varied oeuvre.

Bibliography

E. Wheelwright: 'Personal Recollections of Jean-François Millet', *Atlantic Mthly*, 38 (Sept 1876), pp. 257–76
A. Sensier and P. Mantz: *La Vie et l'oeuvre de Jean-François Millet* (Paris, 1881) [primary source]
J. Cartwright: 'The Pastels and Drawings of Millet', *Portfolio* [London], xxi (1890), pp. 191–7, 208–12
——: *Jean-François Millet: His Life and Letters* (London, 1896)
A. Thompson: *Millet and the Barbizon School* (London, 1903)
L. Bénédite: *Les Dessins de J.-F. Millet* (Paris, 1906; Eng. trans., London and Philadelphia, 1906)
L. Delteil: *J.-F. Millet, Th. Rousseau, Jules Dupré, J. Barthold Jongkind* (1906), i of *Le Peintre-graveur illustré* (Paris, 1906–30/R 1969) [D]
E. Moreau-Nélaton: *Millet raconté par lui-même*, 3 vols (Paris, 1921)
S. Dalí 'Interprétation paranoîaque-critique de l'image obsédante de Millet', *Minotaure*, i (1933), pp. 65–7
R. Herbert: 'Millet Revisited', *Burl. Mag.*, civ (1962), pp. 294–305, 377–86
Barbizon Revisited (exh. cat. by R. Herbert, Boston, Mus. F. A., 1962)
S. Dalí: *Le Mythe tragique de l'Angélus de Millet* (Paris, 1963)
R. Herbert: 'Millet Reconsidered', *Mus. Stud.* [A. Inst. Chicago], i (1966), pp. 29–65
——: 'City vs. Country: The Rural Image in French Painting from Millet to Gauguin', *Artforum*, viii/6 (1970), pp. 44–55
L. Lepoittevin: *Jean-François Millet*, 2 vols (Paris, 1971–3)
T. J. Clark: *The Absolute Bourgeois: Artists and Politics in France, 1848–1851* (London, 1973)
R. Herbert: 'Les Faux Millet', *Rev. A.*, 21 (1973), pp. 56–65
R. Bacou: *Millet dessins* (Paris, 1975); Eng. trans. as *Millet: One Hundred Drawings* (London and New York, 1975)
J.-J. Lévêque: *L'Univers de Millet* (Paris, 1975) [drawings; good plates]
Millet et le thème du paysan dans la peinture française au 19e siècle (exh. cat., Cherbourg, Mus. Henry, 1975)

Jean-François Millet (exh. cat. by R. Herbert, Paris, Grand Pal.; London, Hayward Gal.; 1975–6) [best gen. disc. of Millet's work; full bibliog.]

A. Fermigier: *Jean-François Millet* (Geneva, 1977) [good plates]

M. Melot: *L'Oeuvre gravé de Boudin, Corot, Daubigny, Dupré, Jongkind, Millet, Théodore Rousseau* (Paris, 1978)

Jean-François Millet (exh. cat. by A. R. Murphy, Boston, Mus. F.A., 1984) [catalogues extensive Millet holdings of the Museum of Fine Arts, Boston; previously unpubd letters]

K. Powell: 'Jean-François Millet's *Death and the Woodcutter*', *Artsmag*, 61 (1986), pp. 53–9

B. Laughton: 'J.-F. Millet in the Allier and the Auvergne', *Burl. Mag.*, cxxx (1988), pp. 345–51

——: *The Drawings of Daumier and Millet* (New Haven and London, 1991)

B. Laughton and L. Scalisi: 'Millet's *Wood Sawyers* and *La République* Rediscovered', *Burl. Mag.*, cxxxiv (1992), pp. 12–19

HEATHER MCPHERSON

conservative Salon jury in 1835 and 1836, and despite further state commissions, such as the sensitively carved neo-Renaissance chimney-piece in the Salles des Conférences of the Chambre des Deputés, Palais Bourbon, Paris (1839; *in situ*), he was obliged to earn his living by modelling statuettes for commercial reproduction. In addition to these works, which were either portraits of famous contemporaries such as the singer *Mme Malibran* or fantasy pieces such as *Woman with a Falcon*, he also painted landscapes, of which the gouache *Waterfall among Rocks* (Colmar, Mus. Unterlinden) is an example. From 1843 to 1848 he showed pastels at the Salon.

He took his own life in a fit of depression, hoping 'thus to obtain a pension for his widow'.

Bibliography

A. Le Bail: *Antonin Moine*, Ecole Louvre (Paris, 1977)

I. L.-J. Lemaistre: *La Sculpture française au XIXe siècle* (exh. cat., ed. Réunion des musées nationaux; Paris, Grand Pal., 1986), pp. 204–6, 324

ISABELLE LEMAISTRE

Moine, Antonin-Marie

(*b* Saint-Etienne, 30 June 1796; *d* Paris, 18 March 1849). French sculptor and painter. He was a pupil of Pierre Révoil in Lyon, then of Anne-Louis Girodet and Antoine-Jean Gros at the Ecole des Beaux Arts in Paris from 1817, initially studying painting. He showed an early interest in the sculpture of the French Renaissance, and many of his works have a linear grace that owes much to the school of Fontainebleau and the sculpture of Cellini.

Moine only exhibited sculptures at the Salon from 1831 to 1836, beginning with the intensely Romantic relief *Fall of a Horseman* (plaster; Tours, Mus. B.-A.), which recalls the fantastic paintings of Louis Boulanger. In 1833 he exhibited an important state commission, the charmingly homely bust of *Queen Marie-Amélie* (marble; Paris, Mus. Carnavalet), and in 1836 two magnificent plaster models of female personifications of *The Church* and *Faith* (Paris, Petit Pal.), intended to decorate the holywater stoops of the church of La Madeleine, Paris. However, a number of his more original works were rejected by the increasingly

Moitte

French family of artists. Its most prominent members were Pierre-Etienne Moitte, a late 18th-century engraver who worked after many contemporary artists, and his eldest son, Jean-Guillaume Moitte, a sculptor and draughtsman in the Neo-classical style. Five of Pierre-Etienne's other children became artists. François-Auguste Moitte (1748–90), Rose-Angélique Moitte and Elisabeth-Mélanie Moitte were engravers; Alexandre Moitte (1750–1828) became a painter, and Jean-Baptiste-Philibert Moitte (1754–1808) was an architect.

(1) Jean-Guillaume Moitte

(*b* Paris, 11 Nov 1746; *d* Paris, 2 May 1810). Sculptor and draughtsman, son of Pierre-Etienne Moitte. He first trained in Jean-Baptiste Pigalle's studio, and later in that of Jean-Baptiste Lemoyne. In 1768 he won the Prix de Rome for sculpture and stayed in Rome from October 1771 to May 1773, before making a slow start to his career, chiefly with

drawing. In particular, he drew for Robert-Joseph Auguste designs for silver- and goldsmith's work. In 1783 Moitte was finally accepted (*agréé*) by the Académie Royale de Peinture et de Sculpture and obtained commissions for several statues and low reliefs (1784; *in situ*) for the Hotel de Salm (now Palais de la Légion d'Honneur). Moitte was involved (1786–8) in the decoration of the *barrières* (toll-houses) in Paris, constructed by Claude-Nicolas Ledoux; however, his only royal commission was for a statue of *Jean-Dominique Cassini* (Paris, Mus. Observatoire), one of the more successful works in a series of 'great men'. The plaster was exhibited at the Salon of 1789; its pose was apparently inspired by that of Jacques-Louis David's *Brutus*, exhibited at the same Salon.

In 1792–3 he sculpted a new pediment for the Panthéon, depicting the *Motherland Bestowing Crowns on Virtue and on Genius* (destr.). In 1795 he won the competition for a monument to *Jean-Jacques Rousseau* (unexecuted; sketch model, Paris, Carnavalet). He executed a monument (1805) to *Général Louis Desaix* for the chapel of the hospice of Grand-Saint-Bernard and then the bronze relief for the column of the *Grande Armée* near Boulogne-sur-Mer. He continued to draw profusely, with a nervous, incisive line. Though still not very well known, he was one of France's most committed and talented exponents of Neo-classical sculpture.

Bibliography

Lami

G. Hubert: 'Early Neo-classical Sculpture in France and Italy', *The Age of Neo-classicism* (exh. cat., London, V&A, 1972), pp. lxxvi–lxxxii

G. Bresc-Bautier: *Sculpture française: XVIIIe siècle* (Paris, 1980), no. 56

G. Gramaccini: *Jean-Guillaume Moitte: Leben und Werk*, 2 vols (Berlin, 1993)

PHILIPPE DUREY

Monsiau [Monsiaux], Nicolas-André

(*b* Paris, 1754 or 1755; *d* Paris, 31 May 1837). French painter and illustrator. He was the pupil of Jean-François-Pierre Peyron in Paris and, thanks to a sponsor, the Marquis de Couberon, followed his master to Rome in 1776. He stayed four years and made the acquaintance of Jacques-Louis David and Pierre Henri de Valenciennes. On his return to Paris he exhibited at the Salons de la Correspondance of 1781 and 1782. Monsiau was approved (*agréé*) as an associate of the Académie Royale on 30 June 1787 for *Alexander Taming Bucephalus* (untraced) and was received (*reçu*) only on 3 October 1789, after a previous application had been refused; his *morceau de réception* was the *Death of Agis* (Paris, Petit Pal.). Affected by the hangings in 1792 and 1793 of his two protectors and by the slump in commissions brought about by the Revolution, he turned to book illustration for editions of Ovid, Jean-Jacques Rousseau, Laurence Sterne, Jacques Delille and Salomon Gessner.

Monsiau was a regular exhibitor at the Salon until 1833, and his subject-matter ranged from ancient history to historical genre. In 1804 he was awarded a Prix d'Encouragement for the *Gaul Sabinus and his Wife Eponina Discovered in an Underground Cave* (Autun, Mus. Rolin). His historical subjects include *Molière Reading 'Tartuffe' to Ninon de Lenclos* (1802; Paris, Mus. Comédie-Fr.) and *Poussin Seeing Cardinal Massimi to the Door* (exh. Paris Salon, 1806; untraced), a scene illustrating the great artist's frugality and suspicion of wealth. The *Lion of Florence* (1801; Paris, Louvre) depicts a sublime example of maternal devotion: in the 18th century a lion that had escaped from the menagerie of the Grand Duke of Florence seized a child in its mouth, whereupon the mother prostrated herself and cried out until the lion released the infant. Monsiau gave the mother a near-hysterical posture, and both critics and public greatly admired this unusual subject. In his historical genre scenes Monsiau demonstrated a high degree of novelty not usually present in his history paintings.

Monsiau was favoured with an important Napoleonic commission, the *Comitia at Lyon, 26 January 1802* (exh. Paris Salon, 1808; Versailles, Château), which documents the final session of the meeting of 452 Deputies of the Cisalpine Republic, when the constitution of the new Italian Republic was read out and Napoleon was

proclaimed president. During the Bourbon restoration a bout of ill-health gave a moralizing dimension to one of Monsiau's most successful paintings, the *Devotion of Monseigneur de Belzunce* (1819; Paris, Louvre). Suffering from renal colic, Monsiau was told he needed an operation; he had already started the picture and decided to finish it before having treatment, stating 'if this delay . . . proves to be the cause of my death, my last work will at least be a tribute to virtue' (sale cat., pp. 6–7). The subject concerns the plague in Marseille in 1720, when the bishop of the city, Monseigneur de Belzunce, administered extreme unction to the dying. Monsiau thus combined the two highly topical themes of a heroic deed and the past practices of the newly restored Roman Catholic Church. While an overall sense of didactic sentimentality prevails, the picture was nevertheless bought by Louis XVIII. Monsiau's approach here was not innovative; his style was illustrative and looked back to Jean Jouvenet and Gabriel-François Doyen. He relied on the pyramidal formula with repoussoir figures in the foreground and did not favour the frieze-like compositions of Neo-classicism. The modelling is smooth, the finish precise, and mauve-grey tones predominate. Monsiau's last years were difficult. He was ill and lost his only son at the age of 22 in 1820. He suffered increasing dementia and died in a highly agitated state.

Bibliography

'Notice sur la vie et les ouvrages de M. Monsiau', *Catalogue des tableaux, études, dessins, gravures . . . dépendant de la succession de M. Monsiau* (sale cat., Paris, 30–31 Aug 1837), pp. 3–7
French Painting, 1774–1830: The Age of Revolution (exh. cat., Paris, Grand Pal.; Detroit, Inst. A.; New York, Met.; 1974–5)
J. Foucart, ed.: *Musée du Louvre: Nouvelles acquisitions du Département des Peintures, 1983–1986* (Paris, 1987), pp. 129–31

SIMON LEE

Moreau

French family of artists. The brothers (1) Louis-Gabriel and (2) Jean-Michel Moreau were the sons of a Paris wigmaker. They both worked in the same media but achieved success in different fields, Louis-Gabriel working principally as an innovative landscape painter and Jean-Michel as a book illustrator and a recorder of contemporary manners and events. Horace Vernet was Jean-Michel's grandson, from the marriage of his daughter to Carle Vernet.

(1) Louis-Gabriel Moreau [*l'aîné*]

(*b* Paris, before 24 April 1740; *d* Paris, 12 Oct 1805). Painter, draughtsman and etcher. He trained with the painter Pierre Antoine de Machy and exhibited for the first time in 1760 at the Exposition de la Jeunesse, showing views of ruins painted in gouache and watercolour over pencil, and employing a clear, bright palette. In 1764 he was received as a member of the Académie de St Luc, where he continued to exhibit landscapes with ruins and figures in various media until the Revolution (1789–95). In 1779 he exhibited in Montpellier, and it is possible that he travelled in the south of France, although most of his landscapes show subjects in Paris and its environs. In 1787 and 1788 he failed in attempts to become a member of the Académie Royale de Peinture et de Sculpture, but he was painter to the Comte d'Artois (later Charles X) and had lodgings in the Louvre. From 1791 he was able to exhibit at the open Salon at the Louvre, continuing to do so until 1804. In the years 1793–5 he also worked as a restorer and curator at the newly established Muséum National, Paris.

Moreau's sensitive and original landscape paintings reflect the taste for the 'natural' in late 18th-century France, found also in the writings of Salomon Gessner, Jean-Jacques Rousseau and James Thomson, in such aristocratic fancies as Mme de Pompadour's dairy at Crécy or Marie-Antoinette's rustic *hameau* at Versailles, and also in the growing popularity of the informal 'English' garden. In such apparently artlessly composed works as *View of the Château de Madrid* (1774; Rouen, Mus. B.-A.), the *Demolition of the Abbey of Montmartre* (oil on paper laid down on canvas, exh. Salon 1804; Paris, Louvre) and *View of the Château of Saint-Cloud* (oil on canvas, 1804; Los Angeles, CA, Co. Mus. A.), as well as in such scenes as the *Torrent* (gouache and

watercolour; Cambridge, Fitzwilliam), Moreau combined topographic and picturesque elements with delicate colouring and an attention to the effects of light at different times of day that seem to anticipate the fresh and unemphatic works of the early 19th-century English landscape painters and the artists of Barbizon. The same qualities can also be seen in his etched compositions (examples in Paris, Bib. N.).

(2) Jean-Michel Moreau [*le jeune*]

(*b* Paris, 26 March 1741; *d* Paris, 30 Nov 1814). Draughtsman, engraver and painter, brother of (1) Louis-Gabriel Moreau. He was the pupil of the painter and engraver Louis-Joseph Le Lorrain, with whom he went to St Petersburg in 1758 on Le Lorrain's appointment as first director of the Academy of Fine Arts. Moreau was appointed a professor of drawing at the Academy. He executed a number of works in Russia, including a red-chalk portrait of the *Empress Elizabeth* (Paris, Bib. N.). In 1759 he returned to Paris and, virtually abandoning painting, entered the workshop of the engraver Jacques-Philippe Lebas, producing drawings for engravers to work from after such contemporary artists as François Boucher and Jean-Baptiste Greuze, as well as after Rembrandt and other Old Masters. During the 1760s he also provided drawings to be engraved for Caylus's *Recueil d'antiquités* and for Diderot and d'Alembert's *Encyclopédie* and collaborated as an engraver with Boucher, François Eisen, Hubert-François Gravelot and Charles Monnet (1732–1808) on the illustrations for an edition of Ovid's *Metamorphoses*. By 1770, the year in which he succeeded Charles-Nicolas Cochin (ii) as Dessinateur des Menus Plaisirs du Roi, his career was sufficiently well established for him to employ other engravers including Noël Le Mire, Nicolas and Robert De Launay and Elise Saugrain (*b* 1753) to reproduce his own designs. Popular and successful, he illustrated a large number of literary works including the *Chansons* of Laborde (1773), the collected works of Rousseau (1773–82) and the collected works of Voltaire (1782–9). In his role as draughtsman to the Menus Plaisirs, and from 1781 as Dessinateur et Graveur du Cabinet du Roi, he

recorded many court festivities in drawings of great finesse, such as the pen and wash *Illumination of the Park at Versailles on the Occasion of the Marriage of the Dauphin* (1770; Paris, Louvre), which amply demonstrates his mastery of composition, detail and handling of light. His best-known works, which provide an incomparable record of the fashionable dress and manners of the last years of the *ancien régime*, are the many illustrations that he contributed to the second and third series of the famous *Monument du costume physique et morale* (1777, 1783), published by his uncle by marriage, L.-F. Prault.

In 1785 Moreau travelled to Italy in the company of the architect Gabrielle-Pierre-Martin Dumont, and in 1789 he was received as a member of the Académie Royale on presentation of the pen-and-wash drawing *Tullia Driving her Chariot over the Body of her Father* (Paris, Louvre). He was receptive to new ideas and fared well under the French Revolution (1789–95), turning his talents to the illustration of Republican events (e.g. the pen-and-wash drawing *The Crowning of Bailly*) and a series of engraved portraits of Deputies at the Assemblée National (Paris, Bib. N.), as well as becoming a teacher at the Ecoles Centrales de la Ville in Paris, where among his many pupils was his grandson Horace Vernet. He continued to work as an illustrator, undertaking a series of 112 drawings for the New Testament (1791–8) and providing drawings for an edition of Gessner's *Idylls* (1795). In 1814 he was reappointed Dessinateur et Graveur du Roi by Louis XVIII.

In whatever medium he worked, Moreau was able to capture with great fluency and delicacy fine nuances of gesture, pose and light, a talent that made him one of the greatest book illustrators and most acute observers of fashionable life of the 18th century.

Bibliography

F. Mahérault: *L'Oeuvre gravé de Jean-Michel Moreau le jeune* (Paris, 1880)

A. Moureau: *Les Moreau* (Paris, 1893)

P. Dorbec: 'Les Premiers Peintres du paysage parisien', *Gaz. B.-A.*, n. s. 2, xl (1908), pp. 441–70

C. Normand: *Moreau le jeune* (Paris, 1909)

A. M. Hind, ed.: *Fragonard, Moreau le jeune and French Engravers, Etchers and Illustrators of the Late XVIII Century* (London, 1913)

R. Bouyer: 'Le Paysage au XVIIIe siècle: Louis-Gabriel Moreau l'aîné, 1740–1706' [sic], *A. & Artistes*, xxii (1921), pp. 89–95

Hubert Robert et Louis Moreau (exh. cat., Paris, Gal. Charpentier, 1922)

G. Wildenstein: *Louis Moreau: Un Peintre de paysage au XVIIIe siècle* (Paris, 1923)

J. Cayeux: 'Un Précurseur, Louis Moreau, 1740–1806', *Conn. A.*, xxxvii (1955), pp. 32–7

P. Prouté: *Les Eaux-fortes de Louis Moreau l'aîné, essai de catalogue* (1956)

Hubert Robert et Louis Moreau (exh. cat., ed. J. Cailleux; Paris, Gal. Cailleux, 1957)

G. Wildenstein: 'Sur les Eaux-fortes de Moreau l'aîné', *Gaz. B.-A.*, n. s. 5, lii (1958), pp. 369–78

M. Cormack: 'An Italian Sketchbook by Moreau le Jeune', *Apollo*, lxxxvii (1968), pp. 124–8

C. Constans: 'Les Moreau, peintres français', *Petit Larousse de la peinture*, ii (Paris, 1979)

CELIA ALEGRET

Mottez, Victor(-Louis)

(*b* Lille, 13 Feb 1809; *d* Bièvres, near Paris, 7 June 1897). French painter. In Lille he studied with his father Louis Mottez and with Edouard Liénard (1779–1840), the director of the art school and a former student of Jacques-Louis David. Mottez went to Paris at the end of 1828, when, according to Giard, he met the future king Louis-Philippe, then Duc d'Orléans and a student at the Collège Henri IV; their friendship is one reason for the many decorative commissions that Mottez received during the July Monarchy. In March 1829 Mottez entered the Ecole des Beaux-Arts, where he studied with Jean-Auguste-Dominique Ingres and François-Edouard Picot. He exhibited at the Paris Salon from 1833, gaining a first-class medal for history painting in 1838 and a second-class medal in 1845. He was awarded the Légion d'honneur in 1846.

Mottez travelled widely and frequently in order to educate himself in the techniques of fresco and mural painting. In Florence in 1833 he came to appreciate the work of Giotto and the Italian primitives. In 1858 he published a translation of Cennini's *Il libro dell'arte*. He also studied northern European decorative painting, travelling to Belgium in 1833 and to Germany in 1842. It is possible that he met Peter Joseph Cornelius at this time. During the Second Republic, between 1848 and 1852, Mottez lived in England, where he was exposed to Pre-Raphaelite painting.

Mottez's early works are small-scale, literary genre subjects in the Romantic style. He exhibited a scene from Walter Scott's *A Legend of Montrose* and the *Quarrel between Gurth and Cedric* from Scott's *Ivanhoe* at Douai in 1829 (both untraced). His mature style is heavily indebted to Ingres in the strong contours, the distilled essence of physiognomy and idealized approach to form, the media of fresco and mural decoration, and the selection of subjects from Classical history or mythology or from religion. Between 1839 and 1846 Mottez frescoed the porch (destr.) of St Germain-l'Auxerrois and, near the ambulatory, painted *St Martin Dividing his Cloak* (*in situ*). He also decorated the chapels of St François de Sales and the Immaculate Conception in St-Séverin, Paris (commission given 1852), the chapel of St Martin in St-Sulpice (1859–63; *in situ*) and, for Ste Catherine in Lille, the *Four Evangelists*, the *Denial of St Peter* and the *Agony in the Garden* (untraced). The majority of his surviving decorative paintings are in a bad state of preservation; however, photographs of 1854 (see Foucart, 1969) of *Dance* and *Music*, a pair of frescoes painted in 1846–7 for the apartment of Armand Bertin (destr. 1854), reveal Mottez's iconography (the Bertin family and their friends in the arts, including both Ingres and Victor Hugo as Olympian gods) and style (similar to Ingres's *Apotheosis of Homer*, Paris, Louvre, and *Golden Age*, Dampierre, Château).

Among Mottez's mature easel paintings are: the *Martyrdom of St Stephen* (exh. Salon 1838; untraced), *Ulysses and the Sirens* (1848; Nantes, Mus. B.-A.), *Melitus Accusing Socrates* (exh. Salon 1857; Lille, Mus. B.-A.), *Zeuxis Taking the Most Beautiful Maidens of Agrigento for his Models*

(exh. Salon 1859; Lyon, Mus. B.-A.) and *Phryne Before the Judges of the Areopagus* (exh. Salon 1859; Dijon, Mus. B.-A.). The Musée Wicar, Lille, has a collection of his sketchbooks.

Writings

trans.: *Le Livre de l'art ou traité de peinture* (Paris, 1858) [trans. of C. Cennini: *Il libro dell'arte* (*c.* 1390)]

Bibliography

R. Giard: *Le Peintre Victor Mottez d'après sa correspondance (1809-1897)* (Lille, 1934)

B. Foucart: 'Victor Mottez et les fresques du salon Bertin', *Bull. Soc. Hist. A. Fr.* (1969), pp. 153-73

J. Lacambre: 'Les Elèves d'Ingres et la critique du temps', *Actes du colloque Ingres: Montauban, 1969*, pp. 104, 109

B. Foucart: *Le Renouveau de la peinture religieuse en France (1800-60)* (Paris, 1987)

A. Haudiquet and others: 'Répertoire des artistes', *Les Salons retrouvés: Eclat de la vie artistique dans la France du Nord, 1815-1848*, ii (1993), p. 130

BETH S. WRIGHT

Mouchy, Louis-Philippe

(*b* Paris, 31 March 1734; *d* Paris, 10 Dec 1801). French sculptor. He owed his very successful official career to the protection of his teacher, Jean-Baptiste Pigalle, whose niece he married in 1764, after he returned from a stay in Italy. Accepted (*agréé*) by the Académie Royale in 1766, he was received (*reçu*) as a full member in 1768 on presentation of the statuette *Shepherd at Rest* (marble, exh. Salon 1769; Paris, Louvre), the physiological realism of which, inspired by Pigalle, was far removed from the classical canon to which Mouchy was indebted in later such works as the bland *Harpocrates, God of Silence* (marble, 1789; Paris, Pal. Luxembourg).

Mouchy was associated with Pigalle on a number of projects: working on the pedimental sculpture of the Hôtel des Fermes in the Place Royale, Reims (*c.* 1756); modelling reductions of several of Pigalle's works to be reproduced in biscuit porcelain, including the bronze monument to *Louis XV* (1765) in the Place Royale, Reims;

and carving the minor figures and the *Glory* surrounding Pigalle's statue of the *Virgin and Child* (marble, 1774; Paris, St Sulpice). His busts of *Voltaire* and of the *Maréchal de Saxe* (both 1778-9) (marble, Versailles, Château) were heavily influenced by Pigalle's realistic portrait style, and were once attributed to him. Mouchy was also responsible for carving a copy of Edme Bouchardon's *Cupid Carving his Bow from the Club of Hercules* for the gardens of the Petit Trianon, Versailles (marble, 1778; *in situ*). In 1787 he collaborated with Louis-Simon Boizot on a number of works for St Sulpice in Paris, chief among them being four plaster female statues personifying *Faith*, *Hope*, *Resignation* and *Humility* and the relief of the *Death of St Joseph* (*in situ*).

Among Mouchy's best-known independent works are the three life-size historical portrait statues commissioned by the Comte d'Angiviller, director of the Bâtiments du Roi, for the series of 'Illustrious Frenchmen'. The standing *Maximilien de Béthune, Duc de Sully* (marble, exh. Salon 1777; Paris, Inst. France) is perhaps the best of these. It is a sober work, stripped of the historical accessories that encumber the seated *Charles, Duc de Montausier* (marble, exh. Salon 1789; Paris, Louvre), and free of the theatrical heroics of the standing *Maréchal François-Henri de Montmorency-Bouteville, Duc de Luxembourg* (marble, exh. Salon 1791; Versailles, Château). Mouchy was also responsible for a statue of *Apollo* (marble, 1779; Paris, Louvre), commissioned in 1774 by the Abbé Terray together with a pendant statue of *Mercury* by Pigalle (Paris, Louvre), the two works symbolizing Terray's dual function as director of the Bâtiments du Roi and Minister of Finance.

During the French Revolution, Mouchy was an active member of the Commission des Monuments. His last work was a bust of the *Duc de Sully* (marble, exh. Salon 1801; Versailles, Château) executed for the Galerie des Consuls in the Tuileries Palace, Paris. He was a competent and successful artist, but his work, oscillating between the naturalistic and Neo-classical trends of French sculpture in the later 18th century, is without real individuality.

Bibliography

Lami

M.-F. Raynaud, ed.: 'Inventaire des sculptures exécutées au XVIIIe siècle pour la direction des Bâtiments du Roi', *Archv A. Fr.*, xiv (Paris, 1927), pp. 220–34

J. Thirion: 'L'Apollon de Mouchy', *Rev. Louvre*, i (1976), pp. 35–40

Diderot et l'art de Boucher à David (exh. cat., Paris, Hôtel de la Monnaie, 1984), pp. 467–9 [entry by J.-R. Gaborit]

GUILHEM SCHERF

Nanteuil [Leboeuf], Charles-François

(*b* Paris, 9 Aug 1792; *d* Paris, 1 Nov 1865). French sculptor. He studied with Pierre Cartellier at the Ecole des Beaux-Arts, assimilating a classicizing notion of 'ideal beauty' that lasted throughout his career. He won the Prix de Rome in 1817 and in Rome in 1822 carved the marble *Dying Eurydice* (Paris, Louvre), which made a notable début at the Salon of 1824 and later inspired Auguste Clésinger's erotic marble *Woman Bitten by a Snake* (1847; Paris, Mus. d'Orsay). Nanteuil was an accomplished portrait sculptor, producing many busts, including those of the painter *Prud'hon* (marble, 1828; Paris, Louvre) and of his fellow-fighter against Romanticism, the Neo-classical art critic *Quatremère de Quincy* (marble, Salon of 1850; Paris, Inst. France).

Nanteuil regularly received commissions for large-scale sculpture from the State, such as the group *Commerce and Industry* for the Senate in Paris—inspired by the antique sculpture *Castor and Pollux*—or statues for the historical museum of Louis-Philippe at Versailles, such as the seated *Montesquieu* (marble, 1840; Paris, Pal. Luxembourg; plaster, Versailles, Château). Among his commemorative monuments is an impressive statue of *General Desaix* (bronze, 1844; Clermont-Ferrand, Place de Jaude). Under the Second Empire (1851–70) his increasingly rigorous sculpture helped embellish the Gare du Nord, the Paris Opéra and the rebuilt Louvre.

Nanteuil's most important ecclesiastical commissions were for the pedimental sculpture of Notre-Dame-de-Lorette, Paris (*Homage to the Virgin*, stone, commissioned 1830), and for St Vincent de Paul (*Glorification of St Vincent de Paul*, stone, commissioned 1846). These pediments, decorated with free-standing statues and groups carved from single blocks of stone in the studio, show the influence both of early Renaissance Italian sculpture and of sculptures from Aegina and the Parthenon. Nanteuil was also involved, during the 1840s, in the decoration of the chapel at Dreux built to commemorate Ferdinand-Philippe, Duc d'Orléans, and he carved colossal stone statues of *St Louis* (1843) and *St Philip* (1844) for the principal entrance of the church of the Madeleine, Paris.

Bibliography

Lami

ISABELLE LEMAISTRE

Normand, Charles(-Pierre-Joseph)

(*b* Goyencourt, 25 Nov 1765; *d* Paris, 13 Feb 1840). French designer, engraver and architect. He trained as an architect and in 1792 won the Grand Prix de Rome and travelled to Rome. He was responsible for thousands of engraved plates between 1800 and 1815, notably those for Charles Percier and Pierre-François-Léonard Fontaine's *Recueil de décorations intérieures* (Paris, 1801), the seminal publication of the Empire style. Normand's own designs in the Neo-classical style were published in his *Décorations intérieures et extérieures* (1803), on which he collaborated with the sculptor, Pierre-Nicolas Beauvallet; its 48 plates include designs for furniture, vases and ornaments.

Writings

with P.-N. Beauvallet: *Décorations intérieures et extérieures* (Paris, 1803)

Recueil varié de plans et de façades (Paris, 1815)

Nouveau parallèle des ordres (Paris, 1819); Eng. trans. by A. Pugin (London, 1829); Ger. trans. by M. H. Jacobi and M. March, 2 vols (Potsdam, 1830–36)

with M. Normand: *Modèles d'orfèvrerie* (Paris, 1822)

Cours de dessin industriel (Paris, 1823, rev. 1841)

Le Guide de l'ornemaniste (Paris, 1826, rev. 1847)

Bibliography
Bauchal
H. Béraldi: *Les Graveurs du 19e siècle. Guide de l'amateur d'estampes modernes*, x (Paris, 1890)
S. Jervis: *Dictionary of Design and Designers* (London, 1984)

DONNA CORBIN

Orsel, (André-Jacques-)Victor

(*b* Oullins, 25 May 1795; *d* Paris, 1 Nov 1850). French painter. He was educated by the Abbé Lacombe, a rebellious priest to whom his merchant parents had given shelter during the French Revolution, and he entered the Ecole des Beaux-Arts, Lyon, in 1810. He was a pupil of Pierre Révoil, in whose collection he had already seen works by the Italian primitives. In 1818 he studied under Pierre Guérin at the Ecole des Beaux-Arts, Paris, where he formed a close friendship with Alphonse Périn (1798–1874) who became his heir and biographer. Orsel worked too slowly to complete a submission for the Prix de Rome; it was therefore at his own expense that he set off for Rome in 1822, in order to join Guérin who had just become director of the Académie de France.

During the eight years he spent in Italy Orsel made a more systematic study than any Frenchman before him of the Christian mosaics of ancient Rome, as well as of the frescoes in Florence, Assisi and especially the Camposanto, Pisa. He formed a close and lasting relationship with the Nazarenes, in particular with Friedrich Overbeck. Through these contacts he became convinced that art was fundamental to civilization, that conception was more important than its physical expression and that the painter's profession should be a quasi-priestly vocation. As a result his style changed from a late Neo-classicism strongly influenced by the example of Guérin, seen in such works as *Cain Cursed by Adam before the Body of Abel* (1824) and *Moses Rescued from the Waters* (1829; both Lyon, Mus. B.-A.), to a distinctly Nazarene manner in which enthusiasm for Perugino and the early Raphael is clearly apparent. Orsel's art became increasingly didactic, making extensive use of images and symbols presented in a calm and legi-

ble style. *Good and Evil* (Lyon, Mus. B.-A.), conceived in 1828 but exhibited in the Salon of 1833, represents the culmination of this development. Eleven paintings are presented as one, with multiple allegories, rather stiffly posed figures and clearly delineated contours. Three years after his return to France in 1830, he received two important commissions: one from the Catholic community of Lyon (*Prayer for Cholera Victims*, Lyon, Notre-Dame de Fourvière); the other from the Paris authorities (the *Chapel of the Litanies of the Virgin*, Paris, Notre-Dame de Lorette). Left unfinished at his death, the former was completed by his pupil Gabriel Tyr (1817–68), and the latter by Périn.

Deliberately sparing in its use of forms and generous with symbols and allegories, Orsel's work—contrary to what has often been said—was independent of Ingres's, whose art is more synthetic and pictorial. A kind of Nazarene transplanted to Lyon and Paris, Orsel was more intriguing than convincing, and his experiments had no noteworthy issue. It was Alphonse and Félix Périn in their monograph who established the almost mythical status that Orsel maintains in the history of French art.

Bibliography
A. Périn and F. Périn: *Oeuvres diverses de V. Orsel*, 2 vols (Paris, 1852/*R* 1877)
M. Dorra: 'Le Bien et le Mal d'Orsel: Tableau de manière symbolique au Musée des Beaux-Arts de Lyon', *Bull. Mus. & Mnmts Lyon.*, v/1 (1975), pp. 291–302
G. Chomer: 'Note sur Victor Orsel', *Bull. Mus. Ingres* (1977), pp. 21–9
B. Foucart: *Le Renouveau de la peinture religieuse en France (1800–1860)* (Paris, 1987)

GILLES CHAZAL

Ottin, Auguste-Louis-Marie

(*b* Paris, 11 Dec 1811; *d* Paris, 8 Dec 1890). French sculptor. He was the first of David d'Angers's pupils and worked during his student years as assistant to Antoine-Louis Barye. After success in the Prix de Rome competition of 1836, he spent four years in Rome where Ingres, then the Director of the Académie de France, was impressed by his *envoi* of

1842, *Hercules Presenting the Hesperidean Apples to Eurystheus* (marble; untraced). In Rome, Ottin was converted to Fourierism and later sculpted a polemical fireplace with allegorical figures on the theme of harmony and a portrait of Charles Fourier for the Palazzo Sabatier in Florence (exh. Salon 1850; *in situ*). Ottin's sculpture exemplifies the eclectic spirit of the mid-19th century. *An Indian Hunter Surprised by a Boa Constrictor* (exh. Salon 1846; bronze, 1857, Fontainebleau, Château) is an agitated and colourful piece, owing much to his early collaboration with Barye. In the ensuing years his work on public buildings was either classical or Gothic as the occasion demanded. His most ambitious work, the sculptural tableau of *Acis and Galatea Surprised by Polyphemus* (bronze and marble, 1852–63) for the Medici fountain in the Luxembourg Gardens, Paris, is a highly theatrical and baroque adaptation of a theme already attempted by James Pradier, while in the *Modern Wrestling* (bronze, 1864) in Barentin, Seine-Maritime, he modified a realist subject by giving it a classical treatment. His independent character asserted itself at an advanced age, when he took part in the first Impressionist exhibition of 1874, held in Paris in the former studio of the photographer Nadar. His son, Léon-Auguste Ottin (*fl* late 19th C.), was a painter who worked in oils, watercolour and on glass.

Bibliography

Lami

F. X. Amprimoz: 'Un Décor "fouriériste" à Florence', *Rev. A.* [Paris], xlviii (1980), pp. 57–67

A. Le Normand: *La Tradition classique et l'esprit romantique* (Rome, 1981)

La Sculpture française au XIXe siècle (exh. cat., ed. A. Pingeot; Paris, Grand Pal., 1986)

A. M. Wagner: *J. B. Carpeaux: Sculptor of the Second Empire* (London and New Haven, 1986)

N. McWilliam: *Dreams of Happiness: Social Art and the French Left, 1830–1850* (Princeton, NJ, 1993)

PHILIP WARD-JACKSON

Oudiné, Eugène(-André)

(*b* Paris, 1 Jan 1810; *d* Paris, 12 April 1889). French medallist and sculptor. He was a pupil of André Galle, Louis Petitot and Ingres, and he won the Prix de Rome in 1831. On his return from Rome he was awarded a first-class medal at the Salon of 1839 for his medal commemorating the *Amnesty*, and also in 1843 for his statuary group *Charity* (Le Puy, Mus. Crozatier). After the Revolution of 1848 Oudiné won the competition to design a new five-franc piece: his design symbolically represented the French Republic as *Ceres*. Under the Second Empire Oudiné executed an ambitious series of medals commemorating the *Inauguration of the Tomb of Napoleon I* (1853); the *Apotheosis of Napoleon* (1854) after Ingres; the *Battle of Inkerman* (1854); and the *Plebiscite of May 1870* (*c.* 1875). The latter part of his career saw him moving towards lower, less sculptural relief in his medals for the *Presidency of Adolphe Thiers* (1873) and the Exposition Universelle, Paris, of 1878. Oudiné also continued to be active as a sculptor, executing an entire series of busts, including one of *André Galle* (exh. Salon 1855; Paris, Inst. France), and statues, including a portrait of *Ingres* (Versailles, Château).

Bibliography

Forrer

J. M. Darnis: 'Eugène Oudiné', *Bull. Club Fr. Médaille*, xlix (1975), pp. 200–207

MARK JONES

Ozanne, Nicolas(-Marie)

(*b* Brest, 12 Jan 1728; *d* Paris, 3 Jan 1811). French draughtsman, engraver and marine engineer. He was a precocious draughtsman and at the age of ten was working at the Arsenal in Brest. In 1750 he was named drawing-master of the Gardes du Pavillon Amiral et de la Marine in Brest. Entrusting his appointment to his younger brother Pierre Ozanne (1737–1813), he was called in 1751 to Versailles to participate in the publication of the series of drawings and engravings entitled the *Voyage du Roi Louis XV au Havre en 1749*. He made contact with Parisian artists and the engineers and high functionaries of the Ministère de la Marine. In 1755–6 he had the chance to accompany Joseph Vernet to southern France when the latter painted his views of the *Ports of France* for Louis XV. He

received the appointment of Dessinateur de la Marine in 1756 and published the *Marine militaire ou recueil des différents vaisseaux qui servent à la guerre* (Paris, 1762), a volume of didactic engravings. He was also named maritime instructor to the princes of the royal family and in 1769 became Ingénieur Ordinaire de la Marine. He produced numerous drawings, watercolours and engravings, among them two views of Paris (*Navigation de barques et chalands sur la Seine devant les Tuileries* and *Les Chantiers du quai de la Grenouillère, lors de la construction d'un grand navire*; both pen and black ink and black wash) now in the Musée Carnavalet, Paris. He is best known for his countless maritime drawings (views of French ports, naval battles, illustrated treatises on naval construction), some published as prints, the originals of others housed for the most part at the Musée de la Marine, Paris, and the Cabinet des Dessins, Musée du Louvre, Paris.

Bibliography

C. Auffret: *Les Ozanne: Une Famille d'artistes brestois au 18e siècle* (Rennes, 1891)

J. Vichot: *Essai d'inventaire illustré de l'oeuvre des Ozanne* (Paris, 1971)

L. Duclaux and A. Pache: *Musée du Louvre, Cabinet des Dessins: Inventaire général des dessins: Ecole française*, xii (Paris, 1975), pp. 160–88, nos. 296–399

J. Vichot: *Deux albums de Nicolas Ozanne (1728–1811)* (Paris, 1977)

PIERRE CHESSEX

Papety, Dominique(-Louis-Féréol)

(*b* Marseille, 12 Aug 1815; *d* Marseille, 20 Sept 1849). French painter. Son of a soap manufacturer, he received his first artistic training in Marseille under Augustin Aubert (1781–1857). In 1835 he moved to Paris and entered the atelier of Léon Cogniet at the Ecole des Beaux-Arts. He won the Prix de Rome in 1836 with *Moses Striking the Rock* (Paris, Ecole. N. Sup. B.-A.), and from 1836 to 1841 he was consequently at the Académie de France in Rome, which was then under the directorship of Ingres. This period in Rome was Papety's most productive. He distinguished himself as a history painter of classical and religious subjects and as

an orientalist. He also produced a number of utopian scenes in antique settings influenced by the socialist theories of the French philosopher Charles Fourier (1772–1837). The most famous painting of the latter category, and also his most significant work, is the *Dream of Happiness* (Compiègne, Mus. Mun. Vivenel), which he began in Rome in 1837. It had a great success when, still unfinished, it was exhibited in Paris in 1841, though the critics were less favourable when it was shown finished at the Salon of 1843. During his stay in Rome, Papety made copies after works by Raphael, such as *Mercury* (1840; Marseille, Mus.). He also developed an ethnographic interest and produced numerous paintings on Italian subjects, under the influence of Léopold Robert. Papety made short trips to Florence, Naples, Venice and Padua, painting the various regional and social types and costumes, such as *lazzaroni* and *pifferari*. In these works he tried to show that the modern Italians had retained the thoughtful *gravitas*, nobility and attitudes of their ancient counterparts, as in *Italian Peasant* (London, Wallace), whose figure stands with a classical pose.

Papety espoused Ingres's Neo-classical and specifically *Néo-grec* style as well as subject-matter. He thus produced works that are dull in colour, taking no account of reflections, and decorative in their emphasis on inflexible linear rhythms and on formal compositional arrangement, as in *Greek Women at the Fountain* (1841; Paris, Louvre). This scene of draped Greek girls filling their pitchers with water from a public fountain also shows his interest in architectural forms and his skill in rendering them accurately, something he acquired during his early training in Marseille. Papety received a number of religious commissions to decorate churches in his native town, including Marseille Cathedral, for which he painted *St Philomena* (1841; *in situ*). This depiction of the early Christian martyr displays Papety's archaeological interests, which he combined with an attempt to 'baptize Greek art'. The dress is historically accurate, as is the saint's holding of an olive branch, and the drawing, like the almost sculptural modelling, is firm. He also produced a few historical paintings for Versailles, such as

Guillaume de Clermont Defending Ptolemy (1845; Versailles, Château).

Papety became interested in Greek and Roman archaeology, including Byzantine art, and twice travelled to Greece. His first and most important trip there was in 1846 with François Sabatier, his friend and patron. During this extensive journey, he went alone to Mt Athos to see the Byzantine monasteries. He particularly studied and copied the frescoes in the 10th-century church of the Great Lavra, painted by the Byzantine artist Manuel Panselinos (early 14th century). A great number of Papety's drawings after Panselinos were bequeathed to the Louvre by Sabatier. Papety's second trip to Greece took place in 1847 when he was commissioned by Antoine-Marie-Philippe-Louis, Duc de Montpensier, to make portraits of the Greek royal family and court. His trips to Greece also resulted in many ethnographic and architectural paintings and drawings, such as *Monk Painters of Mt Athos* (c. 1846, Munich, Gal. Lotze).

Bibliography

Bellier de La Chavignerie–Auvray

C. Blanc: *Histoire des peintres: Ecole française*, iii (Paris, 1863), app., pp. 68–9

F. Servian: *Papety* (Marseille, 1912)

F.-X. Amprimoz: 'Les Femmes à la fontaine de Papety et le style néo-grec', *Rev. Louvre*, iii (1984), pp. 196–203

B. Foucart: *Le Renouveau de la peinture religieuse en France, 1800–1860* (Paris, 1987), pp. 217–18

ATHENA S. E. LEOUSSI

Perrin, Jean-Charles-Nicaise

(*b* Paris, 12 Oct 1754; *d* Paris, 23 Sept 1831). French painter. He entered the Académie Royale in 1772 as a pupil of Gabriel-François Doyen and Louis-Jacques Durameau. He won a medal in the drawing class in 1772 but did not reach the final of the Prix de Rome until 1776, when he won a second prize for *Haman Confounded by Esther before Ahasuerus* (untraced). He continued his attempts to win the Prix de Rome until 1780 without success, but in that year he was granted the bursary because the winner Jean-Pierre Saint-Ours was Swiss and therefore ineligible to go. In Rome from 1780 until 1784, Perrin fol-lowed the usual student practice of copying from the Old Masters (he was particularly attracted to the works of Caravaggio and Guercino) and painted original works to be sent to Paris for the judgement of the Académie. In 1784 one of these *envois* was particularly well received, and Perrin was encouraged 'not to abandon his noble simplicity'.

Perrin was made an associate member of the Académie in 1786 and became a full Academician in 1787 on the strength of his *Venus Giving Asclepius Simples to Cure Aeneas* (Paris, Ecole N. Sup. B.-A.). He exhibited this at the Salon of 1787, along with the *Sacrifice of Cynappus, King of Syracuse, by his Daughter* (untraced), and remained a regular exhibitor at the Salon until 1822.

Perrin was attempting to rival his contemporaries Pierre Peyron and Jacques-Louis David in the creation of a monumental, static, sculptural style. In 1788 he produced the *Death of the Virgin* for the chapter house of the Parisian Carthusians (now Versailles, chapel of the Grand Trianon); the picture is based on Caravaggio's painting of the same subject (ex-French Royal Col., now Paris, Louvre), but Perrin's range of reference is wide, including Charles Le Brun, Nicolas Poussin, Jean-Baptiste Greuze, Eustache Lesueur and the Bolognese masters. The effect is one of austerity tinged with sentimentality. An anonymous contemporary critic wrote 'everything about this painting recalls Poussin'. In 1789 he painted the *Death of Seneca* (Dijon, Mus. B.-A.), a popular subject at the time. Perrin's subsequent production showed him capable of dealing with moral history painting, titillating ancient history, Napoleonic propaganda, religious pictures and portraiture. At the Salon of 1791 (which had no entry restrictions) he exhibited a sensitive portrait of *Madame Perrin* (Valenciennes, Mus. B.-A.), which shows that he was still influenced by Durameau.

In 1806 Perrin was given an important commission by Napoleon for the altarpiece of the Imperial Chapel at the Tuileries Palace. This dramatic allegory, *France, Supported by Religion, Dedicates the Captured Enemy Standards to Our Lady of Glory* (Paris, Val-de-Grâce), provoked divergent opinions: P. Chaussard, in the *Pausanias*

français, found it weak and mediocre and felt that the commission should have been given to David, François-André Vincent, Jean-Baptiste Regnault or one of their more able pupils; other contemporary accounts, notably in the pamphlet *Observateur au Musée Napoléon* and Ducray-Duminil's in the *Petites affiches*, describe the work as well-composed and coloured, and worthy of its important location.

In the same year Perrin succeeded Jean-Jacques Bachelier as head of the Ecole Gratuite de Dessin. Among his works of this period are some fine portraits of Napoleon's generals, the most impressive of which is the dashing full-length of *Maréchal Lannes* (Versailles, Château), commissioned by Napoleon in 1804 and shown at the 1810 Salon. In his later years Perrin continued to work steadily, although his paintings were out-of-step with contemporary developments. He was involved with two unrealized projects to commemorate the restoration of the Bourbons: *France Raised up by Time* (oil sketch, Lyon, Mus. B.-A.) and *Allegory of the Bourbon Restoration* (drawing, Nantes, Mus. Dobrée).

Bibliography

P. M. Gault de Saint-Germain: *Catalogue de tableaux, dessins, esquisses, croquis, de feu M. Perrin* (Paris, 1831)

French Painting, 1774–1830: The Age of Revolution (exh. cat., Paris, Grand Pal.; Detroit, Inst. A.; New York, Met.; 1974–5), pp. 560–61

S. Destas: *Etude monographique du peintre Jean-Charles-Nicaise Perrin, 1754–1831* (diss., U. Paris IV, 1977)

Un Peintre sous la Révolution: Jean-Charles-Nicaise Perrin (exh. cat., ed. S. Bellenger, essay by R. Michel; Montargis, Mus. Girodet; 1989)

S. Lee: 'Napoleonic Religion and Conquest: J. C. N. Perrin's Altarpiece for the Tuileries Chapel', *Gaz. B.-A.*, cxxii (1994), pp. 195–206

<div align="right">SIMON LEE</div>

Petitot, Louis(-Messidor-Lebon)

(*b* Paris, 23 June 1794; *d* Paris, 1 June 1862). French sculptor. He was a pupil of his father, the sculptor Pierre Petitot (1760–1840), and of Pierre Cartellier, one of whose daughters he married. He won the Prix de Rome in 1814 with the statue the *Mortally Wounded Achilles Attempting to Draw the Arrow from his Wound* (untraced) and completed his studies at the Académie de France in Rome. After his return to France in 1819 he received numerous commissions for decorative sculpture for the Louvre, Paris, the château of Versailles and the Paris Bourse as well as for the city of Caen.

Petitot's sculpture is generally Neo-classical in style, although sometimes classicizing composition is combined with historical realism, as in the marble relief of the *Surrender of General Ballesteros at Campillo in 1823* (1828; Paris, Louvre), intended for the Arc de Triomphe du Carrousel, Paris, but never installed. Most typical of Petitot's output are the monumental stone allegorical statues of the cities of *Lyon* and *Marseille* (1836) in the Place de la Concorde, Paris, and the stone, seated figures of *Abundance, Industry, The Seine* and the *City of Paris* (1835–46) on the Pont du Carrousel, Paris. Petitot also produced works with sentimental Romantic subjects, including the marble group *Calabrian Pilgrim and his Son Commending themselves to the Protection of the Virgin* (1847; Paris, Jardin du Luxembourg).

Petitot was a talented portrait sculptor, producing, among other works, marble busts of *Pierre Cartellier* and *Emeric David* (1836 and 1841; both Paris, Inst. France). His colossal bronze equestrian statue of *Louis XIV* (1836) in a plumed helmet in the Cour d'honneur at the château of Versailles utilizes a horse modelled by Cartellier. The imposing marble funerary monument to *Louis Bonaparte, King of Holland*, commissioned by Napoleon III for the church at Saint-Leu-La-Fôret, Val d'Oise, occupied Petitot's last years (1852–60). It consists of a sarcophagus, on which is a statue of the deceased in royal robes. To either side are standing statues of *Charity* and *Mercy*. From 1845 Petitot taught at the Ecole des Beaux-Arts, Paris, and in 1860 he became an officer of the Légion d'honneur.

Bibliography

Lami

G. Hubert: 'Autour de la soupe à l'oignon: Le Sculpteur Louis Petitot et la Société Cipollésienne, lettres et dessins', *Archvs A. Fr.*, n. s., xxv (1978), pp. 263–89

La Sculpture française au XIX siècle (exh. cat., ed.
A. Pingeot; Paris, Grand Pal., 1986)

GÉRARD HUBERT

Peyron, (Jean-François-)Pierre

(*b* Aix-en-Provence, 15 Dec 1744; *d* Paris, 20 Jan 1814). French painter and draughtsman. He was the son of a provincial administrator and at the wish of his family studied law until the death of his father in 1765, when as a protégé of Michel-François Dandré-Bardon he enrolled in the Ecole de Dessin at Aix-en-Provence. In 1767 he moved to Paris as a pupil of Louis Lagrenée and also enrolled in the school of the Académie Royale de Peinture. In 1773 he won the Prix de Rome in competition with Jacques-Louis David. Peyron's version of the prize subject, the *Death of Seneca* (untraced), is known through an engraving by the artist. In 1774, working to designs by Charles-Louis Clérisseau, he decorated the salon of the Hôtel Grimod de la Reynière, Paris, with the first examples of Neo-classical grotesque decoration in 18th-century France.

In 1775 Peyron left for Rome as a *pensionnaire* of the Académie de France of which Joseph-Marie Vien had just been appointed director. David, who had won the Prix de Rome competition in 1774, also left for Rome in that year. Peyron stayed for seven years (instead of the usual four) and painted a number of important works, including *Athenian Girls and Athenian Youths Drawing Lots to be Sacrificed to the Minotaur* (large version commissioned 1787 for Versailles but never executed; sketch, oil on paper, 1778; London, Apsley House); *Belisarius Receiving Alms from a Soldier who Had Served under him* (1779) and *Cornelia, Mother of the Gracchi* (1781), both of which were painted for Cardinal Bernis (both Toulouse, Mus. Augustins); and the *Funeral of Miltiades* (1782; Paris, Louvre) and *Socrates and Alcibiades* (1782; untraced, recorded in a print by the artist), both of which were painted for the Comte d'Angiviller, Directeur des Bâtiments du Roi. These early pictures already demonstrate the characteristics of Peyron's style. They are composed with great clarity and elegance in the form of a frieze, the expressions and gestures of the protagonists are sober and without exaggeration, a delicate and enamel-like paint surface is combined with great refinement of colour and Peyron's idiosyncratic handling of draperies is in evidence. A similar assurance is evident in preparatory pen-and-ink drawings such as *Belisarius* (1778; Paris, Louvre) and *Hagar and the Angel* (1779; Darmstadt, Hess. Landesmus.), a study for a painting of the same subject (Tours, Mus. B.-A.). Peyron's return to the austere art of Poussin, the artist whom he most admired, led his contemporaries, including Vien and d'Angiviller, to see in Peyron one of the hopes of the French school in its turn away from the Rococo style towards a new Neo-classical seriousness, and to value him above his rival David.

Peyron left Rome for Paris in October 1782 on the orders of d'Angiviller, who was alarmed by the increasing success of David. He was approved (*agréé*) by the Académie Royale in September 1783 with *Marius at Miturnae* (untraced; preparatory drawing, Madrid, Bib. N.). At the Salon of 1785 his *Death of Alcestis* (Paris, Louvre) was eclipsed by the success of David's *Oath of the Horatii* (Paris, Louvre). At the end of that year, still conspicuously supported by d'Angiviller, Peyron was appointed Inspecteur Général of the Gobelins factory. In June 1787 he was received (*reçu*) as a full member of the Académie with *Curius Dentatus Refusing the Gifts of the Samnite Ambassadors* (Avignon, Mus. Calvet). He exhibited this work at the Salon of the same year together with a sketch for the *Death of Socrates* (Copenhagen, Stat. Mus. Kst) commissioned by Louis XVI. David had deliberately chosen to treat the same subject (New York, Met.). The two works were hung side by side, David emerging as the clear victor in the eyes of their contemporaries.

Following this public check to his career Peyron reduced his output dramatically. At the Salon of 1789 he exhibited the large version of the *Death of Socrates* (Paris, Pal.-Bourbon). His post at the Gobelins was abolished in 1792, during the Revolution, and he was given lodgings at the Louvre. Delicate health and his slow methods of work meant he produced little in this period. He repeated earlier compositions on a relatively small scale and made drawings to be engraved as illustrations for books, including Baron de

Montesquieu's *Le Temple de Gnide* (Aix-en-Provence, Mus. Arbaud), Racine's *Mithridate* (pubd 1801; originals untraced) and the works of Sieur de Crébillon (Paris, Petit Pal.). Peyron's works won prizes in the competitions of 1793 and 1798. Under the First Empire (1804–14) he was awarded several official commissions, including the *Death of General Valhubert* (1808; Versailles, Château), and he continued to exhibit at the Salon but remained on the fringes of artistic life.

Peyron chose the subjects of his history paintings with great care, believing in the exemplary nature of painting in the service of ideas and emotions. Although he was unable to sustain his precocious inventiveness, he helped to establish the direction that French history painting followed for nearly 50 years. He died forgotten by the public, but David acknowledged his formative role and declared, 'Peyron opened my eyes'.

Bibliography

P.-M. Gault de Saint-Germain: Obituary, *Moniteur Univl* (6 Feb 1814), p. 148

P. Rosenberg and U. van de Sandt: *Pierre Peyron, 1744–1814* (Neuilly-sur-Seine, 1983)

UDOLPHO VAN DE SANDT

Philipon, Charles

(*b* Lyon, Sept 1802; *d* Paris, 25 Jan 1862). French draughtsman, lithographer, journalist and publisher. In 1820 he went to the Ecole des Beaux-Arts in Paris where he studied under Antoine-Jean Gros. However, he was soon recalled to Lyon by his father, who wished him to work in the family business; it was not until 1823 that he was allowed to return to Paris, where he established himself permanently.

From 1827 to 1830 Philipon produced rather mediocre satirical lithographs, which were published in Paris. After the July Revolution of 1830 he began to work as a journalist and editor, and at this juncture he found his true vocation. He founded the weekly journal *La Caricature*, which was devoted entirely to politics; among its many contributors were Honoré Daumier and the caricaturists Joseph Traviès and J. J. Grandville. It

lasted from 1830 to 1835, when it closed after a flood of legal actions.

In 1832 Charles Philipon founded *Le Charivari*, a humorous journal, which prompted the establishment of *Punch, or the London Charivari* in England. Philipon ran *Le Charivari* for six years; the contributors included Daumier and Paul Gavarni. Among the many other journals he started were *Les Robert-Macaire* (founded in collaboration with Daumier, 1839); *Le Musée pour rire* (with Maurice Alboy and Louis Huart, 1839); *Le Journal pour rire* (1849); *Le Musée Anglo-Français* (with Gustave Doré, 1854) and *Le Journal amusant* (1857). In addition, Philipon was in charge of the illustrations for *Galerie de la presse, de la littérature et des beaux-arts*. Through the publishing house of Aubert, which he had founded with his father-in-law, Philipon published various works of political satire such as *Ici on fait le barre et la queue proprement: La Physiologie du flâneur* (Paris, 1842) and, with Huart, *Parodie du juif errant* (Paris, 1844). He was one of the most energetic satirists of his time and inspired the best caricaturists of the day to attack the Louis-Philippe government (1830–48). He was a frequent object of legal suits and often imprisoned.

Bibliography

Michaud

L. Delteil: *Manuel de l'amateur d'estampes du XIXe et du XXe siècle* (Paris, 1925), i, pp. 164–9

E. de T. Bechtel: *Freedom of the Press: L'Association mensuelle: Philipon vs. Louis-Philippe* (New York, 1952)

J.Wechsler: *A Human Comedy: Physiognomy and Caricature in 19th-century Paris* (London, 1982)

J. Cuno: 'Charles Philipon, La Maison Aubert, and the Business of Caricature in Paris, 1829–41', *A.J.* [New York], xliii (1983), pp. 347–54

The Charged Image: French Lithographic Caricature, 1816–1848 (exh. cat. by B. Farwell, Santa Barbara, CA, Mus. A., 1989), pp. 119–26

☐

Picot, François-Edouard

(*b* Paris, 17 Oct 1786; *d* Paris, 15 March 1868). French painter and lithographer. He was a pupil of François-André Vincent and of Jacques-Louis

David. He received the Second Grand Prix de Rome in 1811 and then continued his studies in Rome. On his return from Italy he received the commission to paint the *Death of Sapphira* (1819) for the church of St Séverin in Paris (*in situ*) and at the Salon of 1819 he exhibited *Love and Psyche* (1817; Paris, Louvre), which was admired for its graceful and naive figures and was bought by the Duc d'Orléans (later Louis-Philippe, King of France). At the Salon of 1827 Picot exhibited the *Annunciation* (La Rochelle Cathedral), a richly painted work that shows the influence of Raphael. Working within the Neo-classical style, he specialized in history and genre subjects and portraits and continued to show at the Salon until 1839.

Picot received numerous commissions to decorate public buildings, including two ceiling decorations for the Louvre: *Study and Genius Unveiling Ancient Egypt to Greece* (1827) and *Cybele Protecting the Towns of Stabiae, Herculaneum, Pompeii and Resina against Vesuvius* (1832). The works were criticized by such figures as Horace Vernet and Jules Claretie (1840–1913) for being colourless, grey and cold. In the 1830s Picot was commissioned by Louis-Philippe to contribute works to the collection of paintings illustrating French history for the new museum at the château of Versailles, for which he produced, among others, *Maréchal de Boucicaut II* (1835) and the *Taking of Calais by the Duc de Guise* (1838). For the building itself he painted the ceiling decoration *Truth Accompanied by Justice and Wisdom Protecting France against Hypocrisy, Fanaticism and Discord*. Picot was also commissioned to provide decorations for numerous churches in Paris, such as those for a chapel in St Denis du Saint Sacrément, the central chapel of Ste Clotilde as well as the hemicycle depicting the *Crowning of the Virgin* (1836) for Notre-Dame-de-Lorette. At St Vincent-de-Paul he collaborated with Hippolyte Flandrin and was responsible for the decoration (1842–53) of the choir. His central work for this decorative scheme is *Jesus, Accompanied by the Prophets, Receives St Vincent de Paul* (1843; *in situ*), which shows the influence of Byzantine art.

While the medium was still in its infancy, Picot became interested in lithography and produced such works as *Bélisaire*, a lithograph for *Le Miroir* after the last composition of Léon Pallière (1787–1820), and the *Two Lovers* (1820). In addition to winning numerous awards at the Salon, in 1836 he was elected a member of the Académie des Beaux-Arts. He taught many major academic artists of the succeeding generation, including William Bouguereau, Jean-Jacques Henner and Alexandre Cabanel.

Bibliography

Bénézit; Hoefer; Thieme–Becker

J. Claretie: *Peintres et sculpteurs contemporains* (Paris, 1873, 2/1874)

B. Foucart: *Le Renouveau de la peinture religieuse en France, 1800–1860* (Paris, 1987), pp. 187–9, figs 49–55

ATHENA S. E. LEOUSSI

Pradier, James [Jean-Jacques]

(*b* Geneva, 23 May 1790; *d* Bougival, 4 June 1852). Swiss sculptor, painter and composer. Prompted by his early displays of artistic talent, Pradier's parents placed him in the workshop of a jeweller, where he learnt engraving on metal. He attended drawing classes in Geneva, before leaving for Paris in 1807. By 1811 he was registered at the Ecole des Beaux-Arts and subsequently entered its sculpture competitions as a pupil of François-Frédéric, Baron Lemot. A more significant contribution to his artistic formation around this time was the guidance of the painter François Gérard. Pradier won the Prix de Rome in 1813 and was resident at the French Academy in Rome, from 1814 until 1819. On his return to France, he showed at the Salon of 1819 a group *Centaur and Bacchante* (untraced) and a reclining *Bacchante* (marble; Rouen, Mus. B.-A.). The latter, borrowing an erotically significant torsion from the Antique Callipygean Venus, opens the series of sensuous Classical female subjects that were to become Pradier's forte. In *Psyche* (marble, 1824; Paris, Louvre) new ingredients were added to Pradier's references to the Antique. The critic and theorist Toussaint-Bernard Emeric-David detected in it 'a sort of Florentine grace' and a reminiscence of the 16th-century sculptor Jean

Goujon. The sophisticated posture and coiffure, and the contrast between flesh and elaborately involved and pleated drapery, are features that recur in most of Pradier's female subjects.

The government of the restored Bourbons (1815–30) conferred on Pradier a number of prestigious commissions, notably a marble monument to *Jean, Duc de Berry*, for the Cathedral of Versailles (1821–3), and a marble relief for the Arc de Triomphe du Carrousel (1828–31), Paris. As early as 1827 he was made a member of the Institut and Professor at the Ecole des Beaux-Arts. This recognition did not secure him automatic preference in official commissions. His project for the pediment of the Madeleine (1828–9), for example, was turned down in favour of one by Henri Lemaire. At all stages Pradier was strenuous in his pursuit of state commissions. After 1834 his efforts in this direction were to be powerfully abetted by the journalism of Victor Hugo. Notoriously apolitical, Pradier found no difficulty in adapting himself to whatever regime happened to be in power, an adaptability which, by the 1848 Revolution, began to look cynical.

Approval of Pradier's art by the July Monarchy (1830–48) was shown after the Salon of 1831, when Louis-Philippe purchased his *Three Graces* (marble; Paris, Louvre). This group invited comparison with works on the same theme by Canova and Bertel Thorvaldsen and was an unmistakable gesture of loyalty to the tenets of Neo-classicism at the start of the decade that witnessed the emergence of a Romantic style in sculpture. But Pradier, who has been seen as the 'Ingres of sculpture', was no doctrinaire. An area in which he showed particular sympathy with the aspirations of his more overtly Romantic contemporaries was the production of models for statuettes and for figures adaptable for ornamental use. The firms chiefly involved in diffusing his output in this line were the *maison d'éditions* Susse Frères and the founder Salvator Marchi. In his group *Satyr and Bacchante* (marble; Paris, Louvre), shown at the Salon of 1834, Pradier revived in monumental form the explicitly sexual subject-matter of the 18th century. Such erotic motifs frequently occur among Pradier's statuettes. Sometimes their subjects are

mythological, as in the undulating *Leda and the Swan* (plaster; Geneva, Mus. A. & Hist.). In other works Pradier introduced a more novel type of voyeuristic genre, as in *Woman with a Cat* (plaster, c. 1840; Geneva, Mus. A. & Hist.) or *Woman Putting on a Stocking* (bronze, 1840; Paris, Mus. A. Déc.). The series of Pradier's life-size female statues culminates in the *Nyssia* (marble, 1848; Montpellier, Mus. Fabre) and in the seated *Sappho* (marble; Paris, Mus. d'Orsay; see col. pl. XXVII) exhibited at the Salon of 1852, the first illustrating a modern text, Théophile Gautier's *Roi Candaule*, the second bringing a note of 'modern' melancholy to the treatment of a subject already popularized by Pradier's Neo-classical forebears, the painters Antoine-Jean Gros and Anne-Louis Girodet.

Pradier played a major role in many of the ambitious decorative schemes of the July Monarchy, in particular at the Madeleine and the Palais Bourbon. For the tomb of *Napoleon I* at the Invalides he contributed the 12 severe Victories surrounding the sarcophagus (1843–52). For Louis-Philippe's historical galleries at Versailles he executed a number of statues and busts. However, his initially cordial relations with the Orléans family were soured by accusations of commercialism aimed at him by the painter Ary Scheffer. They may also have been adversely affected by Pradier's reputation as a philanderer, a myth that his correspondence, published in 1984, goes far to dispel. However, in the annals of Romanticism, Pradier the dandy and party-giver has tended to eclipse Pradier the artist.

Despite aspersions cast by critics on the correctness of Pradier's treatment of myth, he remained the leading classical sculptor of his day and exerted a strong influence in the 1840s and 1850s, when a reaction to the turbulent styles of Romanticism prevailed. The combination of the archaeological and the hedonistic characterizing the classical sculpture of the Second Empire (1851–1870) took its main direction from him.

Throughout his life, Pradier remained in close contact with his birthplace. In 1830 he obtained a commission from the town for a bronze statue of *Jean-Jacques Rousseau* (Geneva, Ile Rousseau), a task previously offered to Canova. Pradier's monument was unveiled in 1835. The Musée d'Art et

d'Histoire houses an extensive collection of works by Pradier, most of which were acquired after his death. These include oil sketches that indicate an ambition to paint grand mythological subjects, but, of the paintings that Pradier showed at the Salon, only a fragment of a *Descent from the Cross* (exh. 1838; Geneva, Mus. A. & Hist.) survives. A more intimate and colouristic aspect of Pradier's painting may be glimpsed in the *Virgin and Child* (1836; Besançon, Mus. B.-A. & Archéol.), supposed to be a portrait of his wife and baby son.

Writings

D. Siler, ed.: *James Pradier: Correspondance*, 2 vols (Geneva, 1984)

Bibliography

Lami
A. Etex: *James Pradier: Etude sur sa vie et ses ouvrages* (Paris, 1859)
Romantics to Rodin (exh. cat., ed. P. Fusco and H. Janson; Los Angeles, Co. Mus. A., 1980)
Statues de chair: Sculptures de James Pradier (exh. cat., ed. J. de Caso; Geneva, Mus. A. & Hist.; Paris, Luxembourg Pal.; 1985–6)
La Sculpture française au XIXe siècle (exh. cat., ed. A. Pingeot; Paris, Grand Pal., 1986)

PHILIP WARD-JACKSON

Préault, Auguste [Antoine-Augustin]

(*b* Paris, 9 Oct 1809; *d* Paris, 11 Jan 1879). French sculptor. He was born in the working-class Marais district of Paris and was apprenticed to an ornamental carver. He later trained in the studio of Pierre-Jean David d'Angers. His first serious sculptural essays were mostly portrait medallions in the manner of David d'Angers. There is also record of an early relief entitled *Two Slaves Cutting the Throat of a Young Roman Actor*, said to have belonged to Daumier. By the time of his Salon début in 1833, Préault was immersed in the socially conscious subject-matter favoured by the liberal Romantics among whom he moved. His 1833 exhibits were *Two Poor Women*, *Beggary* and *Gilbert Dying in the Hospital* (all destr.). In 1834 his *Pariahs* (also destr.) was refused, presumably because of its pointed social comment,

unacceptable in the bourgeois atmosphere of the July monarchy (1830–48). However, his tumultuous plaster relief *Slaughter* (bronze version, 1854; Chartres, Mus. B.A.) with its emphasis on extreme physical and emotional states was accepted. All these works were broadly and rapidly executed, with bold forms and daring compositions and subjects. Stylistically, they derived less from Préault's teachers and contemporaries than from Michelangelo and his French followers of the 16th and 17th centuries, Germain Pilon, Jean Goujon and Pierre Puget.

The uncompromising nature of Préault's subject-matter and expression caused him to be excluded by the increasingly conservative Salon juries until 1849 (except in 1837, when his *Head of an Old Man*, made several years earlier, was shown). During this time he tried to make his sculpture more widely acceptable by ameliorating his style, as in *Ondine* (1834; Parc de la Bouzaise, Beaune); by choosing more conventional subjects, such as the *Adoration of the Magi* (1838; destr.); and by giving old works new and less controversial titles: *Despair* (1834; destr.), for example, became *Hecuba*. For a while he was kept from starvation only by minor private commissions, but he began to be patronized by the government in 1838, when he received commissions for a stone statue of St Martha now in the Hôpital Pozzi, Bergerac, and a *Crucifixion* (wood; Paris, St Gervais-St Protais). He turned increasingly to literary and fantastic Romanticism in such works as *Ophelia* (plaster, 1842; bronze, 1876; Paris, Mus. d'Orsay) the stone relief of *Silence* (1842) for the Robles tomb in Père Lachaise cemetery, Paris (bronze, 1848; Auxerre, Mus. A. & Hist.) and *Dante and Virgil in Hell* (wax sketch, *c*. 1853; Chartres, Mus. B.-A.).

In the more liberal atmosphere after the revolution of 1848 Préault was again able to exhibit at the Salon. In 1849 he was awarded a second-class medal that exempted him from future judgement by the jury. Although he exhibited in 1850–51 and 1853, he abstained from the Salon for the decade up to 1863, perhaps as a form of revenge. During this period he received a series of commissions, both public and private. The most notable of the latter were tomb decorations in the Paris

cemeteries. Although Préault continued to create portrait medallions and small-scale works, he was also commissioned to produce a number of public monuments. These included *Marceau* (1850) in the Place des Epars, Chartres, the *Gallic Horseman* (1849) on the Pont d'Iéna, Paris, and *Jacques Coeur* (1873) in the Place Jacques Coeur, Bourges.

Préault's fidelity to the Romantic ideals of 1830 increasingly made him an anachronism, and he became better known for his colourful personality, his vivacious presence at theatres and cafés, and his mordant wit than for his work. Nevertheless, his best pieces never failed to exemplify the vigorous style that made him the epitome of the Romantic sculptor and a remarkable precursor of Rodin. It was David d'Angers's opinion that 'if the jury had not always rejected him, France would assuredly have had a new Puget'.

Bibliography

Lami

T. Silvestre: 'Préault', *Histoire des artistes vivants français et étrangers* (Paris, 1856), pp. 281–303

E. Chesneau: 'Auguste Préault', *L'Art*, xvii/2 (1879), pp. 3–15

J. Locquin: 'Un Grand Statuaire romantique, Auguste Préault, 1809–1879', *Ren. A. Fr. & Indust. Luxe*, iii/11 (1920), pp. 454–63

D. Mower: 'Antoine Augustin Préault (1809–1879)', *A. Bull.*, lxiii/2 (1981), pp. 288–307

H. W. Janson: *Nineteenth Century Sculpture* (New York, 1985)

La Sculpture française au XIXe siècle (exh. cat., Paris, Grand Pal., 1986), nos 191, 196, 197, 202, 205, 208

C. Millard: 'Préault's Commissions for the New Louvre: Patronage and Politics in the Second Empire', *Burl. Mag.*, cxxxi/1038 (1989), pp. 623–30

——:'Two Monuments by Auguste Préault: General Marceau and Jacques Coeur', *Gaz. B.-A.*, n. s. 5, cxviii (1991), pp. 87–101

CHARLES MILLARD

Prud'hon, Pierre-Paul [Prudon, Pierre]

(*b* Cluny, Saône-et-Loire, 4 April 1758; *d* Paris, 16 Feb 1823). French painter and draughtsman. Prud'hon is best known for his allegorical paintings and portraits, most of which were done during the turbulent years of the Revolution (1789–99) and the heroic years of the First Empire (1804–15). It is paradoxical that, while actively supporting the rigorous social reforms of the Jacobins and seeking approval in Napoleonic circles, Prud'hon should have produced work that generally shows great charm and sentimental appeal; these qualities distinguish his oeuvre from the more austere Neo-classicism of David and his school and place him historically in close relation to an earlier 18th-century European tradition of *sensibilité* and to the Anacreontic manner that was fashionable with a number of artists working in Italy when he was there. His letters from Rome contain statements of admiration for the noble and graceful forms of ancient statuary and for the work of Raphael; but these are balanced by an equal admiration for the handling of expression by Leonardo da Vinci and Anton Raphael Mengs. Later, in Paris, while he analysed physiognomy and gesture in the work of Poussin, he also studied the subtle chiaroscuro in Correggio's work and the tenebrist practice of Caravaggio and applied these to his mythological and religious works. Prud'hon's style is thus characterized by a softer, more lyrical form of Neo-classicism and occasionally by a dark and disquieting Romanticism. His independence from his Parisian contemporaries can be attributed partly to his idiosyncratic choice of models for study and partly to influences from patrons and teachers during his formative years.

1. Life and work

(i) Early years, before 1784. Born Pierre Prudon, he adopted in 1777 a second name, Paul, chosen in honour of Rubens. Much of his childhood was spent in the company of monks in Cluny until the Bishop of Mâcon recommended him to François Devosges, director of the recently established Dijon School of Art. Outside Paris this was one of the most important art schools in France in the 18th century and equipped students with a wide range of skills. From 1777 to 1780 Prud'hon worked for Herménégilde Joseph Alexandre Gagnaire, Baron de Joursanvault (1748–92), an important local patron and benefactor of young artists. This erudite amateur was a high-ranking freemason and a

great admirer of the ideas of Jean-Jacques Rousseau, and Prud'hon's early portrait of the Baron (Beaune, Mus. Marey) shows him in a temple with various allusions to his positions as patron and freemason. Rousseau's ideas on virtue, nature, freedom and equality had a profound effect on Prud'hon's art and on his outlook on life. On 17 February 1778 he married Jeanne Pennet (1758–1834); Jean, the first of their six children, was born nine days later. In October 1780 Prud'hon went to Paris, where he visited Jean-Baptiste Greuze and Jean-Georges Wille and where he studied at the Académie Royale. After his return to Dijon in 1783, he competed for and won the Prix de Rome of 1784.

(ii) Rome and Paris, 1784–96. During his stay in Rome (Dec 1784–April 1788) Prud'hon filled sketchbooks with studies from the Antique, to which he still referred long after his return to France. His drawings became more incisive, his forms grew rounder and more sculptural and his figures developed a sensual grace and elegance, the hallmarks of his style, as Delacroix noted in 1846. Of his contemporaries in Rome, Anton Raphael Mengs, Antonio Canova and Angelica Kauffman attracted Prud'hon more than did his fellow countrymen. Indeed he was highly critical of the way David's pupils slavishly imitated their master's masculine style and heroic subjects. His major task in Rome, in fulfilling his obligation to the States of Burgundy which sponsored his trip, was to copy Pietro da Cortona's ceiling in the Palazzo Barberini. This was suitably modified to represent the *Glorification of the Dukes of Burgundy* (Dijon, Mus. B.-A.). His correspondence with Devosges indicates that he would have preferred to copy a work by Raphael or Leonardo, whom he called 'my master and my hero'. He was back in Paris in 1788 and exhibited for the first time in the Salon of 1791 with a drawing known as *Liberty Looking to Wisdom for Support* (Cambridge, MA, Fogg). Executed in pencil and black and white chalk, it refers directly to his studies from the Antique and to the soft manner of Leonardo.

Prud'hon's other main area of activity at this time was portraiture. He painted *Cadet-Gassicourt*

(Paris, Mus. Jacquemart-André) in 1791 and a *Young Woman* (Saint-Omer, Mus. Hôtel Sandelin) in 1792. The sitters are depicted out of doors in relaxed, languorous poses, the arrangement he favoured for many of his portraits and which may well owe something to the English portrait tradition. His first oil painting exhibited at the Salon was the *Union of Love and Friendship* (1793; Minneapolis, MN, Inst. A.). His characteristic method of working, which can be seen in the preparatory works for this picture, was to make an initial study of his subject in black and white chalks on tinted paper. Once he started painting he would normally work in grisaille first, then apply the colour and numerous glazes. The subjects of friendship, freedom, wisdom, love and so on were much debated in the political circles to which Prud'hon affiliated himself at this time. His interpretation of them, however, has nothing of the hard-hitting idealism associated with Robespierre and his ruthless colleagues. Prud'hon's soft, painterly emphasis in his portrait of *Saint-Just* (1793; Lyon, Mus. B.-A.) gives him the unlikely appearance of a sensitive, gentle-natured young man.

Prud'hon went to meetings of the Club des Arts, founded by David, and produced several drawings of Revolutionary iconography to be engraved by Jacques-Louis Copia (1764–99) and used as letter-headings for official notepaper or for political tracts. Prud'hon's enthusiasm for Robespierre forced him into exile after the latter's execution in 1794. He went to Rigny, near Gray in Franche-Comté, where he stayed until 1796. There he painted some of his most beautiful portraits, for instance those of the couple that sheltered him and his family, *Georges Anthony* (Dijon, Mus. B.-A.) and *Mme Anthony and her Children* (Lyon, Mus. B.-A.). They show a degree of naturalism found also in David's portraits at this time, but the appealing charm, wistful expressions and loose brushwork are peculiar to Prud'hon. While in exile he also drew book illustrations for the editor Pierre Didot. He produced four drawings for the complete edition of Pierre-Joseph Bernard's poetry (1796 edn), three illustrating *L'Art d'aimer* and the other, with a highly erotic charge, for *Phrosine et Mélidor* (Washington, DC, Lib. Cong.); also for

Didot, he provided the frontispiece for Racine's complete works (1800–01 edn; Paris, Marcille priv. col.) as well as a number of exquisite illustrations for the four volumes (1804) of Rousseau's *La Nouvelle Héloïse* (dispersed; one in Paris, Louvre) and Longus's *Daphnis and Chloe* (Orleans, Mus. B.-A.; Chantilly, Mus. Condé). These adopt an earlier 18th-century *petite manière* of Jean-Michel Moreau quite opposed to the style used by François Gérard and Anne-Louis Girodet. In May 1796 Prud'hon was elected an associate member of the Institut and was back in Paris by November.

(iii) The Directoire and Consulate periods, 1796–c. 1805.

Prud'hon spent the next few years on large decorative projects, such as the rooms in the Hôtel St-Julien (destr.; panels Paris, Louvre; priv. col.) for the wealthy army contractor, M. de Lannoy. The main salon decoration alluded to the relation between wealth and the arts and was of an extremely complex iconographical nature, allowing Prud'hon's imagination free rein. The panels were highly successful and established his reputation as a decorative artist of the first order. A drawing of *Wisdom and Truth Descending to Earth* was also highly praised by critics, and Prud'hon was given a room in the Louvre to work it up into a large-scale painting (Paris, Louvre), which was shown in the Salon of 1799. He painted two ceilings for the Louvre, *Study Guiding the Flight of Genius* (1801; Paris, Louvre, Salle des Antonins) and *Diana Begging Jupiter not to Force her into Marriage* (1803; Paris, Louvre, Salle de Diane). As was the case for all artists lodged in the Louvre, Prud'hon had to move out in 1802 to a studio in the Sorbonne, where he remained for 20 years. He continued to produce portraits under the Consulate and sent a large group portrait of *R. J. Schimmelpenninck and his Family* (Amsterdam, Rijksmus.) to the Salon of 1802. At this point his wife, now mentally unstable, was taken into a nursing home, leaving to Prud'hon the custody of five children. CONSTANCE MAYER became his pupil, friend, mother to his children and mistress. She collaborated with him on many works, Prud'hon usually executing the preparatory drawings and sketches for her paintings.

(iv) The First Empire, c. 1805–15.

Prud'hon's reputation as a history painter and as a portrait painter of members of the imperial household became firmly established under the First Empire. In 1805 he painted *Josephine at Malmaison* (Paris, Louvre; see fig. 64). As in earlier portraits, the solitary figure is given a wooded setting and is romantically portrayed in melancholy reverie. He painted a full-length portrait of *Talleyrand* (Paris, Mus. Carnavalet) in 1807 and in 1812 a half-length portrait of *Baron Vivant Denon* (Paris, Louvre). In the same year he painted the large canvas showing the *Meeting of Napoleon and Francis II of Austria* (Versailles, Château). He acquired the patronage of the rich Milanese art collector Conte Giovanni Battista Sommariva and painted his portrait (Milan, Brera) in 1814. The painting depicts Sommariva seated in the grounds of his property on Lake Como in front of two statues by Canova. Indeed, the works of Canova and Prud'hon dominated Sommariva's collection. From Prud'hon he

64. Pierre-Paul Prud'hon: *Josephine at Malmaison*, 1805 (Paris, Musée du Louvre)

bought *Psyche Transported by Zephyrs* (1808; Paris, Louvre), a sketch for the Salon exhibit of 1812, *Venus and Adonis* (London, Wallace), and *Young Zephyr Swinging from a Tree* (1814; Paris, Louvre). The treatment of facial expression in these works is reminiscent of Leonardo's work: the movement of the figures is extremely graceful and the works are divided between areas of warm colouring and of soft, delicate shading. These traits have led critics to refer to Prud'hon as the French Correggio.

At the age of 50 Prud'hon was awarded the Légion d'honneur and recognized as a history painter on the basis of his Salon entry of 1808, *Justice and Divine Vengeance Pursuing Crime* (Paris, Louvre; see col. pl. XXVIII), for which he had done numerous drawings that are among his most expressive and dramatic works. The painting was commissioned by Nicolas-Thérèse Benoît Frochot, a friend from Rigny who had been appointed Prefect of the Seine district in 1800. Its title refers to lines from an Ode by Horace (III.ii.31–2) about the relentless pursuit of vengeance, and the work was intended to impress this idea on those present in the criminal courtroom of the Palais de Justice. The final painting shows the dead victim in the foreground bathed in moonlight; the allegorical figure of Crime (based on an antique bust of the Roman emperor Caracalla) escapes with the stolen money; he is immediately pursued by Justice and Vengeance flying overhead. The violence of the subject and the exploration of the effects of moonlight place this work in the same category as the Romantic works of Girodet. This and many other works by Prud'hon have suffered as a result of his use of bitumen and his particular mixture of beeswax, resins, oil and lead oxide, which at the time speeded up the drying process but over the years caused craquelure and uneven surface texture. Prud'hon was given very important commissions to design temporary decorative projects in Paris for celebrations in 1805, 1807 and especially in 1810 on the occasion of Napoleon's marriage to Marie-Louise of Austria. He became her drawing master and also produced the designs for her wedding furniture and for the cradle of her son (1811–32), who was to have been Napoleon II.

(v) The Bourbon Restoration, 1815–23. Prud'hon was made a full member of the Institut in 1816. He showed little enthusiasm for the Bourbon government, which nevertheless commissioned several works from him to adorn churches and a ceiling in the Louvre. He failed to complete these with the exception of the pietistic *Assumption of the Virgin* for the chapel of the Tuileries in 1817 (Paris, Louvre). The final years of Prud'hon's life were troubled by financial worries and the suicide in 1821 of Constance Mayer. His last works were mostly portraits executed in an increasingly painterly manner and showing a preference for mature female sitters, such as *Mme Jarre* (Paris, Louvre). Many of these were shown at the Salon of 1822 along with the *Poverty-stricken Family* (M. G. Jakobi priv. col., see H. Weston: 'The Case for Constance Mayer', *Oxford A. J.*, iii/1 (1980), p. 16)—begun by Mayer—and the profoundly moving *Crucifixion* painted for Metz Cathedral (Paris, Louvre). This work, with its sinister light effects and tragic atmosphere, has been hailed as one of the great religious masterpieces of the 19th century.

2. Critical response

In his lifetime and throughout the 19th century Prud'hon was much admired by artists and writers of the Romantic coterie: in the 1820s by Stendhal for his chiaroscuro and for the convincing realism of his figures' expressions, and in the mid-19th century by Delacroix, Millet and by Baudelaire, who saw in him an inspiring force for Narcisse Diaz and for other artists of a poetic inclination. The Goncourt brothers regarded him as a late exponent of the Rococo style, but one with a profound understanding of ancient art. The sentiment and the technique of much of Prud'hon's work find an echo in the painted and graphic work of Corot, Fantin-Latour and the Symbolists, while there have been many tributes to *Justice and Vengeance* from 19th- and 20th-century artists, including a copy by Gericault (Paris, Louvre), pastiches by Daumier (Germany, priv. col., see K. E. Maison: *Daumier: Catalogue raisonné*, ii (1967), no. 813) and an oblique reference in Picasso's *Guernica* (Madrid, Prado).

Bibliography

E. Delacroix: 'Prud'hon', *Rev. Deux Mondes*, xvi (1846), pp. 432–51

E. de Goncourt and J. de Goncourt: 'Prud'hon', *L'Art du XVIIIe siècle* (Paris, 1859–75; Eng. trans., 1948/R 1981), pp. 1–32

C. Clément: *Prud'hon, sa vie, ses oeuvres, sa correspondance* (Paris, 1872)

E. de Goncourt: *Catalogue raisonné de l'oeuvre peint, dessiné et gravé de P. P. Prud'hon* (Paris, 1876)

J. Guiffrey: *L'Oeuvre de Pierre-Paul Prud'hon* (Paris, 1924)

R. Régamey: *Prud'hon* (Paris, 1928)

W. Friedlaender: *Hauptströmungen der französischen Malerei von David bis Cézanne* (Bielefeld, 1930; Eng. trans. as *David to Delacroix*, Cambridge, MA, 1952)

G. Grappe: *P. P. Prud'hon* (Paris, 1958)

A. P. de Mirimonde: *Catalogue du Musée Baron Martin Gray* (Gray, 1959), pp. 117–33

J. H. Slayman: *The Drawings of Pierre-Paul Prud'hon: A Critical Study* (diss., U. Wisconsin, 1970)

F. Haskell: *An Italian Patron of French Neo-classical Art* (Oxford, 1972), pp. 6–8, 14–15, 24 [Zaharoff lect. for 1972 on the patronage of Sommariva]

De David à Delacroix: La Peinture française de 1774 à 1830 (exh. cat., Paris, Louvre; Detroit, MI, Inst. A.; New York, Met; 1974; Eng. trans., 1975), pp. 560–66

H. Weston: 'Prud'hon: Justice and Vengeance', *Burl. Mag.*, cxvii (1975), pp. 353–62

S. Laveissière: *Dictionnaire des artistes et ouvriers d'art de Bourgogne* (Paris, 1980)

F. Mazzocca: 'G. B. Sommariva o il borghese mecenate', *Itinerari contributi alla storia dell'arte in memoria di Maria Louisa Ferrari* (Florence, 1981)

The Art of the French Illustrated Book, 1700–1914 (exh. cat. by G. N. Ray, New York, Pierpont Morgan Lib., 1982), pp. 128–33

H. Weston: 'Prud'hon in Rome: Pages from an Unpublished Sketchbook', *Burl. Mag.*, cxxvi (1984), pp. 432–51

Prud'hon: La Justice et la Vengeance divine poursuivant le Crime (exh. cat. by S. Laveissière, Paris, Louvre, 1986) [excellent study of this ptg and all related works]

T. Kirchner: 'Pierre-Paul Prud'hon's "La Justice et la Vengeance divine poursuivant le Crime"—Mahnender Appell und ästhetischer Genuss', *Z. Kstgesch.*, lx (1991), pp. 541–75

HELEN WESTON

Raffet, (Denis-)Auguste(-Marie)

(*b* Paris, 1 March 1804; *d* Genoa, 16 Feb 1860). French lithographer, painter and illustrator. Following the assassination of his father in 1813, the lack of family resources obliged Raffet to work while still a child. He was apprenticed to a wood-turner and attended drawing lessons in the evenings. At the age of 18 he spent a short period as an apprentice porcelain decorator for which he showed remarkable painting skills, and he then began his training as a painter by attending the classes of Charles Alexandre Suisse. There he was befriended by three fellow students who were also pupils of the military artist Nicolas-Toussaint Charlet. Among them was Louis Henri de Rudder (1807–81), who in 1824 introduced Raffet to Charlet. Six months later, on 11 October 1824, Raffet was admitted to the Ecole des Beaux-Arts in Paris, where he spent five years in Charlet's atelier. Following this, in 1829 he became a pupil of Antoine-Jean Gros. While at the Ecole des Beaux-Arts, Raffet prepared himself for the Prix de Rome competition by painting various classical subjects. However, he tried and failed the competition in 1831, and this led him to abandon classical subjects and to devote himself to contemporary history subjects. Though continuing to produce a few paintings, he began to concentrate on drawing, lithography and illustration. Raffet revolutionized the representation of battle scenes. Both his paintings (e.g. *Episode from the Retreat from Russia*, 1856; Paris, Louvre) and his prints form a glorifying and often humorous chronicle of French political history from the Revolution to the culmination of the Second Empire, the battle of Solferino of 1859.

Raffet's oeuvre as a lithographer and illustrator can be divided into three main periods. The first period, while he was still a student, was one of imitation. Having been taught the techniques of lithography by de Rudder, between 1824 and 1830 he produced albums containing lithographs such as *Vive la République!* and *Mon Empereur, c'est la plus cuite*. During this period he primarily copied the style of Horace Vernet but also that of Charlet and of Hippolyte Bellangé. In the second period (1830–37) Raffet improvised and began to

develop a personal style. His imaginative powers are evident in the depiction of those events that he had not actually seen, as was the case for the lithograph *The Battle of Oued-Allez*. Drawn from the Algerian expedition, this work, often considered his masterpiece, typifies Raffet's style. It shows his emphasis on the French soldiers, whom he placed in the foreground of the battle scene; his rejection of Neo-classicism in favour of a concern with depicting real types and manners; and his ability to suggest wide spaces and large numbers on a small scale. He also produced numerous illustrations for such books as Adolphe Thiers's *Histoire de la Révolution Française* (Paris, 1837).

The third period (from 1837) is one of observation. In 1837 Raffet visited Hungary, Moldavia, Wallachia, the Crimea, Smyrna and Constantinople, during which he met Prince Anatole Demidov, who became his principal patron. Raffet produced numerous, highly accurate ethnographic drawings, which he subsequently lithographed and published in Paris. The most important of these are the hundred lithographs that appeared under the title *Voyage dans la Russie méridionale et la Crimée par la Hongrie, la Valachie et la Moldavie* (4 vols), published in Paris in 1857. He continued to travel with Demidov until the end of his life (e.g. to Spain in 1847) and participated in the French campaign in Italy (1859), an experience that resulted in such lithographs as the *Siege of Rome*.

Bibliography

Bénézit

A. Bry: *Raffet: Sa vie et ses oeuvres* (Paris, 1861)

H. Giacomelli: *Raffet: Son oeuvre lithographique et ses eaux-forts* (Paris, 1862)

H. Beraldi: *Raffet: Peintre national* (Paris, c. 1890)

—: *Les Graveurs du XIXe siècle*, xi (Paris, 1891), pp. 61–149

A. Curtis: *Auguste Raffet* (New York, 1903)

R. J. Wickenden: 'Auguste Raffet (1804–1860)', *Prt Colr Q.* (1917), pp. 25–54

P. Ladoué: *Raffet* (Paris, 1946)

The Charged Image: French Lithographic Caricature, 1816–1848 (exh. cat. by B. Farwell, Santa Barbara, U. CA, A. Mus., 1989)

ATHENA S. E. LEOUSSI

Ramey

French family of sculptors. Claude Ramey (*b* Dijon, 29 Oct 1754; *d* Paris, 4 June 1838) first studied at the Ecole de Dessin in Dijon, under François Devosges III. In 1780 he moved to Paris, where he studied under Etienne-Pierre-Adrien Gois. In 1782 he was awarded the Prix de Rome for sculpture, jointly with Pierre-Joseph Chardigny (1794–1866). From 1782 to 1786 he was a student at the Académie de France in Rome; returning to Paris, he exhibited at the Salons from 1793 to 1827. He produced numerous portrait busts and statues, such as the marble statue of *Eugène de Beauharnais* (exh. 1810 Salon; Versailles, Château). He also used Classical subjects, as in his marble statue of *Sappho* (1801; Paris, Louvre). Among his public commissions was the marble low relief of the *View of Austerlitz* for the Arc de Triomphe du Carrousel, Paris, as well as sculpted decorations for the Louvre, the Palais du Luxembourg and other public buildings. Ramey's son, Etienne(-Jules) Ramey (*b* Paris, 23 May 1796; *d* Paris, 29 Oct 1852), trained with his father, before entering the Ecole des Beaux-Arts in Paris. In 1815 he won the Prix de Rome for sculpture and spent the next five years in Rome, where he made copies of Classical works, such as the marble *Venus Anadyomene* (1820; Dijon, Mus. B.-A.). On his return to Paris, he made his début at the Salon in 1822 and exhibited there in 1824 and 1827, when he showed his most celebrated group, *Theseus and the Minotaur* (Paris, Louvre). He received numerous public commissions for churches and state buildings, both in Paris and the provinces; among them was a plaster *Christ at the Column* (1822) for the Eglise de la Sorbonne, Paris. The marble low relief of the *Chamber of Deputies Offering the Crown to Louis-Philippe* (untraced) was commissioned in 1833 and installed in the Chambre des Députés in 1842. Ramey also produced occasional portrait works, such as the marble medallion of *Mme Dumont*, wife of Jacques-Edme Dumont (1829; Paris, Louvre).

Bibliography

Bénézit; Lami; Thieme–Becker

A. Soubies: *Les Membres de l'Académie des Beaux-Arts*, ii (Paris, 1906), pp. 63–4, 81–2

La Sculpture française au XIXe siècle (exh. cat., ed. A. Pingeot; Paris, Grand Pal., 1986), pp. 28, 33, 39–40, 115

M. Marrinan: *Painting Politics for Louis-Philippe: Art and Ideology in Orléanist France, 1830–1848* (New Haven and London, 1988), pp. 97–8

☐

Réattu, Jacques

(*b* Arles, 11 June 1760; *d* Arles, 7 April 1833). French painter. It is likely that he received his first artistic training from his uncle, the painter Antoine Raspal. He then went to Paris, where he was probably a pupil of Simon Julien before entering the studio of Jean-Baptiste Regnault in 1778. Réattu also enrolled at the Académie Royale but progressed very slowly in the drawing school, not winning a first-class medal until October 1787. He first reached the final of the Prix de Rome in 1788 and won the prize in 1790 with *Daniel Defending Susanna from the Accusations of the Elders* (Paris, Ecole N. Sup. B.-A.). The influence of Regnault is apparent, both in the choice of warm colours and in the striking light effects, characteristics that differentiate Regnault's school from that of Jacques-Louis David.

Réattu arrived in Rome in 1791 to study at the Académie de France, where his Neo-classicism became increasingly evident in his compositions of a few figures on a single plane within a stage-like setting. In 1793, following the assassination of the French representative Nicolas-Jean Hugou de Bassville and the subsequent closure of the Académie, Réattu fled to Naples, where he joined other Académie pupils, including Anne-Louis Girodet. He continued his studies and made several sketches and a painting of Paestum (Arles, Mus. Réattu).

Réattu was committed to the ideals of the French Revolution, and while in Rome he signed a petition to the Convention demanding more freedom for Académie students. On his return to France in November 1793 he decided to put his talents to the service of the Revolution. At first he settled in Marseille and fulfilled the function of quasi-official painter of the Revolution, receiving several commemorative commissions. In 1794 he

was asked to turn the Eglise des Prêcheurs, Marseille, into a 'Temple of Reason' and produced sketches for ten imitation bas-reliefs in grisaille showing the Genius of Ancient Times and the Glory of Republican Virtues (six in Arles, Mus. Réattu). He also painted two exciting and animated allegories, the *Triumph of Liberty* (1794; Arles, Mus. Réattu) and the *Triumph of Civilization* (*c.* 1794–8; Hamburg, Ksthalle). In these Réattu used the complete range of allegorical effects; so complex was the scheme that he felt it necessary to provide explanations. For the *Triumph of Civilization* he wrote: 'Time writes on a column the progress of Civilization crossing the ocean; the Genius of France protects it and hurls lightning against vices and abuses; the major French cities eagerly move towards Civilization' (quoted in 1974–5 exh. cat., p. 569). In the autumn of 1796 Réattu left Marseille for Paris but was unsuccessful there and returned to Arles in 1798.

Between 1802 and 1817 Réattu seems to have abandoned painting altogether, apparently no longer dependent on income from this source; in 1805 he declined to assist in the decoration of the city of Marseille for Napoleon's triumphal visit. Around 1817 he began to paint again, using stories from Ovid and also, for the first time in his career, religious subjects. He worked on numerous commissions for cities in Provence, decorating ceilings and curtains in the theatres of Nîmes, Marseille and Lyon (all destr.; sketches in Arles, Mus. Réattu). He also produced a cycle based on the life of St Paul, which survives *in situ* at St Paul's, Beaucaire.

The high point of Réattu's career was between 1793 and 1798, when his ardent Revolutionary zeal was expressed splendidly in large, dynamic allegorical canvases that combine a reverence for antiquity with energetic compositions. As contributions to the cause, these were recognized by David in a report of 1798. In 1804 Réattu became an associate of the Marseille Académie and in 1824 a corresponding member of the Institut. But with the rise of Napoleon, Réattu's inspiration appears to have evaporated, and his later works are but pale imitations of his committed Revolutionary productions. Like Jean-Baptiste Joseph Wicar at Lille and François-Xavier Fabre at Montpellier, Réattu

bought a house in his home town, Arles, with the intention of creating a museum; that building now bears his name and holds most of his work.

Bibliography

J. Canonge: *Notice historique sur Jacques Réattu* (Nîmes, 1863)
French Painting 1774–1830: The Age of Revolution (exh. cat., Paris, Grand Pal.; Detroit, Inst. A.; New York, Met.; 1974–5)
K. Simons: *Jacques Réattu, 1770–1833: Peintre de la Révolution française* (Neuilly, 1985); review by P. Bordes in *Burl. Mag.*, cxxviii (1986), p. 436

SIMON LEE

Redouté, Pierre-Joseph

(*b* Saint-Hubert, Luxembourg [now in Luxembourg Prov., Belgium], 10 July 1759; *d* Paris, 20 June 1840). French illustrator of Flemish birth. His great-grandfather, grandfather, father and two brothers all earned their living as artists. His father, Charles-Joseph Redouté (1715–76), worked as an interior decorator at the Abbey of St Hubert in the Ardennes and for wealthy Luxembourg clients. His elder brother, Antoine-Ferdinand Redouté (1756–1805), became an interior decorator and designer of stage scenery in Paris. In lasting achievement, however, Pierre-Joseph Redouté was the most distinguished. He worked with great industry and skill during a period in France particularly favourable for the publication of sumptuous and important botanical books. The engraved botanical plates, often coloured, in such books displayed his mastery of plant illustration and stipple engraving. He published in all about 2100 plates, distinguished for their elegance and accuracy, and portrayed at least 1800 species, as well as garden forms.

After basic training as a painter by his father, Redouté left home at the age of 13, studied painting in Liège and wandered as an itinerant portrait painter and interior decorator in Luxembourg, Flanders [now Belgium] and the Netherlands. There he admired the flower-pieces of such artists as Jan van Huysum and Rachel Ruysch, and from them obviously learnt to portray individual flowers with grace and precision, which was what his later patrons demanded for scientific purposes, rather than elaborate flower-pieces intended purely for aesthetic pleasure.

In 1782 Redouté moved to Paris to help his elder brother Antoine-Ferdinand, by then a successful designer of stage scenery. Here he also learnt the art of engraving and spent his leisure painting flowers in the royal botanical garden, the Jardin du Roi. Engravings of his illustrations brought him to the attention of the Dutch artist Gerard van Spaendonck and the magistrate, bibliophile and botanist Charles-Louis L'Héritier de Brutelle (1746–1800), both of whom were very influential for his career. L'Héritier instructed him in botanical detail, employed him as a botanical artist and in 1787 invited him to visit England, where he illustrated new plants and became acquainted with the technique of stipple engraving.

Back in France Redouté continued to draw plants for L'Héritier and in 1793, with his brother Henri-Joseph (see below), was commissioned to

65. Pierre-Joseph Redouté: *The Thory Rose (Rosa reclinata)*, from *Les Roses*, Paris, 1817–24 (Paris, Musée du Louvre)

produce work for the royal collection of paintings on vellum, *Collection des vélins*. Although Redouté was appointed draughtsman to the *cabinet* of Marie-Antoinette in 1786, he and Henri-Joseph continued to portray plants during the French Revolution in 1789. Soon he began to provide illustrations for important botanical works, all published in Paris, such as René-Louiche Desfontaines's *Flora Atlantica* (1798–1800), Etienne-Pierre Ventenat's *Description des plantes nouvelles* (1800–02) and André Michaux's *Histoire des Chênes de l'Amérique*. However, his lasting renown has come from major works with illustrations manifesting his superb mastery of perspective, such as *Plantarum historia succulentarum* (1798–1837) by Augustin-Pyramus de Candolle and *Les Liliacées* (1802–16) by de Candolle, François de la Roche and Alire Raffeueau-Delile.

The Empress Josephine Bonaparte, a lover of art, flowers and gardens, was also a patron of Redouté, and for her he produced two costly and beautiful works illustrating little-known plants grown in her two gardens, *Jardin de la Malmaison* (Paris, 1803–5), with text by E.-P. Ventenat, and its continuation *Description des plantes rares cultivées à Malmaison et à Navarre* (Paris, 1812–17), with text by Aimé-Jacques A. Bonpland. Under Josephine's auspices Redouté began to paint roses, which resulted in his best-known work, *Les Roses* (Paris, 1817–24; see col. pl. XXIX and fig. 65), with text by Claude-Antoine Thory, from which individual plates have often been reproduced.

After Josephine's death Redouté's income fell but not his expenditure, for which he borrowed money he could never repay, even though he had become a Maître du Dessin in the Muséum National d'Histoire Naturelle in Paris in 1822 and a Chevalier of the Légion d'honneur in 1825. His financial troubles led him to publish selections of plates with aesthetic appeal, such as *Album de Redouté* (1824) and *Choix des plus belles fleurs* (1827–33), both published in Paris, but they failed to mend his fortunes. On 19 June 1840 he had begun to paint a lily when he received the devastating news that the French government would not pay for an ambitious proposed painting; he suffered a cerebral haemorrhage and died next day.

His younger brother, Henri-Joseph Redouté (1766–1852), was a skilled zoological draughtsman who accompanied Napoleon Bonaparte on his military expedition to Egypt in 1798 as a natural history artist, recording particular landscapes and Nile fishes. He later contributed many zoological and botanical plates to the *Description d'Egypte* (Paris, 1809–25), as well as plates to botanical books.

Bibliography

A Catalogue of Redoutéau, Pittsburgh, PA, Carnegie–Mellon U., Hunt Botan. Lib. (Pittsburgh, 1963)

F. A. Stafleu: 'Redouté and his circle', *Bibliography and Natural History*, ed. T. R. Buckman (Lawrence, KS, 1966), pp. 46–65

A. Ridge: *The Man who Painted Roses: The Story of Pierre-Joseph Redouté* (London, 1974)

G. De La Roche and others: *Commentaries on 'Les Roses' of P.-J. Redouté* (Antwerp, 1978)

B. Mathew and others: *P.-J. Redouté: Lilies and Related Flowers* (London, 1982)

M. Rix and W. T. Stearn: *Redouté's Fairest Flowers* (London, 1987)

WILLIAM T. STEARN

Regnault, Jean-Baptiste, Baron [Renaud de Rome]

(*b* Paris, ?17 Oct 1754; *d* Paris, 12 Nov 1829). French painter. His first teacher was the history painter Jean Bardin, who took him to Rome in 1768. Back in Paris in 1772, he transferred to the studio of Nicolas-Bernard Lépicié. In 1776 he won the Prix de Rome with *Alexander and Diogenes* (Paris, Ecole N. Sup. B.-A.) and returned to Rome, where he was to spend the next four years at the Académie de France in the company of Jacques-Louis David and Jean-François-Pierre Peyron. While witnessing at first hand Peyron's development of a manner indebted to Poussin and David's conversion to Caravaggesque realism, Regnault inclined first towards a Late Baroque mode in a *Baptism of Christ* (untraced; recorded in two sketches and an etching), then, in *Perseus Washing his Hands* (1779; Louisville, KY, Speed A. Mus.), to the static Neo-classicism of Anton

Raphael Mengs. Until 1787 he would sign his pictures *Renaud de Rome*, to disassociate himself from the mannered taste of French painting before the time of David.

On his return to France, Regnault produced in quick succession his *morceau d'agrément*, *Perseus Delivers Andromeda and Returns her to her Parents* (destr.; reduced version, St Petersburg, Hermitage) and *morceau de réception*, the *Education of Achilles* (Paris, Louvre), which established him at the 1783 Salon as a rising star in the regeneration of French art being promoted by the Comte d'Angiviller, the director of the Bâtiments du Roi. However, if the Italianate, classicizing form of the *Education of Achilles* left little to be desired, its content was another matter. Critics noted its lack of expression, and three highly competent but unengaging royal commissions of the 1780s confirmed Regnault's lifelong inability to summon up David's theatrical power: the *Death of Priam* (exh. Salon 1785; Amiens, Mus. Picardie), the *Recognition of Orestes and Iphigenia* (exh. Salon 1787; Marseille, Mus. B.-A.) and the *Descent from the Cross* (exh. Salon 1789; Paris, Louvre). More congenial to Regnault's talent were subjects of a less elevated character, generally mythological, featuring the female nude (*Cupid and Psyche*, 1785; Angers, Mus. B.-A.; *Socrates and Alcibiades*, 1791; Paris, Louvre). This became his preferred idiom, practised after the Revolution (1789–95) on an increasingly large scale (e.g. the *Three Graces*, 1794; Paris, Louvre; see col. pl. XXX), apparently with little regard to its saleability.

In the 1780s Regnault began to take in pupils. His teaching studio was soon, briefly, to rival David's in popularity, although only a few pupils were to have distinguished careers: Robert Lefèvre, Pierre Narcisse Guérin, Merry-Joseph Blondel and Louis Hersent. Teaching enabled Regnault to survive the difficulties of the Revolution. A commission from the Commune of Paris for a big *Allegory of the Principal Events of the Revolution* failed to materialize (sketch, Versailles, Mus. Lambinet). Appointments as a member of the Commission des Monuments and Commission du Muséum were both lost when the committees were abolished, at the instance of David, in 1793. Regnault's one

important work for the Republic was a painting for the debating chamber of the Convention illustrating the revolutionary slogan *Liberty or Death* (untraced; reduced version, Hamburg, Ksthalle)—a theme that, after the Revolutionary terror, was seen in a less kindly light: the picture was badly received at the Salon of 1795.

Under the Consulate (1799–1804) Regnault painted equestrian potraits of *Kléber* (destr.) and *Bonaparte* (untraced) and a *Death of Desaix* (exh. Salon 1801; Clermont-Ferrand, Mus. Bargoin). The Empire brought two important commissions, a *Triumphal March of Napoleon to the Temple of Immortality* (completed 1806; Versailles, Château) and a *Signature of the Marriage-contract of Jerome Bonaparte* (1806–10; Versailles, Château; see fig. 66), which Regnault abstained from showing at the Salon. Nor did he show his last imperial commission, the *Presentation of Flags to the Senate* (1809–11; Versailles, Château), three substantial treatments of mythological subjects, the *Judgement of Paris* (c. 1810; Detroit, MI, Inst. A.), the *Death of Adonis* (1812; untraced) and the *Toilet of Venus* (1815; Norfolk, VA, Chrysler Mus.), and his one commission from the Restoration, the allegory the *Happy Event* (1817; Fontainebleau, Château). The late 1810s and early 1820s seem to have been rather unproductive, but during the last years of his life he undertook the execution of a series of large mythological paintings including *Io* (Brest, Mus. B.-A.) and *Cupid and Psyche* (Chicago, IL, A. Inst.).

While varying to fit the requirements of very different types of work (porcelain delicacy in the 1785 *Cupid and Psyche*; Rubensian breadth in the *Signature of the Marriage-contract of Jerome Bonaparte*), Regnault's art retains distinct characteristics throughout his career: a polished draughtsmanship, a taste for forms that are Hellenistic rather than Classical, a richness of colouring and tonal contrast that looks back to Italian painting of the 17th century and particularly to Guido Reni. After a moment in the last decade of the 18th century when he appeared a serious rival to David, Regnault came to be perceived as a reactionary, 'academic' figure—a perception to which his abstention from the Salons

undoubtedly contributed—and his posthumous reputation suffered as a result. A more balanced assessment would take account of the actual merit of Regnault's eclecticism in an era dominated by Davidian pictorial theatre, of a freshness of imagination in the treatment of subjects from his favourite source, Ovid's *Metamorphoses*, and of a refined, highly attractive execution.

Bibliography

J.-B. Chaussard: 'Notice historique sur Regnault, peintre d'histoire', *Le Pausanias français* (1806); repr. in *Rev. Univl. A.* (1862), pp. 196–207
'Nécrologie J. B. Regnault', *J. Artistes* (22 Nov 1829), pp. 331–3
A. Lenoir: 'J. B. Regnault (2⊃ Article)' *J. Artistes* (27 Dec 1829), pp. 407–11
—: 'Cabinet de feu M. Regnault', *J. Artistes* (10 Jan 1830), pp. 30–33
De David à Delacroix: La Peinture française de 1774 à 1830 (exh. cat., ed. T. J. Cummings, R. Rosenblum and A. Schnapper; Paris, Grand Pal., 1974–5), pp. 570–77
C. Sells: *Jean-Baptiste Regnault* (in preparation)
CHRISTOPHER SELLS

Révoil, Pierre(-Henri)

(*b* Lyon, 12 June 1776; *d* Lyon, 19 March 1842). French painter and collector. He entered the Ecole de Dessin in Lyon around 1791 as a pupil of Alexis Grognard (1752–1840). He then became a designer in a wallpaper factory. In 1795 he began working in Jacques-Louis David's studio, where, with Fleury Richard, Comte Auguste de Forbin, François-Marius Granet and Louis Ducis, he belonged to what David's pupils called the 'parti aristocratique'. In 1800 he published with Forbin, who remained a friend, a comedy that was performed at the Théâtre du Vaudeville, *Sterne à Paris, ou le voyageur sentimental*. In 1802, on the occasion of the laying of the first stone of the Place Bellecoeur in Lyon by the First Consul, Révoil executed a large and elaborately allegorical drawing, *Bonaparte Rebuilding the Town of Lyon* (preparatory drawings, Paris, Louvre, and Lyon, Mus. B.-A.), which was the basis for a painting exhibited in the Salon of 1804 (destr. by the artist, 1816). During the same period he composed a number of religious paintings, for example *In Honour of the Sacred Heart*

66. Jean-Baptiste Regnault: *Signature of the Marriage-contract of Jerome Bonaparte*, 1806–10 (Versailles, Musée National du Château de Versailles et du Trianon)

of Jesus and Christ on the Cross (both Lyon, St Nizier). In 1807 Révoil was appointed a teacher in the recently founded Ecole des Beaux-Arts in Lyon. His teaching was marked by considerable erudition and contributed to the birth of the 'Lyon school', which came to the fore in the 1820s.

From 1810 Révoil turned to French history for his subject-matter, exhibiting at the Salon the Ring of the Emperor Charles V (Madrid, Fr. Embassy), which brought him some success and the notice of Vivant Denon. In his anecdotal genre paintings Révoil displayed a more profound concern for historical accuracy than the other exponents of the Troubadour style. He sought to re-create a medieval contest in a Tournament in the 14th Century (exh. Salon 1812; Lyon, Mus. B.-A.) with archaeological precision, drawing on medieval miniatures both for the composition of the scene and the depiction of costumes and weapons. Portraiture and the detailed study of costume and of objects, rendered with the accuracy of a goldsmith, took priority in his paintings illustrating anecdotes from French history, such as Francis I Dubbing his Grandson Francis II a Knight (exh. Salon 1824; Aix-en-Provence, Mus. Granet; see also col. pl. XXXI). In 1817 he exhibited Bayard's Convalescence (Paris, Louvre) and Henry IV Playing with his Children (Pau, Château), for which he won a Prix de Genre Secondaire. During the same period he received a commission for the Galerie de Diane in Fontainebleau, the Mother of Henry IV (exh. Salon 1819; in situ), in which he used acid colouring and unusual, dissonant tonalities.

In 1818 Révoil gave up his post at the Ecole des Beaux-Arts in Lyon, moving to Provence, where at the request of the town of Aix-en-Provence he executed a design for a statue of King René of Anjou (drawing, Aix-en-Provence, Mus. Arbaud; statue, Aix-en-Provence, Cours Mirabeau). He returned to Lyon and the Ecole de Dessin in 1823 but was obliged to give up his teaching post after the revolution of 1830, as he refused to swear allegiance to the Constitutional charter because of his royalist convictions. He then went into exile in Provence and virtually stopped painting. His work had begun to bore both critics and the public, who found his erudite historical references difficult to

decipher. At this time Révoil preferred to execute numerous drawings, which were easy to sell, skilfully manipulating lights and darks with a subtle wash technique in such works as Family Reading (Angers, Mus. Turpin de Crissé) and Troubadour and Greyhound (Rouen, Mus. B.-A.). In 1838 he exhibited two further paintings in the Salon, including Charles V at the Abbey of St Just (1836; Avignon, Mus. Calvet), and obtained two commissions for the Musée Historique in Versailles, Philippe-Auguste Taking the Standard at St Denis, 24 June 1190 (exh. Salon 1841) and Tancred Taking Bethlehem, 6 June 1099 (exh. Salon 1840; both in situ). In 1840 he received another commission for the Musée Historique, Pharamond Held Shoulder-high by the Franks (1841–5; in situ), which was completed after Révoil's death by his pupil Michel Genod (1796–1862).

Révoil began forming a collection of medieval antiquities in the early 19th century. The collection was considerable and famous even in 1811, when it was visited by the archaeologist Aubin-Louis Millin; it was sold in 1828 to the Musée Royal in Paris. Révoil was the first person to form a collection exclusively composed of objects from the Middle Ages and the Renaissance. In bringing together these objects, which he called his 'cabinet de gothicités', he wanted to reunite the evidence of a particular era in order to understand the daily life of former times. This motivation is discernible in the catalogue (839 entries) that he drew up for the sale. In it he placed masterpieces and minor objects on the same level, preferring to classify pieces in terms of their function.

Bibliography

E. C. Martin-Daussigny: Eloge historique de Pierre Révoil (Lyon, 1842)

J. Gaubin: 'Pierre Révoil, peintre d'histoire et ancien directeur de l'Ecole des Beaux-Arts de Lyon', Rev. Lyon., v (1852), pp. 229–45

M. Genod: 'Eloge de Pierre Révoil', Rev. Lyon., ii (1862), pp. 171–89

L. Courajod: 'La Collection Révoil du Musée du Louvre', Bull. Mnmt., lii/6 (1886), pp. 143–74, 257–86

M.-C. Chaudonneret: Fleury Richard et Pierre Révoil: La Peinture troubadour (Paris, 1980)

MARIE-CLAUDE CHAUDONNERET

Richard, Fleury(-François)

(*b* Lyon, 25 Feb 1777; *d* Ecully, Rhône, 14 March 1852). French painter. After being taught by Alexis Grognard (1752–1840) at the Ecole de Dessin in Lyon, he entered Jacques-Louis David's studio in 1796, where he was part of the group that included Pierre Révoil, Comte Auguste de Forbin and François-Marius Granet. His earliest works, such as *Death of Constantine* (untraced), were in a banal Neo-classical style. However, he exhibited a painting in the Salon of 1800 that was novel in both subject and atmosphere: *St Blandine* (untraced; known from a drawing by A. M. Monsaldy, Paris, Bib. N.). It honoured a medieval saint, a heroine who was French, Christian and from Lyon; the scene was set in a crypt painted from life (St Irénée in Lyon) and exploited a strong chiaroscuro. Henceforth Richard took his inspiration from French history. At the Salon of 1802 he exhibited *Valentina of Milan Weeping over the Death of her Husband* (untraced; known from an engraving by Auguste Fauchery), which proved to be a huge success. The painting was hailed as an innovation and can be considered the first picture in the Troubadour style. Richard combined the genre scene and anecdote from national history, using a technique inherited from 17th-century Dutch painters. Wishing, as he wrote, to 'ennoble the humble bambocciata tradition', he introduced a moral example of the widow faithful to her husband's memory. The picture owed its success to the fact that Richard had both displayed a certain exoticism by placing the figure in a medieval oratory and transposed the severe, classical *exemplum virtutis* into a simpler and more moving genre.

Richard described his development in his autobiography: having tired of antiquity, he sought his inspiration in the subsequent centuries and for this reason turned to 'the age of chivalry' (i.e. the Middle Ages and the Renaissance). He had been an assiduous visitor to the Musée des Monuments Français in Paris during his apprenticeship with David, and there discovered French history through the royal monuments: he had the idea for his painting of *Valentina of Milan* in front of the tomb of Valentina displayed in the museum. His interest in history and his concern with exactitude led him to copy miniatures from medieval manuscripts in the Bibliothèque Nationale (sketchbooks; Lyon, Mus. B.-A.). The Empress Josephine, fond of novelty, bought *Valentina of Milan* for her gallery at Malmaison and at subsequent Salons acquired seven more of his finest works, including *Francis I and his Sister* (exh. Salon 1804; Arenenberg, Napoleonmus.).

After the Salon of 1808 Richard settled in Lyon, where he taught at the Ecole des Beaux-Arts between 1818 and 1823 and was one of the principal founders of the 'Lyon school'. His output diminished after the Salon of 1810. In 1814 he exhibited for a second time paintings that had been shown in previous salons, and he obtained the title of Genre Painter to Monsieur. In 1815 he was made a chevalier of the Légion d'honneur. In the Salon of 1817 he exhibited *Mme Elisabeth Assisting in the Distribution of Milk* (Versailles, Château), a particularly delicate charity scene, which is poetic in its subtle effects of light. In the same year he received a commission for the Galerie de Diane in Fontainebleau, *Tannegui Duchâtel Rescuing the Dauphin* (exh. Salon 1819; *in situ*).

Richard's last paintings (e.g. *Young Girl at a Fountain*, exh. Salon 1824; Lyon, Mus. B.-A.) were insipid in style and no longer displayed the somewhat acid, subtle colour harmonies or the polished style of his earlier work such as the *Deference Shown by St Louis to his Mother* (exh. Salon 1808; Arenenberg, Napoleonmus.). Although in 1846 Richard exhibited a painting, *Comminges and Adelaide at the Trappist Monastery* (Lyon, Mus. B.-A.), executed some years earlier, he stopped painting after 1824 at a time when Troubadour painters were going out of fashion and when the genre was coming under violent attack from critics.

Writings

'Autobiographie', *Rev. Lyon.*, iii (1851), pp. 244–55

Bibliography

L. Boitel: 'Nécrologie: Fleury Richard', *Rev. Lyon.*, iv (1852), pp. 237–40
M.-C. Chaudonneret: *Fleury Richard et Pierre Révoil: La Peinture troubadour* (Paris, 1980)

MARIE-CLAUDE CHAUDONNERET

Robert, Hubert [Robert des Ruines]

(*b* Paris, 22 May 1733; *d* Paris, 15 April 1808). French painter, draughtsman, etcher and landscape designer. He was one of the most prolific and engaging landscape painters in 18th-century France. He specialized in architectural scenes in which topographical elements derived from the buildings and monuments of ancient and modern Italy and of France are combined in often fantastic settings or fictitious juxtapositions. The fluid touch and rich impasto employed in his paintings, also shared by his friend Jean-Honoré Fragonard, are matched by the freedom of his numerous red chalk drawings and the few etchings that he is known to have produced.

1. Training and early years in Paris and Rome, to 1765

Robert's father was an official in the service of the Marquis de Stainville whose son, the Comte de Stainville (later Duc de Choiseul), became the young artist's protector. According to Mariette, Robert learnt drawing as a pupil of the sculptor René-Michel (Michel-Ange) Slodtz, although other sources suggest, improbably, that he studied with the painter Pierre-Jacques Cazes. It is certain, however, that he received a classical education in Paris, at either the aristocratic Collège de Navarre or the Collège de Beauvais.

In 1754 Robert arrived in Rome in the entourage of the Comte de Stainville, who had been appointed French Ambassador to the Holy See. Robert was to spend the next 11 years in Italy. Although he had not studied at the Académie Royale de Peinture et de Sculpture in Paris, Stainville arranged his acceptance at the Académie de France in Rome, the Director of which was then Charles-Joseph Natoire. Stainville financed his upkeep for three years, until he was awarded an official place as a *pensionnaire* in 1759, due to the intervention of Mme de Pompadour's brother, Abel-François Poisson, Marquis de Marigny, the new Directeur des Bâtiments du Roi. Robert's protector had become Duc de Choiseul in 1756 and Foreign Minister of France two years later; personal influence at the highest levels thus worked in favour of the young painter who, as Natoire wrote on his arrival in Rome, had 'a taste for architecture'. This taste already defined one of the most striking aspects of his art, which consists principally of architecture, often ruined, in landscape settings. It was while in Rome that Robert began his life-long fascination with ruined buildings, both real and invented: in one of a series of 91 red chalk drawings (Valence, Mus. B.-A. & Hist. Nat.) executed at about this time he depicted himself drawing the Borghese Vase with a plaque reading *Roma quanta fuit ipsae ruinae docent* (Rome's very ruins tell of her former greatness).

Among Robert's acquaintances in Rome were the Abbé de Saint-Non, with whom he travelled to Naples (on a drawing expedition) in 1760, and the collectors Claude-Henri Watelet, Aleksandr, Count Stroganov and, above all, Jacques le Tonnelier, Bailli de Breteuil, with whom Robert used to recite Virgil in Latin. Robert also met Fragonard in Rome, and he and Saint-Non drew with him in the gardens of the Villa d'Este at Tivoli (e.g. red chalk drawings, Paris, Louvre). Other artists in Rome included the view painter Giovanni Paolo Panini, who was professor of perspective at the Académie de France and from whom Choiseul commissioned a series of *Views of Ancient and Modern Rome* (New York, Met.), on which it has been suggested Robert collaborated, and of which he owned replicas. Giovanni Battista Piranesi began at this time to publish his great collections of engravings of Roman views, and these and the paintings of Panini influenced Robert's artistic vision.

2. Paris, 1765 and after

Robert left Rome for Paris in July 1765, taking with him the drawings of Italian buildings and landscapes that were a source for his paintings for many years after (e.g. the *Discovery of the Laokoon*, 1773; Richmond, VA, Mus. F.A.). A year later he had the rare privilege of being made an associate and a full member of the Académie Royale at the same session on 26 July 1766. His *morceau de réception* was a painting of the *Port of Ripetta, Rome* (Paris, Ecole N. Sup. B.-A.), of which the first version (Vaduz, Samml. Liechtenstein) had been executed in 1761 for Choiseul, together with its pendant *A Port Embellished with Architecture* (Dunkirk, Mus. B.-A.).

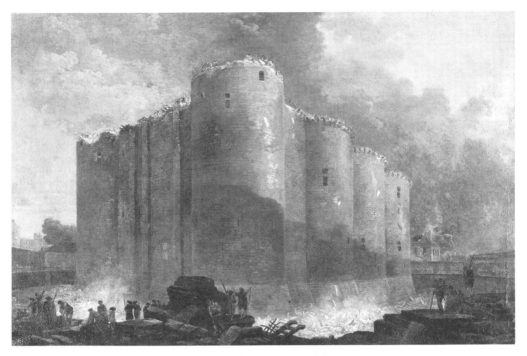

67. Hubert Robert: *Demolition of the Bastille*, 1789 (Paris, Musée Carnavalet)

Henceforth Robert exhibited regularly at the Salon from 1767 to 1798. At his first Salon Robert exhibited a number of works in which the principal elements of his subject-matter and style could be seen: there were thirteen easel paintings—four views of ruins, three of real or imaginary architecture, four landscapes, two 'picturesque' subjects—as well as a large decorative canvas of an Italianate landscape. Almost the whole of Robert's considerable oeuvre could be classified under these headings, which reveal a range of inspiration much more varied than he is usually given credit for. In addition to such scenes of Italian derivation, Robert also showed an interest in the topography of France, in particular of Paris and the Ile de France, as sources for subjects.

The element of fantasy characteristic of so much of Robert's work is least present in his views of Paris. In 1772, for instance, he painted the *Burning of the Hôtel-Dieu* and the *Ruins of the Hôtel-Dieu* (Paris, Carnavalet), taking up a theme

that he had painted in an imaginary vein in 1764 in a depiction of the burning of the monuments of Rome (Frankfurt am Main, Städel. Kstinst.). In 1781, when the Paris Opéra burnt down, he painted the fire (Paris, Carnavalet). Modern as well as ancient ruins attracted him, as in the *Demolition of the Houses on the Pont au Change, Paris* (1788; Munich, Alte Pin.) and in his paintings of the Bastille in 1789 (Paris, Carnavalet; see fig. 67). His interest in French subjects led him in the late 1780s to accept a commission to paint the Roman remains of Languedoc, including the *Maison Carré, Nîmes* (see fig. 68) and the *Pont du Gard* (both 1787; Paris, Louvre).

The imaginative quality of Robert's landscape paintings brought him in 1778 an appointment as Dessinateur des Jardins du Roi, thanks to the support of the new Directeur des Bâtiments du Roi, Charles de Flahaut de la Billarderie, Comte d'Angiviller. The previous year he had presented at the Salon two views of the *Park at Versailles*

68. Hubert Robert: *Maison Carré, Nîmes*, 1787 (Paris, Musée du Louvre)

(versions, Versailles, Château, and Lisbon, Mus. Gulbenkian). He installed François Girardon's famous 17th-century marble group of *Apollo Tended by the Nymphs* in a new setting of an artificial grotto executed to his designs at Versailles; also for Louis XVI he designed new gardens 'à l'anglaise' at the château of Rambouillet, drew up plans for the dairy there and even designed its furnishings. He was also responsible for the design of the picturesque gardens and dairy (destr.) at Méréville, near Paris, for the Marquis de La Borde de Méréville. Robert directed the works at Méréville after having presented his ideas in a number of paintings (e.g. Sceaux, Château, Mus. Ile de France; Stockholm, Nmus.).

In 1788 Robert decorated the dining room of the château at Méréville with four large paintings (Chicago, IL, A. Inst.); the previous year the four canvases of the Roman remains of Languedoc (Paris, Louvre) were completed for Louis XVI as decorations for the château of Fontainebleau. Such decorative ensembles, created for royal patrons and wealthy private clients, formed an important part of his output, and were among the best of their kind painted in the last third of the 18th century. Noteworthy examples include those

at Bagatelle, near Paris, executed in 1778 for the Comte d'Artois, later Charles X, those in the château of Haroué, near Nancy, executed for the Prince of Craon-Beauvau, and those in the Hôtel de Noailles, Rambouillet. Among other such sets of paintings, but whose origins are obscure, is the series in the Metropolitan Museum of Art, New York.

In 1778 Robert, who from 1771 had had royal lodgings in the Arsenal, Paris, was awarded lodgings in the Louvre, where he lived until 1802. In 1784 he was appointed Garde des Tableaux for the Musée Royal that was to be installed there. From this period of his life date not only some of his finest Italian landscapes, including the *Portico of Marcus Aurelius, Rome* and its pendant the *Portico of Octavius, Rome* (both 1787; Paris, Louvre, on dep. London, French Embassy), but also a remarkable series of oil-sketches (Paris, Louvre), continued through the 1790s, presenting his schemes for the replanning of the Grande Galerie of the Musée du Louvre for the purposes of the museum. In some of these the element of fantasy is allowed to dominate over practical concerns, as when Robert presented the building in ruins (see col. pl. XXXII). He continued in his post during the first years of the French Revolution (1789–95), even painting a Revolutionary subject, the *Fête de la Fédération* (1790; Versailles, Château), until he was imprisoned in Paris in 1793–4, first in Sainte-Pélagie and later in Saint-Lazare. While in prison he continued to paint and draw, completing some large canvases.

Outside France, Robert had considerable success in Russia, where Count Stroganov had become Chamberlain to Catherine II and President of the St Petersburg Academy of Fine Art. It was presumably due to him that Robert gained Russian patrons, beginning with the Empress, as well as her son, Grand Duke Paul, for whom he executed some large decorative paintings, still *in situ*, in his palace at Pavlovsk. Robert executed other works that are still *in situ* at Arkhangel'skoye, commissioned by the Yusupov family. Such was his success in Russia that the Hermitage, St Petersburg, now has the richest collection in the world of his work.

Immensely popular in his lifetime, Robert was sometimes criticized in his later career for carelessness and over-production: Denis Diderot, who greeted his early work at the Salons with enthusiasm, later accused him of becoming facile and negligent in his compositions, particularly his figures, which he often derived from the works of François Boucher. In her *Souvenirs* (Paris, 1835–7) his friend Elisabeth-Louise Vigée Le Brun recorded that this productive artist died 'brush in hand' as he prepared to go out to dinner.

Bibliography

Mariette

H. Gabillot: *Hubert Robert et son temps* (Paris, 1895) [remains the best monograph]

P. de Nolhac: *Hubert Robert, 1733–1808* (Paris, 1910)

Hubert Robert (exh. cat. by C. Sterling, Paris, Mus. Orangerie, 1933)

H. Burda: *Die Ruinen in den Bildern Hubert Robert* (Munich, 1967)

M. Beau: *La Collection des dessins d'Hubert Robert au Musée de Valence* (Lyon, 1968)

J. Cailleux: 'Hubert Robert dessinateur de la Rome vivante, 1757–65', *Actes du congrès international d'histoire de l'art: Budapest, 1969*, iii, pp. 57–61

Hubert Robert: Les Sanguines du Musée de Valence (exh. cat., Paris, Jacquemart-André, 1969)

A. Corboz: *Peinture militante et architecture révolutionnaire: A propos du thème du tunnel chez Hubert Robert* (Basle and Stuttgart, 1978)

Hubert Robert, Drawings and Watercolours (exh. cat. by V. Carlson, Washington, DC, N.G.A., 1978)

Le Louvre d'Hubert Robert (exh. cat., ed. M.-C. Sahut; Paris, Louvre, 1979)

Hubert Robert et le paysage architectural de la seconde moitié du XVIIIe siècle (exh. cat. by I. Novosselskaia, I. Nemilova and others, Leningrad, Hermitage, 1983)

Hubert Robert et la Révolution (exh. cat., Valence, Mus. B.-A. & Hist. Nat., 1989)

J. H. Fragonard e H. Robert a Roma (exh. cat., Rome, Acad. France, 1990–91)

JEAN DE CAYEUX

Robert, (Louis) Léopold

(*b* Eplatures, 13 May 1794; *d* Venice, 20 March 1835). Swiss painter. Robert was the most widely known and respected Swiss painter of the early

19th century. His work blends Neo-classical rigour with Romantic sentimentality and subject-matter, and he was greatly admired by both contemporary and later critics, such as Charles Clément, Théophile Thoré and Louis Viardot (1880–83), who likened him to Poussin. His reputation waned towards the end of the century, and his work was not re-evaluated until the 1970s.

In 1810 Robert travelled with the engraver Charles-Samuel Girardet (1780–1863) to Paris, where he began to draw from engravings. He befriended two Swiss artists, Henri François Brandt (1789–1845) and François Forster, both of whom encouraged Robert to pursue his artistic inclinations. After working directly from models, in 1812 Robert presented himself to Jacques-Louis David, who agreed to take him on as a student. Such was David's regard for Robert that he asked him to engrave his recently finished portrait of his wife *Marie-Geneviève David* (1813; Washington, DC, N.G.A.). Robert stayed with David for about three years, improving his technique in composition, figure drawing and painting. He also studied briefly under Antoine-Jean Gros, but proudly pronounced himself to be a 'pupil of David' for the rest of his life.

Robert was unable to compete in the Prix de Rome competitions because of his nationality (his birthplace was then under Prussian rule), and he returned to Switzerland in September 1816. He began his career chiefly as a portrait painter, profiting from the lively trade of commissions from the noble families around Neuchâtel. Indicative of his style at the time are his portraits of *Sophie Mairet* and *Caroline de Meuron* (both 1818; Neuchâtel, Mus. A. & Hist.), the latter the wife of the painter Maximilien de Meuron. *Sophie Mairet* is reminiscent of works by David in its fine sensitivity to the textures of the model's dress and the furnishings (particularly the sewing-box in the foreground) surrounding her. The portrait of *Caroline de Meuron* is richly composed in blacks and whites and demonstrates an intimate understanding of the model's character, not unlike that seen in David's portrait of his wife. Robert's success as a portrait painter brought him to the attention of his first important patron, François

Roulet de Mézerac, who offered to subsidize Robert's continued studies in Italy if the artist would produce paintings for him in exchange. According to the contract signed on 19 May 1818, Robert was to stay in Italy for three years. However, apart from a brief return to Paris in 1831, Robert remained in Italy for the rest of his life.

After arriving in Rome in early summer 1818, Robert quickly sought out Swiss compatriots, particularly Franz Kaisermann, who introduced him to the artistic community there. Eventually he met François-Joseph Navez, François Granet, Victor Schnetz, Léon Cogniet and Ingres, all of whom influenced the formation of his mature style and choice of subject-matter. He also became acquainted with the graphic work of Bartolomeo Pinelli, whose plates of Italian costumes and genre scenes were particularly successful. Typical of Robert's work during his first years in Rome is the *Dead Nun* (1819; La Chaux-de-Fonds, Mus. B.-A.), which he painted for Roulet de Mézerac and which demonstrates his interest in small, graceful, narrative works. In 1819 Robert produced his first drawings of Italian brigands, a subject that helped to establish his reputation. Robert lived comfortably on the money paid for these scenes, often repeating the same work several times; he painted 14 versions of the *Brigand Asleep* (e.g. 1826; London, Wallace). The subject of the life of the brigand appealed to the Romantic sensibilities of European audiences familiar with the works of Schiller and Byron, and Robert eventually produced over 160 paintings on the subject, in which he displayed an awareness of Italian folklore. By 1822 his paintings of brigands, Italian shepherds and pipers were being admired in Rome and Paris.

In 1824 Robert met the critic Etienne-Jean Delécluze, himself a former pupil of David, who later championed Robert's works in Paris. Robert exhibited seven paintings in the Paris Salon of 1824, including the *Neapolitan Sailor* (extant only in a fragment after a fire of 1848, Neuchâtel, Mus. A. & Hist.), which received critical acclaim, charmed huge crowds and was purchased by Ferdinand, Duc d'Orléans. The painting was recognized as a compromise between Ingres's staid *Vow of Louis XIII* (Montauban Cathedral; see col.

pl. XXII) and the fiery passion of Delacroix's *Massacre of Chios* (Paris, Louvre), both exhibited in the same Salon. But Robert's most important painting of the period was the *Return from the Pilgrimage to the Virgin with a Bow* (1827; Paris, Louvre; see col. pl. XXXIII), which Robert showed in the Salon of 1827–8, after exhibiting it privately in his studio in Rome. Conceived as part of a series (not completed) showing the seasons through different Italian sites and customs, the painting depicts the festive activities near Naples at Pentecost. It is strictly drawn and composed in the manner of David, enhanced by striking local colour, costumes and a ravishing landscape of Naples and Vesuvius. Delécluze and Augustin Jal both praised it, the latter considering it to be one of the finest examples of genre painting known. Pierre Guérin, then Director of the Académie de France in Rome, was among those who took part in the furious bidding for the purchase rights. However, Robert sold the work for a loss to Auguste, Comte de Forbin, for the privilege of having it installed in the Musée du Luxembourg in Paris.

During the last seven years of his life Robert continued to paint scenes of brigands and Italian peasants, and widened his circle of friends to include Horace Vernet, Chateaubriand and Charlotte Bonaparte, his pupil and mistress. His most important painting of the period is the *Arrival of the Harvesters in the Pontine Marshes* (1830; Paris, Louvre), which was exhibited in the Salon of 1831. The work was intended as the second in the series on the seasons, this time depicting a Roman landscape in summer; it is set in an empty landscape that emphasizes the movement and gaiety of the foreground figures, again characterized by local colour and costumes. The Parisian audiences responded enthusiastically; the painting was purchased by Louis Philippe, and Robert was awarded the Légion d'honneur. The third picture in the cycle is the *Departure of the Adriatic Fishermen* (1834; Neuchâtel, Mus. A. & Hist.), which Robert altered from the intended scene showing a carnival in Venice in winter. One of his most complicated compositions, it is also one of his most successful in its rich array of costumes, physiognomic types

and details, particularly the nets and fishing apparatus in the foreground. The reasons for Robert's suicide have not been ascertained.

Bibliography

E. Delécluze: *Notice sur la vie et les ouvrages de Léopold Robert* (Paris, 1838)

F.-S. Feuillet de Conches: *Léopold Robert: Sa vie, ses oeuvres et sa correspondance* (Paris, 1848)

C. Clément: *Léopold Robert d'après sa correspondance intime* (Neuchâtel, 1875)

L. Rosenthal: *Léopold Robert: Peintre d'Italie* (Paris, 1898)

D. Berthoud: *Vie du peintre Léopold Robert* (Neuchâtel, 1935)

G. B. Segal: *Der Maler Louis Léopold Robert* (Basle, 1973)

P. Gassier: *Léopold Robert* (Neuchâtel, 1983)

Léopold Robert (exh. cat., Rome, Mus. Napoleonico, 1986)

<div align="right">WILLIAM HAUPTMAN</div>

Robert-Fleury, Joseph-Nicolas

(*b* Cologne, 8 Aug 1797; *d* Paris, 5 May 1890). French painter. In 1816 he entered the studio of Horace Vernet, who recommended he study under Anne-Louis Girodet. He spent four years with Girodet before studying briefly with Antoine-Jean Gros. He then travelled around Europe, especially Italy and Holland, for four years, initially working as drawing-master to an English family. He returned in 1824 to Paris where he made his début at the Salon. Though he had admired the Renaissance and Classical art he had seen abroad and never quite broke free from its influence, he nevertheless developed a predominantly Romantic style which matured during the 1830s to produce such works as *Triumphal Entry of Clovis at Tours in 508* (1837; Versailles, Château). Most of Joseph-Nicolas Robert-Fleury's works depict such dramatic historical subjects as trials and assassinations, painted in high focus with a wealth of period detail (e.g. *Galileo before the Inquisition, 1632*; 1847, Paris, Louvre). He also painted some biblical scenes and a number of works based on the lives of great painters of the past (e.g. *Death of Titian*, 1861; Antwerp, Kon. Mus. S. Kst.). In 1863 he painted four large canvases on historical themes for the Salle d'Audience of the Tribunal de Commerce in Paris and was appointed Director of the Ecole des Beaux-Arts. However, the following year he resigned the post in order to become Director of the Académie de France in Rome. In 1846 he was awarded the Légion d'Honneur, and in 1850 he was elected a member of the Académie des Beaux-Arts. Robert-Fleury continued to exhibit at the Salon until 1867.

Bibliography

E. Montrosier: *Peintres modernes: Ingres, H. Flandrin, Robert-Fleury* (Paris, 1882), pp. 73–143

H. Jouin: *Robert-Fleury* (Paris, 1890)

Rochet, Louis

(*b* Paris, 24 Aug 1813; *d* Paris, 21 Jan 1878). French sculptor and anthropologist. Rochet studied at the Ecole des Beaux-Arts in Paris under Pierre-Jean David d'Angers, but withdrew from the Prix de Rome competition to pursue Oriental languages (especially Chinese) and natural history, at the same time providing models for commercial sculpture. He returned to monumental sculpture in 1838 and followed the example of David d'Angers in sculpting commemorative statues for the provinces, such as *Marshal Drouet d'Erlon* (bronze, 1844–9; Reims, Place de la Couture). Rochet distinguished himself in the costumed pageantry of figures from earlier French history, such as the equestrian *William the Conqueror* (bronze, 1846–51; Falaise, Hôtel de Ville), the *Marquise de Sevigné* (bronze, 1857; Grignan) or *Charlemagne Accompanied by Roland and Olivier* (bronze, 1853–67; erected 1878, Paris, Place du Parvis Notre Dame). The most popular of these historical re-creations was *Napoleon Bonaparte as a Student at Brienne* (plaster, exh. Salon, 1853; marble, exh. Exposition Universelle, 1855; bronze, 1855, erected 1859; Brienne, Hôtel de Ville). The bronze monument to *Don Pedro I of Brazil* (1855–62; Rio de Janeiro) involved Rochet in anthropological and zoological research, as its granite base was enriched by sculptures of groups of natives and local fauna, symbolizing South American rivers. A historicizing approach to style, first used by Rochet in his colossal bronze *Notre Dame de Myans*, erected near Chambéry in 1855, re-emerged in a

later series of Classical subjects, initiated by the 'Archaic' Minerva (plaster, gilded bronze and silver plated, exh. Salon 1864).

Bibliography

Lami

A. Rochet: *Louis Rochet, André Bonne* (Paris, 1978)

La Sculpture française au XIXe siècle (exh. cat., ed. A. Pingeot and others; Paris, Grand Pal., 1986)

PHILIP WARD-JACKSON

Roland, Philippe-Laurent

(*b* Pont-à-Marc, nr Lille, 13 Aug 1746; *d* Paris, 11 July 1816). French sculptor. Born into circumstances of great poverty, he studied briefly at the Ecole de Dessin in Lille and in 1764 moved to Paris, where he entered the studio of Augustin Pajou, collaborating with him on his decorations at the Palais Royal, Paris, and at the opera house at the château of Versailles. In 1771 he left for Italy at his own expense, remaining there for five years. Among his Roman works is the naturalistic terracotta bust of an *Old Man Sleeping* (Angers, Mus. B.-A.) and a charming *Sleeping Boy* (New York, Met.). After his return to Paris he was accepted (*agréé*) by the Académie Royale in 1782 (the *Death of Cato of Utica*, sketch, terracotta statuette, Paris, Louvre). In 1783 he submitted a sketch for his *morceau de réception*, *Samson* (wax head, Paris, Louvre; plaster version, 1786); the marble version (exh. Salon 1795; untraced) was only achieved after the suppression of the Académie. He became a member of the Lille Académie in 1782.

The influence of Pajou brought Roland the commission for a statue of *Louis II, Prince de Condé* (Le Grand Condé) (marble, completed 1787; Versailles, Château), in the series of *Illustrious Frenchmen* commissioned by Charles-Claude Flahaut de la Billarderie, Comte d'Angiviller, director of the Bâtiments du Roi. From 1784 his father-in-law, Nicolas-Marie Potain, comptroller of works at the château of Fontainebleau, secured employment for him as a decorative sculptor in the private apartments of Louis XVI and Marie-Antoinette. The elegant classicism and refined sense of line of Roland's decorative work under

the *ancien régime* are well displayed in the marble caryatids of the chimney-piece made for Mme de Sérilly's boudoir (London, V&A). But he is also a Neo-classical artist, as in the two friezes (1783) for the external façade of the Hôtel de Salon (Paris, Mus. Légion d'Honneur), a *Scene of Sacrifice* strongly influenced by the Antique.

During the Revolutionary period Roland became a founder-member of the Institut de France and a professor at the Ecole des Beaux-Arts. He produced a number of works with Republican themes, including a bas-relief representing *Law* for the peristyle of the Panthéon (stone, 1792–3) and an allegorical statue representing *Law* for the same building (plaster, 1792–3; both destr.). In 1800 he received a prize of 6000 francs for his bust of *Augustin Pajou* (marble; Chaalis, Mus. Abbaye), thanks to which he was able to execute his best-known work of this period, the statue *Homer Playing the Lyre* (plaster model, exh. Salon 1802; marble, exh. Salon 1812 and 1814; marble version, Paris, Louvre). He was also an excellent portrait sculptor and was capable of work in a light-hearted and anacreontic vein, such as the group *Bacchante Seated on a Ram* (terracotta, 1796; New York, Met.). Among his busts are those of the painter *Joseph-Benoît Suvée* (terracotta, 1788; Paris, Louvre) and of his own daughter, *Mlle Roland* (terracotta, exh. Salon 1806; marble, dated Year XIII; Paris, Louvre). The latter is perhaps his masterpiece, with its exquisite modelling and sensitive characterization.

Roland's official sculpture could at times be grandiloquent, but at its best it combined Neo-classical austerity with a vein of sober realism, qualities that he passed on to his pupil and admirer David d'Angers.

Bibliography

Lami

A. Quatremère de Quincy: 'Notice historique sur la vie et les ouvrages de M. Roland lue à l'Académie le 2 octobre 1819', *Recueil de notices historiques* (Paris, 1834), pp. 101–20

P.-J. David d'Angers: *Roland et ses ouvrages* (Paris, 1847)

D. Genoux: 'Philippe-Laurent Roland décorateur: Ses travaux au palais de Fontainebleau en 1786', *Bull. Soc. Hist. A. Fr.* (1964), pp. 119–25

—: 'Quelques bustes et médaillons retrouvés de Philippe-Laurent Roland', *Bull. Soc. Hist. A. Fr.* (1965), pp. 191–200

—: 'Travaux de sculpture exécutés par Roland pour Lhuillier, Rousseau l'aîné et Molinos et Legrand', *Bull. Soc. Hist. A. Fr.* (1966), pp. 189–98

Nouvelles acquisitions du département des sculptures, Paris, Louvre cat. (Paris, 1988), pp. 108–10; (Paris, 1992), pp. 84–9

J. D. Draper: 'Philippe-Laurent Roland in the Metropolitan Museum of Art', *Met. Mus. J.*, 27 (1992), pp. 129–47

GUILHEM SCHERF

Roqueplan [Rocoplan], Camille(-Joseph-Etienne)

(*b* Mallemort, Bouches-du-Rhône, 18 Feb 1800; *d* Paris, 25 Sept 1855). French painter and lithographer. Born into a cultured family, he studied in Paris under Antoine-Jean Gros and Alexandre Abel de Pujol and entered the Ecole des Beaux-Arts in February 1818. He first exhibited at the Salon in 1822 and thereafter regularly until 1855. His oeuvre consists of landscapes, marines, historical subjects and genre scenes in oils and watercolours; there are also a few portraits and pastels. He began with small landscapes influenced by the work of R. P. Bonington, his contemporary at the Ecole des Beaux-Arts, and that of Eugène Isabey. In 1824 he first exhibited a subject taken from Sir Walter Scott (*Quentin Durward*, 1823), entitled *Historical Landscape* (untraced); this was followed by a number of costume pictures derived predominantly from Scott. He progressed in the mid-1830s to large-scale anecdotal pictures, which brought him much fame, for example the *Lion in Love* (exh. Salon 1836; London, Wallace), taken from La Fontaine's *Fables*. In 1837 he executed the *Battle of Elchingem*, a Napoleonic epic in the manner of Gros, for the Musée d'Histoire at Versailles, and four years later he decorated part of the ceiling of the library at the Palais du Luxembourg in Paris. After a period spent in the Pyrenees on account of ill health (1843–6), he reverted to mountain landscapes or scenes of peasant life, painted in a more restrained palette than hitherto, for example *Peasants of the Béarn* (1846; London, Wallace).

Most of Roqueplan's paintings are small and his work on this scale is at its freshest and least contrived, particularly his landscapes. He made a real contribution during the 1830s to the regeneration of landscape painting in France, emphasizing study from nature without preconception. In this he was a forerunner of the Barbizon artists, notably Narcisse Diaz and Jules Dupré, both of whom he knew. He painted scenes in Belgium and Holland as well as many areas in France, including Brittany, which he was one of the first artists to discover. There are also some Italian views, though no documentation of a visit to Italy.

Roqueplan's style was highly eclectic, drawing inspiration from Venetian 16th-century and Dutch and Flemish 17th-century masters; Achille Michallon and Prud'hon; and, particularly, French Rococo paintings and prints—Roqueplan made an important contribution to the Rococo revival in France. The influence of contemporary British artists was strong, notably that of Bonington, Wilkie and Constable (and he presumably knew the copies after Constable made by his close friend Paul Huet). In his own time Roqueplan was highly regarded, not least on account of the charm and grace of his work, the harmony of his colours and delicacy of his lighting. Collectors of his pictures included Richard Seymour-Conway, 4th Marquess of Hertford: he is best represented in the Wallace Collection, London.

Roqueplan was one of the leading lithographers of his day, producing over 60 lithographs, including a set from the Waverley Novels (1829) and albums published in Paris and London in 1830 and 1831. His work frequently appeared in *L'Artiste*. With Achille Devéria, Louis Boulanger and others he also worked on an illustrated edition of La Fontaine's *Contes et nouvelles* (1839). Roqueplan kept a fashionable studio, from which the most successful pupil to emerge was Prosper Marilhat.

Bibliography

A. Jal: *Les Causeries du Louvre (Salon de 1833)* (Paris, 1833), pp. 309–12

C. Blanc: *Histoire (1861–76)*, iii, appendix, pp. 56–8

T. Gautier: *Histoire du romantisme* (Paris, 2/1874),
 pp. 191–9
G. Hédiard: *Les Maîtres de la lithographie: Camille
 Roqueplan* (Le Mans, 1894)
J. Ingamells: *French Nineteenth Century* (1986), ii of *The
 Wallace Collection: Catalogue of Pictures* (London,
 1985–92), pp. 212–24

PAUL SPENCER-LONGHURST

Roques, (Guillaume-)Joseph

(*b* Toulouse, 1 Oct 1757; *d* Toulouse, 27 Dec 1847).
French painter and printmaker. He was trained by
the Toulouse painter Pierre Rivalz and in 1778 won
the Prix de Rome with the *Murder of Philip of
Macedon* (Paris, Ecole B.-A.). He was at the
Académie de France in Rome during the crucial
period in the development of French Neo-classical
painting when Joseph-Marie Vien was director and
Jacques-Louis David a student there. After his
return to France in 1782, his career in the
provinces progressed smoothly in spite of the
political upheavals surrounding the French
Revolution. He was director (?1783–6) of the Ecoles
de la Société des Beaux-Arts in Montpellier and in
1787 was admitted to the Toulouse Académie. He
contributed regularly to the Académie's exhibi-
tions and from 1791 to 1797 played a key role in
training Jean-Auguste-Dominique Ingres, who was
to remain a life-long friend. Under the Empire
(1804–15) he was appointed professor at the Ecole
des Beaux-Arts in Toulouse; gaining further recog-
nition from the works he submitted to the Paris
Salon from 1773 to 1810, he became a corre-
sponding member of the Institut and Chevalier of
the Légion d'honneur.

Roques was susceptible to the influence of
other artists, and his work shows considerable
variety both in style and in subject-matter. As late
as 1788 the *galant* spirit of the Rococo is still
evident in genre scenes such as the *Rose and the
Rosebud* (Toulouse, Mus. Augustins), while it is
the influence of Nicolas Poussin (together with
that of Vien) that predominates in such history
paintings as the *Widow of Amyntas Tells Two
Shepherds of the Misfortunes Leading to her
Husband's Death* (1781; Toulouse, Mus. Augustins).

In contrast, the *Death of Marat* (Toulouse, Mus.
Augustins), commissioned by the city of Toulouse
and exhibited at the Club des Jacobins in 1794, is
close to David, while the series of seven paintings
of the *Life of the Virgin* for Notre-Dame de la
Daurade, Toulouse (*in situ*), are reminiscent of
Ingres in their emphasis on line.

While Roques produced history paintings with
Classical subjects such as the *Death of Lucretia*
(exh. Salon 1801; untraced) he also played an impor-
tant role in the revival of religious painting in
France, producing such works as *St Germain* (1822;
Toulouse, Notre-Dame de la Dalbade), the *Last
Supper*, the *Communion of the Duc d'Angoulême*
(both 1829; Toulouse, St Etienne) and the *Rest on
the Flight into Egypt* (Montaubon, Mus. Ingres).
Contemporary events are reflected in his impor-
tant compositions *Fête de la Fédération* (1790) and
*Festivities on the Garonne in the Presence of the
Emperor* (1808; both Toulouse, Mus. Augustins). He
also painted portraits, notably of *Pius VII* (1814;
Narbonne, Mus. A. & Hist.) and *Dr Dastarat* (1808;
Toulouse, Mus. Augustins); the latter depicts a
philanthropist of Toulouse giving alms to a blind
beggar and is remarkable for its combination of
portraiture and genre scene within a distinctive
urban setting. There is a large collection of his
drawings, mainly portraits, in the Musée Paul
Dupuy, Toulouse. Some etchings by Roques are also
known, for instance five portraits (1818) of the
accused and witnesses in the trial following
the assassination of the magistrate Antoine
Fualdès (for illustrations see 1959 exh. cat., nos
65–70). His children Guillaume Roques (*b* 1778) and
Anne-Charlotte Roques (*b* 1790) were also painters.

Bibliography

Ingres et ses maîtres, de Roques à David (exh. cat.,
 Toulouse, Mus. Augustins; Montauban, Mus. Ingres;
 1955), pp. 34–41
Toulouse, Musée Paul Dupuy: Dessins antérieurs à 1830
 (1958), ii of *Inventaire général des dessins des musées
 de province*, ed. R. Mesuret (Paris, 1958), nos 137–42
*L'Estampe toulousaine aux XVIIe et XVIIIe siècles: La
 Donation Regraffé de Miribel* (exh. cat. by B. Mesuret,
 Toulouse, Mus. Dupuy, 1959), pp. 45–6
Ingres et son temps (exh. cat., Montauban, Mus. Ingres,
 1967), pp. 166–7

P. Guinard: 'La Peinture en Languedoc du XVIIe au XIXe siècles: Acquisitions et orientations', *Inf. Hist. A.*, xiii (1968), pp. 223–9

Toulouse Musée des Augustins: Vingt ans d'acquisitions, 1948–1968 (exh. cat., Toulouse, Mus. Augustins, 1969)

Christian Imagery in French Nineteenth-century Art (exh. cat., New York, Shepherd Gal., 1980), pp. 78–9

LAURE PELLICER

Rousseau, (Pierre-Etienne-)Théodore

(*b* Paris, 15 April 1812; *d* Barbizon, 22 Dec 1867). French painter. He was considered the leader of the Romantic-Naturalist artists of the Barbizon school, but he also had the unhappy distinction of being known as 'le grand refusé', because of his systematic exclusion from the Paris Salon between 1836 and 1841 and his abstention between 1842 and 1849.

1. Life and work

His orientation towards *plein-air* painting was apparent when as a schoolboy in Paris he sketched trees in the Bois de Boulogne. According to Philippe Burty, *Telegraph Tower on Montmartre* (*c*. 1826; Boulogne, Mus. Mun.) was one of Rousseau's first painted studies. Alfred Sensier wrote that it was this work that convinced Rousseau's parents to let him pursue an artistic vocation. A cousin, Alexandre Pau de Saint-Martin (1782–1850), who was a landscape painter, took Rousseau to work in the forest of Compiègne and then advised sending him to the studio of Joseph Rémond (1795–1875), who had won the Prix de Rome for historical landscape in 1821. Rousseau was enrolled in Rémond's studio *c*. 1826 and shortly thereafter began studying with the history painter Guillaume Lethière (1760–1832). He made an unsuccessful attempt at the historical landscape prize in 1829, but the arid goals and stultifying procedures of Rémond's atelier appear to have been extremely uncongenial to Rousseau. The necessity of 'elevating' a landscape by the addition of a mythological theme was especially galling to him, since he had already developed a passionate attachment to nature as a living entity.

The single significant legacy of Rousseau's academic training was his retention of the distinction between a sketch and a finished painting. Sensier, referring to Rousseau's first exhibited painting, *Auvergne Site* (exh. Paris Salon, 1831), described it as a 'composed landscape . . . because Rousseau did not want to show himself to the public in the rough manner of a study which was for him the preliminary exercise of his work'. However, this painting, which has been identified with the *Fisherman* (Rotterdam, Mus. Boymans–van Beuningen), does not show classical finish or geometrical order.

About 1827–8 Rousseau became acquainted with the area around the Forest of Fontainebleau, but his first extensive travel occurred in 1830, when he spent several months in the Auvergne, a region considered particularly rugged and untamed. Rousseau later made many extensive trips throughout France, but he never went to Italy. Once he abandoned the idea of winning the Prix de Rome he turned aggressively nationalistic in his choice of subject-matter, seeking out the regional character of each area.

The main artistic influences on Rousseau and the majority of Barbizon painters were John Constable and 17th-century Dutch landscape painters. The Barbizon artists began painting during the period of Constable's strongest impact in France, from 1824, when the *Hay Wain* (1821; London, N.G.) was shown at the Salon, well into the 1830s. Nearly 30 Constable paintings were in France during the 1830s, many easily accessible to artists; these works proved that a monumental painting did not require idealizing conventions. English landscape of the 19th century had ties with the Dutch focus on everyday, unstructured aspects of observed nature, and this stimulated the Barbizon painters to study Dutch painting. Rousseau and Jean-François Millet jointly bought a Jan van Goyen painting, and Rousseau eventually owned some 50 prints of Dutch paintings, including copies of works by Jacob van Ruisdael. Rousseau is also said to have made copies, in the Louvre, of the animals in Adriaen van de Velde's paintings and of the paintings of Karel Dujardin, whose typical works are Italianate and often not true landscapes.

69. Théodore Rousseau: *Edge of the Forest of Fontainebleau, Sunset*, 1850–51 (Paris, Musée du Louvre)

Rousseau's début at the Salon of 1831 coincided with those of his friend Jules Dupré, with whom he made many sketching trips, and of Narcisse Diaz. They had little difficulty having works accepted, although Rousseau's eventual nemesis, Jean-Joseph-Xavier Bidauld (1788–1846), was already consistently present on the jury. In 1 833 two paintings by Rousseau were accepted, including the large *Coast of Grainville* (St Petersburg, Hermitage). In 1834 one work was rejected; however, *Edge of a Clearing, Forest of Compiègne* (priv. col., see 1967–8 exh. cat.) was accepted, perhaps because it belonged to Ferdinand, Duc d'Orléans, and even received a third-class medal. In 1835 two small sketches were admitted.

Everything Rousseau submitted from 1836 to 1841 was refused; from 1842 until after the Revolution of 1848 Rousseau abstained. Each time,

Bidauld, the single landscape painter on the jury and an intransigent upholder of the classical tradition, rejected Rousseau, although other members of the Barbizon school sometimes were admitted. The rejection of the monumental *Descent of the Cattle* (The Hague, Rijksmus. Mesdag) in 1836 was a particularly severe blow, since this was a major undertaking, inspirational in origin. Ary Scheffer so much admired this work that he publicly exhibited it in his own studio. Perhaps the most significant result of this rejection was that it sent Rousseau on his first long sojourn in Barbizon. Henceforth, his time was increasingly spent here and in the Forest of Fontainebleau. The culminating insult occurred when in 1841 the jury refused the *Avenue of Chestnut-trees* (Paris, Louvre; see col. pl. XXXIV), although it had already been purchased by the government.

The Revolution of 1848 marked the end of this era. Rousseau received an official commission, for the *Edge of the Forest of Fontainebleau, Sunset* (exh. Paris Salon, 1850–51; Paris, Louvre; see fig. 69), which conforms to a favourite type of Rousseau's mature years: a view from within the forest to a clearing outside. In 1849 Rousseau reappeared at the Salon, showing such paintings as *Avenue of Trees, Forest of l'Isle-Adam* (1849; Paris, Mus. d'Orsay), in which he attempted, for the first time in a French exhibition painting, to portray the vertical light of noon, as Constable had in the *Hay Wain*. Rousseau received a first-class medal, which meant he no longer had to submit to the jury; yet he was passed over for the Légion d'honneur, while Dupré was not. This humiliation may have contributed to their breach, but Dupré's place was soon filled by Millet, who moved to Barbizon that year. In 1851 Rousseau was snubbed again, although Diaz was honoured, but in 1852 he finally received the cross of the Légion d'honneur. The zenith of this successful phase came in 1855, when a room at the Exposition Universelle in Paris was devoted to him; this exhibition gave Rousseau an international reputation.

Unfortunately, this period of prosperity did not last; in the early 1860s Rousseau was forced to sell works at auction, with disappointing results. True financial security did not come until 1866, when Paul Durand-Ruel and Hector-Henri-Clément Brame convinced Rousseau to sell them 70 sketches with which he had always refused to part. Then Rousseau was elected president of the jury for the Exposition Universelle in 1867 and received one of the four grand medals of honour. This occasion was not the unqualified victory Rousseau had anticipated, because he was passed over for promotion to Officer of the Légion d'honneur, doubtless because of the animosity of Comte de Nieuwerkerke, Directeur-général des Musées impériaux. Rousseau's friends maintained this was the cause of the series of strokes he suffered from July onwards. These friends appealed directly to Louis-Napoléon; Rousseau was made an Officer on 13 August, in a ceremony presided over by Nieuwerkerke, who uttered conventional flattering words. Nieuwerkerke had his final revenge after Rousseau died in December, because he did not, as was customary, arrange a memorial exhibition.

2. Working methods and technique

The most noteworthy aspect of Rousseau's working methods was his concern with *plein-air* studies. Although he still worked up finished paintings in his studio in Paris in winter, Rousseau made use of a special easel and lean-to to facilitate working outdoors in summer. Such sketches as *Road in the Forest of Fontainebleau, Stormy Effect* (c. 1860–65; Paris, Louvre) are some of Rousseau's most vital works. The subject, with its casual view of trees and cloudy sky and an interest in changes of weather, suits the technique, which is rough, variable and rich though not brilliant in colour, with flecks of pigment reminiscent of Constable.

Oaks at Apremont (c. 1850–52; Paris, Louvre), representative of his studio-reworked paintings, shows Rousseau's transitional position between Romanticism and Naturalism. The majestic oaks are rendered so meticulously that one can easily accept Rousseau's assertions that he made portraits of all of them and listened to their voices; equally meticulous is his observation of the noon light. There is still a Romantic attachment to specific truths of nature, but the mood is less obvious than in earlier paintings, such as *Valley of Tiffauge* (1837–44; Cincinnati, OH, A. Mus.), with its marvellously teeming vegetal life in the foreground (dubbed 'weed soup' by mocking critics).

Rousseau's desire for a personal perfection that always seemed elusive often led him to rework his paintings over a period of many years. The monumental *Forest in Winter at Sunset* (New York, Met.) stands as a testament in that regard, since he worked on it from 1846 until his death. The darkening that has affected many of Rousseau's paintings over the years can partly be traced to this laborious procedure, since he often used chemically incompatible pigments and even bitumens (originally suggested by Scheffer), which eventually proved disastrous, accounting for the

ruinous state of the *Descent of the Cattle* and *Avenue of Chestnut-trees*. One unprecedented exception to his usual procedure is *Hoar-frost Effect* (1845; Baltimore, MD, Walters A.G.). Sensier recorded that Rousseau painted it directly from nature on an unprepared canvas in eight days, in his fever to capture a transient effect of nature. The foreground is covered with scintillating dabs of white and the rose reflections of a vivid winter sunset. Here, both in theme and technique Rousseau foreshadowed Impressionism.

3. Critical reception and posthumous reputation

Rousseau's reputation has always been inseparable from his position both as 'le grand refusé' and as a Romantic rebel escaping urbanization. Yet the artist's enforced exclusion was itself the instrument of enhanced recognition and elevated status. Most critics made a point of referring to Rousseau; as a 'refusé', he was often linked with Eugène Delacroix, for example when an article in *L'Artiste* (1834) stated that the jury exclusions had become 'scandalous', even 'monstrous', since they now included such names as Delacroix and Rousseau. From 1836 critics rallied increasingly to Rousseau's support. Bidauld's part in these systematic exclusions appears to have been well-known and was scathingly noted by Gustave Planche in 1840. After Rousseau had been accepted, such critics as the Goncourts emphasized the artist's truthfulness to nature.

While the Barbizon artists achieved great popularity in England and America around the turn of the century, they have been overshadowed by the movement they herald, Impressionism. This eclipse was partially rectified by the exhibition *Barbizon Revisited* (1962) and the large retrospective exhibition (1967–8) denied Rousseau at his death.

Bibliography

'Salon de 1834', *L'Artiste*, viii (1834), p. 65

G. Planche: 'Salon de 1840', *Rev. Deux Mondes* (1840), p. 100

T. Thoré: *Le Salon de 1844 précédé d'une lettre à Théodore Rousseau* (Paris, 1844), pp. vii–xxxvi; Eng. trans. in J. Taylor, ed.: *Nineteenth-century Theories of Art* (Berkeley, 1987), pp. 319–27

P. Burty: *Les Etudes peintes de Théodore Rousseau* (Paris, 1867); repr. in *Maîtres et petits-maîtres* (Paris, 1877), pp. 71–93

——: 'Théodore Rousseau', *Gaz. B.-A.*, 1st ser., xxiv (1868), pp. 305–25

T. Silvestre: 'Théodore Rousseau', *Figaro* (15 Jan 1868); repr. in *Les Artistes français* i: *Romantiques*, ed. E. Fauve (Paris, 1926), pp. 173–84

A. Sensier: *Souvenirs sur Th. Rousseau* (Paris, 1872) [assiduous transcription of what Rousseau said; numerous errors, nevertheless indispensable]

E. de Goncourt and J. de Goncourt: *Etudes d'art: Le Salon de 1852, la peinture à l'Exposition de 1855* (Paris, 1893); Eng. trans. in E. Holt, ed.: *The Art of All Nations, 1850–1873* (New York, 1981), pp. 82–93 (86)

P. Dorbec: *Théodore Rousseau* (Paris, 1910)

——: 'L'Oeuvre de Théodore Rousseau aux salons de 1849 à 1867', *Gaz. B.-A.*, 4th ser., xix (1913), pp. 107–27

——: *L'Art du paysage en France* (Paris, 1925)

——: 'Le Voyage de Théodore Rousseau en Vendée: Charles le Roux', *Gaz. B.-A.*, 5th ser., xvii (1928), pp. 31–51

M.-T. de Forges: 'La Descente des vaches de Théodore Rousseau au Musée d'Amiens', *Rev. Louvre*, xii (1962), pp. 85–90

Barbizon Revisited (exh. cat., ed. R. Herbert; San Francisco, CA, Pal. Legion of Honor, 1962)

Théodore Rousseau (exh. cat., ed. H. Toussaint; Paris, Louvre, 1967–8)

J. Bouret: *The Barbizon School and 19th Century French Landscape Painting* (Greenwich, CT, 1973)

P. Miquel: *L'Ecole de la nature* (1975), iii of *Le Paysage français du xixe siècle, 1824–1874* (Maurs-la-Jolie, 1975)

A. Terrasse: *Théodore Rousseau's Universe* (Paris, 1976)

P. Mainardi: *Art and Politics of the Second Empire: The Universal Expositions of 1855 and 1867* (New Haven, 1987)

S. Adams: *The Barbizon School and the Origins of Impressionism* (London, 1994)

DOROTHEA K. BEARD

Rude, François

(*b* Dijon, 4 Jan 1784; *d* Paris, 3 Nov 1855). French sculptor. He was of working-class origins and Neo-classical training. After 1830 he identified with the emergent group of Romantic sculptors in France, at the same time retaining his own strong sense of monumentalism. His massive stone relief on the Arc de Triomphe, Paris, popularly known as '*La Marseillaise*' (1833–6; see col. pl. XXXV), and

his bronze allegory *Napoleon Awakening to Immortality* (1845–7; Fixin, Parc Noisot) are memorable nostalgic celebrations of the military heroism of the Revolutionary period.

1. Training in France and exile in Belgium, to 1827

Rude was the son of a Dijon stovemaker and locksmith who supported the aims of the French Revolution to the extent of enrolling his infant son, in 1793, in one of the juvenile battalions known punningly as 'Les Royals Bonbons'. François was early apprenticed to his father, but his interest in art was awakened in 1800, when he attended a prize-giving ceremony at the Ecole des Beaux-Arts in Dijon. François Devosges, founder and director of this regional school, subsequently persuaded Rude's father to allow his son to attend its courses in his spare time. After four years of such study François Rude received his first commission, from a local tax inspector, Louis Frémiet, for a bust (untraced) of a relative, the engraver Louis-Gabriel Monnier (1733–1804). Rude was adopted by the Frémiet family after the death of his father in 1805, and in 1807 he left for Paris, taking with him an introduction to the Director of the Musée Napoléon, Baron Vivant Denon.

With Denon's backing, Rude entered the studio of the decorative sculptor Edme Gaulle (1762–1841), collaborating with him on reliefs for the Colonne de la Grande Armée in the Place Vendôme, Paris. He left Gaulle after less than a year to become a pupil of a more respected sculptor, Pierre Cartellier. In 1809 he was competing at the Ecole des Beaux-Arts, finally winning the Prix de Rome in 1812. Two of his preliminary competition entries survive, a *Marius Meditating on the Ruins of Carthage* (plaster, 1809; Dijon, Mus. B.-A.) and a *tête d'expression*, *Expectation Mingled with Fear* (plaster, 1812; Paris, Ecole N. Sup. B.-A.). The original plaster of his successful Prix de Rome entry, *Aristeus Mourning the Loss of his Bees*, an exercise in bucolic mythology, was later destroyed by the artist but survives in a bronze cast (Dijon, Mus. B.-A.).

The financial plight of the Académie de France in Rome prevented Rude from taking up his scholarship, so he returned to the Frémiet family home

in Dijon. After the Hundred Days in 1815, however, Louis Frémiet found himself compromised by his Bonapartist activities, and he took his family into exile in Brussels, followed by Rude, who remained there until 1827.

The 12 years Rude spent in Brussels were on the whole fallow. He did, however, find work with the royal architect Charles van der Straeten (1771–1834), through the introduction of the exiled Neo-classical painter Jacques-Louis David, the cultural lodestar of the French expatriot community in Brussels. Sophie Frémiet (1797–1861), whom Rude was to wed in 1821, was David's pupil and copyist. The most ambitious of the resulting projects for van der Straeten was the decoration executed in 1823–4 for the hunting lodge of the Prince of Orange at Tervueren. This consisted of eight panels illustrating the *Exploits of Achilles* and a stone frieze of the *Hunt of Meleager* (all destr.; plaster casts, Dijon, Mus. B.-A.). Their composition is austerely classical, enlivened by some passages of distinctive anatomical observation. The sculptural decorations that Rude contributed in 1824–5 to a wooden pulpit for the church of St Etienne, Lille, are equally circumscribed. Although he appears to have made no progress in imaginary sculpture throughout the Belgian period, Rude's portrait busts from these years are impressively forthright naturalistic productions. The marble version of his *William I of the Netherlands* was destroyed in 1819, but a bronze version survives (Ghent, Mus. S. Kst.). His portrait of *Jacques-Louis David* was first executed in 1826. A later marble version (Paris, Louvre) was exhibited at the Salon of 1831.

2. Paris, 1827–c. 1845

Encouraged by Antoine-Jean Gros, Rude returned to Paris in 1827. He was determined to vie with contemporaries who had already established reputations there, notably David d'Angers, Jean-Pierre Cortot and James Pradier. His two 1828 Salon exhibits were a thoroughly official statue of the *Immaculate Virgin* (plaster; Paris, SS Gervais et Protais) and a statue of *Mercury Fastening his Sandal*, also in plaster, which was only completed towards the end of the exhibition. The god is

shown at the point of taking to the air after killing Argus, pausing to fasten his winged sandal. The influence on this of Giambologna's famous statue of *Mercury* (*c.* 1580; Florence, Bargello) indicates a new flexibility in Rude's attitude to sculptural tradition, and the sophisticated movement of his *Mercury* was immediately appreciated by the critics. A bronze version, exhibited at the Salon of 1834, is now in the Louvre, and a reduction, also in bronze, incorporating some additional features and commissioned by the journalist and government minister Adolphe Thiers, is now in the Musée des Beaux-Arts, Dijon.

Like David d'Angers, Rude compromised his Republican convictions by accepting work on the monumental projects in Paris of the restored Bourbon regime. In 1829 he entered a competition for the pediment of the church of La Madeleine (drawing, Dijon Mus. B.-A.), and in the same year he received a commission for part of the frieze for the Arc de Triomphe de l'Etoile, representing *Charles X and the French Army*. The plaster model for the frieze was completed, but the July Revolution of 1830 brought a halt to the work, and the model was probably destroyed in 1833.

Rude consolidated the popular success that he had won with his *Mercury* when he showed the plaster version of the *Young Neapolitan Fisherboy Playing with a Tortoise* at the 1831 Salon. A vogue for Neapolitan figure subjects in painting had already been created during the 1820s by Victor Schnetz and Léopold Robert. This genre, uniting Classical and Romantic features, was an ideal vehicle for artists seeking stylistic compromise and would continue to be popular with academic sculptors up to the 1860s. Rude's capacity to produce in his *Fisherboy* an entirely plausible evocation of this modern arcadian world of contented physicality, though he had never visited Naples, shows to what extent this genre had already become an artistic convention. At the Salon of 1833, where Rude exhibited his marble version (see fig. 70), the public could compare it with the equally well-received *Neapolitan Fisherboy Dancing the Tarantella* (Paris, Louvre) of François-Joseph Duret. Both could be considered an updating of the classical genre piece, but Rude's naturalistic detail and

humorous subject made his work the more distinctive new departure. The marble was purchased for the Musée du Luxembourg by Louis-Philippe (now Paris, Louvre).

In 1831, the newly installed regime of Louis-Philippe began a revised project of decoration for the Arc de Triomphe. The model for the Bourbon frieze having been abandoned, Rude was now commissioned for a section of the new one, showing the *Return of Napoleon's Armies from Egypt*. In 1833, following the completion of this, he was requested by Thiers to produce a total programme for the 'trophies' and capping of the arch. Surviving sketch models (examples in Paris, Louvre and Carnavalet) show that the idea of symbolic trophies had been replaced in Rude's programme by a series of historical allegories, summarizing the different phases of the Revolutionary and Napoleonic wars. However, he finally received the commission for one only of the large stone reliefs. This has since been popularly baptized 'La Marseillaise', but its proper title is the *Departure of the Volunteers in 1792*. It is dominated by a flying female allegory of the Republic, who brandishes her sword while yelling encouragement to the Revolutionary armies. These are represented by six Gallic warriors, surging forward at her bidding, their racial origin indicated by rugged features and long hair rather than by their accoutrements of Classical armour and chain mail. Rude's group, departing though it does from the formula adopted in the three companion reliefs by Jean-Pierre Cortot and Antoine Etex, which are all anchored by a static central figure, nonetheless combines processional and climactic features. Later in the century it was to provide a powerful source of inspiration to Jean-Baptiste Carpeaux and Rodin in their search for emotive effect in monumental compositions.

The Republican theme is not consistently pursued in Rude's other works from this time. Subjects from pre-Revolutionary history were treated by him, as in the marble statue of *Maurice, Maréchal de Saxe* (1836–8; Versailles, Château) and the silver statuette of the *Adolescent Louis XIII* (1840–42; Dampierre, Château), commissioned by Victor, Duc de Luynes. A *Joan of Arc Listening to*

70. François Rude: *Young Neapolitan Fisherboy Playing with a Tortoise*, exh. Salon 1833 (Paris, Musée du Louvre)

her Voices (marble, 1845–52) was originally part of the series of *Great Women of France* in the Luxembourg Gardens, Paris, but was moved in 1890 to the Louvre. The recently shorn head of the visionary shepherdess, and the inclusion of the sheep shears and clippings, bring a potentially 'troubadour' subject dramatically down to earth. In the field of devotional sculpture, Rude's contribution was also far from negligible: from the Romantic pictorialism of his *Baptism of Christ* (marble, 1838–41; Paris, Madeleine), he progressed to a stark medievalism in his bronze *Crucifixion* group (1848–52) for the high altar of St Vincent de Paul, Paris, reminiscent of the 15th-century sculpture of his native Burgundy. On the other hand, his known Republican sympathies increasingly alienated him from the Orléans regime, just as his identification with the Romantic group of sculptors led him to desist from presenting his work at the Salon after 1838, in protest against the Salon juries' rejection of the others. His candidature for membership of the Institut de

France was persistently blocked, and although his teaching style won him a distinct following, with its stress on analytic naturalism, it was known to be of no assistance in gaining the Prix de Rome.

3. Late career, after c. 1845

During the late 1840s, Rude made his most personal profession of political alignment in two works: the tomb of the politician and writer *Godefroi de Cavaignac* (bronze, 1845–7; Paris, Montmartre Cemetery) and *Napoleon Awakening to Immortality* (bronze, 1845–7; Fixin, Parc Noisot). The first took the form of a draped, recumbent effigy of the dead man, holding a pen and a sword. The controversy aroused by this monument resulted in its not being inaugurated until 1856, and then without ceremony. The *Napoleon* was commissioned by a Captain Claude Noisot, a veteran of the Grande Armée, who was devoted to the cult of the Emperor. It was erected with considerable publicity in the patron's picturesque hillside property to the south of Dijon. It is an original and naive popular allegory, representing the Emperor stirring out of his sleep on a rock emblematic of St Helena. The fetters of his captivity are in pieces, but his Imperial eagle is shown lying dead beyond recall. Despite this indication of Rude's anti-Imperial sentiments, his most strident Bonapartist work, the bronze statue of *Maréchal Michel Ney* (Paris, Avenue de l'Observatoire), was inaugurated in 1853, shortly after the establishment of the Second Empire, though the commission had initially been confided to him by the Republican government in 1848. Ney is represented brandishing his sabre and shouting 'Forward!' to his troops. Further commemorations by Rude of subjects associated with the Napoleonic era are the bronze statues of *Général Henri-Gatien Bertrand* (1850–54; Châteauroux, Place Ste Hélène) and of *Gaspard Monge* (1846–9; Beaune, Place d'Armes).

As early as 1839 Rude's marble bas-relief of *Kindness* for the tomb of his master *Pierre Cartellier* (Paris, Père Lachaise Cemetery) had shown a nostalgia for the softness and delicacy of pre-Revolutionary sculpture. His artistic legacy to Dijon—two mythological pieces, *Hebe and the*

Eagle of Jupiter (marble, 1846–57) and *Cupid, Ruler of the World* (marble, 1848–57; both Dijon, Mus. B.-A.), neither of which was completed at the time of his death—exhibits this nostalgia to a degree that has embarrassed Rude's apologists. It nevertheless accords with a wider accommodation of 18th-century style among Second Empire sculptors. The *Cupid* was commissioned by Anatole Devosge (1770–1850), son of his first teacher, and so probably represented for Rude a return to his point of departure in art. After his death, and particularly in his native Burgundy, Rude was exalted as a proletarian yet patriarchal figure, deeply rooted in local tradition. No such stereotype, however, emerges from the informative and scholarly biography by Louis de Fourcaud.

Bibliography

Lami

M. Legrand: *Rude: Sa vie, ses oeuvres, son enseignement* (Paris, 1856)

L. de Fourcaud: *François Rude, sculpteur: Ses oeuvres et son temps* (Paris, 1904)

L. Delteil: *Le Peintre-graveur illustré* (Paris, 1906–26), vi; (R New York, 1969); appendix and glossary, xxxii (New York, 1970)

L. Benoist: *La Sculpture romantique* (Paris, 1928)

Romantics to Rodin: French Nineteenth-century Sculpture from North American Collections (exh. cat., ed. P. Fusco and H. W. Janson; Los Angeles, CA, Co. Mus. A., 1980)

Autour du Néoclassicisme en Belgique, 1770–1830 (exh. cat., ed. D. Coekelberghs; Brussels, Mus. Ixelles, 1985–6)

A. M. Wagner: *Jean-Baptiste Carpeaux: Sculptor of the Second Empire* (New Haven, 1986)

La Sculpture française au XIXe siècle (exh. cat., ed. A. Pingeot; Paris, Grand Pal., 1986)

PHILIP WARD-JACKSON

Sablet

French family of artists of Swiss origin. (1) François Sablet and (2) Jacques Sablet were sons of the painter and picture dealer Jacob Sablet (1720–98). They both studied at the Académie Royale de Peinture et de Sculpture in Paris as pupils of Joseph-Marie Vien, François in 1768–73 and Jacques in 1772–5. Although their careers did not follow a similar course, the attribution of their works has frequently been confused.

(1) (Jean-)François Sablet

(*b* Morges, Vaud, 23 Nov 1745; *d* Nantes, 24 Feb 1819). Painter. Among his early portraits are those of *Charles de Bourbon, Comte d'Artois, as Colonel General of the Swiss and Grison Guards* (1774; ex-Bourbon–Chalus Col., Paris) and *Charles-Henri, Comte d'Estaing* (untraced; engraved by Charles-Etienne Gaucher). He also painted genre scenes, such as *Childhood in the Country* and *Visit to the Wet-nurse* (both untraced; engraved by L. Perrot, *fl* 1786), and mythological scenes (e.g. Stockholm, Nmus.). In 1791 he left Paris for Rome to join his brother. While there he concentrated on landscapes, for example *Gardens of the Villa Borghese* (drawings, Nantes, Mus. B.-A.; Rennes, Mus. B.-A. & Archéol.) and *Landscape at Nemi* (1793; Zurich, priv. col., see 1985 exh. cat., no. 102), also depicting people in local costume (e.g. *Peasant Woman of Genzano*, Lausanne, Pal. Rumine; drawings, Nantes, Mus. Dobrée). In February 1793 he was obliged to leave Rome with the rest of the French community and by October was in Paris as a member of the Revolutionary Commune des Arts. He produced a number of Revolutionary portraits, including *Joseph-Agricol Viala*, *William Tell* and *Lycurgus* (all untraced; engraved by Pierre-Michel Alix), but spent most of his time quietly in Normandy. In 1802 he worked in Paris for the printmakers Francesco Piranesi (1758–1810) and his brother Pietro Piranesi (1773–after 1807). In 1805 he established himself in Nantes, producing small-scale portraits of the city's notables (e.g. Nantes, Mus. Dobrée) with sometimes scathing sincerity. In 1812 he decorated the Bourse in Nantes with six large grisailles depicting the *Visit of Napoleon to Nantes in 1808* (untraced; drawings, Nantes, Mus. Dobrée).

(2) Jacques(-Henri) Sablet

(*b* Morges, Vaud, 28 Jan 1749; *d* Paris, 22 Aug 1803). Painter, draughtsman and printmaker, brother of (1) François Sablet. He trained as a decorative painter in Lyon before his studies in Paris. Thanks

to a grant from the State of Berne, he was able to go to Rome. In 1778 he received a first prize at the Accademia in Parma with the *Death of Pallas* (Parma, G.N.). In 1781, after painting an *Allegory of the Republic of Berne Protecting the Arts* (Berne, Kstmus.), he abandoned history painting for genre scenes; the touching sensibility of such paintings as *A Father's Devotion* (1784; Stockholm, Nmus.) and the *First Steps of Childhood* (1789; Forlì, Municipio) is derived from the writings of Jean-Jacques Rousseau and Salomon Gessner. He collaborated with Abraham-Louis-RodolpheDucros on the publication of a series of Italian costumes in aquatint, providing the drawings from which Ducros made the plates, and himself executed in 1786 a series of etchings of popular characters (see 1985 exh. cat., pp. 100–13). Such paintings as *Popular Entertainments in Naples* (Stockholm, Drottningholms Slott) and *Blind-man's Buff* (Lausanne, Pal. Rumine), remarkable for their life-like expression, luminosity and vivacious colouring, also exemplify his interest in the newly developing taste for such subjects.

Sablet's portraits of his friends, both in the studio and out of doors—*Portrait of an Artist* (1788; Paris, Louvre) and *Conrad Gessner in a Landscape* (1788; Zurich, Ksthaus)—proved so popular that he went on to concentrate on portraits set in a landscape in the English style. He adapted the conversation piece to suit his Roman and cosmopolitan clientele, whose delicate silhouettes he painted against a limpid sky. Such works include *Thomas Hope Playing Cricket* (1792; London, Marylebone Cricket Club); *Princess Anna Maria Borghese Walking with her Sons Camillo and Francesco* (1792; Rome, priv. col., see 1985 exh. cat., no. 26); and the melancholy *Portrait of Two Men in the Protestant Graveyard, Rome* (1791; Brest, Mus. Mun.).

In 1793 Sablet, like his brother, was forced to leave Rome. He went first to Lausanne and then to Paris, where in January 1794 he was received by the Société Populaire et Républicaine des Arts. He exhibited regularly at the Salon, showing Italian costumes, scenes and landscapes, including *Peasant Women of Frascati in a Landscape* (1795; Paris, Louvre), as well as conversation pieces, among them *Portrait of a Family in front of a*

Port (1800; Montreal, Mus. F.A.). He was much praised and patronized by some of the foremost collectors of the day, including Lucien Bonaparte, Prince of Canino, his uncle Cardinal Joseph Fesch and François Cacault. He painted informal portraits of members of the imperial family, *Letizia Bonaparte, Lucien Bonaparte* and his wife *Christine Boyer* (all 1799; Ajaccio, Mus. Fesch). His oil sketch of Napoleon's *coup d'état* on the *18th Brumaire* (1799; Nantes, Mus. B.-A.) provides a rare record of this event. When Lucien Bonaparte was made ambassador in Madrid in 1800, Sablet accompanied him as a member of his entourage. In Spain he painted the portraits of *Lucien Bonaparte at Aranjuez* (1801; Ajaccio, Mus. Fesch) and of his mistress the *Marquesa de Santa Cruz as Venus* (untraced; engraved by Pietro Parboni, fl 1830).

Bibliography

Marquis de Granges de Surgères: *Les Sablet* (Paris, 1888)
Les Frères Sablet (1775–1815) (exh. cat. by A. van de Sandt, Nantes, Musées Dépt. Loire-Atlantique; Lausanne, Pal. Rumine; Rome, Pal. Braschi; 1985)

ANNE VAN DE SANDT

Saint-Jean, Simon

(*b* Lyon, 14 Oct 1808; *d* Ecully, 3 July 1860). French painter and designer. In his youth he attended the studio of François Lepage (1796–1871), a famous Lyonnais flower painter, and the Ecole des Beaux-Arts in Lyon where he was awarded various prizes, culminating in a gold medal in 1826 at the flower design class of Augustin-Alexandre Thierriat (1789–1870). The following year he began exhibiting flower-pieces at the Lyon Salon, including the watercolour *Roses* (Amsterdam, Stedel. Mus.). At this time he was employed by the Didier-Petit textile company, for which he produced floral fabric designs of considerable skill, notably a bouquet of roses depicted with great botanical accuracy against a white background. He was awarded a third-class medal for his oil painting *Flowers in a Hat Hanging from the Branch of an Oak Tree* (Rouen, Mus. B.-A.), at the Paris Salon of 1835. In 1837 he married and his wife's dowry meant that

he could pursue a career as an artist and teacher. A remarkable portrait of her, *The Flower Girl* (Lyon, Mus. B.-A.), was a great success at the Paris Salon of 1838 and was purchased by the State for the Lyon museum. In it he successfully combined the female form with large bouquets of flowers which span the seasons. Jean-Pierre Läys (1825–87), Saint-Jean's servant and pupil, recorded that his master could take two days to paint a single rose. Drawings were, therefore, essential to his working method. Typically, he would submit a small pencil sketch for his client's approval, which would then be worked up into a small oil sketch, and finally an enlarged version.

Saint-Jean worked mainly in Lyon but produced works for patrons in Paris or sold there through the dealer F. Laneuville. By 1845 he could afford to close his teaching studio and rely on commissions. His patrons included Baron Charles Louis Scipion de Corvisart and Richard Seymour-Conway, 4th Marquess of Hertford. The latter bought *Flowers and Grapes* (1844) in 1845 for 6000 francs and commissioned a companion piece (1846; both London, Wallace) through Laneuville for 8000 francs. The high prices commanded by Saint-Jean's works and their relative scarcity meant that by the late 1840s there was a ready market for forgeries. In 1849 he brought a successful legal case against Durand-Ruel, who had sold such a work. The two subsequently became friends and the dealer secured him many major commissions in Russia. In 1851 he was chosen to represent Lyonnais flower design at the Great Exhibition in London.

Bibliography

E. Hardouin-Fugier: 'Simon Saint-Jean et le symbolisme
 végétal', *Bull. Mus. & Mnmts Lyon.*, vi/4 (1977),
 pp. 69–102
——: *Simon Saint-Jean, 1808–1860* (Leigh-on-Sea, 1980)
Fleurs de Lyon, 1807–1917 (exh. cat., Lyon, Mus. B.-A., 1982)
 LESLEY STEVENSON

1772 was admitted to the Académie Royale in Paris, where he was a pupil of Nicolas-Bernard Lépicié between 1776 and 1779. He did not become a member of the Académie and so could not exhibit at the Salon until the French Revolution. He worked for private patrons, producing erotic and pastoral subjects in a style influenced by François Boucher, Jean-Honoré Fragonard and Pierre-Antoine Baudouin; many of these pictures achieved popularity in the form of engravings. His most distinctive paintings are single figures of dancers and young ladies in soft, picturesque landscape settings (e.g. *A Dancer*, Waddesdon Manor, Bucks, NT). In 1793–4 he painted the *Heroism of William Tell* (Strasbourg, Mus. B.-A.) but this politically engaged subject was exceptional in his output. Although he continued to paint erotic scenes such as the *Peeping Toms* (Strasbourg, Mus. B.-A.), his later paintings have a delicate, evocative character that suggests the influence of Pierre-Paul Prud'hon. The moralizing theme and detailed finish of the *False Appearance* (Strasbourg, Mus. B.-A.), which was awarded a prize in the Salon of 1798, demonstrate Schall's ability to adapt both style and content to changing tastes. He also illustrated narrative scenes from historical and literary sources, from which series of prints were made, notably by Charles-Melchior Descourtis. Despite the variety of styles in which he worked, Schall is chiefly of interest as a belated exponent of the Rococo whose work became a major source for the Rococo Revival at the time of his death.

Bibliography

A. Girodie: *Un Peintre de fêtes galantes: Jean-Frédéric
 Schall* (Strasbourg, 1927)
French Painting, 1774–1830: The Age of Revolution (exh.
 cat., ed. P. Rosenberg; Detroit, MI, Inst. A., 1975),
 pp. 603–5
 EMMA BARKER

Schall, Jean-Frédéric

(*b* Strasbourg, 14 March 1752; *d* Paris, 24 March 1825). French painter. He studied at the Ecole Publique de Dessin in Strasbourg *c.* 1768 and in

Schnetz, (Jean) Victor

(*b* Versailles, 14 April 1787; *d* Paris, 16 March 1870). French painter and printmaker. He trained first under Jacques-Louis David and then under Jean-

Baptiste Regnault, Antoine-Jean Gros and François Gérard. He made his début at the Salon in 1808 and exhibited there until 1867. It was in 1819 however that he established his reputation by winning the gold medal for history painting. The following year he exhibited one of his most important paintings, *A Gypsy Predicting the Future of Sixte-Quinte* (1820; untraced). After this there followed a number of paintings on historical and religious subjects such as *General Condé at the Battle of Rocroy* (1824; Versailles, Château), *Eudes, Comte de Paris, Raising the Siege of Paris in 886* (1837; Versailles, Château) and *Procession of Crusaders around Jerusalem the Day Before the Taking of the Town, 14 July 1099* (1841; Versailles, Château). In all these works he took subjects of the type favoured by the Romantics and enhanced their dramatic potential by the dominant use of reds and yellows. The paintings had however an underlying coolness resulting from his Neo-classical training under David, and their main importance lies in this bridging of the two schools of Romanticism and Neo-classicism.

Schnetz was the Director of the Académie de France in Rome from 1840 to 1847, a post in which he proved so popular with the students that he was reappointed in 1852, holding the post until 1865. This long association led to a number of paintings set in Italy such as *Episode from the Sacking of Aquileia by Attila in 452* (1845; Amiens, Mus. Picardie) and the *Funeral of a Young Martyr in the Catacombs of Rome at the Time of the Persecution* (1848; Nantes, Mus. B.-A.). Schnetz was also responsible for several public works such as *Battle at the Hôtel de Ville, 29 July 1830* (1834) for the Hôtel de Ville in Paris, destroyed in the fire of 1871. For the Louvre he painted the ceiling representing *Charlemagne Receiving Alcuin* (Salon of 1833). His painting *St Martin Cutting his Cloak to Give Half to a Beggar* (1824) was destined for the cathedral at Tours and the *Vow to the Madonna* (1831) for St Etienne-du-Mont in Paris (now Paris, Louvre). He also painted *Ste Geneviève Distributing Provisions during the Siege of Paris* (1822) for Notre-Dame de Bonne-Nouvelle in Paris, as well as providing decorations for Notre-Dame de Lorette and St Séverin in Paris. Schnetz

was made a member of the Académie des Beaux-Arts in 1837 and a member of the Légion d'honneur in 1843.

Bibliography
Hoefer
P. Larousse: *Grand Dictionnaire universel du XIXe siècle*, xiv (Paris, 1875), p. 368
H. Marcel: *La Peinture française au XIXe siècle* (Paris, 1905), pp. 120–22
A. Soubies: *Les Membres de l'Académie des beaux-arts*, ii (Paris, 1905–17), pp. 183–5

□

Sergent-Marceau [Sergent], Antoine-Louis-François

(*b* Chartres, 9 Oct 1751; *d* Nice, 15 July 1847). French printmaker, writer, translator and politician. He showed an early talent for drawing and after taking up engraving travelled to Paris to improve his technique. After studying under Augustin de Saint-Aubin for three years, he returned to Chartres where he produced engravings and caricatures. His first major work was the *Galerie des grands hommes, des femmes illustres et sujets mémorables de l'histoire de France* (Paris, 1787–91), a collection of coloured plates. He was a zealous Republican and during the Revolution held a number of important posts: secretary of the Jacobin club, he was also in charge of police administration and was a member of the National Convention. He was consequently involved in a number of unpleasant episodes though, to his credit, he did rescue many individuals from arbitrary execution and made strenuous efforts to save threatened works of art. As a member of the committee for the arts and public instruction, he renovated the Jardin des Tuileries, founded the Musée Français (27 July 1793), and ordered the erection of a statue of Jean-Jacques Rousseau. In 1795 he was accused of inciting revolt and fled to Switzerland for a month until the amnesty of 4 October 1795. At the Salon of 1798 he exhibited *Gén. Marceau* (1798; Paris, Carnavalet), an engraved colour portrait of his wife's brother. In 1803 he was forced to flee again, this time to Italy,

and until 1809 he lived in Venice, Padua and Verona. During this period he worked on *Le Tableau de l'univers et des connaissances humaines*, which was to have had 300 coloured plates but was never finished. From 1809 to 1816 he lived in Brescia, where he produced *Costumi dei popoli antichi e moderni* (Milan and Brescia, 1813), an illustrated work on dress. From 1816 to 1830 he was in or near Milan, and after a brief stay in Turin he settled in Nice following the 1830 Revolution in France. His writings were mainly responses to current political events, though some, such as *Notices historiques sur le général Marceau* (Milan, 1820), were less topical. He also translated Filippo Pistrucci's *Iconologie* (Milan, 1821) and Filippo Aurelio Visconti's *Monuments du Musée Chiaramonti* (Milan, 1822).

Bibliography

Michaud

N. Parfait: *Notice biographique sur Antoine-François Sergent* (Paris, 1848)

H. Herluison and P. Leroy: *Notice sur Sergent-Marceau, peintre et graveur* (Paris, 1898)

□

Seurre

French family of sculptors. The brothers Bernard-Gabriel Seurre (*b* Paris, 11 July 1795; *d* Paris, 3 Oct 1867) and Charles-Emile Seurre (*b* Paris, 22 Feb 1798; *d* Paris, 11 Jan 1858) were pupils of Pierre Cartellier and winners of the Prix de Rome. They distinguished themselves in Paris as monumental sculptors during the July Monarchy (1830–48), making noteworthy contributions in particular to the iconography of the Napoleonic legend. Bernard-Gabriel did so through his reliefs on the Arc de Triomphe. His section of the frieze, the *Return of Napoleon's Armies from Italy* (marble, 1833–6), and his panel, the *Victory of Aboukir* (marble, 1833–6), combine classical clarity with a wealth of local colour. Charles-Emile Seurre was responsible for one of the more human images of the Emperor, *Napoleon I in a Greatcoat* (bronze, 1831–3), for the Vendôme Column. This was removed in 1863 and, after being thrown into the

Seine in 1871, was finally installed in 1911 in the courtyard of the Invalides.

Bibliography

Lami

La Sculpture française au XIXe siècle (exh. cat., ed. A. Pingeot and others; Paris, Grand Pal., 1986)

PHILIP WARD-JACKSON

Sigalon, (Alexandre-François-)Xavier

(*b* Uzès, 12 Dec 1787; *d* Rome, 18 Aug 1837). French painter. He was one of eleven children of a poor schoolmaster, living first in Uzès and later in Nîmes. After a long struggle to raise enough money to study in Paris, Sigalon studied in 1818 for a short period with Pierre Guérin; however, he was largely self-taught. He first exhibited at the Salon of 1822 in Paris with a *Young Courtesan* (Paris, Louvre), which was bought by the government for 2000 francs as a sign of encouragement. At the Salon of 1824 he exhibited his most successful painting, *Locusta, Giving Narcissus the Poison Destined for Britannicus, Tests it on a Young Slave* (Nîmes, Mus. B.-A.), which was awarded a gold medal and was often linked by critics to Delacroix's *Scenes from the Massacres at Chios* (Paris, Louvre) and Ary Scheffer's *Gaston de Foix Dying on the Battlefield after his Victory at Ravenna* (Versailles, Château), both of which were exhibited at the same Salon. All three are large history paintings, which, at that Salon, deliberately challenged the concept of ideal beauty, emphasizing instead physical ugliness, where expressive requirements demanded it, and the non-heroic aspects of the narratives. Sigalon's painting, inspired by Jean Racine's play *Britannicus* (1699), shows a scene of hideous violence, dramatizing the poisoner by making her an ugly harridan, instead of the graceful figure revealed in the preliminary oil sketch (Nîmes, Mus. B.-A.).

By 1825 Sigalon seemed poised for artistic success; he received commissions for three large altarpieces during this period, the *Baptism of Christ* (1829; Nîmes Cathedral), the *Vision of St Jerome* (1825; Châteaurenard, St Etienne) and

Christ on the Cross (1828; Yssingeaux, St Pierre). The latter two paintings were exhibited at the Salon of 1831 and won Sigalon the Légion d'honneur. These were his last significant official commissions, because the reception of his colossal painting Athalie Having her Children Massacred (Nîmes, Mus. B.-A.) at the Salon of 1827 was a critical disaster from which Sigalon never recovered. Proud and obviously sensitive about his insecure background, he withdrew in bitterness to Nîmes. His friend, the critic Adolphe Thiers, attempted to ameliorate Sigalon's near-destitute condition by securing him a commission to copy the ceiling of the Sistine Chapel (Vatican, Rome); the last work that Sigalon completed was a copy (1837; Paris, Ecole N. Sup. B.-A.) of Michelangelo's Last Judgement from the Sistine Chapel.

Bibliography

A. Thiers: Le Constitutionnel (30 Aug 1824); Le Globe (30 Sept 1824)

C. Blanc: 'Xavier Sigalon', Histoire des peintres, iii: Ecole française (Paris, 1865), pp. 1–8

E. Bosc: 'Xavier Sigalon: Notes biographiques', Nouv. Archv A. Fr. (1876), pp. 420–51

L. Giron: 'Le Christ en Croix par Xavier Sigalon', Réun. Soc. B.-A. Dépts, xvii (1893), pp. 280–86

P. Clauzel: 'Sigalon (Xavier) peintre d'histoire (1788–1837)', Réun. Soc. B.-A. Dépts, xxiv (1900), pp. 594–607; 'Note rectificative', Réun. Soc. B.-A. Dépts, xxv (1901), pp. 731–5 [establishes date of birth]; 'Documents inédits', Réun. Soc. B.-A. Dépts, xxxi (1907), pp. 199–205

J. Foucart: 'Xavier Sigalon', French Painting, 1774–1830: The Age of Revolution (exh. cat., ed. F. Cummings and others; Paris, Grand Pal., 1975), pp. 611–15 [only account of Sigalon in Eng.]

M. Frèrebeau: 'Xavier Sigalon: Rival de Delacroix', Gaz. B.-A., n. s. 6 (1977), pp. 17–26

DORATHEA K. BEARD

Signol, Emile

(b Paris, 6 April 1804; d Montmorency, nr Paris, 4 Oct 1892). French painter. He was admitted to the Ecole des Beaux-Arts in Paris in 1820 on the recommendation of Merry-Joseph Blondel and entered the studio of Antoine-Jean Gros in 1821. In 1830 he won the Prix de Rome for his Meleager Taking up Arms Once More at the Insistence of his Wife (Paris, Ecole N. Sup. B.-A.). As a pensionnaire at the Villa Medici in Rome from 1831 to 1835 he demonstrated a capacity for absorbing new sources into his art. He gained particularly (as did Friedrich Overbeck) from his discovery of the Italian 'Primitives', including Giotto, Fra Angelico and Perugino among others, during a period spent in Florence and Assisi in 1833 and soon became one of the most interesting religious painters of his generation.

A number of Signol's works are equal to the best works of the Nazarene school, including Christ in the Tomb (1834; untraced), which depicts Christ watched over by the figure of Religion while awaiting his resurrection, Awakening of the Just, Awakening of the Wicked (1835; Angers, Mus. B.-A.), in which his depiction of the Last Judgement emphasizes the joys of the blessed, and the Christian Religion Comes to the Aid of the Afflicted and Gives them Resignation (exh. 1837) in the church of Lubersac. Their distinctive Nazarene features included a Pre-Raphaelite air, an understanding of Christian symbolism, and references to the theology of Espérance then propounded in France by Henri Lacordaire, Charles-Forbes-René, Comte de Montalembert, Antoine-Frédéric Ozanam and others.

These works were successful, though, arguably, Signol's mature oeuvre surpassed them. His numerous later paintings include: the two panels of The Adultress (exh. 1840 and 1842; Paris, Louvre; Detroit, MI, Inst. A.), the Taking of Jerusalem (1099) (exh. 1848; Versailles, Château), the Crusaders Crossing the Bosphorus (exh. 1855; Versailles, Château)—Christian versions of historical dramas were extremely popular during the 1850s—the Holy Family (exh. 1859) in the church at Bény-sur-Mer and the Four Evangelists (1867) in the church of St Augustin, Paris. Signol's mature works are best represented by his mural paintings executed in wax and/or in oils for various churches in Paris. These murals are: the Death of St Mary Magdalene (1841) in La Madeleine, Christ between SS Louis and Francis (1841) in St Louis-d'Antin, the Marriage of the Virgin and the Flight into Egypt (both 1847) in

St Séverin, *Christ among the Doctors* and *Christ Blessing the Little Children* (both 1853) in the chapel of the Catechism in St Eustache, the *Road to Calvary*, the *Crucifixion*, the *Entombment* and the *Resurrection* (all 1860) in the transept of St Eustache, the *Kiss of Judas*, the *Crucifixion* (both 1872), the *Resurrection* and the *Ascension* (both 1876), all in St Sulpice.

Signol's compositions were in effect an increasingly vehement form of protest against the developments of his century. This protest was expressed through the radical classicism of his pictures (with their monumental layout, the sculptural and geometrical strength of their forms, the concentrated action and balance of warm and cold tones) as well as in his clearly articulated choice of scenes emphasizing the 'greatness of Jesus'.

Bibliography

Bénézit; Thieme–Becker

C.-F.-R. Montalambert: *Du vandalisme et du catholicisme dans l'art (fragmens)* [sic] (Paris, 1839), p. 179

C. Lavergne: *Restauration de l'église S.-Eustache* (Paris, 1856), pp. 20–21

Ernestine Signol: *Souvenirs* (Paris, 1893)

L. O. Merson: *Notice sur la vie et les oeuvres de M. Emile Signol* (Paris, 1899) [given at the Académie des Beaux-Arts, 25 Feb 1899]

M. Denis: *Théories* (Paris, 1912, 4/1920), pp. 101, 111–12

——: *Histoire de l'art religieux* (Paris, 1939), p. 269

M. Caffort: 'Un Français nazaréen: Emile Signol', *Rev. A.* [Paris], lxxiv (1986), pp. 47–53

——: L'Evolution de la peinture religieuse en France et les modèles du seicento', *Seicento: La Peinture italienne du XVIIe siècle et la France* (Paris, 1990), pp. 358–72

——: 'Rigorisme, liguorisme et iconographie chrétienne dans la France de la première moitié du XIXe siècle (l'exemple de la peinture)', *Peinture et vitrail au XIXe siècle: Lyon, 1990*

——: 'Renouveau pictural et message spirituel: L'Exemple des Nazaréens francais', *Cristianesimo nella storia*, 14 (1993), pp. 595–623

MICHEL CAFFORT

Simart, Pierre-Charles

(*b* Troyes, 27 June 1806; *d* Paris, 27 May 1857). French sculptor. Despite the opposition of his family, who were joiners in Troyes, he was enabled to go to Paris to study sculpture by a municipal grant in 1823. This aid and that of the prominent Marcotte family from Argenteuil-sur-Armançon supported him while studying with Antoine Desboeufs (1793–1852), Charles Dupaty (1771–1825) and then Jean-Pierre Cortot. In 1831 Simart first exhibited at the Salon, showing *Coronis Dying* (marble; Troyes, Mus. B.-A.), a work in which a sentimental, melancholic sensibility shows through despite his strictly Neo-classical training. The following year he accompanied James Pradier to Italy, and in 1833 he won the Prix de Rome. During the ensuing stay at the Académie de France in Rome the supervision of Ingres, whom he had already met in Paris, curbed Simart's Romantic tendencies. Under Ingres's influence he produced his harmonious, restrained masterpiece *Orestes Taking Refuge at the Altar of Athena* (marble, 1838; Rouen, Mus. B.-A.), which was acclaimed at the Salon of 1840; Ingres called it 'the most beautiful sculpture of modern times'.

After his return to France in 1839 Simart's career developed rapidly, with important public and private commissions. From 1841 he worked alongside Ingres on the decoration of the château of Dampierre, Yvelines, for Albert, Duc de Luynes; first on a series of marble bas-relief friezes depicting *The Golden Age* and *The Iron Age* (1841–3; *in situ*), then on a chryselephantine reconstruction of the *Athena Parthenos* (1846; *in situ*) to stand before Ingres's mural of *The Golden Age*. In this reconstruction he was guided by the archaeological ideas of his patron and assisted by the architect Félix Duban and the goldsmith Edmond Duponche: it was ill-received when shown at the Exposition Universelle in Paris in 1855, but is notable for the graceful bas-relief of *Pandora Receiving the Gifts of the Gods* which decorates the pedestal.

Simart's most successful works were bas-reliefs, such as the series showing the *Story of Orpheus* (1844) for the Paris home of Gabriel de Vandeuvre (*in situ*; plaster models, Troyes, Mus. B.-A.). His reliefs for the tomb of *Napoleon* in the crypt of the church of the Invalides, Paris (marble, *c.* 1850–53; *in situ*) suffer from cramped positioning: the polychromed plaster models (1846–7; Troyes,

Mus. B.-A.) better demonstrate the sculptor's assimilation of the Parthenon friezes. The problem of transcribing the sobriety and elegance of his models on to a monumental scale also besets his ceiling for the Salon Carré in the Louvre (stucco, 1849–51; *in situ*) and his pedimental sculpture (stone, 1855; *in situ*) for the Pavillon Denon, there. Simart succeeded Pradier at the Institut de France in 1852. His early death was due to an accident.

Bibliography

Lami

G. Eyries: *Simart, statuaire, membre de l'Institut: Etude sur sa vie et sur son oeuvre* (Paris, [before 1860])

A. Le Normand: *La Tradition classique et l'esprit romantique* (Rome, 1981), pp. 251–8

J. P. Boureux: Les Sculptures du XIXe siècle dans le département de l'Aube', *Vie Champagne*, 324 (1982), pp. 19–21

P. Durey: 'La Tombeau de Napoléon Ier aux Invalides', *La Sculpture française au XIXe siècle* (exh. cat., ed. A. Pingeot; Paris, Grand Pal., 1986), pp. 126–82

PHILIPPE DUREY

Steinheil, Louis-Charles-Auguste

(*b* Strasbourg, 26 July 1814; *d* Paris, 16 March 1885). French painter, designer, illustrator and glazier. A pupil of the history painter Henri Decaisne (1759–1852) and of the sculptor David d'Angers, and brother-in-law of the painter Ernest Meissonier, he made his début at the Salon of 1836 in Paris with a genre painting, *Consolation* (untraced); he exhibited there annually until 1855. During the same period he illustrated a number of novels, including Bernardin de Saint Pierre's *Paul et Virginie* (Paris, 1838) and Victor Hugo's *Notre-Dame de Paris* (Paris, 1844), and religious books.

In 1839 Steinheil provided the architect Jean-Baptiste-Antoine Lassus with a cartoon, depicting the *Passion*, for one of the first antiquarian stained-glass windows in France, installed in the Chapelle de la Vierge in St Germain-l'Auxerrois, Paris. It established his reputation among architects and scholars who were eager to rediscover and reintroduce the religious art and artistic techniques of the Middle Ages. Steinheil devoted most of his energies to producing drawings and cartoons, based on original medieval and Renaissance examples but modernized to make them more accessible to contemporary taste. As a result he became one of the most sought after painters of cartoons on all subjects, and he was appointed a member of the Commission des Monuments Historiques. He used his skills to restore the stained-glass windows in Sainte-Chapelle, Paris (1849–55), for which he also produced plans for mural paintings (1855). His major mural designs are in the Chapelle St-Georges (1862) in Notre-Dame, Paris; in the Sacré-Coeur chapel (1866) in Amiens Cathedral, jointly with Théodore Maillot (1826–88); and in the St-Joseph chapel (1872) in Limoges Cathedral. He made designs for sculpture, especially for Adolphe-Victor Geoffroy-Dechaume, also a pupil of David d'Angers, for St Germain-l'Auxerrois (1838) and later for the bronze doors (1872–9) of the main portal of Strasbourg Cathedral, which were inspired by the original doors of 1343. One of his cartoons, *St Agnes*, was produced as a tapestry by the Manufacture des Gobelins (1875–6; Paris, Mobilier N.).

In the restoration of medieval stained glass Steinheil's main task was to provide cartoons to replace missing sections, although because of his training as a master glazier he was able to participate very directly in the practical restoration work. He worked in nearly all the major workshops involved in restoration, together with the most famous craftsmen, including Nicolas Coffetier (1821–84) at Bourges Cathedral (from 1853), Le Mans Cathedral (1858–75) and Chartres Cathedral (1868–83) and Baptiste Petit-Gérard (1811–71) at Strasbourg Cathedral (1847–70). Steinheil also supervised the local master glaziers at Angers Cathedral (1855) and Auxerre Cathedral (from 1866). Working with Coffetier, Steinheil at times overcame the constraints of designing archaeologically accurate stained glass: for example, in the four stained-glass windows representing the *Life of the Virgin* in St-Bonaventure, Lyon (1854–5), he chose the form of a stained-glass tableau extending over the whole bay; and in the series at

Notre-Dame, Paris, that depicts the *Life of St Geneviève* (1860–65), his design and colours recall Pre-Raphaelite painting.

His son, Adolphe-Charles-Edouard Steinheil (1850–1908), was a painter and stained-glass artist.

Bibliography

Bénézit; Thieme–Becker

J. Taralon: 'De la Révolution à 1920', *Le Vitrail français* (Paris, 1958), pp. 277–8

CATHERINE BRISAC

Stouf, Jean-Baptiste

(*b* Paris, 5 Jan 1752; *d* Charenton-le-Pont, Marne, 30 June 1826). French sculptor. He was a pupil of Guillaume Coustou, and although he won only second place in the Prix de Rome competition of 1769 he left for Rome, where he was allowed to study at the Académie de France. On his return to Paris in 1776 he was approved (*agréé*) by the Académie Royale in 1784 and received (*reçu*) as a full member in 1785 on presentation of the statue *Abel Dying* (marble; Paris, Louvre), a work distinguished by its acute sensibility.

Stouf's extant work appears contradictory. Very few low reliefs and terracotta models that he regularly exhibited at the Salon have been traced; these include a terracotta group (Detroit, MI, Inst. A.) usually identified with the group *Hercules Fighting the Centaurs* shown at the 1785 Salon and a model (terracotta, exh. Salon 1791; Paris, Mus. A. Déc.) for a monument to *Jean-Jacques Rousseau*. The latter is a curious production, stemming from his participation in the Revolution, that shows an affably uninspired bust of the writer encircled by lachrymose symbolical figures. Stouf's fame, however, was made by his marble statue of *St Vincent-de-Paul* (exh. Salon 1798; Paris, Hôp. St-Vincent-de-Paul), originally commissioned in 1786 by the Comte d'Angiviller, Directeur des Bâtiments du Roi, for the series of statues of 'Illustrious Frenchmen' intended to decorate the Grande Galerie of the Louvre. This figure of a saint advancing with a weeping orphan wrapped in his cloak and a dead child at his feet was frequently reproduced as an image of philanthropic piety in 19th-century France.

Stouf followed this success with an 'Illustrious Frenchman' commissioned by the Republic, *Montaigne* (marble, exh. Salon 1800; Paris, Louvre), and further marble statues sharing *St Vincent's* clarity of conception: *André Grétry* (erected in the vestibule of the Opéra Comique, 1809; now New York, Met.), a work whose qualities look back to Augustin Pajou, and *Suger, Abbé de St Denis* (exh. Salon 1817; in front of the abbey of St Bertin, Saint-Omer), whose accentuated gestures and drapery seem to foreshadow the work of such Romantic sculptors as Pierre-Jean David d'Angers. During the Empire (1804–15) Stouf received some official commissions, such as a bust of *Lavoisier* for the Galerie des Consuls in the Tuileries (exh. 1801; Versailles, Château) and low reliefs (*in situ*) for the Colonne de la Grande Armée, Place Vendôme, Paris, but his style did not distinctively identify with the Empire, a marble bust shown at the Salon in 1814, *Affliction* (probably the sculpture now in the Musée du Louvre, Paris; already presented in 1789 and 1791), is, rather, a traditional 18th-century image, reminiscent of the paintings of Jean-Baptiste Greuze.

Bibliography

Lami

P. Vitry: 'Les Monuments à J.-J. Rousseau de Houdon à Bartholomé', *Gaz. B.-A.*, ii (1912), pp.106–7

M. Furcy-Raynaud: *Inventaire des sculptures exécutées au XVIIIème siècle pour la direction des bâtiments du roi* (Paris, 1927), pp. 349–53

J. D. Draper: 'A Statue of the Composer Grétry by Jean-Baptiste Stouf', *Bull. Met.* (1970), pp. 377–87

La Révolution française et l'Europe (exh. cat., Paris, Grand Pal., 1989), pp. 889–91 [entries by G. Scherf]

GUILHEM SCHERF

Swebach [Fontaine; Swebach-Desfontaines], Jacques-François(-Joseph)

(*b* Metz, 19 March 1769; *d* Paris, 10 Dec 1823). French painter and engraver. After being taught the rudiments of drawing by his father, the painter, sculptor and engraver François-Louis Swebach, he left Metz for Paris where he studied

under Michel H. Duplessis (*fl* 1780–99). By 1788 Jacques-François had gained a certain reputation for his paintings and drawings of soldiers and horses. He exhibited at the Salon between 1791 and 1823 and received a medal in the Salon of 1810. Between 1802 and 1813 he was Premier Peintre at the Sèvres porcelain factory and was involved in the decoration of several services. Until *c.* 1808 he painted landscapes in collaboration with the French painter Georges Michel (*see* MICHEL, GEORGES). From 1815 to 1820 he worked in St Petersburg for Tsar Alexander I as Premier Peintre to the imperial porcelain factory but continued to send small paintings to the Salon. He enjoyed the favour of critics, who praised his pictures as being full of 'wit and refinement' and described him as the 'Wouwerman of our time'. Apart from a few official commissions, such as the *Cavalcade and Drive in Barouches* for the Château de Malmaison (1800; Montpellier, Mus. Fabre), he worked for private collectors, who prized his small paintings for the accuracy in the depiction of horses, the proliferation of detail and anecdotes, the precise drawing and the bright colours. He was condemned by his success to repeat the same pictures to please his clients: hunting scenes and horse markets (e.g. Metz, Mus. A. & Hist.), military convoys and skirmishes (e.g. *Cavalry Attack*, Abbeville, Mus. Boucher-de-Perthes; *The Skirmish*, Dijon, Mus. Magnin; and *Charge of the Hussars*, Lyon, Mus. B.-A.). He was a rival of Jean-Louis Demarne in the representation of such scenes, set in brilliantly lit landscapes and portrayed with a precision and naivety reminiscent of Nicolas-Antoine Taunay, although less poetic. He could depict narrative and characterize small group scenes with humour, somewhat in the manner of Louis-Léopold Boilly.

Swebach also produced many engravings: he participated in the *Complete Collection of Historical Scenes of the French Revolution* (1802) and engraved the *French Campaign under the Consulate and the Empire: Album of 52 Battles and 100 Portraits of Marshals*. He collected his graphic work in the *Picturesque Encyclopaedia* (1806).

Bibliography

H. Béraldi: *Les Graveurs du XIXe siècle* (Paris, 1892), xii, p. 66

F. Benoit: *L'Art français sous la Révolution et l'Empire* (Paris, 1897), pp. 352–9

E. André: 'Swebach-Desfontaines', *Gaz. B.-A.*, ii (1904), pp. 376–8, 490–99

A. V. W. Wellington: 'Two War Artists under Napoleon and the Tsar: Aleksandr Ivanović Sauerweid and Jacques-François-Joseph Swebach', *Connoisseur*, cxciii (Dec 1976), pp. 300–09

D. Ledoux-Lebard: 'La Campagne de 1805 vue par la manufacture impériale de Sèvres', *Rev. Louvre*, xxviii (1978), pp. 178–85

MARIE-CLAUDE CHAUDONNERET

Tassaert, (Nicolas-François-)Octave

(*b* Paris, 26 July 1800; *d* Paris, 24 April 1874). French painter and printmaker, son of engraver Jean-Joseph-François Tassaert (1765–*c*. 1835). As a child he worked with his brother Paul Tassaert (*d* 1855), producing engravings, but he later turned to painting and from 1817 to 1825 studied at the Ecole des Beaux-Arts in Paris, first under Alexis-François Girard (1787–1870) and then Guillaume Lethière. In 1823 and 1824 he tried unsuccessfully to win the Prix de Rome, an early failure that greatly disheartened him. For much of his career, until 1849, he continued to work in the graphic arts, as well as painting, producing lithographs and drawings on various subjects: historical scenes from the First Empire, portraits, and mythological and genre scenes. He also produced illustrations for the Romantic novels of Victor Hugo, Alexandre Dumas *père* and François-René Chateaubriand. Though he achieved moderate success at the Salon, it was the graphic work that provided his small income during this period. His impoverished lifestyle is reflected in the gloomy painting *Corner of the Artist's Studio* (1845; Paris, Louvre), which depicts a shabbily dressed young artist peeling potatoes to make a modest meal.

Tassaert's first success at the Salon came in 1834 with the painting of the *Death of Correggio* (1834; St Petersburg, Hermitage), which was bought by Ferdinand-Philippe, Duc d'Orléans. It was inspired by the fictitious story that Correggio

had died after contracting a fever caused by his carrying a large weight of copper received in payment for one of his paintings. Tassaert also painted other historical works, such as *Funeral of Dagobert at Saint-Denis, January 638* (exh. 1838; Versailles, Château), and such religious works as the *Communion of the First Christians in the Catacombs* (exh. 1852; Bordeaux, Mus. B.-A.).

It was, however, as a genre painter that Tassaert achieved real success, with a series of works depicting the widespread poverty and misery of Paris. The most famous of these, and all of his works, was the *Unhappy Family* (1849–50; Paris, Louvre), which he was commissioned to paint by the State after his plea of poverty had been sympathetically heard by the Director of the Musées Nationaux, Philippe-Auguste Jeanron. It was inspired by Lammenais's romantic novel *Paroles d'un croyant* and depicted a destitute mother and daughter committing suicide, an increasingly common real-life occurrence at this time. The work was praised at the 1850–51 Salon, where it was described as being in the style of Jean-Baptiste Greuze and Pierre-Paul Prud'hon, and Tassaert was asked to paint four replicas. In the same vein were his pictures of poor children, garret scenes and views of Parisian backstreet life, subjects that earned him his nickname of 'the Correggio of the attic' and 'the Prud'hon of the suburbs'.

At the Exposition Universelle in Paris of 1855 Tassaert's work was well received and in particular prompted a lengthy and favourable review from Théophile Gautier. Other admirers of his work included Eugène Delacroix and Alexandre Dumas *fils*. Despite this encouragement Tassaert became increasingly misanthropic and disgusted with the art world, exhibiting nothing after the Salon of 1857. He became an alcoholic and in 1863 sold 44 of his works to the art dealer Père Martin for a mere 2400 francs and a crate of wine. Close to blindness and in poor health, he moved to Montpellier in 1865 but soon returned to Paris, where he remained until his suicide by asphyxiation. Alexandre Dumas *fils* paid for his body to be conveyed to the cemetery of Montparnasse. His reputation waned swiftly, and his work now seems sentimental and melodramatic.

Bibliography

J. Claretie: *Artistes décédés de 1870 à 1880*, i of *Peintres et sculpteurs* (Paris, 1882), pp. 24–8

B. Prost: *Octave Tassaert: Notice sur sa vie et catalogue de son oeuvre* (Paris, 1886)

The Realist Tradition: French Painting and Drawing, 1830–1900 (exh. cat. by G. P. Weisberg, Cleveland, OH, Mus. A.; New York, Brooklyn Mus.; St Louis, MO, A. Mus.; Glasgow, A.G. & Mus.; 1980–81), pp. 44–7, 94–5, 157–8, 164–5

Taunay, Nicolas-Antoine

(*b* Paris, 11 Feb 1755; *d* Paris, 20 March 1830). French painter. He was the son of Pierre-Henri Taunay (1728–81), a painter–enameller at the Sèvres factory, and entered the studio of Nicolas-Bernard Lépicié at the age of 13. Later he worked in the studios of Nicolas-Guy Brenet and Francesco Casanova. With a group of friends that included Jean-Louis Demarne, Lazare Bruandet and Jean-Joseph-Xavier Bidauld, he made trips to the forests of Saint-Germain, Fontainebleau and Compiègne to learn to draw directly from nature. He visited the Dauphiné and Switzerland in 1776 with Demarne. That same year he made vignette illustrations for an erotic book, *Journée de l'amour* by Charles-Simon Favart (1710–92) and others. Taunay exhibited landscape paintings at the Salon de la Jeunesse in 1777 and 1779 and at the Salon de la Correspondance in 1782.

He was approved (*agréé*) by the Académie Royale in 1784, but he never became a full member. Neither did he win the Prix de Rome, but the patronage of Joseph-Marie Vien, the director of the Académie de France in Rome, enabled him to study in Rome in 1784–7; he also made brief visits to Naples and Sicily. From 1787 to 1827 he exhibited regularly at the Salon, showing not only landscapes with figures but also scenes from history, religion and myth, as well as pure genre scenes. He was in addition an accomplished portrait painter, as shown by his portrait of the flower painter *Cornelis van Spaendonck* (Versailles, Château).

In 1791 Taunay was awarded a first prize for genre painting in the Prix d'Encouragement competition, and in 1793 he exhibited the *Capture of a Town* (Nice, Préfect.) at the Salon. This painting, measuring only 0.81×1.00 m, depicts a medieval battle with menacing horsemen and a procession of prisoners emerging from a smoke-filled background of military defeat. Possibly it was intended to convey criticism of the war, destruction and exile that the French Revolution was causing. Both in their medievalizing subject-matter and in their smooth, polished technique (they were often painted on panel), Taunay's works of this kind were forerunners of the Troubadour style. He became a member of the Institut, which replaced the Académie Royale, at its foundation in 1795. At the 1798 Salon he exhibited the *Exterior of a Provisional Military Hospital* (Versailles, Château), a work that illustrates the misfortunes of war in a picturesque manner reminiscent of Dutch 17th-century genre painting.

In 1801 Taunay contributed to an edition of the plays of Racine by Pierre Didot, illustrating *Les Plaideurs*. During the Empire, through the influence of the Empress Josephine, Taunay received many commissions from Napoleon Bonaparte for battle pictures. These also presented their subjects in an unheroic, anecdotal and domestic way. In the *French Army Crossing the St Bernard Pass* (1808; Versailles, Château), an anonymous wounded French soldier is being cared for by a group of mountain folk; it is a night scene in which the warm, orange glow of a fire is offset against a colder, grey landscape, demonstrating to the full Taunay's talents as a colourist.

In January 1816 Nicolas Taunay, with his brother, the sculptor Auguste-Marie Taunay (1768–1824), went to Brazil to help found an Academy of Fine Arts in Rio de Janeiro. His work in Brazil includes the painting *Santo António Hill* (1816; Rio de Janeiro, Mus. N. B.A.). He returned to France in 1821 and was made a member of the Légion d'honneur in 1824. Among his later pictures are *St John the Baptist Preaching* (1818; Nice, Préfect.) and *Henry IV and Sully* (1822; Evreux, Mus. Evreux).

Bibliography

Thieme–Becker

A. d'Escragnolles-Taunay: 'Nicolas-Antoine Taunay', *Rev. Inst. Hist. & Geog. Bras.*, lxxvii/2 (1916)

De David à Delacroix: La Peinture française de 1774 à 1830 (exh. cat., Paris, Grand Pal.; Detroit, MI, Inst. A.; New York, Met.; 1974–5), pp. 619–21

P. Bordes and R. Michel, eds: *Aux Armes et aux arts! Les Arts de la Révolution, 1789–1799* (Paris, 1988), pp. 48, 78–9

La Révolution française et l'Europe: 1789–1799 (exh. cat., Paris, Grand Pal., 1989), pp. 503, 834–5, 848

VALERIE MAINZ

Traviès, (Charles) Joseph

(*b* Wülflingen, Switzerland, 21 Feb 1804; *d* Paris, 13 Aug 1859). French caricaturist and painter of Swiss birth. His family appears to have settled in France by 1809. He lived among the poor, the rag-pickers and the workers of the outlying districts of Paris, sharing their pleasures and miseries. He worked in the manner of Nicolas-Toussaint Charlet, Jean-Ignace-Isidore Gérard and Daumier, and supplied the periodicals *La Caricature* and *Charivari* with their most powerful prints on political subjects. He used his successful character, the hunchback dwarf Mayeux, to caricature violently the Republican petit-bourgeois, depicting him as a braggart, a liar and a sensualist (see Ferment, p. 67). Traviès was the Republican caricaturist who best expressed the working-class sense of having been betrayed by the bourgeoisie, who had 'confiscated' their revolution of 1830.

Traviès espoused Socialism's most radical causes, those of Jean Journet and Flora Tristan. His first lithographs appeared in 1822. Most of his output dates from 1830–35 (*Charivari*'s best period) and from 1839–45; in the latter works he displays the same political commitment and a better grasp of lithography. He executed more than 600 lithographs. After 1845 he tried unsuccessfully to become a painter: he exhibited at the 1848 and 1855 Salons and received a state commission for a version of *Christ and the Woman of Samaria* in 1853. Nothing remains of these attempts, and he died in poverty in his Paris studio.

Unpublished sources

Paris, Bib. N., Cab. Est., cote Yb3 2774 [typed cat. of Traviès's lithographs by C. Ferment]

Bibliography

C. Ferment: 'Le Caricaturiste Traviès: La Vie et l'oeuvre d'un "prince du guignon"', *Gaz. B.-A.*, n. s. 6, xcix (1982), pp. 63–78

The Charged Image: French Lithographic Caricature, 1816–1848 (exh. cat. by B. Farwell, Santa Barbara, U. CA, Mus. A., 1989)

MICHEL MELOT

Triqueti [Triquetti], Henri-Joseph-François, Baron de

(*b* Conflans, 24 Oct 1804; *d* Paris, 11 May 1874). French sculptor and designer of Italian descent. He studied painting with Louis Hersent in Paris before embarking on a career as a sculptor. He made his début at the Salon of 1831 with a bronze relief of the *Death of Charles the Bold* (untraced); closely based on 15th-century models, it identified him as one of a new generation of Romantic sculptors who rejected the Neo-classical teaching of the Ecole des Beaux-Arts in favour of learning from medieval and early Renaissance examples.

Triqueti occasionally put his knowledge of medieval art into practice as a restorer, working on the famous bone and marquetry reredos from the abbey of Poissy (Paris, Louvre) in 1831, and in 1840–48 on the restoration of the Sainte-Chapelle, Paris, under the supervision of the architect Félix-Jacques Duban. Numerous drawings provide further evidence of his interest in medieval and Renaissance monuments (e.g. *Romanesque Portal of Basle Cathedral*, 1831, Montargis, Mus. B.-A.; *Chevet of St Pierre in Caen*, 1855, Paris, Ecole N. Sup. B.-A.). During his many travels, especially in Italy, he kept notebooks and made drawings (e.g. Montargis, Mus. B.-A.; Paris, Ecole N. Sup. B.-A.) of paintings and sculptures in Milan, Venice, Padua and most often in Florence. His bronze doors for La Madeleine, Paris (1834–41; *in situ*), decorated with reliefs of the *Ten Commandments*, are clearly inspired by the Baptistery doors of Florence Cathedral. (He received this commission despite being a Protestant convert.) His admiration for such 15th-century Florentine sculptors as Benedetto da Maiano (whom he considered superior to Lorenzo Ghiberti) is also reflected in such works as his marble medallion portraits, bordered by foliage and grotesques (e.g. *Blanche Triqueti*, 1852, untraced; plaster version Montargis, Mus. B.-A.).

In 1842 Triqueti was commissioned to decorate the cenotaph of *Ferdinand Philippe, Duc d'Orléans*, at the Chapelle St Ferdinand, Neuilly-sur-Seine (1842–3; *in situ*), to a design by Ary Scheffer. The recumbent marble figure is surrounded by two angels sculpted by Marie, Princesse d'Orléans, and the base has an *Angel of Death* in shallow low relief. The following year he was commissioned by the architect Louis-Tullius-Joachim Visconti to decorate the crypt of Napoleon's tomb at Les Invalides, Paris; although unexecuted, this led him to experiment with marble intarsia, a technique he used in a panel representing *Peace and Plenty* (1845; Montargis, Mus. B.-A.) and, on a grander scale, in scenes from the *Iliad* and the *Odyssey* for University College, London (1865; *in situ*). It was probably the figure of *Ferdinand Philippe* and Triqueti's later statue of *Edward VI Studying the Holy Scriptures*, sold to Queen Victoria, that led to his being given the most important commission of his career and an opportunity to exploit his experimental intarsia to the full: the cenotaph of *Prince Albert* (after 1865) in the Albert Memorial Chapel, Windsor Castle. The Gothic Revival tomb consists of a recumbent figure of the Prince in medieval armour on a base adorned by a delicate colonnette structure; between the columns there are six statuettes of *Virtues* with eight small angels on the corners. There are also marble portraits of all the royal couple's children. The decorations for the walls of the chapel, combining low relief sculpture with variously incised and painted marbles, include scenes from the *Passion*.

Triqueti also produced swords, daggers, hunting-knives, chandeliers, mirrors and vases, both in a Gothic Revival style and, as exemplified by a bronze vase decorated with a Bacchic procession (Paris, Mus. A. Déc.), in a classicizing style

derived from antique sculpture and from Roman silverware (drawings in Paris, Ecole N. Sup. B.-A.).

Bibliography

Lami

M. Beaulieu: 'Un Sculpteur français d'origine italienne: Henri de Triqueti', *A travers l'art italien du XVe au XXe siècles* (n.d.)

B. Read: *Victorian Sculpture* (New Haven, 1982), pp. 97, 139, 194

H. W. Janson: *Nineteenth-century Sculpture* (London, 1985), pp. 121, 124–5, 134, 162, 205

ISABELLE LEMAISTRE

Troyon, Constant

(*b* Sèvres, 28 Aug 1810; *d* Paris, 20 March 1865). French painter. He was brought up among the Sèvres ceramics workers and received his first lessons in drawing and painting from Denis-Désiré Riocreux (1791–1872), a porcelain painter who was one of the founders of the Musée National de Céramique. Troyon began his career as a painter at the Sèvres factory while also studying landscape painting in his spare time. He became a friend of Camille Roqueplan, who introduced him to a number of young landscape painters—especially Théodore Rousseau, Paul Huet and Jules Dupré—who were later to become members and associates of the Barbizon school. After an unremarkable début at the Salon of 1833, where he exhibited three landscapes depicting the area around Sèvres (e.g. *View of the Park at Saint-Cloud*; Paris U., Notre-Dame), he took up his career in earnest and made several study trips to the French provinces. Following the example of contemporary collectors, he began to take a great interest in 17th-century Dutch painting, particularly the work of Jacob van Ruisdael, whose influence is seen in such early paintings as *The Woodcutters* (1839; La Rochelle, Mus. B.-A.). At the Salon of 1841 he exhibited *Tobias and the Angel* (Cologne, Wallraf-Richartz Mus.), a biblical landscape that attracted the attention of Théophile Gautier. The subject was intended to satisfy the critics, but the painting served as a pretext for portraying a realistic and sincere representation of nature,

even though its ordered and classically inspired composition perfectly fitted the requirements of a genre, the origins of which were the 17th-century paintings of Claude and Poussin and their followers.

At the Salon of 1846 Troyon was awarded a First Class medal by Louis Napoleon (later Napoleon III) for the four paintings he exhibited there, all landscapes inspired by the countryside around Paris, confirming a reputation that continued to grow year by year. In 1847 he travelled to the Netherlands and Belgium, where he discovered the work of the painters Paulus Potter and Aelbert Cuyp; this trip was to have a profound influence on the direction of his career. He was made Chevalier de la Légion d'honneur in 1849, and it was from this time that he devoted himself almost exclusively to the painting of animals, a genre that ensured him substantial financial success due to its popularity with his admirers. He was extremely prolific, and his canvases are often large in format, usually depicting farm animals and labourers in the extreme foreground against a low horizon with dramatic, cloud-filled skies or splendid sunrises or sunsets; examples are *Oxen Going to Plough: Morning Effect*, shown at the Exposition Universelle in Paris of 1855, and *View from the Suresnes Heights (Hauts-de-Seine)* (Paris, Mus. d'Orsay), painted in 1856 and exhibited at the Salon of 1859. Troyon was no innovator, but his painting technique was excellent, and he had a sensitive, yet broad-based and solid mastery of his craft. His more exploratory paintings were executed on the coast of Normandy during his last years. These paintings reveal that he was looking closely at variations of light and was expressing a sensitivity not too far removed from that of the precursors of Impressionism.

Bibliography

C. Blanc: *Les Artistes de mon temps* (Paris, 1876)

A. Hustin: 'Troyon', *L'Art*, xlvi (1889), pp. 77–90; xlvii (1889), pp. 85–96

L. Souillié: *Peintures, pastels, aquarelles, dessins de Constant Troyon relevés dans les catalogues de ventes de 1833 à 1900* (Paris, 1900) [biog. entry by P. Burty]

W. Gemel: *Corot und Troyon*, Künstler Monographien, lxxxiii (Bielefeld and Leipzig, 1906)

The Realist Tradition: French Painting and Drawing, 1830–1900 (exh. cat. by G. P. Weisberg and others, Cleveland, OH, Mus. A.; New York, Brooklyn Mus.; Glasgow, A.G. & Mus.; 1980–82)

A. DAGUERRE DE HUREAUX

Turpin de Crissé, Lancelot-Théodore, Comte de

(*b* Paris, 6 July 1782; *d* Paris, 15 May 1859). French painter, lithographer and collector. Born into a distinguished military family, he inherited from his father a talent for painting, which was encouraged by the Comte de Choiseul-Gouffier, who sent him to Switzerland (1802–3) and then to Italy (1807–8). Turpin de Crissé exhibited for the first time at the Salon of 1806, showing *René's Farewell* (sold London, Sotheby's, 25 Nov 1981), a romantic subject taken from Chateaubriand's *René*, and a *View of the Temple of Minerva at Athens* (untraced), which had probably been commissioned by Choiseul-Gouffier. He was welcomed into Napoleon's court as the protégé of Queen Hortense and later of the Empress Josephine, to whom he became chamberlain in 1809. He accompanied her to Switzerland and Savoy in 1810, returning with an album of 33 sepia drawings (Malmaison, Château N.) that express a delightful 'troubadour' feeling for nature.

His landscapes were highly prized—the *View taken from Civita Castellana* (exh. Salon 1808; Malmaison, Château N.) was bought by the Empress. The *View of Switzerland, the Town of Sion in the Valais* (1806; exh. Salon 1810; Boulogne-Billancourt, Bib. Marmottan) is the product of a subtle decorative gift and is pervaded by a restrained bucolic atmosphere. In 1813 he married his cousin Adèle de Lesparda, a pupil of Pierre-Joseph Redouté.

In April 1816 he was made a *membre libre* of the Académie des Beaux-Arts and then a member of the Beaux-Arts commission for the Seine and of the Conseil des Musées. On his travels to Switzerland (1816) and Italy (1818 and 1824) he devoted himself entirely to the study of landscape and antiquity. His search for pictures, medals and curiosities dates from this period. In this he was principally concerned with the objects' aesthetic value, showing little interest in their history. From 1825 he was a conscientious Inspecteur Général des Beaux-Arts, responsible for supervising the royal manufactures, theatres and the arts. By 1818 he had met Ingres in Rome, who drew in pencil both his portrait and that of the Comtesse (both New York, Met.). In 1819 he obtained Ingres's *Paolo and Francesca* (1819; Angers, Mus. Turpin de Crissé), which he considered the jewel of his collection. In 1825 he directed the preparations for an album commemorating the coronation of Charles X, entrusting Ingres with the most important pages (portraits of the King and of Cardinal de Latil; Paris, Louvre; Angers, Mus. Turpin de Crissé). Work on the album was interrupted by the revolution of 1830, which 'restored to him at a stroke his liberty, his cabinet, and the mediocrity of his fortune'. He took up painting again and exhibited landscapes and architectural views regularly at the Paris Salon until 1835.

Turpin de Crissé's surviving works reveal a mastery of drawing constantly refined during his travels in Italy, Switzerland and England. They are classical in their assured, if conventional, composition but show the influence of Romanticism in their acute awareness of light. Typical of his historical landscapes are *Hunter in the Apennines* and *Apollo, Turned out of Heaven, Teaches the Shepherds Music* (exh. Salon 1824; Carpentras, Mus. Duplessis). His lithographs are freer in style and abound in picturesque details. In 1828 he wrote *Souvenirs du Golfe de Naples* with lithographs by other artists after his illustrations, and in 1834 *Souvenirs du vieux Paris* appeared with his own lithographs.

A gift from the artist endowed the Musée Turpin de Crissé at Angers with many records of his travels in Italy, for example *The Temple of Vesta at Tivoli* (1831). His links with the monarchy enabled him to paint pictures (untraced) for the Galerie d'Orléans in the Palais-Royal, Paris, and a *Mass in the Expiatory Chapel* (1835; Paris, Mus. Carnavalet). After 1835 Turpin devoted himself entirely to his collection, bequeathed to the town of Angers in 1859, and from 1889 onwards installed in the Hôtel Pincé. His 'cabinet de

curiosités' included Egyptian sculptures, Greek vases, maquettes, coins, antique jewels and drawings, engravings and paintings by his contemporaries and even some photographs.

Writings

Lettre au conservateur de ses collections publiques par
 J. Levron (Angers, 1937)

Bibliography

F. Deville: 'Notice biographique sur M. le comte Turpin de
 Crissé', Rev. Gén. Biog. & Nécrol., xii/1 (1846),
 pp. 219-222
T. L'Huillier: Une Famille d'amateurs d'art: Les Turpins de
 Crissé (Paris, 1896)
M. de la Grandière: Le Comte Turpin de Crissé: Un
 gentilhomme artiste (Angers, 1935)

VIVIANE HUCHARD

Vafflard, Pierre(-Antoine)-Auguste

(b Paris, 19 Dec 1777; d Paris, 1837). French painter. A pupil of Jean-Baptiste Regnault, he exhibited regularly in the Salon between 1800 and 1831. He executed a number of unremarkable academic works on Classical subjects, for example Electra (1804; exh. Salon 1814) and Orestes Sleeping (1819; both Dijon, Mus. B.-A.). Vafflard gained more success with his Troubadour pictures, which he began to paint in the early 19th century, at the outset of this fashion. They are remarkable for their absence of colour, their theatrical quality and contrasted lighting effects. One of his earliest Troubadour scenes was Emma and Eginhard (exh. Salon 1804; Evreux, Mus. Evreux), based on an episode in the history of Charlemagne's court and painted at a time when the Holy Roman Empire was in fashion in official French circles. In this sentimental painting Vafflard demonstrated his historicizing intentions by emphasizing medieval costume and Gothic architecture and seeking to create an atmosphere similar to the romans de la chevalerie, so highly thought of in France at the end of the 18th century. In the same Salon he exhibited a strange and novel painting, Young Holding his Dead Daughter in his Arms (Angoulême, Mus. Mun.), taken from Edward Young's Night Thoughts

(pubd in French in 1769–70). This English poet was a rare source of inspiration for painters seeking romantic subjects, who tended to prefer Gessner or Ossian. Vafflard's emphasis on the fantastic and the morbid was also unusual at this period, and these effects were further accentuated by leaden tones and a strange lunar chromaticism.

Vafflard established his reputation with the Hospice Dog (exh. Salon 1810; Arenenberg, Napoleonmus.), which was bought by Empress Josephine for her gallery at Malmaison. As in Young Holding his Dead Daughter, although in a less dramatic way, Vafflard exploited contrasts of light that were accentuated by the presence of snow. The subject, a lost, sleeping child brought back by a dog, was the ideal choice for a public, with a taste for charming, sentimental anecdote, that enjoyed scenes showing children with devoted pets by such artists as Jeanne-Elisabeth Chaudet and Henriette Lorimier (fl 1800–54).

Like many Troubadour painters, Vafflard attempted a large painting halfway between the grand style and historical anecdote. He won a Prix d'Encouragement for the Last Respects Paid to Duguesclin (exh. Salon 1806; Rennes, Mus. B.-A. & Archéol.). The work was inspired by Nicolas-Guy Brenet's Death of Duguesclin (1778; Grenoble, Mus. Peint. & Sculp.) and was intended to re-create the famous and mythical 'age of chivalry'. To achieve authenticity, Vafflard crowded the composition with knights in armour and banners, which were attacked by the critics who also disliked the dark tonality and the absence of any chiaroscuro that might enliven this stiff and awkward scene. During the Empire, Vafflard also painted incidents from contemporary history, for example Rosbach's Column Defeated by the French Army (exh. Salon 1810; Versailles, Château).

After 1815 Vafflard's career went into decline. He restored paintings in Versailles and executed a number of religious compositions, which were brighter and more animated than his earlier work, including St Margaret Driven out by her Father (exh. Salon 1817; Paris, Ste-Marguerite) and St Ambrose Saving a Priest from the People's Rage (exh. Salon 1819; Paris, St Ambroise). However, he often lacked work, as he wrote to the Minister of

the Maison du Roi when he attempted, unsuccessfully, to get a commission for ceilings in the Louvre (Paris, Archvs N., o³ 1426). In his last years he abandoned historical subjects to paint a few portraits and intimist scenes in the style of Eugène Devéria, for example *Rest* (1830) and *Waiting* (1831; both Evreux, Mus. Evreux). He made several drawings to be engraved in Godefroy Engelmann's *Galerie militaire dédiée aux braves*.

Bibliography

P. Marmottan: *L'Ecole française de peinture (1789–1830)* (Paris, 1886), pp. 306, 334–5

H. Béraldi: *Les Graveurs du XIXe siècle*, v (Paris, 1889), pp. 167–8

F. Benoit: *L'Art français sous la Révolution et l'Empire* (Paris, 1897/R 1975), pp. 323, 392–3

De David à Delacroix: La Peinture française de 1774 à 1830 (exh. cat., Paris, Grand Pal., 1974), pp. 625–7

MARIE-CLAUDE CHAUDONNERET

Valenciennes, Pierre-Henri (de)

(*b* Toulouse, 6 Dec 1750; *d* Paris, 16 Feb 1819). French painter. He trained at the academy in Toulouse under the history painter Jean-Baptiste Despax (1709–73). In 1769 he went to Italy for the first time, with Mathias Du Bourg, a councillor at the Toulouse parliament. Du Bourg introduced him to Etienne-François, Duc de Choiseul, a keen patron of the arts, who in turn recommended him to Gabriel-François Doyen, one of the leading history painters in Paris, whose studio he entered in 1773. Doyen gave his pupil a sense of the elevated ideals of history painting but was also sympathetic to the lesser genre of landscape. Valenciennes presumably frequented Choiseul's country seat at Chanteloup, near Amboise, meeting there the landscape painters Hubert Robert and Jean Hoüel, both protégés of Choiseul. His early interest in the native landscape can be seen in his sketchbooks (Paris, Louvre), especially one dated 1775 that contains drawings made at Amboise, Compiègne and Fontainebleau, and in a later series of oil studies on paper made in Brittany, at the mouth of the River Rance and around St Malo.

In 1777 Valenciennes made a second trip to Italy, remaining there until 1784 or 1785. Among the earliest records of this stay are three precise drawings of rocks and trees, dated 1780 in Rome (Paris, Louvre). It was probably on a return trip to Paris in 1781 that Valenciennes met Joseph Vernet, who taught him a broader manner of working that was responsive to the effects of aerial perspective, as he later acknowledged (*Elémens de perspective*, p. xviii). It was probably Vernet's advice and practice that encouraged Valenciennes on his return to Rome to make the studies in oil on paper, many of them done in the open air (e.g. *Study of Clouds, from the Quirinal*), that seem to have been his chief occupation in Italy. The mistaken notion that following his return from Italy, Valenciennes travelled in Greece, Asia Minor, North Africa and the East stems from passages in his treatise *Elémens de perspective* exhorting the modern artist to travel as widely as possible; but both the date of his return from Italy and his movements during the next two or three years are uncertain.

Valenciennes's public career began in 1787, when he was approved (*agréé*) by the Académie Royale on 31 March and, in unusually rapid succession, received (*reçu*) on 28 July. His reception piece was *Cicero Uncovering the Tomb of Archimedes* (Toulouse, Mus. Augustins), a historical subject set in an imaginary landscape intended to evoke ancient Sicily in the vicinity of Syracuse. This painting and the *Ancient City of Agrigentum* (Paris, Louvre; see col. pl. XXXVI), another landscape with a classical theme, were shown at the Salon of 1787. The latter shows servants sent out to welcome travellers approaching the city, an ancient hospitable custom. In the background is the Temple of Concord, the ruins of which Valenciennes had visited during a trip to Sicily in 1779. These large-scale Salon paintings, which represent ideal and imaginary visions of the ancient world, use the study of nature only in the most indirect way. They reflect fashionable interest in Sicily but are remote in concept from the everyday observations of Hoüel's series of Sicilian prints published in the same decade. Moreover, they lack the verisimilitude of Vernet's calm or dramatic

landscapes and marines. Instead they represent a vain Neo-classical attempt to regain the arcadian world of Poussin's late landscapes, using an updated archaeology. Valenciennes continued to send similar landscapes to the Salon from 1787 until the year of his death.

Valenciennes's major contribution to the history of art lies in his theory and practice as a teacher and in his efforts to raise the status of landscape. His successful official career did much to raise its low standing, as did his treatise, *Elémens de perspective*, in which he gave landscape painting the full practical and theoretical discussion it deserved but had been previously denied. Indeed, this treatise was to remain the basic handbook for French landscape painters up to the time of the Realists and Impressionists. Valenciennes thought that the landscape painter should be as learned as any history painter, combining his wide general knowledge with the close study of nature to improve the academic credibility and intellectual standing of landscape. In 1812 he became Professeur de Perspective at the Ecole Impériale des Beaux-Arts, helping to form a generation of Neo-classical landscape painters, such as Achille Michallon, Pierre-Athanase Chauvin, Jean-Baptiste Deperthes and Nicolas Bertin. His aspirations were vindicated in 1816, when a special Prix de Rome for landscape was established at the Académie to encourage 'historical landscape' (*paysage historique*) based on historical and literary subject-matter. Indeed, Valenciennes had the pleasure of seeing his pupil Michallon become the first recipient of this prize. There was little demand for elevated landscapes in the manner of Poussin, however, and his followers generally

71. Pierre-Henri Valenciennes: *Thunderstorm on the Lake* (Paris, Musée du Louvre)

made a living from attractive small-scale arcadian and Italianate scenes.

Valenciennes is also notable for having encouraged artists to paint oil studies in the open, thus training them to match in paint the visual effects of nature, especially transient light, atmosphere and aerial perspective (see fig. 71). He urged repeated studies of one view in different lights but saw such works purely as training exercises; they bore no direct relation to finished studio works. His own oil studies were not seen publicly until 1930, when they were donated to the Musée du Louvre. The critical response to Valenciennes was not very complimentary from the 1820s onwards, as the new aesthetics of Romanticism, Realism and Impressionism were not sympathetic to his classical ideal. Had his critics examined the full range of his work, including the oil studies, they might have recognized his importance as a student of nature; instead, he came to be misunderstood as a poor pasticheur of Poussin, with little observation or truth in his art.

Writings

Elémens de perspective pratique à l'usage des artistes (Paris, 1799–1800)

Bibliography

J.-B. Deperthes: Histoire de l'art du paysage (Paris, 1822)

Oeuvres provenant des donations faites par Madame la Princesse Louise Croÿ et Monsieur Louis Devillez (exh. cat., ed. J. Guiffrey; Paris, Mus. Orangerie, 1930), no. 134

Pierre-Henri de Valenciennes (exh. cat., ed. R. Mesuret; Toulouse, Mus. Dupuy, 1956)

C. Sterling and H. Adhémar: Musée national du Louvre: Peintures, école française, XIXe siècle, iv (Paris, 1961)

P. Conisbee: 'Pre-Romantic Plein-air Painting', A. Hist., ii (1969), pp. 413–28

W. Whitney: 'Pierre-Henri Valenciennes: An Unpublished Document', Burl. Mag., cxviii (1976), pp. 225–7

Les Paysages de Pierre-Henri de Valenciennes, 1750–1819 (exh. cat., ed. G. Lacambre; Paris, Louvre, 1976)

P. R. Radisich: Eighteenth-century Landscape Theory and the Work of Pierre Henri de Valenciennes (Ann Arbor, 1981)

PHILIP CONISBEE

Vallayer-Coster [née Vallayer], Anne

(b Paris, 21 Dec 1744; d Paris, 28 Feb 1818). French painter. She spent her childhood at the Gobelins, where her father was a goldsmith. Though she thus belonged to artistic circles, when received (reçue) by the Académie Royale in 1770, on presentation of the still-lifes Attributes of Painting and Musical Instruments (both Paris, Louvre), she was known to have neither a teacher nor an official patron.

She exhibited for the first time at the Salon the following year and achieved a success that never deserted her. She showed still-lifes (which were compared to those of Jean-Siméon Chardin), imitation low reliefs and genre scenes, the last reminiscent of those by Jean-Baptiste Greuze. From 1775 onwards her flower paintings attracted greatest attention: many of these remain in private collections (see Roland Michel), but among others on public view are those in Nancy (Mus. B.-A.) and New York (Met.). She also drew, painted miniatures (see Roland Michel, nos 361–86) and executed life-size portraits. Her portraits were admired by her contemporaries, as is shown by the commissions she received for those of Louis XVI's aunt Mme Sophie and of Queen Marie-Antoinette (both 1780). Among her surviving portraits is that of a Lady Writing, and her Daughter (1775; Barnard Castle, Bowes Mus.). One of her series of portraits of Vestals belonged to Marie-Antoinette, who obtained lodgings for her in the Louvre and in 1781 signed her contract of marriage with the lawyer Jean-Pierre-Sylvestre Coster. However, the appearance of the portrait painters Adelaïde Labille-Guiard and Elisabeth Vigée-Lebrun led to comparisons unfavourable to Vallayer-Coster, who then devoted herself to the genre in which her superiority was recognized. In her last Salon in 1817 she showed a large still-life, Vase, Lobster, Fruit and Game (Paris, Louvre), which belonged to Louis XVIII.

Vallayer-Coster had a very personal way of grouping flowers, fruit, animal trophies, plate and domestic objects in a perfectly organized space over which the chromatic subtleties of her palette could play. With particular arrangements of selected forms such as flowers and fruit she built up a repertory, which, over the years, though

hardly changing, became increasingly subtle. This unsentimental art sometimes achieved, in her assemblages of flags and drums, corals and shells, a strength unrivalled by any of the painters of her generation.

Bibliography

M. Roland Michel: *Anne Vallayer-Coster, 1744–1818* (Paris, 1970)

L. Nochlin and A. Sutherland Harris: *Women Artists, 1550–1950* (Los Angeles, 1976)

MARIANNE ROLAND MICHEL

Vernet

French family of artists. Antoine Vernet (1689–1753) was a prosperous artisan painter in Avignon to whom some decorated coach panels (Avignon, Mus. Calvet) are attributed. Of his three sons, Joseph Vernet (1714–89) earned a reputation throughout Europe as a landscape and marine painter, receiving the commission from Louis XV for the series *Ports of France*. Jean-Antoine Vernet (1716–?1755) also painted seascapes, and (Antoine) François Vernet (1730–79) was a decorative painter; their respective sons, Louis-François Vernet (1744–84) and Joseph Vernet the younger (*b* 1760; *fl* 1781–?1792), were both active in Paris as sculptors. Joseph's son (1) Carle Vernet, a painter and lithographer, became known for his pictures of horses and battle scenes, though his achievement was overshadowed not only by his father's but by that of his son (2) Horace Vernet, a prolific and highly successful painter, especially of battle scenes. The family was connected by marriage to several other notable French artists, Carle becoming father-in-law of Hippolyte Lecomte and Horace that of Paul Delaroche; Carle's sister Emilie married the architect Jean-François-Thérèse Chalgrin.

Bibliography

Bellier de La Chavignerie–Auvray; Bénézit; Lami; Thieme–Becker

A. Dayot: *Les Vernet: Joseph–Carle–Horace* (Paris, 1898)

P. G. Delaroche-Vernet: *Horace Vernet, Paul Delaroche et leur famille* (Paris, 1907)

(1) Carle [Antoine-Charles-Joseph] **Vernet**

(*b* Bordeaux, 14 Aug 1758; *d* Paris, 27 Nov 1836). Painter and lithographer, son of painter Joseph Vernet. At the age of 11 he entered the studio of Nicolas-Bernard Lépicié. His training culminated in the award of the Prix de Rome in 1782; however, his stay in Rome was terminated when he underwent a 'mystical experience' and was sent back to Paris. He was approved (*agréé*) by the Académie Royale in 1789 on presentation of the *Triumph of Aemilius Paulus* (New York, Met.). Although his sister Emilie was guillotined, none of the tragic aspects of the Revolution is apparent in his subsequent work. His wittily malicious satires of Directoire types, *Incroyables et merveilleuses* (Dayot 66), engraved in 1797, made his reputation and set the tone for most of his future aquatinted work, for example *Costumes* (1814–18; D 73). An early practitioner of lithography, he excelled in the acute, unexaggerated observation of contemporary manners, e.g. *Delpech's Print Shop* (*c.* 1818) and the *Cries of Paris* (100 plates, after 1816; D 147).

In 1799 Vernet exhibited drawings of Napoleon's Italian campaign. His most famous battle painting is the huge *Battle of Marengo* (Versailles, Château), for which sketches were shown at the Salon in 1804 and 1806. Some scholars have maintained that Vernet introduced verisimilitude and strategy into contemporary battle paintings; others credit his son, (3) Horace Vernet, and still others attribute this new-found authenticity, as well as an emphasis on the infantry, to Louis-François Lejeune (1775–1848). The careers of Vernet and Lejeune in this genre are parallel, and their early attempts have remarkable stylistic similarities, featuring panoramic views of the battlefield, with very small figures and sprightly horses. The last year in which both artists exhibited contemporary battle scenes was 1824, but, whereas Lejeune's *Battle of Chiclana* has the infantry mass functioning strategically as a dynamic, thrusting wedge, Vernet's *Capture of Pamplona* (both Versailles, Château) has a static, planar row of officers stretched across the foreground, echoed by a large expanse of dull landscape.

Vernet's hunt scenes retain the picturesque charm, elegance and artificiality of the 18th century, even in such late paintings as the *Stag Hunt* (1827; Paris, Louvre). His work is characterized by greater veracity when he painted from direct observation, as in *Riderless Horse Race* (1826; Avignon, Mus. Calvet), which depicts the annual event in Rome; indeed, in his own time he was known primarily as a painter of horses in full movement. He received the Légion d'honneur in 1808 and was elected to the Institut de France in 1815. His greatest legacy was that he fostered the talents of his son and of Théodore Gericault.

Bibliography

P.-A. Vieillard: *Salon de 1824* (Paris, 1825)

C. Blanc: *Histoire*, iii (Paris, 1865), pp. 1–16

A. Genevay: 'Carle Vernet', *L'Art*, viii (1877), pp. 73–83, 97–103

A. Soubies: *Les Membres de l'Académie des beaux-arts*, i (Paris, 1904), pp. 133–8

A. Dayot: *Carle Vernet* (Paris, 1925) [D] [incl. cat. rais. of works that were engraved and of his lithographs]

I. Julia: 'Antoine-Charles-Horace (called Carle) Vernet', *French Painting, 1774–1830: The Age of Revolution* (exh. cat., ed. F. Cummings and others; Paris, Grand Pal., 1975), pp. 649–51 [only significant account of Vernet in Eng.]

The Charged Image: French Lithographic Caricature, 1816–1848 (exh. cat. by B. Farwell, Santa Barbara, CA, Mus. A., 1989), pp. 169–77

(2) (Emile-Jean-)Horace Vernet

(*b* Paris, 30 June 1789; *d* Paris, 17 Jan 1863). Painter, son of (1) Carle Vernet. He was born in his father's lodgings at the Palais du Louvre, where his grandfather Joseph Vernet also lived; his maternal grandfather was Jean-Michel Moreau. To these antecedents and influences are ascribed the supreme ease of his public career, his almost incredible facility and his fecundity. His early training in his father's studio was supplemented by formal academic training with François-André Vincent until 1810, when he competed unsuccessfully for the Prix de Rome. He first exhibited at the Salon in 1812. In 1814 Vernet received the Légion d'honneur for the part he played in the defence of Paris, which he commemorated in the *Clichy Gate: The Defence of Paris, 30 March 1814* (1820; Paris, Louvre; see fig. 72), a spirited painting that represented a manifesto of Liberal opposition to Restoration oppression.

In 1822 the Salon jury, fearing political repercussions, refused the *Clichy Gate* and the *Battle of Jemmapes, 1792* (1821; London, N.G.), although neither painting glorifies Napoleon. In response Vernet withdrew all his paintings from the Salon, except *Joseph Vernet Attached to the Mast Painting a Storm* (Avignon, Mus. Calvet), a government commission, and opened his own 'salon', which was enthusiastically publicized by Victor-Joseph Etienne de Jouy, who equated political and artistic liberty. The public flocked to Vernet's studio, and both his reputation and his prices soared, as his account books reveal. In 1824 the government ordered two official portraits and made Vernet an Officer of the Légion d'honneur. Vernet exhibited nearly 40 paintings at the Salon, including the *Clichy Gate*, the *Battle of Montmirail, 1814* (1822) and the *Battle of Hanau, 1813* (1824; both London, N.G.), on behalf of which the Director of the Louvre, Comte Auguste de Forbin, had waged an astute campaign with the Ministère du Roi, reminding the government of the notoriety and attacks that had occurred in 1822 (Paris, Archvs N.). The range of Vernet's work exhibited at this Salon (see Jal) is vast: while such pictures as *Peace and War* (1820) and the *Veteran at Home* (1823; both London, Wallace) might appear to be simple genre paintings, their political statements are inherent in the image of the veteran being exalted, glorification of Napoleon being prohibited.

From this point Vernet's career was secure. In 1826 he was elected to the Institut de France; from 1828 to 1834 he was director of the Académie de France in Rome; and in 1835 he was appointed professor at the Ecole des Beaux-Arts, Paris, a post he held until his death. Among numerous official commissions he executed historic battle-pieces for Louis-Philippe's Galerie des Batailles at Versailles and such scenes of contemporary ceremonials and battles as *Louis-Philippe and his*

72. Horace Vernet: *Clichy Gate: The Defence of Paris, 30 March 1814*, 1820 (Paris, Musée du Louvre)

Sons Riding out from the Château of Versailles (1847; see fig. 73) and three immense canvases of the *Siege of Constantine* (1839; all Versailles, Château).

Vernet visited Algeria several times between 1833, when he painted the *Arab Tale-teller* (London, Wallace), and 1853; his interest in the Near East seems to have focused on providing an authentic background for biblical themes (e.g. *Joseph's Coat*, 1853; London, Wallace) and on presenting the characters of the Old Testament in the guise of modern Arabs.

Vernet's technique has been described as having a 'Neo-classical porcelain finish' (Julia), but this is not his universal manner, especially in his early work, even if one discounts such sketches and drawings as the *Turkish Soldier* (1827; Paris,

Ecole N. Sup. B.-A.), which has wonderful verve and freedom (see also col. pl. XXXVII). A carefully polished surface occurs most often in the biblical paintings after 1830, which are also his most monumentally composed works. He was notorious for the speed with which he worked. As a result the facture of such works as *Peace and War* is large, loose, almost careless; even the monumental *Charles X Entering Paris, September 30* (1824; Versailles, Château), which was completed before the Salon closed in January, is quite sketchy. Although Vernet has never been accounted a colourist, his *Brigands Surprised by Papal Troops* (1831; Baltimore, MD, Walters A.G.) is unusual in its vividness. The free brushwork of *Mazeppa and the Wolves* (1826; Avignon, Mus. Calvet) draws attention to the terrified horse.

73. Horace Vernet: *Louis-Philippe and his Sons Riding out from the Château of Versailles*, 1847 (Versailles, Musée National du Château de Versailles et du Trianon)

The public was unanimous in considering Vernet one of the greatest artists of his time, and all critics stressed his journalistic approach. In the 1820s the Liberal critics, in an era when independence in art was directly linked to independence in politics, were also very laudatory. Thiers (1824) pointed out that Vernet's realism was achieved by an absence of conventions and rules: 'No subject is forbidden him, no manner of treat-ing them is imposed on him'. Yet adverse assessments were already current before the artist's demise: Silvestre (1857) prophesied that the future would be hard on Vernet. Some of the negative assessments, such as Baudelaire's diatribe (1846), again seem related to political biases; Baudelaire detested the army, Vernet's popularity and his naturalism. By the 1980s, however, Vernet appeared to be benefiting from a general reassessment of 19th-century art, and his naturalism, which appeared as early as the 1830s

(e.g. the *Duc d'Orléans Leaving the Palais Royal*, 1832; Versailles, Château), can be seen as foreshadowing that of Gustave Courbet or Edouard Manet.

Bibliography

V.-J. Etienne de Jouy: *Salon d'Horace Vernet: Analyse historique et pittoresque de quarante-cinq tableaux exposés chez lui en 1822* (Paris, 1822)

A. Jal: *L'Artiste et le philosophe: Entretiens critiques sur le salon de 1824* (Paris, 1824), pp. 127–89 (127–36)

A. Thiers: *Le Globe* (8 Oct 1824), p. 47

C. Baudelaire: 'M. Horace Vernet', *Salon de 1846* (Paris, 1846); repr. in *Arts in Paris, 1845–1862* (Greenwich, CT, 1965), pp. 93–6

T. Silvestre: *Mémoire contre Horace Vernet* (Paris, 1857); rev. version in *Eclectiques et réalistes*, ii of *Les Artistes français*, ed. E. Faure (Paris, 1926), pp. 38–73

L. Lagrange: 'Horace Vernet', *Gaz. B.-A.*, 1st ser., xv (1863), pp. 297–327, 439–65

G. Levitine: '*Vernet Tied to a Mast in a Storm*: The Evolution of an Episode of Art Historical Romantic Folklore', *A. Bull.*, xlix (1967), pp. 93–100

I. Julia: 'Emile-Jean-Horace (called Horace) Vernet', *French Painting, 1774–1830: The Age of Revolution* (exh. cat., ed. F. Cummings and others; Paris, Grand Pal., 1975), pp. 611–14

Horace Vernet, 1789–1863 (exh. cat., intro. R. Rosenblum; Rome, Acad. France; Paris, Ecole N. Sup. B.-A.; 1980) [errors and lacunae in chronology, good intro.]

The Charged Image: French Lithographic Caricature, 1816–1848 (exh. cat. by B. Farwell, Santa Barbara, CA, Mus. A., 1989), pp. 178–86

DOROTHEA K. BEARD

Vien, Joseph-Marie, Comte

(*b* Montpellier, 18 June 1716; *d* Paris, 27 March 1809). French painter, draughtsman and engraver. He was one of the earliest French painters to work in the Neo-classical style, and although his own work veered uncertainly between that style and the Baroque, Vien was a decisive influence on some of the foremost artists of the heroic phase of Neo-classicism, notably Jacques-Louis David, Jean-François-Pierre Peyron, Joseph-Benoît Suvée and Jean-Baptiste Regnault, all of whom he taught. Both his wife, Marie-Thérèse Reboul (1738–1805), and Joseph-Marie Vien *fils* (1762–1848) were artists: Marie-Thérèse exhibited at the Salon in 1757–67; Joseph-Marie *fils* earned his living as a portrait painter and engraver.

1. Early career, to 1775

After spending his youth in various forms of employment, including work as a painter of faience and as an assistant to the artist Jacques Giral, Vien travelled to Paris and entered the studio of Charles-Joseph Natoire in 1740. Three years later he won the Prix de Rome and in 1744 went to the Académie de France in Rome. His participation in the energetic reappraisal of form, technique and purpose taking place in French art from the mid-1740s onwards is well demonstrated by paintings executed before and during his time in Italy. These include the *Sleeping Hermit* (1750, exh. Salon 1753; Paris, Louvre), *Lot and his Daughters* (Le Havre, Mus. B.-A.) with its pendant, *Susanna and the Elders* (Nantes, Mus. B.-A.), and the first six panels of his cycle on the *Life of St Martha* (Tarascon, Bouches-du-Rhone, Ste Marthe). Vien's conflicting attractions to classicism and to the Baroque began early. Although he closely studied the works of Raphael and Michelangelo, he was also attracted to the Bolognese painters of the first half of the 17th century, whose special interest in nature and the Antique he shared. In Rome he played a part in the Académie's contribution to the Carnival celebrations of 1748, making drawings (Paris, Louvre) and etchings (e.g. Paris, Bib. N.) of its procession. Among his portraits of these years is that of his fellow student *Louis-Joseph Le Lorrain Disguised as an Oriental Queen* (Paris, Petit Pal.).

Vien returned to France in 1750. Having failed in his first attempt at election to the Académie Royale with his *St Jerome* (1750; La Fère, Mus. Jeanne d'Aboville), he succeeded in 1751 with the *Embarkation of St Martha*, the seventh panel in his Tarascon cycle; there was some criticism, however, that it relied too heavily on Italian Baroque models. Some of Vien's work of the 1750s shows clearly his desire to return French painting to the mould of its classical period; Nicolas Poussin, Sébastien Bourdon and Charles Le Brun

became his models. Royal patronage helped, and in 1752 he received a commission through the Bâtiments du Roi for three works for the church at Crécy, a village then in the domains of Mme de Pompadour. In 1754–6 he painted a set of austere classical allegories for the Danish Count Adam Gottlob Moltke (Copenhagen, Amalienborg). Although happy to accept Danish patronage, he refused an invitation to become court painter in Copenhagen to Frederick V. Vien preferred to remain in France and advance his career there. In 1757 (the year he married) he was commissioned to paint a tapestry cartoon of *Proserpina Decorating a Statue of Ceres* for the Gobelins manufactory, and in 1759 he was made a professor at the Académie. He submitted to the Salon of 1759 a gloomy and heavily Baroque religious work, the *Pool of Bethesda* (Marseille, Mus. B.-A.), reminiscent of his earlier style. His other submission, a *Supper at Emmaus*, was painted for the Benedictine monastery of Bonne Nouvelle at Orléans. His early enthusiasm for the Baroque had surfaced again. Two years later, however, his *SS Germanus and Geneviève* (exh. Salon 1761) won him extremely favourable notices, especially from Denis Diderot, who wrote of the painting: 'This is not the manner of Rubens, nor is it the style of the Italian school, this is truth itself, which belongs to all ages and all countries' (*Salons*, i, p. 120).

Under the influence of the Comte de Caylus, whose antiquarian interests had been intensified by the excavations at Herculaneum, Vien had submitted to the Salon of 1755 a picture of *Minerva* (St Petersburg, Hermitage) painted using the wax encaustic process. Such efforts to return to a highly serious classical tradition were impeded not only by his own inclinations towards the Baroque but by the fashionable taste of his contemporaries for Neo-classicism. This resulted in a great deal of mediocre, modishly classicizing work: his *morceau de réception* for the Académie, *Daedalus and Icarus* (1754; Paris, Ecole N. Sup. B.-A.), and successive works exhibited at the Salons of 1761 and 1763—the *Corinthian Maid* (untraced, engraved by Jean-Jacques Flipart), the *Virtuous Athenian Girl* (Strasbourg, Mus. B.-A.), *Sacrifice to*

Venus and *Sacrifice to Ceres* (untraced, engraved by Jacques-Firmin Beauvarlet) and *Glycera: The Flowerseller* (Troyes, Mus. B.-A. & Archéol.). In these pictures, the last four of which were painted for Marie-Thérèse Geoffrin, young women in Grecian costume pose in a variety of undemanding actions before altars, urns, vases and tripods in 'antique' interior or outdoor settings. Rather than a true return to the ideals of Poussin and Raphael, they simply represent a facet of 18th-century Salon taste. Nevertheless one work in this vein, the *Cupid Seller* (1763; Fontainebleau, Château; see col. pl. XXXVIII), is one of Vien's most successful, attractive and poetically expressive pictures. It is closely modelled on a Roman painting unearthed at Gragnano near Naples in 1759 (see also the engraving by Giovanni Battista Nolli in *Le pitture antiche d'Ercolano*, Naples, 1762, iii, pl. vii); in this picture Vien achieved a perfect balance between the contemporary taste for delicacy in art and his own classicizing ideals. The setting, composition and costume are all unashamedly classical, as is the frank simplicity of its emotional character.

The sureness of this poetic quality did not survive Vien's transition to large-scale history painting, which was his next experiment. *Marcus Aurelius Distributing Alms* (Amiens, Mus. Picardie), one of four works commissioned in 1764 for the Château of Choisy, near Paris, is clumsily composed, weakly drawn and lacking in any kind of poetic content, despite its attention to line, form, costume and classical detail. When exhibited at the Salon of 1765, it elicited Diderot's displeasure (see Seznec and Adhémar, ii, pp. 87–9). Two years later, however, Vien's *St Denis Preaching the Faith in France* (Paris, St Roch) met with greater success. While not expressing the emotional force of Gabriel-François Doyen's richly Baroque *St Geneviève and the Miracle of the Victims of Burning-sickness* (Paris, St Roch), the painting with which it shared centre stage at the Salon of 1767, Vien's *St Denis* achieved the calm, spare monumentality towards which he had been working since his return from Italy. Like the *Cupid Seller*, it displays many of the trappings of antiquity: St Denis preaches from the steps of a temple

portico, while behind him are the ramparts and buildings of Poussin's classical backgrounds. Its strength, however, comes from the unadorned simplicity with which the scene is represented, from the conviction that emanates from St Denis and from the rapt expressions and attitudes of his audience. The picture's companion piece at the Salon, *Caesar Landing at Cadiz* (Warsaw, N. Mus.), was regarded as a failure.

In 1769 Vien exhibited the *Inauguration of the Equestrian Statue of Louis XV* (untraced; oil sketch, Paris, Carnavalet), painted for the Paris Hôtel de Ville. It was widely criticized for the poor quality of its portraits and draughtsmanship and for its lack of inspiration in conveying any sense of the occasion. Vien's reversion to a simple, classical composition is evident in the bas-relief effect he sought for the cavalcade of horsemen trooping in front of Edme Bouchardon's statue of the King, newly erected in the Place Louis XV, Paris. Many of the same concerns are displayed in the set of four decorative pictures—the *Progress of Love in the Hearts of Young Girls*—which he painted in 1773–4 to replace Jean-Honoré Fragonard's rejected *Pursuit of Love* series (New York, Frick) for the pavilion at Mme Du Barry's château at Louveciennes. These works, the *Oath of Feminine Friendship*, the *Temple of Hymen* (both Chambéry, Préfecture), the *Meeting with Cupid* (Paris, Louvre) and the *Crowning of the Lovers* (Paris, Louvre), echo the one-, two- and three-figure compositions of the early 1760s in their attempt to recapture the simple, Neo-classical 'look' that had proved so successful a decade before—then avant-garde, but by this date the height of fashion.

2. Later career, 1775–1809

In addition to his elevated position at the Académie, Vien was now also active as director of the Ecole des Elèves Protégés (from 1771). In 1775 he returned to Rome to take up the post of director of the Académie de France, taking with him his pupil Jacques-Louis David. Imminent departure did not prevent Vien from exhibiting a few pictures at the Salon that year, including *St Thibault*, for the new chapel at the Grand Trianon, Versailles, painted in response to the developing

vogue for scenes of medieval France. Its figures are wooden, its composition is clumsy, and the work has remained in obscurity on deposit at the Château of Versailles ever since it was painted. During his six-year tenure in Rome, Vien reorganized and reinvigorated the teaching of students while also promoting the cause of Neo-classicism. On his return he embarked on a series of works on subjects from Homer's *Iliad*, exhibiting *Briseis Led from the Tent of Achilles* (Angers, Mus. B.-A.) at the Salon of 1781. Although his teaching had some influence on pupils such as David and Peyron, Vien's Italian sojourn had done little for his own artistic abilities, and critics continued to stress that depictions of strong passions were beyond his skills. Unabashed, he continued in his pursuit of the monumental and the Antique, submitting picture after picture on Homeric subjects to the biennial Salons. A Crown commission began in 1783 with *Priam Leaving to Beg Achilles for the Return of the Body of Hector* (exh. 1785; Algiers, Mus. N. B.-A.) and continued with the *Return of Priam* (Angers, Mus. B.-A.) and the *Farewell of Hector and Andromache* (exh. 1787; Epinal, Mus. Dépt. Vosges & Mus. Int. Imagerie).

Vien's standing with the Académie in Paris, already high, increased until 1789 when, on the death of Jean-Baptiste-Marie Pierre, he was appointed Premier Peintre du Roi. This triumph was short-lived. Protected during the Revolutionary upheavals by his pupil David, whose portrait he painted (Angers, Mus. B.-A.), Vien did not exhibit at the Salon after 1793, preferring to bask in the reflected glory of former pupils. He was ennobled by Napoleon in 1808, and his final undertaking was the compilation of his *Mémoires*.

Vien made two important contributions to the development of French painting in the 18th century. First was his unshakeable belief in the study of the Antique: this was the ultimate reason for his attachment to the work of Raphael, Michelangelo, the Carracci family and Nicolas Poussin. No matter that his attempts at emulation were often little more than mildly titillating fancy pieces in the antique mode. Strongly influenced

in his formation by these models, Vien was also the first French artist of his century to embrace the Neo-classical ideal. When he vacillated towards the Baroque, despite perseverance he largely failed. Lack of technical ability and, more often, lack of conceptual vision hampered him. Gradually the fervour and energy of his youth were replaced by intellectualism, coldness and isolation. Vien's teaching and his absolute insistence on study from the life constituted his second contribution. In life study he found the only viable basis for all art, and it was precisely for lack of it that French painting had become so artificial by the mid-1740s. Notwithstanding the demonstrable limitations of his own artistic vision, Vien practised what he preached.

Bibliography

J. Le Breton: *Notice historique sur la vie et les ouvrages de M. Vien* (Paris, 1809)

F. Aubert: 'Joseph-Marie Vien', *Gaz. B.-A.*, xxii (1867), pp. 180–90, 282–94, 493–507; xxiii (1867), pp. 175–87, 297–310, 470–82

J. Seznec and J. Adhémar, eds: *Salons de Diderot 1759–1781*, 4 vols (Oxford, 1957–67)

P. Rosenberg: 'Une Esquisse de J.-M. Vien: *Loth et ses filles*', *Rev. Louvre* (1968), pp. 208–11

T. W. Gaehtgens: 'J.-M. Vien et les peintres de la Légende de Sainte Marthe', *Rev. A.* [Paris], xxiii (1974), pp. 64–9

The Age of Louis XV: French Painting, 1710–1774 (exh. cat., ed. P. Rosenberg; Toledo, OH, Mus. A.; Chicago, IL, A. Inst.; Ottawa, N.G.; 1975–6)

T. W. Gaehtgens: 'Deux tableaux de J.-M. Vien récemment acquis par les musées de Brest et de Lille', *Rev. Louvre*, 5–6 (1976), pp. 371–8

D. Rice: *The Fire of the Ancients: The Encaustic Painting Revival, 1775 to 1812* (diss., New Haven, Yale U., 1979)

T. W. Gaehtgens: 'Oeuvres de Vien', *Catalogue de la Donation Baderou, Musée des Beaux-Arts, Rouen* (1980), pp. 75–80

C. Gendre: 'Esquisses de Collin de Vermont et de J.-M. Vien', *Rev. Louvre* (1983), pp. 399–403

Diderot et l'art de Boucher à David: Les Salons, 1759–1781 (exh. cat., ed. M.-C. Sahut and N. Volle; Paris, Hôtel de la Monnaie, 1984–5), pp. 410–28

T. W. Gaehtgens: 'Vien, vers un nouveau style', *Conn. A.*, 446 (1989), pp. 87–98

JOSHUA DRAPKIN

Vigée Le Brun [Vigée-Le Brun; Vigée-Lebrun], Elisabeth-Louise [Louise-Elisabeth]

(*b* Paris, 16 April 1755; *d* Paris, 30 March 1842). French painter. She earned an international reputation for her stylish portrayals of royalty and aristocratic society in France and throughout Europe during the period 1775–1825; before the outbreak of the French Revolution she was closely associated with Marie-Antoinette and the taste of the Ancien Régime. After 1789 she continued her highly lucrative career abroad, enjoying celebrity as one of the most successful portrait painters of her era. Her memoirs provide an intimate account of the life of a woman artist working in the orbit of the French court in the late 18th century.

1. France, 1755–89

Elisabeth-Louise Vigée Le Brun was the daughter of Louis Vigée (1715–67), a pastellist who specialized in portraits. She studied with P. Davesne (*fl* 1764–96) and Gabriel Briard (1729–77), and by copying Old Masters. In addition, she received encouragement and advice from Joseph Vernet. By the age of 15 she had already developed a modest clientele for her portraits; on 25 October 1774 she became a member of the Académie de St Luc. On 11 January 1776 she married the art dealer Jean-Baptiste Le Brun; she exhibited her work at the Hôtel de Lubert, their house in Paris, and the salons that she held there provided her with important contacts.

The list that Vigée Le Brun kept of her paintings documents the increasingly high social status of her sitters. Her ceremonial portrait of *Charles-Henri-Othon, Prince of Nassau* (1776; Indianapolis, IN, Mus. A.) employed the traditional appointments, idealized interior setting and elegant stance that had been used by earlier 18th-century portrait painters such as Louis Tocqué to convey the sitter's nobility. In that same year she received her first royal commissions, portraits of one of the brothers of Louis XVI. A trip to the Netherlands and Flanders in 1781 deepened her admiration for Rubens, whose technical practices she began to emulate, switching from canvas supports to panel and experimenting with a warmer range of

colours and the use of multiple, thin layers of transparent or translucent paint. Her *Self-portrait in a Straw Hat* (1782; priv. col.) was based directly on Rubens's portrait of *Susanna Fourment* ('*Le Chapeau de Paille*', c. 1622–5; London, N.G.). In this work Vigée Le Brun introduced a note of informality that she later used to advantage in portraying fashionable aristocratic demeanour, particularly of women. In such works as the *Duchesse de Polignac* (1783; Waddesdon Manor, Bucks, NT), who is portrayed standing at a piano, and the elegant portrait of two friends, the *Marquise de Pezay and the Marquise de Rougé with her Sons*, she employed delicately animated poses, expressive faces and fashionable dress to convey the refinement and grace of Ancien Régime society. Through her smooth handling of the paint in areas of drapery she conveyed the substance of different materials without being excessively naturalistic. In contrast, details like lace edging or embroidery were carefully observed, yet loosely painted, adding visual interest to the work. The faces were finely modelled, with vitality imparted to the skin tones through a delicate layering of colour, especially in the shadows. Vigée Le Brun's contemporaries noted her characteristic preference for striking colour combinations; for example she would accent deep midnight blues in either clothing or background with vermilion or orange areas. In the 1780s she began to employ thin, openly brushed monochromatic backgrounds, similar to those seen in Jacques-Louis David's portraits from the 1790s, and this novel treatment heightened the vitality of the subjects' faces. Some of the exoticism of her female sitters derives from the original costumes and headdresses that she herself often designed or concocted (e.g. *Catherine, Countess Skavronsky*, 1790; Paris, Mus. Jacquemart-André). Vigée Le Brun's awareness of her female subjects' affectations, and her ability to flatter them, can be gauged from the contrasting directness and intensity of her portraits of men, such as that of *Hubert Robert* (1788; Paris, Louvre) or of *Alexander Charles Emmanuel de Crussol-Florensac* (1787; New York, Met.).

In 1788 Vigée Le Brun was first granted favour and patronage by Marie-Antoinette. Until 1783 she

exhibited her work—portraits, self-portraits and allegories of the arts—at the Académie de St Luc and the Salon de la Correspondence, the only venues then available to her. Vernet, whose portrait she painted in 1778 (Paris, Louvre), proposed her admission to the Académie Royale, but Jean-Baptiste Pierre, Premier Peintre du Roi, objected on the grounds that her husband was a dealer; and it was only through royal intervention that she was admitted to membership of the Académie on 31 May 1783, the same day as her rival Adélaîde Labille-Guiard. They filled the two remaining places of the four allotted to women. Vigée Le Brun's *morceau de réception*, *Peace Bringing Back Plenty* (1780; Paris, Louvre) was a history painting, demonstrating her ambition to be considered as one of the highest class of painter. She painted some 30 portraits of Marie-Antoinette, varying in attire and bearing. One of 1783 that portrayed the Queen 'en gaulle', in a simple gauzy dress (Darmstadt, Princess von Hessen & bei Rehin priv. col.) was criticized as indecorous, and was replaced during the 1783 Salon by another portrait (untraced) that featured a more formal gown. In 1785 Vigée Le Brun received an official commission for a portrait of *Marie-Antoinette and her Children* (1787; Versailles, Château), which was intended to counter the increasing criticism of the Queen as frivolous and wayward; by depicting her surrounded by her affectionate children, Vigée Le Brun portrayed Marie-Antoinette as a devoted, virtuous mother and wife. The painting's overall pomp and splendour presented a dignified image of Marie-Antoinette as sovereign, in direct contrast to Adolf Ulric Wertmüller's vacuous image (1785 Salon; Stockholm, Nmus.) of the Queen strolling with her children in the gardens of Versailles. The politically sensitive nature of this image may be gauged from the artist's decision to withhold the painting from the opening days of the 1787 Salon. For such work she was paid considerably more than her contemporaries, even the history painters, and this ability to command extraordinary fees persisted throughout her career. Until 1791 she exhibited regularly at the annual Salon, and critics were generally complimentary; but because of her association with

Marie-Antoinette, she became early in 1789 the victim of a slanderous press campaign. Distressed by these attacks on her private life and by the increasingly violent progress of the Revolution, in October 1789 she left France with Jeanne-Julie-Louise Le Brun (1780–1819), her only child, for what were to be 12 years of exile and travel.

2. Europe and France, 1789–1842

Vigée Le Brun's first destination was Italy, where she stayed until 1793, moving in court circles in Turin, Rome, and particularly Naples, which was ruled by Ferdinand I (1751–1825), married to Marie-Antoinette's sister Caroline (1752–1814). There Vigée Le Brun painted portraits of many English tourists, such as *Frederick Augustus Hervey, 4th Earl of Bristol* (1790; Ickworth, Suffolk, NT). She also visited Florence and Venice. In Florence in 1790 she contributed to the celebrated grand-ducal collection of artists' self-portraits in the Uffizi a *Self-portrait* (*in situ*) that is a quintessential image of a painter at work at an easel, wearing an informal bonnet and holding a palette and a fistful of brushes; at the same time the artist signalled her femininity through the careful depiction of her elaborate ruffled lace collar and the colourful accent of her sash. When this portrait was exhibited in Rome in the same year, it was rapturously received, and earned Vigée Le Brun election to the Accademia di S Luca. In other self-portraits she addressed her role as a tender mother; thus in two portrayals of *Madame Vigée Le Brun and her Daughter* (1786 and 1789; both Paris, Louvre; see col. pl. XXXIX) she is seen embracing her little girl; in the latter version both are in Grecian dress.

There followed invitations to Vienna (1793–4) and then Prague, Dresden and Berlin. In each city Vigée Le Brun received numerous commissions from a noble clientele. From 1795 to 1801 she lived in St Petersburg except for a five-month stay in Moscow beginning in October 1800. Even though the Empress Catherine II found fault with her work, Vigée Le Brun prospered, painting for members of the imperial family and for the Russian nobility (e.g. *Catherine, Countess Skavronsky*, 1796; Paris, Louvre). In 1800 she became an hon-

orary associate of the St Petersburg Academy. During that period she modernized her repertory to include portraits set in romantic landscape, suggesting the pleasure of solitude in natural settings, popularized by the writings of Jean-Jacques Rousseau; examples of such works are *Countess Potocka* (1791; Fort Worth, TX, Kimbell A. Mus.) and *Countess Bucquoi* (1793; Minneapolis, MN, Inst. A.). Although many of Vigée Le Brun's Russian works either repeated or were reminiscent of her earlier compositions—her oeuvre in general being complicated by a large number of copies, replicas and imitations—a number of the portraits displayed a new intensity and spareness very much in keeping with the Romantic era's emphasis on the individual. In these, solitary figures in relatively modest attire gaze directly at the viewer. Placed against subtly modulated plain backdrops, they convey intelligence or personality (e.g. *Countess Golovin*, 1797–1800; U. Birmingham, Barber Inst.).

After Vigée Le Brun's departure from France her name had been placed on the list of émigrés, whose citizenship was thereby revoked and property confiscated. Her husband tried to defend her, publishing in 1793 a pamphlet entitled *Précis historique de la vie de la Citoyenne Le Brun*, but he was forced to divorce her in 1794, on pain of forfeiting their possessions. In 1799 fellow artists circulated a petition, which was granted the following year, requesting that her name be removed from the list of émigrés. Once her citizenship had been restored, Vigée Le Brun returned to France, initially for a brief period preceded by a six-month stay in Berlin. She spent 1802 in France, working on paintings begun during her Russian period. Saddened by the post-revolutionary atmosphere, she then moved to London (1803–5), where her list of clients for portraits included the poet Lord Byron and the Prince of Wales (later George IV). In the summer of 1805 she returned to France for good, except for brief trips in 1807 and 1808 to Switzerland, where she visited Mme de Staël, whose portrait she painted (Geneva, Mus. A. & Hist.). After 1809 Vigée Le Brun divided her time between Paris and a country house in Louveciennes, and once more began to hold popular salons; her husband died in 1813 and her daughter in 1819. She continued to paint,

though sporadically, sending works to the Salons of 1817 and 1824. In 1829 she produced a short manuscript autobiography for a friend, Princess Natalie Kourakin, and in 1834–5, with the aid of her nieces and friends, she expanded her recollections into *Souvenirs*.

Writings

Souvenirs de Madame Louise-Elisabeth Vigée Le Brun, 3 vols (Paris, 1835–7); Eng. trans. as *Memoirs of Elisabeth Vigée-Le Brun* (Bloomington and London, 1989) [numerous other editions and translations]

Bibliography

P. de Nolhac: *Madame Vigée-Le Brun: Peintre de la reine Marie-Antoinette, 1755–1842* (Paris, 1908)
A. Blum: *Madame Vigée-Lebrun: Peintre des grandes dames du XVIIIe siècle* (Paris, 1919)
L. Nikolenko: 'The Russian Portraits of Mme Vigée Le Brun', *Gaz. B.-A.*, n.s. 5, lxx (1967), pp. 91–120
J. Baillio: 'Le Dossier d'une oeuvre d'actualité politique: Marie-Antoinette et ses enfants par Mme Vigée Le Brun', *L'Oeil* (1981), no. 308, pp. 34–41, 74–5; no. 310, pp. 53–60, 90–91
——: *Elisabeth Louise Vigée Le Brun, 1755–1842* (exh. cat., Fort Worth, TX, Kimbell A. Mus., 1982) [includes an appendix with documents, among them excerpts from the scandalous press reports of 1789 as well as Jean-Baptiste Le Brun's pamphlet of 1793]
W. Chadwick: *Women, Art and Society* (New York, 1990)

KATHLEEN NICHOLSON

Vincent, François-André

(*b* Paris, 30 Dec 1746; *d* Paris, 3 or 4 Aug 1816). French painter and draughtsman. He was one of the principal innovators in French art of the 1770s and 1780s, in the field of both Neo-classical subjects and themes from national history. Despite the fact that he worked in a variety of styles, his sense of purpose appears to have been coherent at a time of profound change. His stylistic sources lay in the art of Classical antiquity and such masters as Raphael, the great Bolognese painters of the 17th century and Charles Le Brun; yet he also studied reality in a quasi-documentary way. His work, too often confused with that of Jean-Honoré Fragonard, Jacques-Louis David or Louis-Léopold Boilly, is of a high standard, even though the completed paintings do not always uphold the promise of energy of his drawings and oil sketches.

1. Training and years in Italy, to 1775

He was the son of the miniature painter François-Elie Vincent (1708–90), who was perhaps his first teacher. He then studied in Joseph-Marie Vien's studio at the Académie Royale de Peinture et de Sculpture, Paris. A brilliant pupil, he won the Prix de Rome in 1768 with the painting *Germanicus Quelling a Revolt* (Paris, Ecole N. Sup. B.-A.), which is nearer to François Boucher than to Vien in style. Until July 1771 he was a pupil at the Ecole Royale des Elèves Protégés. Among his pictures of this period is a *Self-portrait in Spanish Costume* (Grasse, Mus. Fragonard), which shows the influence of Fragonard's *figures de fantaisie*.

The time Vincent spent at the Académie de France in Rome, from summer 1771 to autumn 1775, was crucial to his development. He produced many drawings in various styles and techniques of antiquities, landscapes, nudes and after the Old Masters (e.g. Orléans, Mus. B.-A.; Paris, Fond. Custodia, Inst. Néer.; Vienna, Albertina), as well as caricatures of his fellow students (e.g. Montpellier, Mus. Atger; Paris, Carnavalet). Paintings of this period include portraits, both formal (e.g. *Monseigneur Ruffo*, 1775; Naples, Mus. N. S Martino) and informal (e.g. *Jean-Pierre Houel*, 1772; Rouen, Mus. B.-A.). During the months in which Fragonard was in Rome and Naples (December 1773 to June 1774) Vincent produced paintings that are particularly close in style to his: the portrait of Fragonard's travelling companion *Jacques-Onésyme Bergeret de Grancourt* (Besançon, Mus. B.-A. & Archéol.) is an example; the two artists' drawings are also very similar, for example four red chalk drawings, two by Fragonard, two by Vincent, depicting young girls (Besançon, Mus. B.-A. & Archéol. and Bib. Mun.).

2. Ancien Régime career, 1775–c. 1790

Vincent returned to France in October 1775, staying for a time at Marseille, where he painted a triple portrait of himself with the architect Pierre Rousseau (1751–1810) and the painter van

Wyck (1775; Paris, Louvre). He was approved (agréé) by the Académie Royale in May 1777 on presenting a painting of St Jerome (Montpellier, Mus. Fabre), which shows the influence of Guercino. He exhibited 15 paintings at the Salon of that year, including the pendants Socrates and Alcibiades and Belisarius (both Montpellier, Mus. Fabre), Neoclassical themes depicted in a realistic, neo-Bolognese style. His President Molé and the Insurgents (Paris, Pal. Bourbon), a large, colourful and dramatic scene from French history, was a tremendous success at the 1779 Salon. In 1782 he was received (reçu) as a full member of the Académie Royale with the Abduction of Oreithyia by Boreas (Chambéry, Préfecture). He exhibited regularly at the Salon, showing large canvases on religious themes such as Christ at the Pool of Bethesda (1783; Rouen, La Madeleine), and in particular exemplary themes from Greek and Roman history, such as the Intervention of the Sabine Women (1781; Angers, Mus. B.-A.) and Paetus and Aria (1785; Amiens, Mus. Picardie) (see also col. pl. XL). One of Vincent's recognized specialities both before and after the Molé was his 'national' subject-matter, in which he was a precursor of the painters of the Louis-Philippe period. Among his works of this kind is a set of six tapestry cartoons based on the Life of Henry IV (1783–7; Fontainebleau, Château, and Paris, Louvre).

3. The French Revolution and later career, from c. 1790

In 1790 Vincent replaced Charles-Nicolas Cochin (ii) as Garde des Dessins du Roi, and in 1792 he became a professor at the Académie Royale just before its dissolution. He was also on the committees set up to organize and administer the new museum established in the Palais du Louvre, but he had to resign in October 1793, shortly after its inauguration. In 1794 his painting Heroine of St Minier (untraced) won the second prize in the 'Competition of the year II', designed to commemorate 'the most glorious periods of the French Revolution', and his William Tell Tipping over Gessler's Boat (Toulouse, Mus. Augustins), commissioned by the state in 1791, was exhibited at the 1795 Salon. He painted an increasing number of portraits from the 1790s. Sober and warm, they were generally half-lengths, such as that of Mme Justine Boyer-Fonfrède and her Son (1796; Paris, Louvre).

Vincent continued to be innovative in his choice of subject-matter: as with the Rousseauist Agriculture Lesson (Bordeaux, Mus. B.-A.), shown at the Salon of 1798, which illustrates the father of a family teaching his young son how to steer a plough; and the proto-Romantic Melancholy (Malmaison, Château N.), exhibited at the Salon of 1801, which depicts a young girl draped in white, in a cemetery at night. A commission in 1800 for a huge painting of the Battle of the Pyramids was never finished, though there are numerous drawings as well as painted sketches in the Musée du Louvre and at the château of Versailles. With a few exceptions—the Allegory of the Liberation of the Slaves of Algiers (1806; Kassel, Neue Gal.), for instance—Vincent's last years as a painter were largely devoted to portraiture. Though his health was not good, he spent much time teaching, and his studio was, with those of David and Jean-Baptiste Regnault, the most popular in Paris. He painted family portraits, among them Jean-Baptiste Boyer-Fonfrède with his Wife and Son (1801; Versailles, Château), as well as portraits of writers, including Antoine-Vincent Arnault (1801) and François Andrieux (1815; both Versailles, Château), and of artists, such as that of the engraver Charles-Clément Bervic (1813; priv. col.). He continued to produce a large number of drawings in varied techniques, including some striking pen caricatures of his colleagues during meetings of the Institut, which he joined in 1795 (e.g. Rouen, Mus. B.-A.). In 1800 he married Adélaïde Labille-Guiard, his lifelong companion, but she died in 1803. He received the Légion d'honneur in 1805.

Bibliography

H. Lemonnier: 'Notes sur le peintre Vincent', Gaz. B.-A., n. s. 2, xxxii (1904), pp. 287–98
French Painting 1774–1830: The Age of Revolution (exh. cat. by J.-P. Cuzin; Paris, Grand Pal.; Detroit, MI, Inst. A.; New York, Met.; 1975), pp. 661–6
J.-P. Cuzin: 'De Fragonard à Vincent', Bull. Soc. Hist. A. Fr. (1981), pp. 103–24

—: *François-André Vincent, 1746–1816*, Cahiers du dessin français, 4 (Paris, 1988)

JEAN-PIERRE CUZIN

Yvon, Adolphe

(*b* Escheviller, 30 Jan 1817; *d* Paris, 11 Sept 1893). French painter. Having studied at the Collège Bourbon, he was employed by the Domaine Royal des Forêts et des Eaux at Dreux. He resigned in 1838 and went to Paris to become an artist. He studied under Paul Delaroche at the Ecole des Beaux-Arts and had three religious compositions accepted for the Salon of 1841: *St Paul in Prison*, *Christ's Expulsion of the Money-changers* (both untraced) and the *Remorse of Judas* (Le Havre, Mus. B.-A.). Yvon's début attracted some critical attention, and his canvases were purchased for the State; but he was more interested in depicting the exotic worlds popularized by artists like Alexandre Decamps and Prosper Marilhat. In May 1846 he departed for Russia on a voyage of six months that was to have a profound influence on his subsequent career. Drawings made on the trip led to a painting of the *Battle of Kulikova* (1850; Moscow, Kremlin), depicting the Tatar defeat. It was eventually sold to Tsar Alexander II in 1857. Yvon's familiarity with Russia contributed to his appointment as the only official artist accompanying French forces during the Crimean War in 1856. His *Taking of Malakoff*, painted for Versailles (*in situ*), was shown at the Salon of 1857 and again at the Exposition Universelle of 1867.

Following the Revolution of 1848 and the proclamation of the Second Empire, Yvon gained the favour of Emperor Napoleon III and henceforth served as an official artist of his regime. The glorification of the Napoleonic past became State policy, and Yvon's portrayals of patriotic exploits from that period were much in demand. He won praise for his painting, *Marshal Ney Supporting the Retreat of the Grand Army, 1812* (exh. Exposition Universelle 1855; Versailles, Château). He accompanied the imperial forces on the Italian campaigns against Austria, representing in heroic pictorial language the second attack on Magenta and the Battle of Solferino in 1859 (exh. Salon 1863; both Versailles, Château). In 1861 he was commissioned to paint *Eugene Louis, Prince Imperial* and in 1868 painted an official portrait of *Napoleon III* (both untraced).

Yvon received many honours for sustaining the desired imperial image: he was awarded the Légion d'honneur (1855) and promoted within the order (1867) and he was made professor at the Ecole des Beaux-Arts. In 1867 he published a manual of design for use in art schools and lycées. In 1870 Yvon was commissioned by a wealthy American collector, Alexander Turney Stewart, to create a colossal allegory of the *Reconciliation of the North and the South* (untraced). Yvon's reputation hardly outlasted the fall of the Second Empire in 1870. Facile and adaptable though he may have been, he was also prone to a literalism that has dated badly.

Writings

Méthode de dessin à l'usage des écoles et des lycées (Paris, 1867)

Bibliography

A. Thierry: 'Adolphe Yvon: Souvenirs d'un peintre militaire', *Rev. Deux Mondes*, n. s. 2, pér. 8, lxxi (1933), pp. 844–73
E. Heiser: *Adolphe Yvon, 1817–1893, et les siens: Notices biographiques* (Sarreguemines, 1974)

FRANK TRAPP

Ziegler, Jules-Claude

(*b* Langres, Haute-Marne, 16 March 1804; *d* Paris, 25 Dec 1856). French painter, ceramicist, writer and lithographer. He first studied in Paris under Ingres and François-Joseph Heim. In 1830 he toured Italy, spending time in Venice especially, and then went to Munich, where he learnt the technique of fresco painting from Peter Cornelius. After spending some time in Belgium, he returned to Paris and illustrated such Romantic pieces of literature as E. T. A. Hoffmann's *Contes fantastiques*. At the Salon of 1831 he exhibited paintings based on his travels, including *View of Venice* (Nantes, Mus. B.-A.) and *Souvenir of Germany*. In 1833 he established his reputation as a history

painter by showing at the Salon two works that were based on medieval sources: *Giotto in Cimabue's Studio* (Bordeaux, Mus. B.-A.), bought by the State for the Musée du Luxembourg, and the *Death of Foscari* (Arras, Mus. B.-A.). At the Salon of 1835 he was awarded medals for portraits of *Connétable, Comte de Sancerre* and *General Kellermann* (both Versailles, Château). From 1835 to 1838 he frescoed the cupola of the choir of La Madeleine with *A History of Christianity*. He astonished the critics in 1838 with the *Prophet Daniel* (Nantes, Mus. B.-A.), exhibited at the Salon, and was awarded the cross of the Légion d'honneur. Because of his training with Ingres, his paintings are characterized by a great amount of graphic detail and plastic power, yet there is a certain primitivism that links him to other disciples of Ingres such as Eugène Ammanuel Amaury-Duval and Hippolyte Flandrin.

His interest in the decorative arts had begun when he was given a government grant to study the techniques of painting on glass and ceramics in Germany. In 1839 he established a factory at Voisinlieu, near Beauvais, for the production of relief-decorated salt-glazed stone wares and in 1850 made lithographs of some of the pieces for his publication *Etudes céramiques: Recherche des principes du beau dans l'architecture, la céramique et la forme en général* (1850). This venture can be seen as part of the crafts renaissance in western Europe in the mid-19th century. After a five-year period during which he did no painting, he exhibited again at the Salon in 1844 and in 1848 he won a medal for *Charles V after Preparing his Funeral Rites*. As an art critic and theorist he wrote reviews of various exhibitions, and his *Traité de la couleur et de la lumière* was published in 1852. From 1854 he was Director and Curator of the Musée des Beaux-Arts in Dijon.

Writings

Etudes céramiques: Recherche des principes du beau dans
 l'architecture, la céramique et la forme en général
 (Paris, 1850)
Traité de la couleur et de la lumière (Paris, 1852)
Compte-rendu de la photographie à l'exposition de 1855
 (Paris, 1855)

Bibliography

Bellier de La Chavignerie–Auvray
M.-P. Boyé: *L'Alchimiste de la peinture religieuse au XIXe
 siècle: Jules-Claude Ziegler* (Nantes, 1956)

ANNIE SCOTTEZ-DE WAMBRECHIES

Black and White Illustration Acknowledgements

We are grateful to those listed below for permission to reproduce copyright illustrative material. Every effort has been made to contact copyright holders and to credit them appropriately; we apologize to anyone who may have been omitted from the acknowledgements or cited incorrectly. Any error brought to our attention will be corrected in subsequent editions.

Alinari/Art Resource, NY Figs 25, 29, 35, 50, 57, 66, 72

Erich Lessing/Art Resource, NY Figs 3, 6, 12, 20, 21, 22, 27, 28, 36, 42, 43, 45, 47, 58, 62, 68, 69, 70, 71

Giraudon/Art Resource, NY Figs 1, 2, 4, 5, 7, 8, 9, 10, 11, 13, 14, 15, 16, 17, 18, 19, 23, 24, 26, 30, 31, 32, 34, 38, 39, 40, 41, 44, 46, 48, 49, 51, 52, 53, 54, 55, 56, 59, 60, 61, 63, 64, 65, 67, 73

Scala/Art Resource, NY Figs 33, 37

Colour Illustration Acknowledgements

Art Resource, NY Plate I

Erich Lessing/Art Resource, NY Plates II, IV, VI, VII, VIII, X, XIII, XIV, XVI, XIX, XX, XXVIII, XXX, XXXIII, XXXIV, XXXVI, XXXIX, XL

Giraudon/Art Resource, NY Plates V, XI, XVII, XXI, XXII, XXIII, XXIV, XXV, XXVI, XXVII, XXIX, XXXI, XXXV, XXXVII, XXXVIII

Scala/Art Resource, NY Plates III, IX, XII, XV, XVIII, XXXII

Appendix A

LIST OF LOCATIONS

Every attempt has been made to supply the correct current location of each work of art mentioned, and in general this information appears in abbreviated form in parentheses after the first mention of the work. The following list contains the abbreviations and full forms of the museums, galleries and other institutions that own or display art works or archival material cited in this book; the same abbreviations have been used in bibliographies to refer to the venues of exhibitions.

Institutions are listed under their town or city names, which are given in alphabetical order. Under each place name, the abbreviated names of institutions are also listed alphabetically, ignoring spaces, punctuation and accents. Square brackets following an entry contain additional information about that institution, for example its previous name or the fact that it was subsequently closed.

Aix-en-Provence, Mus. Arbaud
 Aix-en-Provence, Musée Arbaud
Aix-en-Provence, Mus. Granet
 Aix-en-Provence, Musée Granet
Ajaccio, Mus. Fesch
 Ajaccio, Musée Fesch
Albi, Mus. Toulouse-Lautrec
 Albi, Musée Toulouse-Lautrec
Albuquerque, U. NM, A. Mus.
 Albuquerque, NM, University of
 New Mexico, Art Museum
Algiers, Mus. N. B.-A.
 Algiers, Musée National des
 Beaux-Arts
Amboise, Mus. Mun.
 Amboise, Musée Municipal [Musée
 de l'Hôtel de Ville]
Amiens, Mus. Picardie
 Amiens, Musée de Picardie
Amsterdam, Hist. Mus.
 Amsterdam, Historisch Museum
Amsterdam, Rijksmus.
 Amsterdam, Rijksmuseum
 [includes Afdeeling Aziatische
 Kunst; Afdeeling Beeldhouwkunst;
 Afdeeling Nederlandse
 Geschiedenis; Afdeeling
 Schilderijen; Museum von
 Asiatische Kunst; Rijksmuseum
 Bibliothek; Rijksprentenkabinet]
Amsterdam, Stedel. Mus.
 Amsterdam, Stedelijk Museum
Angers, Gal. David d'Angers

Angers, Galerie David d'Angers [in
 rest. Abbey]
Angers, Mus. B.-A.
 Angers, Musée des Beaux-Arts
Angers, Mus. Turpin de Crissé
 Angers, Musée Turpin de Crissé
 [in Hôtel Pincé]
Angoulême, Mus. Mun.
 Angoulême, Musée Municipal
Arbois, Hôp.
 Arbois, Hôpital
Arenenberg, Napoleonmus.
 Arenenberg, Napoleonmuseum
Arkhangel'skoye Pal.
 Arkhangel'skoye, Arkhangel'skoye
 Palace (Arkhangel'skoye Dvorets)
Arles, Mus. Réattu
 Arles, Musée Réattu
Arras, Mus. B.-A.
 Arras, Musée des Beaux-Arts
 [Ancienne Abbaye Saint-Vaast]
Autun, Mus. Rolin
 Autun, Musée Rolin
Auxerre, Mus. A. & Hist.
 Auxerre, Musée d'Art et
 d'Histoire
Avignon, Mus. Calvet
 Avignon, Musée Calvet
Avranches, Jard. Plantes
 Avranches, Jardin des Plantes
Baden-Baden, Staatl. Ksthalle
 Baden-Baden, Staatliche
 Kunsthalle Baden-Baden

Bagnères-de-Bigorre, Mus. A
 Bagnères-de-Bigorre, Musée
 d'Art
Baltimore, MD, Mus. A.
 Baltimore, MD, Baltimore Museum
 of Art
Baltimore, MD, Walters A.G.
 Baltimore, MD, Walters Art
 Gallery
Barnard Castle, Bowes Mus.
 Barnard Castle, Bowes Museum
Basle, Kstmus.
 Basle, Kunstmuseum [incl.
 Kupferstichkabinett]
Bayeux, Mus. Gérard
 Bayeux, Musée Baron Gérard
Bayonne, Mus. Bonnat
 Bayonne, Musée Bonnat
Beaune, Mus. Marey
 Beaune, Musée Marey et des
 Beaux-Arts, Hôtel de Ville
Beauvais, Mus. Dépt. Oise
 Beauvais, Musée Départemental de
 l'Oise
Berlin, Alte N.G.
 Berlin, Alte Nationalgalerie
Berlin, Schloss Charlottenburg
 Berlin, Galerie der Romantik [in
 Schloss Charlottenburg]
Berlin, Kupferstichkab.
 Berlin, Kupferstichkabinett
 [formerly at Dahlem, since 1994 at
 Tiergarten]

Berlin, Schloss Charlottenburg

Berne, Kstmus.

 Berne, Kunstmuseum

Besançon, Bib. Mun.

 Besançon, Bibliothèque
Municipale

Besançon, Mus. B.-A. & Archéol.

 Besançon, Musée des Beaux-Arts et
d'Archéologie

Béziers, Mus. B.-A.

 Béziers, Musée des Beaux-Arts
Hôtel Fabregat

Bielefeld, Städt. Ksthalle

 Bielefeld, Städtische Kunsthalle

Blérancourt, Château, Mus. N. Coop.
Fr.-Amér.

 Blérancourt, Château, Musée
National de la Coopération
Franco-Américaine

Bonn, Rhein. Landesmus.

 Bonn, Rheinisches Landesmuseum
[Rheinisches Amt für
Bodendenkmalpflege mit
Regionalmuseum Xanten und
Archäologischer Park Xanten]

Bordeaux, Mus. A. Déc.

 Bordeaux, Musée des Arts
Décoratifs

Bordeaux, Mus. Aquitaine

 Bordeaux, Musée d'Aquitaine

Bordeaux, Mus. B.-A.

 Bordeaux, Musée des Beaux-Arts

Boston, MA, Mus. F.A.

 Boston, MA, Museum of Fine Arts

Boulogne, Mus. Mun.

 Boulogne, Musée Municipal

Boulogne-Billancourt, Bib. Marmottan

 Boulogne-Billancourt,
Bibliothèque Marmottan

Bourg-en-Bresse, Mus. Ain

 Bourg-en-Bresse, Musée de l'Ain

Bourges, Mus. Berry

 Bourges, Musée du Berry [Hôtel
Cujas; Musée de Bourges]

Bremen, Ksthalle

 Bremen, Kunsthalle

Brest, Mus. Mun.

 Brest, Musée Municipal [Musée des
Beaux-Arts]

Brussels, Gal. Arenberg

 Brussels, Galerie Arenberg

Brussels, Mus. A. Anc.

 Brussels, Musée d'Art Ancien

Brussels, Mus. A. Mod.

 Brussels, Musée d'Art Moderne

Brussels, Musées Royaux A. & Hist.

 Brussels, Musées Royaux d'Art et
d'Histoire [Koninklijke Musea voor
Kunst en Geschiedenis]

Brussels, Mus. Ixelles

 Brussels, Musée Communal des
Beaux-Arts d'Ixelles

Budapest, Mus. F.A.

 Budapest, Museum of Fine Arts
(Szépmüvészeti Múzeum)

Buffalo, NY, Albright-Knox A.G.

 Buffalo, NY, Albright-Knox Art
Gallery [formerly Albright A.G.]

Caen, Mus. B.-A.

 Caen, Musée des Beaux-Arts

Calais, Mus. B.-A.

 Calais, Musée des Beaux-Arts et de
la Dentelle

Cambrai, Mus. Mun.

 Cambrai, Musée Municipal

Cambridge, Fitzwilliam

 Cambridge, Fitzwilliam Museum

Cambridge, MA, Fogg

 Cambridge, MA, Fogg Art Museum

Carcassonne, Mus. B.-A.

 Carcassonne, Musée des Beaux-
Arts

Cardiff, N. Mus.

 Cardiff, National Museum of
Wales

Carpentras, Mus. Duplessis

 Carpentras, Musée Duplessis

Chaalis, Mus. Abbaye

 Chaalis, Musée de l'Abbaye de
Chaalis

Chambéry, Mus. B.-A.

 Chambéry, Musée des Beaux-
Arts

Chambéry, Préfecture

Chantilly, Mus. Condé

 Chantilly, Musée Condé, Château
de Chantilly

Chartres, Mus. B.-A.

 Chartres, Musée des Beaux-Arts

Chaumont, Mus. Mun.

 Chaumont, Musée Municipal

Chauny: see Blérancourt

Cherbourg, Mus. B.-A.

 Cherbourg, Musée des Beaux-Arts

Cherbourg, Mus. Thomas-Henry

 Cherbourg, Musée Thomas-Henry

Chicago, IL, A. Inst.

 Chicago, IL, Art Institute of
Chicago

Cholet, Mus. A.

 Cholet, Musée des Arts de Cholet

Cincinnati, OH, A. Mus.

 Cincinnati, OH, Cincinnati Art
Museum

Cincinnati, OH, Taft Mus.

 Cincinnati, OH, Taft Museum

Clermont-Ferrand, Bib. Mun.

 Clermont-Ferrand, Bibliothèque
Municipale

Clermont-Ferrand, Jard. Pub.

 Clermont-Ferrand, Jardin Public

Clermont-Ferrand, Mus. Bargoin

 Clermont-Ferrand, Musée
Bargoin

Cleveland, OH, Mus. A.

 Cleveland, OH, Cleveland Museum
of Art

Cody, WY, Buffalo Bill Hist. Cent.

 Cody, WY, Buffalo Bill Historical
Center

Coëtquidan, Ecole Mil. St Cyr

 Coëtquidan, Ecole Militaire de St
Cyr

College Park, U. MD A.G.

 College Park, MD, University of
Maryland Art Gallery

Colmar, Mus. Unterlinden

 Colmar, Musée d'Unterlinden

Cologne, Wallraf-Richartz-Mus.

 Cologne, Wallraf-Richartz-
Museum

Compiègne, Château

 Compiègne, Château [houses
Musée National du Château de
Compiègne et Musée du Second
Empire; Musée National de la
Voiture et du Tourisme]

Compiègne, Mus. Mun. Vivenel

 Compiègne, Musée Municipal
Antoine-Vivenel

Copenhagen, Ny Carlsberg Glyp.

 Copenhagen, Ny Carlsberg
Glyptotek

Copenhagen, Ordrupgaardsaml.
Copenhagen,
Ordrupgaardsamlingen
Copenhagen, Stat. Mus. Kst
Copenhagen, Kongelige
Kobberstiksamling, Statens
Museum for Kunst
Copenhagen, Stat. Mus. Kst
Copenhagen, Statens Museum for
Kunst
Cork, Crawford Mun. A.G.
Cork, Crawford Municipal Art
Gallery
Dallas, TX, Mus. A.
Dallas, TX, Dallas Museum of
Art
Dampierre, Château
Darmstadt, Hess. Landesmus.
Darmstadt, Hessisches
Landesmuseum
Dayton, OH, A. Inst.
Dayton, OH, Dayton Art
Institute
Detroit, MI, Inst. A.
Detroit, MI, Detroit Institute of
Arts
Dieppe, Château-Mus.
Dieppe, Château-Musée de Dieppe
[Le Musée Dieppois]
Dijon, Mus. B.-A.
Dijon, Musée des Beaux-Arts
Dijon, Mus. Magnin
Dijon, Musée Magnin
Dijon, Pal. Justice
Dijon, Palais de Justice
Dinan, Hôtel de Ville
Douai, Mus. Mun.
Douai, Musée Municipal [La
Chartreuse]
Dublin, N.G.
Dublin, National Gallery of
Ireland
Duisburg, Lehmbruck-Mus.
Duisburg, Wilhelm-Lehmbruck-
Museum
Dunkirk, Mus. B.-A.
Dunkirk, Musée des Beaux-
Arts
Edinburgh, N.G.
Edinburgh, National Gallery of
Scotland

Epinal, Mus. Dépt. Vosges & Mus. Int.
Imagerie
Epinal, Musée Départemental des
Vosges et Musée International de
l'Imagerie
Essen, Mus. Flkwang
Essen, Museum Folkwang
Evreux, Mus. Evreux
Evreux, Musée d'Evreux [Ancien
Evêché]
Florence, Mus. Opera Duomo
Florence, Museo dell'Opera del
Duomo
Florence, Uffizi
Florence, Galleria degli Uffizi
[incl. Gabinetto dei Disegni]
Fontainebleau, Château
Fontainebleau, Musée National du
Château de Fontainebleau
Forlì, Municipio
Fort Worth, TX, Kimbell A. Mus.
Fort Worth, TX, Kimbell Art
Museum
Frankfurt am Main, Städel. Kstinst. &
Städt. Gal.
Frankfurt am Main, Städelsches
Kunstinstitut und Städtische
Galerie
Freiburg im Breisgau, Augustinmus.
Freiburg im Breisgau,
Augustinermuseum
Gap, Mus. Dépt.
Gap, Musée Départemental
de Gap
Geneva, Mus. A. & Hist.
Geneva, Musée d'Art et d'Histoire
Geneva, Mus. Voltaire
Geneva, Institut et Musée
Voltaire
Ghent, Mus. S. Kst.
Ghent, Museum voor Schone
Kunsten
Glasgow, A.G. & Mus.
Glasgow, Art Gallery and Museum
[Kelvingrove]
Grasse, Mus. Fragonard
Grasse, Musée Fragonard
Gray, Mus. Martin
Gray, Musée Baron Martin
Graz, Neue Gal.
Graz, Neue Galerie

Grenoble, Mus. Grenoble
Grenoble, Musée de Grenoble
[formerly Mus. Peint. & Sculp.]
Grenoble, Mus. Peint. & Sculp.
Grenoble, Musée de Peinture et de
Sculpture [name changed to Mus.
Grenoble in 1986]
Grenoble, Mus. Stendhal
Grenoble, Musée Stendhal
The Hague, Gemeentemus.
The Hague, Haags
Gemeentemuseum [houses Oude
en Moderne Kunstnijverheid;
Haagse Stadgeschiedenis; Moderne
Kunst; Museon;
Muziekinstrumenten; Nederlands
Kostuummuseum]
The Hague, Mauritshuis [incl.
Koninklijk Kabinet van Schilderijen]
The Hague, Rijksms. Mesdag
The Hague, Rijksmuseum Hendrik
Willem Mesdag
Hamburg, Ksthalle
Hamburg, Hamburger Kunsthalle
[incl. Kupferstichkabinett]
Hamburg, Mus. Kst & Gew.
Hamburg, Museum für Kunst und
Gewerbe
Hannover, Wilhelm-Busch-Mus.
Hannover, Wilhelm-Busch-Museum
Hartford, CT, Wadsworth Atheneum
Indianapolis, IN, Mus. A.
Indianapolis, IN, Museum of Art
[incl. Clowes Fund Collection of
Old Master Paintings]
Ingelheim, Int. Tage
Ingelheim, Internationale Tage
[C. H. Boehringer Sohn annu.
exh.]
Ivry-sur-Seine, Dépôt Oeuvres A.
Ivry-sur-Seine, Dépôt des Oeuvres
d'Art de la Ville de Paris
Jarville, Mus. Hist. Fer
Jarville, Musée de l'Histoire
du Fer
Karlsruhe, Städt. Gal. Prinz-Max-Pal.
Karlsruhe, Städtische Galerie im
Prinz-Max-Palais
Kassel, Neue Gal.
Kassel, Neue Galerie [formerly
Bildergalerie]

La Chaux-de-Fonds, Mus. B.-A.
La Chaux-de-Fonds, Musée des
Beaux-Arts
La Fère, Mus. Jeanne d'Aboville
La Fère, Musée Jeanne d'Aboville
Langres, Mus. Du Breuil de St-Germain
Langres, Musée Du Breuil de St-
Germain [Hôtel Du Breuil de St-
Germain]
Langres, Mus. St-Didier
Langres, Musée St-Didier
La Rochelle, Mus. B.-A.
La Rochelle, Musée des Beaux-Arts
La Tour-de-Peilz, Château
Lausanne, Pal. Rumine
Lausanne, Palais Rumine [houses
Musée Botanique Cantonal; Musée
Cantonal d'Archéologie et
d'Histoire; Musée Cantonal des
Beaux-Arts; Musée Géologique
Cantonal; Lausanne, Musée
Historique, Cabinet des Médailles
du Canton de Vaud; Musée
Zoologique Cantonal]
Laval, Mus. Vieux-Château
Laval, Musée du Vieux-Château
Lawrence, U. KS, Spencer Mus. A.
Lawrence, KS, University of
Kansas, Spencer Museum of
Art
Le Havre, Mus. B.-A.
Le Havre, Musée des Beaux-Arts
Leipzig, Mus. Bild. Kst.
Leipzig, Museum der Bildenden
Künste
Le Mans, Mus. Tessé
Le Mans, Musée de Tessé [Musée
des Beaux-Arts]
Le Puy, Mus. Crozatier
Le Puy, Musée Crozatier [Jardin
Henri-Vinay]
Liège, Mus. B.-A.
Liège, Musée des Beaux-Arts
Lignières, Château Ussé
Lille, Acad.
Lille, Académie
Lille, Mus. B.-A.
Lille, Musée des Beaux-Arts [in
Palais des Beaux-Arts]
Limoges, Mus. Mun.
Limoges, Musée Municipal

Lisbon, Mus. Gulbenkian
Lisbon, Museu Calouste
Gulbenkian [Fundação Calouste
Gulbenkian]
Lisieux, Mus. Vieux-Lisieux
Lisieux, Musée du Vieux-Lisieux
London, Anthony Reed Gal.
London, Anthony Reed Gallery
London, BM
London, British Museum
London, Hayward Gal.
London, Hayward Gallery
London, Hazlitt, Gooden & Fox
London, Hazlitt, Gooden and Fox
London, N.G.
London, National Gallery
London, N. Mar. Mus.
London, National Maritime
Museum [Greenwich]
London, N.P.G.
London, National Portrait
Gallery
London, RA
London, Royal Academy of Arts
[Burlington House; houses RA
Archives & Library]
London, V&A
London, Victoria and Albert
Museum [houses National Art
Library]
London, Wallace
London, Wallace Collection
Lons-le-Saunier, Mus. B.-A.
Lons-le-Saunier, Musée des Beaux-
Arts
Los Angeles, CA, Co. Mus. A.
Los Angeles, CA, County Museum
of Art [incl. Robert Gore Rifkind
Center for German Expressionist
Studies]
Louisville, KY, Speed A. Mus.
Louisville, KY, J.B. Speed Art
Museum
Louviers, Mus. Mun.
Louviers, Musée Municipal de
Louviers
Lyon, Conserv. N. Sup. Musique
Lyon, Conservatoire National
Supérieur de Musique de Lyon
Lyon, Mus. B.-A.
Lyon, Musée des Beaux-Arts

Lyon, Mus. Hist.
Lyon, Musée Historique de Lyon
Mâcon, Mus. Mun. Ursulines
Mâcon, Musée Municipal des
Ursulines
Madison, U. WI, Elvehjem A. Cent.
Madison, WI, University of
Wisconsin, Elvehjem Art Center
Madrid, Pal. Liria, Col. Casa Alba
Madrid, Palacio Liria, Colección
Casa de Alba
Malmaison, Château N.
Malmaison, Château National de
Malmaison [houses Musée de
Malmaison]
Marseille, Mus. B.-A.
Marseille, Musée des Beaux-Arts
[Palais de Longchamp]
Marseille, Mus. Cantini
Marseille, Musée Cantini
Marseille, Mus. Mar & Econ.
Marseille, Musée de la Marine et
de l'Economie de Marseille [Musée
de la Marine de Marseille]
Meaux, Mus. Bossuet
Meaux, Musée Bossuet [Ancien
Palais Episcopal]
Melbourne, N.G. Victoria
Melbourne, National Gallery of
Victoria [Victorian A. Cent.]
Melun, Mus. Melun
Melun, Musée de Melun
Metz, Mus. A. & Hist.
Metz, Musée d'Art et d'Histoire
Milan, Ambrosiana
Milan, Pinacoteca Ambrosiana
Minneapolis, MN, Inst. A.
Minneapolis, MN, Minneapolis
Institute of Arts
Montargis, Mus. B.-A.
Montargis, Musée des Beaux-Arts
Montargis, Mus. Girodet
Montargis, Musée Girodet, Hôtel
de Ville
Montauban, Mus. Ingres
Montauban, Musée Ingres
Monte Carlo, Mus. N.
Monte Carlo, Musée National de
Monaco
Montpellier, Mus. Atger
Montpellier, Musée Atger

Paris, Fond. Custodia, Inst. Néer.
Paris, Fondation Custodia, Institut
Néerlandais [Frits Lugt Collection]
Paris, Gal. Cailleux
Paris, Galerie Cailleux
Paris, Gal. Charpentier
Paris, Galerie Charpentier
Paris, Gal. Delestre
Paris, Galerie Delestre
Paris, Gal. Druet
Paris, Galerie Druet
Paris, Gal. Dubourg
Paris, Galerie Dubourg
Paris, Gal. Jacques Seligmann
Paris, Galerie Jacques Seligmann
[closed]
Paris, Gal. Joseph Hahn
Paris, Galerie Joseph Hahn
Paris, Gal. Louis-le-Grand
Paris, Galerie Louis-le-Grand
[closed]
Paris, Gal. Pardo
Paris, Galerie Pardo
Paris, Gal. Petit
Paris, Galerie Petit [closed 1933]
Paris, Grand Pal.
Paris, Grand Palais [Galeries
Nationales d'Exposition du Grand
Palais]
Paris, Hôp. Salpêtrière
Paris, Hôpital de la Salpêtrière
Paris, Infirmerie Marie-Thérèse
Paris, Inst. France
Paris, Institut de France
Paris, Jard. Tuileries
Paris, Jardin des Tuileries
Paris, Louvre
Paris, Musée du Louvre
Paris, Louvre, Cab. Dessins
Paris, Musée du Louvre, Cabinet
des Dessins
Paris, Madeleine
Paris, La Madeleine
Paris, Min. Finances
Paris, Ministère des Finances
Paris, Mobilier N.
Paris, Mobilier National
Paris, Mus. A. Déc.
Paris, Musée des Arts Décoratifs
Paris, Mus. Armée
Paris, Musée de l'Armée

Paris, Mus. Cognacq-Jay
Paris, Musée Cognacq-Jay [in Hôtel
Donon]
Paris, Mus. Comédie-Fr.
Paris, Musée de la Comédie-
Française [Théâtre-Français]
Paris, Mus. Jacquemart-André
Paris, Musée Jacquemart-André
Paris, Mus. Luxembourg
Paris, Musée du Luxembourg
Paris, Mus. Mar.
Paris, Musée de la Marine [in Pal.
Chaillot]
Paris, Mus. Marmottan
Paris, Musée Marmottan
Paris, Mus. N. Hist. Nat.
Paris, Musée National d'Histoire
Naturelle
Paris, Mus. N. Légion d'Honneur
Paris, Musée National de la Légion
d'Honneur et des Ordres de
Chevalerie
Paris, Mus. N. Tech.
Paris, Musée National des
Techniques
Paris, Mus. Observatoire
Paris, Musée de l'Observatoire
Paris, Mus. Orangerie
Paris, Musée de l'Orangerie
Paris, Mus. Orsay
Paris, Musée d'Orsay
Paris, Mus. Renan-Scheffer
Paris, Musée Renan-Scheffer
Paris, Mus. Rodin
Paris, Musée Auguste Rodin
Paris, Mus. Victor Hugo
Paris, Musée Victor Hugo
Paris, Pal.-Bourbon
Paris, Palais-Bourbon [Assemblée
Nationale]
Paris, Pal. Indust.
Paris, Palais de l'Industrie
Paris, Pal. Justice
Paris, Palais de Justice
Paris, Pal. Luxembourg
Paris, Palais du Luxembourg
Paris, Pav. A.
Paris, Pavillon des Arts
Paris, Petit Pal.
Paris, Musée du Petit Palais
Paris, Resche

Parma, G.N.
Parma, Galleria Nazionale [in Pal.
Pilotta]
Pasadena, CA, Norton Simon Mus.
Pasadena, CA, Norton Simon
Museum
Pau, Château
Pau, Mus. B.-A.
Pau, Musée des Beaux-Arts
Pau, Mus. N. Château
Pau, Musée National du Château
de Pau
Périgueux, Mus. Périgord
Périgueux, Musée de Périgord
Perpignan, Mus. Rigaud
Perpignan, Musée Hyacinthe
Rigaud
Philadelphia, PA, Mus. A.
Philadelphia, PA, Museum of Art
Philadelphia, U. PA
Philadelphia, PA, University of
Pennsylvania
Phoenix, AZ, A. Mus.
Phoenix, AZ, Art Museum
Plombières-les-Bains, Mus. Louis
Français
Plombières-les-Bains, Musée Louis
Français
Poitiers, Mus. B.-A.
Poitiers, Musée des Beaux-Arts
Pont-de-Vaux, Mus. Chintreuil
Pont-de-Vaux, Musée Chintreuil
Portland, OR, A. Mus.
Portland, OR, Portland Art
Museum
Prague, N.G., Šternberk Pal.
Prague, National Gallery,
Šternberk Palace
Princeton U., NJ, A. Mus.
Princeton, Princeton University,
Art Museum
Providence, RI, Brown U.
Providence, RI, Brown
University
Providence, RI Sch. Des., Mus. A.
Providence, RI, Rhode Island
School of Design, Museum of
Art
Quimper, Mus. B.-A.
Quimper, Musée des Beaux-Arts de
Quimper

Tourcoing, Mus. Mun. B.-A.
Tourcoing, Musée Municipal des
Beaux-Arts
Tournai, Mus. B.-A.
Tournai, Musée des Beaux-Arts de
Tournai
Tours, Mus. B.-A.
Tours, Musée des Beaux-Arts
Troyes, Mus. B.-A. & Archéol.
Troyes, Musée des Beaux-Arts et
d'Archéologie
Turin, Pal. Reale
Turin, Palazzo Reale
Valence, Mus. B.-A. & Hist. Nat.
Valence, Musée des Beaux-Arts et
d'Histoire Naturelle
Valenciennes, Mus. B.-A.
Valenciennes, Musée des Beaux-
Arts
Varzy, Mus. Mun.
Varzy, Nièvre, Musée Municipal de
Varzy
Versailles, Mus. Hist.
Versailles, Musée d'Histoire [in
Château]
Versailles, Mus. Lambinet
Versailles, Musée Lambinet
Versailles, Petit Trianon

Vienna, Albertina
Vienna, Graphische Sammlung
Albertina
Vienna, Ksthist. Mus.
Vienna, Kunsthistorisches
Museum [admins Ephesos Mus.;
Ksthist. Mus.; Mus. Vlkerknd.;
Nbib.; Neue Gal. Stallburg; Samml.
Musikinstr.; Schatzkam.; houses
Gemäldegalerie; Neue Hofburg;
Kunstkammer; Sammlung für
Plastik und Kunstgewerbe]
Vizille, Mus. Révolution Fr.
Vizille, Musée de la Révolution
Française [in Château Vizille]
Warsaw, N. Mus.
Warsaw, National Museum
(Muzeum Narodowe)
Washington, DC, Corcoran Gal. A.
Washington, DC, Corcoran Gallery
of Art
Washington, DC, Lib. Congr.
Washington, DC, Library of
Congress
Washington, DC, N.G.A.
Washington, DC, National Gallery
of Art
Weimar, Goethe-Nmus.

Weimar, Goethe-Nationalmuseum
[Nationale Forschungs- und
Gedenkstätten der Klassischen
Deutschen Literatur in Weimar]
Weimar, Thüring. Landesbib.
Weimar, Thüringische
Landesbibliothek [Grüne Schloss]
Williamstown, MA, Clark A. Inst.
Williamstown, MA, Sterling and
Francine Clark Art Institute
Windsor Castle, Royal Lib.
Windsor, Windsor Castle, Royal
Library
Winterthur, Kstmus.
Winterthur, Kunstmuseum
Winterthur
Winterthur, Samml. Oskar Reinhart
Winterthur, Sammlung Oskar
Reinhart [am Römerholz]
Worcester, MA, A. Mus.
Worcester, MA, Worcester Art
Museum
Zidlochovice Mus.
Fidlochovice, Fidlochovice
Museum (Fidlochovice Mistní
Muzeum)
Zurich, Ksthaus
Zurich, Kunsthaus Zürich

Appendix B
LIST OF PERIODICAL TITLES

This list contains all of the periodical titles that have been cited in an abbreviated form in italics in the bibliographies of this book. For the sake of comprehensiveness, it also includes entries of periodicals that have not been abbreviated, for example where the title consists of only one word or where the title has been transliterated. Abbreviated titles are alphabetized letter by letter, including definite and indefinite articles but ignoring punctuation, bracketed information and the use of ampersands. Roman and arabic numerals are alphabetized as if spelt out (in the appropriate language), as are symbols. Additional information is given in square brackets to distinguish two or more identical titles or to cite a periodical's previous name.

A. America
 Art in America [cont. as *A. America & Elsewhere; A. America*]
A. & Artistes
 Art et les artistes
A. Basse-Normandie
 Art de Basse-Normandie
A. Bull.
 Art Bulletin
A. Hist.
 Art History
A. J. [London]
 Art Journal [London]
A. J. [New York]
 Art Journal [New York; prev. pubd as *Coll. A. J.; Parnassus*]
A. Mag.
An. Bourgogne
 Annales de Bourgogne
An. Monég.
 Annales monégasques
Antol. B.A.
 Antologia di belle arti
Apollo
Archit. Dig.
 Architectural Digest
Archit. Rev. [London]
 Architectural Review [London]
Archvs A. Fr.
 Archives de l'art français [cont. as *Nouv. Archvs A. Fr.; Archvs A. Fr.*]
Artforum
ARTnews
ARTnews Annu.
 ARTnews Annual
Artsmag

Art-Union
Atlantic Mthly
 Atlantic Monthly: Devoted to Literature, Art and Politics
Auvergne Litt.
A. VA
 Arts in Virginia
Baltimore Annu.
 Baltimore Annual
Bull. Amis Gustave Courbet
 Bulletin des amis de Gustave Courbet
Bull. Archéol. Cté Trav. Hist. & Sci.
 Bulletin archéologique du Comité des travaux historiques et scientifiques
Bull. Assoc. Guillaume Budé
 Bulletin de l'Association Guillaume Budé
Bull. B.-A.
 Bulletin des beaux-arts
Bull. Cleveland Mus. A.
 Bulletin of the Cleveland Museum of Art
Bull. Club Fr. Médaille
 Bulletin du Club français de la médaille
Bull. Detroit Inst. A.
 Bulletin of the Detroit Institute of Arts
Bull. LA Co. Mus. A.
 Bulletin of the Los Angeles County Museum of Art
Bull. Mém. Soc. Archéol. Bordeaux
 Bulletin et mémoires de la Société archéologique de Bordeaux

Bull. Met.
 Bulletin of the Metropolitan Museum of Art
Bull. Mnmtl
 Bulletin monumental
Bull. Mus. Augustins
 Bulletin du Musée des Augustins
Bull. Mus. Carnavalet
 Bulletin du Musée Carnavalet
Bull. Mus. Dijon
 Bulletin des musées de Dijon
Bull. Mus. France
 Bulletin des musées de France
Bull. Mus. Ingres
 Bulletin du Musée Ingres
Bull. Mus. & Mnmts Lyon.
 Bulletin des musées et monuments lyonnais
Bull.: Philadelphia Mus. A.
 Bulletin: Philadelphia Museum of Art [prev. pubd as *Philadelphia Mus. A.: Bull.; PA Mus. Bull.*]
Bull. Soc. Antiqua. Ouest
 Bulletin de la Société des antiquaires de l'Ouest
Bull. Soc. Archéol. Midi France
 Bulletin de la Société archéologique du Midi de la France
Bull. Soc. Archéol. Tarn-et-Garonne
 Bulletin de la Société archéologique de Tarn-et-Garonne
Bull. Soc. Hist. A. Fr.
 Bulletin de la Société de l'histoire de l'art français

Burl. Mag.
Burlington Magazine
Byblis
Centbl. Bibwsn
Centralblatt für Bibliothekswesen
Chron. A. & Curiosité
Chronique des arts et de la
curiosité [cont. as Beaux-A.:
Chron. A. & Curiosité; Arts
[Paris]]
Conn. A.
Connaissance des arts
Connoisseur
Country Life
Crit. Inq.
Critical Inquiry
Currier Gal. A. Bull.
Currier Gallery of Art Bulletin
Die Weltkunst
Doss. Archéol.
Dossiers de l'archéologie [prev.
pubd as Doc. Archeol.; cont. as
Hist. & Archéol.]
Etud. A.
ii) Etudes de l'art [Musée national
des beaux-arts d'Alger]
Etud. Rev. Louvre
Etudes de la revue du Louvre
F.A.Q.
Fine Arts Quarterly
Gaz. B.-A.
Gazette des beaux-arts [suppl. is
Chron. A.]
Hist. & Crit. A.
Histoire et critique des arts
Inf. Hist. A.
Information d'histoire de l'art
Jard. A.
Jardin des arts
J. Artistes
Journal des artistes
Jb. Bern. Hist. Mus.
Jahrbuch des Bernischen
historischen Museums
J. Soc. Pop. & Répub. A.
Journal de la Société populaire et
républicaine des arts
J. Walters A.G.
Journal of the Walters Art
Gallery

J. Warb. & Court. Inst.
Journal of the Warburg and
Courtauld Institutes [prev. pubd as
J. Warb. Inst.]
Ksthist. Tidskr.
Konsthistorisk tidskrift [Art
historical magazine]
Kunstchronik
La Renaissance
L'Art
L'Art: Revue hebdomadaire
illustrée
L'Artiste
Lett. & A.
Lettres et les arts
Lett. Fr.
Lettres françaises
Mag. A.
Magazine of Art [incorp. suppl. RA
Illus. until 1904]
Mag. Enc.
Magazine encyclopédique
Mag. Pittoresque
Magazine pittoresque
Médec. Fr.
Médecine de France
Mél. Ecole Fr. Rome: Moyen Age,
Temps Mod.
Mélanges de l'Ecole française de
Rome: Moyen âge, temps
modernes
Mém. Acad. Sci., A. & B.-Lett.
Dijon
Mémoires de l'Académie des
sciences, arts et belles-lettres de
Dijon
Mém. Acad. Sci., B.-Lett. & A.
Clermont-Ferrand
Mémoires de l'Académie des
sciences, belles-lettres et arts de
Clermont-Ferrand
Mém. Soc. Eduenne
Mémoires de la Société
éduenne
Minneapolis Inst. A. Bull.
Minneapolis Institute of Arts
Bulletin
Minotaure
Minotaure: Revue artistique et
littéraire

Mitt. Ges. Vervielfält. Kst
Mitteilungen der Gesellschaft
für vervielfältigende Kunst [prev.
pubd as Chron. Vervielfält.
Kst]
Mnmts Hist. France
Monuments historiques de la
France [cont. as Mnmts Hist.]
Münchn. Jb. Bild. Kst
Münchner Jahrbuch der bildenden
Kunst
Mus. Ferrar.: Boll. Annu.
Musei ferraresi: Bollettino
annuale
Mus. France
Musées de France
Mus. Stud.
Museum Studies [Art Institute of
Chicago]
N.G. Canada Bull.
National Gallery of Canada
Bulletin
Nouv. Archvs A. Fr.
Nouvelles archives de l'art
français [prev. pubd as & cont. as
Archvs A. Fr.]
Nouv. Est.
Nouvelles de l'estampe
Nouv. Rev. Rétro.
Nouvelle Revue rétrospective
Oxford A. J.
Oxford Art Journal
Pantheon
Pantheon: Internationale
Zeitschrift für Kunst [cont. as
Bruckmanns Pantheon]
Pap. Amer. Assoc. Archit.
Bibliographers
Papers of the American
Association of Architectural
Bibliographers
Pays Ange
Pays d'Ange
Pays Lorrain
Portfolio [London]
Prt Colr/ Conoscitore Stampe
Print Collector/Il conoscitore di
stampe
Prt Colr Newslett.
Print Collector's Newsletter

Appendix C
LISTS OF STANDARD REFERENCE BOOKS AND SERIES

This Appendix contains, in alphabetical order, the abbreviations used in bibliographies for alphabetically arranged dictionaries and encyclopedias. Some dictionaries and general works, especially dictionaries of national biography, are reduced to the initial letters of the italicized title (e.g. *DNB*) and others to the author/editor's name (e.g. Colvin) or an abbreviated form of the title (e.g. *Contemp. Artists*). Abbreviations from Appendix C are cited at the beginning of bibliographies or bibliographical subsections, in alphabetical order, separated by semi-colons; the title of the article in such reference books is cited only if the spelling or form of the name differs from that used in this dictionary or if the reader is being referred to a different subject.

Bauchal
C. Bauchal: *Nouveau dictionnaire biographique et critique des architectes français* (Paris, 1887)

Bellier de La Chavignerie-Auvray
E. Bellier de La Chavignerie and L. Auvray: *Dictionnaire général des artistes de l'Ecole française depuis l'origine des arts du dessin jusqu'à nos jours*, 2 vols (Paris, 1882-5), suppl. (Paris, 1887)

Bénézit
E. Bénézit, ed.: *Dictionnaire critique et documentaire des peintres, sculpteurs, dessinateurs et graveurs*, 10 vols (Paris, 1913-22, rev. 3/1976)

DBF
Dictionnaire de biographie française (Paris, 1933-)

Hoefer
F. Hoefer, ed.: *Nouvelle biographie générale depuis les temps plus reculés jusqu'à nos jours, avec les renseignements bibliographiques et l'indication des sources à consulter*, 46 vols (Paris, 1853-66/R Copenhagen, 1963-9)

Lami
S. Lami: *Dictionnaire des sculpteurs de l'Ecole française*, 8 vols (Paris, 1898-1921/R Nendeln, 1970)

Mariette
P.-J. Mariette: 'Abecedario de P.-J. Mariette et autres notes inédites de cet amateur sur les arts et les artistes', *Archv A. Fr.*, ii (1851-3), iv (1853-4), vi (1854-6), viii (1857-8), x (1858-9), xii (1859-60)

Michaud
L.-G. Michaud, ed.: *Biographie universelle ancienne et moderne*, 84 vols (Paris, 1811-57)

Portalis-Beraldi
R. Portalis and H. Beraldi: *Les Graveurs du dix-huitième siècle*, 3 vols (Paris, 1880-82)

Souchal
F. Souchal, ed.: *French Sculptors of the 17th and 18th Centuries: The Reign of Louis XIV* (Oxford, 1977-)

Thieme-Becker
U. Thieme and F. Becker, eds: *Allgemeines Lexikon der bildenden Künstler von der Antike bis zur Gegenwart*, 37 vols (Leipzig, 1907-50)